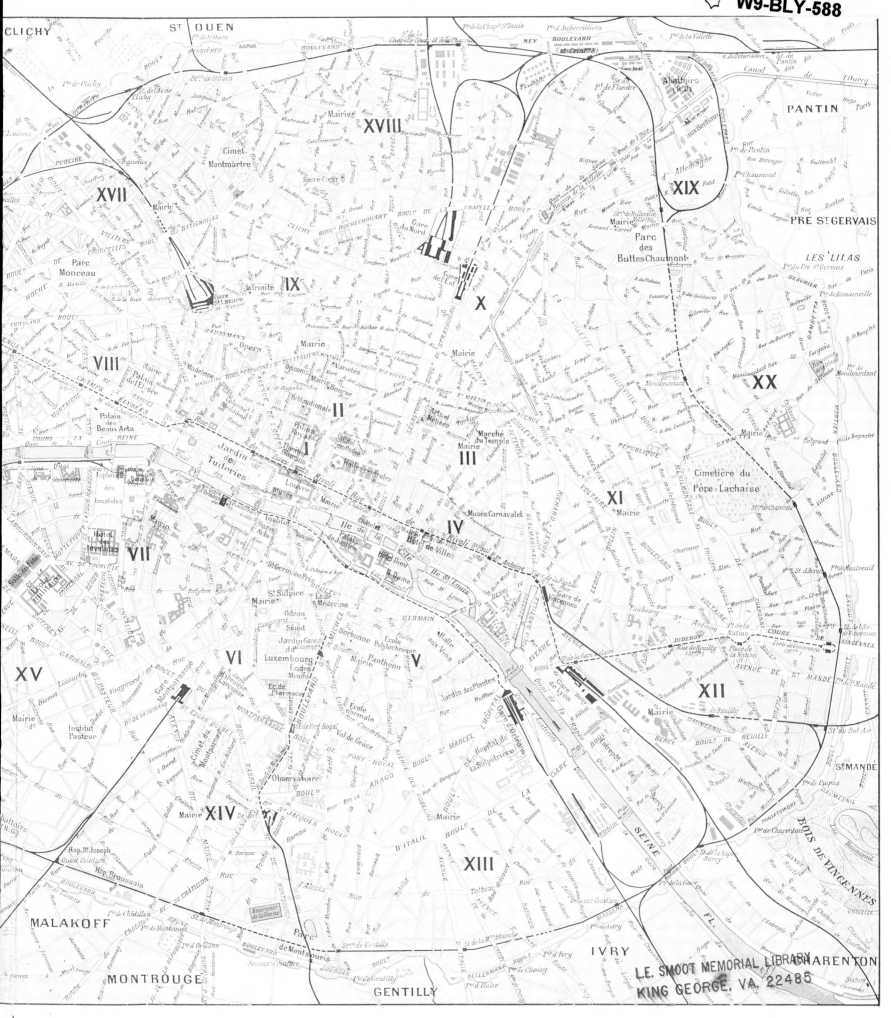

IMPRESSIONISM
Art, Leisure, and Parisian Society

Yale University Press · New Haven & London · 1988

Robert L. Herbert

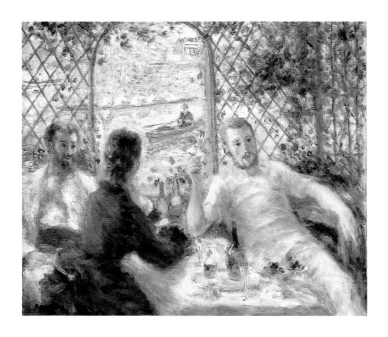

Impressionism

Art, Leisure, and Parisian Society

For Meyer Schapiro

Designed by Gillian Malpass
Set in Linotron Bembo and Goudy Old Style by
Best-set Typesetter Ltd, Hong Kong
Printed in Italy by Amilcare Pizzi S.p.A., Milan

Frontispiece: Renoir, *The Canoeists' Luncheon*, 1879–80, Art Institute
of Chicago (Pl. 250).
Endpapers: *A. Levy, Plan of Paris*. Engraving from Fernand
Bournon, *Paris-Atlas*, 1900.

Library of Congress Cataloging-in-Publication Data

Herbert, Robert L., 1929–
 Impressionism: art, leisure, and Parisian society.

 Bibliography: p.
 Includes index.
 1. Impressionism (Art)—France—Paris.
2. Painting, France—France—Paris. 3. Painting,
Modern—19th century—France—Paris. 4. Painters—
France—Paris—Biography. 5. Paris (France)—
Biography. 6. Paris (France)—Social life and
customs—19th century. 7. Leisure in art.
8. Amusements in art. I. Title.
ND550.H47 1988 759.4′361 87-24967
ISBN 0-300-04262-0

Contents

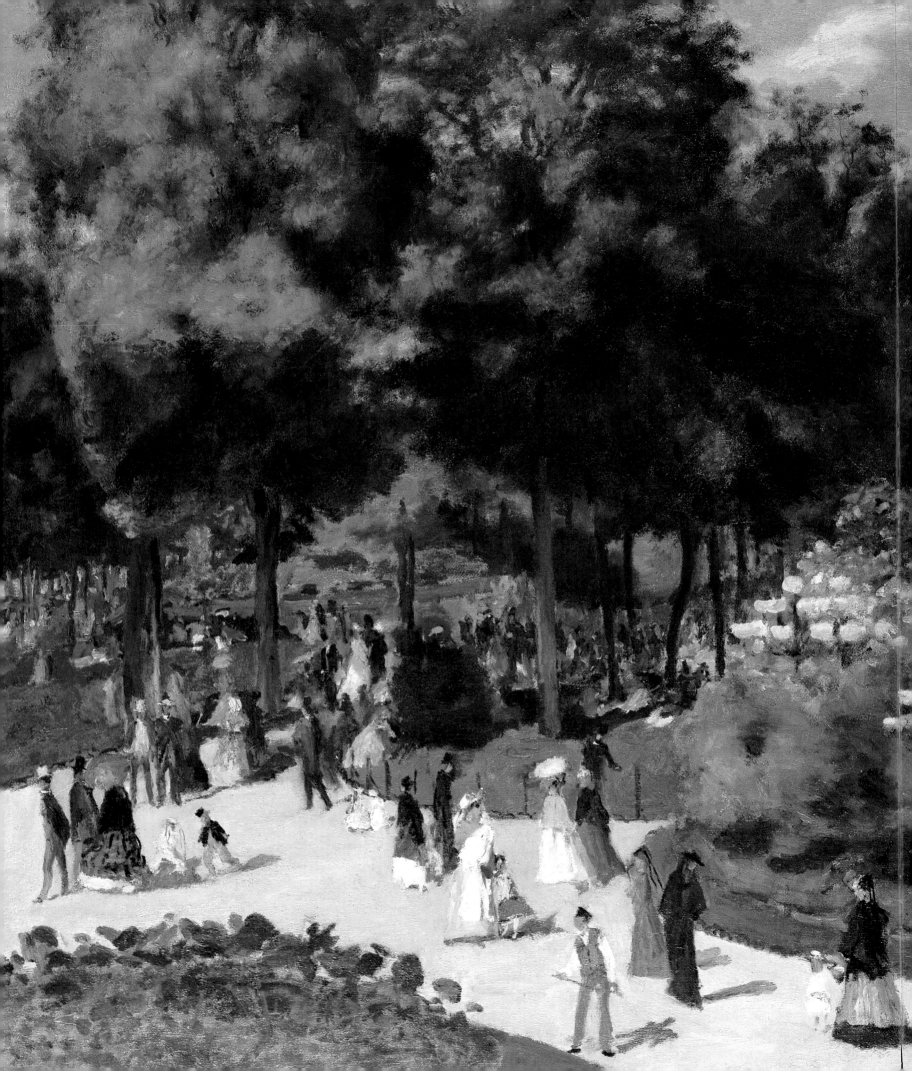

Acknowledgments

The origins of this book go back to my lectures at Yale University in the early 1960s, but I began writing it only in 1982. Its genesis was slow because of my teaching duties and other publications that I had undertaken in the intervening years. Thanks to a Guggenheim Fellowship in 1972 I was able to devote a year to extensive reading in the history of Paris and its environs, material that entered my courses long before I was able to work on this book. In 1978 I took the occasion of the Slade Lectures at the University of Oxford to divide the subject into manageable units, substantially as they now appear. Finally, thanks to Yale University's generous leave policy and to a Humanities Fellowship from the Rockefeller Foundation, I was able to complete most of the writing in 1986. I am truly grateful to Yale, the Guggenheim Foundation, my hosts at Oxford (particularly Francis Haskell), and the Rockefeller Foundation for their support.

I want to give special thanks to the many students who offered their skepticism as well as their encouragement when they heard my lectures or shared in seminars and informal discussions. These include the advanced readers at Oxford when I was there in 1978, and the graduate students at Yale over the past twenty-five years or more. I cannot here name them individually, but I wish to record a collective debt that mingles affection with admiration.

Among colleagues from who I have learned so much over the years I must single out Susanna Barrows, George Heard Hamilton, Anne Hanson, John McCoubrey, John Merriman, Daniel Robbins, Vincent Scully, and Richard Shiff. My manuscript was read in its entirety by Eugenia Herbert and Richard Shiff, and portions by Moshe Barasch, Michael Burns, and Judith Metro; I greatly appreciate their advice. My editor John Nicoll took an interest in the book in 1978 and ever since has been unfailingly generous. Gillian Malpass designed this book and watched over its every detail with wonderful efficiency, and Juliet Thorp collected photographs with unflagging zeal; they both share largely in whatever merits this book has.

For various arrangements, photographs, and information, I am grateful to the Acquavella Galleries, Thos. Agnew & Sons, Ruth Berson, François Caradec, Jacques Caumont, Philip Conisbee, Anne Distel, Sarah Faunce, Dick Fish, Henrietta Gough, Jennifer Gough-Cooper, Anne Higonnet, John House, the Lefevre Gallery, Stefanie Maison, Mark Murray, Dr. Peter Nathan, Elizabeth Peterkin, Lord Poltimore, David Richards, George Shackelford, Polly J. Sartori, Robert Schmit, Richard Thomson, Paul Tucker, Kirk Varnedoe, and Wildenstein & Co.

I have used many libraries and museums and wish to give warm thanks to the following: Helen Chillman, Librarian of Slides and Photographs, and Nancy Lambert, Art Librarian, at Yale University; Karen Harvey, Librarian of the Hillyer Library, Smith College; Elizabeth Jones, Conservator, and Alexandra Murphy, Curator, at the Boston Museum of Fine Arts when I consulted them; Philip S. Vainker, at the Burrell Collection, Glasgow; Daniel Rosenfeld and Lora Urbanelli, at the Rhode Island School of Design.

For the history and interpretation of Impressionism my most substantial debts are owed to the many authors I acknowledge in my bibliography. Among earlier writers I should mention particularly Meyer Schapiro, Georg Simmel, and Siegfried Kracauer. Among more recent writers, I am especially beholden to Françoise Cachin, Timothy J. Clark, John House, Joel Isaacson, Linda Nochlin, Theodore Reff, John Rewald, Richard Shiff, Paul Tucker, and Raymond Williams.

For her historian's perspectives, her wisdom, her patience, and her companionship, Eugenia W. Herbert is the person to whom I owe the most.

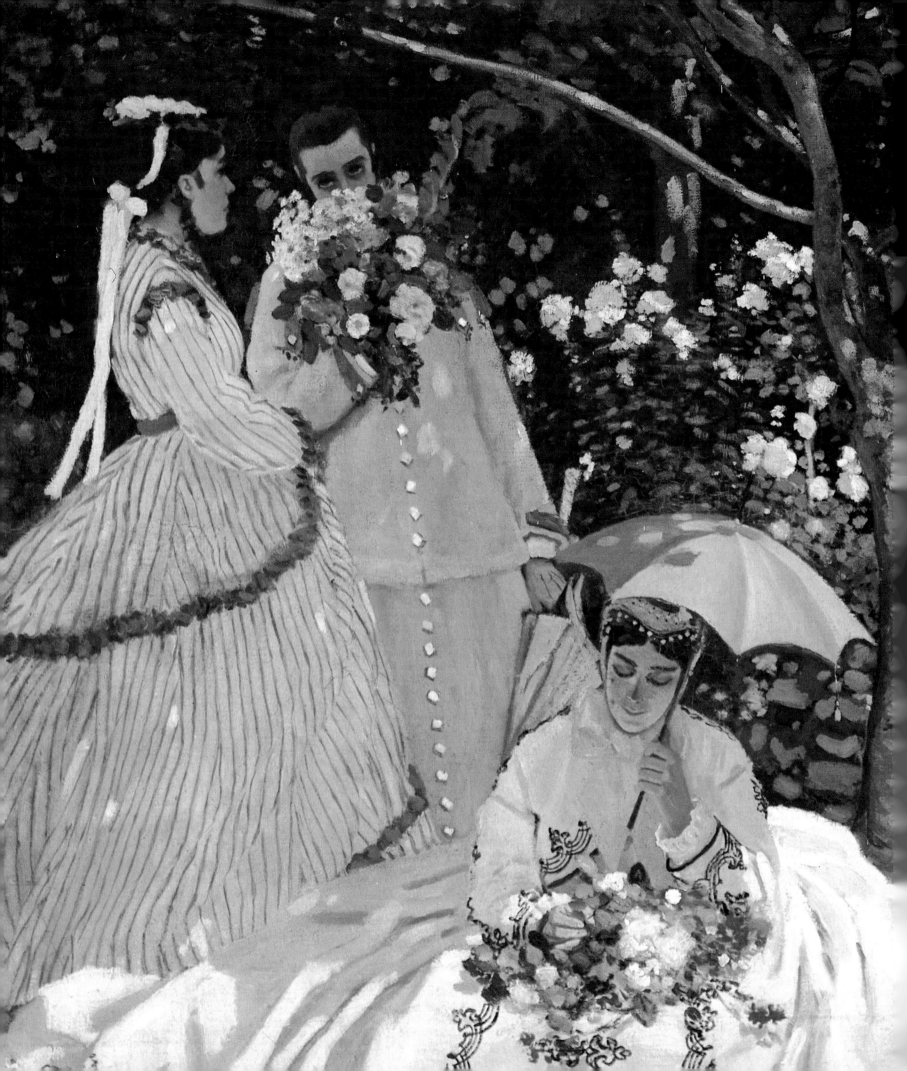

Illustrations

Paris is understood as the place of publication, and the medium is oil painting, unless otherwise stated. Dimensions are given in centimetres.

1. Monet, detail of *Garden of the Princess* (Pl. 14).
2. Charles Marville, *The Rue des Sept Voies*, before 1862. Photograph, 31.4 × 26.8. Paris, Musée Carnavalet.
3. *The Avenue de l'Opéra.* Photograph from Fernand Bournon, *Paris-Atlas*, 1900, p. 7.
4. Philippe Benoist after Hoffbauer, *The Petit Pont as it appeared c. 1830.* Color lithograph from Fédor (T.J.H.) Hoffbauer, *Paris à travers les âges*, vol. 2, 1882, pl. IV.
5. A. de Bayalos after Hoffbauer, *The Petit Pont as it appeared c. 1880.* Color lithograph from Fédor (T.J.H.) Hoffbauer, *Paris à travers les âges*, vol. 2, 1882, pl. V.
6. *The Paris World's Fair, 1867.* Unsigned engraving from L. Dubech and P. d'Espézel, *Histoire de Paris*, 2 vols., 1931, vol. 2, p. 162.
7. Manet, *View of the Paris World's Fair*, 1867. 108 × 196. Oslo, National Museum.
8. Renoir, *The Champs-Elysées during the Paris Fair of 1867*, 1867. 76 × 130. Private collection. Photograph courtesy of Wildenstein & Co.
9. Renoir, *Le Pont des Arts*, 1867. 62 × 102. Los Angeles, The Norton Simon Foundation.
10. Renoir, detail of *Le Pont des Arts* (Pl. 9).
11. Alexandre Decamps, *Job and his Friends*, c. 1855. 119.4 × 85.7. Minneapolis Institute of Arts. Gift of Mrs. Erasmus C. Lindley.
12. Monet, *Saint-Germain l'Auxerrois*, 1867. 79 × 98. Berlin, Nationalgalerie, Staatliche Museen Preussischer Kulturbesitz.
13. Monet, *The Quai du Louvre*, 1867. 65.5 × 93. The Hague, Haags Gemeentemuseum.
14. Monet, *Garden of the Princess*, 1867. 91 × 62. Oberlin, Allen Memorial Art Museum. Gift R.T. Miller, Jr. Fund, 48.296.
15. Philippe Benoist, *View of Paris from the Louvre.* Lithograph from Armand Audiganne and P. Bailly, *Paris dans sa splendeur*, 2 vols., 1863, vol. 2, pl. 60.
16. Manet, *The Barricade*, c. 1871. Lithograph, 46.5 × 33.4. Courtesy, Museum of Fine Arts, Boston.
17. *Plan of Paris from the Louvre to the Gare Saint-Lazare.* Detail of engraving, Ward, Lock & Co., from Karl Baedeker, *Paris and Environs*, Leipzig 1891, frontispiece.
18. Monet, *Boulevard des Capucines*, 1873. 61 × 80. Moscow, Pushkin Museum.
19. *The Grand Hôtel under construction, c. 1860.* Unsigned engraving from Lucien Dubech and P. d'Espézel, *Histoire de Paris*, 2 vols., 1931, vol. 2, p. 150.
20. Renoir, *The Great Boulevards*, 1875. 50 × 61. Philadelphia Museum of Art, Henry P. McIlhenny Collection.
21. *The Grand Hôtel.* Unsigned engraving from Adophe Joanne, *Le Guide Parisien*, 1863, p. 13.
22. Jean Béraud, *Paris, On the Boulevard*, c. 1878–82. 64 × 80. Collection unknown. Photograph courtesy of Sotheby's.
23. Caillebotte, *The Man at the Window*, 1876. 117.3 × 82.8. Private collection.
24. Caillebotte, *The House Painters*, 1877. 87 × 116. Private collection.
25. Caillebotte, detail of *The Man at the Window* (Pl. 23).
26. Caillebotte, *Paris, A Rainy Day*, 1877. 209 × 300. The Art Institute of Chicago, Charles H. and Mary F.S. Worcester Fund.
27. Caillebotte, *Le Pont de l'Europe*, 1876. 131 × 181. Geneva, Musée du Petit Palais.
28. Monet, *Le Pont de l'Europe*, 1877. 64 × 81. Paris, Musée Marmottan.
29. Monet, *Gare Saint-Lazare*, 1877. 75.5 × 104. Musée d'Orsay.
30. Monet, detail of *Gare Saint-Lazare* (Pl. 29).
31. Manet, *The Railroad*, 1873. 93 × 114. National Gallery of Art, Washington. Gift of Horace Havemeyer in memory of his mother, Louisine W. Havemeyer.

32. Manet, *The Rue Mosnier*, 1878. Pencil and ink, 27.6 × 44.2. The Art Institute of Chicago. Given by Alice H. Patterson in memory of Tiffany Blake, 1945.15.
33. Manet, *Street Pavers, Rue Mosnier*, 1878. 64.5 × 81.5. Private collection. Photograph courtesy of Christie's.
34. Manet, *The Rue Mosnier Decked Out in Flags*, 1878. 65 × 81. Private collection, Switzerland.
35. Manet, *The Rue Mosnier Decorated with Flags*, 1878. 64.8 × 80. From the collection of Mr. and Mrs. Paul Mellon, Upperville, Virginia.
36. Degas, *James Tissot*, 1868. 151 × 112. Metropolitan Museum of Art. Rogers Fund, 1939.
37. Degas, *The Place de la Concorde*, 1875. 79 × 118. Presumably destroyed during World War II. From Emil Waldmann, *Die Kunst des Realismus and des Impressionismus*, Propylaen Kunstgeschichte vol. 15, Berlin 1927, pl. 42.
38. Manet, *The Street Singer*, c. 1862. 175.2 × 108.5. Courtesy, Museum of Fine Arts, Boston. Bequest of Sarah Choate Sears in memory of her husband.
39. Manet, *The Balloon*, 1862. Lithograph, 40.3 × 51.5. New York Public Library.
40. Jules Lefebvre, *Autumn*, 1883. 137 × 86.5. Private collection. Photograph courtesy of Christie's.
41. Manet, *Music in the Tuileries*, 1862. 76 × 118. Reproduced by courtesy of the Trustees, The National Gallery, London.
42. Manet, detail of *Music in the Tuileries* (Pl. 41).
43. Daumier, *Friends (What a fortunate encounter . . .).* Lithograph from *Le Charivari*, 12–13 May 1845. New Haven, Yale University Art Gallery.
44. Degas, *Edmond Duranty*, 1879. 100.9 × 100.3. The Burrell Collection, Glasgow Museums and Art Galleries.
45. Degas, *Diego Martelli*, 1879. 110 × 100. Edinburgh, National Gallery of Scotland.
46. Jean-Dominique Ingres, *Monsieur Bertin*, 1832. 116 × 95. Musée du Louvre.
47. Degas, *Women on a Café Terrace, Evening*, 1877. Pastel over monotype, 41 × 60. Musée d'Orsay.
48. Morisot, *Interior*, 1872. 60 × 73. Private collection.
49. Cassatt, *Cup of Tea*. 1880. 64.7 × 92.7. Courtesy, Museum of Fine Arts, Boston. M. Theresa B. Hopkins Fund.
50. Caillebotte, *Interior, Woman at the Window*, 1880. 116 × 89. Private collection.
51. Degas, *Edmond and Thérèse (Degas) Morbilli*, 1867. 117.5 × 90. Courtesy, Museum of Fine Arts, Boston. Gift of Robert Treat Paine, 2nd.
52. Degas, *Interior*, c. 1868–69. 81 × 116. Philadelphia Museum of Art, Henry P. McIlhenny Collection.
53. Daumier, *The Print Collector*, c. 1860. 40 × 32. Paris, Musée du Petit Palais.
54. Degas, *The Print Collector*, 1866. 52 × 39. Metropolitan Museum of Art. Bequest of Mrs. H.O. Havemeyer, 1929. The H.O. Havemeyer Collection. (29.100.44).
55. Degas, *Portraits in an Office, New Orleans*, 1873. 73 × 92. Pau, Musée municipal.
56. Degas, *Portraits, At the Stock Exchange*, 1879. 100 × 82. Musée d'Orsay.
57. Degas, detail of *Portraits, At the Stock Exchange* (Pl. 56).
58. Degas, *Sulking*, c. 1873. 32.4 × 46.4. Metropolitan Museum of Art. Bequest of Mrs. H.O. Havemeyer, 1929. The H.O. Havemeyer Collection. (20.100.43).
59. Degas, *Woman with Chrysanthemums*, 1865. 74 × 92. Metropolitan Museum of Art. Bequest of Mrs. H.O. Havemeyer, 1929. The H.O. Havemeyer Collection. (29.100.128).
60. Degas, *The Loge*, 1880. Pastel, 66 × 53. Washington, D.C., Mr. Paul Nitze.
61. Degas, detail of *Aux Ambassadeurs* (Pl. 83).
62. Manet, *Olympia*, 1863. 130.5 × 190. Musée d'Orsay.
63. Manet, *The Execution of Maximilian*, 1868. 252 × 305. Mannheim,

Stadtische Kunsthalle.

64. Manet, *The Ragpicker*, 1869. 195 × 130. Los Angeles, The Norton Simon Foundation.

65. Manet, *The Old Musician*, 1862. 187.4 × 248.3. National Gallery of Art, Washington. Chester Dale Collection.

66. Manet, *Woman Reading in a Café*, 1879. 61.7 × 50.7. The Art Institute of Chicago. Mr. & Mrs. Lewis Larned Coburn Memorial Collection, 1933.435.

67. Manet, *Chez le Père Lathuille*, 1879. 93 × 112. Tournai, Musée des Beaux-Arts.

68. *An Arbor at Père Lathuille.* Unsigned engraving from Edmond Texier, *Tableau de Paris*, 2 vols., 1852, vol. 2, p. 332.

69. Adriaen van Ostade, *Peasant Couple*, 1653. Panel, 27.3 × 22.1. Reproduced by courtesy of the Trustees, The National Gallery, London.

70. Manet, *At the Café*, 1878. 77 × 83. Oskar Reinhart Collection, Winterthur.

71. Manet, detail of *At the Café* (Pl. 70).

72. Renoir, *The Little Café*, c. 1877. 35 × 28. Collection: State Museum Kröller-Müller, Otterlo, The Netherlands.

73. Renoir, *The End of the Lunch*, 1879. 100 × 81. Frankfurt, Stadelsches Kunstinstitut.

74. Ernest Ange Duez, *Paris, Au Restaurant le Doyen*, 1878. 88 × 114. Collection unknown. Photograph courtesy of Sotheby's.

75. Manet, *The Plum*, c. 1878. 73.6 × 50.2. National Gallery of Art, Washington. Collection of Mr. & Mrs. Paul Mellon.

76. Degas, *Absinthe*, 1876. 92 × 68. Musée d'Orsay.

77. Manet, *Corner in a Café-Concert*, 1878–79. 98 × 79. Reproduced by courtesy of the Trustees, The National Gallery, London.

78. Manet, *Café-Concert*, 1878. 47.5 × 30.2. Baltimore, Walters Art Gallery.

79. Jules Chéret, *Aux Folies-Bergère*, 1875. Poster. Paris, Museé de la publicité.

80. Manet, *A Bar at the Folies-Bergère*, 1881–82. 96 × 130. Courtauld Institute Galleries, London (Courtauld Collection).

81. Degas, *The Impresario*, c. 1876–77. 48.9 × 35.6. By permission of The Fine Arts Museums of San Francisco. Gift of Mr. & Mrs. Louis A. Benoist.

82. Degas, *Aux Ambassadeurs: Mlle Bécat*, c. 1877. Lithograph, 20.5 × 19.3. The Art Institute of Chicago. William McCallin McKee Memorial Collection, 1932.1296.

83. Degas, *Aux Ambassadeurs*, 1877. Pastel over monotype, 37 × 27. Lyon, Musée des Beaux-Arts.

84. Degas, *La Chanson du chien*, c. 1875–78. Pastel over monotype. 55 × 45. Collection unknown.

85. Degas, *Café-Concert*, c. 1877. Pastel over monotype, 24.1 × 44.5. In the collection of the Corcoran Gallery of Art, Washington. William A. Clark Collection.

86. Roman Ribéra, *Café-Chantant*, 1876. 24 × 31.7. In the collection of the Corcoran Gallery of Art, Washington.

87. Degas, detail of *La Chanson du chien* (Pl. 84).

88. Degas, *The Glove*, c. 1878. Pastel on canvas, 53 × 41. Cambridge, Harvard University Art Museums (Fogg Art Museum). Bequest – Collection of Maurice Wertheim, Class of 1906.

89. Degas, *Café-Concert (Spectators)*, c. 1875–78. Pastel over monotype, 21 × 43. Collection unknown.

90. Renoir, *The Loge*, 1874. 80 × 63.5. Courtauld Institute Galleries, London (Courtauld Collection).

91. Degas, *The Orchestra of the Opéra*, 1868–69. 56.5 × 46.2. Musée d'Orsay.

92. Manet, *The Spanish Ballet*, 1862. 61 × 91. Washington, Phillips Collection.

93. Manet, *Lola de Valence*, 1862 (later reworked). 123 × 92. Musée d'Orsay.

94. Manet, *Lola de Valence*, 1862. Lithograph, 29.5 × 24. Paris, Bibliothèque nationale, Cabinet des estampes.

95. Manet, *The Tragic Actor*, 1865–66. 187.2 × 108.1. National Gallery of Art, Washington. Gift of Edith Stuyvesant Gerry.

96. Abel Damourette, *At the Opéra* and *At the Théâtre français*. Engravings from Edmond Texier, *Tableau de Paris*, 2 vols., 1852, vol. 1, p. 8.

97. Renoir, *The First Outing*, 1875–76. 64.8 × 50.2. Reproduced by courtesy of the Trustees, The National Gallery, London.

98. Cassatt, *Woman in Black at the Opera*, c. 1879. 80 × 64.8. Courtesy, Museum of Fine Arts, Boston. Charles Henry Hayden Fund.

99. Cassatt, drawing for *Woman in Black at the Opera*, c. 1879. Crayon, 10.2 × 15.3. Courtesy, Museum of Fine Arts, Boston.

100. Renoir, *At the Concert*, 1880. 99.2 × 80.6. Sterling and Francine Clark Art Institute, Williamstown, Massachusetts.

101. Cassatt, *Two Young Women in a Loge*, 1882. 80 × 64. National Gallery of Art, Washington. Chester Dale Collection.

102. Degas, *Dancer with a Bouquet, Seen from a Loge*, c. 1877–79. Pastel and mixed media over monotype, 40.3 × 50.5. Providence, Rhode Island School of Design, Museum of Art. Gift of Mrs. Murray S. Danforth.

103. Degas, *At the Ballet, Woman with a Fan*, c. 1883–85. Pastel, 64 × 49. Philadelphia Museum of Art, John G. Johnson Collection.

104. Degas, *Dancers at the Old Opera House*, c. 1877. Pastel over monotype, 21.8 × 17.1. Washington, National Gallery of Art, Ailsa Mellon Bruce Collection.

105. Degas, *L'Etoile*, c. 1878. Pastel, 60 × 44. Musée d'Orsay.

106. Degas, *The Curtain*, c. 1880. Pastel over monotype, 35 × 41. From the collection of Mr. and Mrs. Paul Mellon, Upperville, Virginia.

107. E. Guérard, *Foyer de la danse, à l'Opéra*, 1843. Engraving from Edmond Texier, *Tableau de Paris*, 2 vols., 1852, vol. 1, p. 106.

108. Degas, *La Famille Cardinal: Talking to Admirers*, c. 1880–83. Monotype, dimensions unknown. From Ludovic Halévy, *La Famille Cardinal*, Blaizot ed., 1938, p. 77.

109. Degas, *La Famille Cardinal: Pauline and Virginie Conversing with Admirers*, c. 1880–83. Monotype, 16 × 21 (plate). Private collection.

110. Degas, *Ludovic Halévy and Albert Boulanger-Cavé Backstage at the Opéra*, 1878–79. Pastel and détrempe, 79 × 55. Musée d'Orsay.

111. Degas, *La Famille Cardinal: Dancers Coming from the Dressing Rooms*, c. 1880–83. Monotype, dimensions unknown. From Ludovic Halévy, *La Famille Cardinal*, Blaizot ed., 1938, p. 37.

112. Degas, *Dancer's Dressing Room*, c. 1878. Pastel, 58 × 44. Private collection.

113. Degas, *Dancer in Her Dressing Room*, c. 1880. Pastel and gouache, 60 × 43. Oskar Reinhart Collection, Winterthur.

114. Degas, *Nude Woman Combing her Hair*, c. 1877–79. Pastel over monotype, 21.5 × 16.1 (plate). Collection unknown.

115. Degas, *Waiting for the Client*, c. 1879. Pastel over monotype, 16.5 × 12.1. Collection unknown.

116. Manet, *Nana*, 1877. 154 × 115. Hamburg, Kunsthalle.

117. Degas, *Preparation for the Dance*, c. 1877. Pastel on board, 60.9 × 95.2. The Burrell Collection, Glasgow Museums and Art Galleries.

118. Degas, *The Mante Family*, c. 1880. 90 × 50. Collection unknown.

119. Degas, *Before the Rehearsal*, c. 1880. 63 × 48. Courtesy of the Denver Art Institute, Denver, Colorado.

120. Degas, *Waiting*, c. 1882. Pastel, 48.2 × 61. Malibu, J. Paul Getty Museum, and Los Angeles, The Norton Simon Foundation.

121. Degas, *The Rehearsal*, c. 1874. 66 × 100. The Burrell Collection, Glasgow Museums and Art Galleries.

122. Degas, detail of *The Rehearsal* (Pl. 121).

123. C. Bergamasco, *Jules Perrot*, c. 1861. Photograph. Mr. David Daniels.

124. Degas, *Ballet Class*, 1878–80. 81 × 76. Philadelphia Museum of Art.

125. Degas, detail of *Ballet Class* (Pl. 124).

126. Degas, *The Dancer Jules Perrot*, 1875. Essence on tan paper, 48 × 30 (sight). Philadelphia Museum of Art, Henry P. McIlhenny Collection in Memory of Frances P. McIlhenny.

127. Degas, *Jules Perrot, Seated*, c. 1875. Black chalk and pastel, 44.5 × 29.8. Mr. David Daniels.

128. Degas, *Monsieur Perrot's Dance Class*, c. 1875. 85 × 74. Musée d'Orsay.

129. Degas, *Dance Class*, c. 1876. 83 × 76. Metropolitan Museum of Art, Gift of Mrs. Harry Payne Bingham.

130. Degas, *The Dance Lesson*, 1872. 32 × 46. Musée d'Orsay.

131. Degas, *Rehearsal*, c. 1879. 47 × 61, New York, The Frick Collection.

132. Manet, *Masked Ball at the Opéra*, 1873. 60 × 73. National Gallery of Art, Washington. Gift of Mrs. Horace Havemeyer in memory of her mother-in-law, Louisine W. Havemeyer.

133. Manet, detail of *Masked Ball at the Opéra* (Pl. 132).

134. Henri Valentin, *Mabille, the Spectators* and *Mabille, the Spectacle*. Engravings from Edmond Texier, *Tableau de Paris*, 2 vols., 1852, vol. 1, p. 8.

135. Renoir, *Dance at the Moulin de la Galette*, 1876. 131 × 175. Musée d'Orsay.

136. Renoir, detail of *Dance at the Moulin de la Galette* (Pl. 135).

137. Antoine Watteau, *The Shepherds (Pastorale)*, c. 1718–19. 56 × 81. Berlin, Staatliche Schlösser und Gärten, Schloss Charlottenburg.

138. *Moulin de la Galette*, c. 1900. Photograph Roger Viollet.

139. Monet, *Le Déjeuner sur l'herbe* (central fragment), 1865–66. 248 × 217. Musée d'Orsay.

140. H.T. Hildibrand after E. Grandsire, *The Buttes Chaumont*. Lithograph from Adolphe Alphand, *Les Promenades de Paris*, 2 vols., 1873, vol. 2, n.p.

141. Monet, *The Parc Monceau*, 1878. 73 × 54.5. Metropolitan Museum of Art. Bequest of Loula D. Lasker, New York City, 1961. (59.206).

142. Monet, *The Tuileries*, c. 1876. 53 × 72. Paris, Musée Marmottan.

143. H.T. Hildibrand after H. Hochereau, *Mare Saint-James, Bois de Boulogne*. Lithograph from Adolphe Alphand, *Les Promenades de Paris*, 2 vols., 1873, vol. 2, n.p.

144. L. Chaumont after E. Hochereau, *The Bois de Boulogne, before 1852*. Engraving from Adolphe Alphand, *Les Promenades de Paris*, 2 vols., 1873, vol. 2, n.p.
145. *The Bois de Boulogne, after 1870*. Unsigned engraving from Adolphe Joanne, *Paris illustré*, 1885, following p. 186.
146. *Plan of the Pré Catelan, Bois de Boulogne*. Unsigned engraving from Adolphe Alphand, *Les Promenades de Paris*, 2 vols., 1867, vol. 1, p. 90. Among the references: 1 = Theater of Flowers. 3 = Café. 10 = Cow barn.
147. Renoir, *Skaters in the Bois de Boulogne*, 1868. 72 × 90. Private collection.
148. Renoir, detail of *Skaters in the Bois de Boulogne* (Pl. 147).
149. Renoir, *The Morning Ride*, 1873. 261 × 226. Hamburg, Kunsthalle.
150. Cassatt, *Woman and Child Driving*, 1881. 89.5 × 130.8. Philadelphia Museum of Art.
151. Morisot, *Summer's Day*, 1879. 45.7 × 75.2. Reproduced by courtesy of the Trustees, The National Gallery, London. Lane Bequest, 1917.
152. Morisot, detail of *Summer's Day* (Pl. 151).
153. Manet, *The Races at Longchamp*, 1864. Watercolor, 22.3 × 56.5. Cambridge, Harvard University Art Museums (Fogg Art Museum). Bequest, Grenville L. Winthrop.
154. Degas, *Manet at the Races*, 1870–72. Pencil, 32 × 24. Metropolitan Museum of Art.
155. Manet, *Women at the Races*, 1865. 42.2 × 32.1. Cincinnati Art Museum, Fanny Bryce Lehmer Endowment.
156. Manet, detail of *The Races at Longchamp* (Pl. 153).
157. Manet, *The Races at Longchamp*, c. 1867. 43.9 × 84.5. The Art Institute of Chicago, Potter Palmer Collection, 1922.424.
158. Manet, detail of *The Races at Longchamp* (Pl. 157).
159. Manet, *The Races in the Bois de Boulogne*, 1872. 73 × 92. New York, From the collection of Mrs. John Hay Whitney.
160. Degas, *Steeplechase, the Fallen Jockey*, 1866. 180 × 152. From the collection of Mrs. and Mrs. Paul Mellon, Upperville, Virginia.
161. Degas, *The False Start*, c. 1869–72. 32 × 40. New Haven, Yale University Art Gallery, Gift of John Hay Whitney.
162. Goya, *The Agility and Daring of Juanito Apinani* (*Tauromachia*, pl. 20), c. 1815. Etching, 24.5 × 35.5. Oxford, Ashmolean Museum, Douce Collection.
163. Degas, *Jockeys in front of the Grandstands*, c. 1869–72. 46 × 61. Musée d'Orsay.
164. Carle Vernet, *Mounted Jockeys*, c. 1820–25. Watercolor and ink, 15.7 × 29.3. Private collection. Photograph courtesy of Hazlitt, Gooden & Fox.
165. Albert Cuyp, *Starting for the Hunt*, c. 1652–53. 108 × 154. Metropolitan Museum of Art. Bequest of Michael Friedsam, 1931. The Friedsam Collection.
166. Degas, *At the Races in the Country*, c. 1872. 36.5 × 55.9. Museum of Fine Arts, Boston. 1931 Purchase Fund.
167. Degas, *At the Races, Gentlemen Jockeys*, c. 1877–80. 66 × 82. Musée d'Orsay.
168. Degas, detail of *At the Races in the Country* (Pl. 166).
169. Degas, *Before the Start*, c. 1875–78. 32.8 × 40.5. Private collection.
170. Degas, *Jockeys*, c. 1882–85. 26 × 39. New Haven, Yale University Art Gallery. Gift of J. Watson Webb, B.A. 1907, and Electra Havemeyer Webb.
171. Manet, *Le Déjeuner sur l'herbe*, 1863. 208 × 264. Musée d'Orsay.
172. Gustave Courbet, *Young Women on the Banks of the Seine*, 1856–57. 174 × 200. Paris, Musée du Petit Palais.
173. Titian (formerly attributed to Giorgione), *The Concert*, c. 1508. 105 × 136.5. Musée du Louvre.
174. Marcantonio Raimondi after Raphael, *The Judgment of Paris*, detail. Engraving. New Haven, Yale University Art Gallery. Gift of Edward B. Greene, Yale 1900.
175. Puvis de Chavannes, *Autumn*, 1864. 285 × 226. Lyon, Musée des Beaux-Arts.
176. Manet, *The Game of Croquet*, 1873. 46 × 73. Frankfurt, Stadelsches Kunstinstitut.
177. Alexandre Cabanel, *The Birth of Venus*, 1863. 130 × 225. Musée d'Orsay.
178. Monet, *Le Déjeuner sur l'herbe*, 1865–66. 130 × 181. Moscow, Pushkin Museum.
179. Carle Van Loo, *Halt of the Hunting Party*, 1737. 220 × 250. Musée du Louvre.
180. Monet, Drawing for *Le Déjeuner sur l'herbe*, 1865. Charcoal, 31 × 47. From the collection of Mr. and Mrs. Paul Mellon, Upperville, Virginia.
181. Monet, *Women in the Garden*, 1867. 255 × 205. Musée d'Orsay.
182. Monet, *Camille Monet on a Garden Bench*, 1873. 60 × 80. From the private collection of Walter H. Annenberg. Photograph by kind permission of The Lefevre Gallery (Alex Reid & Lefevre Ltd.).
183. Manet, *In the Conservatory*, 1879. 115 × 150. Berlin (West), Nationalgalerie, Staatliche Museen Preussischer Kulturbesitz.

184. Manet, detail of *In the Conservatory* (Pl. 183).
185. Manet, *Autumn*, 1881. 73 × 51. Nancy, Musée des Beaux-Arts.
186. Alfred Stevens, *Spring*, 1874. 118.2 × 59.3. Sterling and Francine Clark Art Institute, Williamstown, Massachusetts.
187. Manet, *Jeanne: Spring*, 1881. 73 × 51. Private collection.
188. Morisot, *Summer*, 1878. 76 × 61. Montpellier, Musée Fabre.
189. Renoir, *Girl with a Watering Can*, 1876. 100 × 73. National Gallery of Art, Washington. Chester Dale Collection.
190. Renoir, *La Parisienne*, 1874. 160 × 106. Cardiff, National Museum of Wales.
191. Renoir, *The Garden of the Rue Cortot*, 1876. 151 × 97. Carnegie Museum of Art, Pittsburgh. Acquired through the generosity of Mrs. Alan M. Scaife, 1965.
192. Renoir, *The Promenade*, 1870. 81 × 65. Edinburgh, National Gallery of Scotland.
193. Renoir, *The Swing*, 1876. 92 × 73. Musée d'Orsay.
194. Renoir, detail of *La Grenouillère* (Pl. 212).
195. *The suburbs west of Paris*. Engraving from Karl Baedeker, *Paris et ses environs*, Leipzig and Paris, 1903, n.p.
196. Gustave Doré, *Arriving at Asnières*. Engraving from Emile de LaBédollière, *Les Environs de Paris*, 1861, p. 133.
197. Gustave Doré, *Leaving Asnières*. Engraving from Emile de La-Bédollière, *Les Environs de Paris*, 1861, p. 141.
198. Trichon after Foulquier, *Rowing Meet at Asnières*. Engraving from Eugène Chapus, *Du Paris au Havre*, 1855, p. 11.
199. A. Andrieux, *Boating at Asnières*, 1857. Engraving. Photograph Roger Viollet.
200. Monet, *The Seine at Asnières*, 1873. 55 × 74. Private collection. Photograph Studio Lourmel.
201. Monet, detail of *The Seine at Asnières* (Pl. 200).
202. *Dumas's villa "Monte Cristo" at Port-Marly*. Photograph Roger Viollet.
203. Fernand Heilbuth, *Bougival*, c. 1876–82. 94 × 57. Collection unknown.
204. Boetzel after Charles Weber, *Bougival*. Engraving from *L'Illustration*, 24 April 1869. Photograph Roger Viollet.
205. Monet, *The Seine at Bougival, Evening*, 1869. 60 × 73.5. Northampton, Mass., Smith College Museum of Art.
206. Pissarro, *Springtime at Louveciennes*, c. 1868–69. 53 × 82. Reproduced by courtesy of the Trustees, The National Gallery, London.
207. Monet, *The Bridge at Bougival*, 1869. 65.5 × 92.5. Manchester, New Hampshire, The Currier Gallery of Art.
208. Corot, *Le Quai des Pâquis, Geneva*, 1842. 34 × 46. Geneva, Musée d'Art et d'Histoire.
209. Monet, detail of *The Bridge at Bougival* (Pl. 207).
210. Miranda after D. Yon, *La Grenouillère*. Engraving from *L'Illustration*, 16 August 1873, pp. 112–13.
211. Monet, *La Grenouillère*, 1869. 74.6 × 99.7. Metropolitan Museum of Art. Bequest of Mrs. H.O. Havemeyer, 1929. The H.O. Havemeyer Collection (20.100.112).
212. Renoir, *La Grenouillère*, 1869. 66 × 86. Stockholm, Nationalmuseum.
213. Monet, detail of *La Grenouillère* (Pl. 211).
214. Monet, *Bathing at La Grenouillère*, 1869. 73 × 92. Reproduced by courtesy of the Trustees, The National Gallery, London.
215. Renoir, *La Grenouillère*, 1869. 65 × 93. Oskar Reinhart Collection, Winterthur.
216. Monet, *The Boat Landing*, c. 1868–69. 54 × 74. Mr. J. Ortiz-Patino. Photograph courtesy of Thos. Agnew & Sons.
217. Monet, detail of *Bathing at La Grenouillère* (Pl. 214).
218. Monet, *Train in the Countryside*, c. 1872. 50 × 65. Musée d'Orsay.
219. Monet, detail of *Train in the Countryside* (Pl. 218).
220. Monet, *The Railroad Bridge, Argenteuil*, 1873. 58.2 × 97.2. Private collection.
221. Corot, *The Bridge at Mantes*, c. 1868–70. 38.5 × 55.5. Musée du Louvre.
222. *The Railroad Bridge at Bezons*. Unsigned engraving from Eugène Chapus, *De Paris au Havre*, 1855, p. 14.
223. *Smoke of Altar and Smoke of Forge*. Unsigned engraving from Pierre de Lachambeaudic, *Fables*, 1855, p. 86.
224. Monet, *The Railroad Bridge at Argenteuil*, 1874. 54.5 × 73.5. Philadelphia Museum of Art, John G. Johnson Collection.
225. Monet, detail of *The Railroad Bridge, Argenteuil* (Pl. 220).
226. Pissarro, *The Railroad Bridge at Pontoise*, c. 1873. 50 × 65. Private collection. Photograph by kind permission of The Lefevre Gallery (Alex Reid & Lefevre Ltd.).
227. Sisley, *The Bridge at Villeneuve-la-Garenne*, 1872. 49.5 × 65.4. Metropolitan Museum of Art. Gift of Mr. and Mrs. Henry Ittleson, Jr., 1964. (64.287).
228. Sisley, detail of *The Bridge at Villeneuve-la-Garenne* (Pl. 227).

Preface

It is about twenty-five years since I began lecturing along the lines of this book. My notes for those early lectures tell me how crude my approach then was to the social history of Impressionism; my book has certainly benefited from its long gestation. It took shape in my mind, though not on paper, when I gave the Slade Lectures at Oxford in 1978. My ten lectures, which eventually became the principal subdivisions of this book, were entitled: The Transformation of Paris; The Artist as *flâneur*; Urban Detachment and the Urban Stranger; Café and Café-Concert; Dance and Theater; The Races; Parks and Gardens; The Transformation of the Suburbs; Suburban Leisure; Seacoast Leisure. Well before those lectures, fellow historians had been turning increasingly to the social context of Impressionism, a shift that has now made it the dominant approach among younger scholars. Numerous articles and exhibitions of recent years have studied Impressionism in the light of contemporaneous society, and one book has almost single-handedly reoriented the field: T. J. Clark's *The Painting of Modern Life, Paris in the Art of Manet and his Followers* (New York, 1984).

Unlike most other recent studies, which too often are limited to an assemblage of social motifs, Clark's book tries to articulate the social structures and attitudes that characterized Paris in the third quarter of the century, and to interpret Manet's painting in their light. His first chapter is particularly successful in this regard, and throughout his book the reader encounters the kind of idea that excites and instructs. I nonetheless take issue with much that he writes, and our two books have rather little in common. Most of the subjects I discuss are simply omitted by Clark, and he concentrates on Manet far more than he should (I would not reduce the number of his pages on Manet, but add others). Degas is given a very secondary role, Monet and Renoir the back of his hand, and Morisot is hardly mentioned. This is because Clark's chief concern—though he might deny it—is style, and particularly the way in which Manet's pictorial structures look forward to the loss, in the twentieth century, of a felt harmony between pictorial structure and illusions of the social world. He regrets the disjunctures of Manet's art, correctly related to the dis-locations of Paris and of Parisian society, but he concentrates upon him out of the conviction that he is the chief progenitor of abstraction.

Clark's book is also saturated in theory, and represents (more brilliantly than most) the inroads of literary criticism indebted to semiotics and structuralism. This trend shows at its best in Richard Shiff's *Cézanne and the End of Impressionism* (Chicago, 1984), a shrewd and highly original reinterpretation of impressionist esthetics. In other hands this current has been less rewarding. Too often it leads to nearly exclusive attention to style, at the expense of history, to ideas that have more to do with twentieth-century criticism than with French painting of the previous century. The allure of literary criticism, of "deconstruction," semiotics, and structuralism has reinforced the formalism that marked so much writing about modern art and esthetics from the early years of the century. Attractive though it is, especially for its contacts outside art history, it nonetheless perpetuates the view that art is somehow above the history of mundane events, that it exists in a rarified realm of its own.

Much writing about art now strikes me as history-less. Because the social matrix for art is not examined, because art seems to beget art without the intercession of society, too many authors write about one another's theories rather than about paintings. My book, by comparison, will seem old-fashioned. It is long on practice and short on theory. I must admit that, like others, I went through a phase during which the attractions of theory loomed large; earlier drafts of this book would have seemed more in tune with current trends. I shed that costume, however, and donned my ordinary clothing for the sake of the final manuscript. I also take my distance from the kind of art history that is devoted to finding precedents and "influences" in earlier art. Too many writers mix and match reproductions of pictures, looking for earlier examples of the same theme within the seemingly autonomous world of images. It is a great temptation to assume that the "answer" to a given picture's café table or river bridge is found among earlier representations of tables or bridges; this pseudo-method should be called "iconodolatry." Of course painters do indeed look at earlier pictures, for art is built upon professional conventions that no one is free to ignore. The trouble is that all too often the string of earlier representations becomes a self-sufficient cycle, a closed one in which chrono-logy is confused with history, and mere research with analysis. It is a higher calling *in addition* to look beyond our repertory of reproductions to the history of café tables and bridges con-temporary with the paintings, to whatever we can learn about those social forms and their uses, and then to interpret the artists' interpretations of them.

Two interpretations, therefore? Yes. I am aware that my attempts to restore paintings to their socio-cultural context cannot constitute "objective" history. No such thing exists. We cannot escape our subjectivity, nor the shared prejudices of our own generation. What we can do is attempt to approach the goal of objectivity, even knowing that we can never reach

it. It is a way of using the energy of our passions—all history should spring from passions and ideals—while we try to avoid prejudice. To paraphrase Whistler: Objectivity is a nurse who keeps us from falling into prejudice. I believe that I have illuminated paintings with the aid of social history, and I mean their forms, not just their images. I think I have demonstrated the impossibility of separating form from subject, that an artist develops forms partly in response to the subject (and not just to forms in earlier art). To this end I have studied the artists' lives, and time after time I am able to show their involvement in the subjects they rendered. I do not, therefore, use biography for its own sake, but as an aid to interpretation. The same is true of nineteenth-century history, which is put through the filter of convincingness, so that it matches in reliability and utility the pictures' visual terms.

The test will be in the value of the results, which are presented as assured convictions for the most part. I usually introduce a given theme with a description of its place in French society, but I then follow this with a series of judgments and analyses of related paintings that leave no doubt about my interpretation. To those who protest that I am trying to persuade the reader to a point of view by disguising it as objectivity, I have two answers. The first is that I am indeed trying to persuade, but instead of wagging the authorial finger, I try to construct a word-stage on which my ideas will be convincing because I give the reader a chance to examine them without much interference. I have a horror of outright preaching. When I mention that Baron Haussmann took a mistress from the ballet corps, I do not feel that I have to condemn him overtly; the reader will condemn him because I show that his action was part of a pattern of male power common to the era.

The second answer is that I believe my points of view are vindicated by my findings. Picture after picture is given a new reading, and in the multiple dialogues among artists, their contemporaries, and their subjects, new emphases develop which enrich our understanding of Impressionism. Differences between Manet's and Renoir's paintings, for example, are shown to have some of their origins in the one's being an upper-class Parisian, confident of his *chic* and yet capable of probing into the disquiet behind the pursuits of fashionable people, while the other, who hated both the *chic* and the harshness of modern life, had the aspirations of a working-class youth who transformed the seamstresses of Montmartre into dwellers of a perpetual Arcadia. Degas's distrust of human goodness is embodied alike in his renderings of dancers as automatons, and in his revelations of the predatory backstage actions of members of the Jockey Club. Monet's ambitions, those of an aggressive provincial determined to make his way, are revealed in his giving to his first wife the wardrobe and the gardens of a wealthy estate owner, until he ultimately possessed, for his second wife, a true estate. Stated this way, these readings seem sensationalist, but in the body of my text they are closely attached to the structures and images of painting in a way that, I believe, makes them subtle and persuasive.

Throughout the book I have defined Impressionism in a pragmatic way. The term is essentially one of convenience, and refers to the work of a group of avant-garde painters who made common cause and who were associated together by their contemporaries. Manet did not share in the independent exhibitions organized by the others, but he was consistently treated by the press as a leader of the group. Degas and Monet were poles apart in many ways, and yet both jettisoned most traditional subjects in favor of a strong commitment to contemporary life. It could be argued that Caillebotte's harsh architectural lines and his glaring light, compared to Monet's or Morisot's more vaporous tones, mark him out so strongly from the others that he should not be called an impressionist. However, we should not narrow down the definition of Impressionism to say, broken brushwork, and then use such a lens to cast non-conforming artists into the shade. Like his fellow impressionists, Caillebotte renounced history, mythology, and religion in favor of the contemporary world; like many of them, he drew most of his subjects from Paris and its suburbs; like them, he was attracted particularly by the new Paris, not by the quaint old streets or buildings; like them, he treated color as the vehicle of light, which he rendered in unusual effects of strong sunlight, moist reflections, and back-lighting, on planes that tilt radically upwards to give us a sense of immediacy. He was a friend of many of the leading critics who defended Impressionism, he was regularly associated by them with his fellow painters, and he was a vital figure in their group exhibitions, not just a passive participant.

Among the many things that link the impressionists is that all of them jettisoned the customary way of modeling in light and dark and based their pictures instead on bright chromatic harmonies and free-flowing brushwork. These were used to give the illusion that natural light was being recorded instinctively, without formulae. This spontaneity is more appearance than reality, as we shall see when the painters' brushwork and compositional methods are discussed. Another linking feature is the painters' resistance to anecdote and detailed visual narrative. They presented the world in a detached manner whose provocative elisions and omissions entered into the development of modern art. For that reason they are distinguished in this book from contemporaries like Béraud, Duez, or Heilbuth, who painted similar themes but who lacked meaningful innovations in pictorial language. I realize that this will lay me open to a charge of élitism, but the impressionists are the artists whose inventiveness had the greatest impact on subsequent history. Since my intention is to revise the history of Impressionism, I am intent upon dealing with its principal artists and not with other aspects of the history of art.

Most books on Impressionism are organized chronologically, partly to preserve the interest of the movement's biography, partly to concentrate on the evolution of style. If, however, one wishes to deal with subjects and their meanings, such an arrangement is a disadvantage, because the continuity of similar subjects is broken up by the need to observe chronology. My book, therefore, is organized topically, so that the study of theater spectators, or fashion, or gardens, can focus on the social customs relating to each, while I group together paintings that are not usually compared with one another. When Renoir's *Moulin de la Galette* is compared with Manet's *Masked Ball at the Opéra*, and both with Degas's ballet dancers, one learns a lot about each artist's work, as well as about the social roles taken on by dancers. This results in new dialogues among pictures and revealing patterns of social

history, although it means that the evolution of impressionist style appears as discontinuous fragments. Any reader who regrets the comfort offered by an overall chronology should first read one of the histories of Impressionism (see Bibliography), but the discomfort will be more apparent than real: each section is organized chronologically, and frequent reference is made to style.

An advantage of the way I have organized this book is the demonstration that the comprehension of style (including composition, brushwork, color, and so forth) is enhanced when it is closely linked with subject. Most art historians say that form and content work together, but they usually give precedence to form. Formalists, upon looking at my table of contents, will fear that I have gone too far in the other direction, but I have not. I did not first decide what the social issues were for the 1860s and 1870s, and then find pictures that suit them. Had I done that, the book would have dealt with factory work, housing, displacement of the working class, syndicalism, bankruptcy, prostitution, changes in retail trade, and other topics that form the social history of the period. Instead I started with the pictures of the impressionists and then tried to answer the questions posed by the kinds of subjects that they preferred and the way they painted them. Much was excluded by the painters (including most of the issues listed above), even though they were the first generation of modernists to deal principally with contemporary life. To a surprising degree their pictures concern leisure and entertainment, and when this became apparent to me long ago, I set about trying to explain why this was so.

The book that has resulted, given this focus, does not discuss all aspects of Impressionism. I deal only with two decades, from the early 1860s until the mid-1880s. Furthermore, portraiture, landscape, and still life do not figure here in their own right, although a few portraits and many landscapes appear in various portions of the book. Because of the orientation towards Parisian leisure, Pissarro and Sisley are given little place, and Cézanne none at all. Nonetheless, themes of leisure and entertainment are so much the heart of Impressionism that this book touches upon many of its main features. As the reader will discover, I am convinced that Impressionism's place as the foundation of early modern art is closely allied to the significance in modern urban culture of cafés, outdoor concerts, theater, vaudeville, dance, picnics, swimming, boating, suburban outings, and seashore vacations. It is not just that Degas, Manet, and Monet looked forward to twentieth-century artists because of their style, it is also that popular songs and suburban leisure have loomed ever larger in modern culture. The proportion of time now given over to all aspects of leisure and entertainment, including its electronic forms, rivals work time, and to study Impressionism is to reveal the origins of this singular phenomenon.

The evidence I have used comes primarily from guide books, the accounts of visitors to Paris, the memoirs and observations of Parisians, histories of Paris from the turn of the century, and other contemporaneous writings, as well as from the biographies of the painters. I have not relied on the reviews of art exhibitions as much as most of my colleagues do. I worry about the limitations of art reviews; they functioned within very limited circles, and more surely reveal the authors' attitudes than the inner workings of paintings. At times, of course, they are valuable for this very reason: Duranty had a *parti-pris* for Degas, and Rivière, for Renoir; shared attitudes between writers and painters become part of the historical record. Still, the reader should anticipate more reliance upon writings that deal not with art, but with the social customs that are given image by the paintings. Degas's *Print Collector* (Pl. 54), for example, is illuminated more by reference to ideas of detachment and urban acquisitiveness than by attempts to link it with critics' views. I realize that these other writings sprang from their authors' subjective attitudes, but since they were not addressed to art, they are not entangled with its interpretation, and I feel more competent about sifting them for my purposes. The witness who is unaware of the reasons for questions is apt to give more honest answers.

A Note on Style

Notes have been reduced to a minimum, and to credit the publications I have used I rely chiefly on the Annotated Bibliography. (Both it and the notes employ short titles to direct the reader to the List of References.) I have included a chronology of Parisian history and Impressionism because, although I frequently refer to major events in French history, I did not find room in my text for a capsule history of the era. The chronology is no more than a skeletal set of events, of course, so anyone who wants more than this can find further readings in my bibliography.

I am sensitive to feminists' objections to the eternal "he" when referring to a genderless person, and yet I find frequent use of "one" to be stiff, the phrase "she or he" clumsy, and "s/he" impossible to pronounce. I therefore introduce "she" instead of "he" from time to time, to alert the reader to the need to avoid taking the masculine as normative.

I have made my own translations from the French, except where otherwise credited. In order to be sure of exact meaning I have resorted to literal translations that do not preserve original flavor or rhyme. In notes I supply French for unusually pungent phrases, but otherwise I do not give the original language. Renderings into English of individual words and phrases follow common English usage, but are not entirely consistent: "Eugénie," for example, but "Napoleon" without accent since its pronounciation is usually anglicized. The plural of "café-concert" in French is "cafés-concert," but the Anglo-Saxon tongue is uncomfortable without the terminal *s*, hence the hybrid "cafés-concerts." I have not translated proper nouns, nor names of streets and places. Modern names have been used for Paris streets, since their location on current maps is what counts, although I miss the charm of the old names. Aristocratic titles are preserved in the French to avoid odd hybrids, hence the "duc de Morny" and the "princesse Mathilde," not the "Duke de Morny" or "Princess Mathilde." "Opéra" is used to indicate the Parisian building itself and the national institution; the lower case form refers to opera generally.

Chronology
Paris and the Impressionists

1848

February: Louis Philippe deposed, Second Republic proclaimed. In June, uprising of Parisian workers suppressed by army under Cavaignac, followed in autumn by election of Louis Napoleon as president of the Republic.

1851

December: Louis Napoleon's *coup d'état*, aided by his half-brother, Morny; he dissolves National Assembly and is named President by plebicite; many go into exile, including Hugo.

1852

Bois de Boulogne annexed to Paris. Vast city works undertaken, including clearing of areas on Ile de la Cité and near Louvre; construction begins to join Louvre to Tuileries. Opening of railway to Strasbourg. December: As Napoleon III, Louis Napoleon declares Second Empire.

1853

Haussmann made Prefect of the Seine, and plans for remodeling of Paris are rapidly pushed forward. Boulevard de Strasbourg and rue Soufflot opened. Louis Napoleon marries Eugénie de Montijo of Spain; the Empress becomes the leader of fashion and society.

1854

Crimean War: French and British troops land at Gallipoli, siding with Turkey against Russia.

1855

World's Fair on the Champs-Elysées. Opening of railway to Lyon and Mediterranean. Louis Napoleon and Eugénie exchange cross-Channel visits with Victoria and Albert. Autumn: Russians give up Sebastapol after eleven-month siege, effectively ending Crimean War; Louis Napoleon treats "victory" as personal and national triumph.

Courbet shows paintings in his "Pavilion of Realism." Offenbach's first great season at the "Bouffes-Parisiens."

1856

Opening of avenue de l'Impératrice. March: In Paris, treaty signed to end Crimean War. June: Baptism of Prince Imperial.

1857

Completion of most features of the Bois de Boulogne, including the racetrack of Longchamp. Opening of avenues around the Arc de Triomphe. Army completes conquest of Kabyles of Algeria. Louis Napoleon and Eugénie again visit England.

Millet's *Gleaners* shown in Salon, and Courbet's *Young Women on the Banks of the Seine.*
Baudelaire, *Les Fleurs du mal*; Flaubert, *Madame Bovary.*

1858

Completion of boulevard de Sébastopol. Orsini's attempt on Louis Napoleon's life. Anglo-French expeditionary forces invade China, and continue incursions for several years. Suez Canal company formed by de Lesseps.

Offenbach, *Orphée aux enfers.*

1859

Boulevard Saint-Michel completed. Haussmann's powers increased by decree. May: Louis Napoleon leads troops into northern Italy to

Manet's *Absinthe Drinker* rejected by Salon.

oppose Austria, in support of new North Italian kingdom; in June, French victories at Magenta and Solférino; Eugénie creates fashion with "Magenta red;" in July, armistice between France and Austria, but French troops remain in northern Italy.

1860

Expansion of Paris by annexation of adjacent communities; Bois de Vincennes annexed. Britain and France sign treaty promoting free trade. Nice and Savoy annexed to France.

Thérésa's first success as café-concert singer; she rapidly rises to stardom.

1861

Opening of boulevard Malesherbes, and rebuilt Parc Monceau.

Manet shows two paintings in Salon.
Morny's operetta *Monsieur Choufleury*, reworked by Offenbach and Halévy. Wagner's *Tannhäuser*, under attack, withdrawn from Opéra after four performances; Baudelaire, *Richard Wagner et Tannhäuser*. Goncourt brothers, *Soeur Philomène*.

1862

Construction of new opera building begun. French expeditionary force battles Juarez in Mexico; in following year they implant a provisional government. Treaty of Saigon confirms French role in Annam.

Hugo, *Les Misérables*.

1863

Morny, part of syndicate that builds a new Deauville on the Channel coast, inaugurates its rail line and, the next year, its racetrack. Cambodia made French protectorate.

Manet shows fourteen paintings at the Galerie Martinet; his *Déjeuner sur l'herbe* and other pictures appear in the Salon des Refusés; he marries Suzanne Leenhoff in October.

1864

First international victory at Longchamp by a French horse. Inauguration of regular service between Le Havre and New York. The French install Maximilian of Austria as Emperor of Mexico.

Morisot, Renoir, and Pissarro make their first appearances in the Salon.
Offenbach, *La Belle Hélène*.

1865

Establishment of Communist International in Paris. Death of Morny.

Manet's *Olympia* and *Christ Mocked* at the Salon; Degas and Monet make first appearances there.
Goncourt brothers' novel *Germinie Lacerteux*, and their play *Henriette Maréchal*.

1866

Completion of boulevard Saint-Germain.

Monet's *Camille* at the Salon. Zola begins to defend Manet in the press.
Offenbach, *La Vie parisienne*.

1867

Universal Exposition in Paris draws eleven million visitors. Decree authorizes questioning of government in parliament. Liberalization of laws regulating theaters leads to rapid expansion of cafés-concerts, vaudeville, and other forms of entertainment. Maximilian, French puppet ruler of Mexico, virtually abandoned by France the previous year, is defeated and executed. French troops are sent to Rome to support Papal States against Garibaldi.

Pissarro, Renoir, Sisley, and Monet rejected by Salon. Monet paints views of Paris from the Louvre; he spends the summer painting at Sainte-Adresse. Manet holds exhibition of his own work, as does Courbet; Manet begins painting of Maximilian's execution.
Zola's pamphlet *Edouard Manet*, and his novel *Thérèse Raquin*; Goncourt brothers, *Manette Salomon*; Offenbach, *La Grande-Duchesse de Gerolstein*. Death of Baudelaire.

1868

Gare Saint-Lazare greatly enlarged, adjacent streets redesigned. New laws improve freedom of the press and right of public assembly.

Manet, Cassatt, Degas, Morisot, Pissarro, Monet, Sisley, Bazille exhibit at the Salon. Morisot meets Degas and Manet.

1869

Inauguration of Folies-Bergère. Opposition gains in legislative elections; Haussmann in political trouble. Opening of Suez Canal.

Manet summers in Boulogne. Monet and Renoir paint at La Grenouillère and Bougival.
Flaubert, *L'Education sentimentale*

1870

Ollivier forms new cabinet; Haussmann dismissed. May: new constitution approved. July: France and Prussia go to war. September: Napoleon III surrenders at Sedan, and Third Republic declared in Paris; Prussian army besieges the capital.

Monet marries Camille Doncieux in June; they go to Trouville for the summer, to England in the fall; Pissarro also in England. The painter Bazille killed in the war; Renoir, Degas, and Manet in uniform but not under fire.
Hugo returns from exile.

1871

January: Paris surrenders after siege and famine; German Empire declared at Versailles. February: France cedes Alscace and Lorraine to Germany and agrees to huge war reparations; Thiers forms government. Paris Commune founded in March, and city is cut off from rest of country; bloody repression under Marshal MacMahon follows in June, and many surviving Communards imprisoned or banished; Thiers elected president of Third Republic.

December: Monet settles in Argenteuil after fifteen months in England and Holland; Pissarro had returned in June.

1872

Reparations paid, German army of occupation leaves.

Cassatt's first appearance at the Paris Salon. Manet moves to studio on rue de Saint-Petersburg, near Gare Saint-Lazare. From October to March 1873, Degas visits family in New Orleans. Monet's first full year at Argenteuil.
Zola, *La Curée*.

1873

Old opera house destroyed by fire. Marshal MacMahon, candidate of right, elected president (the "Republic of Dukes"). Financial crisis, followed by several years of depression. Louis Napoleon dies in exile in England.

1874

Vendôme Column, razed during Commune, is reerected.

First exhibition of the impressionist group; Manet never shows with them. Manet's *Railroad* at Salon, his other works rejected. Manet and Renoir frequently paint with Monet at Argenteuil. Morisot paints at her sister's estate at Maurecourt; in December she marries Manet's brother Eugène. Cassatt settles in Paris.

1875

New opera house inaugurated; ground-breaking for Sacré-Coeur. New republican constitution approved.

Manet's *Argenteuil* at the Salon. Morisot paints at Gennevilliers, then at the Isle of Wight.

1876

Second impressionist exhibition; Caillebotte joins group. Renoir settles in Montmartre. Duranty's pamphlet *La Nouvelle peinture*.

Mallarmé, *L'Après-midi d'un faune*; in a London journal he publishes "The Impressionists and Edouard Manet."

1877

Avenue de l'Opéra opened (final touches await 1878). Paris population surpasses two million (in 1831: 861,400). MacMahon, attempting to put pro-monarchists in power, is defeated in succession of manoeuvres and loses ground to Gambetta and the republicans.

Third impressionist exhibition; Rivière edits *L'Impressionniste*. Monet paints views of the Gare Saint-Lazare. Manet's *Nana* rejected by Salon, shown on boulevard des Capucines. Cassatt meets Degas; her parents and sister move permanently to Paris. Halévy's and Meilhac's *La Cigale* staged, with Degas's probable collaboration. Goncourt, *La Fille Elisa*; Daudet, *Le Nabab*. Zola's *L'Assommoir* a huge success.

1878

World's Fair; national holiday on 30 June, with first public playing of *La Marseillaise* since the Commune.

Monet and Hoschedé families move to Vétheuil. Duret's *Les Peintres impressionnistes*.

1879

Jules Grévy elected president of Republic. Partial amnesty for Communards.

Manet's *Boating* and *In the Conservatory*, Renoir's *Mme Charpentier and her Children* at the Salon. Fourth impressionist exhibition; Cassatt and Gauguin included; Morisot and Renoir abstain. Renoir has one-artist show at offices of *La Vie moderne*, and shows at Salon. Death of Camille Monet; Monet and Alice Hoschedé henceforth live together. Zola, *Nana*; Goncourt, *Les Frères Zemganno*.

1880

First modern "Bastille Day" inaugurated 14 July; full amnesty for Communards. Jesuits expelled from France, and exclusively secular instruction mandated for public schools.

Fifth impressionist exhibition; Renoir and Monet abstain. Manet's *Chez le Père Lathuille* at the Salon; his *Execution of Maximilian* exhibited in New York and Boston. Manet and Monet have one-artist shows at *La Vie moderne*. Monet begins nearly annual campaigns of painting along Channel coast.
Maupassant, *Boule de suif*. Death of Offenbach.

1881

Sixth impressionist exhibition; Monet and Renoir abstain; Renoir travels to Algiers, then to Italy; Morisot summers at Bougival, Manet at Versailles.

1882

Compulsory primary education established. Death of Gambetta.

Seventh impressionist exhibition; Degas and Renoir abstain. Manet's *Bar at the Folies-Bergère* and *Spring* at Salon; he is seriously ill.

1883

Durand-Ruel inaugurates one-artist shows of impressionists. Morisot moves to house on rue de Villejuste. Monet settles in Giverny. Death of Manet on 30 April.

1884

Legalization of trade unions.

Retrospective exhibition of Manet's work. Onset of Renoir's "Ingres Period;" he drafts plan for a "Society of Irregularists." Monet paints on Mediterranean coast.

1885

Pissarro meets Signac and Seurat, begins to paint in their new manner, later called "Neo-Impressionism." Monet paints at Etretat. Zola, *Germinal*. Death of Hugo.

1886

Eighth and last impressionist exhibition; Monet and Renoir abstain; Seurat (*Sunday on the Island of the Grande Jatte*) and Signac included. Durand-Ruel shows impressionists in New York. Monet at Etretat in late winter, at Belle-Isle in autumn.

Chapter One
Paris Transformed

Your city, O Paris, is the world!
Your people, humanity.
 —H. Derville, *Paris nouveau*, 1857

City without past, full of minds without memories, of hearts without tears, of souls without love! City of uprooted multitudes, mobile heap of human dust, you can grow and become the capital of the world: you will never have citizens!
 —Louis Veuillot, *Les Odeurs de Paris*, 1867

Elegance shoulders the uncouth to the rear, and with it hustles into oblivion much of romance.
 —Edward King, *My Paris*, 1868

When Henry Tuckerman came to Paris in 1867, one of the thousands of Americans attracted there by the huge international exposition, he was bowled over by the extraordinary changes since his previous visit twenty years before. The visitor, he wrote,

> finds the noble arcade of the Rue Rivoli indefinitely extended, the new wing of the Louvre, an imposing and solid line of masonry, approaching its junction with the Tuileries. ...Another striking change is visible in the fresh tint of nearly every structure along the principal thoroughfares— the effect of whitewash, paint, or the mason's hammer renewing the face of the stone-work, and giving a singular lightness to the streets; sidewalks, too, have multiplied, and the whole aspect of Paris made new, commodious, and progressive.[1]

He notes the surprisingly cosmopolitan nature of the renovated city, in which the Gallic character he knew has been "invaded and encroached upon" by "foreign elements." In restaurants he is amused, and a little dismayed, at being offered "cotelettes à la Victoria." Streets, theaters, and cafés are thronged by foreigners and French dressed in the latest fashions. Signs of prosperity and change greet the visitor at every turn:

> Baron Haussmann, the Prefect, has cut through streets, demolished whole quarters, made space and substituted modern elegance for old squalor. Those parts of the city which are in a state of demolition, present enormous high walls with the irregular smoke-stains of the dismantled chimneys, moving zig-zag higher and higher, and looking ready to topple over as you slowly pass through a crush of vehicles and debris of mortar and stones.

In the midst of his wonder and fascination, Tuckerman is also struck by the loss of the old Paris, and he places himself among those

> who, in the midst of the "improvements," like to recall the Paris of the time before the Empire; to turn from foreign clubs and cosmopolitan corso, from American gossip and Imperial receptions, from gas and glitter and the immense crowds..., and revive the memories of a favorite saloon, the talk of a cosy old café, the traditions of the first revolution—the spirit whereof yet gleams from the savage eyes of many a surly *ouvrier*, on his long walk from his work to the suburbs—in a word, the characteristic and normal traits and triumphs of the French metropolis, when it was more exclusively the nursery of Gallic genius and character....[2]

He wonders, then, if all the glory of the new Paris has not been won at considerable cost: loss of the historic old Paris and of the old "Gallic genius." All his instincts as an ardent democrat are sharpened by what he sees about him, "a certain reserve alien to the genius of the place, and discordant with our recollection of it." On the street he witnesses a policeman in the act of silencing a pedestrian for singing the Marseillaise, forbidden because of its evocation of revolution. He is unable to get his English newspaper from the post office, because it contains an article "obnoxious to the government," and when he expresses surprise that *Uncle Tom's Cabin* is translated as

1. Monet, detail of *Garden of the Princess* (Pl. 14).

Père Tom, the bookseller answers: "Monsieur, there have been so many jokes about 'His Uncle' that the word is suspicious here." Tuckerman hardly needed such reminders of imperial power to conclude that "the trampled throne, the spasmodic republic, the bloody massacre, the cunning usurpation" have intervened "between the Paris of my remembrance and the Paris of today." He informs his readers that no alert American would be fooled by "the physical renovation of the metropolis, the sagacious device of a great *Exposition* of the world's products" into an unalloyed admiration of the material splendors laid before him.

As for the Parisians, they have simply been bought off by prosperity. "From the duchess to the drab," he writes, "the shop-keeper to the dandy, all have their brokers; increase of luxury, larger need of cash, in a word, 'pecuniary considerations,' have done more to strangle incipient revolution than the army." Louis Napoleon, Tuckerman sees, "works cunningly upon the prejudices and passions of the people, making old men exclaim 'he is doing for France more than his uncle,' as they complacently examine a new vista of streets."[3] Tuckerman was an unusually perceptive observer, but he was not alone in his views. A good many Parisians, from the exiled Victor Hugo on the Left to Louis Veuillot on the Right, shared his view that Paris's rampant prosperity and public show were a disguise for Louis Napoleon's dictatorial power and for his destruction of the old Paris, whose torn-down sites he handed over to speculators, and whose salvaged bits and pieces were placed in the new Musée Carnavalet, cynically devoted to "vieux Paris."

To the historian of Impressionism, it is important to look at this altered Paris, because its new streets and squares, its expositions, cafés, restaurants, and theaters are the images we see in the paintings of Manet, Degas, Morisot, Cassatt, Monet, Caillebotte, and Renoir. Manet shows us men and women in the fashionable new *brasseries* and cafés; he paints the approaches to the fairgrounds of the 1867 exposition and the streets in the renovated district where he lives, near the Gare Saint-Lazare. Degas shows men outside the stock exchange and at the racetrack; he shows middle-class women in fashionable hat shops, and prostitutes seated at sidewalk cafés. Monet represents the *grands boulevards*, glittering centers of commerce and tourism, he and Renoir paint the new squares and quais. Caillebotte takes us upon the new bridge over the tracks of the Gare Saint-Lazare, and Monet places us in the train shed and also out on the tracks.

Does this mean that they are partisans of the Emperor's new society, that they celebrate its shiny exterior, that they wear the mask of gaiety which, Tuckerman tells us, "reconciles many a giddy noddle to the loss of the liberty cap"? The answer to this question is not a simple yes or no. The impressionists, whose politics, as far as they can be determined, vary greatly one from the other, do not line up neatly on the side of Tuckerman or Veuillot. They do not cozy up to the Emperor nor to the government which succeeded his. The nature of their art which, superficially viewed, seems a whole-hearted adoption of the new city, is extraordinarily complex. In it we shall find not just happy strollers and charming waitresses: we shall find also pensive women alone in cafés or theater loges; couples seated in cafés or offices, bearing troubled expressions;

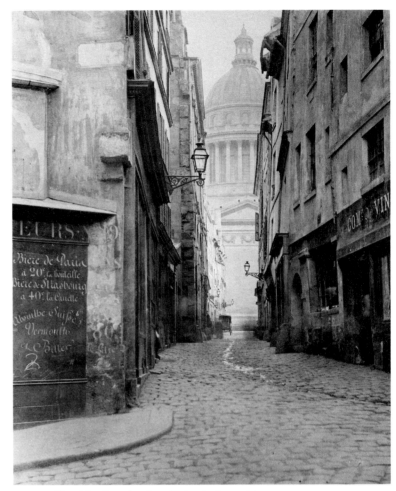

2. Marville, *The Rue des Sept Voies*, before 1860.

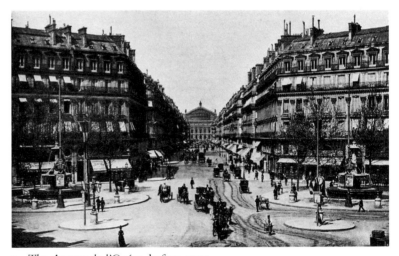

3. *The Avenue de l'Opéra*, before 1900.

men at windows, looking out on a few isolated pedestrians in the unfriendly expanse of pavement and sidewalk. We shall follow the impressionists out to the suburbs, also, and witness the effects on once-quiet villages of picnickers and others who seek entertainment outside the city. We shall go further, out to the seaports along the Channel coast, and see how impressionist painting reveals the conversion of fishing ports into outposts of Parisian society.

Paris Transformed

Before 1848 Paris was characterized by narrow, encumbered streets and bridges (Pl. 2). Earlier plans for transverse avenues that would speed movement through the city had seldom been carried through. The rue de Rivoli, cherished idea of the first Napoleon, was completed only over the years 1853 to 1857, providing the first clear route through the heart of the city from east to west. The new boulevard Saint-Michel through the Latin Quarter was continued northwards by the new boulevard Sébastopol. By the 1870s hundreds of miles of old streets had been altered, widened, and connected with new ones, including the hub of avenues around the Etoile, the boulevard Saint-Germain and the avenue de l'Opéra (Pl. 3). New streets like the boulevard Magenta were established to reorient the central city towards its suburbs, the near suburbs being annexed to the city in 1861.

Along the Seine, whole strips of buildings were razed to provide new quais which opened the banks of the river to vehicular and pedestrian traffic. Before 1848 the Seine often had to be approached at right angles along narrow streets. Masses of buildings crowded the river's edges, frequently preventing movement along its banks. Between 1852 and 1863 eight new bridges were built, several others were rebuilt (including the removal of shops and other forms of superstructure), and tolls were suppressed on all but two of them. These drastic changes played a major role in opening up the river and its banks to increased commerce. They opened it up also to light and air, and contributed to the embellishment of the city that catered to tourism, a rapidly growing industry in its own right.

A good sense of the extent of these alterations can be gained from the views published by the architect Fédor Hoffbauer in 1885. He juxtaposed aspects of the contemporary city with visual reconstructions of the same sites as they would have appeared one or more generations earlier. Plate 4 shows the Petit Pont, which joins the Ile de la Cité to the left bank, as it looked in about 1830, and Plate 5, the same area in 1880. The old bridges have been replaced by single spans that offer no obstruction to river traffic. For the sake of improved land traffic, the old shops on the bridge in the distance were eliminated. The buildings along the bank were removed, a new street put in their place, and a new row of buildings was erected, set back from the river.

These changes are not only of substance, but of "style," that is, the altered forms of the later view embody the new Paris. Instead of being massive, and varied in their individual masses, the later forms are light in weight and very regular. The new bridge seems to leap across the river with the quickness of the new city. Our view down the river is no longer obstructed, and the new street that runs along it further opens up this view, accentuated in turn by the implacable regularity of those new buildings. Dark shadows are no longer cast across the river, and the small compartments of limited space have given way to the open display of light and air.

These and other alterations of Paris were done at great costs, of which the least significant was the monetary one. Many tens of thousands of people were evicted from old buildings to make way for new streets, quais, bridges, and

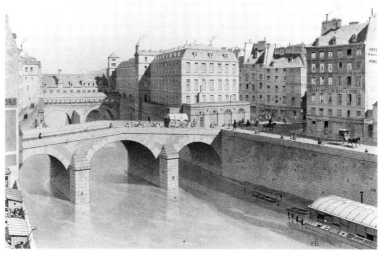

4. Hoffbauer, *The Petit Pont as it appeared c. 1830.*

5. Hoffbauer, *The Petit Pont as it appeared c. 1880.*

buildings, nearly 14,000 from the Ile de la Cité alone. In a pattern all too familiar to twentieth-century city dwellers, poor residents (including Tuckerman's "surly *ouvrier*") were pushed out to the edge of the city, their homes replaced by government and commercial buildings, or by new apartments beyond their means. And an equally grievous loss was suffered as the result of the destruction of tens of thousands of old structures, some of them notable monuments, others the quasi-anonymous urban buildings of the fifteenth to eighteenth centuries. Some writers voiced regret at the destruction of historic Paris: Veuillot, Hugo, des Essarts, Bouilhet, Fournel, de Lasteyrie. Haussmann was accused of vandalism. "Cruel demolisher," wrote the poet Charles Valette in 1856, "what have you done with the past?/ I search in vain for Paris; I search for myself."[4] By the early 1860s there was a widespread movement to record buildings of "vieux Paris" before they were destroyed, and artists like Martial and Delauney made such sites the mainstay of their etchings. However, the boom in commerce and real estate, which shifted vast sums of money into the coffers of the entrepreneurs who increasingly dominated society, simply swamped the opposition. Théophile

Gautier, for example, expressed some regret at the loss of historic buildings, but was seduced by the grandeur of the new city and the forward surge of France's industry and commerce. He phrased it succinctly and cruelly: "Every man who takes a step forward treads on the ashes of his forefathers." There is a cost, yes, in the loss of so much of old Paris, but this loss is put under the "purifying sign" of the renovated city, which

> ventilates itself, cleans itself, makes itself healthier, and puts on its civilized attire ["toilette de civilization"]: no more leprous quarters, no more malarial alleys, no more damp hovels where misery is joined to epidemic, and too often to vice.[5]

History has to retire in favor of progress, according to partisans of the new order, and history means not just old buildings, but the traditional subjects of the arts. Artists are urged to cast historical subjects aside in order to plunge into the present. In 1858 Maxime Du Camp cried:

> Everything advances, expands, and increases around us.... Science produces marvels, industry accomplishes miracles, and we remain impassive, insensitive, disdainful, scratching the false chords of our lyres, closing our eyes in order not to see, or persisting in looking towards a past that nothing ought to make us regret. Steam is discovered, and we sing to Venus, daughter of the briny main; electricity is discovered, and we sing to Bacchus, friend of the rosy grape. It's absurd![6]

The confrontation between the old and the new, between Venus and steam power, was made very graphically in the huge World's Fair of 1867 (Pl. 6), devised by Napoleon III as a proof of France's rise to new prominence in industry and the arts. Industry was represented by the latest machinery, both of large and small scale, the arts by a fine-arts section and, more numerously, by reproductions and imitations of earlier art with the aid of modern machinery. It was the "Exposition universelle" which drew Henry Tuckerman and millions of visitors to Paris, where they witnessed perhaps the highest moment of the Second Empire (they little expected it would

6. *The Paris World's Fair, 1867.*

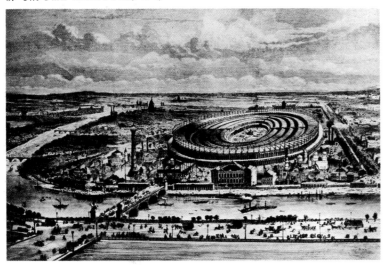

shortly afterwards begin to falter). Edward King, another Exposition visitor, began his book about Paris in 1867 by asserting that

> The modern Babylon gets improvements, wondrous adornment, so marvelously quick that one might imagine the last of the Caesars had been taught the secret of summoning the obedient genii. Myriad blue-bloused workmen stand in rows, wield their nervous arms, and straightway magic palaces rise, glittering promenades are thronged, where of late stood only mean and narrow streets, dirty and hideous pavements.[7]

The fair, ostensibly dedicated to progress and peace, was built on the Champ de Mars, the military parade ground in front of the Ecole Militaire, an irony not lost on Tuckerman, nor on some other contemporaries. That new industry, progress in short, was linked with the armed might of the last of the Caesars was made clear in the military displays of the "National Panorama," one of the "magic palaces" on the fairgrounds (few visitors, if any, recognized the ominous portent in one of Prussia's main exhibits, a huge Krupp cannon).

In Edouard Manet's painting of the 1867 fair (Pl. 7), three imperial guardsmen on the far right represent the Empire. One is seated, and another has his hat off, so they have no threatening aspect, but their red trousers are the brightest spots of color in the painting. Like Henry Tuckerman, Manet has made us aware that soldiers are omnipresent in 1867. His painting is both a confrontation with the Empire and a celebration of it.[8] Fearing exclusion by the jury of the offical Salon exhibition (Monet, Renoir, Pissarro, and Cézanne were all rejected), Manet had built his own exhibition pavilion on the place de l'Alma, across the river from the fairgrounds. He showed fifty of his paintings there, not far from another self-directed pavilion, this one by Courbet, that other *enfant terrible* of the Second Empire whose Pavilion of Realism of 1855 had given Manet the idea. By the time of the fair, Manet had succeeded Courbet as the most controversial living artist, and he had something of the older painter's pride in the powers of self-advertisement. The giant fair nonetheless overwhelmed his exhibition, and his confrontation with officialdom drew little public notice.

Had Manet walked westward down the Seine a short distance from his unpopular pavilion, he would have reached the hill of the Trocadéro, newly landscaped for the occasion; it was from this hill that he has us look out on the 1867 fairgrounds. Probably done in June 1867, the painting is ambitious in its size, but it was never completed. Along the left, its most unfinished section, one makes out the overlarge stone arches of the Pont de l'Alma (leading to his and Courbet's exhibitions). Near it is the National Panorama, the one devoted to changing displays of military prowess. Above the roofs of the numerous "magic palaces" rise two lighthouse towers, whose purpose was to demonstrate the wonder of electric light, the French tower left of center, the British one off to the right, further back. In the constant disputes between past and present which Maxime Du Camp had pointed to in 1856, the British lighthouse was attacked as too much industry, too little art. Its open girder work was compared unfavorably to the well-sheathed French spire. Industry has its

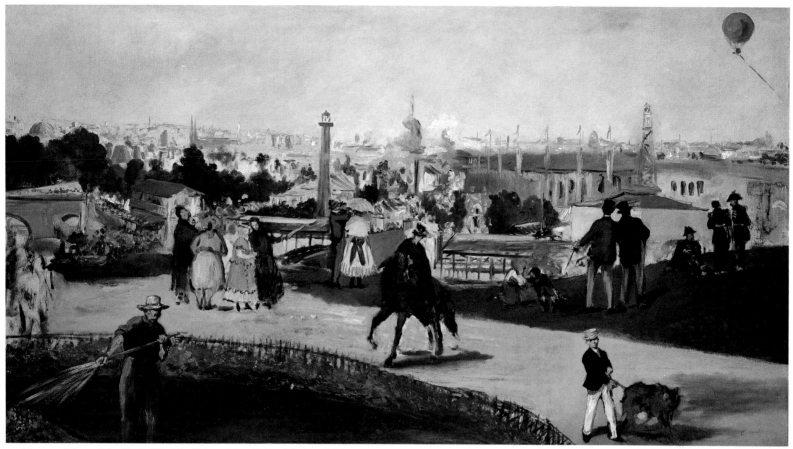

7. Manet, *View of the Paris World's Fair*, 1867. Oslo, National Museum.

symbol also in the puffs of smoke from the fairgrounds' steam works in the center which partly obscure the distant dome of the Invalides: a piece of visual naturalism in which Manet confounds a well-known symbol of military authority. Far more prominent than this obscured dome, echo of the past, is the balloon in the upper right, "The Giant," that saucy symbol of progress which belonged to Manet's friend, the famous photographer and caricaturist, Nadar.

From the balloon Nadar could have looked down on the sweeping curve of the Seine which separates the Champ de Mars from the hill of the Trocadéro. One of the curious features of Manet's painting is the disappearance of the river behind the slope in the foreground, as though he had stood further back and looked through binoculars, whose distortions create such flat, rising planes. This radical shortcut let him juxtapose the people in the foreground directly to the fair buildings, requiring us to compare, or adjust, the two areas of concern. In the foreground Manet arranged a panorama of Parisian society in 1867. In the lower left is a groundskeeper, one of the ubiquitous "blue-bloused workmen" that Edward King noticed. Above him are two women in lower-class dress, while next to them, walking to the right, are two more elegantly costumed women. Further back is a well-dressed couple, the man gazing at Nadar's balloon through binoculars. In the center is that contemporary figure, an *amazone*, a woman riding without escort. Behind her are two city children seated on the grass, providing contrast for the elegant young boy in the right foreground. Above him, next to the

guardsmen, are two fashionably dressed men. Like the other figures, they are given a contrived position, since they stand on a neat line going from the workman in the lower left back across to the guardsmen. Crossing this line is its symmetrical counterpart, from the boy and his dog in the lower right back to the women on the left; the Amazon is the common pivoting point for both diagonals. Further symmetry is established by the couple to the left of the Amazon and the children to her right. The more we look into this picture the more apparent is its order for, despite his spirit of confrontation, Manet gives his composition something of the implacable regularity of Napoleon's and Haussmann's scheme of things.

Of course this form of celebrating Paris in 1867 would not have been to the liking of either of those autocrats. Manet had marked himself out as a rebel against the government's art policies and the radical abbreviations of his style were hardly its kind of art. Louis Napoleon would have been even more convinced of Manet's rebelliousness had he known of the artist's next major undertaking. His *View of the Paris World's Fair* was left in an unfinished state and never shown, partly because Manet turned his attention to another notable current event. On 19 June 1867, the French puppet, Emperor Maximilian of Mexico, was executed by Mexican nationalists. When news of this event reached France in July, Manet began the first of a series of four paintings (Pl. 63) and a lithograph on the subject. Although his intentions in choosing it are not known, the fall of Maximilian could only be seen as a disgrace

to the French government and indeed, the printing of his lithograph of the execution was subsequently forbidden by the government censor.

Not to be favored by the government was the lot also of Renoir, Monet, and the other impressionists. They did not have Manet's notoriety, but it should also be said that their paintings seldom confronted established authority to the same polemical degree. The history of their rejection by official exhibition juries is the more expected one: the reluctance of members of established institutions to accept the innovations of their challengers. Both Monet and Renoir were rejected by the jury of the 1867 Salon, whose exhibition coincided with the World's Fair. They joined with Manet, Morisot, and several others in trying to arrange a separate exhibition of their work, but the project was not realized that year. Like Manet, they nonetheless found ways to join in the celebration of Paris in its festive garb, that is, in its newly widened streets, squares, and quais, whose reconstruction had been accelerated to provide a proud setting for the great fair.

For *The Champs-Elysées during the Paris Fair of 1867* (Pl. 8), Renoir chose a panoramic view that emphasized trees, shrubbery, and lawns, with only two hints of the surrounding city: in the distance, the roofs of the Palais de l'Industrie (built for the 1855 fair), and on the right, the Café des Ambassadeurs. The axis of the avenue slants back to the right, but it is so unobtrusive that we might imagine ourselves in a huge park.

Along the sand pathways some thirty adults and children can be distinguished, all of them neatly dressed. A further number are bunched on the left and in the right distance; a group sits on the grass in the lower left, others in the center. In the foreground is a newly planted mound, attended by a worker in vest and shirtsleeves. This portion of the composition reminds us of Manet's view of the fair, but whether or not Renoir saw the unfinished work in Manet's studio, he gave to the Champs-Elysées a similar, well-disposed order.

In another picture done that same spring, *Le Pont des Arts* (Pl. 9), Renoir shows the extent to which he favored the new city over the old. He could, after all, have selected one of the quaint, dark streets that still twisted through Paris, many of them near the narrow rue Visconti on which he, Bazille, and Monet then lived. To have done so, however, would have placed him automatically in the camp of romantic artists of the previous generation, rather than the forward-looking group he had attached himself to. This can be made clear by comparing *Le Pont des Arts* with a work by one of the great romantics, Decamps's *Job and his Friends* (Pl. 11). Each typifies its generation, and the differences are instructive. Decamps treats a biblical subject, and gives it the urban environment favored by so many painters and writers of the Romantic era, one of those cramped streets rich in shadows and human events (Pl. 2), those same streets whose destruction was lamented by Henry Tuckerman when he reached Paris in 1867. Renoir

8. Renoir, *The Champs-Elysées during the Paris Fair of 1867*, 1867. Private collection.

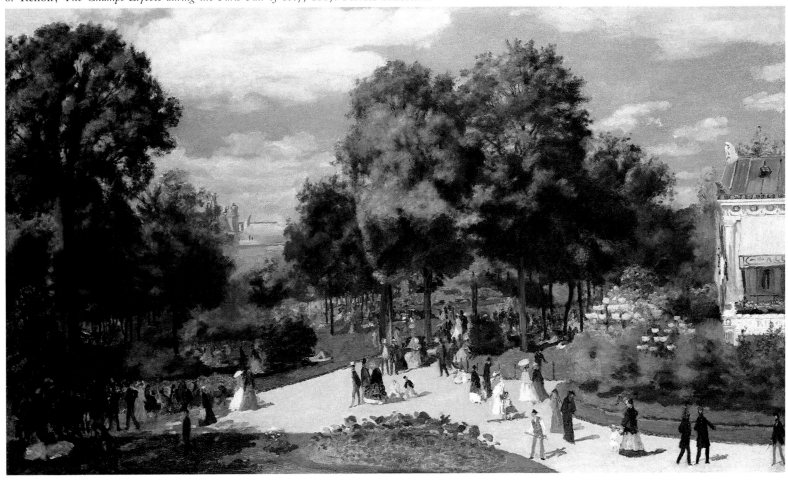

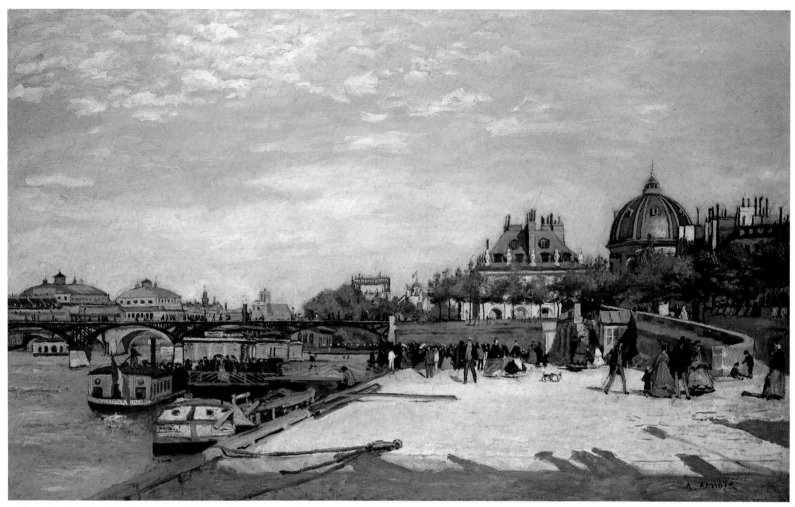

9. Renoir, *Le Pont des Arts*, 1867. Norton Simon Foundation.

instead chose one of the most conspicuous of the new vistas of the Second Empire. He shows the Pont des Arts from the quai Malaquais (Pl. 17) which Haussmann had altered and widened. We are directly below the Pont du Carrousel, whose shadow along the base of the picture tells us of the people walking across the bridge overhead. What a contrast this shadow is with those in Decamps's painting! Decamps's "malarial alleys" dominate his painting in order to reinforce the drama of his subject. Renoir's shadow pulls us instead into the matter-of-fact activity of the present moment. He floods his picture with light and air, as Haussmann has done for Paris, and he shows us the tourists and strollers who admire the new Paris while benefiting from the new prospects it offered them. Responding to the dome of the Institut de France, the visible presence of history, on the right side, there loom along the left edge of the composition the twin roofs of the theaters of the Châtelet, built only five years earlier. Some forty people, anonymous as ants, cross the new bridge in the left mid-distance. In the middle distance (Pl. 10) people are coming to and from the sightseeing boat, whose wake is churning below the French flag, just beyond the moored barge in the fore-ground. These people, dressed in current fashion, are framed on the right by a working-class woman and two children, and on the left by a sailor seated at the quai's edge. To round out this society, two imperial guardsmen stand at the top of the curving ramp.

As he had in his Champs-Elysées picture, Renoir furnishes a representative selection of current society, albeit one that favors the well-to-do visitors and strollers of 1867. These casually posed figures, standing and walking about, have supplanted Job and his friends. Religion, history, and mythology, the mainstays of French painting until 1848, were simply done away with by the impressionists. This casting out of history had been well launched by Courbet, Millet, and other artists in the 1850s, but the process was completed and urbanized, as it were, by the impressionists. It was a drastic "purification," a wrenching of art into the present. It may not seem as ruthless a process as Haussmann's demolishing of thousands of historic buildings, but by refusing to go through government art schools, by creating independent exhibition societies, by opposing so much of traditional art, the impressionists helped destroy the whole academic system. After 1870 few significant artists grew out of the old system, and one can easily detect the anguish of conservative artists, unwilling to give up their Venuses and Bacchuses, unwilling to forsake the whole system of schools, prizes, and exhibitions that underpinned traditional subjects and styles.

Directly across the river from Renoir's site is the eastern end of the Louvre. Like the quai Malaquais, this area had been cleared and reconstructed by Haussmann, and it is here in April and May 1867, just when Renoir was painting the Pont des Arts, that Monet set up his easel for his first important

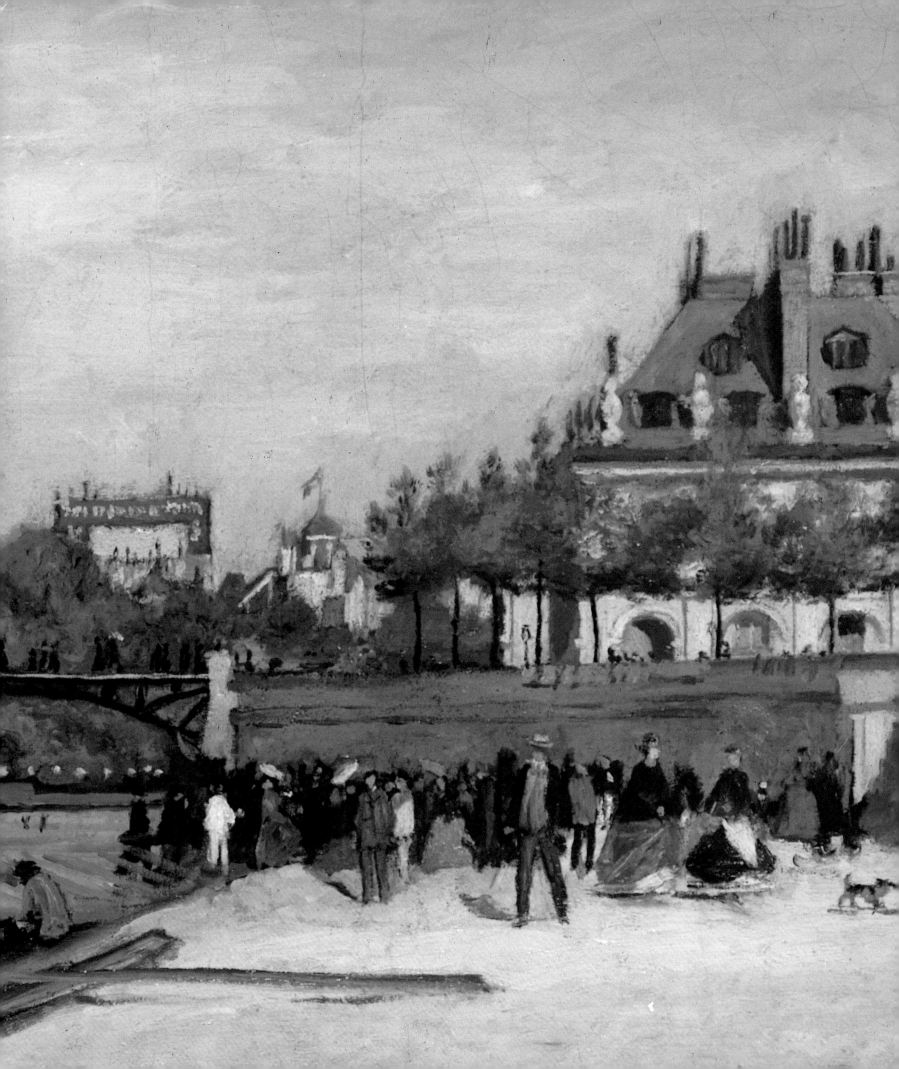

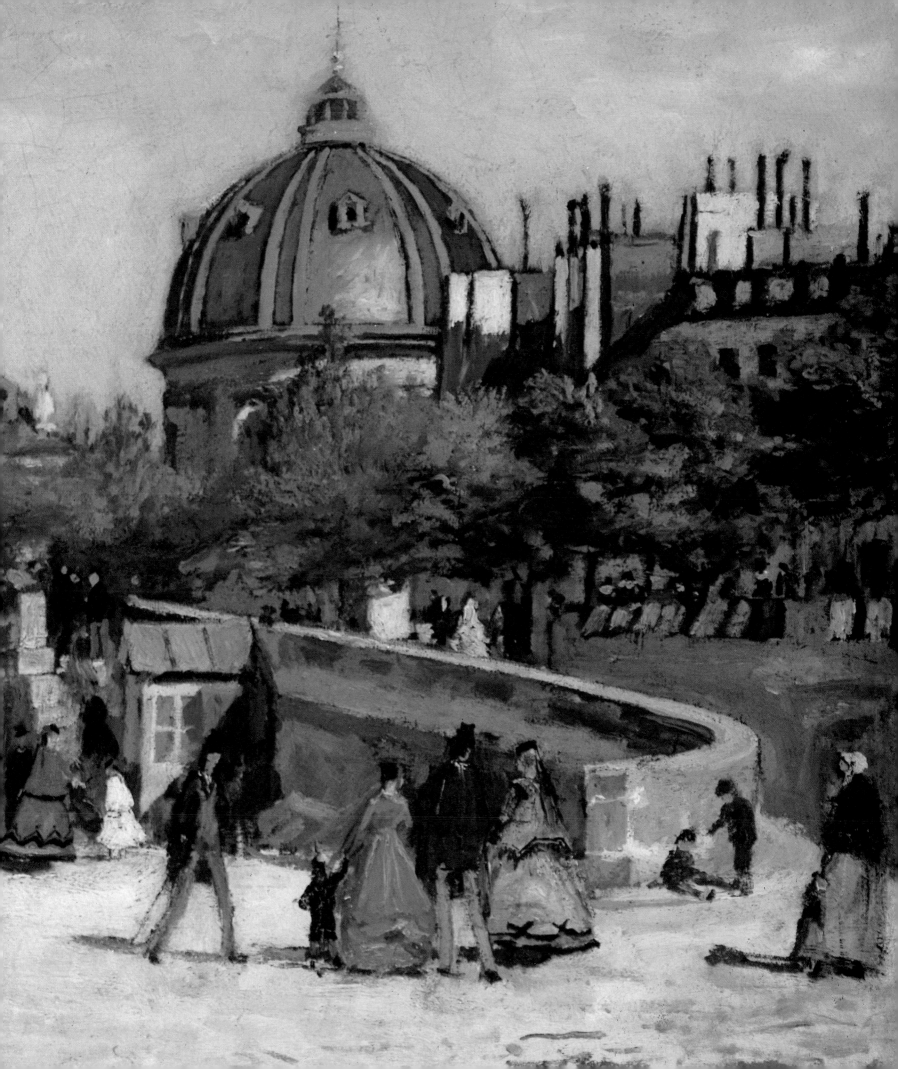

11. Decamps, *Job and his Friends*, c. 1855. Minneapolis Institute of Arts.

moored bathing establishment below the distant foliage, that is, along the edge of the Ile de la Cité. Above it is the brightest patch of color in the whole picture: the red, white, and blue of the national flag, marking a government dock at that point (perhaps another *bâteau mouche* for the visitors swarming through Paris). This is a curious, indirect way of locating the Seine which, after all, determines the plans of the adjacent quai and the buildings beyond to the left, on the island, and to the right, on the opposite bank.

It becomes obvious that Monet's interest is not that of the topographical artist (Pl. 15), whose purpose is to provide the maximum of information. Taken from higher up on the Louvre, and closer to the building's corner, the lithographer's view is remarkably different. It represents Paris of several years earlier, when the trees along the quai were still quite young. Even so, the topographer's goal is to exhibit to its

12. Monet, *Saint-Germain l'Auxerrois*, 1867. Berlin, Nationalgalerie.

13. Monet, *The Quai du Louvre*, 1867. The Hague, Gemeentemuseum.

pictures of Paris.[9] From the second-floor balcony of the Louvre itself Monet made three paintings. In one (Pl. 12) he showed the gothic church of Saint-Germain l'Auxerrois and the newly cleared-out square in front of it, well populated by a dense throng under the shelter of young trees. A number of sightseeing carriages and about twenty-five people are out in the open, well-dressed people rather like those Renoir painted on the quai opposite. In the other two paintings Monet looked over towards the dome of the Panthéon, creating a deeper space whose skyline is punctuated by easily recognized domes and spires. In the foreground of one of this pair (Pl. 13) he represents numbers of people on sidewalks and in the street, and in mid-distance, the narrow but prominent sweep of the Seine. In the other, *Garden of the Princess* (Pl. 14), the dome of the Panthéon is placed exactly on the center line of a dramatic vertical composition.

In *Garden of the Princess*, the water virtually disappears and it requires familiarity with the scene to realize that the river flows along between the trees in mid-distance and the darker mass of foliage further off. Through a convenient gap in the near foliage, the knowing eye also spots the superstructure of a

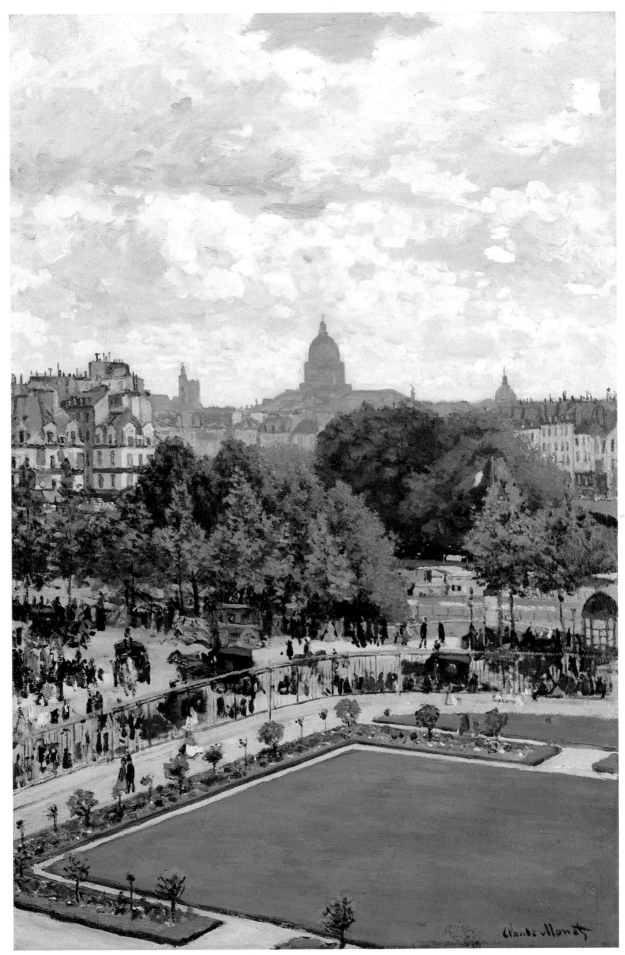

14. Monet, *Garden of the Princess*, 1867. Oberlin, Allen Memorial Art Museum.

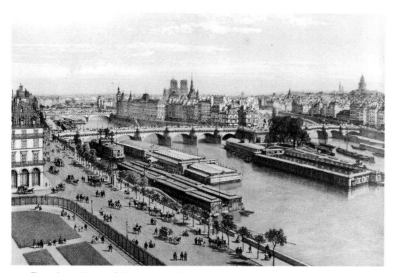

15. Benoist, *View of Paris from the Louvre*, 1863.

advantage the rebuilt city, and foliage would not be permitted to hide any significant features. Monet's goal is to make a naturalistic interpretation of the city so that the observer locates the Seine by adjusting a series of clues, seemingly casual in their arrangement. Other aspects of the painting lead to a feeling of this same apparent casualness. In the foreground, the large green segment of the garden floats off the bottom and right edges. Thanks to its eccentric angles, we have a feeling of excitement and tentativeness in Monet's picture, appropriate to our height and to the expression of wonder that the new Paris induced in Monet, and now in us. Our eye plunges across and up, to find the compact mass of urban activity in the center (Pl. 1). The fact that this Y-shaped funnel of action is buoyed up by the tilted plane of the garden is one of the secrets of Monet's structure, for it lacks the prominent inward-slanting axes and the heavy weights that we find at the base of traditional cityscapes. As a painter, not a topographer, Monet builds his composition with just a few units, and these are simply treated; his aim is effect, not information. The same was true of Manet, who dropped the Seine out of the middle of his picture of the World's Fair (Pl. 7), and of Renoir, who obscured the axis of the Champs-Elysées (Pl. 8).

Squeezed into its confined area, the only activity in Monet's painting consists of several dozens of pedestrians, one horseman, and five carriages (one of which heads towards us to mark the path of the street to our left). With astonishing virtuosity, the twenty-seven-year-old artist invents a visual shorthand—the notorious "tongue-lickings" hated by conservative critics—to capture the movement and variety of urban traffic:

> The flicker of the passage of a form behind a grille of repeated verticals is masterfully recreated. The visual effect of such a situation, in which neither body nor grille can be clearly perceived, is captured by the thin, incomplete, and dryly brushed uprights of the fence—here interrupting a figure, there interrupted by one.[10]

The only figures easily detached from the crowd, more clearly silhouetted than any others, articulate the open spaces: to the right of center, two figures punctuate the gap between the trees; they are walking in front of the ramp that curves down to the lower quai. Towards the left edge, a woman and man stroll inside the garden, making its geometric emptiness all the more apparent.

The artful care with which Monet built his exhilarating view of Paris, although its parts may seem randomly chosen, is signalled by its echoing symmetries. The dome of the Panthéon is flanked by the tower of Saint-Etienne du Mont and the dome of the chapel of the Sorbonne. The clump of buildings on the far left is echoed by another on the right edge. The dome above, on the picture's central axis, is saluted by the tree along the bottom edge, just right of center. Stability is reinforced by our sensing the visual square that the city forms beneath the skyline (the distance from the top of the Panthéon to the base of the picture exactly equals its width). The sky, taking up two-fifths of the surface of the canvas, establishes the moist, grey light so typical of the Paris basin, that soft, shadowless light which helps unify the composition. We are tempted, in fact, to think of this painting as a homage to natural substances. Approximately four-fifths of its area represents sky, tree foliage, and the garden. However, except for the sky, this is man-made, or man-determined nature. More than that, it is the newly rebuilt, well-controlled nature of the Second Empire, symbolized by that busily colored flag amongst the foliage. The Garden of the Princess, evocation of aristocratic lineage, is observed from the balcony of the royal, now imperial palace, looking over towards the pantheon of France's great figures. Buildings redolent of French history and authority surmount a space whose support is that neatly trimmed garden, blocked off from the ordinary life of the street, accessible to those willing to observe its well-regulated paths. Monet's painting, like those of Renoir and Manet, is characterized by order, symmetry, nature made the servant of government as well as of artistic purpose, throngs channeled into prescribed patterns, clear, natural light suffused throughout the scene. What is this but a homage to Paris in 1867, to the city which, like it or not, was being endowed with purifying light and air by society's new planners?

The End of Empire

Henry Tuckerman, that unreconstructed republican from America, wondered just how long the bubbling prosperity of Louis Napoleon's Paris could keep discontent from bursting forth. If, he wrote, "we inquire into the condition of the working class, we learn that occupations too expensive for the coffers of the state are projected to keep them busy, and therefore less disposed to rebel." Tuckerman was no revolutionary, but he had sensed a pent-up desire for change, a desire frustrated since the European-wide ferment of 1848. An intelligent observer in 1867 was bound to sympathize, he said, with

> the problems which, in spite of bayonets, surveillance, treaties, cowardice, and hypocrisy, wait solution in Europe. The conviction is overwhelming that the people 'stand and wait;' their experiments, however futile in appearance, are

16. Manet, *The Barricade*, c. 1871. Boston, Museum of Fine Arts.

what they regarded as betrayal and incompetence, Parisian insurgents established a radical government, the Commune of Paris, and took over the city. Hopes of a permanent revolution proved chimerical, and in May government troops marched in from Versailles to put down the Commune. The civil war that ensued was short-lived, but it left deep wounds. Paris was badly damaged (the most famous loss was the palace of the Tuileries), thousands of communards were executed without trial, and the political and psychological scars that resulted were palpable for decades.

Manet and Degas both served in the artillery, but apparently did not see active service. They suffered through the famine, however, and although they were not partisans of the Commune, both were repelled by the slaughterous repression of the insurgents.[12] Manet's reaction endures in the form of two lithographs and associated drawings, one that shows dead fighters by a barricade, the other (Pl. 16), Versailles troops shooting communards. For the latter, Manet used the composition of his *Execution of Maximilian* of 1867 (Pl. 63), transplanting it to the barricaded streets of Paris. His customary reserve and his graphic shorthand suggest the neutrality of a reporter, but at the very least he was pointing to tragedy, not to triumph. We know that he was much shaken by the whole bloody era and suffered a depression that lasted into 1872. Among the other impressionists, Bazille enlisted in the Zouaves and was killed; Renoir was conscripted into the cavalry and was returned unharmed to civilian life. After the outbreak of war in the summer of 1870, Monet and Pissarro had left for England, where they sat out the war and the Commune; Monet went on to Holland and did not return to Paris until late the next year. None of the impressionists, with the possible exception of Pissarro, was a partisan of the Commune, and, as we shall see in succeeding chapters, they accommodated well to the Third Republic as it recovered from the ashes of 1871.

War reparations were paid to the Prussians with unexpected speed, and a reasonable normalcy returned to Paris by 1873, although the aftermath of the war and the Commune continued to dominate politics and people's memories. A number of Haussmann's projects, only partly carried out, were completed in the next few years, including the boulevard Saint-Germain, the avenue de l'Opéra, and the Opéra itself. Louis Napoleon had intended that huge building to be the setpiece of his empire, but it opened only in 1875, five years after his fall. Essentially, however, the construction of the 1870s was a consolidation of the transformation of Paris that was largely completed by 1870, and the main features of Parisian life followed the patterns already established. Newcomers continued to flood into Paris, among them many who catered to the growing population by providing the goods and services it demanded. There was a steady increase in the numbers of cafés, cafés-concerts, restaurants, theaters, and hotels, and a constant growth also in large department stores, and in shops selling Parisian fashions, cosmetics, and similar goods.

The population that supported this urban commerce, abetted by seasonal influxes of foreign and provincial visitors, had nearly doubled between 1840, the year of Monet's birth, and 1870. In certain districts the rise in population was remarkable. In 1830, the village of Montmartre had numbered

only suspended, not abandoned; their wrongs accumulate only to be the more certainly vindicated.[11]

Tuckerman correctly predicted a crisis, but he could not have foreseen the peculiar and tragic form it took: war, seige, and famine in Paris, the brief hegemony of the Commune, and its bloody repression in the May days of 1871.

For, three years after the Paris Universal Exposition came a great watershed in the history of Paris and of France. Haussmann, under increasing attack for the ruthlessness of his projects and the financial legerdemain that sustained them, was finally dismissed by Louis Napoleon in January 1870. Seven months later the Emperor was manoeuvred into war with Prussia, and on 2 September, at the head of his troops, he suffered a disastrous defeat at Sedan. Krupp's cannons rumbled towards Paris, this time not for exhibition, but for the real business of seige and bombardment. In January, after a four-month seige of the capital, which suffered ever-worsening famine, the interim French government had to sign a humiliating armistice with the new German empire.

Defeat and occupation would have been a sufficient national trauma, but still more was to come. In mid-March, angered at

about 6,000 inhabitants and, with its immediate environs, perhaps double that number. By 1861 it had 106,000 and in 1886, just before Toulouse-Lautrec settled there, it had risen to 201,000. To cater to this huge mass of people, horse-drawn omnibuses rumbled along the new streets in great numbers. In 1855, the omnibuses carried 40 million passengers, in 1873, 116 million, and in 1882, about 200 million.[13] These figures say nothing of horse-drawn cabs and carriages for hire, and other vehicles that clogged traffic to the constant complaint of contemporaries. Already in 1866, Louis Veuillot could lament that

> The streets of Paris are long and wide, bordered by immense houses. These long streets become longer every day. The wider they are, the more difficult it is to cross them. Vehicles encumber the vast pavement, pedestrians encumber the vast sidewalks. To see one of these streets from the top of one of these houses, it's like an overflowing river that carries along the debris of a society.[14]

And in the following decade, city traffic grew to such an extent that by the early summer of 1881, a daily average of between 11,000 and 18,000 vehicles were counted crossing the Pont Neuf, 20,000 along the rue Royale, and the staggering figure of 100,000 down the rue Montmartre.[15]

Les Grands Boulevards

The most prosperous district in central Paris through this whole period of 1850 to 1880 was formed by the *grands boulevards* near the Opéra, the linked avenues which stretch northeast from the church of the Madeleine (Pl. 17). This continuous arc changes its name successively from the boulevard de la Madeleine to the boulevard des Capucines, then to the boulevard des Italiens, before bending eastward to become the boulevard Montmartre and the boulevard Poissonnière. In one day, 20,000 vehicles passed along the boulevard des Italiens, according to that survey of 1881. (As a measure of the significance of this figure, the important commercial boulevard Saint-Denis further east had only 15,000 vehicles a day.) "What is the secret of the great attraction of this promenade?" wrote Edward King, at the time of his visit in 1867:

> Other streets are as fresh and gay, have the same advantages of lightness, airiness, verdure of trees in the midst of rush and crowds, but no longer the same prestige. The boulevards are now par excellence the social centre of Paris. Here the aristocrat comes to lounge, and the stranger to gaze. Here trade intrudes only to gratify the luxurious. . . . On the grands boulevards you find porcelains, perfumery, bronzes, carpets, furs, mirrors, the furnishings of travel, the copy of Gérôme's latest picture, the last daring caricature in the most popular journal, the most aristocratic beer, and the best flavored coffee. But prices have of late years crept up in this fashionable quarter, and he must have a long purse who will "do" the boulevards.[16]

It is true that Haussmann and Louis Napoleon could not claim credit for making this area, already prominent under Louis Philippe, into the center it was in their day and con-

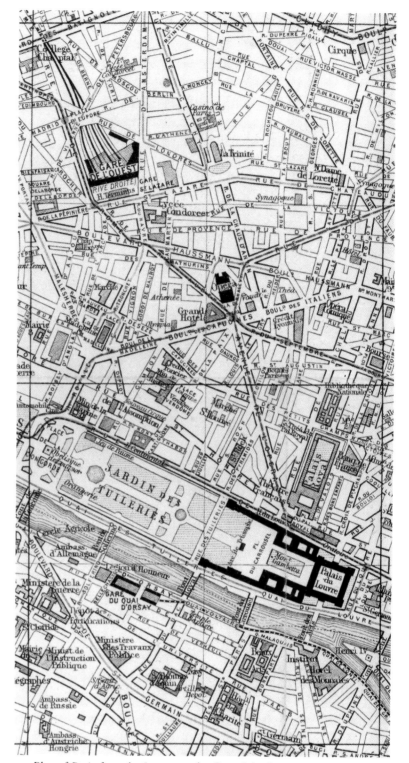

17. *Plan of Paris from the Louvre to the Gare Saint-Lazare, 1891.*

tinued to be during the Third Republic, but their policies had a large, indirect share in its glitter. The Opéra was strategically placed as the culminating point of the new avenue de l'Opéra (Pl. 3). Although this avenue was not entirely pierced through and completed until 1877, the immediate environs of the huge new building were recast, so that it was joined to the expanded Gare Saint-Lazare, to the northwest, and ringed by a whole series of entirely new streets, including the rue Auber, the rue

Halévy, and the rue du Dix-Décembre (now the rue du Quatre-Septembre); the latter led to the Bourse, the city stock exchange, to the east. Between the Opéra and the Bourse, along the boulevard des Italiens, there was a thriving financial center, including a number of new deposit banks. The rue de la Chaussée d'Antin, described as the "rendez-vous principal de la fashion parisienne,"[17] intersected the boulevard des Capucines as it changed its name to the boulevard des Italiens. Several major theaters were also near the Opéra (among them the Vaudeville, the Italiens, the Nouveautés, and the Opéra comique), and the wealthy, cosmopolitan crowds were served by some of the city's most famous cafés and restaurants. Along the boulevard des Italiens were the restaurant Maison Doré, and the cafés Riche, du Helder, Anglais, and Tortoni; along the boulevard des Capucines, the Café Américain, the Grand Café, and the Café du Grand Hôtel.

The last-named café was on the ground floor of the Grand Hôtel, in the heart of the district described by Henry James as "the classic region, about a mile in extent, which is bounded on the south by the Rue de Rivoli and on the north by the Rue Scribe, and of which the most sacred spot is the corner of the Boulevard des Capucines, which basks in the smile of the Grand Hotel."[18] In Monet's *Boulevard des Capucines* of 1873 (Pl. 18), the Grand Hôtel is the building to the left. Typical result of the rampant speculation of the Second Empire, the Grand Hôtel was opened in 1862, one of the many buildings erected by the real-estate firm established by the Pereire brothers. It occupied the entire triangular plot between the boulevard des Capucines, the rue Scribe, and the new place de l'Opéra. An engraving of it under construction (Pl. 19) shows the extent of the renovations in this area (the flattened zone in the upper right is the site of the new Opéra). Baron Haussmann's policies facilitated the demolition of old buildings along established thoroughfares, and the resultant changes of ownership favored entrepreneurs like the Pereires. The Prefect's powers were such that he could impose uniform designs upon these buildings, as well as upon those along entirely new

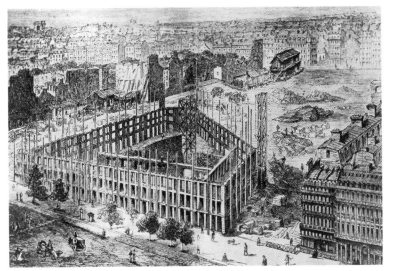

19. *The Grand Hôtel under construction*, c. 1860.

streets. The Grand Hôtel was required to align the levels of each story with those of nearby buildings, a policy which ensured near uniformity of design along entire streets. It was just such uniformity, not to say banality, that struck Henry Tuckerman and others as a great loss, compared to historic Paris. L. Vitet, writing in the prestigious *Revue des deux mondes* in 1866, complained of the monotony. He understood, he said, the virtues of modernization, "but in the midst of this more convenient, less harsh, less suffocating life, what happens to art?" The evil, as he saw it, was the triumph of the engineer over the architect, of material over art: "merely editors of projects, or passive surveyors of projects that they have not conceived, the architects of the city of Paris today are engineers. Should we be astonished that in their hands art is suffering?"[19]

We know that Renoir shared these ideas by 1877, when he published the first of a series of statements which decried the loss of historic buildings and their replacement by structures that are "cold and lined up like soldiers at review";[20] statements which demanded instead that initiative be granted to the individual artist. His painting of *The Great Boulevards* (Pl. 20) was done two years before he composed the first of these pleas for individual creativity, but it seems reasonable to assume that he had these views already by 1875. His picture shows a Haussmannian building much like the Grand Hôtel, but only a portion of it, its regular lines softened, its roofline partly absorbed by the sky, partly assimilated by the line of tree foliage. Although these trees form a clear recession into depth, there is no strong canyon of space favored by contemporary photographers and others who were bent on capturing the long, regular vistas that characterized Second Empire planning (Pl. 3). In the foreground, near a kiosk,[21] a figure is seated in the shade of the trees, reading a magazine or book. Out on the pavement, in the shadow of these trees and the unseen buildings to the left, two top-hatted men converse; near them is an elegantly dressed woman, with an equally well-got-up boy and girl. To the right, a carriage is coming down the boulevard, bearing another top-hatted man and a woman with a parasol.

18. Monet, *Boulevard des Capucines*, 1873. Moscow, Pushkin Museum.

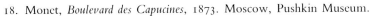

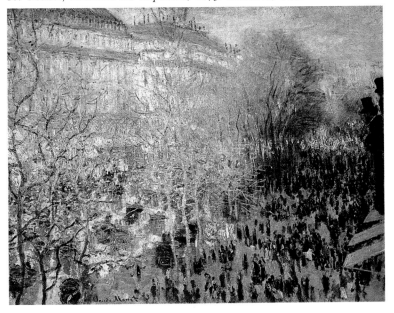

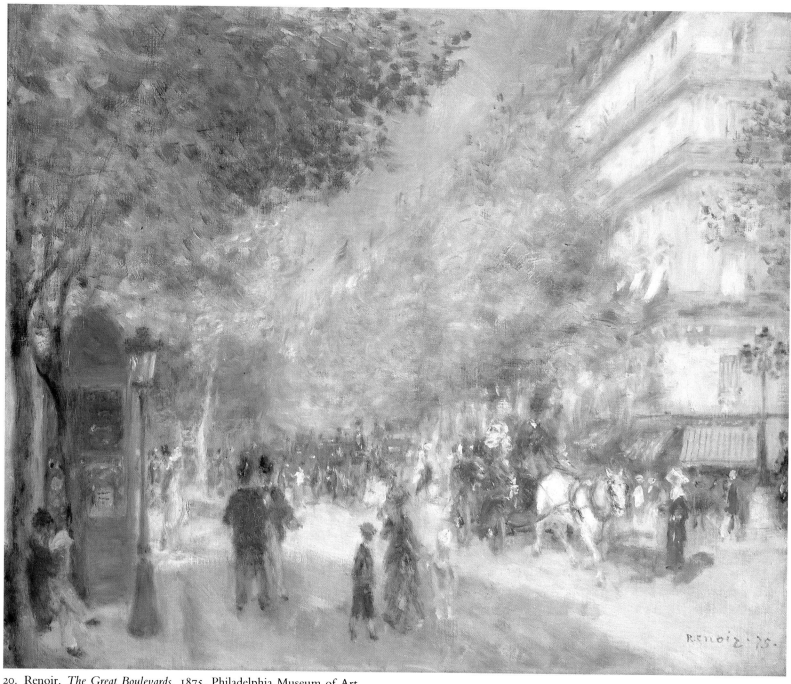

20. Renoir, *The Great Boulevards*, 1875. Philadelphia Museum of Art.

Such figures characterize the wealthy patrons of the *grands boulevards*, and, like the kiosk, they constitute also diverse spots of color and life which emphasize the animation of the district with pleasing irregularity. Together with the foliage overhead (which occupies slightly more than one-quarter of the picture's surface) and the strong play of light and shadow from the midday sun, Renoir's figures cover over the stark regularity of Haussmann's conception. They help expiate the crime of monotony with the aid of the picturesque. One can find similar figures in contemporary topographical views, for example, in the representation of a similar street corner (Pl. 21) published a decade earlier. The comparison shows Renoir's alertness to the tradition of such prints. After all, he wanted to find a client capable of buying the more elegant and permanent

record of a famous street which an easel painting provides (the impressionist exhibitions and Renoir's dealer Durand-Ruel were located in this same district). The commerce he was engaged in, in other words, was related to that of the guide book.

Despite these real, if indirect connections, Renoir's painting separates itself from the guide-book print, revealing their different functions. The print, like the text it accompanied, had to supply a lot of information. Its many figures and vehicles are a cross section of traffic along the *grands boulevards*. To the right is a corner of the new opera building, and far down the Capucines, on the extreme left, is the church of the Madeleine. Dominating all is the Grand Hôtel; nothing is allowed to interfere with the description of this massive struc-

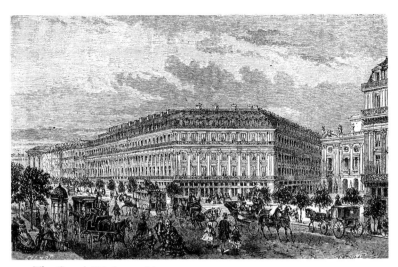

21. *The Grand Hôtel*, c. 1863.

ture. The trees, so prominent in Renoir's picture, are inconspicuous here. They had been newly planted in 1861 or 1862, when the Grand Hôtel was completed, and the boulevard refurbished, but the function of the illustration required their subordination in any event. By contrast, the function of Renoir's painting was to embellish the elegant street, and his foliage, like that in Monet's *Garden of the Princess* (Pl. 14), was treated as a kind of verdant costume, pulled over the body of the city, which would be too plain without it.

It is not only the image of foliage, but also the brushwork and color which seem like a gauzy textile that Renoir has placed between the viewer and the harder substances that traditional painting would have disclosed. The famous "impression"—the term "impressionism" had been coined a year before Renoir's painting—is the effect of immediacy which the artist sought, an effect achieved by strong color and rippled brushwork, which replace the crisper forms that resulted from conventional modeling. In Jean Béraud's slightly later *Paris, On the Boulevard* (Pl. 22), for example, each of the forms is readily distinguished from its environment. Béraud is bent upon giving a lot of information, a plain view, not an embellished one, of a typical spot along one of the *grands boulevards*. We can distinguish thirteen posters on his Morris column, the legend "[Café-] Restaurant Américain" on the awning to the right, and above it, "Grand Re[staurant]." From an outdoor vendor, or perhaps from hosing down the restaurant terrace, a homely liquid stream makes its way to the gutter, the kind of detail that has no place in Renoir's idealized view. Eleven main figures people the foreground, including an American (or perhaps British?) couple with a boy in sailor costume, and a smart French couple. Scattered behind these are twenty-nine subsidiary figures, standing on the sidewalk, seated at the restaurant, or riding in carriages. Overhead, the trees, so unlike Renoir's, are rather mechanically separated by virtue of individual points of foliage, repeated in the shadows on the pavement.

Monet's *Boulevard des Capucines* (Pl. 18) looks down on a similar area near the Opéra. It was done in the autumn of 1873, preceding the first exhibition of the impressionist group (so named in the wake of that show). Like Renoir, Monet used natural forms to disguise the banality of Haussmannian

architecture. We are looking out over the boulevard des Capucines towards the place de l'Opéra (Pl. 17). The Grand Hôtel is to the left, and in the center, divided by the almost imperceptible place de l'Opéra, is its virtual twin, a huge building that incorporated the Théâtre de Vaudeville; Béraud's Café-Restaurant Américain was on the ground floor of this huge structure of 1869. Tree branches, perhaps still bearing a few autumn leaves, hide portions of the buildings and help soften the remainder. Their screening effect is enhanced because Monet adds their orange-yellow and orange-brown tones to the sunstruck pavement and buildings, the whole calculated to create the sense of midday sunlight in moist air. The line made by the huge shadow gives the axis of the street, but unlike Béraud's composition and contemporary stereopticon photographs, Monet's composition flattens and widens the avenue. It seems, in fact, more like a city square than the long ravine of space that contemporary photographers liked to capture. The distant sidewalk forms a horizontal, not a receding diagonal, and below it the street assumes the shape of a broad rectangle, subdivided into light and dark geometric pieces. As our eye

22. Béraud, *Paris, On the Boulevard*, c. 1878–82. Collection unknown.

sweeps to the right, we suddenly come to the silhouettes of two top-hatted men leaning into the picture from an unseen balcony; below them are the buildings along this side of the boulevard, a surprising effect which brings us closer to the street by making us aware of our vantage point. If the extreme right portion of the composition is blocked off, the scene becomes strangely flat and distant.

What Monet accomplished here, in 1873, and Renoir two years later, was to readjust the new Paris according to the conventions of their new art. They gave the city, to use Gautier's phrase, its "civilized attire."[22] Haussmann and Louis Napoleon had boasted of giving the city light, air, and space, and with their trees and gardens, they literally brought nature into the Parisians' daily environment. These beneficial by-

products of their modernization were, of course, stated to be its actual goal and succeeded in winning the endorsement of many who regretted the destruction of old Paris. Even Vitet, when he attacked the dullness of Haussmann's plans in 1866, admitted the gains:

These large spans, these openings, these junctions, these vast outlets that abridge distances, these creations of entirely new districts suddenly sprung from the ground, these trees, these gardens, this water that here and there interrupts and cuts across the fastidious series of streets and buildings, these are really conquests.[23]

Monet and Renoir took a positive view of Haussmann's alterations. They reoriented his spans, openings, and outlets, they interpreted his light and air in terms of the intense color-light of their new palette, they rendered his trees in flickering brushwork that hides the banality of his buildings and blocks off his long, authoritarian vistas. It is as though the painters, with the passing of time, had fulfilled the wishes of Louis Bouilhet, one of Haussmann's staunchest opponents, who had written in 1859 of the new streets and buildings in his *Demolitions*:

To cover them, climb up, O vines,
Break up the sidewalks' asphalt,
Throw over the modesty of the stones
The veils of your black branches.[24]

Monet's vantage point was the second floor at the corner of the boulevard des Capucines and the rue Daunou, in Nadar's former studio. The boulevard des Capucines offered social prestige, a location convenient to both city dwellers and suburbanites (the Gare Saint-Lazare was nearby), and a large walk-in clientèle from the crowded street. The craze for photographs had coincided with the rise of the Second Empire, and fortunes were rapidly won and lost in this business, whose volatility so well characterized Louis Napoleon's Paris. Nearby were the quarters of Mayer et Pierson, prominent photographers of suitably international name, and on the boulevard des Italiens was the "exhibition room" of Eugène Disdéri, inventor of the photographic visiting card.[25]

When Monet painted his picture in the fall of 1873, Nadar's studio was vacant. He had moved on to other quarters, and had offered his space to Monet and his friends who were then working out their first group exhibition, to open the following April. The idea for an exhibition separate from dealers and official exhibition societies was endorsed most enthusiastically by Monet, who was constantly in need of money, and who pursued it with great determination. A sudden slump in the economy pinched off most of the scant dealers' sales the young painters had been making, and they felt driven to fend for themselves. By the end of December 1873, the group had registered itself as a "Société anonyme des artistes, peintres, sculpteurs, graveurs, etc." In banding together in this manner, Monet, Pissarro, Renoir, Degas, Berthe Morisot, Sisley, and several of their friends were emulating both the guild-like associations of artisans and craftsmen, and the small cooperative businesses that tried to find their places in Parisian commerce. "The Limited Company of Painters, Sculptors and Engravers," that is, was forced to seek its own clients, and

what better place than that most fashionable of locations, the boulevard des Capucines? Art lovers already knew the district well, not just for its shops, theaters, and cafes, but also for its numerous art dealers. Georges Petit, for example, was just a block away, on the rue de Sèze, at the beginning of the Capucines, and Durand-Ruel was further down the Italiens, on the rue Laffitte. The area remained important to the impressionists, and six of their eight group exhibitions through 1886 were held along or near the *grands boulevards*.

Degas was one of the most faithful contributors to those now famous exhibitions, partly because, like Monet, Renoir, Pissarro, and Sisley, he had urgent need of money. Until about 1874, unlike the others, he had lived a life of relative ease and sold few works, openly expressing disdain for the art market. The death of his father in February 1874 revealed the very poor state of the family banking business, and the family's struggling enterprise in New Orleans was itself deeply in debt. Degas felt obliged to help liquidate the business debts by seeking all means of selling his work, a painful procedure for a proud man. He might anyway have joined Monet and the others in their entrepreneurial ventures, but necessity was an additional factor.

The association of Degas's art with the impressionists' exhibitions shows particularly well in his *Women on a Café Terrace, Evening* (Pl. 47). The boulevard Montmartre continues the boulevard des Italiens at its eastern end, near the rue Le Peletier. It was on this street, near the Italiens, that the impressionists held their second and third exhibitions in 1876 and 1877. Degas's café view was in the 1877 show, so he brought the nearby street scene into the exhibition, as Monet had in 1874, on the boulevard des Capucines. Degas's composition was singled out by Renoir's friend, the critic Georges Rivière, for its truthful, unembellished observation of ordinary life. Degas, he wrote,

is an observer; he never seeks exaggeration; the effect is always obtained from nature herself, without caricature. That is what makes him the most valuable historian of the scenes he shows us. . . .Over here are some women at the entrance of a café, in the evening. One of them strikes her thumbnail against her teeth while saying "not even that much," which is quite a poem. . . .In the background is the boulevard whose bustle is diminishing little by little. This is another really extraordinary page of history.[26]

Appropriately enough for the effervescent nature of a boulevard exhibition, Rivière published his article in *L'Impressionniste*, the short-lived journal which he put out with Renoir's help during the 1877 show (it was here that Renoir launched his written campaign against monotony in architectural design). Like others marketing a new product, the painters had to advertise in the hope of attracting sympathetic attention. Along the *grands boulevards*, after all, wealthy people went shopping, and paintings were among the objects they shopped for. Two years later, still in need of the advertising that favorable reviews provide, Renoir associated himself with *La Vie moderne*, a weekly launched by his patrons, the Charpentiers, publishers of contemporary literature. Renoir's brother Edmond was put in charge of exhibitions in the weekly's premises, suitably located on the boulevard des Italiens. The

new journal announced that "our exhibitions will merely transfer momentarily the artist's studio to the boulevard, to a hall where it will be open to everyone, where the collector can come when he pleases...."[27]

One of the impressionists' collectors, Gustave Caillebotte, took on a unique role in the boulevard exhibitions, for he was a painter, and therefore both patron and participant. Several years younger than the other impressionists, he had met Degas by 1874 (Degas had listed him as a potential participant in the first impressionist show). Upon Renoir's invitation, he joined the group in the second exhibition, held in 1876 on the rue Le Peletier. Independently wealthy, he began buying works by his fellow exhibitors—he was the owner of Degas's *Women on a Café Terrace, Evening* (Pl. 47)—and eventually bequeathed to the Louvre an extraordinary collection of impressionist pictures. Immensely loyal, it was he who found and paid for the quarters for the 1877 exhibition on the rue Le Peletier. Wealth and social position obviously do not guarantee artistic talent, but Manet, Morisot, and Cassatt prove that they do not inhibit it, either. Caillebotte's financial independence coincided with his father's death in 1874 (the consequences for him were the opposite of Degas's bereavement the same year), but so too did his radical independence as an artist. In the second impressionist exhibition, in 1876, he showed his *Floor Scrapers*, three workmen vigorously scraping the wood floor of a bourgeois apartment. It was loosely associated with Degas's pictures of washerwomen, in the same exhibition, as a piece of contemporary realism, but it had no close precedents in recent French painting and was striking evidence of an original point of view.

In the same exhibition, Caillebotte showed *The Man at the Window* (Pl. 23), a picture in which, like Monet's *Boulevard des Capucines* (Pl. 18), the viewer looks out over a Paris street. Seen from this bourgeois apartment, Caillebotte's streets have a stark emptiness that contrasts sharply with Monet's boulevard. The apartment is that of the artist's family, on the third floor of a building on the corner of the rue de Miromesnil and the rue de Lisbonne.[28] We are looking over the shoulder of Caillebotte's brother René, down the rue de Miromesnil to its intersection with the boulevard Malesherbes, which it meets at an acute angle. It is afternoon, because we are facing northward, and the sunlight is coming from the west. Perhaps it is Sunday or a holiday, but since this is a residential area whose ground-floor shops attracted only a modest clientèle, there is little reason for the streets to be as well peopled as Monet's boulevard.

In fact, Caillebotte's painting is, precisely, a record of a new Haussmannian residential quarter built in the 1860s, not of the fashionable boulevards, and therefore we should expect it to create a very different effect. Caillebotte's brother watches a street that is quiet, but full of psychological import. Because of the vantage point the artist has chosen, the insistent angles of Haussmann's regular building lines virtually crush the space of the street (Pl. 25). In that imploding space is the psychological focus of René Caillebotte's gaze, therefore of ours: the woman who is about to cross the intersection. Her distance and size make her curiously vulnerable, like some insect captured by the artist's perspective lens. She is the anonymous city dweller, whose fragile aloneness is so different from any of the

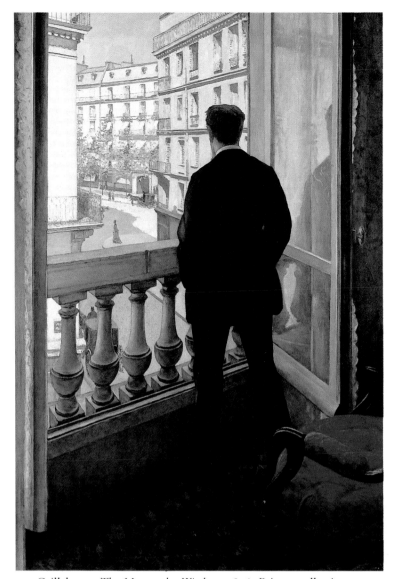

23. Caillebotte, *The Man at the Window*, 1876. Private collection.

busy figures crowding Monet's boulevard of shoppers and strollers. Because René stares directly at her, he is not at all like Monet's top-hatted men leaning out over the boulevard des Capucines. These men are peering out over the public space, participating in the current of activity that flows along that fashionable avenue. René Caillebotte is sheltered by the obtrusive reality of his interior. Because his empty chair faces the window, we can surmise that his vigil on the city is habitual.

Caillebotte's figure is the thoughtful observer, the characteristic urban person who appears in so much naturalist literature of the period, in the act of seeking the meaning of private interior versus public exterior. Caillebotte's view has been likened to the ideas expressed by Edmond Duranty, one of the leading naturalist writers, in his pamphlet *La nouvelle peinture*, a polemical defense of the impressionists' exhibition of 1876 in which *The Man at the Window* appeared. Duranty was especially close to Degas, who was consistently rumored to have been his collaborator on the brochure. Duranty makes an ardent plea for painters to cast aside traditional subjects, and turn to contemporary city life:

And because we cling closely to nature, we shall no longer separate the figure from the background of an apartment or of the street. In real life, the figure never appears against neutral, empty, or vague backgrounds. Instead, around and behind him are furniture, fireplaces, wall hangings, or a partition that express his fortune, his class, his profession....[29]

He asks the artist to remove the wall that separates the studio from ordinary life outside, to create "an opening on the street." Thirteen times in this thirty-four-page essay, Duranty juxtaposes apartment or studio to the street. In so doing, he gives witness to the topicality of Caillebotte's pictorial dialogue between anonymous pedestrian and brother/self/viewer. He points out that "the frame of the window, depending on whether we are near or far, seated or standing, cuts off the outside scene in most unexpected ways...." Because the observer's eye is constantly moving, she might see just a portion of a nearby figure, or at other times, "the eye takes one in from up close, in its full size, while all the rest of a street crowd...is pushed off into the distance by the play of perspective."[30]

Caillebotte's *Man at the Window*, in other words, takes up a theme common in contemporary naturalism. Nor must it be thought that his matter-of-fact presentation was inconsistent with the psychology inherent in it. Duranty's pamphlet and his early writings on realism tell us that the artist who deals with contemporary life *seems* to disappear behind the apparent objectivity of his presentation, but in fact has implanted in the viewer's mind the conclusions he aims for.[31] By choosing salient elements from daily life, the artist is far from neutral in his observations. Out of the vast array of objects and events that make up experience, he selects only a few. These choices alone constitute acts of judgment, but in addition the artist transforms them by the artificial conventions of his art. For this reason observation itself is not a passive act, but one that transforms the things being seen by lifting them out of the full context of life's complexities and subjecting them to the handful of associations that the artist cleverly manipulates. "What a wonderful thing observation is," wrote Victor Fournel,

and what a fortunate man an observer is! For him boredom is a word empty of meaning; nothing dull, nothing dead to his eyes! he animates everything he sees....Where others see only a rose, the observer discovers a worm lurking in its calyx....What a cruel thing observation is, and how unfortunate is the observer.[32]

Gare Saint-Lazare

The year after the appearance of Duranty's pamphlet, which firmly attached Impressionism to the ideas of naturalism already current in literature, the painters held their third group exhibition. It was again on the rue Le Peletier (a few doors from the site of the second show), and again the artists were aided by friendly pens, including this time Rivière's journal devised for the exhibition, *L'Impressionniste*. The second of Renoir's two articles[33] is what retains our attention today, but the review was dominated by Rivière's passionate and rather

maladroit attacks on the contemporary press for ignoring or disliking the exhibition. His steady refrain was that the impressionists had turned their backs on traditional subjects and were instead devoted to contemporary life, rendered in sincere and highly original works. Among the most original of the paintings shown in 1877 were three street scenes by Caillebotte and seven views of the Gare Saint-Lazare by Monet. These works had few precedents in French painting, and they take important places in the artistic record that the impressionists made of the transformation of Paris.

Each of Caillebotte's three city views has a striking, funnel-like perspective which immortalizes Baron Haussmann's long vistas. (Pl. 3) *The House Painters* (Pl. 24) shows two workers looking at the shop facade they are painting, while to the left the street zooms back with unaccustomed abruptness. *Paris, A Rainy Day* (Pl. 26) presents umbrella-laden figures at the intersection of eight streets near the Gare Saint-Lazare. *Le Pont de l'Europe* (Pl. 27) takes the viewer to the street bridge over the tracks of Saint-Lazare. The modernity of these paintings lies, in part, in their exploitation of Haussmannian planning, a seeming acceptance of the Second Empire's most controversial feature: its ruthless urban geometry. The site of the first of

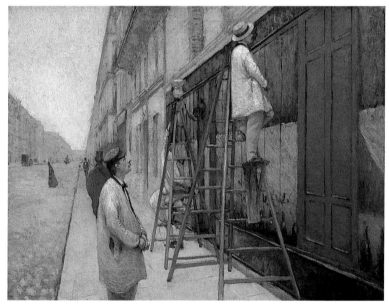

24. Caillebotte, *The House Painters*, 1877. Private collection.

the three paintings is unidentified, but *Paris, A Rainy Day* represents one of those star-burst intersections that typified Haussmann's work, the crossing of the rue de Turin, the rue de Moscou, the rue de Leningrad, the rue Clapeyron and the rue de Bucarest (Pl. 17). The Pont de l'Europe is a multi-spanned bridge completed in 1868. Both sites were entirely recast during the impressionists' lifetimes, and nothing remained of the previous era.

To place Caillebotte's paintings in historical perspective, the twentieth-century viewer does well to recall the earlier opposition to the Second Empire's destruction of the old city. The opponents were a minority, swamped by the power of autocratic government and by entrepreneurial prosperity, but among their number were prominent artists and writers, whose most frequent target was the long, straight avenue,

25. Caillebotte, detail of *The Man at the Window* (Pl. 23).

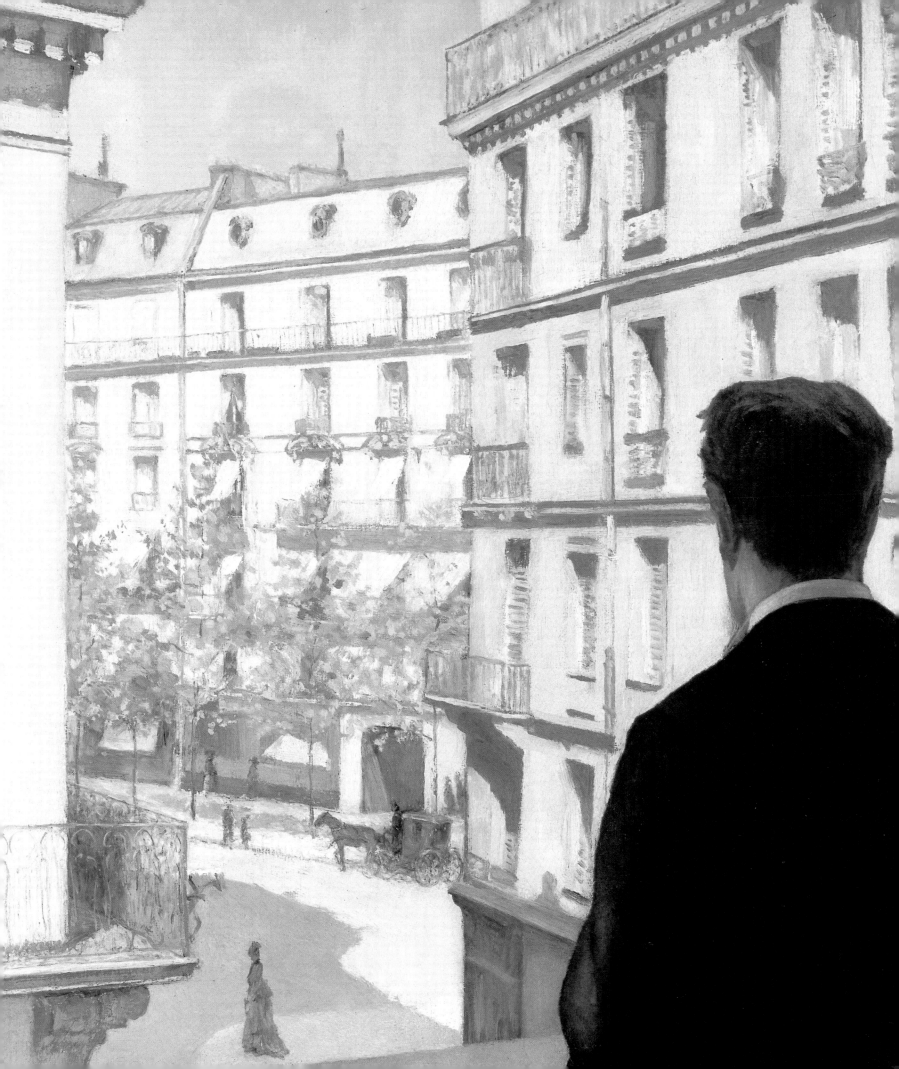

symbol of arbitrary power and of the triumph of utility over history. The exiled Victor Hugo addressed a poem to Haussmann that wonderfully expresses this view:

Today this enormous Paris is a charming Eden,
Full of cudgels and decked out in Ns.
Lutèce, the old Hydra, is dead;
No more anarchic streets, running freely, crammed full,
Where in the evening, in a dark corner, a facade
With leaping gables made one dream of Rembrandt;
No more caprice; no more meandering crossroads
Where Molière confronted Léandre with Géronte;
Alignment! You are today's password.
Paris, which you've pierced from side to side in a duel,
Receives right through the body fifteen or twenty new
 streets
Usefully leading out from barracks!

Boulevard and square have your name as their cockade,
And everything done looks forward to cannon balls.[34]

Unlike Hugo, Caillebotte, born in 1848, was a child of the Second Empire. Only twenty-eight years old when he painted his city views, he treated Haussmann's new streets as a normal constituent of his environment. The site of *Paris, A Rainy Day* was only five streets away from the family apartment on the rue de Miromesnil, on the other side of the Gare Saint-Lazare, and still closer was the sexpartite bridge over the tracks featured in *Le Pont de l'Europe*. The Paris of Hugo's memory could not have supported the vehicular and pedestrian traffic near the Gare Saint-Lazare. A year after the new span was completed, that station was receiving over thirteen million passengers, 40% of all rail clients in Paris.[35] More than 80% of the Saint-Lazare traffic involved the suburbs, for there poured out onto nearby streets a modern commuting society: workers,

26. Caillebotte, *Paris, A Rainy Day*, 1877. Art Institute of Chicago.

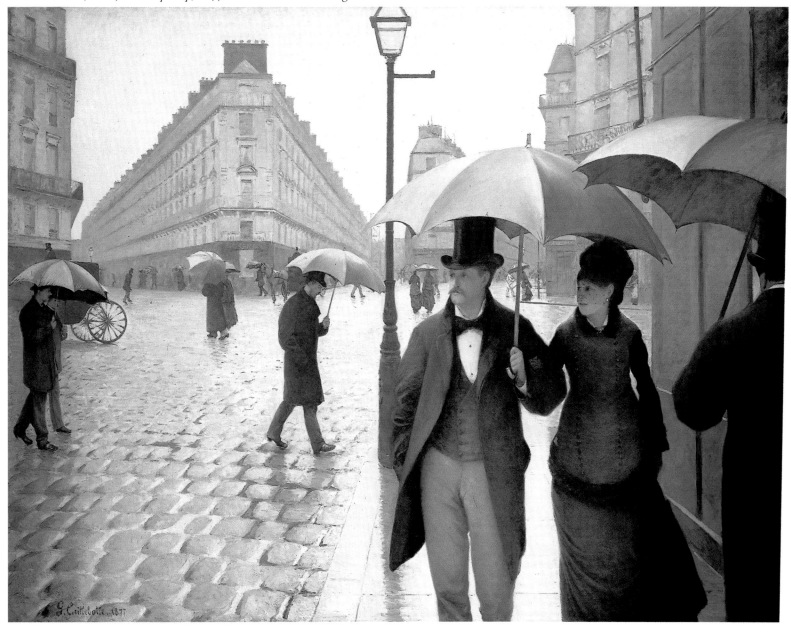

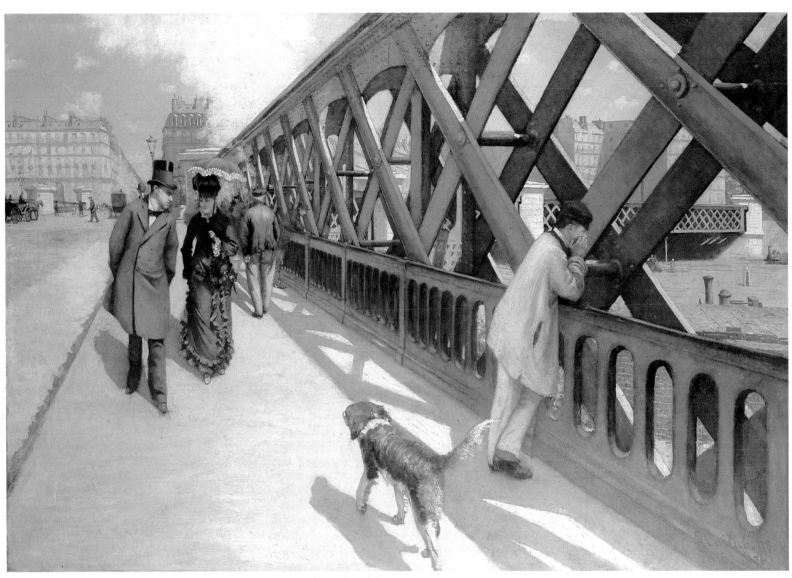

27. Caillebotte, *Le Pont de l'Europe*, 1876. Geneva, Musée du Petit Palais.

clerks, businesspeople, and shoppers who helped swell the crowds along the *grands boulevards* directly south of the station.

Caillebotte's *Le Pont de l'Europe* deals with this contemporary society, organized along Haussmann's lines, not along the picturesque, irregular lines that Hugo would have preferred. The perspective draws the eye inward, as was true of *The Man at the Window* (Pl. 23). It is an even starker network of perspective, because we are not sheltered by the imposing balusters of the earlier picture. Out on the street itself, little impedes the speed of our eye into Caillebotte's visual tunnel.[36] The prominent dog, like some animated projectile, hurries our view into the picture. We look down on it as though it were a horse, hitched to a carriage in which we are riding; not all of its shadow has made its way into the painting. This sense of rapid movement is enhanced by the force of the two figures who come towards us, especially the man, whose rapid pace has carried him beyond the woman, in whom, nonetheless, he shows an interest (as she does, in him). The perspective lines converge on the man, so he literally looms out from the far point of our vision, creating a push and pull of psychological and perceptual tension.

Distinct from the elegantly dressed pair are the men in working-class clothes. One, his back to us, walks into the picture, and yet he lines up with the bourgeois pair to form a diagonal grouping that blocks off the sidewalk from our view. The worker to the right, looking out over the unseen tracks, is so prominent that the viewer has to reckon up his particular significance, *vis-à-vis* the elegant strollers. A working-class variation upon Caillebotte's bourgeois *Man at the Window*, he looks out, not on residential streets, but the tracks. Instead of protective stone balusters, it is the metal barrier and the huge girderwork through which he looks. Leaning on the metal railing, he is part of the world of industry and work, an association consistent with the rest of the picture. The worker further back looks towards the girderwork as he walks away from us, and further along are two more workers, both leaning on the railing, like the foreground figure. The raw industrial forms are the everyday domain of the working class, in contrast to the upper-class strollers (including the bourgeois whose bowler hat peers over the shoulder of the man), who keep their distance from the bridge supports. Perhaps they are merely out for exercise, but there is a purposive air about their brisk pace. The well-dressed male is a *flâneur*, a stroller, featured in contemporary naturalist writing, who reconnoiters

23

city streets and stores up his observations for eventual use (hence the artist gives his own features to this man). The workers are treated as idlers (*badauds*), absorbed in a familiar environment, and lacking the *flâneur's* powers of detached, analytical observation.

The key to Caillebotte's painting is the cyclopean metal-work, embodiment of industrial power, aggressive symbol of the transformation of Paris. Caillebotte's frank use of its unembellished geometry brings this raw power out into the open. Its stark lines are deliberately ugly, all the more so because they dwarf the humans. Revealed in a strong, pale light which casts prominent blue-grey shadows, they repeat the perspective lines of sidewalk, street, and buildings beyond. They stand for Haussmann's controlling directives which slashed through this part of Paris to create a new quarter around the expanded rail station. Nothing of the old city is here: roadway, bridge, and buildings all date from the previous twenty years. Everything in Caillebotte's painting conforms to the altered city: the plunging perspective, the opposed forward force of the figures on the left, the rapid pace of dog and *flâneur*, the plain surfaces of sidewalk and pavement, the impersonal brushwork, the bleached light. The girderwork, given its overpowering presence, and the perspective, given its exaggerated, eye-sucking action, reveal the extent of Caillebotte's achievement. He does not praise the new Paris. He strips away the natural and the delicate (none of his three city views shown in 1877 has trees or foliage), and in doing so he exposes the harsh power, full of tensions, which underlay industrial Paris and its new society.

We are far, here, from Monet's and Renoir's *grands boulevards*, whose lively prosperity takes the most optimistic view possible of the renewed city. They cloak its harshness in foliage and sparkling light, and they point to its sociable, elegant exterior. Caillebotte's view is closer to that later expressed by the writer Joris-Karl Huysmans. At the end of his review of the fifth impressionist exhibition in 1880, Huysmans, echoing Maxime Du Camp's earlier cry, appealed to painters to represent contemporary subjects, including factories and railroad stations, and also public places, such as "these vast boulevards whose American pace forms the essential framework for our epoch's needs."[37] Wide, straight streets and unvarnished utility were associated with America. Huysmans employed the slight pejorative of this analogy to indicate his reluctant acceptance of the new vernacular. A naturalist did not praise the environment he wrote about or painted, but treated its homely ordinariness as the only proper setting for his art.

Ordinary though it is, Caillebotte's naturalism seems willful, even aggressive, when compared to the anecdotal naturalism of an artist like Jean Béraud (Pl. 22). Of course, Béraud does not want Caillebotte's starkness. He has chosen a lively boulevard, not a road bridge, and his treatment of it has to suit the subject. The contrast between the two is therefore one of different streets in Paris. Granting this, the comparison makes us more aware of just how curious was Caillebotte's choice of street and also just how striking are the devices he used to recreate it. Béraud's perspective lines, for example, recede about as quickly as Caillebotte's, but their rapid flight is obscured by the activity of sidewalk and street. The man standing by the kiosk, glancing at his newspaper, is a *flâneur* costumed like Caillebotte's stroller. He is aloof from the other figures, but is treated as one of many people on the boulevard, not as a protagonist through whom we are forced to enter the scene, as in the Caillebotte. Working-class men are here, too, but they are the coachmen whose carriages bear bourgeois passengers, and there is nothing of the symbolic confrontation of classes that Caillebotte creates. Béraud's several couples, also, have untroubled relationships which pose none of the questions raised by Caillebotte's odd encounter of man and woman. His sidewalk and street have the stains that form a patina of daily use, instead of the glaring starkness of Caillebotte's surfaces, whose pictorial functions are made all the clearer by this contrast.

Caillebotte's *Le Pont de l'Europe* was accompanied in the impressionist exhibition of 1877 by Monet's view of the same bridge, seen from the tracks (Pl. 28), and seven other paintings of the Gare Saint-Lazare, including interiors of the train shed (Pl. 29). Monet had been living Argenteuil for several years, but in the winter of 1876 to 1877 he rented a studio on the rue d'Edimbourg and began a group of paintings of the Gare Saint-Lazare. His studio placed him near Caillebotte, Manet, and Degas, and their devotion to urban subjects probably helped turn him temporarily from the suburbs to the city. Manet had already painted the tracks (Pl. 31), and Caillebotte's *Le Pont de l'Europe* was underway before Monet launched his series. Shared interest is the issue here, not "influence," and besides, Monet had regularly used the Gare Saint-Lazare going to and from Argenteuil since 1872. He had painted the railway bridge at Argenteuil, and a few pictures of industrial sites along the Seine, so the city station was a logical extension of his interest in contemporary subjects.

Monet's paintings of the Gare Saint-Lazare do not closely resemble Caillebotte's *Le Pont de l'Europe*. Huysmans, in his call for modern industrial subjects already referred to, acknowledged Monet's attempts to paint the station, but wrote that the painter did not succeed "in extricating from his unclear abbreviations the colossal amplitude of these locomotives and stations." Huysmans preferred Caillebotte to Monet, partly because he wanted clear images of the "imposing grandeur" of industry, partly because he was one of those writers who responded best to figure pictures and their narrative potential. He did not see that Monet's "unclear abbreviations" were the vehicle of his interpretation of steam, the underlying force of industrial power.

In Monet's *Le Pont de l'Europe*, we are out on the extremity of the suburban quai looking up at the bridge as it crosses over towards the rue de Rome. We are roughly opposite Caillebotte's vantage point, which would have been just beyond the left edge of Monet's picture. The perspective shares Caillebotte's sense of drama. The bridge plunges inward from the right edge, and its axis—it is the rue de Londres—continues into the gap between the buildings in the distance. The top edge of the bridge, if continued downward, would reach the lower left corner of the canvas, so it is a radical use of perspective, one that has an emotional effect on us. To the left is a stationary locomotive, attended by two trainmen. We are on a slight rise above them, on the quai that then, as now, reaches far out on this side of the station (which is well off to

our left). Steam and smoke pervade the scene, activating it while obscuring our view, merging at the top with the moist vapors of the sky to provide a unity of picture surface and of imagery. The steam and smoke in the foreground are so close as to be threatening. Has a train just gone by? Are these hissing arabesques instead rising from steam pipes along the tracks? In either case we are down in the entrails of the city, in one of those service arteries whose noises, smoke, smells, and movements were, in the preceding generation, commonly likened to hell. Most viewers of the 1870s would have brought to Monet's paintings these long-standing associations of the railroad with power, danger, and a bestial, possibly malevolent, force. Georges Rivière, in his friendly review in the special exhibition journal of 1877, referred to Monet's paintings of the station in highly colored terms, in which locomotives are monsters:

Around the monster, men crawl over the tracks, like pygmies at the feet of a giant. . . . One hears the workers' cries, the piercing whistles of the engines sending out their cries of alarm, the incessant noise of iron and the formidable and puffing breathing of the steam.

One sees the grandiose and distracting movement of a station whose ground trembles at every turning of a wheel. The walkways are damp with soot, and the air is clogged with the acrid odor that comes from burning coal.[38]

By contrast with *Le Pont de l'Europe*, Monet's view within the train shed (Pl. 29) is deliberately balanced, and the drama subdued. It is an unorthodox view with few precedents in the history of painting, but one that users of the station would have been familiar with. We are placed at the terminus of the tracks, looking along the axis of the rails towards the Pont

28. Monet, *Le Pont de l'Europe*, 1877. Musée Marmottan.

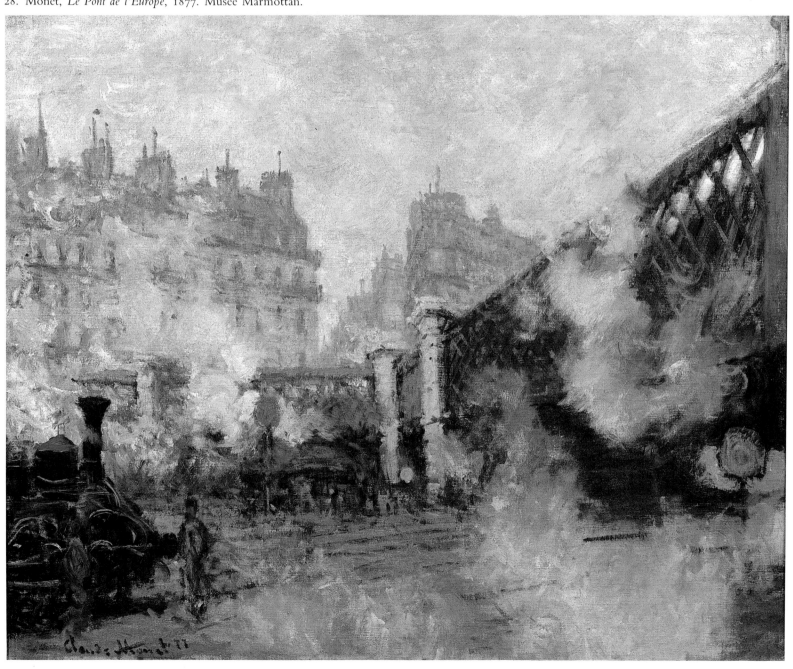

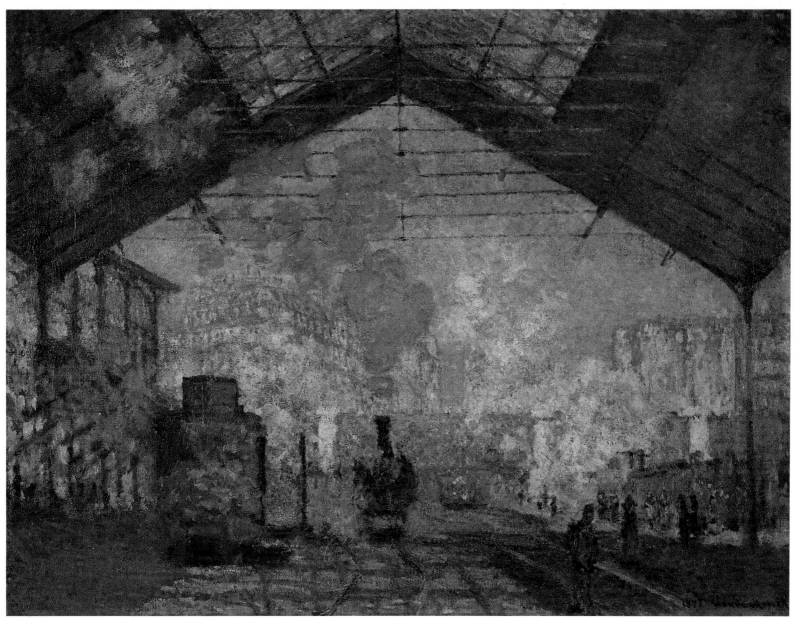

29. Monet, *Gare Saint-Lazare*, 1877. Musée d'Orsay.

de l'Europe, whose criss-cross girderwork forms a pale, horizontal band on the level of the locomotive's smokestack. From the way the blue clouds of smoke billow upwards, we can see that the engine is either backing out of the station, or possibly just entering it. To the right, nearby, is a rail worker, and further back are numerous passengers on the quai, which stretches off towards the distant bridge. On the left is the coal or wood car of an engineless train. The potential movement of both trains is directly towards, or away from, the observer, with the result that neither seems to move (Pl. 30). The sense of being held in a timeless moment is abetted by the puffs of steam which come from the undercarriage of the engine. They hide its wheels and further diminish its power to threaten us by making it float in an atmosphere of light, steam, and smoke.

To further the effect of a hovering balance, of a delicate resolution of forces, Monet constructed a symmetrical, measured composition. The locomotive is just to the left of the picture's center line, which is exactly marked by the peak of the gable overhead. The distance from the top of the picture to the top of the horizontal bridge (which coincides, not by accident, with the top of the engine's stack) is exactly half the width of the canvas, so that the areas left and right of the central axis, above the distant bridge, are perfect squares. On either side of the composition, at the same distance from its edges, are the spindly metal uprights which support the roof. They emphasize its lightness and airiness, for which even stronger evidence is given by the sunlight flooding through the skylight. The sun casts a measured pattern on the ground; its grid obscures the tracks (another instance of blurring the indicators of speed and power), and repeats the network of parallel lines found on the left, overhead, and in the buildings on the far right. Taken together with the shadows above and below, and the vertical supports on both sides, these networks act like so many filaments, drawn tightly around the central volume of colored light and steam.

30. Monet, detail of *Gare Saint-Lazare* (Pl. 29).

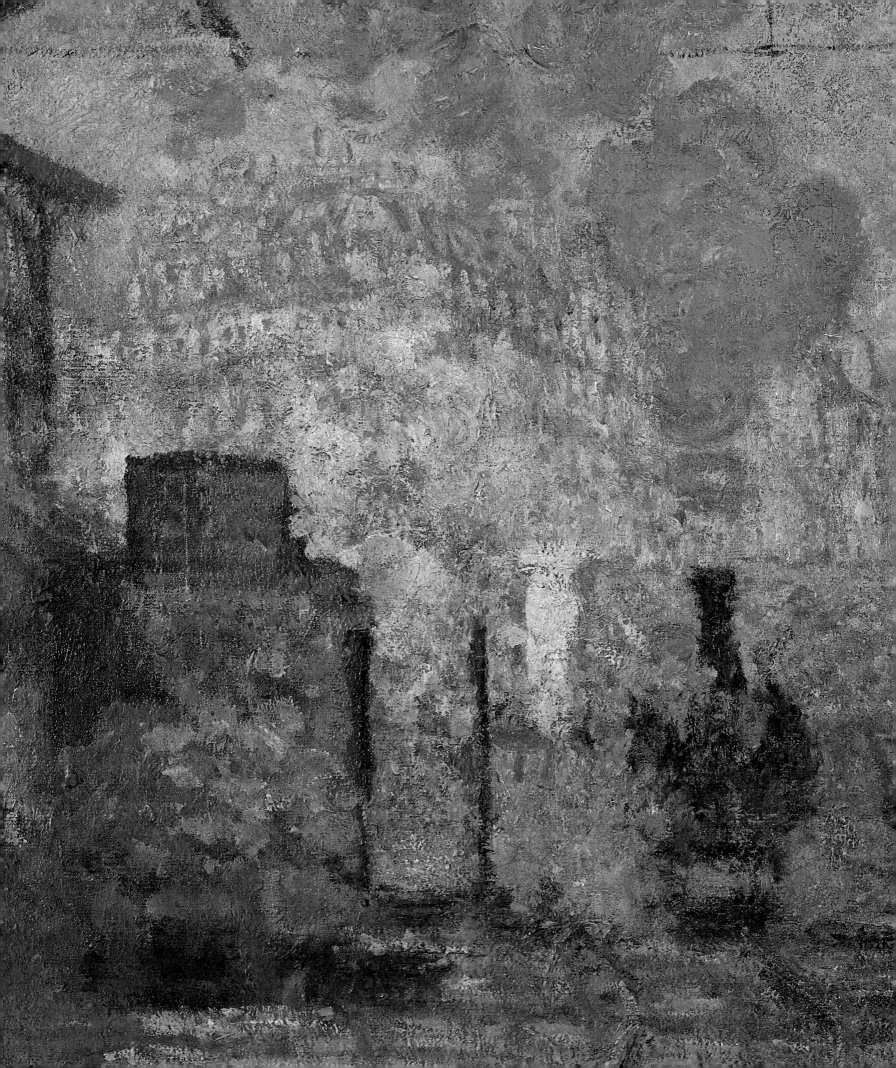

By stressing the airiness of the train shed, Monet has caught the spirit of Eugène Flachat, the engineer who had redesigned the station a decade earlier, making the main, gabled shed one of the most daring of contemporary structures.[39] With skillful use of iron columns, reduced to slender shafts, and of overhead braces, Flachat constructed a wide span whose openness he exposed through huge skylights. Monet, by giving such prominence to the sunlight flooding down onto the tracks, particularly to its geometric network, seems to pay tribute to Flachat's engineering. The rational patterns of the building's design, recapitulated in the painting, are a celebration of the way sunlight is organized for modern man. From the station we look out to the large volume of sunlight, but since it also enters the station from above, industrial steam and nature's vapors have been joined together. Solid mass is overcome in favor of light and air—by Flachat and by Monet. When we think of Impressionism, do we not think first of its rejection of traditional mass and modeling in favor of color and light? And have we not already recalled that Louis Napoleon and Baron Haussmann forced a new pattern upon Paris, widening streets, creating new avenues, parks, and squares, with the ostensible purpose of bringing light and air into the city? Flachat, for that matter, had been a prominent utopian socialist in his youth. The cry for modern engineering raised by the Saint-Simonists and other utopians, although by now transformed into the hum of technocrats at work, could still be construed as a progressive cry. After all, progressive social forces in France had long been demanding that Paris rid herself of dark, fetid streets and courtyards, of dank, windowless factories and slums. Louis Napoleon knew how to draw these genuine convictions into the web of autocratic power.

Manet's Modern Paris

Monet's and Caillebotte's paintings of the Gare Saint-Lazare had been preceded by Manet's *The Railroad* (Pl. 31), shown in the official Salon exhibition of 1874 (two other paintings were rejected by the Salon jury). Manet placed Victorine Meurent, one of his favorite models, and the daughter of a friend on the edge of the street overlooking the tracks near the Pont de l'Europe. The huge bridge protrudes into the right edge of the composition, but is largely obscured by the smoke and steam; above Victorine's head show the buildings on the far side of the railway cut.[40] The child looks out over the tracks, while the woman looks up from her reading to acknowledge the viewer's presence. The two figures dominate the picture, yet Manet's title gives us little indication of who they are. On the contrary, it seems a deliberate provocation, because the figures obscure our view of the railroad. The matter-of-fact presence of the two figures, nonetheless, is the heart of this striking composition. Like Degas, who put the vicomte Lepic and his two daughters in the foreground of the picture he called *Place de la Concorde* (Pl. 37), Manet offers not a conventional representation of a feature of Paris, but a new interpretation of it. Humans mediate the view, which becomes more than a view: it is a way of experiencing the modern city.

Manet lived near the Gare Saint-Lazare and had long acquaintance with its environs. In 1864 he had moved to the boulevard des Batignolles, just north of the station, and in 1871, not long before he began this picture, he took a studio at the beginning of the rue de Saint-Petersbourg (now the rue de Leningrad), a few doors from the eastern edge of the tracks (Pl. 17). The rue de Saint-Petersbourg extended from one of the radiating arms of the Pont de l'Europe, and in Caillebotte's painting (Pl. 27), we are looking directly down its axis (Manet's studio was just behind the top hat of Caillebotte's stroller). From his studio window, Manet could look at an angle out on the Pont de l'Europe. A visitor to the studio in 1873, the year Manet was working on *The Railroad*, described it as follows:

> A pure and gentle light, always equal, penetrates the room from the windows which look out on the place de l'Europe. The trains pass close by, sending up their agitated clouds of white steam. The ground, constantly agitated, trembles under our feet and shakes like a fast-moving boat.[41]

Manet chose to paint in this distinctively urban place, and its proximity to the railroad, felt in the trembling floor, was a constant reminder of contemporary life. His picture presents the railroad not in its obvious outer aspects, but indirectly, as it slices through his district, and as it affects everyday experience. Instead of the comforting perspectives and solid forms of tradition, he paints flat forms that have an odd abruptness. The woman looks out at us, while the child gazes off in the opposite direction; both are confined by the iron grill. Through its bars we see only indistinct forms, since the steam obscures so much. Against this backdrop, the tentativeness of the modern city is caught in the two figures, who fail to display any affectionate relationship. They face in opposite directions, and the woman forces us to recognize ourselves as that characteristic city dweller, the unknown passer-by. The viewer, in effect, has interrupted her reading. She looks up from her book in that moment when one registers the presence of another person, while guarding a neutral expression. As for us, we are passing down the street and look over at these two people stationed next to the tracks. It is the encounter of one stranger with others, one of those chance meetings that mark the modern city. We do not know if the woman is the mother, the sister, or the baby-sitter of the young girl. They are merely placed side by side, and the lack of any apparent bond between them reinforces the idea that we have simply happened upon them. It is in this fashion that Manet has characterized the role of the railroad in the modern city, its movement and its steam (like some exhibit in a cage, to be dispassionately observed), its comings to and fro, its moments of sitting idle while waiting.

Taken together, the paintings of the Gare Saint-Lazare and its environs by Manet, Caillebotte, and Monet show the diverse ways in which the impressionists interpreted the modern city, diverse and yet interwoven by threads of common interest. Each of the three painters turned his back on history, on anything that smacked of sentiment or the merely picturesque. Each chose a central feature of the altered city, the hub of its new network of movement. Each expressed the mobility brought about by the industrial revolution, not by close views of speeding trains, but by oblique renderings of the ways the city and its people are forced to change their patterns of association. Manet and Caillebotte place us on the street where

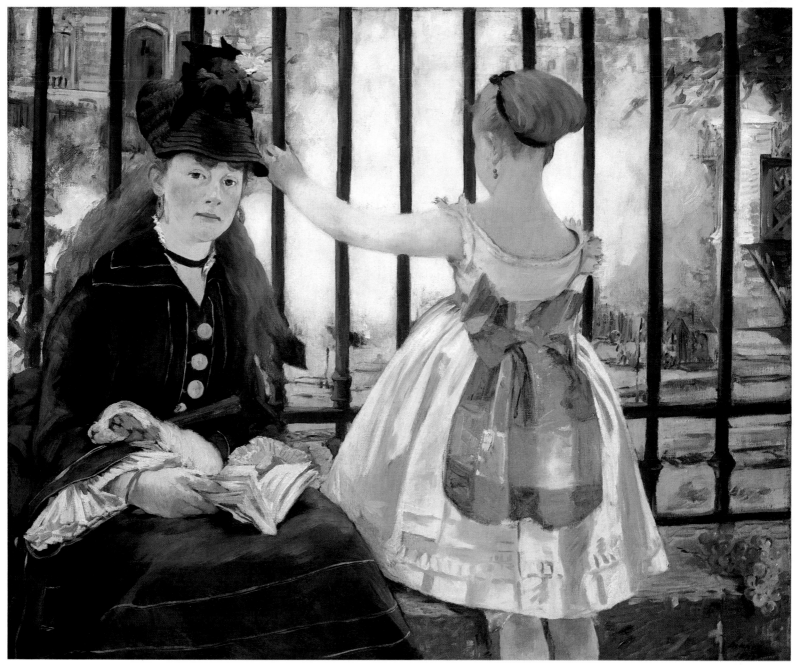

31. Manet, *The Railroad*, 1873. Washington, National Gallery.

their figures are separated from the tracks by harsh forms of industrial power. The iron grill and the girderwork, which art historians see too exclusively as elements of style, are symbols of the segmenting of Paris, of the discontinuities between street and tracks, between the environment of middle-class strollers and railroad workers. The painters' figures are on one side of a barrier, out-of-doors but artificially caged off from the spectacle they are reconnoitering. These figures share the same urban space, but the relationships among them, and therefore with the viewer, are discontinuous, unclear, an odd mixture of immediacy and lack of psychological contact.

Monet, less a figure painter than Manet or Caillebotte, relies more on the large effects of his active industrial spaces. Like them he features industrial ironwork, but he places us on the inside, looking out to the city. In *Le Pont de l'Europe* (Pl. 28)

we are down inside the deep railway cut, and our un-accustomed closeness to the tracks and trainmen, a somewhat threatening proximity, makes the city above us seem all the more distant. Within the iron train shed (Pl. 29), we are in the more familiar position of a commuter but, since we are not used to being taken inside a station by a painter, our attention is seized. In the preceding generation, Théodore Rousseau had often placed the viewer under a canopy of trees, looking out into a sunstruck clearing. Monet's pictorial structure is curiously similar, but we are in a noisy train shed, close to moving trains whose smoke and hissing steam activate the space, one that would not normally be considered beautiful or paint-worthy. Rousseau had fled such urban places for the comfort of nature; Monet thrusts them in front of us.

Monet exhibited several of his paintings of the Gare Saint-

Lazare with the impressionists in 1877, and in the same exhibition Caillebotte showed his *Pont de l'Europe*. Perhaps prompted by their display, Manet returned the following year to the environs of the station (Pls. 32–35). He made three pictures of the rue Mosnier (now the rue de Berne), a new street which begins just opposite his studio window on the rue Saint-Petersbourg and runs northward to its intersection with the rue de Moscou. It is separated from the railroad tracks only by a narrow row of buildings. The nearest building of that row shows in one drawing (Pl. 32), and a portion of it, bearing a large advertisement, in two of the three oils. In the drawing we find a puffing locomotive beyond the hoardings to the left and, further off, the tunnels of the Batignolles bridge; a figure is looking at the tracks through the boards. In each of the three paintings, the left edge of the composition stops short of the tracks; the essence of modern Paris is captured without the aid of this restless emblem of urban life.

Street Pavers, rue Mosnier (Pl. 33) concentrates on an equally clear sign of Paris's constant metamorphosis. In the foreground are seven or eight pavers, whose nearly completed work is approaching Manet's end of the street. Beyond them are a few carriages and pedestrians. The other two oils of the rue Mosnier show the street decked out for the national holiday of 30 June 1878, a celebration of the new World's Fair, intended to mark France's rehabilitation from the disasters of 1870–71. The MacMahon government set aside half a million francs for the embellishment of the capital.[42] Many street projects were hurried to completion (Manet's *Street Pavers* apparently documents this civic stir), the city was generally *endimanchée*, outdoor music and dancing were provided, and the streets were festooned in flags. In *The Rue Mosnier Decked out in Flags* (Pl. 34), a huge red flag covers the entire left side of the composition, hiding that side of the street.

The Rue Mosnier Decorated with Flags (Pl. 35) is a less daring but a more finished and more interesting composition, not least because of its use of irony. Plate 34 can be construed as a pure homage to the national festival, but in Plate 35 we see more than festive flags. On the left, behind temporary hoardings, is the rubble-filled lot alongside the railway. Nearby is a one-legged man who, like the rubble pushed behind the fence, exposes the realities that lay beneath the showy displays of the

MacMahon government.[43] On 2 May, at the inauguration of J. B. A. Clésinger's statue of *La République* at the exposition's entrance portal, the Marseillaise had been played in public for the first time since 1870. MacMahon protested, since the association of the song with revolution and with the Commune was so strong, but he was enough of a pragmatist not to insist, and the famous national air was restored to use. Manet's crippled man need not necessarily have stirred memories of the Franco-Prussian war and the Commune, but his juxtaposition to the flags is at the least a mordant touch. Manet, portraitist of Clemenceau and of Rochefort, was an ardent republican, participant in the siege of Paris and of its attendant famine, author of lithographs of death dealt by the repression of the

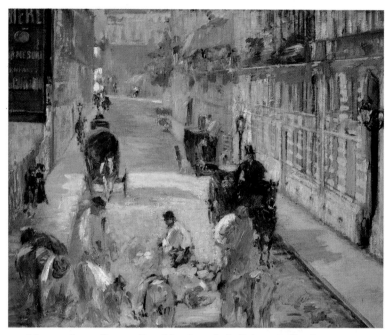

33. Manet, *Street Pavers, Rue Mosnier*, 1878. Private collection.

34. Manet, *The Rue Mosnier Decked Out in Flags*, 1878. Zürich, Bührle Collection.

32. Manet, *The Rue Mosnier*, 1878. Art Institute of Chicago.

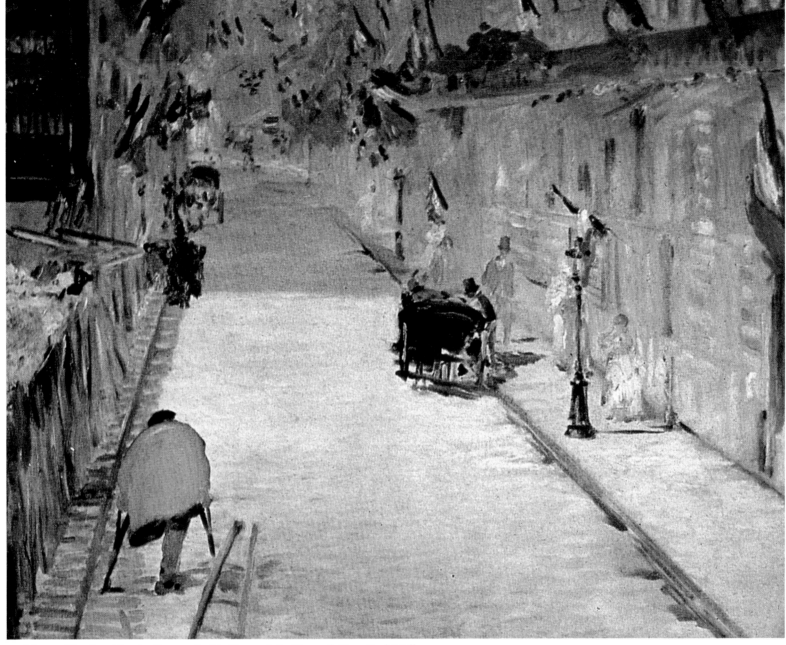

35. Manet, *The Rue Mosnier Decorated with Flags*, 1878. Mr. and Mrs. Paul Mellon.

Commune. It would be naive to think that his mutilated, blue-frocked worker is an accidental image in his decoding of the holiday.

It would be equally naive to think that Manet's painting is a literal transcription of the rue Mosnier at a specific moment. Like most of his pictures, it is a composite, a putting together of various observations, but one that is calculated to seem all of one piece. In the eleven years that had intervened since his painting of the Paris fair of 1867 (Pl. 7), his naturalism had evolved, as had that of Monet, Degas, and the other impressionists. The darker tones and obvious symmetries of the composition of 1867 have ceded place to a much lighter palette, to translucent, sunstruck surfaces, and to an insistence upon the seemingly casual, everyday appearance of things. The strong angle of the sun coming from the west—it comes

across the railroad cut, since there is no building immediately to the left—shows that it is late afternoon, an effect aided by the high horizon line. (The street actually rises steadily uphill from its beginning on the rue de Leningrad, so Manet, like Caillebotte in his *Pont de l'Europe*, had a natural source for his broad expanse of pavement.) Adding to the feeling we have of suddenly looking out of Manet's window, the ladder of a window-repairman protrudes into the foreground (the nimbleness it implies is a further comment upon the one-legged worker). To the right, near a top-hatted stroller, a shirt-sleeved worker is bending over a utility cart. We realize with wry amusement what all this normalcy means: the holiday flags are not perched above a festive celebration. Instead they surmount a transient moment of everyday reality, either the late afternoon of the holiday or, equally likely, the next day.

Manet's three paintings therefore constitute a portrait of the street that he looked out on from his studio window. The view with the pavers precedes the holiday; the one dominated by the huge flag shows the height of the celebration; the third shows the street returned to normal.

A year after the rue Mosnier series, Manet wrote to Haussmann's successor proposing a series of paintings for the rebuilt Hôtel-de-Ville, on the theme of "le ventre de Paris" (the belly of Paris): public markets, parks, racetracks, underground activities, railways, and bridges.[44] The ceiling would bear images of living men who, like the flags of the rue Mosnier, would look down on daily life below. Military prowess would have no place in this overhead pantheon, for the artist stipulated "all the men now living who in civil life have contributed or are contributing to the greatness and wealth of Paris." The men who governed Paris in 1879 would have found more than one thorn in this bouquet, and naturally made no reply to it. Fortunately the paintings that Manet had already done on most of these themes remain to us, and they are a rich compensation for the loss of his proposed series. Together with the paintings of Monet, Caillebotte, Renoir, Cassatt, Morisot, and others, they form an artistic register of the transformation of Paris, a register whose many entries are still waiting to be examined.

Chapter Two
Impressionism and Naturalism

The only, the true sovereign of Paris I will name for you: he is the *flâneur*.
— A. Bazin, *L'Epoque sans nom, esquisses de Paris 1830–1833*, 1833

That kind of man [the *flâneur*] is a mobile and passionate daguerreotype who retains the faintest traces of things, and in whom is reproduced, with their changing reflections, the flow of events, the city's movement, the multiple physiognomy of the public mind, the beliefs, antipathies, and admirations of the crowd.
— Victor Fournel, *Ce qu'on voit dans les rues de Paris*, 1858

... we like to *pose*, to make a spectacle of ourselves, to have a public, a *gallery*, witnesses to our life. So profit from this Parisian mania in order to enrich your album with sketches, your notebooks with remarks, and your cerebral portfolios with observations.
— Alfred Delvau, *Les plaisirs de Paris*, 1867

The *flâneur*, the purposeful male stroller, was a principal performer in the theater of daily life in Paris in mid-century, if we judge by his importance in writings of the era. A journalist, writer, or illustrator, he looked about with the acute eye of a detective, sizing up persons and events with a clinical detachment as though natural events could tell him their own stories, without his interference. He was an ambulatory naturalist whose objectivity set the stage for Impressionism. Among the painters, only Manet, Degas, and Caillebotte could be counted among the *flâneurs*, but the other impressionists adopted the characteristic features of this modern Parisian: objectivity and a devotion to contemporary life. This means that naturalism, a term of literary derivation, should also be used to interpret Impressionism. The appropriateness of the term has already been shown in the previous chapter, when Duranty's views and Caillebotte's *Man at the Window* were juxtaposed. Impressionist painting was noteworthy for its rejection of romanticism and for its wholehearted plunge into contemporary life. The impressionists turned their backs on the drama of romantic painting of the 1830s and 1840s, upon its exotic subjects, its declamatory manner, its appeal to the viewers' emotions by virtue of displaying the artist-author's feelings. They also spurned most of the art of the Barbizon painters who had followed romanticism, but who had retained many of its characteristics: "romantic naturalism" is an appropriate epithet for vanguard art of the 1850s. The impressionists overlapped with the Barbizon artists and learned from them but, except for Pissarro and Cézanne, they rapidly left behind the world of peasants, villagers, and pastoral animals, together with the biblical and mythological past that such images evoke. Instead, they turned towards Paris and its suburbs, towards images of leisure and entertainment that Corot or Millet would have regarded with disdain: café-concert, theater, racetrack, riverside bathing, pleasure boating. Brilliantly colored singers and fashionably dressed Parisians supplanted peasant women in homespun; horses were mounted by jockeys, not by farmers; peonies and gladioli replaced cabbages; swimmers and boaters in straw hats were pictured on the water's edge, not rivermen.

Because parallels with writers are more evident for Manet and Degas than for Renoir or Monet, it is with their historians that we find the furthest advances towards a broader conception of Impressionism. Scholars have pointed out their devotion to contemporary urban settings and have brought out the paradoxical qualities of an art that was "natural," and yet thrived on artifice; comparisons with Baudelaire and the Goncourt brothers have been revealing. In particular, the idea of the *flâneur* has been a welcome borrowing from literature, and it is the ideal beginning point for an inquiry into impressionist naturalism.[1]

The Artist as *Flâneur*

The Parisian *flâneur* was the role in which Baudelaire, Manet, Degas, Caillebotte, Duret, Duranty, Halévy, and Edmond de Goncourt cast themselves as did so many of the artists and writers of their era. That it was a role, a pose, was already evident in the 1830s, when the *flâneur* was first clearly

defined.[2] This personage was so much in vogue, it was said, that all the men of Paris imitated him even though few could claim his intrinsic qualities. The *flâneur* was characterized by exquisite manners and by impeccable dress, on which he lavished a great deal of time. He was devoted to newspapers, in order to be abreast of all current events and current gossip, and since the 1830s was the very decade in which a thriving daily press first became established in Paris, *flâneur* and journalism were interconnected.[3] The *flâneur* promenaded on the boulevards where he displayed himself while reconnoitering all that went on. In Walter Benjamin's famous formulation:

> The street became a dwelling for the *flâneur*; he is as much at home among the facades of houses as a citizen is in his four walls. . . . The walls are the desks against which he presses his note-books; news-stands are his libraries and the terraces of cafés are the balconies from which he looks down on his household after his work is done.[4]

The *flâneur*'s apparently idle strolling was the essence of his character, for he guarded his freedom of action (in an interior such as a salon or restaurant he could be pinned down), while looking about so keenly that he was the best-informed person in Paris. Like a policeman,[5] he had acute powers of observation and could deduce much from external details. Paris became a theater for him, and the streets were its principal stages.

Aloof from direct involvement, always detached and unruffled, the *flâneur* rather consciously emulated the British aristocrat and gentleman. He was, in fact, one of the key players in that social phenomenon, anglomania. The British were the principal foreign investors in French commerce and industry, and were the most influential foreigners in Paris in the 1830s and 1840s. They financed, built, and staffed most of the first French railways, they were major suppliers of agricultural and industrial equipment, they were the source of new ideas about animal breeding, and they were the originators of the terms, and often the conventions, of early modern sports, above all, horse racing, rowing, sailing, and running ("le footing"). The French debt to British manners included the establishment of the first men's clubs in Paris, so prominent subsequently in the impressionist period: the Cercle de l'Union in 1828, and Le Jockey Club in 1833. The French dandy—at first called a *fashionable*—was not quite the same as his British model. Comte d'Orsay, Alfred de Musset, Roger de Beauvoir, Barbey d'Aurevilly, and Baudelaire made a considerable transformation of their model. Barbey d'Aurevilly was chiefly responsible for converting dandyism into an artistic/intellectual pose and, further, into "an attitude of protest against the vulgarized, materialistic civilization of the bourgeois century."[6] Baudelaire, thirteen years younger than Barbey, conferred his unique genius upon this pose and is of special interest to historians of Impressionism because of his friendship with Manet. In poems and essays, he gave memorable expression to key concerns of the *flâneur*: the excitement of Paris crowds, the ability to move anonymously among them, the power of cool observation when supported by underlying passion, the ability to create an enduring art work from a transitory bit of modern life.[7]

By the early 1860s, the Parisian *flâneur* had absorbed many of the leading characteristics of the dandy. The dandy was not necessarily a *flâneur*, but the *flâneur* was almost always a dandy. In his British top hat and formal clothes, however, the *flâneur* was not immediately distinguished from the mass of French upper-class men of the Second Empire. In other words, an aloof manner, fastidious dress, absorption in newspapers and current gossip, and strolling along public thoroughfares formed the exterior that most upper-class men presented to Parisian society. The *flâneur*, to those who knew him, could nonetheless be distinguished from his look-alikes by the subtlety of his observations and by the use to which he put them. His conversations were rich in things esthetic and elegant, not in such mundane matters as sales or investments, and he flaunted his wit in artful phrases whose irony was fully appreciated only by the inner circle of writers, painters, musicians, intellectuals, and *fashionables* to whom they were addressed. These witty sallies were not idly thrown out. They were the coinage of the *flâneur*'s reputation, and it was upon his reputation, in reciprocal relationship with his talent, that his success depended.[8] He did not despise money (Delvau's words cited at the head of this chapter include the verbs "profit" and "enrich"), but despised talking about it. The *artiste-flâneur* disguised the true nature of his profession by speaking not about the money it yielded, but about the terms of his art. This allied him, in appearance at least, with the aristocrats of old, whose inherited wealth authorized devotion to the arts and disdain of the materialistic bourgeoisie.

We have already seen pictures of the *flâneur*. He appears in Béraud's *Paris, On the Boulevard* (Pl. 22), to the right of center, in a characteristic pose. Detached from the others to show his indifference to the ordinary, he reads his paper. The other figures are mere strollers and gapers (*badauds*), but, a true *flâneur*, he is busy with his thoughts and capable, like a detective, of sizing up his surroundings while appearing to be absorbed in his paper. In Caillebotte's *Le Pont de l'Europe* (Pl. 27), the artist shows the *flâneur* in a more active guise, equally characteristic of the role. He is moving briskly along the street, separated from the others by his costume (therefore by his class) and by the purposeful way he reconnoiters his surroundings. He is actually working at his trade for, as Delvau advised, he is stuffing his "cerebral portfolios" with observations to be used later.

Manet was a notable example of the *flâneur*. In his dress, his exquisite manners, his *savoir-faire*, and his devotion to shocking the bourgeoisie, he epitomized this urban species. Degas was so much the lone wolf that he deviated from the type, but he shared many of the *flâneur*'s qualities and represented him often in his paintings. We might first look at his delineations of the *flâneur* and then at the way both artists interpreted Parisian life as artists and *flâneurs*.

In his portrait of James Tissot (Pl. 36), Degas shows his painter friend as the dandy he was, a *flâneur*-dandy who has been out for a stroll, and who has dropped in on his friend for a moment. Degas displays him as though he were a fashion model. He puts his top hat and cape, carelessly but ostentatiously, on the table and gives a rakish angle to his stick, to emphasize his refined indifference. Closer inspection shows that the weight of Tissot's body, sprawled sideways in the chair, is on his elbow. This, the twist of his upper body, and

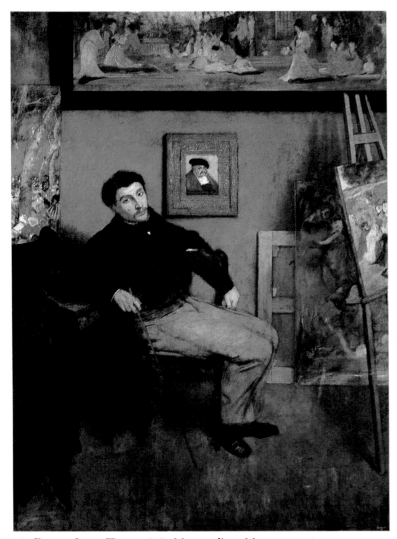

36. Degas, *James Tissot*, 1868. Metropolitan Museum.

the drawn-in feet, reveal that he is on the qui-vive, ready to depart at a moment's notice.

Degas has therefore drawn a portrait of a *flâneur* by putting on show his refined casualness, his status as stroller-visitor, his alertness—and by abstaining from the traditional psychology of expression. Some might accuse him of failing to interpret character because Tissot's face shows no revealing emotion, but of course a *flâneur* and a dandy are properly characterized by seeming indifference. And Degas hints at his *own* aloofness, that of the *artiste-flâneur*, by sticking to externals, by refusing to become involved with his sitter. He denies Tissot any interior feelings and hides his profession. Tissot is surrounded by paintings, it is true, but these would be associated with the artist whose studio he is visiting. He is made into a painter without paintings, a mere *élégant*.

By so treating him, Degas seems to put down a rival painter, and yet there is a clue to Tissot's profession. Just to the right of his head is a portrait of Frederick the Wise, which then passed for a work by Cranach.[9] His prominent moustache prompts a comparison with Tissot's, so, to the inner circle of his and Degas's friends, Tissot would have been associated with the sixteenth-century painter. Another piece of wit suitable to the *artiste-flâneur* is the treatment of the easel to

the right. It leans rather amusingly into the composition, reinforcing the tilt of Tissot's body. The easel's precariousness is emphasized by the absence of its rear leg. It was once there, but was painted out (a prominent portion shows through along the base of the large canvas behind it): another example of Degas's wit, or a bit of forgetfulness?[10]

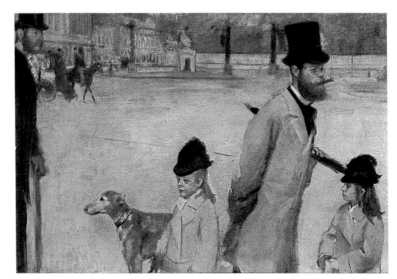

37. Degas, *The Place de la Concorde*, 1875. Presumed destroyed.

It is as a *flâneur* that Degas presented another of his artist friends, the printmaker vicomte Lepic. In *Place de la Concorde* (Pl. 37), Lepic, impeccably dressed in his light walking coat, strides resolutely to our right. He clenches his cheroot firmly in his teeth, squeezes his umbrella between his cocked left arm and his body, and, like Caillebotte's *flâneur* (Pl. 27), pushes his right arm behind his back: all indications of his purposeful, absorbed strolling. A veritable distillation of the *flâneur*, Lepic proves his aristocratic remoteness by showing no interest in whatever has attracted his daughters' attention. Although they have their own upper-class tone (the daughter to the right emulates her father's upraised chin), they have the opposite of the *flâneur*'s indifference. We do not know what has drawn their curiosity—an omission that Degas teases us with—but by looking to the left, they augment Lepic's detachment. The dog seconds their role, and its pedigreed look makes it a fit companion (Lepic was a dog breeder). The man on the left who stares at this group supplies another contrast to Lepic. He lacks Lepic's more formal coat, and he stands there as a mere *badaud*, an onlooker who is easily distracted by what comes within his notice. "The idler [*badaud*]," wrote Victor Fournel, "under the influence of the spectacle, becomes an impersonal being; he is no longer a man: he is the public, the crowd." Lepic appears as Fournel's true *flâneur*, who observes and reflects, instead of taking part, who is therefore entirely in control and "in full possession of his individuality."[11]

Manet less often represented the *flâneur* in his paintings, but was himself a very complete exemplar of the breed. "With Manet," wrote his friend Antonin Proust, "the eye played such a big role that Paris has never known a *flâneur* like him nor a *flâneur* strolling more usefully."[12] He recounted how Manet would make quick visual notes while out walking, and

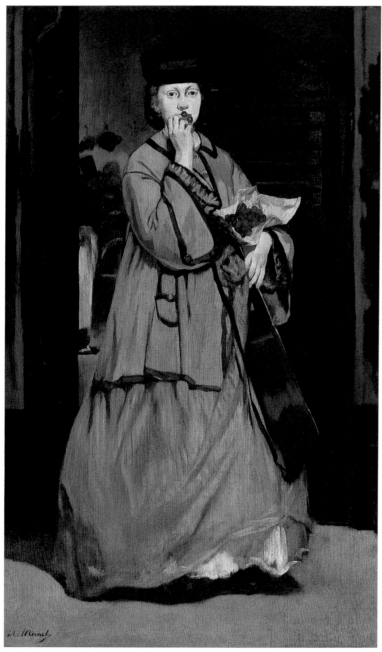

38. Manet, *The Street Singer*, c. 1862. Boston, Museum of Fine Arts.

"the symphony in white major of which Théophile Gautier has spoken."

A woman was coming out of a sleazy cabaret, lifting up her skirt, holding a guitar. He went right up to her and asked her to come pose for him. She simply laughed. "I'll nab her again," he said, "and then if she still doesn't want to, I have Victorine."[13]

The first thing to notice in this citation is that Manet was strolling through a typical piece of Haussmannian Paris: vast destruction making way for a new avenue. His art was born of such transformations, but because he kept the *flâneur's* distance, the desolate cedar became a purple tone, and house-wreckers, a "symphony in white." This displacement of radical change, of destruction, into artistic terms, was a way of refusing direct involvement with it, of guarding one's emotional reserve. Indirect involvement is, however, vested in the painting that came out of this *flâneur's* experience.

Victorine Meurent modeled for Manet's picture. She is leaving the "sleazy cabaret," whose interior is visible over her shoulder. In her left hand the model/musician holds both her guitar and a fold of her dress, which she lifts to facilitate the forward movement of her feet. The resultant exposure of her undergarment reveals her lowly status and insinuates sexuality, typical of the *flâneur's* conception of such a woman's availability. Since her figure is essentially static, this sugges-tion of mobility aids the impression that she is leaving the cabaret (the left flap of the door has not yet swung shut). She is an itinerant who moves from place to place, mingling the illusory joy of her music with the plight of her vagabondage, a fate symbolized by the cherries she is eating, which stand not only for sexuality, but also for being down on one's luck.[14]

Manet's painting of 1862 is, after all, a gloss upon the ex-tensive reshaping of Paris under Louis Napoleon. He did not represent the demolitions that surrounded him, but an itinerant whose lot in life was a commentary on the upheavals that the city and its people were undergoing. That same year,

39. Manet, *The Balloon*, 1862. New York Public Library.

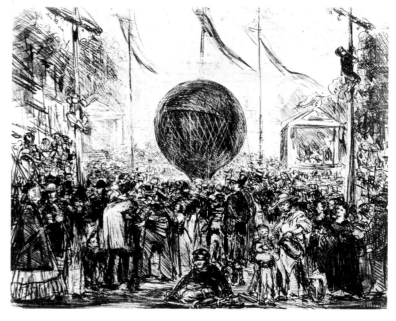

in one instance he gave the genesis of a painting. It is *The Street Singer* (Pl. 38) of 1862:

I have said what a *flâneur* Manet was. One day we were ascending what has since become the boulevard Malesher-bes, in the midst of demolitions intersected by the yawning gaps of already leveled properties. The Monceau district had not yet been laid out. At each step Manet stopped me. Over here a cedar rose up isolated in the midst of a demoli-shed garden. The tree seemed to search under its long arms for the clumps of destroyed flowers. "You see its skin," he said, "and the purplish-blue tones of the shadows?" Further along, the wreckers stood out white against the less white walls that were tumbling under their blows, enveloping them in a cloud of dust. Manet remained absorbed for a long time, admiring this spectacle. "There it is," he cried,

Like Degas, Manet withheld any particular emotional expression from his model's face, which is masked by a blank stare. Lack of expression kept the observer at a distance, whereas contemporary urban genre guided the viewer towards a known attitude, one of amusement, condescension, or admiration. In *Autumn* (Pl. 40), for example, Jules Lefebvre pulled out all the stops of romantic pity. His figure is a homeless wanderer in the woods, cowering in anxiety and loneliness. Manet's painting strikes us as much more modern for having stripped away such appeals to sentiment. His *Street Singer* is one of a number of paintings that situated him at the beginning of his career as the *flâneur* who intended to shock Paris into recognizing his brilliance.

Artifice and Caricature

Manet treated Paris as a theater, and on its streets and squares he sometimes found his best lines. His art of this period has been called "realism of the *flâneur*," and in *Music in the Tuileries* (Pl. 41), painted at the same time as *The Street Singer*, the artist inserted contemporary figures into a composition full of daring abbreviations.[16] Although Manet showed some deference to historical precedent, his picture does not exhibit the usual modeling in half-tones, nor the expected subtlety in drawing (Pl. 42). Its flat, decorative aspect might seem today to suit the somewhat impudent refinement of its figures, but at the time it was painted, its visual shorthand was a startling provocation. In it Manet represented himself, Baudelaire, Aurelien Scholl (one of the most conspicuous of self-proclaimed *flâneurs*), and other *fashionables*. They occupy a stagelike space appropriate to the idea that Paris was a theater in which one must always take a role. This idea was not limited to the *flâneur*, but was so widespread that nearly every visitor to Paris adopted it. Felix Whitehurst likened the women and men seated in chairs along the Champs-Elysées, gazing at the passing spectacle, to patrons of opera stalls, and Henry Tuckerman felt that even "the names of Parisian vocations, places and characters hint a play as those of no other capital can; and the most serious aspects of life inevitably wear a theatrical guise."[17]

To Tuckerman, Parisians treated their city as a theater because they exalted the transitory, the sensual, and the artificial. As an Anglo-Saxon (and presumably also, a Protestant), Tuckerman valued self-denial, thrift, and a preference for the natural, qualities so opposed to those of Paris that his observations have sharp edges, giving them a peculiar utility. If we ignore the pejoratives of his phrases, how apt they seem to Manet and to his *Music in the Tuileries*. Parisians, he wrote, touch everything with "a certain union of vanity and expressiveness." Their indifference to rural nature is so widely recognized, he reminds his reader,

> that, when we desire to express the opposite of natural tastes, we habitually use the word "Frenchified." The idea which a Parisian has of a tree is that of a convenient appendage to a lamp. The traveller never sees artificial light reflected from green leaves, without thinking of his evening promenades in the French capital, or a dance in the groves of Montmorenci.[18]

The artifice that Tuckerman pointed to with mixed

40. Lefebvre, *Autumn*, 1883. Private collection.

in his lithograph *The Balloon* (Pl. 39), he juxtaposed a crippled boy with the balloon used by Louis Napoleon as a symbol of imperial progress.[15] Like the *flâneur*-writer, he knew how to prompt his gifts with the telling incident, which he then developed into a finished piece. In doing so, he also, like Haussmann, ran roughshod over the historic past. Yes, in *The Street Singer* there are echoes of Velasquez and Spanish painting, but the brushwork and modeling were daringly abbreviated, and his view of contemporary life was far from the acceptable genre painting of the day. This is because of the absence of a moral statement that could be readily grasped.

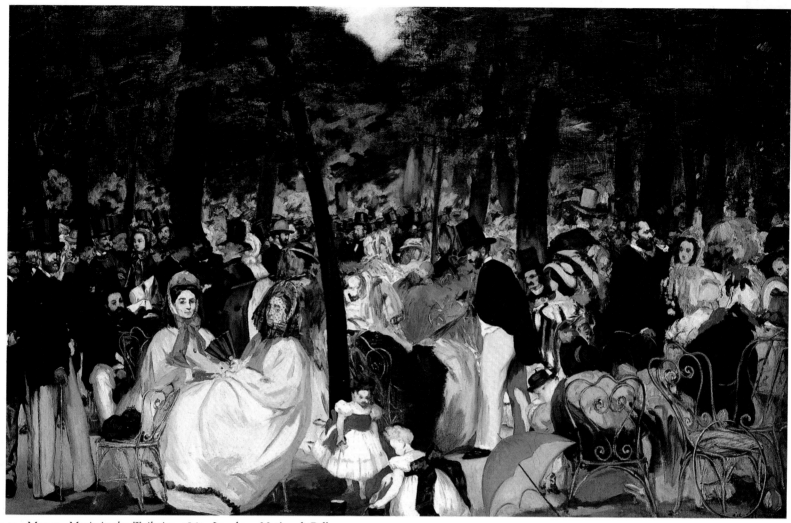

41. Manet, *Music in the Tuileries*, 1862. London, National Gallery.

admiration and dismay is precisely what Manet, Baudelaire, and other *flâneurs* were devoted to.[19] The flat bands of the trees, in *Music in the Tuileries*, the black clothes, the golden arabesques of those new metal chairs, the bright colors of un-modeled bonnets, ribbons, and sashes, these are the elements of pictorial artifice which lie at the heart of Manet's innovations. They are both subject and form, salient pieces of that modern life which Baudelaire had been urging upon his contemporaries. It is not despite, but because of their immediacy, their theatricality, their share in a transitory present moment, that they suit both painter and poet. In Baudelaire's essays and poems there is no doubting the significance of art over nature, of creative consciousness over mere raw material and instinct, therefore of the artifical over the imitative.[20] In his *Painter of Modern Life*, published in 1863 (the year Manet exhibited his *Music in the Tuileries*), Baudelaire placed the artist-dandy at the center of his world because he alone could reveal the "eternal beauty and amazing harmony of life in the capital cities," a beauty and a harmony drawn from the external and transitory manifestations of urban life, those vivid extensions of "universal life."[21]

Tuckerman, of course, was too much the forthright demo-crat to understand the artist-dandy's conversion of Parisian vanity and display into an enduring artistic language. Few contemporaries did. Only in recent decades have we come to see that in *Music in the Tuileries*, Manet set modern art on its path by finding pictorial forms that were inextricably linked with contemporary subjects. The appropriate phrase "realism of the *flâneur*" does not refer to the hackneyed concept of faithful imitation, but to "a kind of sign-language" Manet employed in this picture, in which color, line, and shape acquired a new autonomy.[22] This autonomy is not the same thing as "pure" form, of course, and with some effort we can recapture the excitement with which Manet and Baudelaire made enduring painting and poetry out of fleeting glimpses of contemporary urban life.

To capture an elusive but characteristic moment in the life of the city was also the purpose of the caricaturist, that vital modern artist who was the subject of provocative essays by Baudelaire. The rapid growth of caricature from the 1830s onward, and generally also of journalistic illustration, was an essential ingredient in the spread of the daily paper and the weekly journal.[23] The *flâneur* was drawn to caricature because it so readily matched his interests. The latest gossip, event or personage was rendered with the quickness that suited the urban observer and with the pungency that appealed to his

42. Manet, detail of *Music in the Tuileries* (Pl. 41).

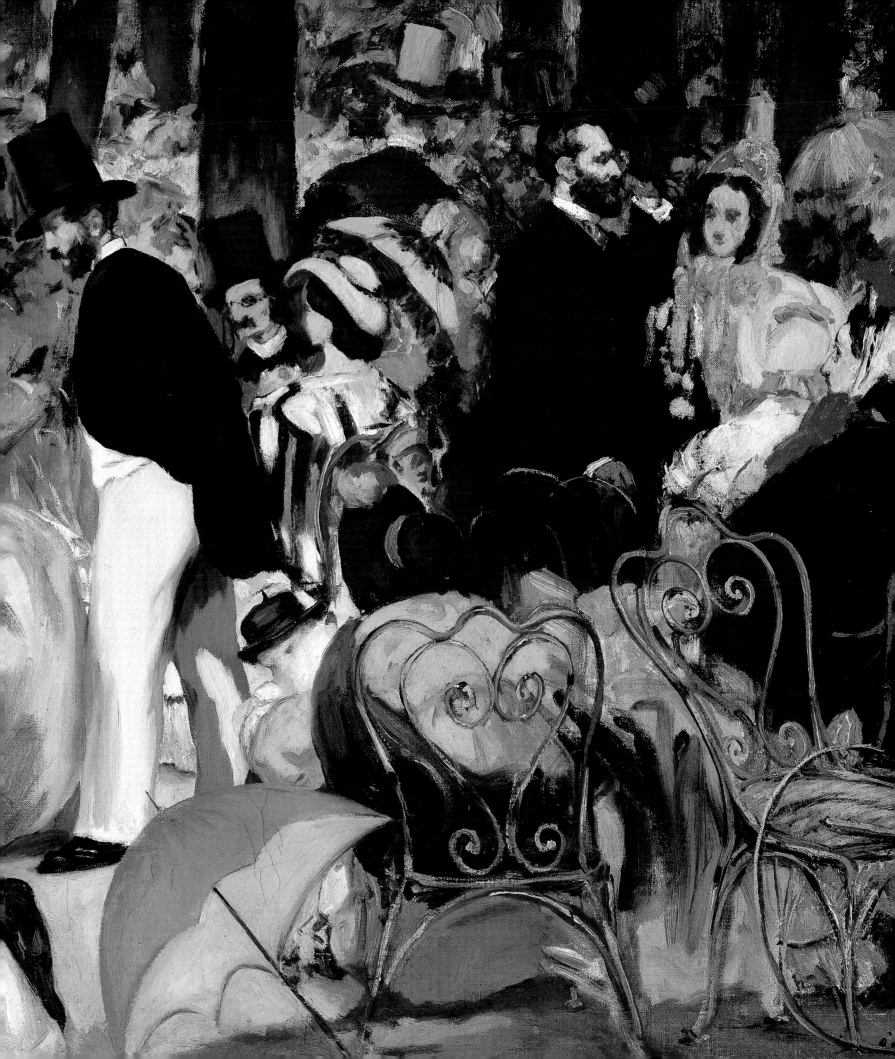

wit. The caricaturist was, in effect, a visual *flâneur*, and his cartoons appeared in the same journals that carried the essays and stories of the *flâneur*-writer. The links between caricaturist, *flâneur*, and painter show most clearly in the concomitant rise of art criticism, for caricaturist and writer alike developed special sub-categories to deal with the headlong pace of art exhibitions, which grew in geometric proportions after 1830. (And caricatures were prominently displayed in windows along the *grands boulevards*, where one also found paintings and the leading commodities of the day).

By the 1860s caricatures and journalistic illustrations were such well-established modes of interpreting urban life that their graphic devices began to penetrate the oil paintings, as well as the drawings, of Manet, Degas, and others.[24] The pre-impressionist norms of painting in oils were rapidly subverted by qualities associated with the graphic arts, because of the painters' search for spontaneity (either actual or simulated): direct, "sketchy" line revealing its speed of execution; stress on conspicuous rather than subtle features; reduction of careful three-dimensional modeling; abrupt placement of one color area next to another; scumbled, summary, or out-of-focus backgrounds; juxtaposition of flat, often "decorative" elements without benefit of the full range of devices that were earlier used to give depth and perspective. Resorting to such

43. Daumier, *Friends (What a fortunate encounter...)*, 1845. Yale University Art Gallery.

graphic shorthand gave many impressionist paintings the appearance of small prints suddenly blown up to the size of oils.

The degree to which painting was penetrated by a graphic shorthand associated with caricature can be readily seen in the mature works of Manet and Degas. In Manet's *Rue Mosnier Decorated with Flags* (Pl. 35), the one-legged man has the immediacy and the social mordancy of caricature; the abbreviations that render street, flags, and buildings are like a luminous transcription of the backgrounds of Daumier's lithographs (Pl. 43). With Degas, the relationship to caricature is more pervasive. In caricature his caustic wit found an essential ally, for his work is full of thinly disguised attacks on his contemporaries, so often caught in vulnerable and unflattering moments.[25] Even when that is not the case, his works exhibit more than one tie with the tradition of journalistic illustration. He numbered many cartoonists and journalists among his friends, and his portraits of them are cases in point. He presented the cartoonist Carlo Pellegrini in a cunning silhouette that gives the essence of the figure at one glance. The writer Edmond Duranty (Pl. 44) is in the flattering environment of his library, but the books and papers surrounding him have an astonishing freedom from exactness (his manuscript is only a series of inky slashes), and Degas's careful placing of his head and hands summons up the studies of physiognomics and gesture which are so intimately tied to caricature.[26]

In 1879, the same year as the Duranty portrait, Degas represented another friend, the Italian journalist and critic Diego Martelli (Pl. 45). Duranty is surrounded by books, the writer in his own library; Martelli is the visiting journalist more than the man of letters, and Degas hints at the itinerant nature of his profession by poising his stubby body above a floor in steep perspective, so that it almost slides out of the composition. This effect, vital to our reading of the portrait, is abetted by the folding chair, which seems insufficient for Martelli's chunky frame, and by the fact that he has set aside his work for the moment and is looking down and out of the picture.

The extent to which Degas exploited the transitory, and the risks he took in pushing his painting towards the summarily executed norms of caricature, can be verified by looking at the unclear edges of Martelli's trousers and their altered interior line, allowed to run "unfinished" over the surface. How different this is from portraits of the preceding generation. Ingres's *Monsieur Bertin* (Pl. 46), for example, also represents a journalist, but one who, in 1832, was in charge of the hugely successful *Journal des débats*. Ingres represents him as the epitome of the tough-minded bourgeois, whose power and sensuality are vested in massive, sculptural solidity. Instead of a folding stool, Bertin is seated in a substantial chair whose heavy, curving back reinforces his bulk. To return to Degas's portrait of Martelli is to register the enormous shift in artistic sensibilities over the intervening half-century. A newcomer to Impressionism might think that Degas's *Martelli* was hastily improvised, and certainly Degas wanted to suggest spontaneity. Four major drawings, however, and a variant in oil, prove the contrary.[27] The key features of the portrait were not spotted suddenly in Martelli's room and then introduced to the composition. They grew instead from a complicated process of invention, rearrangement, and decision and were the

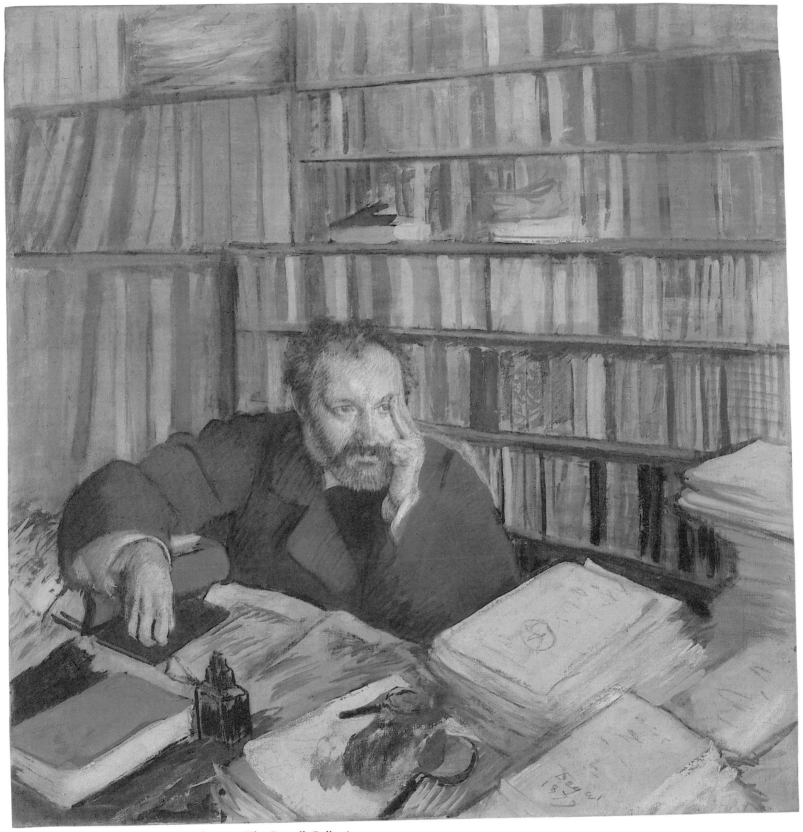

44. Degas, *Edmond Duranty*, 1879. Glasgow, The Burrell Collection.

result of a studio procedure by which Degas exploited his cunning as a master of pictorial intrigue.

Like Manet and Baudelaire, Degas was as much concerned with artifice as with nature. (To mock *plein-air* painting, he once held up a crumpled handkerchief and said it was the only model he needed in order to paint clouds). His pride lay in inventing, not in imitating. This is a simple, but vital distinction to make for him, as for all good artists. In his *Place*

41

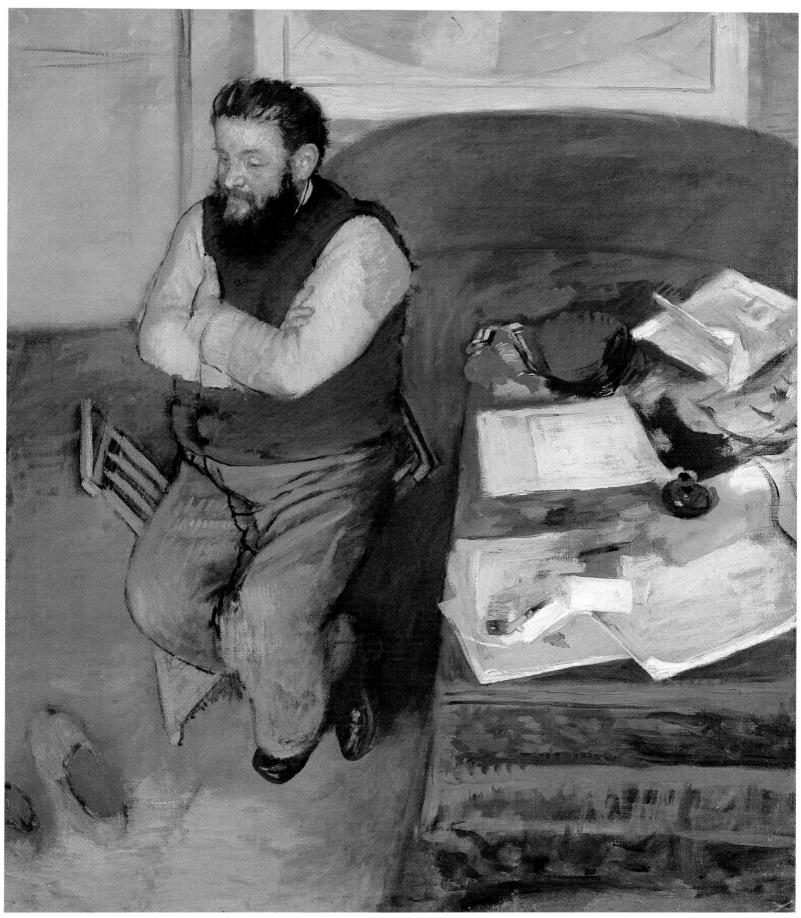

45. Degas, *Diego Martelli*, 1879. Edinburgh, National Gallery of Scotland.

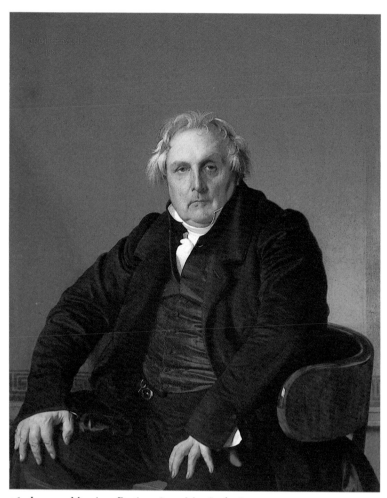

46. Ingres, *Monsieur Bertin*, 1832. Musée du Louvre.

de la Concorde (Pl. 37), it is so easy to accept the illusion of a natural incident that we have to concentrate our attention if we are to see the devices of this shrewd tactician. In the initial discussion of the painting earlier in this chapter, the words were deliberately chosen to make it appear as if Lepic himself were walking to the right, and his daughters were actually looking to the left. We personify painted images this way as a short cut to a discussion of the illusion. It is the artificial devices Degas used that create the illusion, but they are not of themselves natural. The triangle formed by Lepic, his daughters, and the dog, for example, is an oddly flattened and crowded shape. With all that space behind them, why are they thrust forward on the surface like that? The principal reason is that the internal opposition of left and right movements is made more striking and more immediate by being squeezed into such a simple shape, which in turn is compressed by the rectangle of the picture's edges. Another reason is that the broad expanse of the Concorde is rendered more stark by contrast with the overfull foreground (we deduce that it is the sidewalk or a traffic island). The observer only sees the public space by looking through and beyond these people, so the essential dialogue of the city with its people takes place on Degas's platform of geometric shapes.

That visual illusions were created with the aid of studio conventions is nothing new in the history of art. What was new in Impressionism was the sense of graphic immediacy

that arose from the painters' turn towards the settings of contemporary life. The artistic controls that lay beneath this apparent spontaneity were at first so apparent that they upset most contemporaries who were looking for familiar modes of pictorial organization. Gradually, however, the bright palette and the immediacy of Impressionism won over the public, and by the early twentieth century it became the most natural way of rendering nature. At that point, with such wide acceptance, the impressionists' underlying conventions were no longer obtrusive. On the contrary, earlier art now seemed old-fashioned and unnatural. It was especially abstract art that, by comparison, made Impressionsim seem to be the normal way of representing the world, so much so that vanguard artists and critics believed that the impressionists had merely produced simple imitations of the exterior world. Since the 1950s, historians have had to work hard to demonstrate that Impressionism was not, after all, a kind of mindless naturalism, that it was indeed based on artistic conventions. Paradoxically, we have to make an effort to recover the newness with which the impressionists' contemporaries saw their painting if we are to understand how their apparent spontaneity and casualness was given conscious artistic shape.

The Artist as Investigator

Among modern historians, it is Walter Benjamin who most brilliantly reconciled these seeming opposites, spontaneity and artistic control. His analysis was directed to literature, but its broad lines are applicable to painting as well. It is essentially a dual formulation: the artist as *flâneur*, who converts the street to his work-place, the issue already discussed, and the artist as detective, for whom the street is also a work-place. The detective, Benjamin wrote,

only seems to be indolent, for behind this indolence there is the watchfulness of an observer who does not take his eyes off a miscreant. . . . He develops forms of reaction that are in keeping with the pace of a big city. He catches things in flight; this enables him to dream that he is like an artist. Everyone praises the swift crayon of the graphic artist. Balzac claims that artistry as such is tied to a quick grasp.[28]

For the artist-observer, Balzac used the analogies of bird of prey, and of the hunter transplanted to the city. Benjamin's choice of detective stems from his absorption in the literature of the *flâneur*,[29] perhaps directly from Victor Fournel's *Ce qu'on voit dans les rues de Paris* (what one sees in the streets of Paris) of 1858. Fournel begins a key chapter of his book by invoking Edgar Allen Poe's *Man in the Crowd*, the very same story Benjamin uses when he discusses the *flâneur*. In Poe's tale, the observer/author, from the window of a coffee house, spots among the passers-by a stranger whom he follows, convinced that his exterior announces a mystery to be solved. Fournel continues:

Like Poe, I have often isolated myself in the crowd, out in the street, in order to change myself into a spectator and sit in the pit of this improvised theater. . . .
It would certainly be a very interesting exercise to read the daily occupations, the varied professions, the intimate and domestic life that mark each person, posted on his

countenance, as it were, on his demeanor and tone of voice, as on the signboard of a shop; to look into the character indicated by a gait or physiognomy; to ask oneself what long habit of disorder or of probity, what series of virtues or of crimes have come to engrave an indelible and vivid expression on this or that face one is examining....

It is thus that each day at my leisure I take the personal responsibility of doing some Gall and some Lavater. Nothing escapes my look which pierces the most impenetrable shadows.... Each individual furnishes me, if I wish, with the material of a complicated novel; and, like Cuvier reconstituting an animal from one tooth, and a whole world from one animal, I reconstitute all these scattered lives; I make move, think, and act at my will this theater of automatons whose strings I hold.[30]

Fournel's deployment of terms deserves careful study. He treats the street as a theater; he regards the crowd as would a detective or a caricaturist, bent upon singling out pronounced features (Gall and Lavater were phrenologists who established a "science" of reading character into cranial shapes); he claims for himself a piercing eye, not a passive one; he likens himself to Cuvier the natural scientist, and also to a puppet master who controls his manikins. In all these analogies, the artist-observer finds parallels for his own sense of mastering the urban crowd by converting well-chosen figures to his artistic purposes. Particularly useful to the historian are his comparisons with the detective and the natural scientist. Both are investigators, in whom the naturalist writers found allies.

The role of detective-investigator came logically to such writers as Edmond de Goncourt, and it is all the more striking a role in his case, because of his upper-class refinement. "Today I went searching for the human document in the region of the Ecole Militaire," he wrote in his diary in 1876:

One will never know, given our natural timidity, our discomfort among the plebeians, our horror of the *canaille*, how much the cost has been of the evil and ugly document with which we have constructed our books. This profession of conscientious policeman for the popular novel is assuredly the most abominable trade that an essentially aristocratic man can pursue.

However, the attraction of this new society..., then... the tension of one's senses, the multipicity of observations and notes, the effort of the memory, the play of perceptions, the rushing and hasty work of a brain which is *spying* on the truth [qui *moucharde* la vérité], intoxicates the observer's sang-froid and makes him forget, in a sort of fever, the toughness and disgust of his observation.[31]

It is once again Degas, among the impressionists, whom such a passage evokes when we think of painters. Degas's *Women on a Café Terrace, Evening* (Pl. 47) seems the kind of "ugly document" that Edmond de Goncourt would have sought out while writing, say, *La fille Elisa* (1875), a novel about a prostitute.

The role of scientific investigator also came easily to writers of the Second Empire and Third Republic. By mid-century, the model of investigation derived from the natural sciences had become all-pervasive. It thoroughly penetrated the arts,

and lay behind the rejection of romanticism. Flaubert and Duranty stressed the need for the author to remove himself from the role of editor or judge of the action he described, and to acquire instead the precision and neutrality of the scientist. "Science, art, philosophy, all that is only description," wrote Duranty. The Goncourt brothers said their ambition was to create a "science," to make themselves "moral physionomists."[32] They praised themselves for overcoming their instinctive revulsion in order to study medical cases which they used in composing *Germinie Lacerteux* (1865). In their introduction to that book they defined the novel as a "living form of literary study and social investigation." Zola admired Claude Bernard's scientific rationalism and claimed that his novels were based on the experimental method.

The best statement on scientific investigation as it relates to the arts was made by Ernest Renan. In his *L'Avenir de la science* (The Future of Science), he first claims that old masterpieces of art have lost much of their esthetic value because their original settings are no longer available to the observer: "A work of art has value only in its framework, and the framework of every work is its epoque." He then continues:

Doubtless the patient investigations of the observer, the numbers accumulated by the astronomer, the long enumerations of the naturalist, are hardly proper to inspire feelings of beauty. Beauty is not in analysis. But real beauty, that which does not rest on fictions of human fantasy, is hidden in the results of analysis. To dissect the human body is to destroy its beauty, and yet by this dissection, science comes to recognize a beauty of a superior kind. ...Doubtless this enchanted world in which man lived before arriving at [modern] reflective life...has an inexpressible charm, and it may be that in face of this severe and inflexible nature that rationalism has created for us, some will regret the miracle, and will reproach experience for having banished it from the universe. But this could result only from an incomplete view of science. Because the real world which science reveals to us is far superior to the fantastic world created by the imagination.[33]

We cannot pretend that Renan speaks for Degas, but the painter, like many naturalists, disowned the "fantastic world" of romanticism, and he would have agreed with Renan's insistence that accurate observation precede the play of the imagination. A close look at *Women on a Café Terrace, Evening* will show the value of comparing the attitude of the naturalist with that of the impressionist painter.

In his little composition, Degas situates us along the boulevard Montmartre, at nighttime. In the distance we see a crowded sidewalk and the gaslights of the shops of the *grands boulevards*. In the lower right corner sits a woman in a position of lassitude, wearing a revealing costume. Facing her is a young woman equally bored, her thumb to her teeth. Next to her is a woman leaving the scene, trailing her purse behind her, while a fourth looks to the right, as though she were about to take the chair being vacated. These two figures slip between the supports of the terrace roof; lacking top and bottom, these uprights lend an odd air of movement and tentativeness to the sidewalk café. To the right, disappearing behind the end of the terrace, is the form of a man striding by.

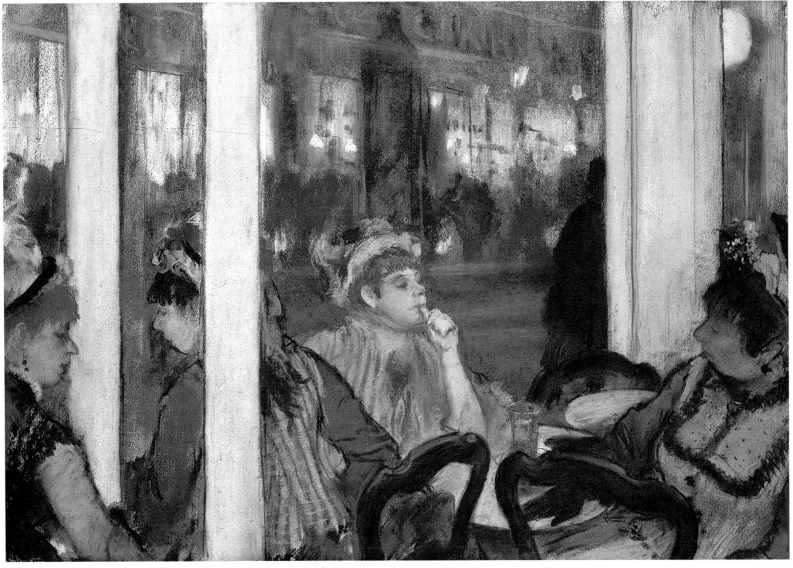

47. Degas, *Women on a Café Terrace, Evening*, 1877. Musée d'Orsay.

What should we make of all this? Aided by contemporary representations of costume, and by numerous witness accounts of the boulevard Montmartre, we deduce that the women are prostitutes, "beauties of the night," to use Alfred Delvau's phrase.[34] They find their clients among the men who are out shopping or going to and from nearby theaters. These women, like the two to the left in Degas's composition, come and go from the terraces where they watch out for clients; they change places frequently out of impatience or to put themselves in more advantageous positions. Often they sit and wait, as Degas's other two are doing. The one in the center has her thumb to her teeth, either to indicate boredom or, perhaps, to vent her disappointment. Georges Rivière, reviewing this pastel when it was exhibited in 1877, interpreted her gesture as meaning "not even this much!"—that is, no customers that evening.[35]

The dark form of the man moving off to the right is a clue to the street commerce these women engage in, or at least a hint of it. Contemporary writers tell us of the great discretion observed by the middle-class client who, like a detective, could signal a prostitute without giving himself away to others. The woman who is leaving to the left might well have been given a discreet sign by this man. When one stares at this little monotype for a time, a reciprocity develops between her movement and his. Moreover, in Degas's brothel scenes (Pl. 115) and in his views of the backstage of the ballet (Pls. 105, 106), the male pursuer is frequently indicated by only a partial view of dark coat, trousers, and shoes. Of course, we cannot insist on a knowing exchange between Degas's two figures, but the presence of a male passer-by is an essential element of this pastel. Degas makes us into an investigator, seated on that terrace, sizing up various clues in order to understand what is going on about us, wondering if that fleeting figure is Poe's or Fournel's man in the crowd. We then realize why Degas once defined his art in these terms: "A painting is a thing which requires as much trickery, malice, and vice as the perpetration of a crime; make counterfeits and add a touch of nature."[36]

In such works as *Women on a Café Terrace, Evening*, Degas seems to adopt that attitude of Renan's man of science. He destroys the pre-modern world of fantasy and its noble ideals, among them its concept of feminine beauty and of the uplifting subject. He wrenches us into the present by his odd

45

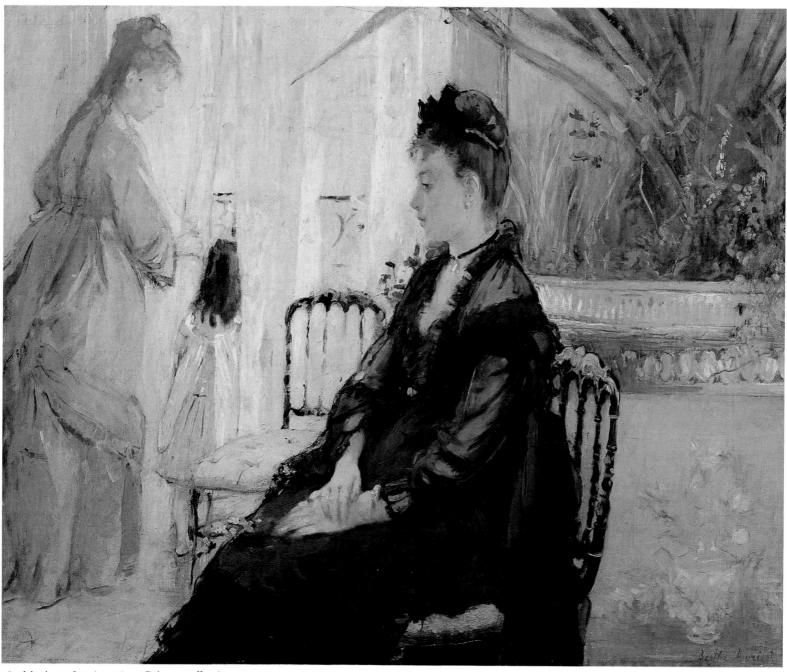

48. Morisot, *Interior*, 1872. Private collection.

matter-of-factness, by this "severe and inflexible nature that rationalism has created for us." Like the naturalist, Degas sets aside emotion. He does not interfere with the subjects of his inquiry and does not judge their actions. He merely presents "the patient investigations of the observer," investigations only of that which could be present to the eye. He does this even if, to use Renan's words again, his "enumerations...are hardly proper to inspire feelings of beauty." Like Renan, he gives up the charm of earlier conceptions and instead lays before his viewer the results of his analysis, disclosing a new and a profound beauty, because "the real world which science reveals to us is far superior to the fantastic world created by the imagination."

If Degas can reasonably be likened to the natural scientist,

as well as to the *flâneur*-writer and the detective, it is because he seems to survey his terrain dispassionately and then record his findings (we know he *creates*; he only seems to record) in an apparently neutral fashion, as though giving a report. This neutral vision is so vital to Impressionism that it needs to be given its own term: "detachment." Although "objectivity" is an alternative—we shall examine the meaning Georg Simmel gave it—it seems to adhere more to the things being observed than to the observer. Detachment, by suggesting the act of disconnecting or disengaging, better suggests the artist's conscious efforts to suppress his opinions and to remove any expression of the traditional judgments brought to bear on his subject. Curiously, this direct access to the subject, this elimination of authorial commentary, also detaches the ob-

server of the picture from its subject. Failing to have a clear guide from the author as to the attitudes to take, the observer is encouraged to adopt the same detachment. In *Women on a Café Terrace, Evening*, as we saw, we ourselves have to assume the position of a client on that terrace, trying to figure out what it is we are looking at. In Manet's *Railroad* (Pl. 31), we are also put to the test, because we are not supplied with the usual clues that would let us sort out the figures and our relationship to them. "Detachment," therefore, has the virtue of complexity. It describes the artist's viewpoint, but also the viewer's, and accordingly, lets us deal both with the genesis of the painting and its perception. The psychology of the viewer becomes intertwined with the artist's because of, not despite, his detachment.

The Artist as Observer of Domestic Manners

"Detachment" has so far been discussed in terms of the male investigator whose territory is the street, the public arena. The advantage of the term, however, is its general application. If we study paintings of the domestic interior we shall discover that it applies there equally well, and to women artists, not just to men. Berthe Morisot and Mary Cassatt, for example, exhibit the detachment that characterizes naturalist writers and impressionist painters, whether male or female. Morisot's *Interior* (Pl. 48) is a thoroughly impressionist painting. Its contemporary subject, its light-struck palette, and its loose brushwork suggestive of spontaneity, separate it from painting of the preceding generation. Like many works of Manet and Degas, it fails to offer a narrative in the traditional fashion, and its figures neither display emotion nor reveal much character through bodily expression. A woman splendidly dressed in black sits pensively, apparently absorbed in her own thoughts (she is not in mourning because she wears a gold bracelet). She must be a visitor, for she wears a hat and sits erect in the chair. Further back, her hostess, who wears no hat, and whose hair is informally arranged, holds back window curtains and bends her head towards the child, whose apron marks her as a member of the household. We deduce they are mother and child, and their natural relationship, no matter

49. Cassatt, *Cup of Tea*, 1880. Boston, Museum of Fine Arts.

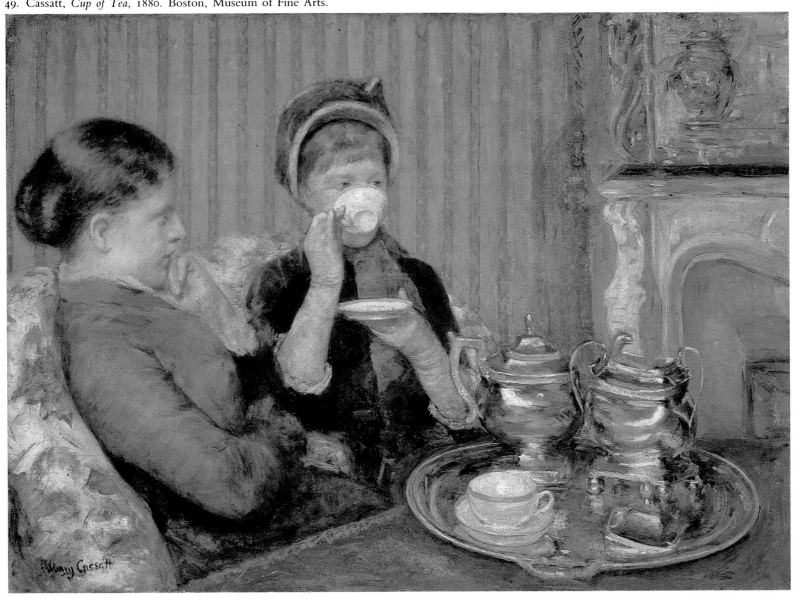

how understated, contrasts with the solitary nature of the woman in black, further marking her off from the shared moments of domestic life in this upper-class apartment (the huge, bronze *jardinière* alone indicates a rich interior). Perhaps the mother and child are waiting for a new arrival, perhaps only looking out over the city. We are not told, for the anecdote is reduced to such a simple level that no "narrative" is present. The painter seems singularly detached from what she presents to us, and we are permitted to make our deductions without her involvement.

Equally dispassionate is Mary Cassatt's *Cup of Tea* (Pl. 49) of 1880. One young woman, hatless, sits meditatively while the other takes a sip from her nearly drained cup. She is surely a visitor, for she has an alert carriage that contrasts with the well-settled pose of her hostess. Together they have "a refined scent of Parisian elegance," according to the critic J.-K. Huysmans.[37] They are both looking off to the right, but since there is no third teacup, it is unlikely that another person is present. Perhaps some little household incident has drawn their attention, but it is equally likely that they have simply come to the end of conversation. The preoccupation with cup and saucer seems to bespeak the tactful young visitor who knows how to substitute gesture for talk.

In these two paintings we face a domestic world whose elements are reconstituted with the detachment of the naturalist who lays out her findings for us to observe. We are spared the sentiments of the romantic era, and therefore our own attitude is as detached as the artists'. To that extent these two works share much with, say, Degas's *Place de la Concorde* (Pl. 37) or Manet's *Railroad* (Pl. 31). These four artists were equally devoted to contemporary life, rendered in naturalistic terms, without idealization, without need for "noble" subjects, without literary sources, above all, without the intrusive presence of the artist's own attitude.

Of course, the detachment that links these artists does not homogenize their temperaments, nor cover over the differences between male and female artists. The masculine qualities of the *flâneur*, already dwelt upon, are too evident to require further comment. Cassatt and Morisot are rather like the natural scientist, but they are not like the *flâneur*. Instead of prowling cafés or canvassing public thoroughfares, they lift a bell-jar off the society of upper-class women and examine its ways with an acuteness and a sympathy that few men could attain to (one thinks of the later Henry James, perhaps, but not of Balzac or Zola). The two pictures under discussion single out the rounds of daytime visits among women, a central feature of nineteenth-century social life. Relationships among women are their subjects, and the prominence of social conventions is signaled by a telling use of household furnishings, in Morisot's painting by the massive bronze planter, and in Cassatt's by that monumental tea service, almost oppressively large, as though the two young women were its servants.

If we turn to the ways in which men deal with domestic interiors, we shall easily distinguish them from Cassatt and Morisot, without denying common links of naturalism and detachment. Caillebotte's *Man at the Window* (Pl. 23) allows the powerful male figure to dominate both exterior and interior. The woman in Morisot's *Interior* is also at a window but far from dominating the street, she is sheltered from it and

is more thoroughly the creature of a domestic space. Caillebotte's *Interior, Woman at the Window* (Pl. 50) has more obvious analogies with Morisot's picture, but the psychological separation of his two figures is more troubling. Morisot's seated woman is shown in a moment of unexplained reflection, but the overall setting mitigates her isolation. Because we assume that Caillebotte's pair are husband and wife, we take the painting as a comment on their relationship. The man's absorption in his paper divides him from the woman; her gaze out the window implies longing for another space.[38]

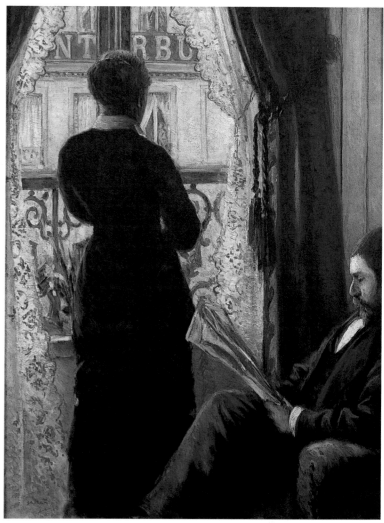

50. Caillebotte, *Interior, Woman at the Window*, 1880. Private collection.

Degas, more than Caillebotte, was the male investigator eager to pry into anxiety rather than to celebrate domestic harmony. In *Edmond and Thérèse Morbilli* (Pl. 51) a rather curious mood is developed. The husband is seated with an assurance that borders on the assertive. This is his space, and he commands it. His dangling hand seems both powerful and sensual. The tan drapery behind him matches the illuminated side of his head so as to bring it forward and also to separate him from the compartment of space in which the woman is found. Her space is a confined one, and its drapery echoes the color of her dress to mark it as hers, a reticent color and space compared to her husband's sensual tones. She places one hand

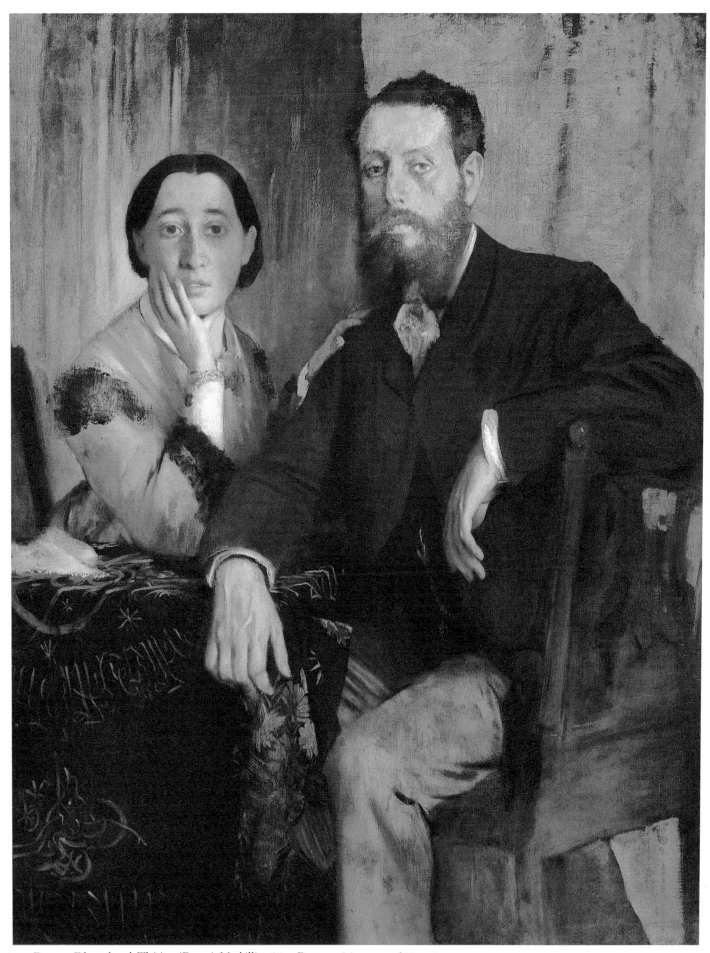

51. Degas, *Edmond and Thérèse (Degas) Morbilli*, 1867. Boston, Museum of Fine Arts.

submissively on his shoulder, and raises the other to her face in a gesture of shyness.

The more we concentrate on this picture, the more we feel that the recessive space allotted to the woman makes her husband loom unusually large, almost emphatically so. Degas staged the lighting so that Morbilli's head casts a prominent shadow on his wife's face, further subordinating her by making her peer out between two shadows. Neither figure appears to welcome us. On the contrary, they do not smile and the man's protective, nearly belligerent pose is seconded by the woman's gesture of shyness, as though they were both reacting to our intrusion. This is all the more extraordinary, because the woman is Degas's own sister! Why should either figure adopt such poses when facing a brother? We might rather expect the opposite, some sense of a bond with the artist, therefore with the observer (furthermore, Morbilli was a cousin whom Degas and his sister had known for a long time). Perhaps the absence of signs of affection and warmth was owing to the latent jealousy of a brother for his sister's husband. If so, it would hardly be unconscious, for the artist carefully constructed every feature of this composition. It might be that Degas exploited his own feelings knowingly, in order to create a strangely detached view of a contemporary couple.[39]

His best known representation of domestic strain is *Interior* (Pl. 52), one of the very rare impressionist paintings that has a precise literary source. Degas referred to it simply as "my genre painting," but we know that it is based on Zola's *Thérèse Raquin*.[40] It depicts Thérèse and Laurent who, a year earlier, had murdered her first husband. It is now their wedding night, but guilt has altered their feelings and they cannot abide one another. In this painting Degas's misanthropy reaches an extreme point and sets him apart from Morisot and Cassatt. He has brought his cynicism in from the street, and in this interior, detachment turns into alienation. Even so, Degas was not isolated from the naturalism that so thoroughly marked his era. Balzac and Flaubert had often dealt with marital dissonance, and his alertness to Zola's text makes him an ally of the naturalism of his own generation (he was

generally closer in spirit to the Goncourt brothers than to Zola, whose penchant for the violent was foreign to him). That he was drawn to domestic discord does not make him more a naturalist than Morisot, but it makes him a different one.

Degas's Objectivity: The Artist as Stranger

Although naturalism and its corollary, detachment, are the appropriate terms for Impressionism, their relevance has often been ignored. The sticky issue is "detachment," because the painters, by omitting authorial judgment, have fooled many into believing that their art was an empty-headed kind of picture-making.[41] The most penetrating analysis of detachment or, to use his word, "objectivity," is Georg Simmel's, in his justly famous essays, "The Stranger" of 1908, and "The Metropolis and Mental Life" of 1903.[42] He was not writing about painters, but his analysis is of great value for the interpretation of Impressionism. Although it grows from his discussion of the newcomer to the city, one free of long attachment to his adopted place of residence, it incorporates key components of the modern urban dweller's outlook and need not be limited to the "stranger" or to men (whom he always posits, instead of women).[43]

"Objectivity," writes Simmel, "is by no means non-parti-

53. Daumier, *The Print Collector*, c.1860. Paris, Musée du Petit Palais.

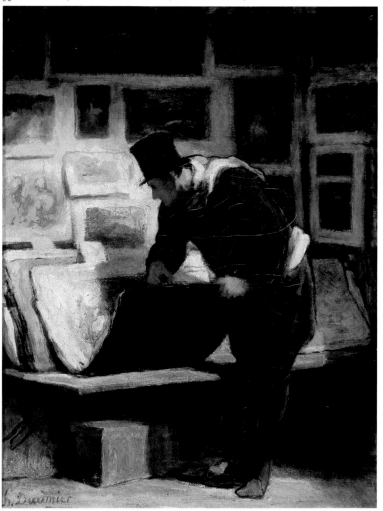

52. Degas, *Interior*, c. 1868–69. Philadelphia Museum of Art.

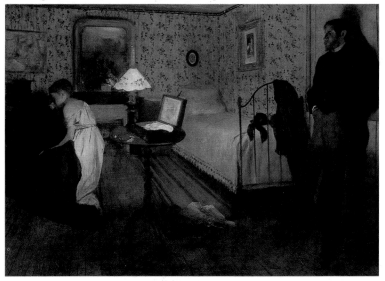

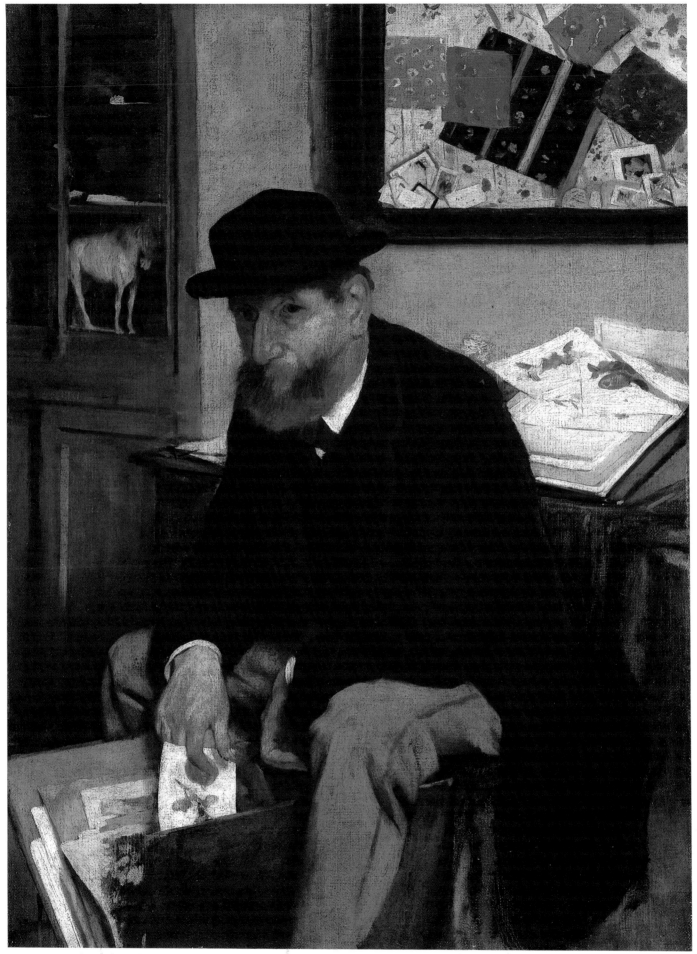

54. Degas, *The Print Collector*, 1866. Metropolitan Museum.

cipation," but is instead "a positive and definite kind of participation." It characterizes a mind that does not merely register a message, but on the contrary, one that focuses its energies on the subject of its attention by eliminating accidental, temporary, and distracting qualities. Objectivity, in other words, "does not signify mere detachment and nonparticipation, but is a distinct structure composed of remoteness and nearness, indifference and involvement."[44] In this Simmel rejoins the definition of the *flâneur* whose acute powers of observation, according to Victor Fournel, are an active force that is projected outwards: "he animates everything he sees."[45] He also rejoins the broad current of naturalism in which Flaubert, Duranty, the Goncourts, and Baudelaire all found common cause, despite their differences. They disliked an obvious authorial presence and insisted instead on the apparent neutrality of the writer-reporter, yet they treasured the essential passion that remained artfully hidden.[46] Although physically close to the objects of his attention, Simmel's observer, quite like the naturalist writer and the natural scientist, avoids emotional engagement with them, that is, he maintains a psychological distance. This distance, viewed from the perspective of some fellow citizens, might seem to result from callous indifference, but it can also be defined as freedom. Compared to ordinary persons, Simmel's objective individual is freer because "he examines conditions with less prejudice; he assesses them against standards that are more general and more objective; and his actions are not confined by custom, piety, or precedent."[47]

With the aid of Simmel's formulation, we can see that detachment is not merely aloofness, but a complex dialogue of nearness and remoteness, of close attention and uninvolvement. In Cassatt's *Cup of Tea* (Pl. 49), we are brought very close to the two young women, but we are utterly removed from them. We confront Manet's *Street Singer* (Pl. 38) directly, but her blank stare and self-containment detach us from her. Even though the woman in his *Railroad* (Pl. 31) looks up at us, we are given no hint of recognition, and seem to have chanced upon her as might Simmel's stranger. More disconcerting still, given the dramatic nature of the event, is the detachment imposed on us by Manet's cool treatment of *The Execution of Maximilian* (Pl. 63).

Degas, among the impressionists, is the most complete embodiment of Simmel's "objective individual." His *Print Collector* (Pl. 54), compared with Daumier's painting of the same subject (Pl. 53), lets us distinguish impressionist detachment from mid-century naturalism. Both collectors are treated as contemporaries, but Daumier distances us from his by using a Chardinesque glow that avoids the immediacy of Degas's harsh light. His figure is further away, as though we are at the front of the shop, or outdoors, looking through the window. He is unaware of our presence and is ennobled by his devotion to his album. Degas's collector, on the other hand, is extremely close to us and has engaged our eyes. He is crouched over his folio, sheltering it with his legs. Clearly he is looking at us as a potential rival or, at least, as an intruder (his pose shares something with Edmond Morbilli, (Pl. 51). Of course, Degas did not simply "see" this scene. He created it by combining various observations and studies in a complicated process of great deliberateness. We can therefore be sure that

he has calculated his effect of physical nearness and psychological distance. In this urban encounter in a public space, the viewer confronts a stranger from whom he is detached, yet with whom there is this odd involvement. Simmel's definition of objectivity can be used to describe Degas's composition: "it is a particular structure composed of distance and nearness, indifference and involvement."

Further insights into the nature of Degas's collector result from a close look at his surroundings, compared with Daumier's. In the earlier picture we see only prints and drawings, but Degas's figure is encircled by curios of different sorts: flower prints, the statuette of a horse, a table heaped with albums and prints, and on the wall above, a miscellany of visiting cards, small prints or photos, and swatches of Japanese textiles (used as covers of small notebooks). These objects suggest a connoisseur, yes, but not Daumier's kind, devoted to one species of art. He is instead the acquisitor-collector who hunts for the rare, overlooked print, who monopolizes the shop's folio, and who looks with unfriendly eye on us, setting up a psychological tension that lets us know we face a competitor. He is on the qui-vive, an alert urban dweller who lives by his wits.[48]

Another Degas, *Portraits in an Office, New Orleans* (Pl. 55), is one of the rare impressionist works ever to have entered into a discussion of the new urban objectivity. Rudolf Arnheim interpreted this picture in terms that complement Simmel's conception.[49] It represents Degas's family's enterprise in New Orleans. His uncle is seated in the foreground, examining cotton. Near him is his brother-in-law, reading a newspaper, while his brother is leaning against the counter on the far left. The matter-of-factness of this scene, all the odder because it presents the artist's own family, is one of its leading characteristics. Degas does not link one figure with another in a traditional sense. Instead he examines them with the same dispassionate eye that his uncle turns on his cotton sample. This detachment constitutes a new kind of pictorial order, for the causal and psychological connections among these businessmen are not indicated. Judged by the conventions of earlier painting (therefore of earlier society), the relationships in Degas's picture indicate, in Arnheim's formulation, "the atomization of society in an age of individualism." It suggests "a communal pattern in which all joints are loose. No over-all constellation holds the crowd together, and hence there is no limit to the changes that may occur in the relationships between the participants."

Arnheim's perceptive remarks imply a great deal, but he did not look for an underlying explanation for this matter-of-fact rendering of modern businessmen. For that we should turn to Simmel, who probed into the meaning of modern individualism and impersonality. Following Marx, Simmel claimed that it is the modern money economy that lies behind the "objective individual." Money and commodities dominate the new urban economy, which forms such a huge and complex market that direct contacts between those who make the goods and their customers are no longer common. Monetary transactions take place in abstract ways, thanks to the many intermediaries between maker and buyer, so that the social relationships that once bound them together are done away with. Stock markets replace direct investment in land or

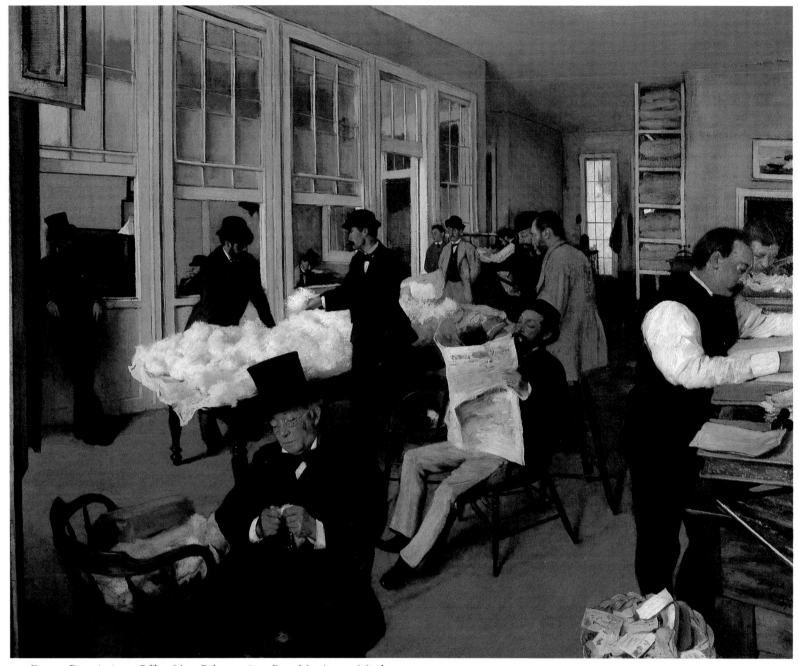

55. Degas, *Portraits in an Office, New Orleans*, 1873. Pau, Musée municipal.

business; instead of artisans that one knew, large stores supply furniture and clothing; instead of water carriers and nightsoil men, municipal services take care of water and sewage. Money increasingly substitutes for direct human interaction, and from its abstract nature there flows a broad current of change. Modern city dwellers have been uprooted from any country or village origins, and they discard allegiance to pre-modern values. They invest in new enterprises rather than in landed property, and consequently they object to old customs and laws which prevent assaults on the land represented by mining, highway building, deforestation, or other measures of "progress." This is why the modern person is free, un-attached, in Simmel's definition of objectivity. Like the *flâneur*, Simmel's urban dwellers avoid emotional involvement in order to make rational calculations born of objective judgments. They are willing to take risks on new products or new

processes because they are free from the tradition and sentiment that might interfere with their computations:

> The calculating exactness of practical life which has resulted from a money economy corresponds to the ideal of natural science, namely that of transforming the world into an arithmetic problem, and of fixing every one of its parts in a mathematical formula. It has been money economy which has thus filled the daily life of so many people with weighing, calculating, enumerating, and the reduction of qualitative values to quantitative terms.[50]

The impersonality of the money economy, in other words, is the setting for the impersonality and the detachment of the individual.

Simmel had more than one city in mind, but Paris in the Second Empire and Third Republic would vindicate his an-

53

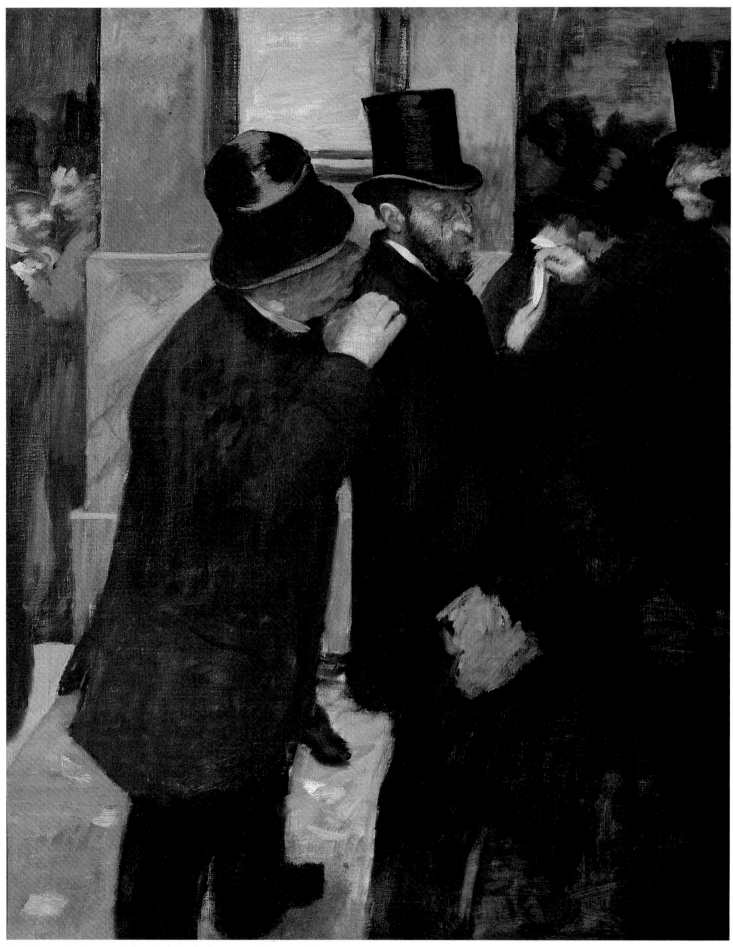

56. Degas, *Portraits, At the Stock Exchange*, 1879. Musée d'Orsay.

alysis better than most. The wholesale remaking of the city under Louis Napoleon and Haussmann, with its destruction of traditional neighborhoods, helped transform the capital into a society of strangers. The rampant speculation of that era, the development of a "mushroom aristocracy,"[51] the clash of new and old values, were inextricably bound up with its position as cultural and fashion center of Europe. Zola's and Daudet's novels are justifiably full of financial adventurers; speculators and men of new fortunes were prominent among the impressionists' patrons.[52] This was the heyday of speculating in art, and Paris was the central market for that commodity. A conspicuous representative is Ernest Hoschedé, Monet's patron, whose collection of impressionist and other paintings was engulfed in a notable bankruptcy. Another example is Ernest May, a more successful investor who is the central figure in Degas's *Portraits, At the Stock Exchange* (Pl. 56). He was one of the artist's clients, and a sometime friend, who formed a notable collection of mid-century and contemporary art. Faithful to his own objectivity, Degas represents May not as the connoisseur, but as the stock-market expert. He exposes the source of May's wealth and lets us deduce that the same calculative abilities lay behind his collecting of art.

The impersonality that characterizes the money economy, according to Simmel, is only a thin coating over the tension that results from the need to detach oneself from the persons and objects confronted at every turn in the modern city. The anxiety of physical nearness and psychological remoteness is best glossed over by a pretended indifference or, to use Simmel's preferred term, "reserve." Detachment and Simmel's terms "objectivity" and "reserve" are all closely related concepts. Exposed to so many stimuli, the city dweller "would be completely atomized internally and come to an unimaginable psychic state" if she had to reckon fully with each encounter, hence this reserve. Because the effort to achieve apparent indifference is actually full of anxiety, it is sometimes mixed with aversion, even with antipathy:

> Our minds respond, with some definite feeling, to almost every impression emanating from another person. The unconsciousness, the transitoriness and the shift of these feelings seem to raise them only into indifference. Actually this latter would be as unnatural to us as immersion into a chaos of unwished-for suggestions would be unbearable. From these two typical dangers of metropolitan life we are saved by antipathy which is the latent adumbration of actual antagonism since it brings about the sort of distancing and deflection without which this type of life could not be carried on at all.[53]

Degas's *Portraits, At the Stock Exchange* exhibits this mixture of detachment and antipathy. Not only are May and his friend Bolâtre presented in an unflattering light, but the two men further back on the left (Pl. 57) are literally caricatures of financial conspirators. Caricature bears with it the sense of social attack, of antipathy, adulterated with humor so as to make it acceptable. The frequent appearance of caricature, or something close to it, in Degas's work speaks for the misanthrope, the detached observer whose emotional solution to the dilemma of nearness and remoteness was a pronounced cynicism. This suits the temperament of the *flâneur*, who is

57. Degas, detail of *Portraits, At the Stock Exchange* (Pl. 56).

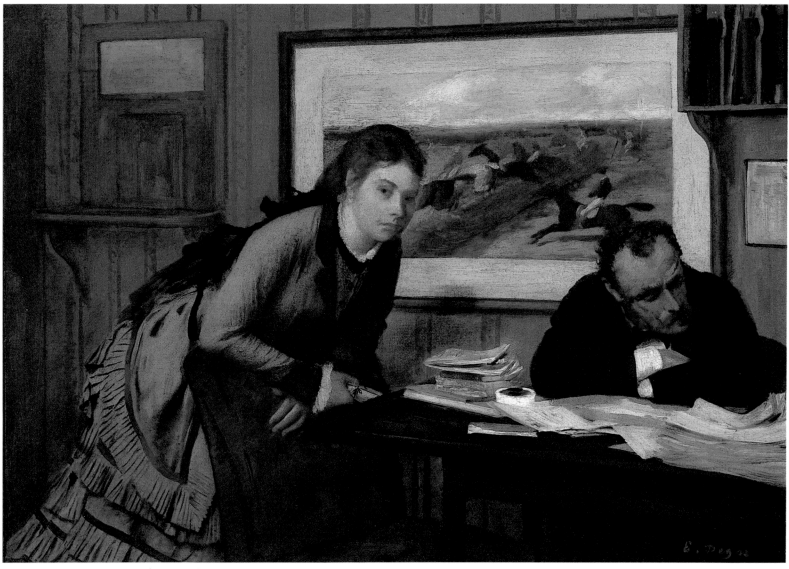

58. Degas, *Sulking*, c. 1873. Metropolitan Museum.

appropriately defined as having a "disdainful skepticism" and an "unhealthy pride."[54] Degas's cynicism was in baleful harmony with his social isolation, and was clearly attached to the money economy. After his family's banking business went bankrupt in 1874, he was obliged to sell his paintings—"articles" he derisively called them—as so many wares. The combination of sharp dealing and self-consciousness which ever after characterized his transactions reveals the predicament of the scion of a wealthy family, forced to accomodate to the new era.

A banking office, in fact, is the setting for one of Degas's most striking expressions of anxiety and antipathy, *Sulking* (Pl. 58).[55] We do not know a particular text or anecdote that might lie behind this picture, but its force as an expression of the instability and tension of modern life must owe something to the family business. When we confront the picture, we realize that we are intruders. The woman is relatively neutral, though not forthcoming in her stare. The man's sidelong glance acknowledges us reluctantly, while it rejects the woman; his unexplained anger generates great discomfort in us (anger at our interruption, or anger preceding our appearance,

or both?). Degas sets up a secondary tension by simultaneously separating the two figures and joining them with the strong axes of the desk and the British sporting print on the wall. All this fictional tension is transferred to us and becomes real, when we read the painting. This sequence of pictures, *The Print Collector, Portraits in an Office*, and now *Sulking*, offers convincing proof of the connection between an artist's own history and the social significance of art. Simmel's "money economy" was never given more profound embodiment, and capitalism, never a more troubling analysis.

We can pursue Degas's biography one step further, to prove beyond doubt that he was an exemplar of the anxious condition of the modern city dweller. His cynicism and temperamental isolation led him, in later years, to retreat from society, to the point of becoming a veritable recluse and a pronounced anti-semite. Before he reached that stage, however, his paintings manifested his underlying loneliness, another feature of the struggle for objectivity and indifference. Louis Wirth, Simmel's American admirer, noted that the dilemma of nearness and remoteness could induce not just nervous tension and antipathy, but also loneliness: "Frequent close physical contact,

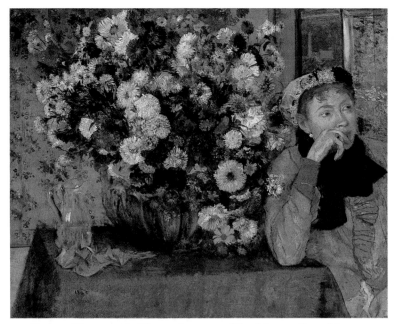

59. Degas, *Woman with Chrysanthemums*, 1865. Metropolitan Museum.

60. Degas, *The Loge*, 1880. Mr. Paul Nitze.

coupled with great social distance, accentuates the reserve of unattached individuals toward one another and, unless compensated by other opportunities for response, gives rise to loneliness."[56]

Woman with Chrysanthemums (Pl. 59) is one of the many paintings by Degas that produces a disturbing sense of loneliness. It is, to begin with, an odd composition. If it is a portrait, why is the woman not given central place? If a painting of flowers, why is the woman seated there? Above all, why is she looking out of the picture? Her pose, most particularly the way her hand is pressed to her lips, suggests a mood somewhere between melancholy and worry. It is not simply the pensiveness of the woman seated in Morisot's *Interior* (Pl. 48). The theme of being alone, with hints of estrangement, is also the subject of *The Loge* (Pl. 60). It can be regarded at first merely as a piece of observation. From a lower level of boxes, the tops of whose chairs show at the base of the composition, we look up to a private box where a lone woman is seated. Gradually, however, Degas's clever construction works its way on us, and we become increasingly penetrated by that woman's lonely condition. This is all the more true because in a representation of a theater, we would expect some suggestion of the social pleasure of a public entertainment. The absence of anyone in the lower box (perhaps this is intermission?) fortifies the lack of companions for the woman above. And why is the observer staring up at her? Is the possibility of our own isolation implied, by our having spied this brooding image? The gaiety of the sculpted front of the loge mocks her aloneness, for in all the space that is available, there she is, squeezed into that corner, her head severed from her surroundings by the dark railing of the loge.

Degas's responsiveness to moods of loneliness is allied to his frequent probing of tension or estrangement among his figures.[57] He was more a misanthrope than the other impressionists, more a victim of the operations of the money economy, more the member of an uprooted upper class forced to descend to the bourgeois market, more the urban stranger than they. To say this is not, however, to deny him his place in a generation characterized by detachment from history, from religion, from mythology, even from emotional involvement with fictional personages. The impressionists were all naturalists who stared present-day life in its face, who revealed the predicament of modern beings, their contemporaries and ours, forced to confront others whom they do not know, and denied the means of healing over the breach that industrial capitalism opened out among them. Manet's *Street Singer* (Pl. 38) and his *Railroad* (Pl. 31) make us recall our sense of aloneness when we encounter strangers on the street; Morisot's and Caillebotte's interiors (Pls. 48, 50) alert us to the fact that modern women and men can live in solitary psychological worlds, despite their apparent togetherness.

In the next chapter we shall see that even in Parisian cafés and restaurants, those arenas of good food and good cheer, the anxieties of modern life are brought forth and analyzed by these prescient artists, and we shall see that Manet, no less than Degas, Manet the convivial man about town—no misanthrope he!—that Manet too was concerned with separateness as well as with union, with loneliness as well as with gaiety. This does not mean that we have to anticipate a dreary wandering through seamy taverns: gaiety is there along with loneliness, cleverness is more in evidence than sordidness. It does mean that Degas's predilection for the estranged moment, although it has a bitter character all his own, is shared by other painters. Their constructions gain in naturalness, as they gain in beauty, when we recognize their complexity.

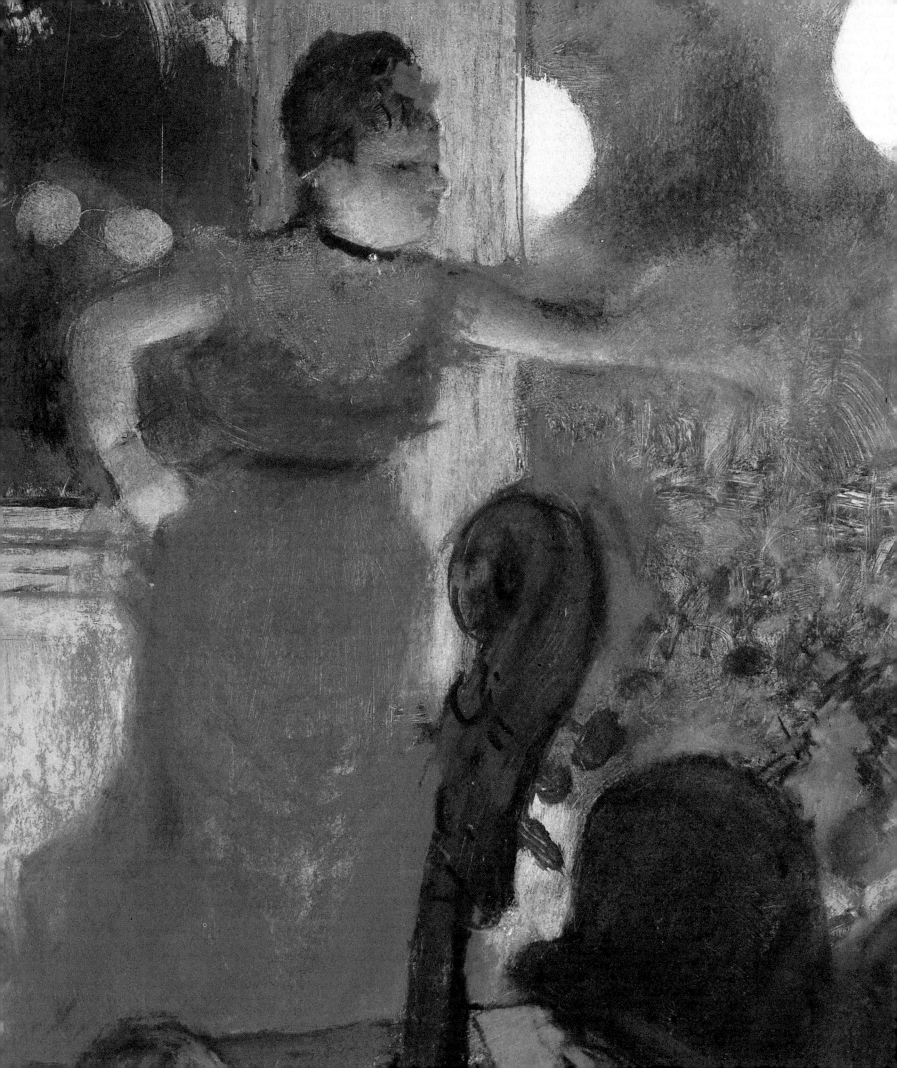

Chapter Three
Café and Café-Concert

Cafés have invaded the boulevards, concerts have invaded the cafés, and crowds have invaded everywhere to the great joy of the barkeepers who are getting rich.
—Marc Constantin, 1872

Bread! Bread! they used to demand. Spectacles and hussies, that's what they cry today.
—Anon., *Paris désert. Lamentation d'un Jérémie haussmanisé,* 1868

To become a harlequin is some compensation for failing to be a republican citizen.
—Henry Tuckerman, 1867

Even a casual glance at successive editions of guide books to Paris, from their beginnings in the 1840s to the end of the "Belle Epoque," reveals the striking truth: leisure and entertainment took an ever-increasing place in the life of Paris. In the guide books—their very growth is an index of leisure—notices devoted to idle hours and entertainment greatly expanded, while those that referred to historic sites and famous buildings simply held their own (and visiting such places is, of course, an aspect of leisure). At the end of the century the life of Paris, if one were to judge by guide books, was dominated by the following: theaters in infinite variety, opera, comic opera, vaudeville, music halls, cafés-concerts, cafés, restaurants, popular balls, circuses, racetracks, promenades (along streets as well as in parks and gardens), shopping, and excursions along the Seine and out to the suburbs, excursions that may have included bathing, boating, riverside dining, dancing, picnicking, or simply promenading. The numbers involved are not easy to establish, but they were already noteworthy by the 1860s. The American James McCabe estimated that in 1867 theaters in Paris seated a total of 30,000 on a good night, and in cafés-concerts, circuses, and other enclosed places, an additional 24,000.[1]

Tourists came to Paris to enjoy what the natives already prized, an elegant urban culture. The extra revenues they brought contributed fundamentally to Paris's prosperity, as did the plaudits they lavished on Parisian products catering both to body and to mind. Paradoxically, tourists—transients by definition—fitted readily into the Parisian culture of entertainment and leisure, for the city's life was sustained by a volatile population. By 1886 the city's inhabitants numbered 2,345,000, three times the figure for 1831. Furthermore, most of the newcomers had been born outside Paris. From 1875 to 1891, for example, only 7% of the net increase in Paris's population was due to new births, 93% to immigration from elsewhere (and these figures do not include temporary visitors from abroad and from the provinces). Already by 1872, 7.4% of Paris's residents were foreign-born, a huge percentage compared to prior generations and to other European cities. By 1891, only 32.2% of the capital's population had been born in the city, whereas in London, center of a vast colonial empire, and in Boston, major city in a nation of immigrants, respectively 62.9% and 38.5% of the inhabitants were native born.

Paris's population was also marked by a very high percentage of single men and women. Paris and its immediate suburbs had the highest divorce rate in France: in 1885, 47 divorces for every 100,000 people, compared to 3.5 for the rest of the country. Adding legal separations to divorces brought the Paris figure up to 60 per 100,000, compared to 12 for all of France. Moreover, many Parisians never married at all, for Paris had the lowest marriage rate among Caucasians in all of Western Europe and the United States. To these revealing facts we might add another: among married couples, 323 per 1000 had no children, an unusually high figure for that era.[2]

These various statistics show us that the traditional family and the domestic hearth, so vital to middle-class mores and to traditions of painting earlier in the century, were no longer as central to Parisian life. The foreigners, the provincial immigrants, the temporary visitors, the professional couples with-

61. Degas, detail of *Aux Ambassadeurs* (Pl. 83).

out children, the construction workers and laundresses who left their families in the provinces, these were the ones who populated the Second Empire and the Third Republic. It was among these uprooted peoples, living in a city undergoing constant and drastic alterations, that the *flâneur* and the impressionist artists took their places. Paris was indeed a city of strangers.

The burgeoning population of Paris formed an ideal clientèle for entrepreneurs of distraction, both the owners of the rapidly expanding network of entertainment, and also the municipal and national institutions which treated entertainment as instruments of policy. Henry Tuckerman, when he visited Paris in 1867, contrasted the "dignity and permanence" of American and British life with that of Paris, whose citizens, he wrote, dwelled in

> a kind of metropolitan encampment, requiring no domicile except a bedroom for seven hours in the twenty-four, and passing the remainder of each day and night as nomadic cosmopolites: going to a café to breakfast, a restaurant to dine, an estaminet to smoke, a national library to study, a *cabinet de lecture* to read the gazettes, a public bath for ablution, an open church to pray, a free lecture room to be instructed, a thronged garden to promenade, a theatre to be amused, a museum for science, a royal gallery for art, a municipal ball, literary soirée, or suburban rendezvous, for society.

Unlike James McCabe and other American visitors in 1867, who reveled in all the glitter, Tuckerman understood that leisure and display formed a vital element of French politics, one that was used to great advantage by Louis Napoleon's government, and one that truly characterized the new society of the French capital:

> To cultivate illusions is apparently the science of Parisian life; vanity must have its pabulum and fancy her triumph, though pride is sacrificed and sense violated thereby; hence a coincidence of thrift and wit, shrewdness and sentimentality, love of excitement and patient endurance, superficial enjoyment and essential deprivation....[3]

Offenbach and Manet

In 1867, when Tuckerman made those observations, one of the great masters of illusion and display reached the heights of a giddy climb to fame. Jacques Offenbach had two smash hits that year, both calculated to coincide with the 1867 exposition. *La Vie Parisienne*, commissioned expressly for the fair, was ready ahead of time (it premiered on 31 October 1866), leaving Offenbach and his habitual collaborators, Henri Meilhac and Ludovic Halévy, several months to prepare *La Grande-Duchesse de Gerolstein*. The latter opened on 12 April 1867 and was, like its predecessor, a huge success. Offenbach was not an impressionist in any sense of the term, but the study of his operettas is so rewarding for the history of Impressionism that it must have its place. Moreover, Siegfried Kracauer's *Offenbach and the Paris of His Time*[4] is one of the great pieces of cultural history, and in many ways the ideal model for a book on Impressionism, even though the author never mentions Manet, Morisot, or Degas. Thanks to his perceptive analysis of Offen-

bach, we can find illuminating parallels with Manet that greatly extend our understanding of the works of this painter, himself a master of illusion and display.

Offenbach's first major success, *Orphée aux enfers* of 1858, owed some of its vogue to its witty satire of contemporary society. Jupiter, forever chasing women, was seen as Louis Napoleon, and his jealous wife Juno, as Eugénie. Like the Emperor, Jupiter needed public support, so Offenbach replaced the classical chorus with voices labeled "public opinion," making clear the manipulation of the populace. Jupiter and his courtiers used shabby subterfuges to maintain their power, and they succeeded, despite the threat of the Olympians to stage a revolution, because indulgence in pleasures was offered to all. "In short," wrote Kracauer, "the operetta made a mock of all the glamour that surrounded the apparatus of power." The fact that there was considerable sting in Offenbach's spoof of the Empire was revealed by Jules Janin's attacks on the operetta for profaning "glorious antiquity" through its allusions to contemporary society.[5] In *La Belle Hélène* of 1864, Offenbach poked more fun at the vainglory which characterized Louis Napoleon's reign (Kracauer reminds us that at a masked ball in 1857, Eugénie appeared as Night, with a Milky Way of diamonds, and two others came as the Bosphorus at sunset, and the Sea of Marmora on a misty day). Helen's adultery is frankly justified for reasons of state, and like members of Louis Napoleon's court, Orestes parades his girls on the "boulevards" of Sparta, boasting that the state's coffers will pay for his excesses.

In 1866 and 1867, with *La Vie Parisienne* and *La Grande-Duchesse de Gerolstein*, Offenbach dropped mythological settings in favor of contemporary life. *La Vie Parisienne* opens in the Gare Saint-Lazare, as a party returns from the fashionable resort of Trouville; its final act takes place in a café-restaurant. In between, the visitors Baron and Baroness de Gondremark are victims of the *boulevardiers* Gardefeu and Bobinet, who take advantage of the foreigners' desires to attend the latest plays, musicals, and cafés-concerts, and to embark on amorous escapades. Appropriate to the Paris exposition, for which it was initially commissioned, *La Vie Parisienne* gives other prominent roles to foreigners, and its chorus, suitably enough, is composed of foreign tourists:

> We are going to invade
> The sovereign city,
> The resort of pleasure.

In *La Grande-Duchesse de Gerolstein*, set in the fictional duchy of Gerolstein, one of the principal characters is General Boum, always anxious to enjoy war; periodically he shoots his pistol into the air and sniffs the fumes, in preference to snuff. Analogies with contemporaries were not hard to find, and Offenbach had to cope repeatedly with the government's censors.[6] His original title, simply *La Grande-Duchesse*, was rejected on the grounds that Russia might take offense if it were thought that Catherine II were being satirized (Alexander II was in Paris for the exposition). Further, the censor objected to a young general's declaration, "Madam, I have just won the war in eighteen days," fearing that it would be taken as a reference to Moltke's defeat of the Austrians at Sadowa, a campaign that had lasted eighteen days (Offenbach changed

the line to "four days"). The objection was not so far-fetched. There was widespread discussion in 1867 of the possibility that Louis Napoleon might again venture on war as a way of solidifying his control, and the operetta was treading on delicate ground by having the Grand Duchess's ministers plan a war as a solution to their own difficulties. More absurdly, the censor also forbade Hortense Schneider to wear an imaginary royal decoration, lest it offend one or another of the visiting royalty (she subsequently had her portrait painted as the Grand Duchess, wearing the forbidden *grand cordon parodique*).

In reviewing the social role of Offenbach's operettas from 1855 to 1867, the year of *La Grande-Duchesse*, Kracauer demonstrated that Offenbach's operettas used illusion and display as devices to undermine the pompous exterior of Empire, and to reveal the political truths that lay beneath. The *offenbachiade*, he wrote,

> had originated in an epoch in which social reality had been banished by the Emperor's orders, and for many years it had flourished in the gap that was left. Thoroughly ambiguous as it was, it had fulfilled a revolutionary function under the dictatorship, that of scourging corruption and authoritarianism, and holding up the principle of freedom. To be sure, its satire had been clothed in a garment of frivolity and concealed in an atmosphere of intoxication, in accordance with the requirements of the Second Empire. But the frivolity went deeper than the world of fashionable Bohemia could see.
>
> At a time when the bourgeoisie were politically stagnant and the Left was impotent, Offenbach's operettas had been the most definite form of revolutionary protest. It released gusts of laughter, which shattered the compulsory silence and lured the public towards opposition, while seeming only to amuse them.[7]

What about the parallels with Manet in all of this? They fairly leap to the eye, as the French would say.[8] Manet once represented Offenbach, who can be seen in *Music in the Tuileries* (Pl. 42), a picture devoted to one of the most fashionable of the Second Empire's social pageants. Offenbach is shown among a group of immaculately dressed contemporaries, including Manet himself, his brother Eugène, Baudelaire, and Gautier. The composer's image would not be enough to warrant comparison with Manet, of course, and it is to his great operettas of the 1860s that we should turn. If we look first at Offenbach's two early successes, *Orphée aux Enfers* (1858) and *La Belle Hélène* (1864), and then at two of Manet's notorious canvases, his *Déjeuner sur l'herbe* (Pl. 171) and *Olympia* (Pl. 62), we shall see that the painter, like the musician and his librettists, offered up spoofs of the gods, saucily converted to contemporary purposes. The *Déjeuner* shows two men clothed in the apparently casual, but in fact elegant clothing of contemporary artists, and two women, one nude and the other, in the middle distance, in a diaphanous garment. The poses of the three foreground figures were taken from the river gods in Raimondi's engraving after Raphael's *Judgment of Paris*; the fourth figure is as much a nymph as a contemporary. *Olympia* is a modern version of Titian's *Venus of Urbino*. Manet replaces the goddess of love with a contemporary courtesan, that kind of woman—Cora Pearl, Blanche d'Anti-

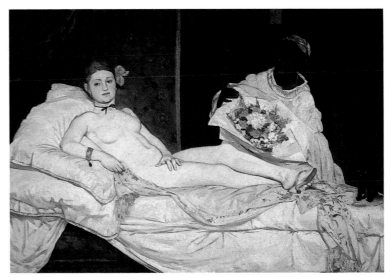

62. Manet, *Olympia*, 1863. Musée d'Orsay.

gny, Hortense Schneider—whose public prominence symbolized the luxury and the hypocrisy of the Second Empire (Cora Pearl was for a time the favorite of Prince Napoleon, the Emperor's cousin; in 1867 she made a few appearances as Cupid in a revival of Offenbach's *Orphée*).

In these, and in other pictures, Manet was, like Offenbach, making fun of tradition by clothing mythological figures in contemporary costume. His citations from past art were not generally recognized at first, but no one doubted his assault upon the conventions of art and, therefore, upon the academic tradition which was deeply embedded in government institutions. The *Déjeuner* was refused by the official Salon jury in 1863, but raised a furor when it was shown in the exhibition of rejected artists, the *Salon des refusés*. *Olympia*, although accepted by the jury in 1865, was subjected to virulent criticism from the defenders of tradition. Jules Janin's discomfiture before Offenbach's bawdy gods was felt again by Manet's critics, unwilling to see mythological figures, so closely attached to royalty and to the authority of established art, transformed into mischievous commentaries on current society and its mores. Manet's devotion to the pleasures of eye and brush, we might think, should have disarmed his critics, but his assault upon convention was so outrageous that only years later would the brilliance of his technique become evident and the elegance of his life be recognized as of one piece with his art.

When Offenbach was completing *La Vie Parisienne* and *La Grande-Duchesse* for the 1867 fair, Manet, hoping to benefit from the same crowds, was preparing his one-artist show in the pavilion he had erected on the place de l'Alma. His fate was the opposite of Offenbach's. Few visitors came to his exhibition, and it received scant notice in the press. The reasons for this are many. He was not at all as well known as Offenbach, and in any event an art exhibition would not benefit as much as an operetta from the fairgoers' thirst for entertainment. Equally to the point, Manet's forum was not that of a comic opera, where witty satire was anticipated, and the shocking quality of his style was not sufficiently cushioned by clever adaptations of tradition; these would have been understood only by a few insiders.

Manet's opposition to authority found another outlet in the summer of 1867, in this case an overtly political work of art that had no close parallel in Offenbach's satirical repertoire. He embarked on a series of studies and large oils devoted to the execution in June by Juarez's Mexican troops of France's puppet, Emperor Maximilian. Since Maximilian's fall meant the end of Louis Napoleon's ambitions for Mexico, it was a defeat and, to many, a disgrace, all the more crushing because of the boastful nature of the Paris fair. Manet projected a major composition (Pl. 63) on the theme and worked on it and its related studies through 1867 and 1868. Imperial censors would have thwarted any effort to show it in public, and Manet exhibited it only a decade later. He entertained more hopes for a lithograph of the composition, but in 1869 the government censor forbade its printing, an action publicly noted by Zola which confirmed the artist's opposition to the Empire.[9]

Although Manet's failures were in striking contrast to Offenbach's successes, there were nonetheless parallel changes in the direction their art took in 1867. For both artists, that year marked a definitive turn towards contemporary life. They no longer needed mythological or historical figures in order to comment upon their society. Goddesses and gods had been useful earlier when imperial censorship successfully stifled opposition, which therefore had to find covert ways of manifesting itself. Censorship continued in 1867, but in order to placate growing opposition, Louis Napoleon had made a turn towards the Left, and a number of liberal measures were introduced which led to a return of more overt criticism.

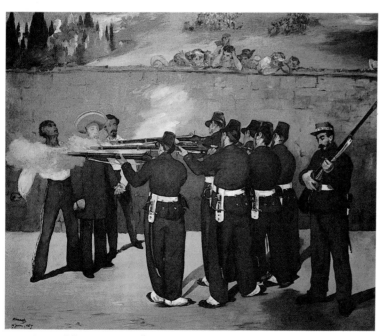

63. Manet, *The Execution of Maximilian*, 1868. Mannheim, Stadtische Kunsthalle.

Daumier's cartoons, for example, became political again after 1867, following a long period of relatively subdued views, and Henri Rochefort, a journalist who had displayed little political consciousness before then, made such a success of his attacks on the Emperor that he had to flee to Belgium (a decade later

Manet painted a portrait of him, and a painting of his escape from the prison of New Caledonia).

Neither Manet nor Offenbach were overtly "political" artists, but the more liberal mood of 1867 and afterwards was manifested in their work by a complete devotion to subjects drawn from current society. Their art seemed to live in the immediate present, to arise from a world of artifice, peopled by courtesans, actresses and actors, musicians, writers, bohemians, and *fashionables*. Their settings were frequently public places, those theaters, dances, cafés, restaurants, cafés-concerts, gardens, and parks, where their exquisite figures paraded their leisure as a way of rebuking bourgeois conventions. Their greatness resides in part in the genius with which they consistently undermined the hallowed conventions of their era by pointing mocking fingers at the cloak of hypocrisy thrown over imperial society.

Bohemians, Marginals, and Performers

Because Paris was itself a theater—tourists and residents agreed, each treating the other as characters worthy of being stared at—it is no wonder that artists devoted to contemporary life treated Parisians as actors on their painted stages. Manet, Degas, and Renoir, the chief figure painters among the impressionists, portrayed a wide cross section of the city's population, from street people to aristocrats. Of all these people, their sympathies were extended most often to writers, painters, journalists, courtesans, dandies, musicians, and performers, that informal grouping of marginals for whom there is no blanket term unless we accept the vague one then current, "la Bohème." Through their common interests and intersecting lives, these people formed a loosely jointed community somewhat apart from the rest of the population. They lacked the relative stability of the bourgeoisie, from whom they took their distance.

Renoir was legitimately a member of this bohemia, being the son of a tailor, a slum dweller, a porcelain worker while still a boy, and then a resident of Montmartre where he lived among that area's assortment of shop assistants, restaurant employees, laundresses, models, concierges, workers, and performers. He frequently took his models from among them, including several figures in his *Moulin de la Galette* (Pl. 135), and the young performers in *Little Circus Girls* of 1879 who were daughters of the circus owner Fernando Wartenberg.

Degas is a quite different case. He was from a banking family, but his misanthropy and the failed fortunes of the family business in 1874 gave him a sharp-eyed and embittered distance from his own kind. His ballet dancers, ballet masters, laundresses, jockeys, journalists, musicians, cabaret performers, and milliners were all people who served or entertained the well-to-do, so Degas did not have to desert his class to construct an art devoted to them. In them he found levels of professional skill that he admired and associated with his own craft. We shall encounter them in future portions of this book.

As for Manet, he came to public attention well before Degas and Renoir, and it is his treatment of street bohemians and social marginals that we should first examine. Manet deliberately retained his place in high society, and from the confidence this gave him, he moved with a *flâneur's chic* among the

flotsam of Parisian society. Throughout the 1860s and 1870s he had both studio and apartment in the Batignolles, the district just north of the Gare Saint-Lazare which was being extensively refashioned by Haussmann, as we saw in Chapter One. New streets were being cut through old ones, and the hills of the Batignolles, a village annexed to the city in 1861, were being leveled to permit the extension of the railroad and of streets and boulevards coming from the center. It embraced a mixture of costly new apartment buildings, empty lots, railroad tracks, warehouses, and remnants of the old Batignolles. It was there that Manet frequently crossed the paths of the itinerants, ragpickers, and gypsies who became his models. We have already met one of them or, rather, a model treated as such, in *The Street Singer* (Pl. 38). In other paintings, drawings, and etchings of the period, he pictured Paris's bohemians: *The Absinthe Drinker* of 1859; *Gypsy with Cigarette* of about 1862; *The Old Musician* (Pl. 65); several kinds of street entertainers, dancers, guitarists, courtesans, actresses and actors, gypsies, and three paintings of beggar-philosophers of which Plate 64 is an example. Among his models were Colardet, a ragpicker, Janvier, a locksmith (who posed for Christ, in *Jesus Mocked by the Soldiers* of 1865), and Lagrène, a gypsy.

The marginals that Manet represented were much admired by the generation of painters and writers he led in the 1860s, a realist school with prominent leanings toward romanticism, a fondness for Spanish art, and touches of nascent Impressionism. Ragpickers were especially favored by the artists. They were not the lowest of the working class, but self-employed men and women who formed a guild that regulated the gathering of urban detritus. They had their own clubs in Paris and the near suburbs; one of the best known, near the Panthéon, was devoted to communal drinking of absinthe. Manet, like Baudelaire, associated them with the tradition of the beggar-philosopher, a well-established Parisian type whose gradual disappearance, owing to Haussmann's transformations and police repression, was cause for grievance. The ragpicker was a liberated spirit who moved about at night, flouting the habits of the bourgeoisie in their comfortable beds; he was despised by society (a piece of irony, since he was an entrepreneur), therefore an outcast, but this freed him from society's restrictive conventions; he gathered up discarded scraps from the city, just as writers and painters chose bits and pieces of urban life—commonplace realities, not the ideal elements sanctioned by academics—with which to create their works.[10] Further, ragpickers had self-esteem (Manet's old man, Pl. 64, has an almost defiant bearing) and were proud of their opposition to a government whose agents constantly harried them. These were all comforting parallels for avantgarde artists who were in psychological if not social opposition to the mainstream.

Manet's principal homage to street bohemians is his huge painting of 1862, *The Old Musician* (Pl. 65). The model for the violinist was the gypsy Jean Lagrène, an elder of the Parisian gypsy colony who lived not far from Manet's studio in a temporary encampment, harrassed by the police.[11] He had earlier hurt his arm while a construction worker on Haussmann's projects and thereafter made his living principally as an organ grinder and artists' model. Behind him in Manet's picture, seated on the embankment, the ragpicker Colardet

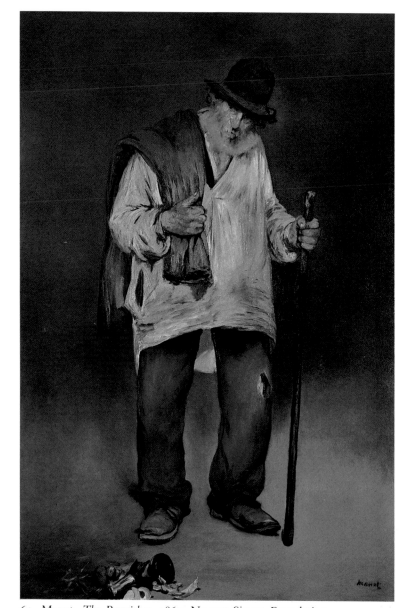

64. Manet, *The Ragpicker*, 1869. Norton Simon Foundation.

reappears. Manet has reproduced him from his *Absinthe Drinker*, that scandalous composition redolent of Baudelaire's world, rejected by the Salon jury in 1859. On the right edge is a key personage of mid-century realism, the wandering Jew. Opposite him is a young girl holding a baby; from other evidence the model is known to have been a slum child from Petite Pologne, the section of the Batignolles where Manet had located his studio in 1861. Next to her are two children in unconventional costume. The one nearest the old man looks as though he might have stepped out of a Spanish painting of a beggar boy. The other, dressed in white as Gilles or Pierrot, invokes the itinerant troupes of performers who often stayed in Petite Pologne. The constant excavations there left vacant lots and upturned yellowish earth, so the setting of this painting, indefinite though it is, seems appropriate to this gathering:

So one fine day the hamlet became a village, the village a borough, and the borough a city; but a dirty city, with narrow, airless streets, without trees, without *squares*,

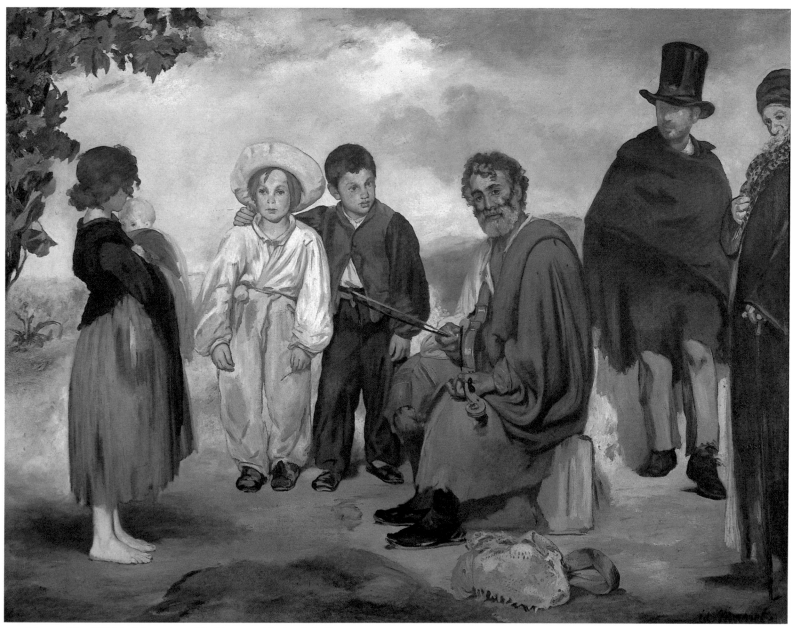

65. Manet, *The Old Musician*, 1862. Washington, National Gallery.

formed by deposits of plaster and limestone that have been left to accumulate without care....[12]

Unlike *The Street Singer* (Pl. 38), which also sprang from this arena of demolition, *The Old Musician* does not encourage a clear explanation of what is going on. It is true, five figures form a symmetrical half-circle around the musician, while his gaze outwards and his pizzicato invite us to complete the circle. Yet the fiction of a group in attendance upon a roadside fiddler is not easily sustained in terms of traditional painting. The figures are arbitrarily clothed and placed as though they had walked on from different dressing rooms. Only two of them look directly at the musician; the others gaze abstractedly elsewhere. How, then, can we reconcile the disparate features of this curious composition?

The strongest bond that joins Manet's painted figures is their common origin among the street bohemians. And they

are more than mere *motifs*. Manet not only painted them, he chose to work among them in Petite Pologne (after all, he could have found a studio elsewhere!). Like Daumier before him, and Picasso afterwards, he associated himself with artists and performers on the fringes of society (the violinist is surely a surrogate for the painter, and a flattering one since the others revolve around him). Their uprootedness was particularly appropriate to the northern edge of Paris in 1862. It was being half destroyed and half-rebuilt by "progressive" forces which thrived on itinerant labor—Lagrène is a case in point—and on the altered land values of these transformed districts, from which "insalubrious streets" and unwanted people were being removed.[13] By not observing all the conventions of psychological unity among his figures, by using broad strokes of paint which fail to model form with customary subtlety, Manet himself uprooted tradition in the very way he composed his picture.

There is consistency, therefore, in Manet's choice of subject and the way he built his pictures. The transformations that Louis Napoleon, Haussmann and the "mushroom aristocracy" were imposing on Paris went more deeply than they knew and touched on the underpinnings of social structure and on the substructures of art. Manet, an oppositional Republican, member of an artistic vanguard, sought out the symbols of mobility, uncertainty and transformation, and conveyed them in unorthodox forms. One of the hidden costs of Second Empire progress was the loss of the old verities of image and form in art.

Loss, yes, but there are knowing references to tradition in *The Old Musician*, and they help unify it. There is a heavy "Spanish" touch throughout in both image and rendering. The broadly painted earth tones recall Velasquez and other artists of the seventeenth century. The dark costumed boy, as we saw, looks like a citation from Spanish art, and the whole arrangement has echoes of *The Drinkers*, a composition by Velasquez which Manet had copied.[14] The fact that the figures seem to be plucked from art history also unifies them. Despite their topicality, they appear as so many costumed players in a timeless piece of art from which specific moment and place have been removed. They are part way between the Batignolles and "art," part way between reality in 1862 and timeless fiction. This dialectic was essential to Manet early in his career, when he was attempting to free himself from tradition. The conventions of art that he was rebelling against were in fact revivified by his consciousness of contemporary Paris and of living models. Colardet and Lagrène *were* real people. It is as though the painted images of Spanish and of romantic art had come to life in the Batignolles as Manet walked about. He carried with him memories of paintings and these acted, perhaps unwittingly, as guides when he chose his models. By investing traditional images with the vitality of living Parisians, painted in his new manner, he gave energy to old forms. The result was a meeting of past and present, past in the forms of prior art now revitalized, present in his cast of bohemians, cleaned up, as it were, by the art, which blanks out most of the disturbing features of the present by omitting overt signs of protest, misery, even of sentiment.

Manet's paintings of the 1860s often have this mixture of past and present both in style and in imagery. The *Déjeuner sur l'herbe* (Pl. 171) and *Olympia* (Pl. 62) converted renaissance gods into picnickers and courtesans, and stirred controversy because they were neither historical nor modern figures. Over the course of the decade, he gradually shed more and more references to the past, but it was not until the 1870s, after the violent end of the tinsel empire in the Franco-Prussian War and the Commune, that he made a thorough break with history, and committed himself wholeheartedly to new-wrought forms as the expression of contemporary life.

His own life in the 1860s reveals the position of an artist who is of the upper class, yet partly displaced from it. He could remain an elegant member of high society, enjoying the company of a monied and cultured élite, and yet move among the city's marginals. In that, he was like other *flâneurs* who had made itinerants, street entertainers and bohemians into favored subjects since the 1840s. Along with Baudelaire, Duranty and the Goncourt brothers, Manet was a member of a fashionable artistic society; like them, he encountered street bohemians in real life and then inserted them into his art, that special realm where fiction and reality mingle in disconcerting ways.

Café and Brasserie

The café was the tangible meeting place of Parisian society, the place where the social day began for some, on their way to work, the place where the more fashionable people ended their day, at 2 or 3 a.m. Edward King, in his impressions of Paris published a year after the fair of 1867, insisted that "The huge Paris world centres twice, thrice daily; it is at the café; it gossips at the café; it intrigues at the café; it plots, it dreams, it suffers, it hopes, at the café."[15] Native Parisians agreed, and supplied the reasons. Alfred Delvau said that Parisians thrived on publicity, on "the street, the cabaret, the café, the restaurant, in order to show ourselves in good moments or bad, to chat, to be happy or unhappy, to satisfy all the needs of our vanity or our intellect, to laugh or to cry."[16] Parisians, in other words, elevated public life over the private, and for this they needed public spaces.

The café was an ideal social place because (to recall Georg Simmel's terms) it provided a solution to the problem of nearness and remoteness. The frustration of being constantly with strangers is mitigated because the café permits close proximity without prior acquaintance. Cafés are an accommodation to one's experience of society: one meets others in a place that offers parallels of private life—eating, drinking, resting—while it shelters these actions under the overarching social relationship. For a city marked by foreigners and recent arrivals, the neutral terrain of the café was especially valuable.

In cafés, natives and adoptive Parisians were able to observe life while displaying themselves as worthy performers in the spectacle of the capital's culture. For the writer-*flâneur* Delvau and the painter-*flâneur* Manet, the café was a source of art. There they reconnoitred their subjects and took advantage of fellow wits to hone the edges of their observations. By appearing in the right cafés, they added to their reputations as clever commentators and this, too, eventually gave them a helpful cachet among the cultured élite who were their associates and clients. In the 1860s Manet held forth at the Café Guerbois (in what is now the avenue de Clichy) in the company of Degas, Monet, Zola, Duranty, Zacharie Astruc, and others friendly to his causes. After the Commune, when he switched allegiance to the Nouvelle Athènes on the place Pigalle, a number of journalists and writers followed there, as well as Monet, Degas, Renoir, and, occasionally, Pissarro. Before we examine several paintings of the café, we must look briefly into the history of this lively institution.

Coffee reached Western Europe in the third quarter of the seventeenth century, brought by mariners who had acquired a taste for it in the Near East. It was first established in seaports, but spread rapidly to major cities inland. Considered a dangerous stimulant, it was closely monitored by municipal and royal authorities who licensed and taxed its use. They also worried about its association with those citizens who made the new coffee houses into social and political gathering places. Already in 1675, Charles II of England tried to close down the coffee houses as places of sedition (popular pressure made

him desist, however), and for the next two centuries they were frequently subjected to government surveillance and suppression.

In Paris, as elsewhere in Europe, coffee was served in restaurants (at first in specially designated sections) and in taverns, as well as in the new coffee houses. By the middle of the eighteenth century the café-tavern and café-restaurant were firmly embedded in Parisian social habits (Voltaire's favored Café Procope is still pointed out to tourists). Over the next hundred years they increased in both numbers and variety, covering the whole range, from dark, working-class establishments to brilliant, mirror-clad interiors along the most expensive boulevards. Because tobacco and alcohol, two more well-taxed commodities, were consumed in the cafés, and

66. Manet, *Woman Reading in a Café*, 1879. Art Institute of Chicago.

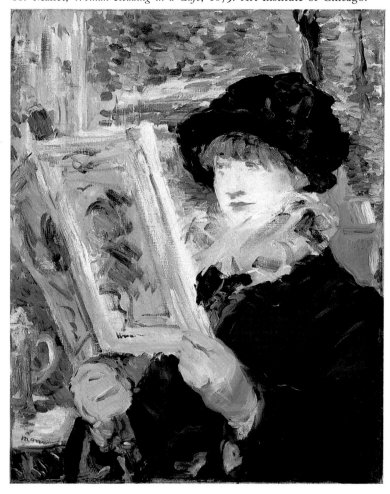

because a number of them became singing clubs, where could one find more logical places for police spies to thrive? Coffee, tobacco, alcohol, and song were regarded as attributes of political opposition, so one of Louis Napoleon's first decrees (29 December 1851) put cafés under direct governmental authority and placed an outright ban on group singing in cafés; thousands were closed down early in his reign.[17]

Despite police surveillance, cafés generally prospered during the Second Empire. They took on new forms that are familiar to us from the lives of famous writers and impressionist painters. Cafés and restaurants now pushed out onto the city's

sidewalks, encouraged by Haussmann's wider pavements; they were successful enough for their owners to be undismayed by the rental fees that they were obliged to pour into municipal coffers. For Paris of the 1860s and 1870s, characterized no longer by narrow streets but by wide avenues and spacious walkways, the sidewalk café was the perfect amenity. It served meals at all hours, it catered to the client who only wanted a beer or a coffee, and it provided a front seat for the theater of the streets. With both interior spaces and outdoor terrace, it was an irresistible lure for shoppers, tourists, and those who worked nearby. In 1876, Henry James marveled that to enjoy the evening out of doors in Paris one was not obliged to sit on stoop or curb, as in New York, but could instead choose a seat at one of the sidewalk cafés: "The boulevards are a long chain of cafés, each one with its little promontory of chairs and tables projecting into the sea of asphalt."[18] Thanks to Haussmann's vast extension of gaslight, which facilitiated nighttime shopping, the sidewalk cafés enjoyed evening hours and contributed to the sights and sounds of the nocturnal promenade. We have seen one such cafe already, in Degas's *Women on a Café Terrace, Evening* (Pl. 47).

By Degas's and Manet's day, many of these emporia were called "brasseries," since they featured beer (the term derives from copper brewing vats). Beer had not been a prominent drink in Paris before 1848, for Parisians associated it with peasants and small-town folk. This became a positive factor, however, when enthusiasm for the common man developed in the wake of the revolution of 1848. The provincials who flocked to Paris in the Second Empire brought with them their taste for beer, and so did the greatly increased number of foreign visitors, especially those from the Lowlands, Germany, and Great Britain. Many traditionalists lamented the newly won prominence of beer, considered a provincial and foreign habit when compared to wine. Marc Constantin was one of these, and in 1872, in the last sentence of his history of the café, he expressed the hope that the brasserie would disappear, "and no longer in the capital of the civilized world will we see the ignoble beer mug replacing the divine wine bottle."[19]

Manet was no traditionalist and one sign of his being up-to-date is the beer which he featured in several of his café pictures (Pls. 66, 70, 77, 78). They attest to his whole-hearted plunge into contemporary Parisian society (consider that *Between two bock beers* was the title of a topical review in 1877).[20] Paintings of the previous decade like *The Old Musician* (Pl. 65) and *The Ragpicker* (Pl. 64), with their earthy tones and posed figures, belong as much to the mid-century as to Impressionism. It is true that Manet's later café pictures are also posed, that they were indeed painted in the studio, and that they have many forebears among the taverns and cafés of seventeenth-century painting. All of this is well disguised, however, and they give the appearance of freshly observed works. It is this immediacy which rewards examination.

Woman Reading in a Café (Pl. 66) is the sketchiest and simplest of Manet's café pictures, but no less revealing for that. The beer mug is the emblem of the brasserie, and the foliage beyond suggests one of those cafés that had a flowered terrace or courtyard (compare Pl. 67). The woman is in stylish dress, and holds in her gloved hands an illustrated journal on a baton, the kind one takes from a rack in the café. Such jour-

nals had grown mightily in the 1860s and 1870s, and they are closely attached to Impressionism.[21] They published *flâneurs'* accounts of current life, articles and advertisements devoted to the latest fashions, and illustrations and caricatures whose subjects and whose very form—quick and summary—have obvious parallels with the painters' art. Dominated by pictures, they could be quickly skimmed, unlike traditional "serious" journals with their wordy pages. A few of Manet's drawings were reproduced in one of these journals, *La Vie moderne*, and several of the impressionists showed works in the exhibition rooms attached to the *grand boulevard* offices of this friendly review, founded in 1879 by Renoir's patrons, the Charpentiers.[22] *Woman Reading in a Café* was one of several works Manet showed there in 1880. Because journalists and painters met in cafés, and because some reviews were virtually edited in cafés (a few were actually published by such cafés-concerts as the Divan Japonais), Manet's picture is a veritable homage to his own circle.

This homage is not limited to the picture's content, for his painterly shorthand is equally calculated to stir his friends' admiration. His *bravura* declares his intention of getting away with as showy a treatment as possible. Against the dark tones of the woman's hat and clothing (the composition's anchor) he plays the wavy flashes of grey and blueish white of her tulle collar, the crab-like curves of her tan gloves, and the rectilinear streaks of the journal, composed of delicate greys formed of lavender, blue and other tones mixed with white. The picture on the cover of the journal and the foliage to the rear are so

67. Manet, *Chez le Père Lathuille*, 1879. Tournai, Musée des Beaux-Arts.

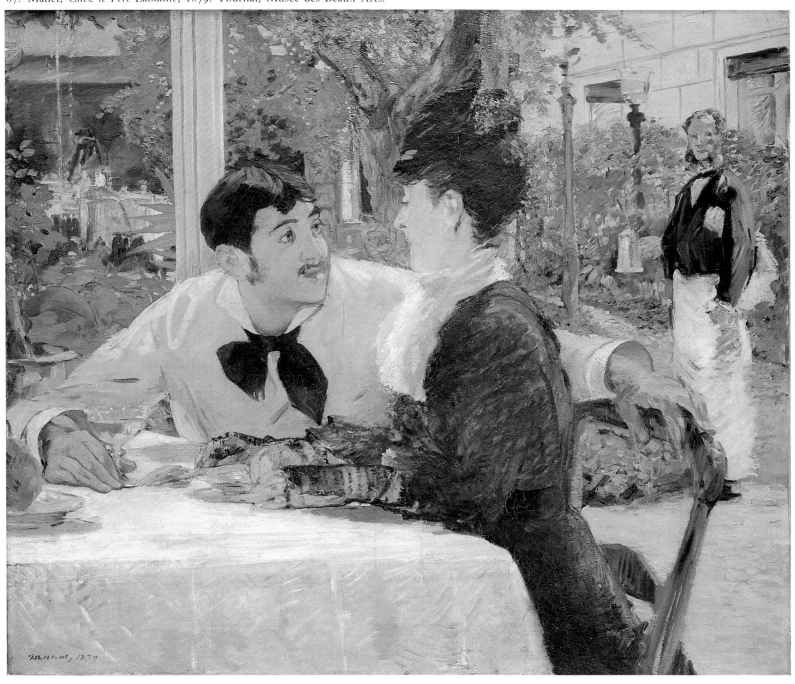

indistinct that they have a precarious fictional life, more color and brushwork than image. All this tentativeness suits the subject admirably. It is a small occasion, but one that is perfectly typical of this glittering city, simply an elegant woman's pause for a beer and a glance at a journal.

Chez le Père Lathuille (Pl. 67) is a larger and more complicated picture. After years of confronting offical art circles Manet was now somewhat less of an *enfant terrible*, and his canvas was accepted for the official Salon of 1880. The greens and reds of foliage are about as indistinct as those of *Woman Reading in a Café*, but here they are massed in suitable areas and hence are more easily read. Manet places us in the garden terrace of a famous café-restaurant in the Batignolles district, not far from the Café Guerbois and the Nouvelle Athènes. Père Lathuille was already well known at the beginning of the century; it appears in the background of Horace Vernet's

68. *An Arbor at Père Lathuille*, 1852.

painting of 1820, *The Battle of Clichy*. In 1852, the restaurant was illustrated in Edmond Texier's *Tableau de Paris* (Pl. 68), where it represented the pleasures of an excursion to a "guinguette," a freer, countrified place beyond the city's limits. In 1862, when Manet painted *The Old Musician* (Pl. 65), this region had just been annexed and was undergoing its Haussmannization. By 1879, broad streets and commercial prosperity ran over its leveled hills and through its demolished village streets. Manet continued to favor the Batignolles and his painting preserves something of the old traditions: the illustration in Texier's book shows a young woman on the lap of a man, in the midst of a wine-drinking party (the "divine wine bottle" still had pride of place in 1853!), arched over by a bower of foliage.

The pair in *Chez le Père Lathuille* have been described as "lovers,"[23] but this is not so. Manet's vignette of Batignolles life is more subtle than that, and careful observation discloses the particular adventure that is taking place here on the edge of the city. The waiter is holding a coffee urn, doubtless wondering if it is time to serve coffee to this table. He would wish to do so, because the woman is his last customer—at least the tables beyond the glass partition are empty. Of course, he would serve coffee only at the end of the meal. On the table, in effect, we see the last course. The woman holds a broad-

bladed fruit knife in her right hand, and on the plate between her hands is a rounded fruit. The waiter is therefore right: she should soon finish her fruit and be ready for coffee. By now we have noticed that there is only one place setting; the man has none. The wine glass he touches is not his, it is the woman's, white wine to go with her fruit. He fondles *her* glass, the familiar gesture by which a man encroaches on a woman's terrain. His right arm rests on the back of her chair, another territorial manoeuvre. As for her, she has leaned forward and avoids his touch, her back very erect. In truth, her whole body is proper and stiff, her gloved arms forward in sphinx-like rectitude. Will she succumb to his blandishments?

The fact is that the young man did not come to this restaurant with her. Not only does he lack a meal, he lacks a chair. Unless we were to grant him peculiar simian proportions and a stool, we have to conclude that he is squatting down

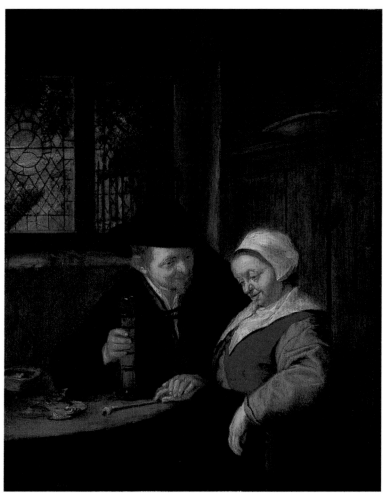

69. A. van Ostade, *Peasant Couple*, 1653. London, National Gallery.

next to her. In the American vernacular, he is putting the make on her. She is a well-got-up woman dining alone, and he is a young artist or fashionable bohemian on the lookout for a conquest. The model was Louis Gauthier-Lathuille, the son of the proprietor of Père Lathuille whom Manet encountered while he was on military leave, and whom he first painted in uniform.[24] Manet then thought better of it and gave him his own artist's smock. The woman was first posed by the actress Ellen Andrée, and then by Judith French, a cousin of Offen-

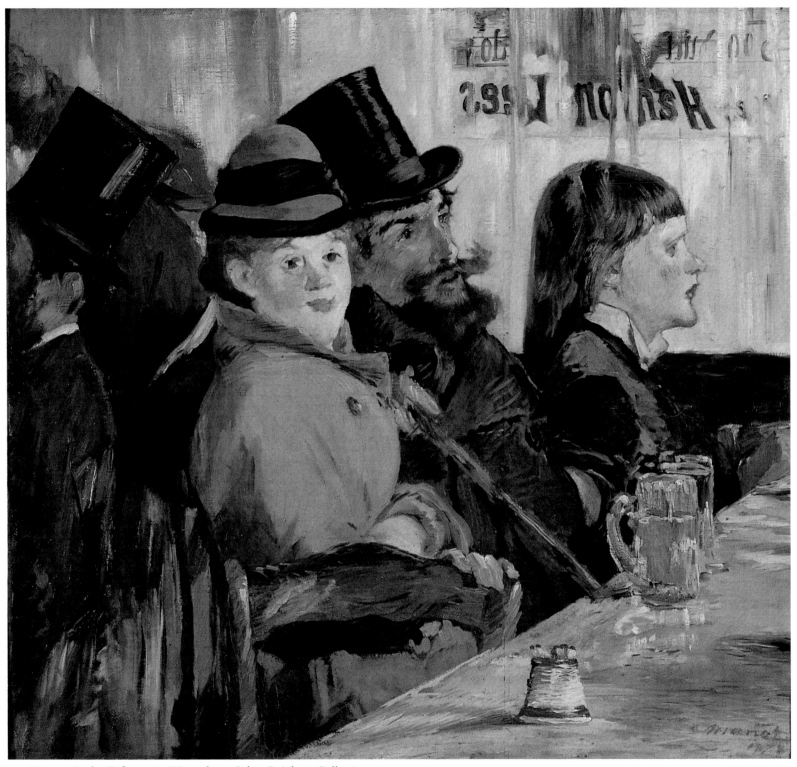

70. Manet, *At the Café*, 1878. Winterthur, Oskar Reinhart Collection.

bach. The composition is consequently an artful concoction in which Manet used familiar Parisians to create one of the many encounters between strangers that people his art. Contemporary novels and operettas are rich in similar cases in which a younger man seeks the favors of an older woman whom he finds alone in café or theater. We do not, therefore, deal with "lovers," but with a more equivocal relationship that characterizes urban encounters.

The subtlety of Manet's conception becomes apparent when his picture is put alongside one by Ostade (Pl. 69) that shows a peasant couple, evidently a brothel scene. The chances are that Manet was consciously restating in modern terms the theme of courtship and seduction found in many Dutch paintings of the seventeenth century. In the Ostade, the woman is being coy enough to hold back a little, but she permits the man's hand to lie atop hers, and we do not really doubt the outcome. Besides, the man is larger than she and dominates her, whereas Manet's young man is in the position of a supplicant.

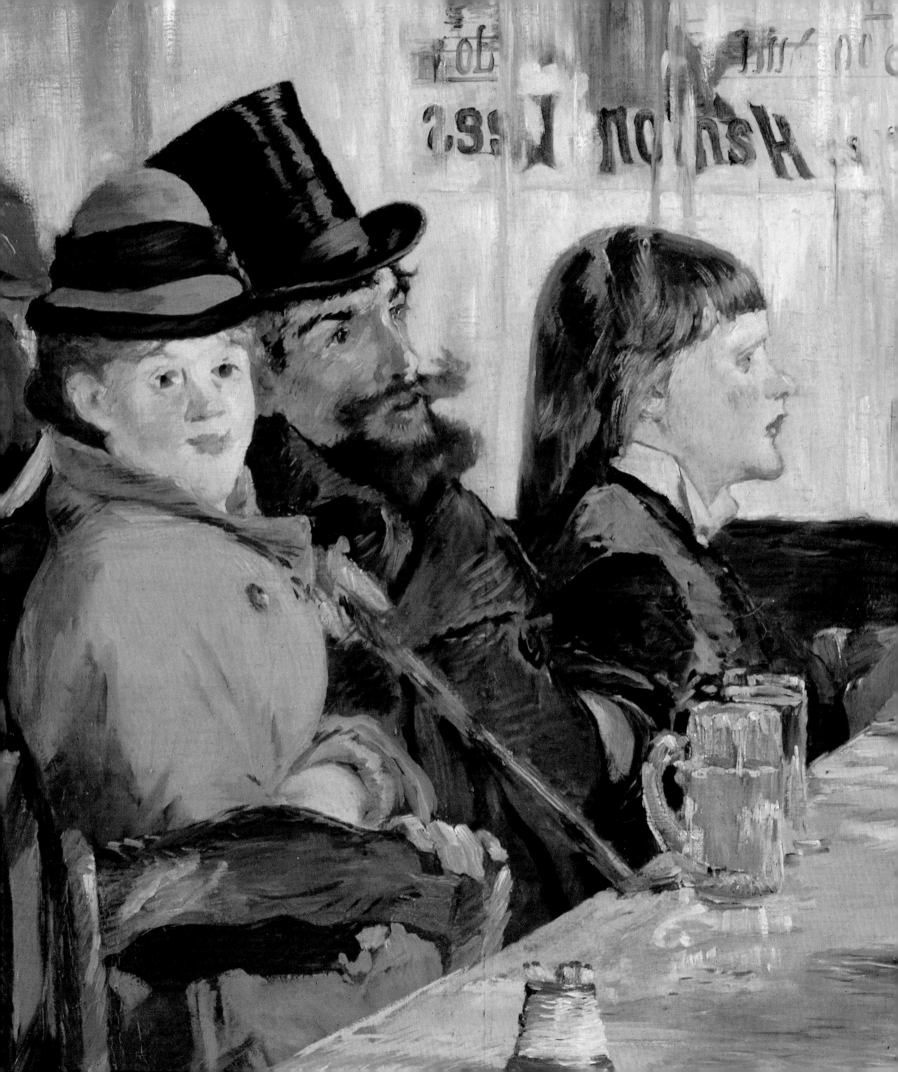

Manet was equally subtle when he dealt with another kind of relationship in *At the Café* (Pl. 70). Here we are indoors in a thoroughly urban setting, not in a *guinguette*. A man is cut off at the left, a waitress bends over behind him, and a woman's reddish-brown hat shows over her shoulder: fragments of a crowded interior. A young bourgeoise (posed by Ellen Andrée) looks over at us with an ambiguous, possibly bemused expression. Her right hand touches the back of the chair turned towards us, a gesture we can interpret as protecting it against another's use or, alternatively, as a delicate invitation to come and sit. In front of her is a partly quaffed stein of lager, in connubial propinquity with a bock beer. That must be her husband next to her, because his forearm is leaning on her shoulder. Yes, it is definitely her husband (posed by the engraver Henri Guérard), because the hand that is supported by her shoulder is tapping the stick against the edge of the table, to emphasize what he is saying. His half-open mouth shows that he is apostrophizing the air, as husbands are apt to do; his left hand, thrust into his coat, completes the orator's pose. Given this, his wife looks at us as much as to say: "Isn't that just like a husband, prattling away and nobody listening!"

Surely the girl to the right is not listening (Pl. 71)? She sits with gloved hands perched on the edge of the table, as detached from the others as the lid of a canopic urn from its

72. Renoir, *The Little Café*, c. 1877. Otterlo, Rijksmuseum Kröller-Müller.

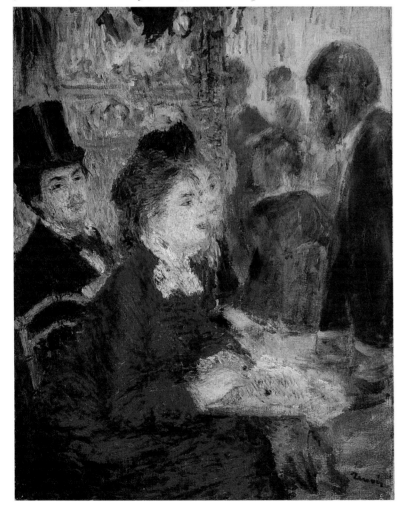

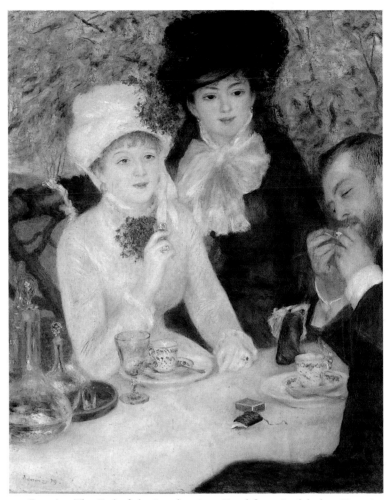

73. Renoir, *The End of the Lunch*, 1879. Frankfurt, Stadelsches Kunstinstitut.

body. Her rather large head is in rigid profile and set against the window as though in a separate frame. She is probably the child of the central couple, at least it is easier to assume so than to believe she came alone. Like many adolescents, she is with her parents, yet not with them. The backward letters of the poster behind the lace curtain, like those of the cubist pictures that this painting looks forward to, seem to hint of things that separate out from their customary unity. They help pull the girl away from her parents towards the outside, as though they could voice the unstated thoughts of her mind.

Given his *flâneur*'s detachment, Manet does not interpose his own ideas, but in fact he has shrewdly placed in front of us a wry commentary upon marriage and the bourgeois family. The three figures are side by side, and yet in separate psychological worlds. This is surely a delicate prying at the bonds that are supposed to unite them, but a prying nonetheless. Manet is the alert observer of new urban truths; he usually abstains from showing us loving couples or families.

The opposite view is taken by Renoir, whose café pictures remain faithful to his insistence upon a perfect human and social harmony. In the tiny picture appropriately called *The Little Café* (Pl. 72), he places two beautiful young women at a table between two admiring men. It seems like one of the casual encounters fostered by the Parisian café. The man on the left is at a nearby table and merely looks over at the women. The other man leans on the table, fists bent under,

while talking with them. This is perhaps the beginning of a foursome but Renoir, also a naturalist, leaves it at that.

We face a more confirmed grouping in *The End of the Lunch* (Pl. 73). In the garden of a Montmartre café[25] a woman (posed by the ubiquitous Ellen Andrée) holds her liqueur glass and gazes at her dinner companion as he lights a cigarette. An acquaintance has come over and joins the seated woman in admiring the man. And "admiring" is the right word. Although the man fills in only a narrow angle of the canvas, he anchors the triangle of human heads. The women dominate the composition and are to be esteemed for their beauty, but they are there to serve male interest. Renoir's conservatism shows in another way: in each of his pictures, unlike Manet's *At the Café*, the figures on the edges of the composition face inwards to establish an old-fashioned pictorial balance.

Unlike Manet, therefore, Renoir recreated in painting the loving, male-oriented relationships that he aspired to, for himself and for society. His letters, his essays, and the aphorisms that his son published[26] disclose his fears of modern industrial society with its forces for disintegration, and show his determination to express ideals of social accord by way of craftmanship placed at the service of beauty. In many ways admirable, this outlook lacks the penetration of Manet, for whom the café was a microcosm of urban truths that had to be stared in the face.

Brandy and Absinthe

With Manet's *The Plum* (Pl. 75), we shift from the wry amusement of *Chez le Père Lathuille* and *At the Café* to a picture that has a more perceptible emotional edge. A young woman, neatly though not elegantly dressed, sits at a café table. In front of her is the brandy plum of the title, long a Parisian specialty, and in her left hand she holds an unlit cigarette. Her other hand supports her head in the traditional gesture of pensiveness, helping create a mood far from the celebratory one of Renoir's *End of the Lunch*. Is she waiting for someone to give her a light? We notice also that she has no spoon. Perhaps she is reflecting for a moment while awaiting the spoon? Manet's anecdote may be no more complicated than that. He may have stored up a real observation of the sort and subsequently made it the basis of his picture.

However, the effect of pensiveness, tinged with melancholy, that emanates from this painting cannot be explained by unlit cigarette and unspooned plum. There is much more here, for despite Manet's detachment, despite his figure's expressionless face, a sense of aloneness pervades our experience of the painting. We are caught in Georg Simmel's dilemma of nearness and remoteness as we try to sort out our feelings. The angle of the table tells us that we are either standing or seated near this stranger; because we see underneath the table, we find that we are close enough to sense a slight discomfort. Nevertheless, we are not able to make psychological contact with the woman, hence our conclusion that she is not just alone, but lonely. She is one of the many figures by Manet or by Degas who, regardless of the absence of emotional display, convince us of the poignancy of contact with urban strangers: Manet's *Street Singer* (Pl. 38), Degas's *Woman with Chrysanthemums* (Pl. 59) and *The Loge* (Pl. 60).

The devices Manet uses to work on our perceptions are clever despite their apparent innocence. The bare table—contrast it with Renoir's—denies the woman any comfort, and because it floats, supported only by one iron leg, it adds an element of tentativeness. Its forceful effect becomes more evident when we compare it to the draped table in *Paris, Au Restaurant le Doyen* (Pl. 74) by his friend Ernest Ange Duez.[27] Duez's table is an important prop on his busy stage, but its actual rendering does not take on a vital role. He has told us all too much. We are supposed to be concerned about this lone woman, but she is hardly by herself. Eleven persons accompany her, including the men to the right whose crudely told curiosity spoils what chances the painting might have had. Manet is much more the picture-maker than Duez. Instead of giving a stage to his figure, he hems her in by that network of rectangles which compress the space and create a sensation of confinement. Her head is further bounded by the repetition of the picture's frame in the gold casing around the metal grill behind her.[28]

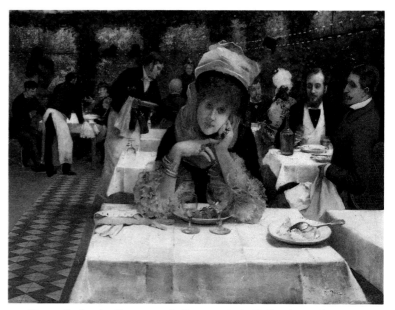

74. Duez, *Paris, Au Restaurant le Doyen*, 1878. Collection unknown.

To many modern observers, Manet's figure represents a specific type, namely a prostitute.[29] This is an assumption based on the fact that contemporaries frequently refer to prostitutes seated alone in a café, looking for a client. Manet represented high-class courtesans, it is true (*Nana*, Pl. 116), and surely encountered prostitutes among the street bohemians he knew so well. It is also true that the woman's cigarette marks her as a liberated spirit, since "respectable" women refrained from smoking alone in cafés. However, her costume is not that of a cruising prostitute (compare her with Degas's *Women on a Café Terrace, Evening*, Pl. 47) and is of the kind worn by shop attendants, milliners' apprentices, or florists, young city women who did smoke in public. Some of these women, underpaid and frequently out of work, were obliged to turn to occasional prostitution, but their exteriors would not suffice to reveal this. Manet has avoided the conventional signs of a prostitute (provocative costume, pose, gesture, or glance), and

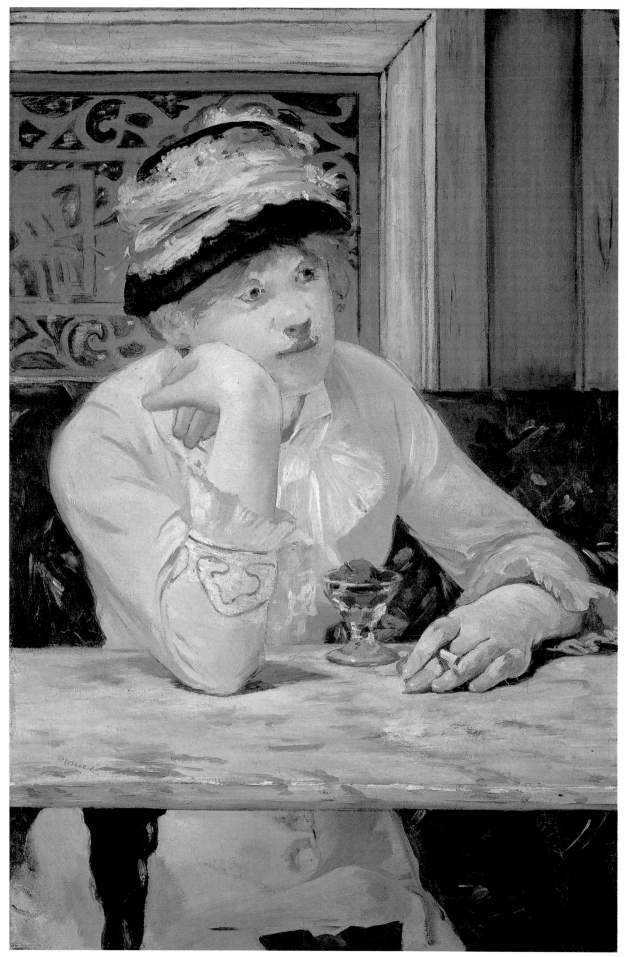

75. Manet, *The Plum*, c. 1878. Washington, National Gallery.

all that we can be sure of is that we face one of the many single women who staffed Parisian commerce, one of those whose aspirations to glorious careers were so frequently checked by reality.

A momentary check, a pause in life, a bit of loneliness, this is the mood that Manet creates. How different is the down-and-out woman in Degas's *Absinthe* (Pl. 76)! Shoulders slumped, eyes cast down, feet splayed out, her costume frowzy, she is the café habituée rooted to her seat, without aspirations. She will derive little comfort from the man next to her, the kind of elbow-leaner who will remain there for hours, eventually shuffling off to an uncertain destination. This is one of Degas's most devastating images of public life. The drink in front of the woman is readily identified as absinthe, thanks to its pale, greenish color and the nearby carafe of water. As for the man's drink, it was recognized by the Scottish owner of the picture, familiar with Paris, as a "mazagran," cold black coffee and seltzer water in a glass.[30] A mazagran commonly served as a hangover remedy, and, since absinthe was taken by its votaries at all hours, we are entitled to view the scene as taking place in the morning. This suits the grey light which floods in through the lace-curtain windows reflected in the mirror behind the pair. Whether early morning or later in the day, the scene deserves the phrase used by Walter Crane when he saw it in 1893, "a study of human degradation, male and female."[31]

The French did not regard absinthe at all like the "hygienic beverages" (wine and beer) that we have seen in Manet's and Renoir's paintings. The assumption of its addictive and dangerous qualities may have contributed to the Salon jury's rejection of Manet's *Absinthe Drinker* of 1859 (the one whose figure returned three years later in *The Old Musician*, Pl. 65). "For this is a terrible and frightening drink, this absinthe," wrote Alfred Delvau in 1862 (and he was no prude):

The drunkenness it gives doesn't resemble any known drunkenness. It is not the heavy drunkenness of beer, the fierce drunkenness of brandy, the jovial drunkenness of wine. No, it makes you lose your footing right away....It sticks immense wings on your shoulders and you leave for a country without horizon and without frontier, but also, without poetry and without sun. You think you are headed towards infinity, like all great dreamers, and you are only headed towards incoherence....[32]

Absinthe had been a working-class drink at the beginning of the nineteenth century, but with the advent of the Second Empire it suddenly took on immense popularity. Like beer, it rode the crest of the ever-wider wave of alcohol that flowed through the expanding population of the capital. Entrepreneurs took over the original recipes, putting in only a trace of wormwood (the supposedly dangerous, Baudelairean ingredient that was its attraction) or none at all, adding hyssop, mint, and anise for color and flavor. It was the perfect example of Second Empire capitalism, a mass-produced, commercial, and rather fraudulent concoction taken over from *le peuple*, creating money for its suppliers and for café proprietors, while inducing both gaiety and despair in its users. By the end of the century its consumption by volume (130,000 hectoliters) far exceeded that of all liqueurs combined (82,000 hectoliters).

When Marie Corelli published a novel in 1890 that attacked Parisian vice and decadence, she chose *Wormwood* for its title, certain that the notoriety of the drink would be an immediate signal of her theme.

As for Degas's painting, it was done at a time when absinthe was a favorite target of France's temperance movement. Furthermore, Degas placed it in front of a woman, and women's drinking had become a volatile subject by 1876. Seven years earlier, the Goncourt brothers had published *Germinie Lacerteux*, a novel which horrified many because it chronicled the decline of a Parisian maid into alcoholism. Then, in the spring of 1876, Zola began the serial publication of *L'Assommoir*, a scandalous novel which told of a laundress's sliding into alcoholism; it dealt also with working-class drinking and with prostitution (Nana, the laundress's daughter). Moreover, working-class drinking had been roundly attacked since 1871 because it was convenient for the conservatives who stocked the temperance movement to believe that the horrors of the Commune were due in part to excessive drink among Parisian workers. These included the fabled *pétroleuses*, women accused of setting the fires that had ravaged the city. The communards were called "apostles of absinthe,"[33] and in the early 1870s a broad campaign was launched against public drunkenness. One of Zola's grandest efforts was to expose this campaign as a hypocritical attempt to control working-class cabarets, while leaving untouched the drinking that went on in high-class places.

Degas's painting, therefore, joined the naturalist current led by Zola and the Goncourts. And like his literary associates, he presented his ugly story with apparent detachment, all the while using his art to engage our emotions. It is his curious construction of space that draws us into his picture and eventually obliges us to address his issue (the perfect cynic, he exposes the issue but refuses to take a stand). Unlike Duez (Pl. 74), who creates the familiar stage in front of which we can walk back and forth, Degas fashions a space which requires our involvement. In the foreground is a table with a match container and a newspaper on a baton. A folded newspaper forms a bridge to the next table, beyond which we find the sodden pair. They show no interest in reading, nor in one another. As for us, we realize we have to be seated behind that foreground table and are therefore near that couple, staring at them, although psychologically remote from them. We confront them with peculiar directness, because our eye flashes over the table tops, a passage made the swifter because Degas omitted all supports for them (careful examination of the original shows no hint of table legs). By making the marble tops hover in mid-air (the contrast with Duez is striking), by placing his two figures on the far side of a spatial hole, and by forcing us into close participation, he has created a dynamic space, an unstable and tentative one. His detachment is only a clever facade: he has manipulated us with the devices of his art.

Once we allow ourselves to play Degas's visual game, we are caught between fiction and reality (for our own psychological reactions are real). So, too, was Degas, the artist who constantly made art out of his surroundings and who signed his name, that of the artist-reporter, along the axis of the newspaper in his picture. Degas's actual models were also suspended somewhere between image and real life. They are

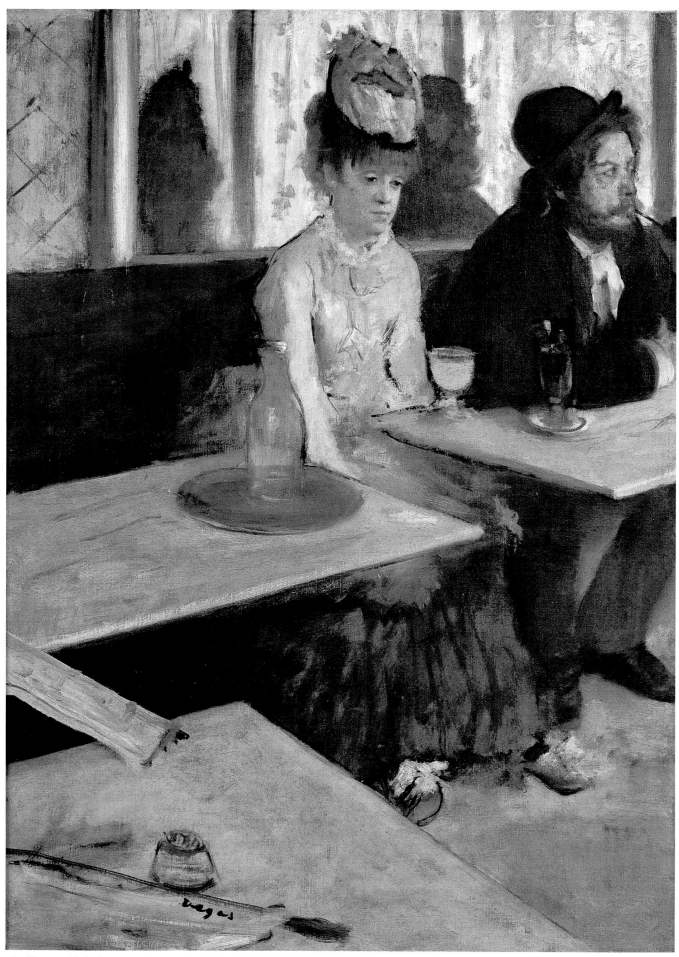

76. Degas, *Absinthe*, 1876. Musée d'Orsay.

the now-familiar actress and model Ellen Andrée and the bohemian artist Marcellin Desboutin. Both were in the impressionists' orbit, friends of Zola and Duranty as well as of the painters. Manet had painted Desboutin in 1875 as the bohemian artist, and he and Renoir painted Andrée as a respectable café client (Pls. 67, 70, 73). Since they frequented the same cafés as the impressionists, their appearance on Degas's canvas brings fiction rather close to reality, although Degas toyed with them by lowering their bohemian level to sordid depths.

Café-Concert and Music Hall: Women who Serve

The somber mood of Degas's *Absinthe* is a rarity among impressionist pictures, but it is consistent with the penetration with which he and Manet portrayed café life. The same penetration shows in their representations of the kind of café that, like the brasserie, found special fortune in their generation, the café-concert. In the next section of this chapter, Degas's portrayals of café performers will be discussed, and at that time this popular Parisian institution will be described. Meanwhile, to introduce Manet, who gave performers only a marginal presence in his major renderings of the café-concert, it need only be said that this kind of café had a stage on which singers, acrobats, comedians, musical groups, and vaudevillians took their turns amusing the clients. Many indoor cafés-concerts had rather small stages, but new ones were built in the 1860s and 1870s with huge stages, rather like music halls. Outdoor cafés-concerts used covered pavilions fronting on fenced-off areas where the clients sat. Both indoor and outdoor types charged extra for the entertainment, either by elevating the prices of their drinks, or by levying an entry fee or seat charge.

Manet represented outdoor performers only a few times, in modest works that are overshadowed by his pictures of waitresses and clients in indoor cafés-concerts. For *Corner in a Café-Concert* (Pl. 77), Manet asked a waitress whom he admired to pose for him in his studio and she agreed on condition that her boyfriend accompany her. It is he whom Manet placed in the foreground, with his worker's smock, cap, and clay pipe. (The purplish tones of his drink suggest wine, the traditional drink of the Parisian worker.) His solidly planted form anchors the whole composition.[34] Beyond him sits a man, shown wittily by his grey hat, and further along is a woman in lost profile. This sequence of heads gives some depth to the composition, but serves chiefly to help induce our perception of a crowded scene. The stage is relegated to the rear, where we see a dancer or singer; to the left and right are musicians indicated by fragmentary profiles and portions of trombone, violin bow, and bass.

From the compact group of heads and hats in the foreground rises the brightly lit face of the waitress. Her head caps a substantial pyramid formed with the other heads and, lower down, her clutch of beer balances the raised hand of the worker. These symmetries hold the picture together, but they are inherently unstable. The waitress leans in towards the left to deposit a beer, but she looks off to the right: her professional eye is on the lookout for another client's signal. Manet therefore characterizes her craft by showing her movements,

which contrast with the placid bulk of the blue-frocked worker.

In the smaller *Café-Concert* (Pl. 78), Manet also typifies the busy life of a café-concert by combining a solid pictorial form with forces that threaten to break it apart. The three principal figures form a triangle, but they look in different directions and exist in three separate psychological realms. The waitress is taking advantage of a calm moment to have her own beer. She stands confidently, hand on hip, while looking off to the left. She belongs in this place and her assurance lets her dominate it. The woman in the foreground is in a pensive mood and sits in a drooping position. Like the figure in *The Plum* (Pl. 75), she is not a proper bourgeoise, for she is smoking, the mark of the liberated women of uncertain status who now frequented cafés. She has only recently sat down, for her cigarette is newly lit and her beer is hardly tasted. In front of her is a package in shiny blue paper, either a pastry or a sweet, a sign that she has dropped in while on her way somewhere else.

In contrast to this wistful figure, the top-hatted male seems entirely at his ease. Hands over his cane, head erect, he looks at the performer on the stage, whom we see reflected in the mirror in the upper left. His costume is a bit eccentric and, like his cut of beard, harks back to the Second Empire. He might be a Bonapartist (he recalls Daumier's invented figure *Ratapoil*) or an actor who affects such clothing.[35] He stands for the whole class of artists, actors, dandies, and entertainers, urban adventurers who belonged in these settings. With the cool detachment of the *flâneur*, he could move freely in such public places, treating them as stages for self-display. He shares a sense of self-confidence with the worker in *Corner in a Café-Concert*, despite their differences. This is because men could patronize cafés without the ambiguity or insecurity attaching to unaccompanied women, who ran the risk of attracting admirers whether they wished to or not. The contrast of the two men in Manet's pair of café-concert pictures with the female clients in *The Plum* and *Café-Concert* shows how observant Manet really was (as well as how readily he identified with such self-possessed males).

Manet's two pictures also show why the Parisian café-concert was such an ideal mixing place. Strangers who would not associate out on the street could here sit side by side. By giving only minor place to the performance (more sketchily painted, as though partly out of focus), Manet reminds us that singers or comedians were intended principally to draw customers for drink; the real business of the café-concert takes place in the foreground of his compositions. Patrons could keep to themselves or tide over fragmentary conversations by listening to the performance. Seated individually at tables in these smaller cafés-concerts, and not in the fixed seats of a music hall or theater, they could move about if they wished. Manet shows the casualness of these social juxtapositions, and yet he hints more at separateness than at conviviality. The glitter and attraction of the cafés are captured in the brilliance of his color and brushwork, but his figures do not communicate with one another.

Clients are only temporary visitors, but the waitresses belong there, and Manet's two pictures are virtual celebrations of their roles. Café waitresses were greeted in Manet's generation

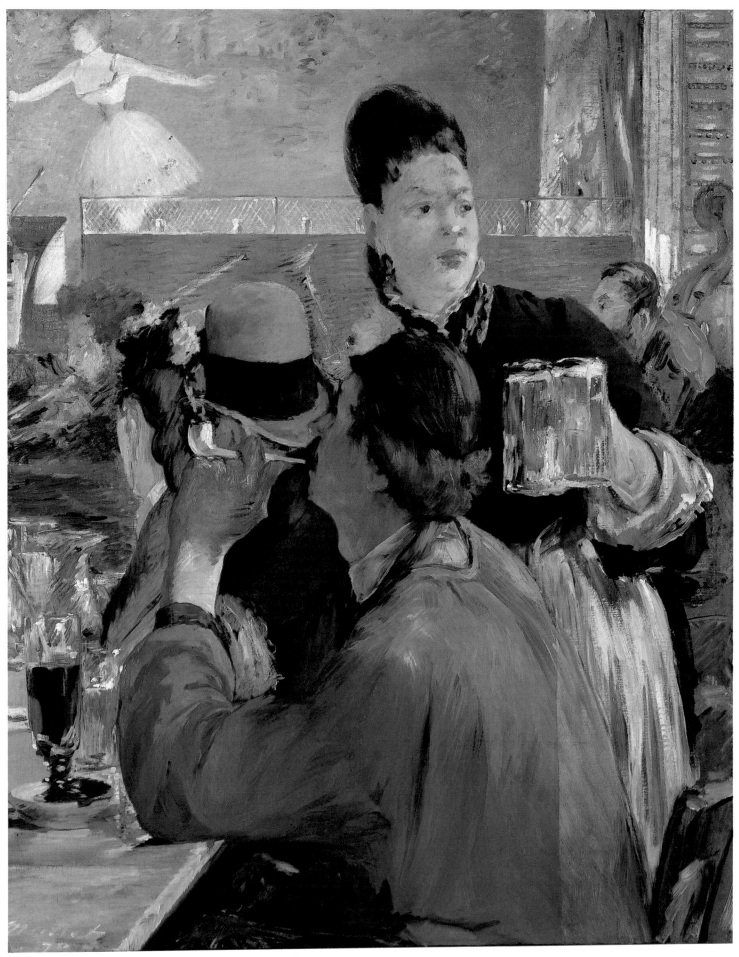

77. Manet, *Corner in a Café-Concert*, 1878–79. London, National Gallery.

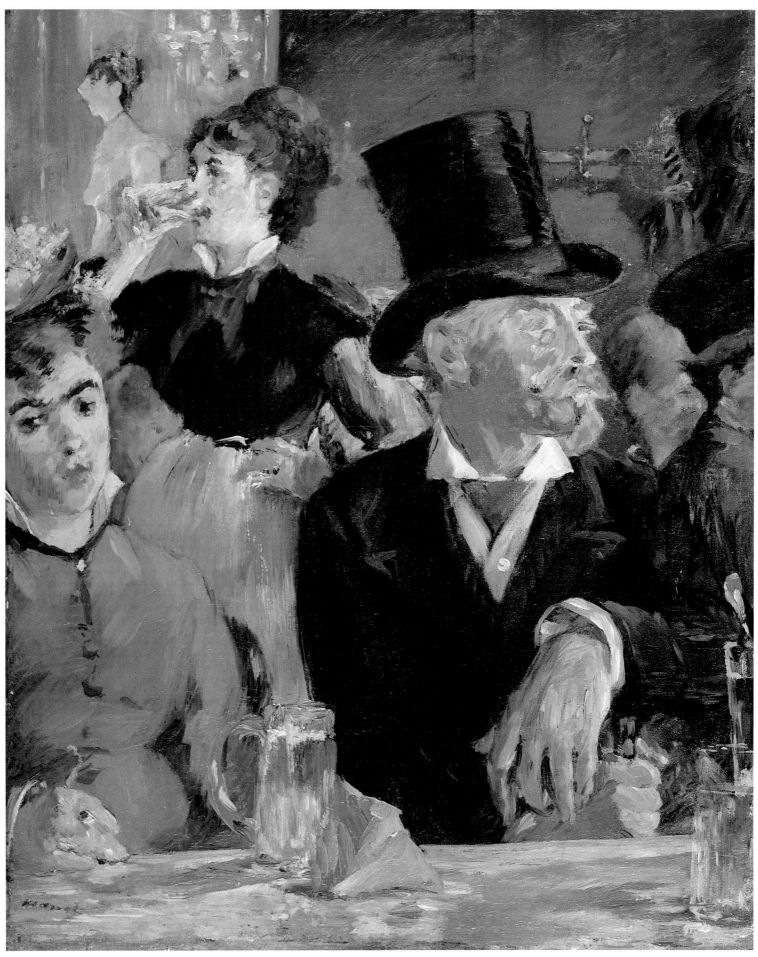

78. Manet, *Café-Concert*, 1878. Baltimore, Walters Art Gallery.

as typifying the new Paris. Before the Second Empire, ambulatory café service had been provided largely by men (women were frequently behind the counter), but the entrepreneurs of the rapidly spreading brasseries and cafés-concerts quickly learned that young women increased the sales of drinks. In the 1860s the Parisian café waitress became a stock figure in cartoons and illustrations. Like other young working women, she was often the prey of males and assumed to be "available." Some were, of course, because the open society of cafés made them ideal market places for sex, as well as for other kinds of business (salesman and brokers cultivated clients there). The thronging population of Paris, which included so many single men and women, fostered the rise of clandestine prostitution, as distinct from that regulated by government. It is not surprising that *brasseries à femmes* came into existence, establishments in which waitresses used their jobs as covers for prostitution.[36] Men might have felt free to regard waitresses like Manet's as fair game, but Manet, who invented every stroke of their forms, held them aloof from any of the by-play with male clients favored by contemporary illustrators. In these arenas of drink, music, and leisure, it is they and the distant performers who embody work; Manet gives them dignity.[37]

The woman facing us behind her counter in Manet's *Bar at the Folies-Bergère* (Pl. 80) is a more ambiguous figure. The curious reflections in the mirror to the right provoke the issue of male-female commerce, but the picture as a whole does not resolve it. Like the waitresses, this woman is a *verseuse*, a server of drinks, but she does not move about. The stationary bar to which she is so firmly fixed suggests an environment different from the cafés-concerts we have just looked at, and indeed it was. The Folies-Bergère was more a music hall than café-concert, and its history has to be consulted if we are to make sense of Manet's canvas. Shown in the Salon of 1882, it is the last ambitious picture he exhibited before his early death the following year, and his last major statement on the public places of *Paris-spectacle*.

The Folies-Bergère (near the rue Bergère) owes the first half of its name to the eighteenth-century "folie," an open-air place where Parisians could drink or dance while being entertained. Its evolution is another capsule history of Second Empire speculation.[38] It began as a department store devoted to bedding, opened in 1860, one of the newer urban forms of commerce. Perhaps because of its favorable location on the rue Richer, just above the *grands boulevards*, it added a "salle des spectacles" to the rear of the store in 1863. This was so successful—active leisure being more lucrative than passive—that in 1869 the whole enterprise shifted to variety shows in emulation of London music halls. In November 1871, the talented entrepreneur Léon Sari took it over. He remodeled it inside and out, refurbishing two large spaces. One was the "Garden," an impressive hall with balconies (covered by an awning until it was roofed over in 1925).[39] The other, where Manet places us, was the horseshoe-shaped theater with fixed seats in the orchestra and a balcony above, supported on columns (two of them show in Manet's mirror, near the reflected marble counter). Sari removed the seats on the ground floor under the balcony to make room for tables, chairs, several bars, and space for walking about (the *promenoir*). In the balcony he limited the boxes to two front tiers and left room for another promenade behind them. We are on this level in Manet's picture, facing one of the mirrors which clad the perimeter wall (they show clearly in Chéret's poster, Pl. 79), in front of which the woman tends her counter. The mirror reflects the balcony on the opposite side.

Sari learned that he could make more money than would the usual café-concert if he combined its freedom of movement with some of the features of a theater. He could charge admission, and extra for seats in the orchestra and the balcony loges. In addition, he could earn money from the alcohol sold on both floors. Some clients would come for the spectacles, which were on a grander scale than a café-concert: circuses (with animals), acrobats, whole operettas, ballets, troupes of comedians, etc. Others came principally to socialize, and could ignore the stage presentation while chatting and drinking along the promenades. There was precedent for this in the ordinary café-concert, such as the one Degas shows in *Café-Concert (Spectators)* (Pl. 89), where there are rows of bench seats facing the stage, and tables and chairs along the rear and sides. Closer to Sari's ambitions were the "cafés-spectacles" of the 1830s and 1840s,[40] and the huge Ba-ta-clan, named after one of Offenbach's operettas, a café-concert rebuilt in 1863. Sari surpassed them by offering more spectacular entertainment and better-appointed promenades. He had his

79. Chéret, *Aux Folies-Bergère*, 1875. Paris, Musée de la Publicité.

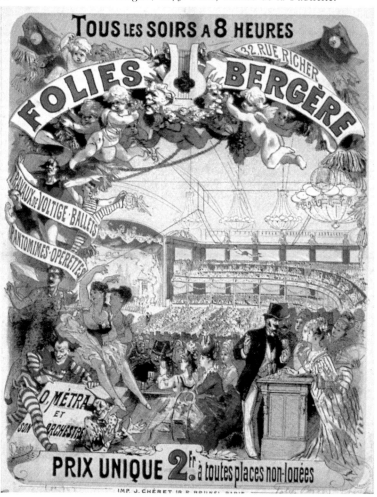

own orchestra and dance troupe, but also booked the reigning favorites among vaudeville, circus, and other diversions, including the Hanlon Lees, American trapeze performers whose poster shows in the window of Manet's *At the Café* (Pl. 70). In the late 1870s, Sari charged two francs for the cheapest seats and five for reserved seats, about twice the prices at the Ba-ta-clan. Drinks were much higher than in ordinary cafés, as one might expect.

Manet's painting, therefore, evokes one of Paris's more expensive and *chic* places. It is true that a student, sales clerk, or prostitute could come to the Folies-Bergère, but only by dressing up and squandering a small fortune. If the Folies was a social mixing place, it was nonetheless quite dominated by the well-to-do. Manet's own society went there, urbane writers, critics, collectors, painters, actors, demi-mondaines, and members of the Jockey Club. Appropriately enough, several of his models and friends can be found in the reflected balcony: the painter Gaston Latouche said that he posed for the man to the right.[41] Manet's barmaid was a waitress from the Folies-Bergère, Suzon, of whom he made a separate pastel portrait in street clothes. For the *Bar* she posed in his studio (where he kept a marble table used in several other café paintings), as had the woman in *Corner in a Café-Concert* (Pl. 77), and for the same reason: Manet felt the need of the real person as he constructed the imaginary one.

What should we make of the arresting figure he painted? Some contemporaries thought she was little better than a prostitute, since barmaids had long had a reputation for low morals, and the Folies was well known as a racy place. Many modern historians also have concluded that she should be seen as a prostitute.[42] Of course, Sari hired pretty women to enhance the sale of alcohol, and his advertisements frequently showed top-hatted men leaning on one of the bars, flirting with the barmaids (Pl. 79). These *verseuses* were aspiring actresses and other young women trying to make a career in Paris. Thanks to the memoirist Arnold Mortier, we have a glimpse of one of them. Writing in 1876 of the new women of the current season at the Athenée-Comique, he mentions "Blanche Rose. Blond with dark eyes. At the Folies-Bergère took care of a little bar where Enlgish bookmakers used to gather every evening. It's for that reason that she smiled at Sari who was in the audience."[43] In these few words Mortier documents the rise of one of Sari's barmaids who graduated to the stage. We can be quite sure that Blanche-Rose and Suzon lived less conventional lives than a proper bourgeoise, and that they might well have had lovers, or occasionally slept with a theater manager. But between this and prostitution there is an enormous gap.

In painting Suzon at her bar, Manet, like Mortier, showed he was among the cognoscenti who appreciated beautiful, modish women and used them to embody modern Paris. In his painting, the whole world of the Folies-Bergère is reduced to this young woman and to our thoughts as we confront her. She has a striking presence, all the more so because she is firmly painted, compared to the softened images in the mirror, and she is solidy installed within the shallow space, thanks to the marble counter, bearer of one of the most beautiful still lives in French painting. Centrally positioned, she utterly dominates a busy composition whose flatness is con-fining, despite the rather smoky distance we can see in the mirror. Squeezed though she is between mirror and counter, she has an immense dignity and self-containment. (Any doubts about this can be resolved by comparing her with Duez's woman, Pl. 74). She is also a disconcerting figure because her matter-of-fact, cool glance seems to lack expression.

Her aloofness is all the more disturbing because the common assumptions about barmaids would make us expect a more forthcoming woman. That Manet defeats these expectations by fashioning an image of remoteness is one of the keys to his picture. In his austere figure we find the anonymity and loneliness inherent in the arbitrary encounters of modern life.[44] We have already seen these traits of urban tension in *The Plum, The Street Singer*, and even in *The Railroad* (Pls. 75, 38, 31), works that range over Manet's whole career. Like the *Bar*, these are all productions of the *flâneur* and the naturalist who disdains emotional involvement with the anonymous events of city life in order to master them, and who therefore grants a singular detachment to his figures, lest they reach out towards our emotions. Suzon's impassivity should make us think again of Georg Simmel's concept of objectivity, and also of his inter-pretation of the money economy which reduces human en-counters to abstract terms and leads to the blasé look that protects against involvement.[45] Suzon's distant aspect would therefore result from Manet's having responded not to the attraction of Sari's performances, nor to the glamour of the society which swarmed through his building, but instead to the condition of this participant and victim of commercialized leisure.

None of this denies that we continue to have trouble reading her iconic image. Our difficulty is compounded by her displaced reflection in the mirror, a rendering that is faulty, judged by the tradition of naturalistic illusions.[46] The whole reflected world is shifted to the right as though the mirror were on a slant, even though the counter seems parallel to it. Not only is Suzon's reflection too far to the right, but the man her image addresses would have to be standing in the viewer's spot, that is, if we demand reasonableness from the picture. Evidently it is an unreasonable construction, and sorting out its internal contradictions is the elaborate puzzle the artist has forced on us. Manet had often submitted to the Salon juries his most outrageous works, including those with strange depar-tures from customary perspective, such as *The Execution of Maximilian* (Pl. 63), rejected in 1869. To tweak the noses of conservatives was part of his performance as the *bel-esprit* who ran circles around the stodgy bourgeoisie. And performance it was: contemporaries recount his pleasure in receiving a stream of visitors to his studio while he was painting *A Bar at the Folies-Bergère*.

As for Sari's performers, they are amusingly reduced to an acrobat's legs and trapeze in the upper left corner of the paint-ing, so that Manet can concentrate on one edge of the vast music hall. Suzon faces us with her impassive gaze, the pro-fessional waiting for our order. Unlike her, however, the image in the mirror bends slightly towards the mustachioed man, as though responding to him. The man's face is quite expressionless, but his direct gaze (turned into a bold stare by the fixity of painting) shows his interest in the woman. In this fashion, Manet makes us consider this woman's actual role as

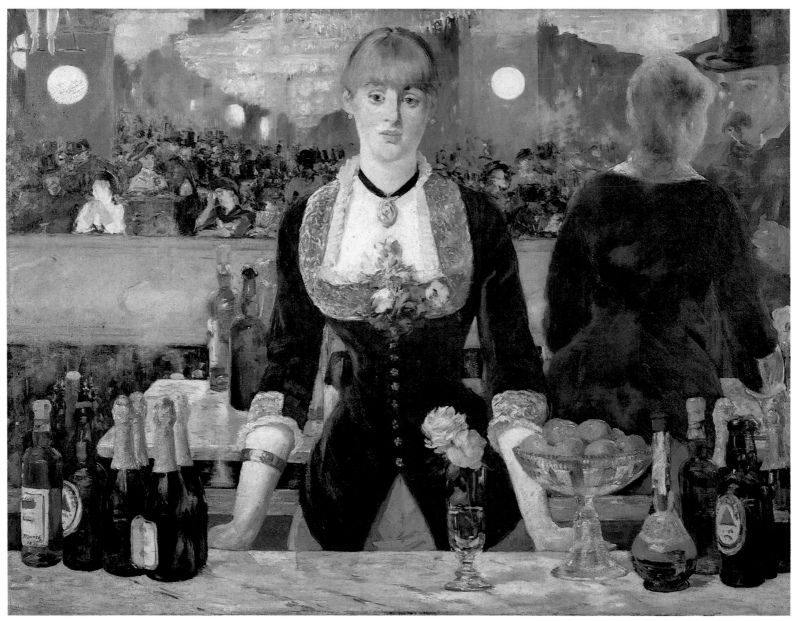

80. Manet, *A Bar at the Folies-Bergère*, 1881–82. London, Courtauld Institute Galleries.

professional barmaid, and her potential role as envisioned by that man. Her frontal image is correct, even distant from us; nothing hints at her availability after hours. In the mirror, her more yielding nature is revealed, detached as it were from her body by the man's powers of wish-fulfillment.

It is precisely because Manet first establishes a cold dialogue between the statuesque barmaid and the viewer that the second dialogue in the mirror gains its peculiar force. We can't really be that man, yet because we are in the position he would occupy in front of the bar, he becomes our second self. His disembodied image seems to stand for a male client's hidden thoughts when facing such an attractive woman. The apparently aberrant detachment of the reflection in the mirror from the woman, and of the man from ourselves, is the game this wily artist is playing. The very fulcrum on which the picture balances, in other words, is a violation of the conventions of traditional art. To have "corrected" it would have destroyed the painting.

Café-Concert: Women who Perform

Degas did not at all follow Manet in his subtle depictions of barmaid or waitress of the café-concert. Their opposed temperaments nowhere show better than in this contrast, for Degas concentrated almost exclusively on the female performer. Beginning in 1875, he devoted about forty pastels and prints to this theme.[47] Only one of them (Pl. 89) features the clients of the café-concert. All the others are interpretations of singers in action. To study them is to confront more directly than with Manet the nature of the café-concert and its place in Parisian society.

Although there were various antecedents to the café-concert, the sudden rise in their popularity began in the 1850s, with the advent of the Second Empire and the dramatic changes wrought in the capital. Early historians all agree that the Café des Ambassadeurs and the Café Morel had set the vogue in the 1840s. They were housed in twin buildings

81

designed by Jacques Hittorff in 1841 for the park-like area where the Champs-Elysées meets the place de la Concorde (a corner of the Ambassadeurs shows in Renoir's painting of 1867, Pl. 8). Taking their cue from the open-air concerts that had for many years been held there, both cafés added outdoor pavilions behind the main buildings. This whole region had long been set aside for fairs, circuses (Hittorff also built the nearby circus building in 1841), Punch and Judy shows, and various itinerant entertainments, so Parisians of the Second Empire were conforming to a well-established tradition when they sought distraction on this once royal edge of the city.

By the 1850s, visitors and Parisians could choose among three cafés-concerts there, the Ambassadeurs, the Alcazar d'été (formerly Café Morel), and the Café de l'horloge. Extensive use of gas lamps—foreigners constantly remarked on Paris's extravagance in this regard—extended warm-weather days well into the night. Their luminous spheres glow prominently in Degas's best-known compositions (Pls. 83, 84, 85). At first hung from trees by café proprietors, gas lamps were spread throughout this verdant area by municipal authorities, who helped sanction its appeal as one of the principal nocturnal promenades of the city. By the 1860s it was fairly crowded with organized entertainments: cafés-concerts, municipal concerts, the circus, semi-permanent fair buildings, several theaters, an enclosed Panorama, and one of the most popular of the city's gaslit dancing gardens, the Bal Mabille. There was no doubt of this district's function as a place of gay abandon to compensate for the vast demolitions and removals which were dislocating the population of the city's center.

The imperial presence was discreet but thorough. The municipal concerts, inaugurated in 1859, were frequently tied to imperial celebrations; the circus was renamed the Cirque de l'Impératrice; the Panorama held paintings of Louis Napoleon's battles; imperial censorship passed on every song, operetta, and play performed in the various cafés and theaters. Gone were the itinerants who used to set up portable platforms and pass the hat afterwards. Their places were taken by impresarios who hired entertainers, enclosed them in pavilions and fenced-off areas, and raked in the money spent on the alcohol which sustained these new fortunes.

The impresarios chafed under constant censorship, but for all that, imperial dictatorship was at times a welcome partner. In 1863 and 1864, a sweeping set of decrees suppressed many of the privileges which had hemmed in the theatrical world, and opened theater construction and management to anyone who could put up the money and observe basic building codes. There was an immediate boom in new construction and in the conversion of buildings (such as the Folies-Bergère) to various kinds of theater: vaudeville, café-concert, comic opera, comedy, pantomime, drama, and circus. This was followed in 1866 and 1867 by another set of authoritarian decrees, of particular benefit to cafés-concerts. These wiped out the guild restrictions that had protected established theater and music by forbidding café entertainers to wear costume, employ props, or use more than brief excerpts from published plays and music.[48] Whether or not devised with the 1867 Universal Exposition in mind—they probably were—these decrees led to a remarkable expansion of cafés-concerts, which rose from a modest number, probably two to three dozen in the early 1860s, to more than 100 a decade later, and nearly 200 by the early 1880s.

On summer evenings the Ambassadeurs and the Alcazar d'été were especially frequented by Parisians and by foreign visitors, whom guide books directed there. Since Degas favored the Ambassadeurs, we might look at what gave it a special éclat. It had pride of place as one of the oldest cafés-concerts, and the advantage of its tree-lined surroundings. Its repertoire was much like that of the indoor cafés-concerts in the rest of the city: clowns, comedians, singers, acrobats, short plays, operettas, and vaudeville. Its personnel was also like that of its wintertime rivals: an orchestra of fifteen to twenty musicians, twelve to fifteen performers, and fifteen to thirty waiters and other salaried staff. All these employees catered to a constantly shifting clientèle of about 1,200 seated within the authorized perimeter. It was a big business, and as such it could afford to hire major stars, often plucking them from the previous winter's greatest successes elsewhere. Notably more smart (therefore more expensive) than most of its rivals, it was regularly listed as a "very fine establishment,"[49] even in

81. Degas, *The Impresario*, c. 1876–77. San Francisco, Fine Arts Museums.

guide books that looked down on such places as too bawdy. In some ways the Ambassadeurs was the open-air equivalent of the Folies-Bergère.

Like the Folies, the Ambassadeurs had an enterprising manager. Pierre Ducarre took it over in time for the Universal Exposition of 1867 and was its owner-director until the end of the century. Degas frequented the Ambassadeurs in the mid-1870s and seems to have admired Ducarre. He made four pencil studies of him on one sheet and began an oil of him, showing a powerful figure walking away from the observer (Pl. 81). Ducarre himself defined success in this new business in words that would have appealed to Degas: "One must always be on the lookout for novelties, for original creations, for unexpected talents. And no matter how much success is enjoyed by an establishment, one must always think of improving on it, of perfecting it."[50] Ducarre launched a number of new stars, including Libert, one of the rare male performers drawn by Degas, and Emélie Bécat (Pl. 82).

Degas was not attracted by the male singers, comedians, or acrobats who took the stage of the Ambassadeurs, any more than he was interested in male ballet dancers. Despite the fame of some men (one thinks of Paulus, whose great acclaim began around 1880, but who had already appeared at the Ambassadeurs in 1871 and 1872), it was the female singer who dominated the era. The famous Thérésa (Emma Valadon) set the tone with her smashing success in 1864 at the Ambassadeurs' nearby rival, the Alcazar d'été. She quickly became one of the stars of Paris, "the Patti of the beer mug," invited to appear before the imperial court, and subject of admiring phrases of Mallarmé and of Degas ("She opens her huge mouth and out comes the grossest, the most delicate, the most wittily tender voice there is."[51]) Her success is a revealing index of Second Empire and Third Republic morality, not despite, but because of the slang, the sexual innuendos, the working-class origin of much of her material:

One only has to look at Mlle Thérésa to recognize that she is a child of the people. She has that kind of virility that is shared by both sexes in the lower levels of population; its charm is in its force. One of the personages that she portrays is said to have posed for a Venus; in this case the model's marble seems to have been shaped more by a pruning hook than a chisel. Moreover, in her physiognomy, a lot of expression in the gaze; an ensemble that is not at all displeasing, and sometimes her gestures have an elegance that contrasts with the vulgarity and the excessively broad tone of her lyric repertoire.[52]

Like that writer and the dandies who crowded the Ambassadeurs, Degas admired the street-wise virility of the women who sang on its stage. Since he worked in a silent medium, he concentrated on gesture as a way of suggesting this admirable vulgarity. The Thérésa-like figure of *La Chanson du chien* (Pl. 84) holds her forearms up to give prominence to her drooping hands.[53] Her closed eyes and uptilted chin, however, convey a sense not of a funny animal, but of entire absorption in her song: a mixture of the delicate and the gross, as Degas said. The same mixture was found in Emélie Bécat, the singer he turned to more often than to any other. He made five prints of her, including Plate 82; one contains three separate composi-

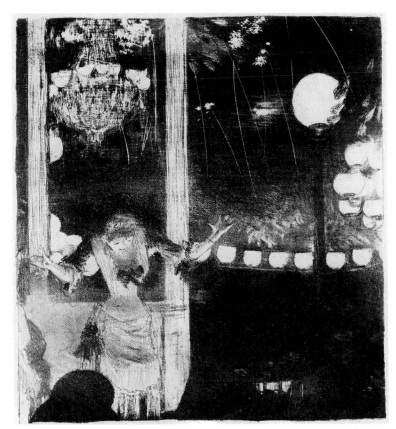

82. Degas, *Aux Ambassadeurs: Mlle Bécat*, c. 1877. Art Institute of Chicago.

tions of her on the same sheet. In Plate 82 she has both arms spread widely, shoulders hunched, and head bent down. Heavy bows on bodice, elbows, and the back of her costume would have accentuated the constant motions of her body. In other prints he shows her doubled forward, hands on knees, or with one arm stretched eccentrically outward, its forearm dangling down. One can imagine her singing a refrain from her first hit, *Le Turbot et la crevette* (The Turbot and the Shrimp):

Turbot, turbot of my heart.
You've got me! You've got me!
You'll be my downfall.[54]

Bécat was appreciated for her "epileptic style," a frenetic use of body and limbs. In this she was like other notable café singers, for they all developed particular kinds of gesture and movement which helped identify them and which they utilized to inject sexual or political meaning into otherwise innocent-sounding phrases. These striking styles were especially necessary in the café-concert. Clients were free to come and go, to drink and chat, so it took a strong act to claim their attention. Besides, the anonymity of the well-packaged entertainment and of its huge audience could be partly disguised by the frenzied clamor of the performer, who seemed to seek a personal exchange with each client, enlisting them as participants. Edward King, that rather stuffy American visitor, lamented this participation as well as the fare offered in the outdoor café-concert:

The songs are local, glaring with coarse mannerisms and rude gestures...; a fat woman rises, makes a short, un-

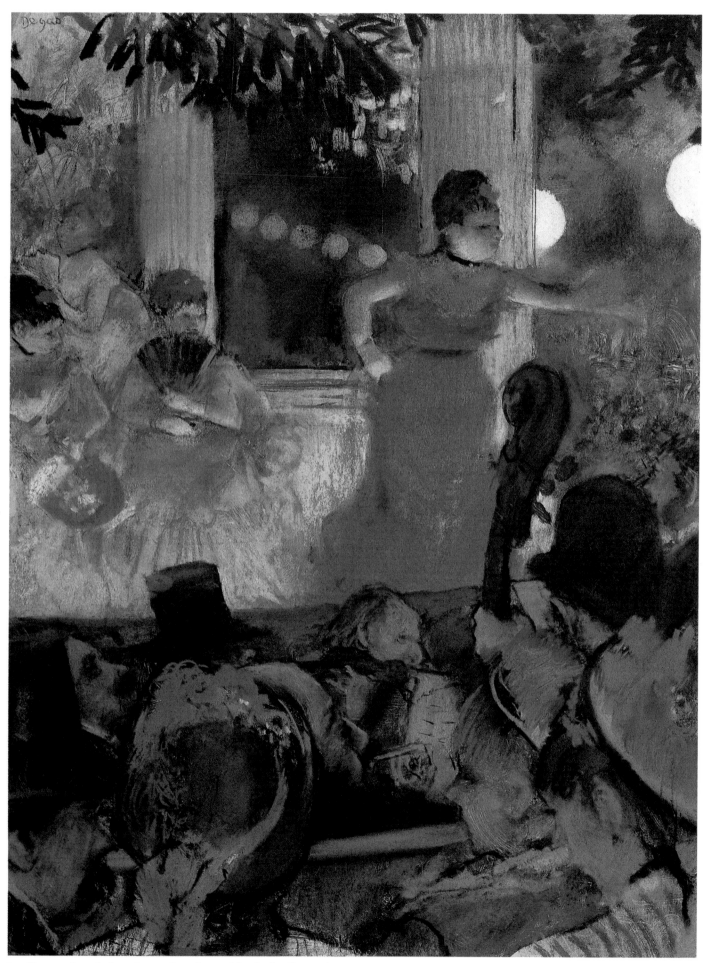

83. Degas, *Aux Ambassadeurs*, 1877. Lyon, Musée des Beaux-Arts.

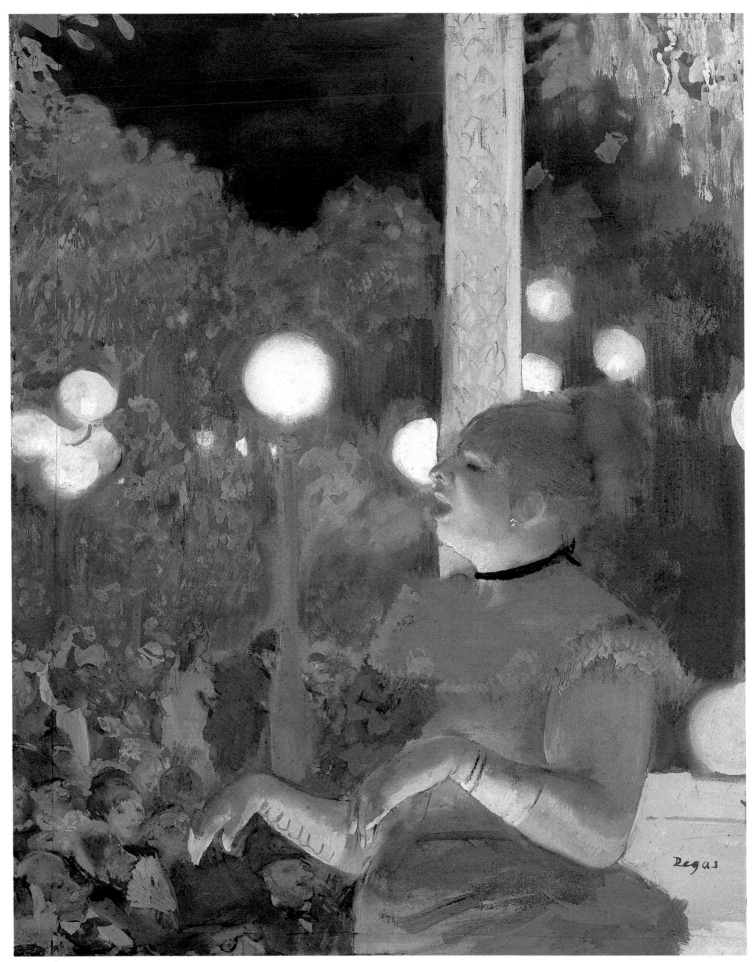

84. Degas, *La Chanson du Chien*, c. 1875–78. Collection unknown.

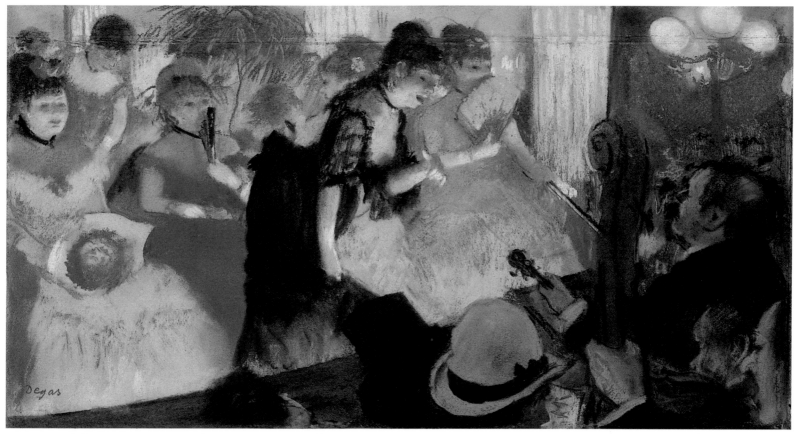

85. Degas, *Café-Concert*, c. 1877. Washington, Corcoran Gallery.

graceful bow, and sings a burlesque song. It is an echo of boulevard life.... The audiences are more enthusiastic here than under roofs; they rise and swing hats and bonnets, they scream and throw bouquets, and sometimes a daring suitor goes to the footlights and hands to his goddess, in person, his offering of flowers or epistle of love.[55]

The singer reaching out toward her audience is the theme of two of Degas pastels (Pls. 83, 85) shown in the third impressionist exhibition in 1877 (alongside *Women on a Café Terrace, Evening*, Pl. 47, and several ballet dancers). Both may represent Victorine Demay, whose repertoire had many "an echo of boulevard life."[56] In one she plants right hand on hip and pumps her left arm, which Degas makes disappear in the process. In the other she bends low and emphatically gestures back at herself with her left thumb. We can almost hear Demay singing to her cornet player in "Horace's Trumpet":

> I'd like t'be the deal chair
> Where you sit—so's I can hear you better.

Or refusing the offer of a nutcracker from an admirer:

> Me, I crack nuts
> By sittin' down on 'em![57]

In Plate 83 we have to imagine ourselves as members of the audience seated behind three women whose costumes have the loud effects sought by women of dubious virtue, the kind the rakish man on the left comes here to meet. Just beyond are the musicians, whose diverse origins and mediocre pay are captured in their motley assortment of hats and varied cut of hair. What an urban scene this is, despite the outdoor setting: people of different positions, different attitudes, different classes (except for the working class), virtually a microcosm of the city's varied and shifting population! Drawn by the brilliant gaslight of the stage, we look up to the singer in red (Pl. 61). She gestures off to the right, a move that renders the composition dynamic, but threatens its stability. Her rightward movement is checked by the brightly colored women to the left, who serve as a counterbalance, by the wide strip of the pavilion support which pins her down, and by the row of lights that continues the axis of her outstretched arm. Further, her potential movement is blocked by the huge volute of the bass viol, that symbol of manhood rising upward from the male orchestra.

In Plate 85, the singer, bending over to display her charms, seems to be addressing the orchestra leader. There are no customers represented here, so the orchestra takes on the role of the men in the audience to whom the singer most often appeals. Café-concert songs were usually devoted to love, and Degas alludes to them by having the women face the men, the men who run the show, as they run life, by providing the music. Their instruments—the leader's bow, his firmly held violin scroll, and again that oversized bass—enter naughtily into the confrontation.

The women who grace the stage in both pastels were collectively known as the "*corbeille*," a rich term meaning theatrical dress circle, the reserved enclosure in a stock exchange, a flower bed, a flower or fruit basket, or simply a basket.

Ducarre and other impresarios quite knowingly exploited the women for their appeal; male performers were kept offstage. A few of the *corbeille* were entertainers awaiting their turns, some were beginners who would appear without pay in the hopes of proving themselves, and others were not performers at all, simply attractive women hired to round out the visual offering. The sexual role of the *corbeille* was widely commented upon. Men pursued them, of course, and the reputations of the cafés-concerts owed something to this commerce. Because the directors of the better establishments forbade open signalling from the stage, there grew up a special gestural language. The way one held an admirer's bouquet could signal agreement to meet after the show; tapping one side of the face with a fan could be a similar positive sign. The women in Degas's two *corbeilles* flourish bouquets and fans, and their separate movements and poses—in Plate 85, the woman in pale blue immediately behind the singer has turned entirely around—suggest their ambitions to be recognized as individuals.

Café-Concert: Clients and Artists

Neither Degas nor Manet was a passive recorder of what went on in the cafés-concerts. To gain a fuller understanding of their knowing interpretations, we have to look further into the nature of this particular form of commercialized entertainment. We are hindered as much as helped by modern art historians who have usually placed too much emphasis on the low life that patronized these places. It is best to begin by looking into the performers, their songs, and their clients to see the degree to which the *canaille*, the riffraff, were represented. We can then turn to the other social strata who fit into this strange and wonderful institution, especially since among them were artists like Manet and Degas, hardly to be counted among the riffraff.

Leading café-concert singers, like Thérésa and Bécat, were almost all from the *menu peuple*, the lower classes, and prided themselves on their origins. By birthright they had access to street slang, to gutter humor and gestures which were central to their art. The titles of some typical songs, virtually untranslatable, are a good indication: "I advise you not to stick your nose in there"; "It's squeezing me. Move it out of here"; "I've helped myself to a lot."[58] Both singers and songs, moreover, grew out of a populist and radical tradition that included Béranger in the first quarter of the century, as well as Pierre Dupont and Joseph Darcier, both associated with the revolution of 1848. Béranger was twice imprisoned for his songs, Dupont and Darcier suffered heavily from censorship. Darcier's role continued well into the impressionist era, as performer, songwriter, and as Thérésa's mentor. He was co-author of "La canaille," a song launched by the robust Rosa Bordas (Rosalie Martini) in 1869. Its famous refrain was "J'en suis! J'en suis!" (meaning "I am also *canaille*"). Bordas sang it at the Hôtel de Ville during the Commune, and when she took it up again after the bloody repression of the Paris revolt, her listeners greeted it as a pro-communard song.[59]

Somehow Bordas's rendering of "La canaille" escaped the censor (perhaps because it had been approved before 1870), but we can be sure the one or more police agents or *mouchards* (informers) reported the incident. The more oppressive the

government, the more worried it was about these "parliaments of the people." All through the Empire, cafés and cafés-concerts were well attended by informers, great numbers were closed down for political reasons, and the government censor required approval of every café song before it could be aired. Faced with the sheer volume of such texts the censors were hard put to suppress all instances of excessive vulgarity and political dissent, especially since a singer's wink or gesture could subvert the most innocent-sounding phrase. For example, the imperial censor may have been suspicious about "Le Sire de Framboisy," a song by Bourgat and Laurent de Rille, but did not prevent its becoming a rallying cry for opposition to the Emperor. By burlesque expressions and dumb show, the singers made the medieval Sire and his wife into a parody of Louis Napoleon and Eugénie. Jules Vallès, that unrepentant communard, believed that in a time of censorship and repression, the famous Thérésa embodied the spirit of freedom and opposition, and "sapped an empire by holding it up to laughter."[60] Vallès's phrase foretells Kracauer's view that Offenbach's operettas had a role in the downfall of Louis Napoleon. Café song and operetta were not all that far apart. The larger cafés-concerts frequently put on operettas, and Offenbach's chief rival Hervé (Florimond Ronge) wrote for the café-concert, including one of Thérésa's hits, "La gardeuse d'ours" (The Bear Keeper). For a time, he also directed the orchestra of the Eldorado, one of the leading cafés-concerts. The Ba-ta-clan, as we saw, was named for one of Offenbach's operettas, and composers of café songs regularly mined successful operettas for phrases, refrains, and personages.

Censorship of comic opera and of café-concert programs did not end with the fall of the Second Empire. Jules Simon, minister of education in the early years of the Third Republic, was an outspoken enemy of the cafés-concerts, which "distribute and sell poison among us."[61] Fear of the Commune led Simon and many others to associate cafés and cafés-concerts with the menacing *canaille*, and police shadowing continued. In the five months following President MacMahon's dissolving the Chamber of Deputies on 16 May 1877, 2,200 cafés were shut down as part of a campaign to stifle the opposition.[62] MacMahon, general of the troops that repressed the Commune, was repudiated in the elections of October 1877, which restored a republican majority to the Chamber. Censorship gradually slackened, but police spies continued to haunt cafés and cafés-concerts (and the official censors' posts were abolished only after the turn of the century).

Government monitoring of cafés and cafés-concerts would seem to prove that they were indeed the precincts of the *canaille* who resisted ordained politics and morality. However, the clients of the cafés-concerts included many middle-class and upper-class people, and we have to puzzle out their roles if we are to make sense of these marketplaces of salty entertainment, and of the impressionists' paintings of them. It has already been remarked that the Ambassadeurs, the Folies-Bergères, and the unidentified cafés painted by Manet and Degas were rather expensive places. The artists did not frequent commonplace cafés, and prices alone largely excluded the working class from the Ambassadeurs and the Folies. Zola, in an angry polemic full of irony, asks:

Is it the worker who goes into fashionable cafés, where high prices give nice people the right to enter? They're all there, drinking, talking business, politics, or smut. The waiters are neat, there is gold décor, no one has yet denounced cafés in parliament. Useless people drown themselves in absinthe without having the worker's excuses, and they die softheaded, their hands unstained by any work, after having slumped over the same marble table for thirty years.[63]

There is also plentiful visual evidence to confront the privileged world that Manet and Degas recreated. The Musée Carnavalet has many prints of workers' restaurants and cafés by Henri Valentin and a host of other illustrators, and in the album of etchings that Léopold Flameng published in 1860, *Paris qui s'en va, Paris qui vient*, there are representations of the Cabaret de la Mère Marie and other plebeian cafés. Merely to glance at Roman Ribéra's *Café-Chantant* (Pl. 86) is to see how far one can get from Degas's *Ambassadeurs* (Pls. 83, 85).

86. Ribéra, *Café-Chantant*, 1876. Washington, Corcoran Gallery.

When Manet and Degas looked around them at the Ambassadeurs or the Folies-Bergère, they did not see the working class. They saw some clerks, shop assistants, prostitutes, and demimondaines, and a lot more middle-class and upper-class customers, including perfectly respectable women whose presence particularly irritated conservatives like Louis Veuillot.[64] These latter were slumming and were often represented in contemporary illustrations, looking out from their loges over the cheaper seats below—the audience was a wonderful part of the show. Manet and Degas would also have seen fellow artists, *flâneurs*, dandies, and the élite of Parisian intellectuals. If they could have grouped in one place those known to have frequented the better cafés-concerts (most of whom wrote about them), they would have spotted Delvau, Fournel, Mallarmé, the Goncourts, Daudet, Taine, Veuillot, Banville, Sardou, and Renan, as well as the composers Auber, Rossini, Hervé, and Offenbach (also the latter's librettists Halévy, Degas's close friend, and Meilhac).

For painters, journalists, writers, and musicians, the café-concert was a source of ideas, of useful refrains, odd tunes, popular phrases and striking costumes—therefore a productive bit of amusement. Café songs and vaudeville thrived on current events which were filtered through lively music, clever phrases, and telling gestures. In them Manet found parallels for his scintillating brushwork, his quick grasp of things, and his opposition to the stodgy terms of official painting. Degas's sardonic wit equally found matches there for his caricatural treatment of clients and performers, and for his idiosyncratic combination of pastel over monotype, a technique that alone constituted a repudiation of the hierarchy of the fine-arts establishment. (For that matter, the compositions of his café-concert pastels owed a debt to Daumier's cartoons.[65])

The combination of leisure and work that artists and writers met with in the café-concert was an irresistible lure, all the more so because they enjoyed the irreverent, fractious environment. The café-concert expressed the spirit of opposition to government and to sanctioned morality that most of them shared. For them, in an era of limited freedom of expression, it was a safe way of venting their opposition (relatively safe: police spies kept a careful eye on artists and intellectuals, not just on political activists). The working-class origins of the performers and of their language gave them the feeling of sounding the depths of their society, of communing with *le peuple*, even though we know that all of Thérésa's songs, all of Bécat's and the others', were written by professional musicians. The origins were often among the *canaille*, but the products came from the hands of skilled professionals, managed by clever entrepreneurs.

The bawdy songs of the cafés-concerts helped make them into mixing places, where class differences could be partly papered over. They acted as an outlet for Parisians' awareness of the vast army of workers on whom they depended, and for the specter of revolution, reinvigorated by the Commune in 1871. Class fears were partly discharged at the Ambassadeurs where one could flirt with dangerous sexual and political expression, in an environment that grouped several classes of client (comfortably dominated by those with money), the liberating effects of drink and tobacco, and the frequent interjection of nonsense songs and refrains which further diluted the force of the street references. Georges Rivière, Renoir's friend, well understood how singers like Thérésa or Bécat could appeal to the bourgeoisie. In reviewing Degas's splendid pastel shown in 1877 (Pl. 83), he wrote that the red-robed figure must be singing "a coarse song, accompanied by vulgar gestures," and then remarked "How this gesture and this voice ought to be carefully studied in the silence of the boudoir by a pretty marquise who will court her friends' bravos when she sings 'Am I a pasteboard woman?'"[66]

The café-concert let artists and writers associate with the performers who were, in a manner of speaking, their alter egos. The singer's or the clown's act had more than one parallel with the painting, the musical composition, or the essay. All were one form or another of entertainment, the shrewd mask held up to the public. Thérésa's song had elements of the *canaille* but was written by well-paid professionals like Hervé or Darcier; Manet's painting included a worker (Pl. 77), but was destined for a small élite of viewers.

87. Degas, detail of *La Chanson du chien* (Pl. 84).

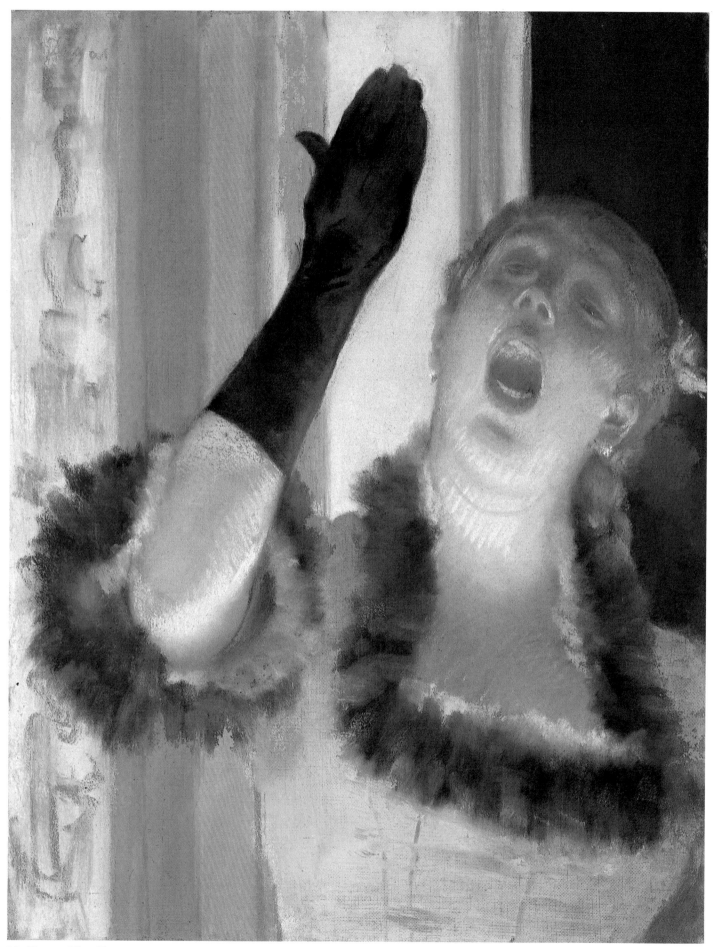

88. Degas, *The Glove*, c. 1878. Harvard University Art Museums.

For the most part, artists and writers did not look at one another. That would have brought on too much self-aware-ness. They looked instead at the performers, the waitresses, and the lowlife among the clients. They were like the tourists who went to a fishing village and looked only at the natives, who bought engravings of the fishing boats, not of the train that brought them there, and who tried to ignore their fellow tourists, in order to preserve an "authentic" experience. Say-ing this is not to deny the genuineness of Manet's interest in young women alone in their thoughts and in waitresses at their jobs, nor to deny his revelations of urban tensions. It is instead to confirm the distance he felt from his café figures, a distance that did not exlude sympathy, but that let him maintain his male detachment and demonstrate it to his fellow *fashionables*.

Much the same can be said of Degas's café-concert pastels, although his cynical penetration of contemporary foibles is a different kind of detachment. For example, his only café-concert composition that concentrates on customers (Pl. 89) gives them none of the dignity Manet confers on café clients and waitresses. Manet merely hints at possible relationships between his men and women while keeping them aloof from one another. Degas's small pastel shows lecherous men hover-ing over women of doubtful virtue, and all the other figures are caricatures, victims of his compulsion to attack society. In *La Chanson du chien* (Pl. 87), the men and women below the singer are also caricatures, brilliant miniature heads not two inches high in the foreground, and hardly more than half an inch in the distance. It is as though the woman's animal pos-ture had the power to metamorphose her auditors. At the base of the composition a pair of dark-rimmed glasses peers up over a pyramidal snout, and among the tiny heads to the rear is the profile of a porcine male under a round, yellow hat.

To the modern observer there is an oddly familiar aspect to this crowd milling among trees under the looming presence of a singer on a raised platform. We are reminded of the outdoor concerts of our own era in city parks or college grounds. Public concerts by rock musicians, in fact, find their ancestry in the Parisian café-concert. They perpetuate its salient features in their own versions of eccentric costumes and gestures, sug-gestive body movements, incessantly repeated refrains. They also draw much of their material from working-class culture, and performers scare the bourgeoisie, as did Thérésa, Darcier, and Bécat, with their vulgarity and their uninhibited private lives. (Nonetheless, like Thérésa, they are greeted by royalty.) Degas's vision seems equally modern. In *La Chanson du chien* we even have the familiar experience of being suspended somewhere on the boom of a camera that has zoomed in on the performer. This is because his images of café singers have contributed to the way we frame entertainers of our own period. It is not enough simply to say that his forms and compositions look forward to twentieth-century art. That is the customary circular reasoning of art historians: an artist is modern because he was...modern. The real explanation is that Degas invented forms that suited the café-concert, and the two moved together into our century.

89. Degas *Café-Concert (Spectators)*, c. 1875–78. Collection unknown.

His most powerful rendering of a café-concert singer is *The Glove* (Pl. 88), exhibited with the impressionists in 1879; or perhaps we should say that something in our own culture makes us single it out with that particular kind of praise (it is not more beautiful nor more animated than Plate 83, but it is more powerful). Again we have zoomed in on the entertainer as though aided by the moving camera (how could we have explained where we are located in the terms of Degas's generation?). We are extremely close to her, to an absolute stranger who is singing to us. We share the curious experience of the café-concert in which we can be absorbed in the song, hence in a private moment with the singer, and yet be part of a multitude: the combination of nearness and remoteness that Georg Simmel pinpointed as the essence of urban life.

Degas's singer has a forceful presence. Her head is lit from below, resulting in a potent ugliness that we associate with photographic negatives and with the garish effects of klieg lights, those artificial suns which require the performer's thick make-up. (It was Henry Tuckerman who said that Paris and Parisians were characterized above all by a predilection for artifice.[67]) The singer's mouth is open so wide that our own facial muscles stretch as we reckon up the loud note she is holding. There is a quickness about this picture, a poster-like immediacy which seizes hold of our perception. Arm rises from black circle, and head from black trapezoid; both are set against vertical stripes whose strident tones give rhythm to the silent song. The forearm is suspended at an aggressive angle, its black glove echoing the nighttime void to the right. It arrests motion and commands us to listen to the perpetu-ally held note. Everything makes us concentrate on the one event: this woman is belting out a song, overpowering us. To us—we can never escape our own vision—she needs only a microphone in that upraised hand to become a contemporary. From her we can trace the performer that marks her age: Thérésa, Yvette Guilbert, Edith Piaf, Judy Garland, Janis Joplin.[68] Our century has brought with it a vast rise in enter-tainment, particularly music, which has become one of the basic motors of industrial society. Paris of the impressionist era set us on that path, and Degas invented forms that invested its earliest images with remarkable animation and enduring force.

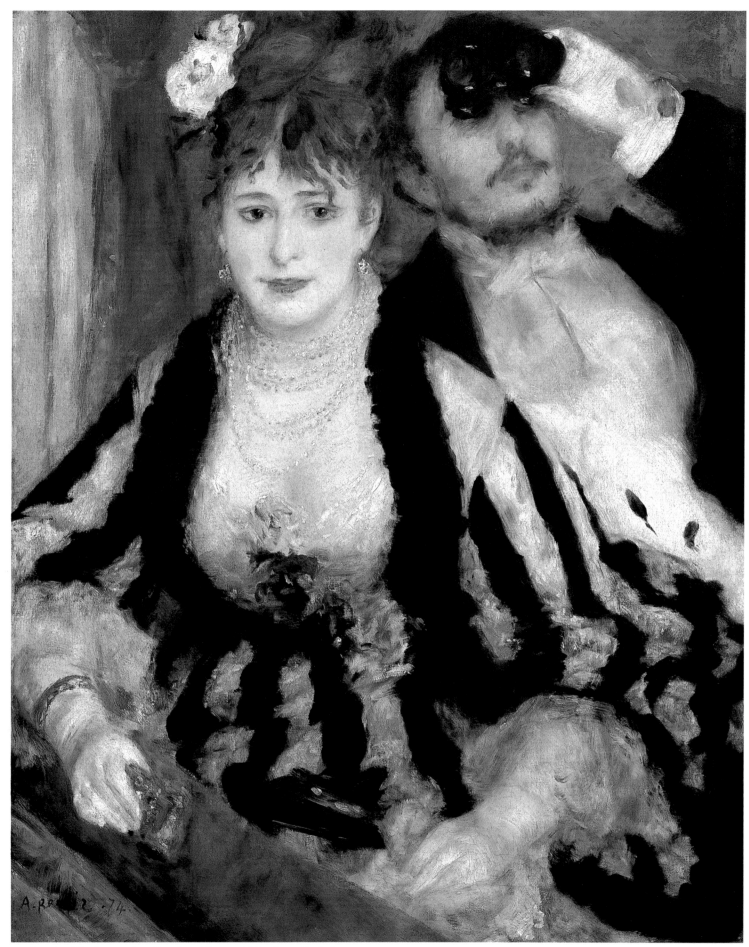

90. Renoir, *The Loge*, 1874. London, Courtauld Institute Galleries.

Chapter Four
Theater, Opera, and Dance

Has not the Variétés given such ravishing renderings of Offenbach's "Grande Duchesse de Gerolstein"...that to hear bewitching Mlle. Schneider and make the acquaintance of the Grande Duchesse, Fritz, and Prince Paul, monarch after monarch has rushed there on the very first evening of arrival?
 —Henry Morford, 1867

...one is more deliciously stirred by the sight of the ballet corps than by the great arias of the tenor in vogue or the reigning prima donna. They are so eloquent, these little dancers—even those who are not dancing—with their rose jerseys and their gauze skirts! Eloquence of the flesh, certainly!
 —Alfred Delvau, 1867

Must we admit that the center of this powerful city...is today an opera house? Must our glory in the future consist above all in perfecting our public entertainments? Are we no longer anything more than the capital of elegance and pleasure?
 —Le Temps, 18 August 1867

The editorialist of *Le Temps* was of the few who struck such a sour note in 1867. Like the visiting monarchs, most Parisians and visitors in the year of the Universal Exposition enjoyed to the fullest the various entertainments that made Paris "the theater of nations." The appearance of Thérésa in a proper theater—she had been booked into the Théâtre du Châtelet for the duration of the Exposition—confirmed the potency of the café-concert repertoire. Offenbach's *La Vie Parisienne* was playing, as well as his *Grande-Duchesse*, and it, too, had pushed aside an old barrier: it was on the boards of the Théâtre français, the first operetta ever to be staged there. Elsewhere in this banner year, the Théâtre lyrique rivaled the opera by giving Gounod's *Romeo and Juliet* its premier, and then by presenting in alternation Miolan-Carvalho and Pauline Nilsson. The illustrious Adelina Patti triumphed at the Opéra, which dedicated a season of gala representations to visiting royalty.

Seekers after non-musical theater could take in a revival of *The Woodland Doe* (*La Biche au bois*, by Cogniard and Clairville) at the Théâtre de la Porte Saint-Martin, of Eugène Sue's *Wandering Jew* at the Théâtre de l'Ambigu, or of *The Seine Boatsmen* (*Les Canotiers de la Seine*, by Thiéry and Dupeuty) at the Folies dramatiques, the latter praised by the leering Henry Morford for its "sensational effects" and "rampant wickedness."[1] For those bent on seeing a new play or review, each of the city's thirty-odd theaters included at least one in its repertoire (a notable instance: *Les Idées de Madame Aubray*, by Dumas fils at the Théâtre du Gymnase). Guide books—many published especially for visitors to the Universal Exposition—also steered audiences towards other spectacles: several circuses, a number of concerts, pantomimes, magic shows, puppet and shadow plays, dozens of balls (commercialized dance halls or gardens), and several dozen cafés-concerts. No other European city could boast of this array of organized diversions, and McCabe's figure of 54,000 seats per night seems a reasonable one.[2]

1867 was a special year, we must admit, for Louis Napoleon and municipal authorities did their utmost to encourage professional entertainment, both for the revenues they earned, and for what Tuckerman called "the holiday antidote" which, he said, "has, for the time at least, neutralized the bane of political discontent."[3] Although accompanied by censorship, the government's subsidies and encouragements, and its liberalizing of laws relating to theater, led to such a spread of stage entertainments that the rich fare of 1867 shortly afterwards became the normal offering. There was, it is true, a falling off as a consequence of the Franco-Prussian war, the Commune, and their aftermath, but by the middle of the next decade, when the impressionists turned towards theater, opera, and café-concert, there were ten to fifteen more theaters and double the number of cafés-concerts. Some of the latter, like the Bata-clan and the Folies-Bergère, as we saw, were as large as theaters, and they staged operettas, ballets, and short plays, along with vaudeville, circuses, comedians, and singers.

In the 1860s, the impressionists frequented the theater, concerts, the opera, comic opera, and at least occasionally (the evidence is scanty) the circus and the café-concert. Among their friends were actors, actresses, musicians, composers, librettists, and playwrights. They nonetheless did not embark on their paintings of public entertainments until the 1870s.

This owes principally to the fact that each of them was in a relatively early stage of career and linked his subjects with those sanctioned by the previous generation and by tradition. A full plunge into contemporary life would require a decade or so of preparation. Renoir, not yet twenty in 1860, passed beyond the level of student by the end of the decade, but concentrated on modernizing established subjects, especially the female nude. His painting *The Clown* of 1868 was his first major depiction of the world of entertainers; it had no counterpart in his oeuvre for several years.

Degas, seven years Renoir's senior, painted portraits of a number of musician friends in the late 1860s. An opera lover from boyhood, he only gradually introduced subjects from the opera into his repertoire. His *Semiramis Constructing a City* of 1860–61, inspired by a revival of Rossini's opera *Semiramis*, is essentially a history painting. *Eugénie Fiocre in the Ballet "La Source"* of 1866–67, based on Saint-Léon's new ballet, is somewhere between the traditions of history painting and of the orientalizing subjects of the previous generation. In 1868 came the first of his radically modern treatments of the opera, *The Orchestra of the Opéra* (Pl. 91), a prescient work that looked forward to a number of opera and café-concert compositions. The picture began as a portrait of his friend the bassoonist Desiré Dihau. Like vicomte Lepic in *Place de la Concorde* (Pl. 37), Dihau is placed in an active setting, a participant in Degas's project to modernize portraiture. To the left is another

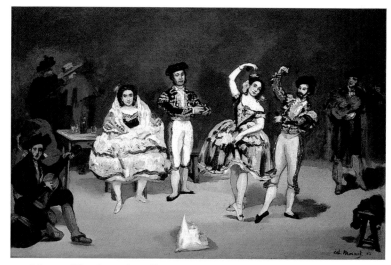

92. Manet, *The Spanish Ballet*, 1862 Washington, Phillips Collection.

91. Degas, *The Orchestra of the Opéra*, 1868–69. Musée d'Orsay.

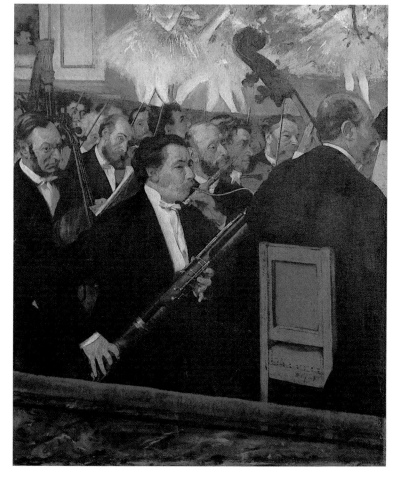

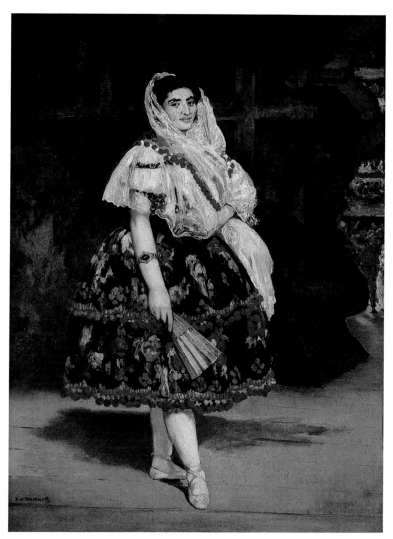

93. Manet, *Lola de Valence*, 1862. Musée d'Orsay.

friend, the cellist and composer Pillet, and to the right is the double-bass player Gouffé. Between Dihau (who occupies the place normally taken by the first violinist) and Gouffé are three known musicians, but on the other side are four friends who were not members of the orchestra.[4]

The Orchestra of the Opéra is held together by an obvious armature of strong diagonals: edge of the orchestra pit, cello, bassoon, and neck of double bass; but for all its deliberate construction, it strikes us as a believable piece of opera life. We are seated in the front row facing the musicians. We look up to the dancers, whose legs are bathed in the glare of footlights. Degas does not include their heads, for our attention would then be drawn away from the foreground. Headless, the dancers form a decorative frieze that stays in the background; legs and arms alone give rhythm to the music. Our front-row view of the dancers is seconded by the head of a man (the composer Chabrier, according to Lemoisne) who peers over the edge of the stage box in the upper-left corner—an amusing touch worthy of Daumier, whose caricatures set a precedent for his kind of composition.[5] Despite the precocity of this painting, it was only in 1872 that Degas undertook his remarkable and abundant works devoted to all aspects of the

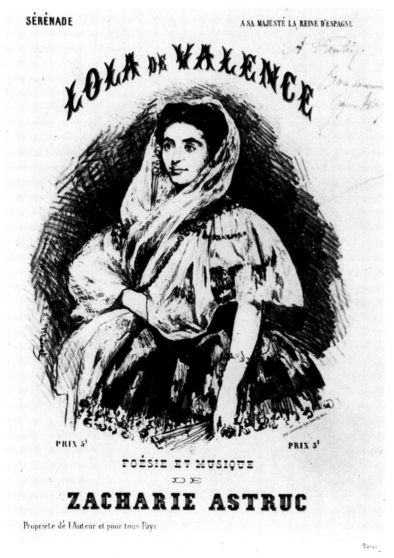

94. Manet, *Lola de Valence*, 1862. Paris, Bibliothèque nationale.

opera: audience, musicians, performers on stage, rehearsals, and backstage views.

As for Manet, not only was he older than the others

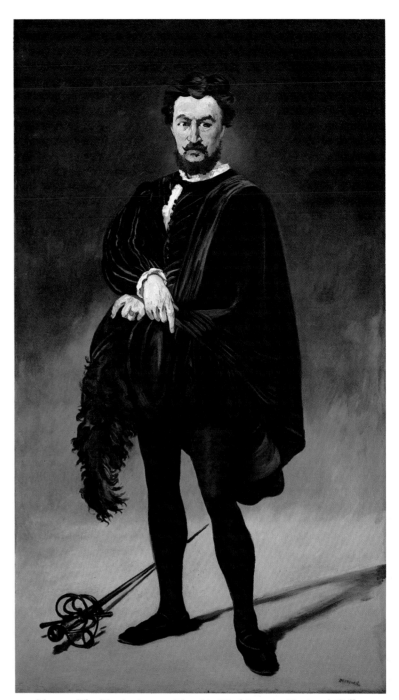

95. Manet, *The Tragic Actor*, 1865–66. Washington, National Gallery.

(Renoir's senior by nine years), he also made his presence known at an earlier age than they. He was thirty-one in 1863 when his *Déjeuner sur l'herbe* (Pl. 171) at the Salon des Refusés gave him all the notoriety a Parisian dandy could have wished for. His oeuvre was already well stocked with pictures of Parisian entertainments and performers, several of them shown the same year in an exhibition on the *grands boulevards* at the Galerie Martinet: *The Street Singer* (Pl. 38), *Music in the Tuileries* (Pl. 41), *The Spanish Ballet* (Pl. 92), and *Lola de Valence* (Pl. 93). The last two were among several works inspired by a dance troupe from Madrid which visited Paris twice in 1862.

For *The Spanish Ballet* Manet assembled the dancers in Alfred Stevens's studio, larger than his own. The resulting

picture, which evokes Spain in style as well as in subject, speaks more of studio than of stage. *Lola de Valence* was initially a frank studio pose, but Manet reworked it for his exhibition pavilion of 1867, adding the stage flats and the distant view of performers and audience. In the exhibitions of 1863 and 1867, he appended a sultry quatrain by Baudelaire, inspired by the painting and destined particularly for the related etching of the dancer. Baudelaire's own notoriety (his famous trial for obscenity had taken place in 1857) would have reinforced Manet's daring and drawn attention to his predilection for performers and bohemians. Manet also made a slightly different, lithographed version of the same figure for the sheet music *Lola de Valence* by his friend Zacharie Astruc (Pl. 94).[6] In 1866, he again provided the cover of a music sheet, *Plainte moresque*, this one for the Catalan guitarist and composer Jaime Bosch. Bosch played at musical evenings at the Manets, for Mme Manet was an accomplished pianist, and evening recitals were a regular feature of their household.

If we add to these hispanicizing images the portrait done in 1865–66 of Philibert Rouvière as *The Tragic Actor* (Pl. 95), we shall have mentioned nearly all of Manet's images of professional performers done in the 1860s. Looking as they do towards Spanish painting (*The Tragic Actor* recalls Velasquez), these works continue the French mid-century vogue for Iberian themes and styles most famously represented by Courbet. In that sense they are on a fulcrum between past and present, much like *The Old Musician* (Pl. 65) or the *Déjeuner sur l'herbe*. After 1870 Manet committed himself more fully to contemporary life and, in creating forms to suit, he left behind the world of Velasquez, Baudelaire, and Courbet. He ceased painting theater interiors and performers, and replaced them, in effect, with his café-concert pictures (Pls. 77, 78). In his final decade of work he bore out the observations of Fournel, Tuckerman, and Morford: Paris itself became his theater.

Spectators

Among the impressionists it was Degas, Renoir, and Cassatt who pictured spectators in the polite world of the enclosed theater. They preferred balcony loges, although Degas also showed the audience in orchestra seats in three pictures.[7] The reasons for this preference are obscure, but it may owe to the fact that the audience seated together on the main floor of opera house or theater lacked the framing effects provided by the loges. Those who rented loges set themselves off by the partial enclosure; they were on display when seated towards the front, although they could seek seclusion in the shadows when they wished (the chairs were movable). Individual loge doors opened onto corridors, where a good deal of social activity took place not only between acts, but before, after, and sometimes during performances. (In *Candaules the King* [*Le Roi Candaule*], a rollicking one-act comedy of 1873 by Halévy and Meilhac, most of the action takes place in the corridor outside the theater loges, whose doors occasionally open to reveal spectators looking out over the stage.) Because notable persons were often in the loges, they were a sideshow to the main attraction for the audience below and for tenants of other boxes. One was eager to see who was with whom, what the latest fashions were, and how those in the loges re-

ceived the performance (vital clues to group reactions). To the knowing, the presence or absence of a given subscriber at a time of political crisis could be an important straw in the wind.

Views of theater boxes had been a staple of illustrators of the mid-century. Edmond Texier, wishing to characterize Parisian society of 1852, published Abel Damourette's view of a middle-class loge juxtaposed with an opera box (Pl. 96). Everything indicates the differences between the classes. The two theaters themselves are unalike, since the opera box has interior curtains and better chairs. There the women are more fashionably dressed and coiffured, as are the men (one of whom voices a confidence or perhaps seeks an introduction). In both images, the spectators are looking in different directions, acting out the social significance of the loges, as distinct from the theatrical one. The woman to the right in the opera box engages our eye, so that we are assumed to be in another box on the same level.

Renoir's *Loge* (Pl. 90), which was in the first impressionist show in 1874, is the first major impressionist painting of the well-known subject. Here too we are assumed to be in a nearby loge or across the way. The curving line of the balcony level (compare Pls. 101 and 98) might explain the angle at which we see the loge's velvet railing and its partition above, but Renoir was not concerned with Degas's spatial dynamics and merely established a perfunctory setting for his model. She was posed by a certain Nini, whose surname is unknown; her companion was modeled on the artist's brother Edmond.

The Loge is one of Renoir's most glorious pictures, and one of the masterpieces of Impressionism, worthy of Titian, Velasquez, and Rubens. It has their opulence of painted surface and of rich garments, the two so closely associated that we cannot separate one from the other. The woman's extraordinary striped garment forms a lyre shape around her bosom, which is touched with flowers and surmounted by a cascade of pearls. The loge, where women were on display, was a logical choice for the artist who wanted to exhibit a beautiful model and his skill at presenting her. The man in the picture is seated to the rear, following the nearly universal custom of this tradition of representation. The woman that a man brought to the theater, whether spouse or friend, sat forward in the loge as a demonstration of his pride and social position. Here her status is confirmed by the ermine wrap which shows to the right, above her elbow. She is the kind of richly dressed woman with whom Manet could consort daily, but whom the lower-class Renoir had to invent as the embodiment of his aspirations, as though he had his nose pressed to the window of the upper-class world. Nini's splendor derives from this longing.

In *The First Outing* (Pl. 97), painted two years later, Renoir returns to the theme of the theater box, but this time he presents a young woman perhaps sixteen or seventeen years old, who is not self-consciously on display. Also in contrast to *The Loge*, she is accompanied by a woman. There, although subordinated to Nini, the man's assumption of the proprietary position and his use of opera glasses prove him to be a man of the world. It is against his image that we read the woman's, aided half unconsciously by the way the black stripe flowing over her left shoulder takes the position of his right arm. In

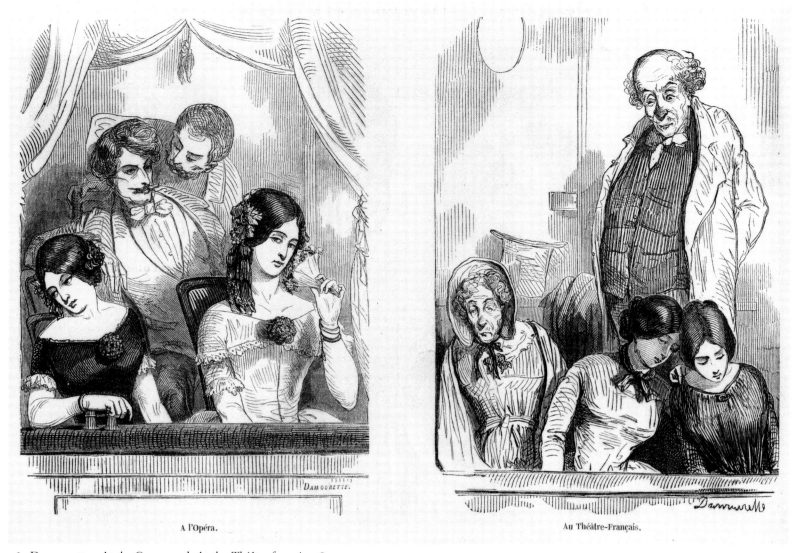

A l'Opéra.

Au Théâtre-Français.

96. Damourette, *At the Opera*, and *At the Théâtre français*, 1852.

The First Outing, the companion is a less important personage, just enough of a female presence to certify the innocence of the protagonist. That the young woman is innocent seems clear, because she has no coquettish mannerisms and is unconscious of being appreciated by the viewer. The sketchily indicated figures of the crowd below and in nearby boxes—their indistinctness keeps the focus on her—seem to be engaged animatedly with one another, but she looks fixedly outward, too new at the theater to be at her ease. Her costume and that of her companion suggest a less grand place than that of *The Loge*, an environment closer to the ones Renoir frequented himself.

We can better appreciate Renoir's image if we compare it to those of other male observers of his time, for example, that jaded conservative Hippolyte Taine, the famous philosopher. Taine's pseudonymous memoirs[8]—he made sure his identity was known—begin with a scene at the Théâtre des Italiens, where the author spots a prince who is ostentatiously sporting two women in his loge, an opera dancer and an actress. Both the anecdote and its appearance at the beginning of this famous book tell us a good deal about the social significance of the theater box. Taine was one of those repressed men who took a

rather prurient interest in the affairs of others. He went often to the theater to indulge his indignation—twice a week at one period, he informs us. At the Italiens he saw a young woman who, though a class above Renoir's, reminds us of *The First Outing*. Taine, the good bourgeois whose book is full of estimates of money value, claims to be annoyed by the thoughtless, unproductive display of wealth she represents. His real feelings show in his obsession with her:

A charming young girl of sixteen in the third box, front. Her father and mother accompany her; sometimes the brother also, an *élégant*, a member of the Jockey Club...; quite regularly also, a great tall fellow...probably a husband in expectation. She is a happy child, wealthy, born in splendor.... Such a person is a rare creature in this world of enriched plebeians, ambitious workers, forever smarting under some trouble, or eaten up by covetous desires. I have been watching her five or six evenings; she refreshes and relaxes me. A very pretty toilette night before last; a waist of blue silk, close-fitting and showing her figure; rising a little in front upon the bosom; above, a soft nest of lace. Very modest and still very young, her dress is cut quite high

97. Renoir, *The First Outing*, 1875–76. London, National Gallery.

in the neck; a simple rose in her hair.... It is clear that she is at her ease; that she does not dream of rivalries, of intrigue, of coquetry; that she has never had a thought for money.... She is here, because it is a fashionable place, because she has nothing to do, because from the box a review can be had of the gay world.... Of the one hundred and twenty francs that the box cost [i.e., seasonal rental], she has never thought a moment. She would be very much surprised if she were told that [it] would pay the room rent of one of the women who open the boxes.[9]

Taine was the typical bourgeois, caught between jealousy of the upper class and fear of "ambitious workers." Renoir, unashamed of the workers, saleswomen, and models among whom he lived in Montmartre, looked upwards with a frankness that Taine lacked. As a consequence, his images of women in their loges have an honesty and directness that are their strength, that induce us to accept their sensuality as undemeaning to them. In the late twentieth century, the feminist movement has taught us to be wary of praising such associations of beauty and femininity, lest we limit women to the values men place upon them. The contrast with Taine is helpful here, since it lets us sort out Renoir's view from that philosopher's hypocritical mixture of attraction and censure. One can readily imagine a more incisive view of women than Renoir's—perhaps Manet's was that—but his guilelessness has some claims on morality.

When we turn to Mary Cassatt's paintings of women in theater boxes, we find another kind of picture. Cassatt was younger than Renoir and developed more slowly as an artist. She made a copy of Renoir's *First Outing*, and at least one of her pastels of a theater loge recalls Degas.[10]

However, by the time of her mature works at the end of the 1870s, she was very much on her own. In her initial exhibition with the impressionists, in 1879, she exhibited a painting of her sister Lydia in a theater box, the first of a whole group of works dedicated to women in loges. In 1880 she painted *Woman in Black at the Opera* (Pl. 98), and two years later finished *Two Young Women in a Loge* (Pl. 101). These two are the masterpieces of the series. Both are usually treated as variations upon earlier compositions of Renoir and Degas, and more surprisingly, as owing a great deal to Manet's example (principally because of the color black in the Boston picture). Of course we should compare works in order to isolate each artist's vision, but Cassatt's two painting are no closer to Renoir than he to Degas, or Degas to Manet.

Woman in Black presents a woman in matinee clothing, using her upward-titled opera glasses to scan other loges. Renoir's Nini also has binoculars (Pl. 90), but because she is herself on show, she holds them in her lowered hand. Her consort uses his glasses from the vantage point of the shadows, position of discreet surveillance. In Cassatt's picture, a boorish man in the distance leans out of his box to point his glasses in the viewer's direction, an amusing touch that gives emphasis to the pervasive idea in this generation of spying on one's society (the *flâneur*'s eye!). None of the women in theater boxes by Renoir and Degas is shown using her glasses. Cassatt's woman is the active spectator, and not merely the target of a male viewer's gaze.[11] Her firm gesture and concentrated profile give her an

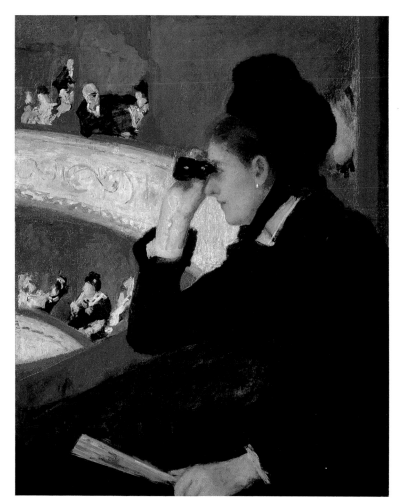

98. Cassatt, *Woman in Black at the Opera*, c. 1879. Boston, Museum of Fine Arts.

99. Cassatt, drawing for *Woman in Black at the Opera*, c. 1879. Boston, Museum of Fine Arts.

air of self-containment, a no-nonsense maturity (she looks strikingly like the artist herself) which is confirmed by her plain costume. We cannot imagine the young woman of Renoir's *First Outing* using opera glasses with such angular assurance.

The tiny preparatory drawing (Pl. 99) for *Woman in Black* reveals the strong pattern which underlies the painting. The

lines of the railing capture the woman's upper arm, and her eyes are already aimed along the edge of the upper railing. The broad front of the balcony embraces the light areas of hand and face, its upper line marked by the edge of the woman's hair. In the oil these decisions were carried out with suitable adjustments. Cassatt formed a whole series of angular shapes which unconsciously fashion our impression of the woman as a forthright, independent person. She widened the red velvet of the railing so that it outlines both sides of the woman's arm, she separated the hat's strap from the collar of the dress to provide a network of parallel diagonals, and made these form a right angle with the top of the hat.

The two young women Cassatt painted in 1882 (Pl. 101) are an entirely different kind of spectator. Modeled after Mary Ellison, a visiting American, and Mallarmé's daughter Geneviève, these twin figures, seated in the full brightness of the impressionist palette, are as much on display as the matronly beauty of Renoir's *Loge* (Pl. 90). What they display, however, is not sensuous maturity, but the rigid correctness of upperclass adolescents, well schooled by their elders in polite demeanor. They had to distinguish themselves from young *cocottes* who would be brought here by certain men, so their stiffness is proof of their social worth. Nor do they wear jewelry (the woman in black at least wears a pearl in her ear), another sign of abnegation appropriate to their age and purity. If they seem a bit priggish compared to their contemporary in Renoir's *First Outing*, it is because Cassatt makes them conscious of being on show, of offering no cause for objection by being forward in gesture, look, or manner. Renoir's young girl is much more natural in the plainer theater she sits in, because she is innocent of any feeling of being on view as the representative of family and class.

Our reading of Cassatt's painting is much influenced by our realization that the two girls are a class above Renoir's *ingénue* (and Cassatt, a class above Renoir). We deduce that from their costume and their location. The bare-shouldered dress, after all, reveals a lot of flesh, unlike Renoir's figure (uniformly described by historians as more sensual), but we accept it as the formal wear suitable to their station in life. We know that they are in a high-class theater from the reflection in the mirror, and further, that they sit in one of the expensive lower boxes close to the stage. The mirror is almost as curious as Manet's in *A Bar at the Folies-Bergère* (Pl. 80), but the reflection of one girl's shoulder off to the right indicates that they are seated at a slant to it, and that it therefore shows the opposite side of the theater at an inward angle. The advantage to Cassatt is that the reflection first says "theater!" then, even after we locate the loge, it enframes the young women as though they were in the middle of the whole space (she used a mirror to the same effect in the 1879 picture of her sister, mentioned above).

Here we should look at another painting by Renoir to make clear the particular nature of Cassatt's construction. *At the Concert* (Pl. 100), sold to a dealer in 1880, was exhibited with the impressionists in 1882. Circumstantial evidence points to its having been initially a commissioned family portrait.[12] The head and shoulders of a man, painted out, now show through in the upper right, and the obvious way the subjects' arms frame the sheet of music and the bouquet reveals the thin fiction of a converted portrait piece. We look into an opera

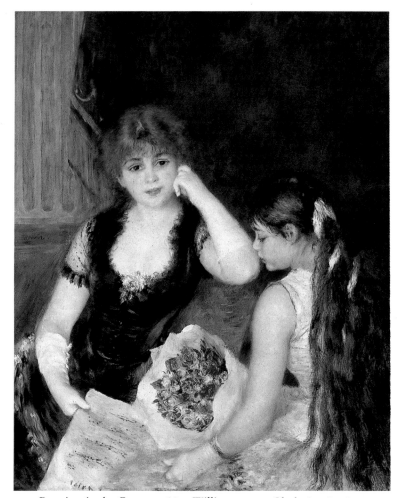

100. Renoir, *At the Concert*, 1880. Williamstown, Clark Art Institute.

loge where Renoir has a beautiful, upper-class woman adopt a pose favored earlier in the century by the great portraitist Ingres. Unlike Nini in the painting of 1874 (Pl. 90), she is seated well inside the loge and is not on public view. Her daughter (or young guest) is properly deferential.

Cassatt could also have represented one or both or her youthful models as dutiful daughters, but instead she chose to demonstrate their coming independence. She set one off against the other to remind us of two sides of adolescence. The mirror prompts us to think that the left figure is another version of the one to the right, her shyer self. She shields herself with her fan and forms a barrier with her arms. Even her flowers are more reticent, just scumbled color notes on her fan. Her companion, despite her stiffness, is more sure of herself, more fully three-dimensional. She appears especially forthright and independent when compared with the submissive girl in Renoir's *At the Concert*.

One of Cassatt's more subtle touches is the way she positions the viewer. We are slightly below the two girls, and this puts them on a visual pedestal. They are sculptural and aloof in another sense, as well. Their twinning recalls the repeated forms of antique bas-relief, an effect augmented by the geometry and the flatness of the fan, the wrapped arms and the repeated angles of elbows, fan, and bouquet paper. These flat angles, and the way the fan's curve is continued by one figure's elbows and the other's shoulder, bring about a merging of

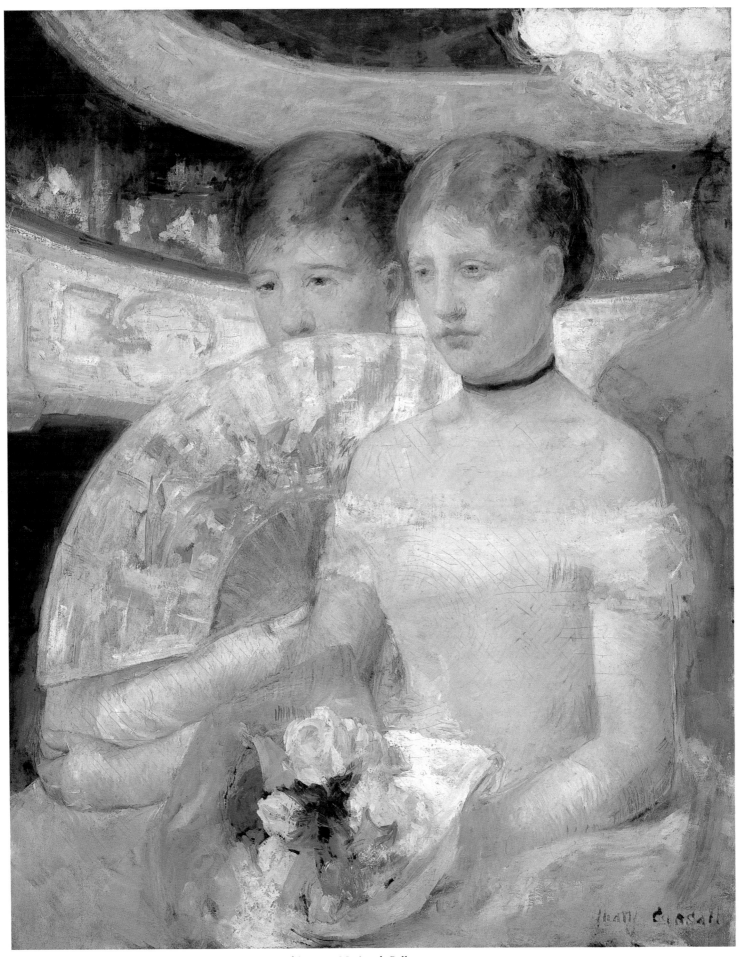

101. Cassatt, *Two Young Women in a Loge*, 1882. Washington, National Gallery.

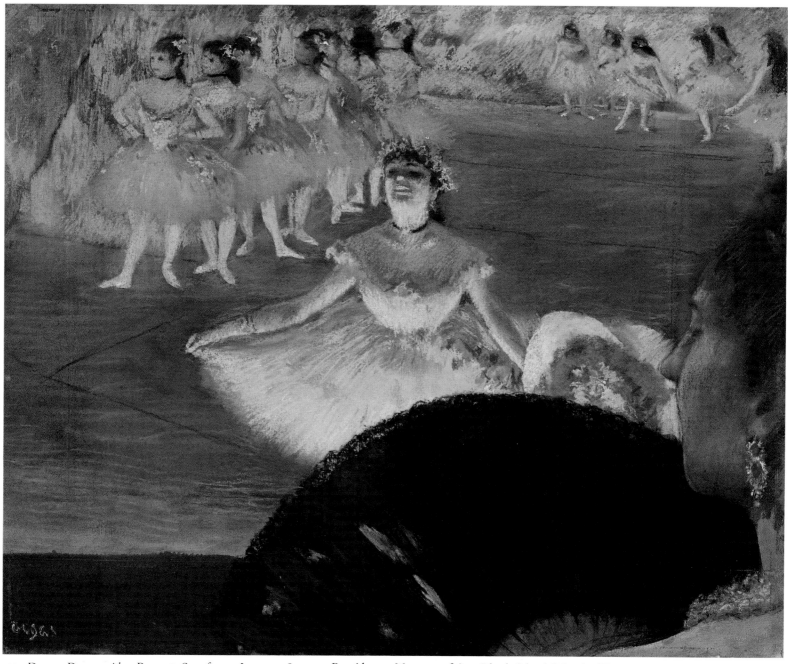

102. Degas, *Dancer with a Bouquet, Seen from a Loge*, c. 1877–79. Providence, Museum of Art, Rhode Island School of Design.

surface and illusion. Of course, within her shallow space Cassatt had to give a satisfactory sense of depth, and this she did by correlating brushwork, color, and image. From the bouquet to the fan, then to the reflected balcony, we shift towards progressively less intense color and less distinct brushstrokes.

The large fan and the geometric rhythms of Cassatt's picture have led art historians to declare its debt to an earlier Degas, *Dancer with a Bouquet, Seen from a Loge* (Pl. 102), of about 1878. It is true that this composition inspired her pastel of 1879, *Young Woman in a Loge Holding a Fan*, but that was a piece of apprenticeship soon left behind. It seems more logical to differentiate Cassatt's work from this Degas and from his other pastels that show spectators in opera loges. In *The Loge* (Pl. 60), which was discussed at the end of Chapter Two, we discovered a singular mood of aloneness which we now know

is entirely foreign to the conceptions of both Cassatt and Renoir. In most of his other works on this theme, Degas places us inside the loge, looking out over the stage, a vantage point never taken by his two contemporaries.

Dancer with a Bouquet was initially a monotype which showed the stage without loge or woman in the foreground. When he reworked it with pastels, Degas added strips of paper to bottom and right sides to accommodate the loge.[13] One can imagine his moving various pieces of paper about until he found the minimum that would convey what he sought: loge railing, fan, and profile. The flatness of the railing and fan, owing to their geometry as well as to their placement parallel to the surface, is a startling departure from traditional art which provided more transitions between foreground and distance. To integrate his dark loge with the brightly lit stage, despite this abruptness, Degas formed a strong diagonal

connecting the woman and her fan first to the dancer taking her bow, then to the group of blue-skirted dancers, and finally to the green flat behind them. He also made a pun of the fan shape, repeated in the lead dancer's tutu, her shoulders and bodice, and in the overall shape of the group of dancers behind her, puns which unify the whole thanks to their echoing geometry (he also has his spectator sniff the dancer's flowers).

Other loge views by Degas are as artfully contrived, but more dynamic in their arrangements. The later *At the Ballet, Woman with a Fan* (Pl. 103) is all angles, compared with *Dancer with a Bouquet*, and much more animated. The woman's body and her fan slant inwards at opposing angles, the edge of the loge is also at an angle, and the dancer taking her bow has none of the stability of her counterpart in the other pastel. The agitation of this scene is expressed also by the headless dancers who skitter across the upper stage. Degas could not resist his own wit, so he made more puns between stage and loge: the claw-like hand on the railing and the adjacent dancer's hand; the spectator's glance, steered by her nose, and the responding bend of the dancer's head. These puns have a bit of Degas's mockery in them as he makes society matrons confront ballet dancers. For that reason we are inclined to equate his manipulation of artistic means with manipulation of people. We should not forget, however, that Cassatt and Renoir handled their figures just as arbitrarily—but to different ends.

103. Degas, *At the Ballet, Woman with a Fan*, c. 1883–85. Philadelphia Museum of Art.

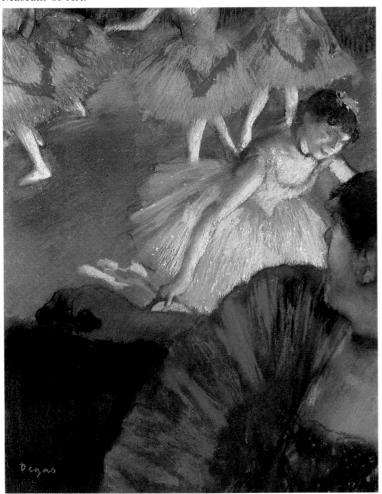

In Degas's two pastels that we have been looking at, he has us stand or sit immediately behind a woman, so that we look beyond her partial profile to the ballet dancers. This makes us into a spectator twice over. We look at the stage, but also at another operagoer (in Degas's day ballet was always an interlude in an opera), a complication of the viewer's role avoided by Cassatt and Renoir. In their pictures we are the traditional "fly on the wall," the viewer without a strong fictional presence, therefore we do not share with their figures the sight of the stage. The audience alone constitutes our spectacle. In Degas's loge views, we cannot disregard our imaginary presence. We assume the position of a man, standing or seated behind our companion (not next to her, the place of another woman), and a wealthy man at that, for in these compositions we are invariably located in one of the select boxes overlooking the stage. Because we see so little of the woman in front of us, we cannot read into her any of the character Renoir and Cassatt gave to their figures. We see just enough to confirm her social standing: she is matronly, and appropriately dressed (an impressive blue earring in one case, an expensive gown in another). Lacking personal qualities, she is a mere feminine and class presence, a social attribute. Neither Cassatt nor Renoir would have reduced women to such fragments, even had they concerned themselves with stage performance. Renoir did not have Degas's upper-class irony, the privileged view from the front box, and Cassatt did not have Degas's cynicism—nor his maleness.

The Privileged View

The boxes over the stage, and those nearest to it, indeed gave the privileged view. The highest privilege of all went to the Emperor, who had perennial claim on three front boxes. He was widely reported to have had no love of opera, but felt obliged to appear frequently in this arena of social display. He would arrive with an ostentatious military escort suitable not only to his safety (he was nearly assassinated in front of the Opéra in 1858), but also to the importance his government granted to the "Imperial Academy of Music," the official name of the Opéra. In 1861, the architect Charles Garnier was put in charge of a new opera building that was to crown the future avenue de l'Opéra. It was the most important new structure of the Second Empire, the hub of the redesigned area crossed by the *grands boulevards*. Vast sums were poured into it, but it was completed only under the Third Republic, in 1875. Meanwhile, the old Opéra on the nearby rue LePeletier was the beneficiary of huge government subsidies, amounting annually to 900,000 francs at the end of the Empire. Its importance can be gauged by the size of its personnel. They numbered 650, and were paid 1,700,000 francs a year.[14]

The Emperor could not move freely backstage at the Opéra, as could other important men, but he could treat the imperial loge as the temporary quarter-deck of his power. He was not at all bashful about using his perch to scout out beautiful women, for example, and contemporaries remarked on the boldness with which he wielded his opera glasses, fixing them on a woman (usually *the* woman of the evening) long enough to embarrass Eugénie.[15] Such actions confirmed his reputation as a womanizer. Like other powerful men—and partly to

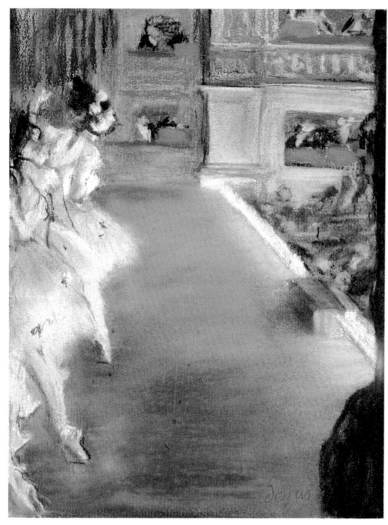

104. Degas, *Dancers at the Old Opera House*, c. 1877. Washington, National Gallery.

prove his regal power—he had quasi-public affairs, beginning with Elisabeth-Anne Haryett from England, and including "la belle Nicchia," the comtesse de Castiglione.

There is one incident that encapsulates much of Louis Napoleon's use of the opera loge. On 25 May 1870, he arrived during the second act of a revival of Weber's *Le Freychutz*. Late arrival showed his disdain of ordinary conventions, all the more so because the paid claque interrupted the performance by standing up to cry "Vive l'Empereur!" The première of Délibe's and Saint-Léon's *Coppélia* formed the second part of the program that evening. Louis Napoleon had heard of Giuseppina Bozzacchi, a sixteen-year-old dancer about to make her debut in the new piece:

> During the interval between the opera and the ballet the Emperor entered a small box, adjoining the Imperial Box and overlooking the stage from behind the curtain, and from there, unobserved, watched the stage being set for the first act of *Coppélia*. His intention had been made known beforehand to [Emile] Perrin, who purposely engaged Giuseppina and the Italian Ambassador in conversation in full view of the little box. The Emperor only rejoined the Empress when the order was given for the rising of the curtain.[16]

We can recapture something of the view, if not the attitude, of the Emperor, thanks to Degas. In the pastels already mentioned (Pls. 102, 103) and in numerous other works, he assumed the vantage point of the Emperor and other stage-box viewers. In *Dancers at the Old Opera House* (Pl. 104) we look out on the stage from a box just below the Emperor's when he was gazing upon Bozzacchi. On the other side we see the stage boxes and front loges, where white and black spots pick out men in formal wear. In *L'Etoile* (Pl. 105) we are in a higher loge, close to the Emperor's private box, and have an uninterrupted view of the dancer making her salute. We also see our opposite number, the man who appears in the wings, more favored even than the stage-box tenants (but he had often descended from one of the front boxes, as we shall see shortly). In the original, his bulbous nose, moustache, and beard show clearly. Added to the impression made by his lurking half-figure, they characterize him as the predatory middle-aged male who looms so large in the opera of Degas's day.

Backstage at the opera was the veritable fiefdom of wealthy men, who treated the ballet dancers as a kind of game preserve. Subscribers to the principal loges had ready access to the dancers' foyer known as the "green room" (Pl. 107), to corridors and dancers' dressing rooms, and to the wings of the stage, even during performances. Degas represented them making free of all these places in any number of paintings, pastels and prints. In *The Curtain* (Pl. 106), for example, one subscriber stands with seigneurial casualness, looking into the stage during preparations for a performance. He is the only figure who is nearly intact; all the others consist of fragments. Next to him a dancer darts to the right, while on the far side, half-hidden by a flat, are two subscribers, one whose arm rests on a cane, another who shows only part of a leg. Further back, where a rising curtain reveals the legs of two groups of dancers, there is another pair of male trousers off to the right. Their owner is apparently talking with the black-stockinged dancer whose feet face his.[17]

This pantomime of male and female legs, typically impressionist in its apparent informality and spontaneity, is another of Degas's wily formulations in which artistic structure supports social revelations. Dancers' legs were the essence of their profession and also the favored sign of their sexuality. Their appearance under a rising curtain becomes a disclosure, with a hint of expectancy, if not of outright peeping. The men on the left, because they are partly hidden, seem staked out, awaiting the unveiling, while the principal man stares upstage; his hat brim coincides with the curtain's edge to emphasize this exact moment.

The territorial rights of the male subscribers had long been recognized, and widely commented upon, without much disguise. Gavarni, Guys, and Daumier, those great illustrators of the preceding generation whom Degas especially loved, made much of these relationships, and conventional views of backstage at the opera invariably showed older men hovering closely over the dancers (Pl. 107). By the 1860s, popular stereoscopic photographs, commercially distributed on the boulevards, showed dancers and their male admirers in the green room.[18] Hippolyte Taine waxed indignant at this "market for girls," and linked the opera with other Parisian entertainments by

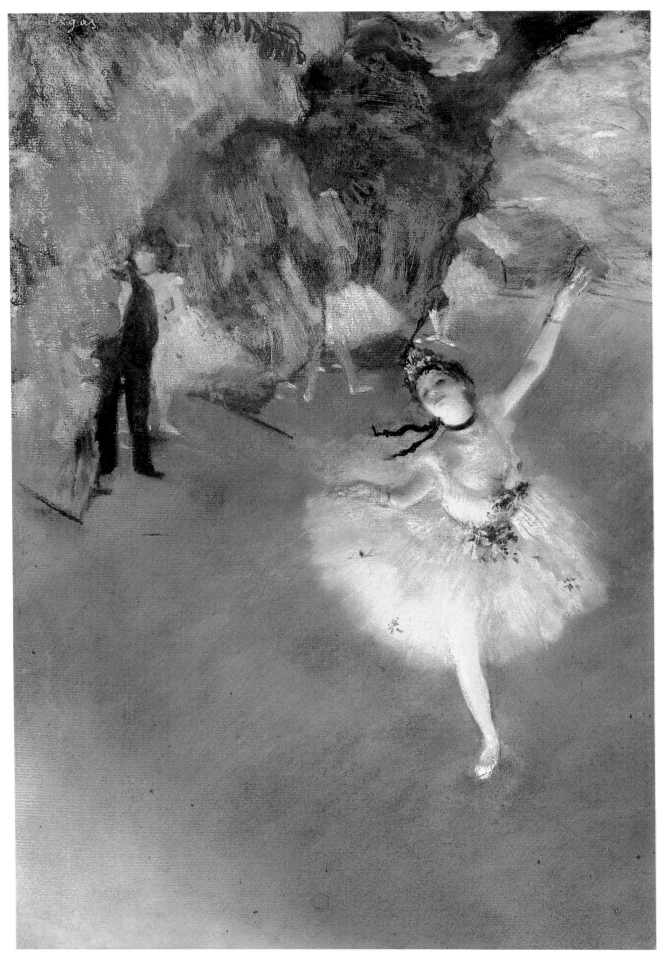

105. Degas, *L'Etoile*, c. 1878. Musée d'Orsay.

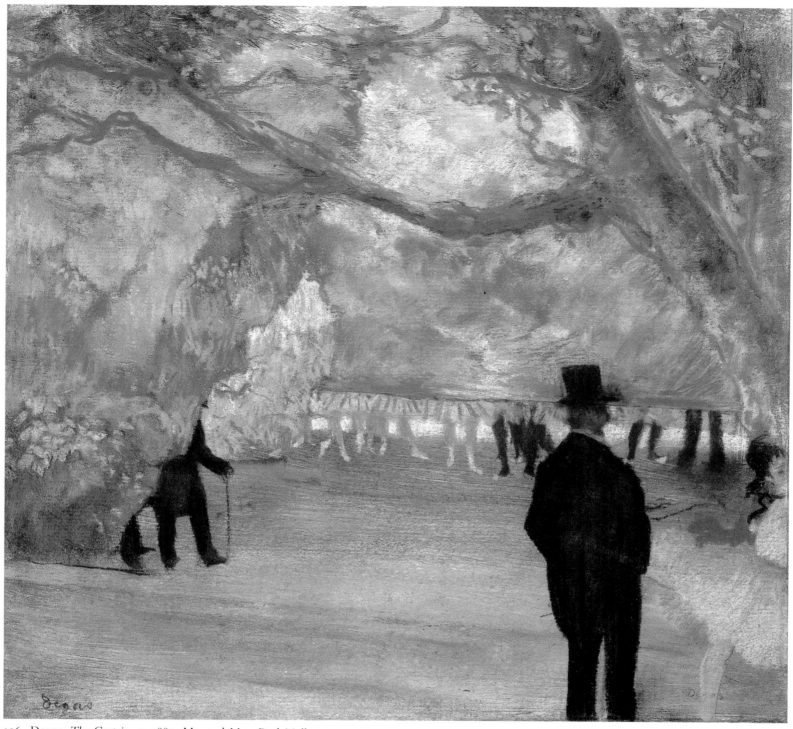

106. Degas, *The Curtain*, c. 1880. Mr. and Mrs. Paul Mellon.

claiming that "the audience is made up three-fourths of mere pleasure-seekers, who come to listen to a grand dramatic poem as they would go to the café or the vaudeville." Consistent in his hypocrisy, he blames the dancers, who have "all the gestures and little vulgar tricks of the trade. A nauseous voluptuousness to suit the customer."[19] (A frequent guest of princesse Mathilde, he made no mention of her notorious liaison with comte Nieuwerkerke, the minister of fine arts; upper-class sex was not vulgar.)

The issue had been dealt with openly by the popular guide-book author Eugène Chapus in *Le Sport à Paris*. It seemed appropriate in a book on sport to comment on the opera, where the eager backstagers were generally called "lions":

Despite the measures that were destined to thin out the crowds of visitors backstage at the Opéra, one only succeeded, curious thing! in eliminating a few feuilleton writers, also some authors and composers. There is no room for professional curiosity. But, if only you are a financier, an invester wearing yellow gloves, a stockbroker, a rich foreigner, a diplomat, an embassy attaché, a man of the world in high repute; if only you have influence in

powerful places; if only, again, you can fabricate for your-self a more or less real title...; if only you are something like the uncle of a dancer or her *protector*, the tutor of a *panther* or her mahout, then the portals become open to you.... Many serious men whom one thinks occupied by weighty business, many financiers whom one imagines in their clubs smoking and playing whist, many diplomats whom one believes circulating in high society...are there, in the evening, finding fantastic shelter amidst the hubbub behind the scenes of the Opéra. [Pp. 242–3]

In Degas's day, members of the prestigious Jockey Club dominated the "lions." Money and prestige guaranteed their favor with the opera's managers, and some of their members were on the governing board. In a famous incident in March 1861, Richard Wagner learned of their power. Ballet interludes were normally placed in the second acts of operas to allow the Jockey Club lions (like the Emperor himself!) to return at leisure from their supper beforehand, to which they often took their mistresses from the dance corps. Furious at the German composer for inserting his ballet in the first act of *Tannhäuser*, they whistled in unison to disrupt the performance. Eventually, when the new Opéra opened in 1875, the lions lost much of their power, but in the Second Empire, about fifty members of "le Jockey" occupied seven loges and reigned over the dancers' backstage foyer. The fifty men did not crowd into their loges on the same night, but took either Monday, Wednesday, or Friday night in regular cycle. The duc de Morny, a member of the opera board from 1855 on-ward, alternated with the government minister Fould and General Fleury (Morny took Fridays). Among those sub-scribers listed for 1865, Degas's friend vicomte Lepic had a ground-floor loge near those of comte LeHon and the duc d'Albuféra.[20]

Backstage with Halévy and Degas

It is the duc de Morny who should draw our attention for a moment, since he was the patron of one of Degas's closest friends, Ludovic Halévy. The lives of Morny and Halévy are well documented and very rewarding for the study of Degas's own role as a backstager at the opera. The artist's devotion to dancers at the opera cannot readily be understood unless we examine the roles of powerful men. Morny was second only to the Emperor in power and a man of great subtlety and intellect. His multifarious activities had far-reaching effects in the worlds of opera, theater, operetta, horse racing, and painting. To become acquainted with him is to learn a good deal about the interlocking domains of politics, finance, high society, and the arts. (He was also one of the creators of Deauville and will reappear in the last chapter.)

Morny was Louis Napoleon's half-brother, the illegitimate son of the Emperor's mother, Queen Hortense, and General de Flahaut. A key figure in the coup d'état of 1851, he was made president of the legislative body by the Emperor. His fortune came in the usual ways: sugar beets, newspapers, and real estate, and the growing railroad network. A social lion, he was a leading member of the Jockey Club (we shall also encounter him in the next chapter, when Degas's racetrack

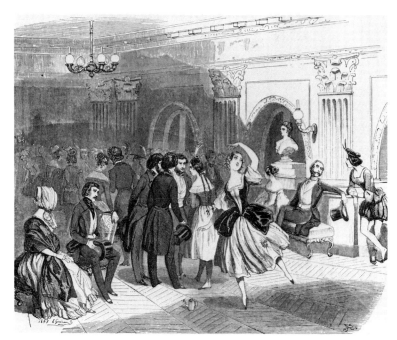

107. Guérard, *Foyer de la danse, à l'Opéra*, 1843.

paintings are discussed) and one of the premier hosts of Paris. His liaison with comtesse LeHon was public knowledge and enhanced, rather than diminished, the reputations of both. Morny was, in other words, a typical upstart of the Second Empire (his title was invented in 1862 by his half-brother). In his official residence he had an art gallery with an up-to-date collection consisting of important Dutch pictures (a mid-century taste) and works by established contemporaries: Delacroix, Théodore Rousseau, Ziem, Gérôme, Meissonier, Robert-Fleury, and others. The public could apply in writing to see the "musée Morny," and the gallery was used as a re-ception room for guests waiting to enter Morny's theater.[21]

For the duke indeed had his own theater. He prided him-self on his artistic talents, wrote poetry, songs, plays, and operettas. He cultivated playwrights, musicians, and critics who knew how to add to his luster. Offenbach and Théophile Gautier labored in this high-class vineyard, and so did Degas's intimate friend, the young Ludovic Halévy (1834–1908). He came under Morny's wing in 1860 along with Offenbach for whom he had already written libretti. Halévy and the illustrious musician wrote music and words for a number of short pieces which Morny presented under the pseudonym "Saint-Rémy" in his own theater, in the homes of society friends, at the imperial château of Compiègne, and occas-ionally in public theaters, including Offenbach's Bouffes parisiens. Halévy, already a government functionary before he met Morny, used his new connection to be named re-cording secretary of the legislative corps in 1861, a post he kept until about the time of Morny's death in 1865.

Degas, a schoolmate of Halévy, may have kept abreast of all this activity, but it is only in the following decades that the two are known to have associated closely at the opera and the theater. Degas collaborated with Halévy and his partner Meilhac in writing and staging *The Grasshopper* (*La Cigale*) in 1877, a comedy that satirized impressionist painters.[22] In the late 1870s or early 1880s, Degas devoted a whole series of

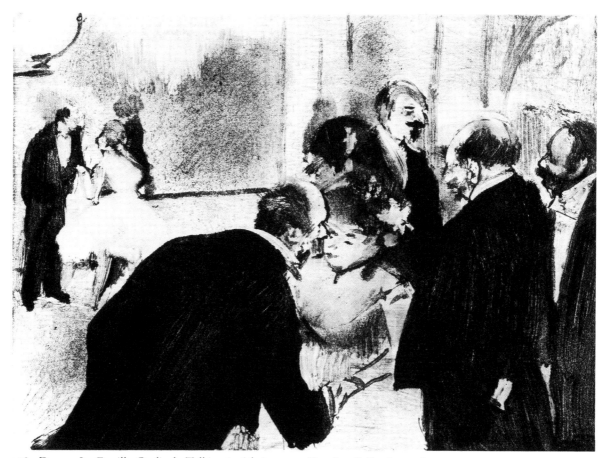

108. Degas, *La Famille Cardinal: Talking to Admirers*, c. 1880–83. Collection unknown.

109. Degas, *La Famille Cardinal: Pauline and Virginie Conversing with Admirers*, c. 1880–83. Collection unknown.

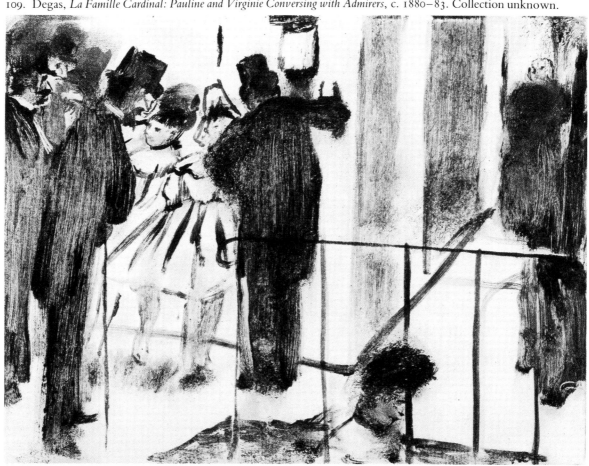

monotypes to Halévy's stories of opera intrigue grouped under the title *La Famille Cardinal*. It is not at all certain that Halévy ever sanctioned his friend's venture—Degas's suite was never published in their lifetimes—but the monotypes reveal a geat deal about both men, and about life behind the scenes at the opera.[23]

Halévy's notebook for 6 April, tells of his eavesdropping backstage at the Opéra, where Mme Cardinal was talking with a cast-off lover of her daughter Virginie. From this and other observations Halévy constructed several short stories around the lower-class family whose two daughters Pauline and Virginie were ballet dancers. Mme Cardinal, one of the many mothers who watched over their adolescent daughters backstage, closely shepherded their love affairs towards the most lucrative marriages possible (hence Halévy's ironic use of Bernardin de Saint-Pierre's famous youthful innocents, *Paul et Virginie*). In *Talking to Admirers* (Pl. 108), Degas assimilated the two daughters with traditional representations of the green room, a veritable salon for the dancers and their "protectors" (Pl. 107). The dancer in the foreground appears older than the Cardinal sisters, but Degas did not attempt literal interpretations of Halévy's texts. Her dissipated look suits her career as a mantrap. The men, equally caricatured, are balding, middle-aged connoisseurs of flesh and fame.

In *Pauline and Virginie Conversing with Admirers* (Pl. 109) the two sisters, who appear younger if not more innocent, are in one of the corridors of the old Opéra. They are surrounded by four men identified by Halévy as himself (for he figures in the story), a senator, a secretary of a foreign embassy, and a painter. They were pressing the sisters to dine with them the next day, but the ever-vigilant mother intervened—Degas has her shadowy figure approach from the upper right—and arranged things to suit appearances while forwarding her daughters' chances.[24]

In both monotypes, as in others of this series (nearly forty altogether, plus an equal number of associated prints and drawings), Degas extracted a lot from a technique whose graphic nature so well suits the subject. With brush, rag, and fingers, he applied black ink to a plate, laid a sheet of paper over it, and put it through a press to produce a unique strong impression (sometimes followed by other, fainter ones). He used a brush to sketch in the dancers, the lines of railing, corridor, and walls, and a rag to form the dark masses of the men (hence the visible streaks). Before printing, he wiped away some of the ink to fix the men's contours, most conspicuously the jagged right side of the man with his arm on the wall of the corridor, and the sloping left edges of the two men facing the central dancer in the other print. The silhouettes alone convey much of the bite of the shrewd characterizations in the corridor scene, but they have nearly as strong a role in the view of the green room, even though facial caricatures seem to control our first reaction.

It is fitting that Degas's most sustained body of illustrations was devoted to Halévy's *La Famille Cardinal* (other monotypes, pastels, and paintings fall into groups, but do not form narrative sequences). Each man was a satirist in his own realm, and each found material in the opera. It is no accident that Halévy placed his partly fictional, partly real self and "a painter" among the men paying court to the Cardinal sisters.

Owing to extensive acquaintance among Opéra personnel, both men were allowed to roam the corridors. Halévy's uncle, the composer Fromenthal Halévy, had directed the chorus of the Opéra, and his father Léon was a well-known playwright who moved in the same privileged circles, so the son was intimate with the Opéra from an early age. Degas's access to backstage was presumably provided by any number of friends: Halévy, the box-subscriber Lepic, the cellist and composer Pillet, the bassoonist Désiré Dihau, and several of the ballet teachers, including François Mérante. The two had many friends in common. These included Albert Boulanger-Cavé, a noted backstage dandy, the painters Gustave Moreau and Jacques-Emile Blanche, the opera singer Rose Caron, and the composer Georges Bizet, whom Degas had met when both were students in Rome, and for whom Halévy and Meilhac wrote the libretto for *Carmen* (produced in 1875). In 1879, Degas protrayed Cavé and Halévy standing in the wings of the Opéra (Pl. 110).

Halévy's familiarity with Opéra corridors and dressing

110. Degas, *Halévy and Cavé Backstage at the Opéra*, 1878–79. Musée d'Orsay.

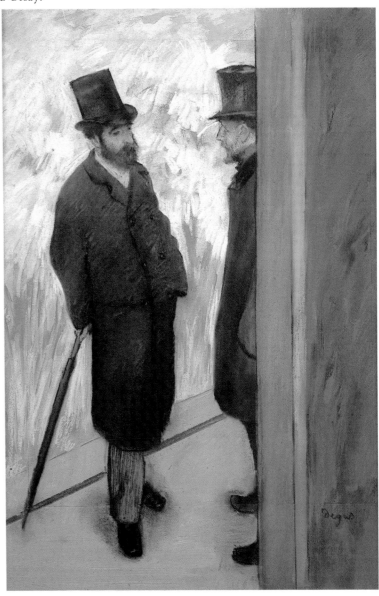

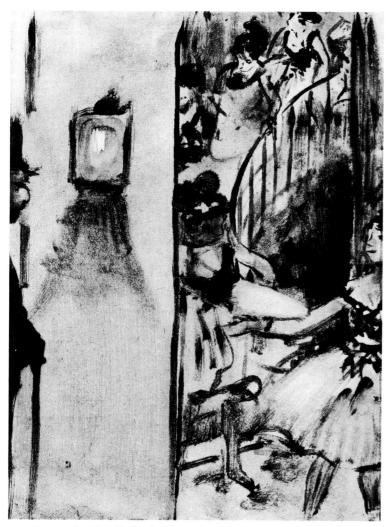

111. Degas, *La Famille Cardinal: Dancers Coming from the Dressing Rooms,* c. 1880–83. Collection unknown.

flats and corridor walls, these rectangular areas both reveal and conceal: partial concealment makes disclosure all the more intriguing. Here we see a star dancer whose pink tutu is being adjusted by an assistant or her mother (mothers often took on this role), crouched down behind her. To her left, only noticed upon a second glance, is the profile of a mustachioed man in formal dress, watching. In another pastel (Pl. 112), male pride of possession is more baldly revealed. The "protector" has left his chair to watch the last-minute adjustment of his dancer's blue tutu. His cane, like the protruding musical instruments in other compositions, has a waggish masculine aspect, but his eager, crouching stare is the chief give-away of sexual absorption. Even so, Degas is quite restrained, if not subtle, compared to imitators like Jean-Louis Forain and Jean Béraud, who show dancers literally jumping into the laps of their sugar daddies, or men openly fondling dancers behind the scenes.

The sexual commerce that Degas disclosed in his pastels (he showed Plate 113 in the fourth impressionist exhibition in 1879) was a central fact of Parisian society. The subjection of young dancers by Jockey Club members was a *raison d'être* of members' association with the opera. They were not at all averse to their exploits being known, if appropriately screened by innuendo and limited to knowing sniggers. Baron Hauss-

112. Degas, *Dancer's Dressing Room,* c. 1878. Private collection.

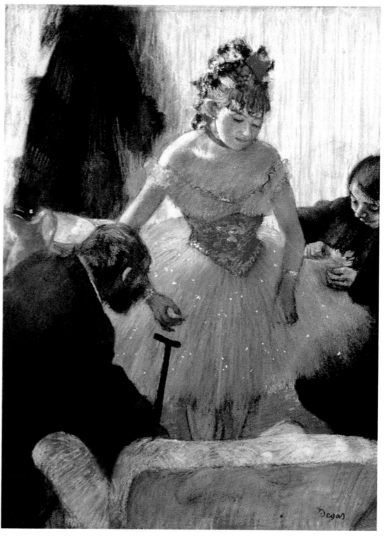

rooms is recorded in his notebooks and given witness in *La Famille Cardinal.* In his series, Degas represented Halévy in nine different monotypes. In formal dress and top hat, he talks with Mme Cardinal behind stage flats, in corridors, and in dressing rooms. Less distinctly rendered, Halévy watches dancers descend a staircase in two other monotypes. In *Dancers Coming from the Dressing Rooms* (Pl. 111), a summarily indicated Halévy—the partial figure again suggests the act of spying—stands near a gaslight while

> fifteen or so young persons who, chatting, laughing, crying out, arguing, or shoving, descended like an avalanche.... I respectfully made room for this agreeable freshet, and the whole little company, natty, décolleté, dressed in silk and satin, tumbled nimbly down the stairs.[25]

Degas's intimacy with the same scenes shows not only in his suite of monotypes, but also in the large body of his paintings, pastels, and drawings. Some of them have the character of Halévy's observations, although no specific texts are known for them, nor are any needed. In *Dancer in Her Dressing Room* (Pl. 113), we are positioned in a corridor, looking into a dressing room. To specify our location, Degas devoted one-third of his composition to the inward-slanting door on the right, and gave the door jamb a narrow strip on the left. Like stage

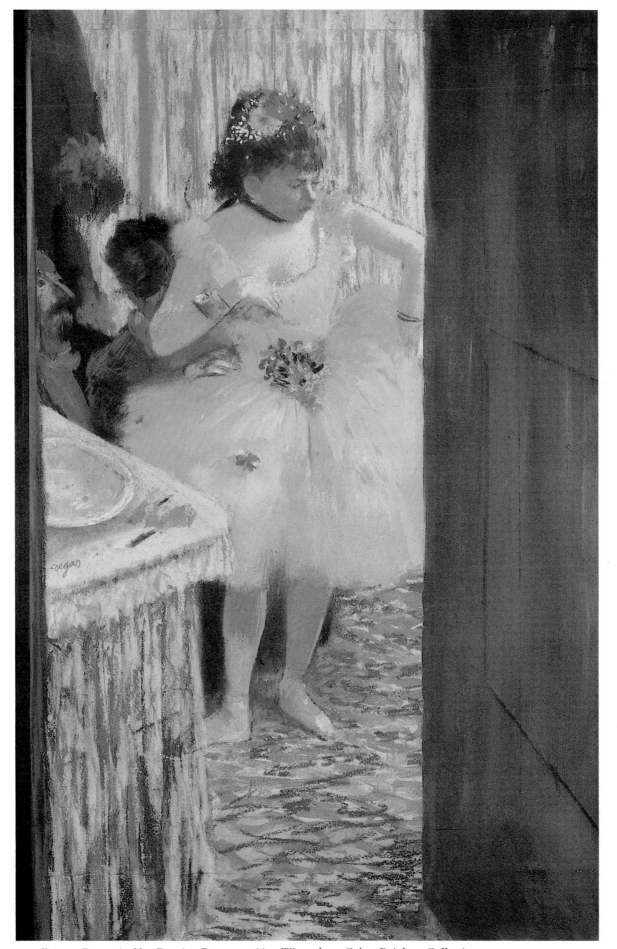

113. Degas, *Dancer in Her Dressing Room*, c. 1880. Winterthur, Oskar Reinhart Collection.

mann, for example, went out driving with his mistress, the ballet dancer Francine Cellier. She dressed like his daughter, a disguise that must have been transparent to his male cronies (as it certainly was to the ballet corps). When his wife temporarily left him, Haussmann gave up Cellier under the threat of public disclosure.[26] Halévy and Degas were discreet, of course, in their fictionalized revelations, and as long as real persons were not identified, their disclosures could be readily appreciated by the class of men they put on exhibit. Such men could more easily accept Halévy than Degas, one assumes, because of his irony and humor. Degas may possibly have made these men more uncomfortable than Halévy (this was true in conversation: his mordant wit made him feared), because his images, unmediated by humor, removed more of the veil of polite discourse that partly disguised these relationships. His sense of humor was much more biting than Halévy's, and his irony more sardonic. Where Halévy provoked laughter, Degas brought out a disdainful smile. Where Halévy saw foibles, he saw pitiful weaknesses. We should remember, nonetheless, that his monotypes, had they been published, would have been greeted as illustrations, a more permissive category than oils or pastels exhibited as "works of art." In those, Degas was much more circumspect.

For all their differences, both Halévy and Degas found in the corridors and dressing rooms of the Opéra a truer world than the sham one of public morality, and a more human world, because truer. Siegfried Kracauer, as brilliant on Halévy as he is on Offenbach, wrote of him in terms that could apply also to Degas:

A man with an inexhaustible sense of wonder, he strolled through life, observing the worlds of art, fashion, and politics, and his exploration of Second Empire society certainly gave him a greater knowledge of it than most of his contemporaries. He knew its shams, it realities, and its corruption, saw how the strings were pulled behind the scenes to move the marionettes hither and thither, and he succumbed to none of the current illusions himself.[27]

Degas and Halévy seem admirable because of their penetration and the quality of their art, also because of their lack of cant compared with the men they lampooned. Still, they enjoyed some of the privileges of the lions. Unlike ordinary citizens, they could go backstage, consort with the dancers, and use them...in their art. Ironic detachment and not crude exploitation determined their actions, but they both shared the views of upper-class men. Because Mme Cardinal was a veritable procuress, and her daughters, lower-class vamps, their male pursuers were blameless.

Also like Jockey Club members, both artists looked in from the wings, and this in a metaphorical as well as in a literal sense. The ironic objectivity that they maintained gave them enough distance from their peers to act as critics, but they were no social rebels. Halévy's case is clearer because of his voluminous writings. He thrived under Second Empire censorship because he helped provide his contemporaries with the outlets of satire and laughter through which passed the vapors of opposition. His mixture of acquiescence and opposition shows in a revealing passage from his notebooks. He was backstage at the Théâtre français in 1866, when battles were

raging in Italy and Germany. While conversing with the mother of one of the actresses, he watched the Emperor roar with laughter at the play (A Man Who Pursues Women [Un monsieur qui suit les femmes]):

Mother Montaland...had made a little hole in the decor so that she could see what impression her daughter Céline made on her sovereign. While talking with this respectable woman, I admired without envying him the calmness of this man who comes to laugh at the Palais-Royal while a million and a half men by his fault, if not his will...were preparing to kill one another in Germany and Italy. While I was thinking of that, Mother Montaland, radiant, nudged my arm and said, "He is ogling Céline." I looked, and sure enough, he was ogling Céline.[28]

Like Halévy, Degas unmasked the hypocrisy of his contemporaries but remained among then (until the bitter withdrawal of his later years), never thinking that his revelations should lead to changes in his society.

This combination of highly critical insights and an inactive, if not impassive social attitude, also underlies Degas's monotypes of sexual encounters in domains outside the walls of the Opéra. He dealt more openly with sex in works not for public viewing, small monotypes, many reworked in pastel, that were known only to a few of the artist's intimates. *Nude Woman Combing her Hair* (Pl. 114) shows a woman being admired by an attentive male. She has the thick body and brilliantly colored stockings that Degas gave his brothel workers, but the well-appointed if gaudy interior more logically suggests the boudoir of a kept woman. There are several such views of private boudoirs, but many monotypes, more than fifty, which represent the most elemental sexual institution, the brothel. *Waiting for the Client* (Pl. 115) typifies the group, for our viewpoint—a neutral one, not one that posits our psychological presence—is from within the salon, the prostitutes' domain. The customer's form, limited to the front edge of his black garb surmounted by a nose and beard, slides into the composition. Although essential to the business, he is usually shown by Degas in this shadowy fashion, as though he were an outsider, almost an intruder. Since he has not yet entered into the transaction, his arrival points more to the commerce involved than to sexual interplay. The insider's vantage point, however, does not imply sympathy with the prostitutes. They are caricatures, with brutish faces and homely poses. Their bestial nature would confirm the belief of most customers that prostitutes are sexual animals, so their animality (and the payment!) relieve one of guilt.[29]

Degas's images of brothels prove that he was aware of the whole spectrum of sexual traffic, and therefore that he himself made the parallels between backstage dalliance and commercial sex. One more image placed alongside his compositions of dancers in their dressing rooms (Pls. 112, 113) will help extend these remarks on the rendering of sexual relations in the impressionist era. Manet's *Nana* of 1877 (Pl. 116) invites the comparison, since it also shows a middle-aged male watching a woman who is dressing. Its differences from Degas are as instructive as its similarities. Zola's novel *Nana* had not been begun in 1877, but its protagonist, the daughter of the alcoholic laundress Gervaise, appeared the previous year in the

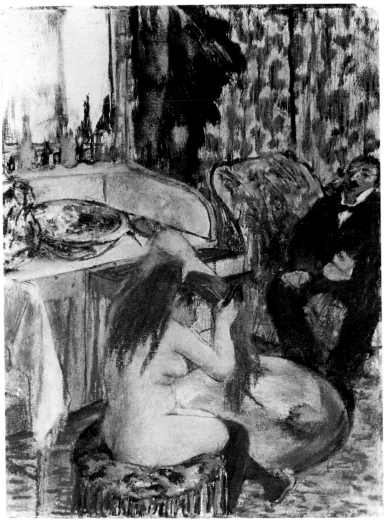

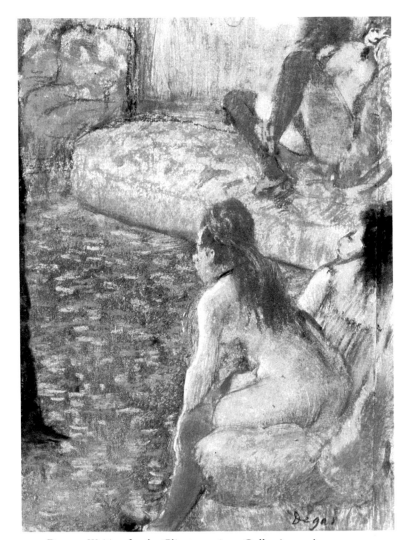

114. Degas, *Nude Woman Combing her Hair*, c. 1877–79. Collection unknown.

115. Degas, *Waiting for the Client*, c. 1879. Collection unknown.

serial publication of *L'Assommoir*. Manet was deliberately courting a scandal by his title, which made certain the identification of his heroine as a courtesan. When the picture was rejected by the Salon jury in 1877, Manet showed it in the window of a shop on the boulevard des Capucines. It provoked strong reactions and was a "succès de boulevard."[30] The top-hatted male keeps his composure, but from his chin and his outstretched leg the golden borders of the sofa reach out to embrace his prize. Some of the *boulevardiers* would have recognized Manet's model, the actress Henriette Hauser, then the mistress of the Prince of Orange (hence her nickname, "Citron"—Lemon). Even had they not, the picture's content is clear. Nana's deshabille is complemented by the satin pillows which extend from her hips like provocative wings. She stands before a mirror as might Venus, the goddess of love, but being impure, she cannot see her reflection. She looks out at the viewer, the alert *cocotte* eager to be admired and always ready to consider another relationship. Like many courtesans in contemporary literature—and the picture's rare defenders in 1877 called upon literary naturalism—she has a saucy independence and seems capable of controlling the man who supports her. To that extent she is a variant upon the notorious

Olympia (Pl. 62), Manet's courtesan of pronounced and disturbing independence, exhibited twelve years earlier. Even the size of the picture adds to Nana's boldness. It is five feet high, compared with two feet for Degas's dressing-room pastels.

One reason that Degas's pictures are smaller than *Nana* is that he had no wish to be a public performer. He would have regarded *Nana* as too brazen, and Manet too declamatory, too lacking in subtlety. Manet conspires with the viewer, so that we are shocked—but amused—by our presence in front of his Nana. Degas's figures do not look out at us, they do not take us into their confidence with a wink or a bold glance. That would be incompatible with the craftiness that was his own strong suit. He hid behind his compositions which he wished viewers to accept as matter-of-fact pieces of contemporary life, all the more convincing because they seem to be chanced upon without the intercession of the artist. We prowl the corridors of the Opéra and peer into dancers' dressing rooms with no one else standing alongside us. Like a skillful detective or a natural scientist concealed in a blind, we examine life in a stealthy fashion that spares involvement with the subject we confront.

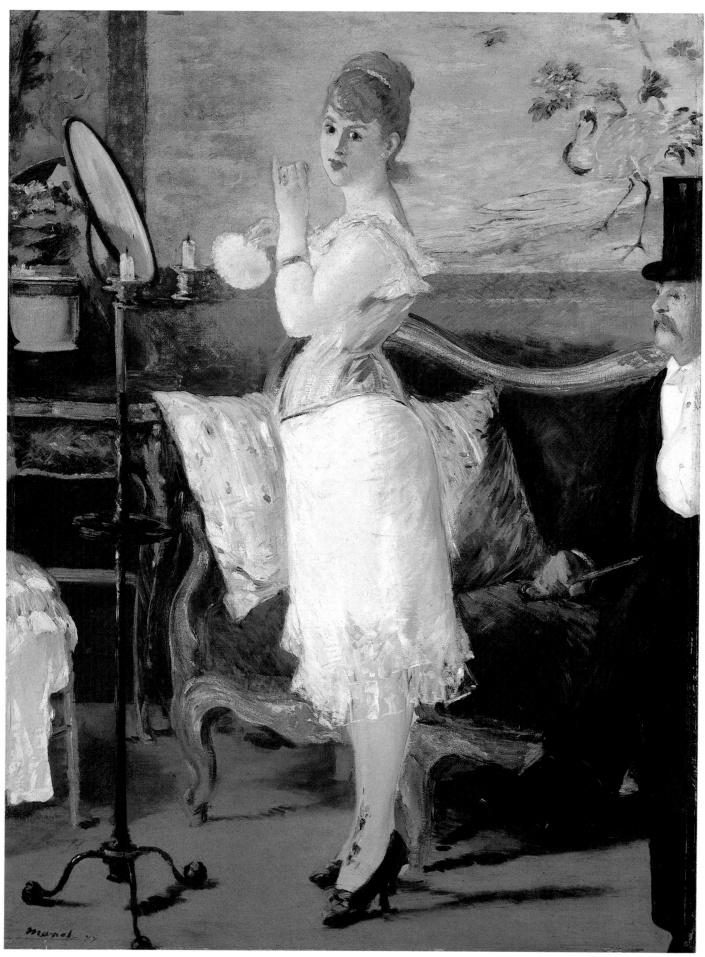

116. Manet, *Nana*, 1877. Hamburg, Kunsthalle.

Mothers and Daughters

Degas's fascination with life backstage at the Opéra extended well beyond the encounters of dancers and the men who laid siege to them. Like Halévy, he frequently met mothers of the dancers, who were such a fixture of rehearsals, corridors, and dressing rooms that they are ubiquitous in nineteenth-century memoirs and histories of the opera. "Ordinarily," wrote Charles de Boigne, "the dancer is not born on the steps of a throne, but she nonetheless *always* has a mother, sometimes a father."[31] Halévy hardly exaggerated when he wrote of a dance examination in 1870 that

> all around, restless, bewildered, breathless, and purple-faced, are mothers, mothers, and yet more mothers.... What serious and delicate matters there are to be considered: that the ribbons of their ballet shoes are securely tied, that their tights have no creases and are firmly fixed about the hips, that the seams are straight, the bows properly tied, and the tarlatan skirts puffed out prettily. The inspection over, the mothers energetically rub chalk on the soles of their daughters' ballet shoes, before embracing them with the words, "Go, my child, take care of your *pointes*, hold your shoulders back, think of your mother, and of your father too, who will curse me and box your ears if you do not get your 800 francs today."[32]

Degas represented mothers in many of the activities Halévy describes. Most frequently they are engaged in adjusting the dancers' costumes (Pls. 119, 121) but often they are standing or seated (Pls. 120, 124), absorbed in their own thoughts, reading, or watching. Only in a few instances do mothers interact with their daughters. Of the two mothers who are prominently featured in *Preparation for the Dance* (Pl. 117), one stands obdurately with hands on hips, while her daughter throws her arms around her neck as though pleading. More commonly such displays of maternal involvement, where shown, are relegated to minor place. In *Monsieur Perrot's Dance Class* (Pl. 128), for example, there is a mother hugging her daughter in the rear of the room.

The reason for the mother's presence is given by Halévy's reference to the child's 800 francs (not a month's wage, but a semi-annual or annual salary for an advanced dancer). At age seven or eight the apprentices began official ballet classes, and studied long hours, without pay, for several years.[33] They had to pass repeatedly through tests in order to be promoted, hence the crucial importance of the examinations that Degas so frequently represented. Only through periodic examinations could they reach the third quadrille, at age nine or ten, when they first received a stipend, 300 francs in the 1860s. This was an important supplement to a working family's income, and if the child attained the rank of *coryphée*, her earnings of 1,500 francs would exceed that of many fathers. The time a mother spent in managing her daughter's progress was therefore an investment, and the family could live in the hope that the daughter might become a *première danseuse* in her late teens, and then earn 10,000 to 20,000 francs: the same chimera that in other domains sustained "individual initiative" and entrepreneurial capitalism.

Before the survivors of examinations could reach those

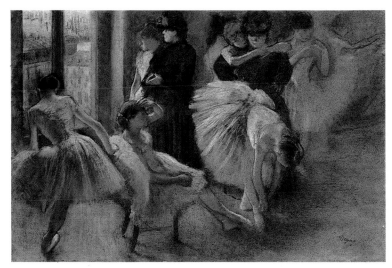

117. Degas, *Preparation for the Dance*, c. 1877. Glasgow, Burrell Collection.

exalted ranks they were indeed poor, and they were fulltime child workers. Schooling ceased when they entered the ballet corps, so the dancers were often illiterate until they patched together a rudimentary education in later years. They worked long hours, morning to evening, ate cold lunches, and walked to and from their homes (most came from some distance away, Montmartre or Belleville).[34] Small wonder, then, that they were prey to the "protectors" who offered money and presents. "I meet an urchin fourteen years old," wrote Halévy in his notebooks of backstage observations. "She is dark as a mole and thin as a rail, but those who attend to this business and know their ropes tell me that she will be charming at eighteen. And already some wretches are bringing her pendants and earrings at twenty-five francs apiece."[35]

Nearly all dancers were from the lower classes, daughters of shop clerks, meat haulers, cab drivers, or concierges. Families above these seldom sent their daughters to the state opera school because of the company they would be keeping. A proper bourgeois girl would literally be descending to the working class were she to become a ballet dancer. These divisions began to break down in the 1880s and were largely dissolved by the turn of the century, owing to the rapid alteration of class structure in Paris. The glamour of the star dancer made her envied and therefore increasingly respectable (some achieved distinguished marriages and then moved in upper-class circles).

In the 1860s and 1870s, signs of the coming breakdown of the old class lines were found in the growing number of daughters of Opéra personnel who joined the ballet. The families of staff members, orchestra musicians, and dance instructors supplied some of the young apprentices, an easier decision for them because they were themselves partly marginalized by their association with the artistic world and generally more liberated in their attitudes. Degas's *Mante Family* (Pl. 118) is a case in point. Mme Mante's husband was a bassoonist in the Opéra orchestra, and all three of their daughters entered the ballet corps at about age seven.[36] Degas shows the two who went on to lifetime careers in the opera (both eventually became dance instructors), Suzanne on the right, born in 1873, and Blanche, one or two years older.

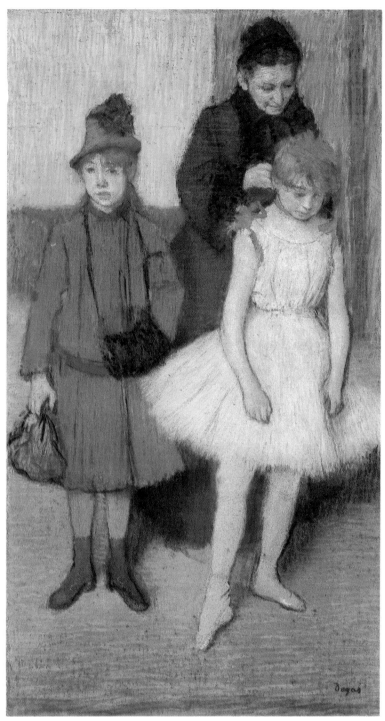

118. Degas, *The Mante Family*, c. 1880. Collection unknown.

Mme Mante smiles slightly as she adjusts Suzanne's hair, while Blanche, in street dress, stands alongside. Mme Mante is not at all like Degas's other mothers, who are often virtual caricatures (Pl. 124, for example), and who exhibit in both clothing and facial features the aspect of working-class women. Although Mme Mante is soberly dressed, she has the open, refined, and intelligent look that Degas gave to middle-class women.

Degas's composition turns on the contrast between the two sisters. Suzanne tilts to the right as she flexes her outstretched foot, and her mother turns in the same direction. Blanche overlaps her mother's outline, but is temporarily neglected,

and glances off to the left. She appears not only bored, but disconsolate.[37] Perhaps she is piqued at her mother's attentions to her sister, or perhaps her own exam is over and she is merely bored while waiting to leave. Degas does not explain the situation, but lets us puzzle over a contrast that he has deliberately constructed: street clothes versus tutu, dark colors versus light, slumped versus upraised shoulders, inactive, frontal pose versus twisted stance, non-dancer versus dancer. The most obvious touch remains effective even after we have recognized its arbitrariness: the isolation of Blanche's head against the swatch of light-colored background. We do not know whether or not Degas observed signs of rivalry between the Mante sisters. It is just as likely that his impatience with conventional portraiture led him to this slight but intriguing look into life among beginning dancers. Already at the outset of his career, in his family group *The Belleli Family*, he had distinguished the temperaments of his cousins' two daughters by giving them different poses. Subsequently, in other pictures of two or more figures he often set one against another with disturbing results. (Pls. 51, 56). There is a context for these unconventional groupings in the efforts of photographers to enliven posed groups in *cartes de visite*, that singular vogue of the late 1850s and 1860s.[38]

Suzanne Mante's pose is repeated in *Before the Rehearsal* (Pl. 119), an asymmetrical and dynamic composition that makes *The Mante Family* seem rather deliberately posed. The repetition of the pose, however, argues for the different effects that Degas created from essentially the same process: the constant rearrangement of his repertoire of poses, like so many manikins, until they settle into new compositions. Suzanne's counterpart, several years older, bends forward as though to examine her feet, the left firmly planted but rotated to the rear, the right stretched out like Suzanne's. Her companion is tensing both legs also, while bending forward to adjust her tights. She can be found, with slight changes, in other drawings and pastels, alone and accompanied by dancers in entirely different positions from that of her comrade here. Crowded into the upper-right quadrant behind the two dancers are two mothers. The older adjusts the skirt of her daughter or granddaughter while the younger looks on. Neither expresses the pleasure shown by Mme Mante, since the work-a-day routine and need for careful appraisal loom larger than affection. J.-K. Huysmans, in his review of this painting in 1880, emphasized the working-class aspect of both mothers and dancers. The older woman is "any old mother," like "a ruddy-faced old concierge," and the younger (he calls her a "comrade" where most others have seen a young mother) is a "vulgar type" in a ludicrous hat:

What truth! What life! How all these figures hold the space, how exactly the light bathes the scene, how the expression of these physiognomies, the searching look of the mother whose hopes rise when her daughter's body unbends, the indifference of comrades for well-known weariness, how these are etched out and noted with the perspicacity of an analyst at once cruel and subtle.[39]

Huysmans may seem to exaggerate when he writes of boredom and fatigue in these figures, but he was assuming that his reader would have anticipated idealized, prettified dancers,

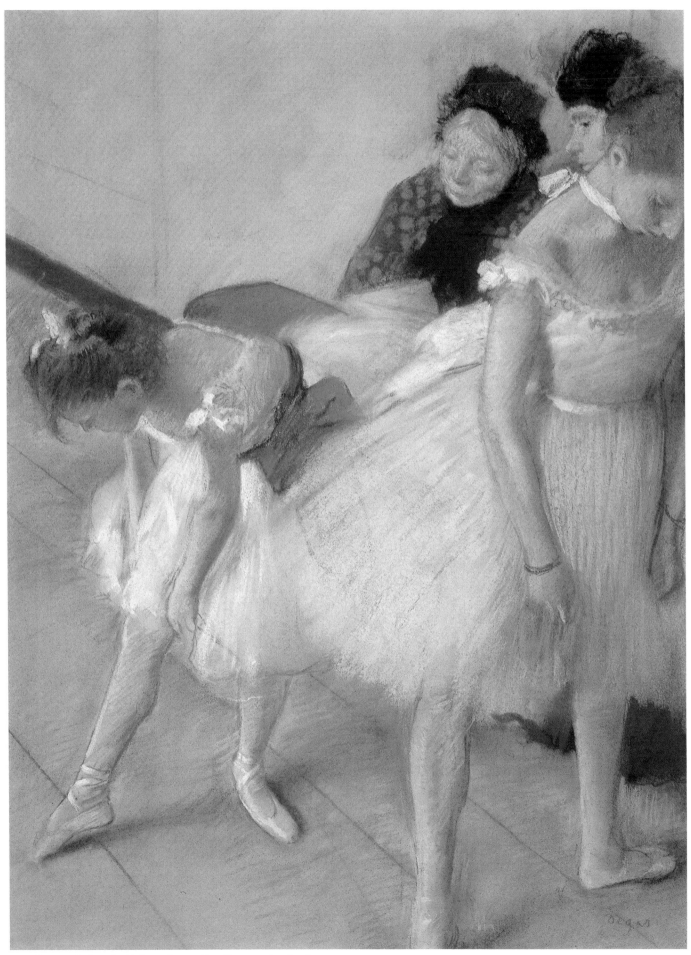

119. Degas, *Before the Rehearsal*, c. 1880. Denver Art Institute.

and he wanted to call attention to Degas's incisive renderings. Moreover, he was familiar with a broad spectrum of Degas's ballet pictures which he had commented upon since 1876. *Waiting* (Pl. 120), for example, although slightly later, represents a large class of works that show visibly tired dancers. They sit with chin on hands, slumped over, with both hands rubbing their ankles, with head leaning against a wall, dozing, or with elbows leaning on knees. They stand with arms leaning on a chair back or with shoulders flexed and elbows thrust behind them. In *Waiting* the dancer nurses one ankle, but has both feet splayed outward as part of the incessant training of the body, even while seated.

That ballet meant fatigue was a truth known to insiders—journalists, Opéra personnel, former dancers—whose writings frequently remind readers of the homely truths behind the glittering stage presentations. One memoirist, writing about the opera in 1857, said that "Dancers are often compared with race horses; the advantage is entirely to the horses. At least from time to time the horses have a few moments of respite, they are let off their training. A dancer is always in training." Horses, he wrote, look excited and eager after a race,

> But the dancer! After her performance, she [is] exhausted, out of breath, nearly dead, hardly holding herself up; she blows like a steam engine; her face, painted with sticky cosmetics, has smeared and looks like a rainbow; her bosom is wet, soiled by sweat; her mouth grimaces, her eyes have a haggard look, what a sight![40]

Degas was therefore not alone in recognizing the hard work that propped up the dancers' performances. His uniqueness lies instead in the memorable visual forms he gave to such observations. *Waiting* gains its particular poignancy by the

120. Degas, *Waiting*, c. 1882. J. Paul Getty Museum and Norton Simon Foundation.

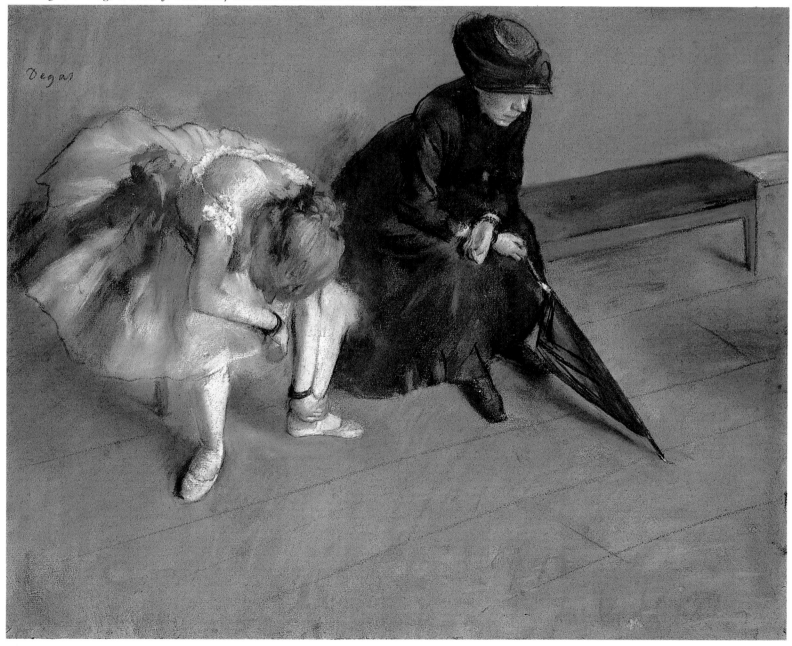

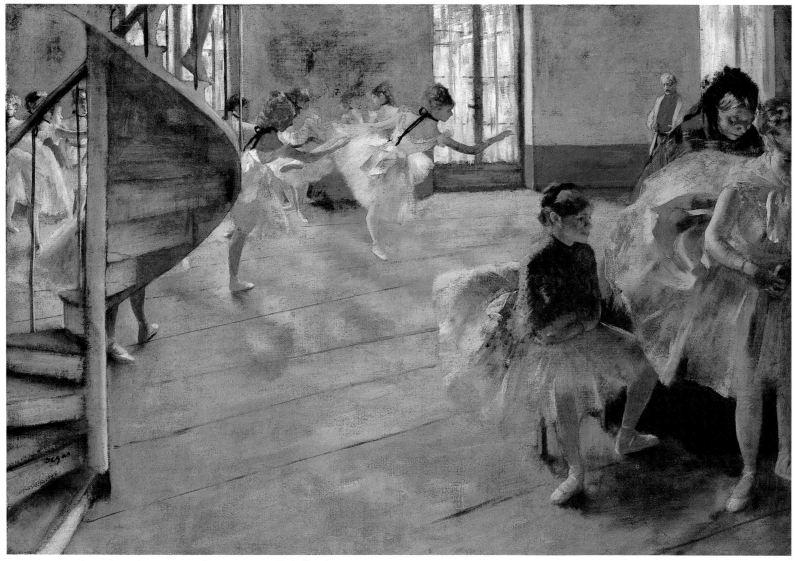

121. Degas, *The Rehearsal*, c. 1874. Glasgow, Burrell Collection.

pairing of daughter and mother. To further the mood of list-lessness that both figures project, Degas placed them at the top of the composition so that we unconsciously sense the possibility of their sliding downwards. The dancer's auburn hair and aquamarine ribbon and sash are ironic notes, accents of brightness belied by her slumped posture.[41] Her mother, instead of bright tones and feathery roundness, is made up of blackness and angularity. She draws pictures on the floor with her umbrella, matching her daughter's fatigue with her own tedium. She does not show signs of attachment or concern, but exhibits a sense of enduring, of making do.

It will seem a brusque jump to turn from this somber picture to Manet, but his *Bar at the Folies-Bergère* (Pl. 80) and *The Plum* (Pl. 75), as we saw, also require us to ponder the meaning of lassitude and detachment within settings devoted to entertainment or leisure. Manet's *Railroad* (Pl. 31) is even closer to Degas's *Waiting* in some regards. In does not show working-class figures, but it draws us into the peculiarities of urban encounters, when the mutual sympathy we expect is defeated by the odd detachment of the adult from the child. In the Degas, the lack of any bonds of affection between mother and daughter results from the artist's observation that, being

members of the working class, they are inured to routine. The daughter's routine is all activity, the mother's, all watch-fulness, but Degas chose the one moment when they can share something. That this is weariness and not love is Degas's sober lesson. Mother sits next to daughter but is detached from her, because that is the condition of modern urban life, the dis-quieting truth behind the masks of gaiety that parade across stages and platforms.

Dance Masters and Manikins

Waiting was done a decade after Degas had first turned to pictures of ballet rehearsals. The "cruelty" that Huysmans saw in his pictures of dancers in 1880, the artist's emphasis upon fatigue, boredom, and the watchful attentions of male pur-suers, developed only over several years of observation and work. The paintings of 1872 to about 1876 are infinitely sub-tle, but they concentrate more on rehearsals and dancers' work, and on complicated spatial structures. *The Rehearsal* of about 1874 (Pl. 121) is a superb example of his early manner. Figures are crowded into the upper left and lower right, active versus passive figures, separated by a clear zone that demon-

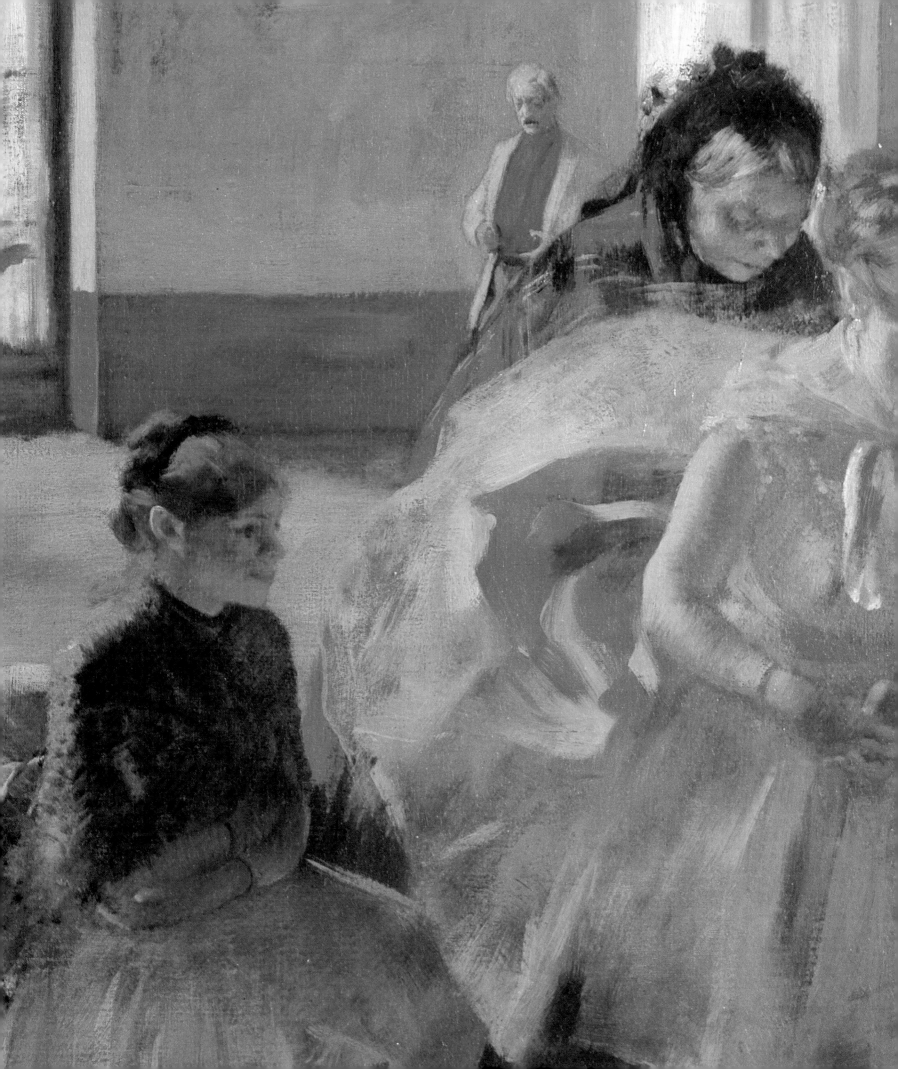

strates once again how the dynamics of a painting depend upon its structure not upon "subject matter." The striking staircase (a small model of it was found in Degas's studio after his death) has its spiral rhythm magnified by the legs which emanate from it at top, right, and center. Through the railing at the left we see four dancers, and on the other side of the stairs, in front of five figures along the wall, two russet-haired dancers aim their pirouettes to the right. Their light and elevated forms are opposed by the dancer seated on the right who turns her back to them, shawl and arms held against the chill and feet splayed out, a grouse compared to their herons. Her blue-green shawl sets off its color opposites, the strong reds of the mother's shawl and the teacher's shirt.

When Edmond de Goncourt saw this painting on a visit to Degas's studio in 1874, he drew the artist into an explanation:

> The painter shows us his pictures, supplementing his explanations from time to time by mimicking a choreographic development, by imitating, in dancers' language, one of their arabesques. And it is really very amusing to see him up on his toes, his arms extended, mixing the esthetic of the dance master with the esthetic of the painter, speaking of the *tender softness* of Velasquez and of the *silhouetted flatness* of Mantegna.[42]

Degas presumably mentioned Velasquez in connection with the picture's translucent tones and irregular, softened edges, which integrate forms with the atmosphere around them, a central impressionist goal (Velasquez was also one of Manet's and Renoir's favorite artists). Mantegna stood for the opposite, a linear flatness which stressed shape and surface. In many ways the contrast is the essence of pictorial structure, the actual flat surface supporting the illusion of three-dimensional space. Degas's spiral staircase is such a powerful spatial form that we cannot readily flatten it, but the dancers' billowing tutus on the right shift more easily from cloudy substance to surface ovoid.

Looming up behind the standing dancer is the same mother found in Plate 119. She is none other than Sabine Neyt, Degas's housekeeper, whom he identified in a drawing. She was a convenient model for the artist, a working woman who suited her fictional role. (With darker hair she also appears in *Dancer's Dressing Room*, Pl. 112.) Degas felt comfortable using his housekeeper as a model, perhaps because their relationship was so familiar and so clear, employer to employee. He was partial to working people—jockeys, ballet dancers, singers, and laundresses constitute about two-thirds of his vast output—partly because they were free of bourgeois pretension. Halévy's son Daniel more than once spoke of Degas's admiration for ordinary people. According to his diary for 1891, Degas said that "It is among the common people that you find grace." He commissioned walking canes from workers in the Marais district, and when he told Halévy about their workshops, he said "Everybody is lively, everybody is working. And these people have none of the servility of a merchant in his shop. Their society is delightful."[43]

Beyond the figure of Degas's housekeeper in *The Rehearsal* is a dance instructor, given prominence by his red shirt (Pl. 122). He is a kind of father in the curious parallel to family structure that Degas established in so many of his rehearsal scenes: fathers exact obedience while dutiful daughters work and mothers look on. In *Ballet Class* (Pl. 124), a dance master observes a pas de trois, while a young mother sits at her ease in the foreground. This picture was done four to six years later, and has Huysmans's "cruelty" of observation, though it is more amusing than morose. The mother has none of Sabine Neyt's dignity in the earlier picture. She sits in a casual way, well bundled in cheap clothing. Her face, with its puffy cheek and receding chin, is a rather malicious invention. The silhouette of the male teacher has more than a touch of caricature, also (Pl. 125). A strong highlight picks out his bald pate; his eyebrows, nose, and moustache, squeezed together, echo the snouted visage of the seated mother.

The contrast of this burlesqued teacher with the red-shirted figure in *The Rehearsal* reflects Degas's increasing disillusionment with life as the 1870s wore on, but it also points out the earlier picture as a particular kind of homage. The teacher there is none other than Jules Perrot, the most famous male dancer of the middle third of the century, and subsequently a gifted choreographer. By 1874, when Degas was working on this picture, he had been retired for many years. He had last served as dance instructor in 1864. For his image, Degas took a portrait photograph (Pl. 123) of about 1861,[44] and copied all its major features, including the position of the hands. He reversed the relation of dark jacket to light shirt, if for no other reason than to insert the vital red.

Far from being the only homage to Perrot, *The Rehearsal* is one of four finished compositions devoted to him, supported by five major drawings.[45] It seems likely that Degas met Perrot—perhaps he sought him out—after completing

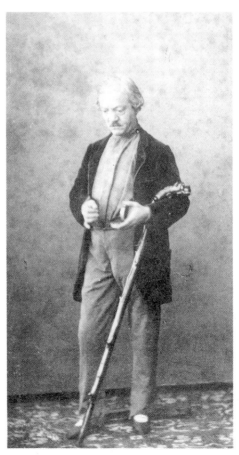

123. Bergamasco, *Jules Perrot*, c. 1861. Mr. David Daniels.

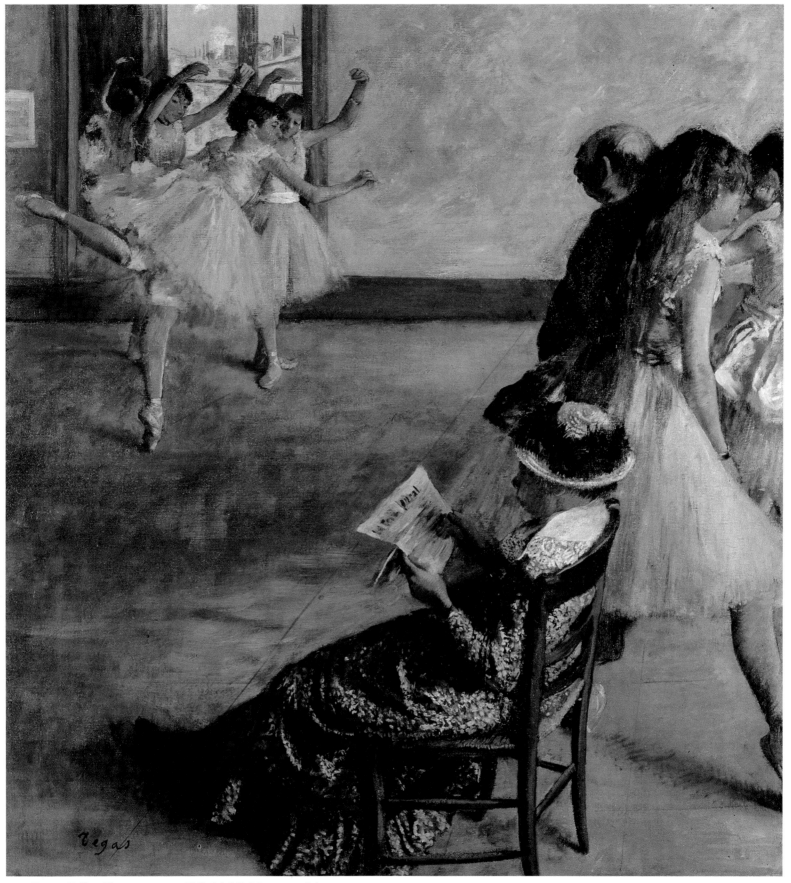

124. Degas *Ballet Class*, 1878–80. Philadelphia Museum of Art.

125. Degas, detail of *Ballet Class* (Pl. 124).

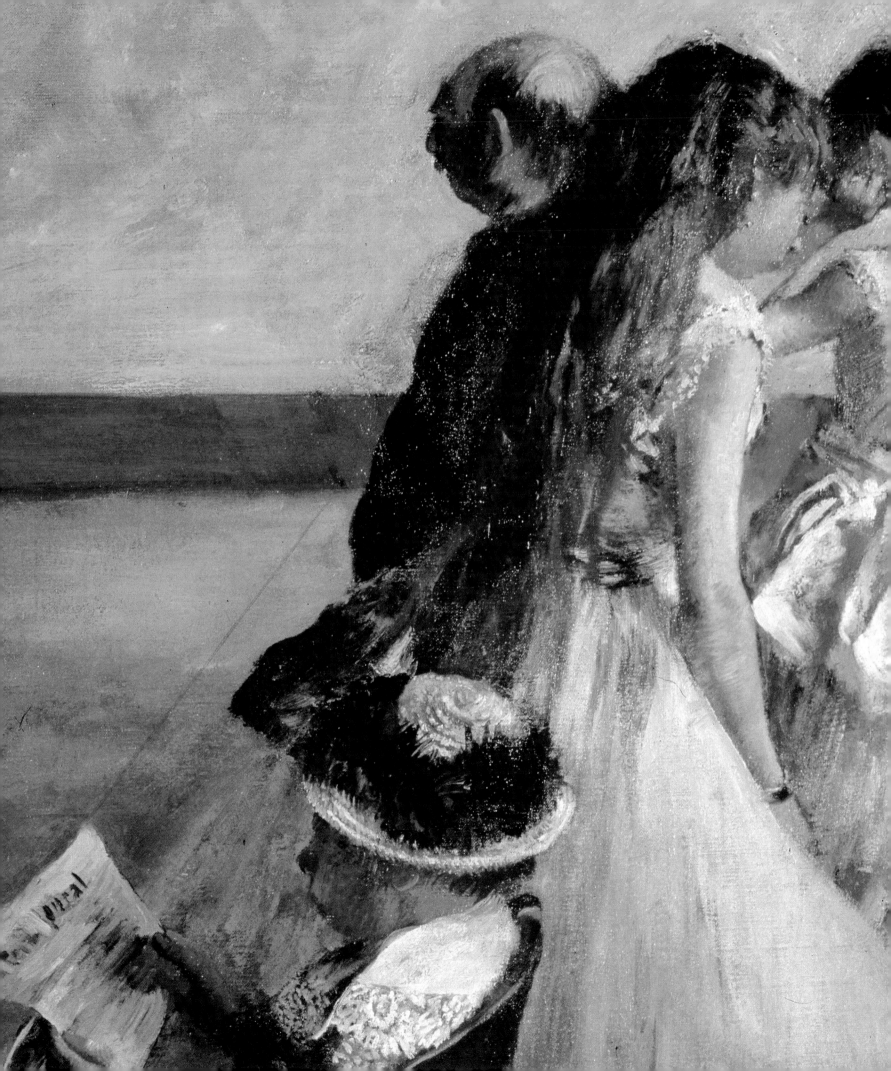

he altered the foreground dancer so that she looks toward him, reversing the initial dominance of dancer over teacher, and reinforcing Perrot's place as the composition's protagonist. This homage to Perrot is also a genre scene. Simpler in its spatial order than the Glasgow *Rehearsal* (Pl. 121), it has a more complex assortment of dancers and mothers, twenty-two of them disposed symmetrically on three sides of Perrot. Packed on or near the raised stand at the rear are twelve dancers, each in a different pose, and five mothers. One is seated, wrapped in a shawl like Sabine Neyt's, another stands, her arms around her daughter's neck as though to console her. In the foreground, seated on the piano, is one of those memorable Degas forms, the dancer who scratches her back while thrusting her chin in the air. She nearly hides a dancer who holds her hand to her ear as she studies a sheet of paper. Below is a watering can used to keep the dust down[47] and a tiny dog, presumably escaped from one of the mothers, two amusing touches that lessen the formality of the lesson.

The Dance Class (Pl. 129) is another homage to Perrot. It followed shortly upon the other picture, and is an object les-

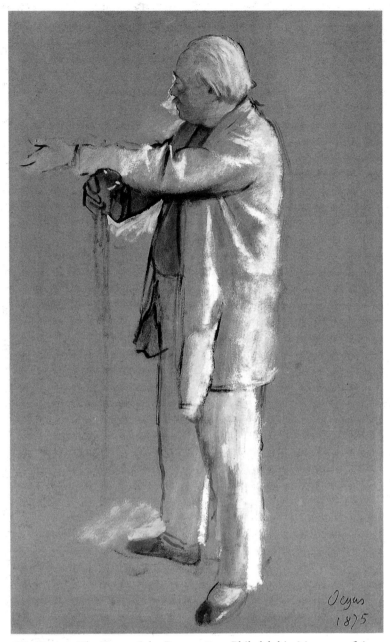

126. Degas, *The Dancer Jules Perrot*, 1875. Philadelphia Museum of Art.

127. Degas, *Jules Perrot, Seated*, c. 1875. Mr. David Daniels.

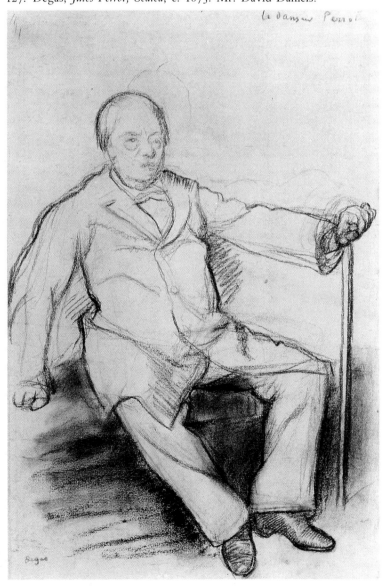

The Rehearsal, and got him to pose. He made a life drawing of him and a magnificent studio drawing based on it, which he signed 1875 (Pl. 126). It is this drawing which he used for several compositions, including *Monsieur Perrot's Dance Class* and *The Dance Class* (Pls. 128, 129). He also made a painting and a drawing of Perrot seated (Pl. 127), a sympathetic and nearly tragic figure looking older than his sixty-five years, with bandy legs spread as though to indicate his inability to dance.[46]

Monsieur Perrot's Dance Class began as a rather different picture. Originally there stood in Perrot's place an unidentified teacher, seen entirely from behind, and in the foreground, instead of the dancer standing by the piano, there was another who faced forward and to the left, adjusting her slipper (x-rays clearly show the two original poses). She was the painting's principal personage. When Degas substituted Perrot's figure,

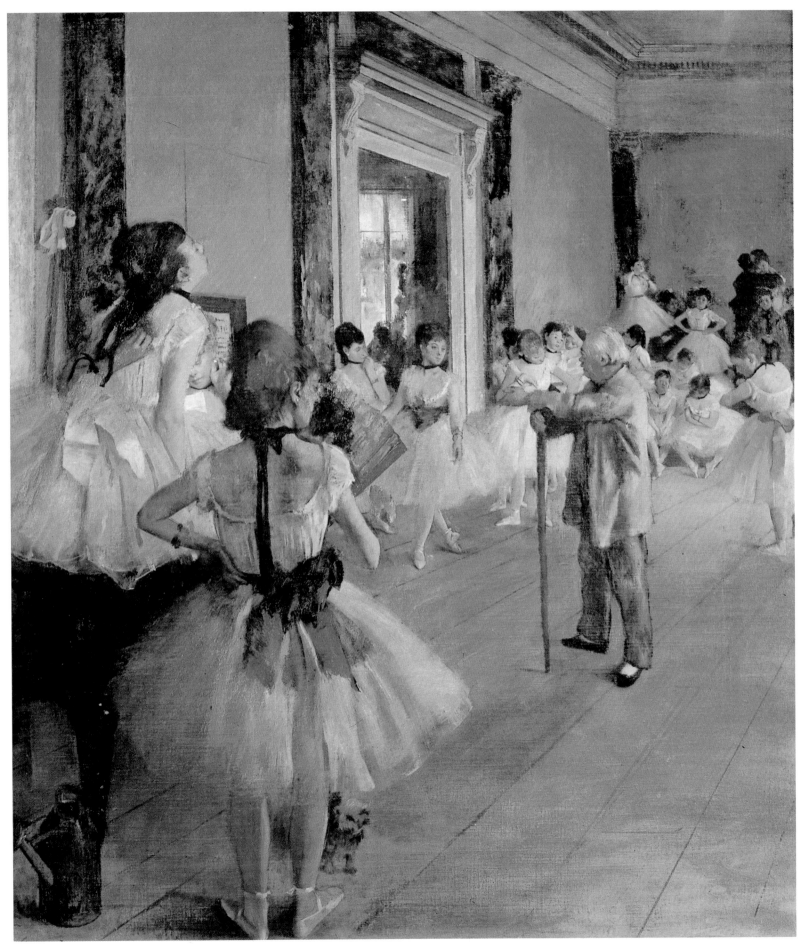

128. Degas, *Monsieur Perrot's Dance Class*, c. 1875. Musée d'Orsay.

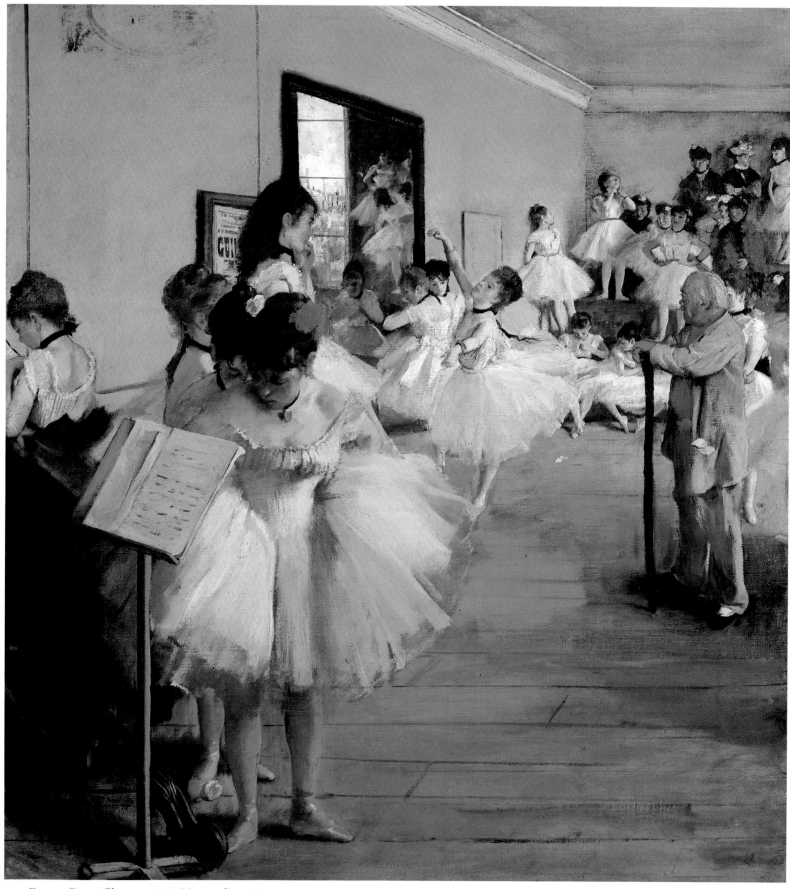

129. Degas, *Dance Class*, c. 1876. Metropolitan Museum.

son in the ways Degas fashioned his compositions. He made minor alterations to Perrot, whose left hand now rests on the top of his cane; his shirt is a more pronounced red, and a handkerchief is stuffed into the pocket of his smock. No longer in the center of a spatial wedge, he is off to the side as though Degas wished to integrate him into a scene that would appear less contrived. To that end the floorboards oppose our ready entry and no longer zoom inwards, and the foreground dancer faces outward. There is a similar number of auxiliary figures, but differently arranged. The dancer under Perrot's gaze continues an arabesque begun by the edge of the frontal dancer's tutu, a movement which flattens the picture and speeds our eye into the background. Other flattening devices are found in the vertical ascension from the foreground dancer through the girl above her (whose higher elevation is not explained) to the edge of the mirror. That vertical and the angle formed with the top of the mirror are repeated in the music stand and in Perrot's cane and arm.

Of course the most conspicuous alteration is the stripping away of the marble pilasters and other complications of the walls in favor of the drastically simplified planes of the second picture. Together with the lowered ceiling this has the effect of letting our eye move rapidly over the surface, another of the paradoxical combinations of easily read geometric shapes with illusions of nearly touchable depth. The contrast between the two rooms may be entirely of Degas's invention, a manipulation of architecture no different in kind from the management of his manikin figures. Their disposition alone proves that these pictures are pure inventions, not scenes that the artist somehow copied. Furthermore, he seems never to have represented the stage nor the rehearsal rooms of the new opera building, opened in 1875, although most of his ballet compositions date after that year. Many (including Pls. 124 and 131) are known to show rooms of the old building, although it was destroyed by fire in 1873. He simply preserved drawings of the old Opéra, and used them and his memory to make up his own kind of time capsule.

Before his pictures honoring Perrot, Degas had already painted at least one teacher in action, Mérante, who instructs young dancers in *The Dance Lesson* of 1872 (Pl. 130), and he knew other instructors as well. The special fascination of Perrot was the contact he provided with the great era of romantic ballet. French ballet had declined precipitously after 1860, according to both contemporaries and modern historians. Although Degas followed dancers' careers into the 1890s (he wrote their names on some drawings), he must have looked back with longing to the earlier era. Perrot was unrivaled among male dancers, partner of Marie Taglioni, lover of Carlotta Grisi, leading choreographer in St. Petersburg from 1848 to 1859, a name that Degas had grown up with. He was only three years younger than the painter's father, who had been chiefly responsible for introducing Degas to music, and whose most moving portraits by his son show him listening to music. Perrot, in fact, is the only man of his father's generation of whom he made repeated images. (The old dancer's use of carved wooden canes—one shows in his photo, Pl. 123—would be an additional association: Degas had a number made for himself.)

Given Degas's preoccupation with ballet, it is also fair to

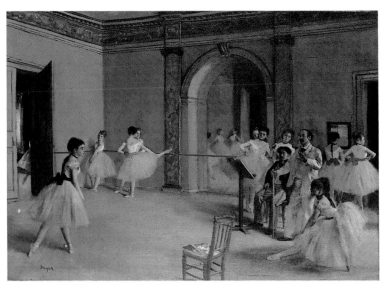

130. Degas, *The Dance Lesson*, 1872. Musée d'Orsay.

say that he identified himself with dance masters in a general sense, not just with Perrot. There were women teachers, but he seems never to have painted them. Women could be mothers in his invented world, and their daughters were the dancers, but only men could direct them. Consistent with this view, Degas eliminated male dancers, even though his surviving rehearsal notes describe boys at work.[48] It could be argued that by Degas's day male dancers had been virtually pushed off the stage by young women—the "protectors" had their role in this—but Degas would have developed his division of female performer and male director in any event. He avoided male performers in his café-concert pictures, and his singers are always led by the male bandleaders.

Degas's instinctive feelings were with the ballet masters, for in his own art he directed the same young women. He arranged and rearranged them in the form of drawings, as so many manikins. He invented their rooms, in order to be as free in his patterns as a choreographer. In the solitude of his studio he manipulated his imaginary dancers, molding them to his compositions. He fulfilled the ambitions of the Parisian *flâneur*: "I will make move, think and act, at my will this theater of automatons whose strings I hold."[49] Even though they are rehearsing, and not on stage, his puppets are performing for the master. They are costumed, they wear makeup, and like café singers, they are often lit from below or behind so that their faces, partly in shadow, appear to be masks.

Rehearsal (Pl. 131), exhibited with the impressionists in 1879, is one of the most arresting of these backlit compositions. Light streams in from the rear windows, as it does in the earlier Glasgow picture (Pl. 121). Here it models the dancers in reverse, and stresses the artifice involved, that is, natural light is made to seem artificial in the fiction of the picture, as it is in actuality: it is the artist himself who took the colors of his palette and made up the dancers' masks. "Light," that is, artists' paint, reveals backstage truths, the hard work and ugly grimaces which cannot be seen by spectators at a performance. This is—again!—the work of a naturalist. "Oh! all the things in the world, as long as one sees them from behind!" wrote

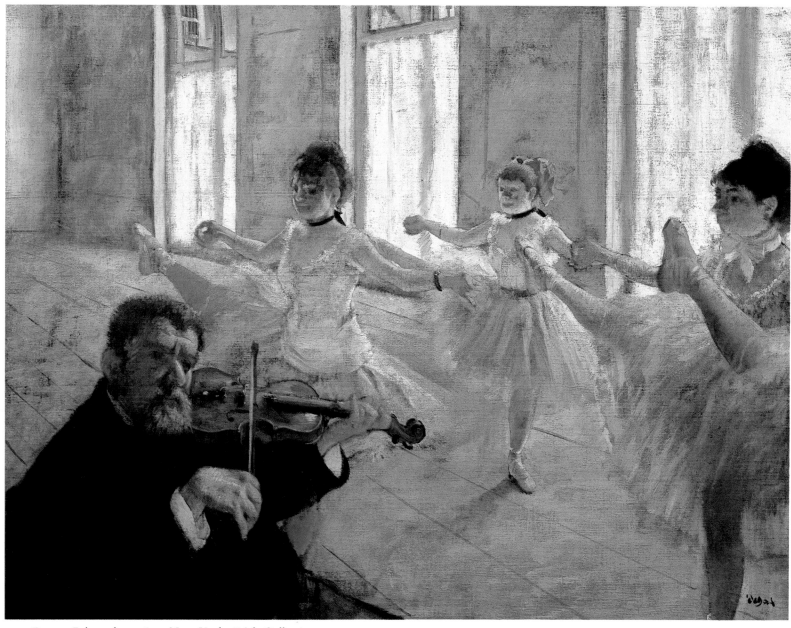

131. Degas, *Rehearsal*, c. 1879. New York, Frick Collection.

the Goncourt brothers. And their historian Enzo Caramaschi, who cited those words, qualified their art in phrases appropriate for Degas:

> These friends of truth are, besides, on another level, the friends of artifice. Their long familiarity with the things of the theater and with the society of theater professionals, their habit, as a consequence, of approaching the dramatic event from the wings and from stage tricks rather than from the side of the audience, all this must have sharpened their sensitivity to the role that illusion and artifice play in the human game.[50]

It is Edmond de Goncourt who, in explaining *The Rehearsal* (Pl. 121), said that Degas used "the esthetic of the dance master," and in the later composition with a violinist (Pl. 131), he placed himself, and therefore the viewer, where the ballet master would stand. The old musician looks in our direction, and we are unusually close to the dancers. This closeness does not let us make contact with them, however. By subjecting them to the rules of the dance master/artist, Degas has treated them as automatons. We are so used to his images that we do not often enough realize how strange they are: his dancers, like his jockeys, never talk to one another. Voiceless marionettes, they are depersonalized representatives of their class, they are human commodities (and are treated as such by the members of the Jockey Club who wait nearby). With stylized gestures, they move in front of us, their bodies ordered into repetitive visual patterns that materialize rhythms of the dance. Mechanized, synchronized, they hover before us as though they were objects on an assembly line. Karl Marx had described the strange world of the factory, in which objects replace humans, objects that move close to the worker, then beyond him, objects that the worker could not afford to buy and from which he is therefore alienated, even though he made them.

It is as though Degas sensed the mechanization of human relationships that Marx wrote about, by bringing us close to these puppet dancers, while still denying us any psychological involvement with them.

Despite this robotization, we are too close to the dancers to remain indifferent. Like spectators of the cinematic close-ups which Degas predicted, we are somehow taken up by a vision that is impersonal, but one that gives us intimate views of other beings. The result is the tension that is the mark of Degas's most eloquent works, a tension that George Simmel writes about when he fastens on the dilemma of the modern city dweller, caught between nearness and remoteness. In Degas's painting this is transformed into the strain between the actual flat surface, with its clearly marked out diagonals and verticals, and the illusion of a deep and dynamic space. This strain, a distinctive feature of his work of the late 1870s, was developed in remarkably short time: in the first dance rehearsals of 1872 (Pl. 130) there is little tension between surface and depth.

Because the figures in the 1879 picture are cut off on the right and along the bottom, the edge of the canvas becomes an active agent. The dancers' raised legs are seconded by the floorboards in their powerful diagonal thrust into space. Held out tautly, the legs induce a sense of movement even though we should imagine motion as temporarily suspended. The whole composition would explode along that diagonal were it not for the plunging verticals of the windows and the implied movements of the violinist. His bow forms a controlling vertical (his music determines their rhythm), and his violin, suspended in space like their legs, forces their movement back towards the horizontal. This is another reason why Degas is so modern a century later: our era of moving pictures, of airplanes and rockets, of swarming urban masses, has come to regard movement and tension as its leading signs.

Another aspect of the odd tension that emanates from this picture stems from our closeness to the dancers. The raised leg that protrudes into the composition startles us into realizing that the rest of this woman's body is immediately to our right. Like the dance master, we stare fixedly at the dancers' limbs in order to judge them. "Observation is so precise," wrote Huysmans, reviewing Degas's pictures in 1880,

> that in this series of girls, a physiologist could make a curious study of each one's organism. Here, the miserable old man getting thinner, whose color is fading under the regime of cheap cheese and wine; there, original anemic specimens, these girls in deplorable health from sleeping in garrets, worn down by premature devotion to such work; there again, nervous, dried-up girls whose muscles show through their jerseys, veritable goats built for jumping, real dancers with springs of steel and knees of iron.
>
> And how many among them are charming, charming because of a special beauty compounded of plebeian coarseness and of grace.[51]

In the last sentence quoted, Huysmans shifts from an observational naturalism to sexuality. Far from being incompatible, the two are closely linked. Women were normally well clad in Degas's day, so the exposure of legs—even of uncovered arms—was stimulating. Marie Taglioni had revolutionized the ballet not only by dancing on her toes, but also by popularizing the tutu, and historians have assumed that the subsequent domination of female dancers owed a lot to sexual attraction. Arnold Mortier reported that at the first rehearsal in the new opera building in December 1874 (to which the male subscribers were invited!), the orchestra complained because they could not see the dancers' legs.[52] Dancers were especially sexy because they were lower-class women and, for many, the *gamine*, the early adolescent girl, had a special appeal.

Degas was an experienced artist for whom nudity was commonplace, but his attraction to *gamines* dancers cannot be denied. They were pervasive in his life, as this anecdote from Daniel Halévy shows:

> Cavé, who lunched with us today, had recently gone to a velocipede competition to which Degas had summoned him to see two dancers from the Opéra doing stunts on tricycles. And Cavé told us how funny Degas's attitude was towards these little creatures, and their attitude towards him. He finds them all charming, treats them as though they were his own children, makes excuses for anything they do, and laughs at everything they say. On the other hand, they absolutely venerate him and the most insignificant little "rat" would give a good deal to please Degas.[53]

For Degas the dancer was both a real person, and the essential female of his art (about half of his entire output was devoted to ballet dancers). He much preferred her to the nudes of traditional painting for, as the embodiment of contemporaneity, she entered fully into his argument with bygone art. In one of his few statements that is confessional, if unwittingly so, he revealed the identity of naturalism and sexuality. It is a fragment of a letter that Duranty published in his famous pamphlet on Impressionism of 1876:

> Isn't it really curious? A sculptor or a painter has for a wife or a mistress a woman who is slender, light, vivacious, with turned up nose and small eyes. They love everything in this woman down to her very faults. Perhaps they went through real drama to win her. Well, this woman is the ideal of their heart and mind who aroused and set going their real taste, sensitivity, and inventiveness, because they discovered her and chose her, yet she is absolutely the opposite of the female that they persist in putting in their paintings and statues. They keep returning to Greece, to women who are somber, severe, strong as horses.[54]

In another statement, this one an outrageous and offensive aphorism, he revealed his maleness: "Art is a vice; one doesn't marry it legitimately, one rapes it!"[55] Nothing is known of Degas's own sexuality, aside from what can be deduced from such statements and, with unending controversy, from his art. He had adolescent dancers pose nude for him in his studio, but it seems quite likely that he kept them within the realm of his art and went to the brothel for the "hygienic outlet" that was considered normal for a middle-class professional and a bachelor.

In addition to his letter to Duranty, Degas wrote a sonnet that shows how perspicacious Huysmans was to locate the beauty of his dancers in their combination of "plebeian coarseness and of grace":

Dance, winged urchin, on lawns made of wood.
Your thin arm, stretched along the correct line,
Equalizes, balances both your flight and your weight.
I wish you, I who know, a famous life.

Nymphs, Graces, come down from ancient crests;
Taglioni, come, princess of Arcadia,
Ennoble and shape, smiling at my choice,
This new little being, with her bold look.

If Montmartre has provided her soul and her ancestry,
Roxelane her nose and China her eyes,
In your turn, Ariel, give to this recruit

Your light daytime step, your light nighttime step,
But, to honor my known taste, let her keep her own savor
And perpetuate in golden palaces her street-bred race.[56]

Surely Degas's sonnet means that his own art would bring the tradition of nymphs and goddesses down to earth, into present-day reality. His dancers are the successors of these other-worldly beings, yet by rendering them in harsh light he showed that he did not have to place them on pedestals. In the sad fixity of the gaze of his old violinist, and in the manikin poses of his dancers, we feel the loss that Degas must have suffered in casting out so many illusions.

Society Dances

Degas's paintings, though special to him, speak also for his generation's veritable obsession with opera and ballet. Despite the drop in the quality of the ballet after about 1860, the opera continued until the end of the century to be the most glittering of Parisian cultural institutions. To assess its prestige, we need only recall the vast sums poured into it during the Second Empire; the opening of the new opera building in 1875, which confirmed its place as the epicenter of Haussmann's transformed city; its use by the men of the Jockey Club, that is, by the combined political, financial, and social powers of France. Degas's art cannot be identified with the attitudes of the leaders of society, but it certainly echoed their treatment of the opera as the nucleus of shared interests.

Among the tokens of the ballet's role in upper-class society were its appearances outside the walls of the Opéra. Operas were occasionally produced in other theaters (especially the Théâtre lyrique and the Théâtre de la Porte-Saint-Martin), and "Ballet-pantomimes" and various ballet "divertissements" were a regular feature in many theaters. Some society women went to costume balls dressed as ballerinas in "the shortest of gauze skirts and pure silk fleshings," the occasion excusing a daring emulation of those young vessels of sexuality.[57] There were not only individual "ballerinas," but organized amateur ballets. Prosper Mérimée recounted the performance of a ballet called "The Elements" at a masked ball given by the duchesse d'Albe, Eugénie's sister. Sixteen society women, in ballet dress, with hair powdered in silver or gold, danced as naiads or salamanders. Among the guests were the daughter of a British lord, dressed as a nymph of the woods, and princesse Mathilde, the Emperor's cousin, dressed as a Nubian in a costume Mérimée called "too accurate."[58]

For the annual costume ball sponsored by Louis Napoleon and Eugénie, it was a tradition to have society ladies appear in a quadrille "suitable for ladies not wearing ballet costumes," such as gypsies or members of the court of Louis XVI.[59] Some of these were directed by François Mérante, the opera teacher whom Degas knew, and at one of them Anna Bicknell saw the famous Marie Taglioni looking on ("pursed up mouth and very prim appearance" was Bicknell's comment). Another was the "bee's quadrille," organized in 1863 by the Emperor's cousin of sibilant name, comtesse Stéphanie Tascher de la Pagerie, and including four other present or future princesses or countesses: "The bees made their entry in four golden hives which were carried by supers of the opera dressed as gardeners.... Then on a given signal they emerged sparkling from their golden hives and danced a ballet under the direction of Mérante."[60] If Degas heard of countess-ballerinas dressed as naiads or bees, no doubt he would have congratulated himself on his resolve to supplant classical nymphs with the urchins of Montmartre. Perhaps there is a deeper layer of irony in his sonnet than is evident at first glance. Society women, as it turns out, were not the only ones who dressed as nymphs. In the Mardi Gras parade in 1867, behind the garlanded ox (the "boeuf gras") there rode a huge van bearing Parisians dressed as nymphs and goddesses.[61]

The masked balls at which the society ballets were given— they may have had a role in removing the stigma from ballet dancers by the end of the era—were pervasive in Parisian society. The Emperor and Eugénie were fond of quitting the Tuileries to attend masked balls and this, according to Anna Bicknell, because they could play the game of being anonymous, even though no one was fooled. The Emperor, she wrote, "was easily recognized by his peculiar walk and attitude," and at any party he attended, all guests were demasked and frisked before entering, and numerous detectives were about, some trying to pass as servants.[62] Eugénie once arranged a ball at her sister's town house. A temporary banqueting hall was built in the garden,

in imitation of the great picture by Paul Veronese, "The Marriage of Cana" (in the Louvre Gallery), with most effective results. A curtain concealed the entrance till it was drawn at a given signal, when the orchestra played the march from Meyerbeer's "Prophète," while the guests descended the steps of a magnificent staircase on which medieval pages, dressed in the Guzman-Montijo colors, stood, holding gilt candelabra, and motionless as statues.[63]

The duc de Morny gave notable balls in his splendid official residence, and so did the principal members of the court and government. There was room for inventiveness and frivolity, but sometimes there was a special theme. The comtesse de Pourtalès once required her invitees to come as domestic servants, surely one of the more vulgar ways of asserting class consciousness. Baron Haussmann's balls were regarded as unusually lively, and of course were not entirely free of politics. Piétri, the police prefect, regularly invited leading journalists and editors to his balls, many of them secretly on the government payroll.[64]

Masked balls and society dances were therefore important political arenas in the Second Empire. Henry Tuckerman was struck by the prominent place that these balls assumed in

Paris. His chapter "A Ball at the Tuileries" is devoted to the theme that these dances became a quasi-official way of keeping the lid on dissent. "The domino reconciles many a giddy noddle to the loss of the liberty cap," he wrote, and in the choice of guests given honored place (measured against those who were excluded), in the symbolism of the pageantry, in the encounters and the gossip, one could detect the political pattern:

> If we desire to feel the public pulse in England, we attend a parliamentary debate, or have a talk at the club; and in America we read the newspapers. There is a more amusing way of doing this in Paris, and that is by going to the balls. Dancing there is a function of life, a normal phase of national development; it is what racing and boxing are in Britain, and speechifying in the United States—a safety-valve for unappropriated animal spirits, in the escape of which, when narrowly observed, we may trace the grade of the political thermometer. Balls in Paris are representative, and share the distinctions of society; the middle class, the ruling powers, and the fanatics of all ranks, may find appropriate gyrations in their respective spheres.[65]

In the first decade of the Third Republic, masked balls kept their place as key social events. President MacMahon was a dour man, but his government had learned from Louis Napoleon the political virtues of pageantry, and Tuckerman's "appropriate gyrations" continued. The most famous of all costume balls had long been those given at the opera house, and these also thrived in the early 1870s (the pompous spaces of the new Opéra, opened in 1875, did not suit them, and they faded in popularity). The masked balls at the Opéra were held Saturday nights from December until Mardi Gras. The doors opened at midnight, and the last dance ended at five a.m. They were not like masked balls given by court or society figures, whose invitations guaranteed a select and usually decorous attendance. Anyone who could pay ten francs (the price in 1870) had the right to attend the Opéra balls, as long as they wore mask and costume or formal attire. This price and the accompanying costs of the evening kept the working class outside (a crowd always gathered to watch the maskers arrive), but middle-class people willing to save up for an unusual night joined the wealthy, who continued to dominate the crowd. It is a fragment of this crowd that Manet showed in his *Masked Ball at the Opéra* (Pl. 132) of 1873. He presents us with a phalanx of men, unmasked, and three masked women, all in evening dress, one male Polichinelle, and three costumed women. Study of the picture tells us more about Manet than about the masked ball, for as we shall see, he painted but one aspect of a multi-layered social institution.

During the Second Empire the Opéra balls netted the management about 10,000 francs each season,[66] so they resisted the constant efforts to abolish or reform them. Reforms were demanded because of the Rabelaisian mood that inevitably took over the building. The *Guide Joanne* of 1870 warned the reader that the crowd was "boisterous not well behaved," that a respectable woman had to be chaperoned and that even then, she had to remain in a loge. There she could look out over the throng, her only overt reason for coming (the covert one, of course, was to be seen or possibly to be met, incognito). The

arena she overlooked consisted of the entire orchestra pit, floored over to form a level with the stage.

The dance floor, reserved for those in costume, was judged a wild scene by every contemporary chronicler. "Do not flatter yourself it is a stately affair," wrote Edward King, "where grave masks dance genteelly with grotesque figures; it is a mad whirlpool, wherein all that is graceful is cast away and unlimited license of attitude takes possession of the field. It is a salmagundi of all ages, classes, and conditions; an apotheosis of embracings, of whirlings, of jumpings."[67] The orchestra for these revels, placed on a raised platform at the rear of the stage, was always one of considerable distinction, and acquired particular luster beginning in 1867, when it was led by Johann Strauss.

Strauss, like Offenbach, was a typical success story of the Second Empire. He was playing Viennese waltzes in a café-restaurant during the 1867 exposition when he was "discovered" by Princess von Metternich, one of the most daring society figures of the time, and then by Henri de Villemessant, the powerful owner of *Le Figaro*, and champion of Offenbach. With the Paris presentation of his "Blue Danube Waltz," Strauss acquired fame to rival Offenbach's, and he added his own compositions to the luster of the Opéra balls for the next several years:

> Laughter and loud voices fill the air, the floor trembles beneath the rush of the dancers, and high over all, you hear that magic music of Johann Strauss, throbbing and thrilling with a passionate sweetness and overpowering sensuousness which more than explain the intoxication of the revelers.[68]

The corridors and lobbies of the Opéra formed a somewhat more sedate region than the dance floor during the masked ball, but were not as discreet as the loges. Around the edges were tables and chairs, and there were vendors of expensive fruits, drinks, cigarettes, flowers, fans, gloves, and masks. A woman who mingled in the crowds here, unless very closely guarded by a man, ran the danger of having her costume examined by many hands. A few society women took the risk, but most remained in the sanctuary of the loges. The women who frequented the promenades in costume were a mixture of demimondaines, actresses, dancers, and others for whom courting fashionable men could perhaps lead to money, a job, or a coveted role. Contemporaries assumed that Manet's three costumed women were working the crowd in that manner.[69]

Manet's choice of the masked ball in 1873 had few precedents in his work. He had often represented fashionable Parisians, but the only picture that had treated a comparable aspect of urban entertainment was *Music in the Tuileries* of 1862 (Pl. 41). That composition showed several women and children attended by a large number of gentlemen whose top hats accentuated a similar frieze-like arrangement. Among them were men of Manet's social set, a choice he made again in 1873. By then his charm and his fame made his studio a welcome place for an alert group of literati, collectors, artists, dandies, and other *mondains*, some of whom were pleased to pose for him. From Duret and other commentators, we know that he inserted at least six friends in *Masked Ball at the Opéra*, including the composer Chabrier (whom Degas had put in the stage box in Plate 91), who faces forward under the left

pier (Pl. 133), and the banker-collector Albert Hecht, also a friend of Degas. By painting his friends, Manet made masks of them, recognizable figures in a crowd where one might have encountered effigies of President MacMahon or Gambetta: masks of notable contemporaries had long been a regular feature of these balls.[70] Manet's own image is second from the right edge, and he signed the picture by affixing his name to the dance card on the floor in front.

Embraced by the cluster of black costumes are three masked women, two to the right of center and one on the far right, below Manet's erect head. These would be society women daring enough to forsake the safety of the loges to flirt with the men. The one to the right is confronting a smiling male while holding on to her mask to guarantee her incognito. The other two are being looked over by men on either side whose poses suggest inquiry into their identity. The central woman has a bouquet and an orange (this was the business of the numerous vendors), possibly gifts of her admirer who could hope to win a meeting later. Together these two central figures form a couple, but one which mocks marriage.

Such flirtations were the stuff of popular cartoons (the caricatured treatment of several of the men's faces suggests as much) which derived principally from the work of Gavarni and Guys, two of the *artistes-flâneurs* whom Manet, Baudelaire, and Degas all admired. The same kind of dalliance, with and without consequences, was commonly exploited by contemporary writers. The Goncourts' play of 1865, *Henriette Maréchal*, revolves around the wife of an industrialist who, bored, ventures out of her loge. She lends herself to the game of pursued and pursuer, and finally grants a meeting to the much younger Pierre. This begins an affair which ends only months later when Pierre avows his love for her daughter! The play was doubly scandalous, but Mme Maréchal's adultery struck the bigger blow at the conventions of bourgeois life: a bit of flirtation, yes; adultery, never. The play's notoriety put the Goncourt brothers firmly in the camp of the naturalists, and Manet's painting, though it is no illustration of the play,[71] shows his commitment to issues of contemporary life deemed important by prominent writers.

At the heart of the picture's inner workings is the opposition of the mass of black-clad men and the bright accents of Polichinelle and the costumed women: the coolest versus the warmest, the soberest versus the most animated. The thickset horizontal of the men's hats appears all the flatter because of the parallel sweep of the balcony overhead. Its stony plainness is broken by the legs of a woman astride the unseen railing and by the thighs and knees of another costumed woman. In the foreground, Polichinelle, the only man in masquerade, faces the serried ranks in a theatrical pose, as though he had wandered in from the dance floor, or from another painting. The other men ignore his existence, thereby preserving his function as an unreal presence, as their alter ego, the spirit of revelry which they hide under their somber dress. To the right, one costumed woman places a hand on the shoulder of a reluctant *élégant*, who looks away. On the other side Polichinelle calls us to witness a group of men who surround a buxom reveler in striped stockings. With folded arms she acts immune to their blandishments and unworried by the cluster of hands which conceal her bosom. The most pro-

minent of the women stands nearby. In a saucy travesty of military dress, like some "daughter of the regiment," she bends slightly foward towards her pleased dandy, her left hand on his starched front, her right around his waist.

Manet surely saw the "mad whirlpool" of dancing which King described, but his painting reverses King's terms. On his canvas the masked ball *is* a stately affair, and there is no "unlimited license." Manet, like the men he placed himself among, rested on his detachment, on his *chic*. Black was one of his favorite colors, as it was Baudelaire's, by virtue of a plainness which spoke of lack of ostentation, yet which also asserted an upper-class elegance. Like the men whom Degas represented in his backstage views of the later 1870s, Manet's men dressed in black to signal self-control and a knowing reserve, a public decorum all the easier to maintain because of the certainty of being masters of the women they sought or who sought them. Manet was not yet in 1873 the artist of *A Bar at the Folies-Bergère* (Pl. 80). By the time he came to that composition a decade later he had learned to question the relation of a man to a woman who served him, and to grant the woman her own detachment and reserve.

Popular Dances

The masked balls at the Opéra were at the top of a long list of public dances. Tuckerman's claim that, in Paris, dancing was a "function of life" was based on his awareness of the vast network of dances that spread throughout Paris and its near environs. It required five pages of the *Guide Joanne* of 1870 to list public balls, and these were limited to the best known. Balls were held in dance halls, both specially designed and temporarily comandeered spaces, and outdoors in public squares, gardens, parks, courtyards, even in streets on special occasions. The commercialization of leisure proceeded space after 1850, to the point that some neighborhood dances were taken over by entrepreneurs. The balls at the *barrières*, the old city gates, were still dominated by the working class and the military in the impressionists' day, and they continued with only modest adulteration. Elsewhere special buildings and enclosures were remodeled or constructed to cater for tens of thousands of dancers, ranging from the ragpickers who frequented the bal du Vieux-Chêne on the rue Mouffetard, to the laundresses and market women at the Grand Salon Ragache on the rue de Sèvres, and to the artists and middle-class enthusiasts at the Casino on the rue Cadet in Montmartre.

The most famous of all these was the Bal Mabille on what is now the avenue Montaigne, close to the Champs-Elysées and not far from the Café des Ambassadeurs. It had a restaurant and covered dance floor, but the principal dancing was done outdoors. The orchestra sat under a mock Chinese pavilion, and the whole enclosure, marked by copses of trees, baskets of flowers and imitation grottoes, was lit by gas lamps in the form of palm trees whose branches supported the pulsating globes. The orchestra was considered excellent, and was regularly led by a serious musician. In the 1860s it was Olivier Métra, a gifted composer whose ballet *Yedda* was produced at the Opéra in 1879 (by then he was director of the orchestra at the Folies-Bergère). To keep the crowd a reasonably decorous one, the entrance fee at Mabille was high. In 1870 Joanne listed

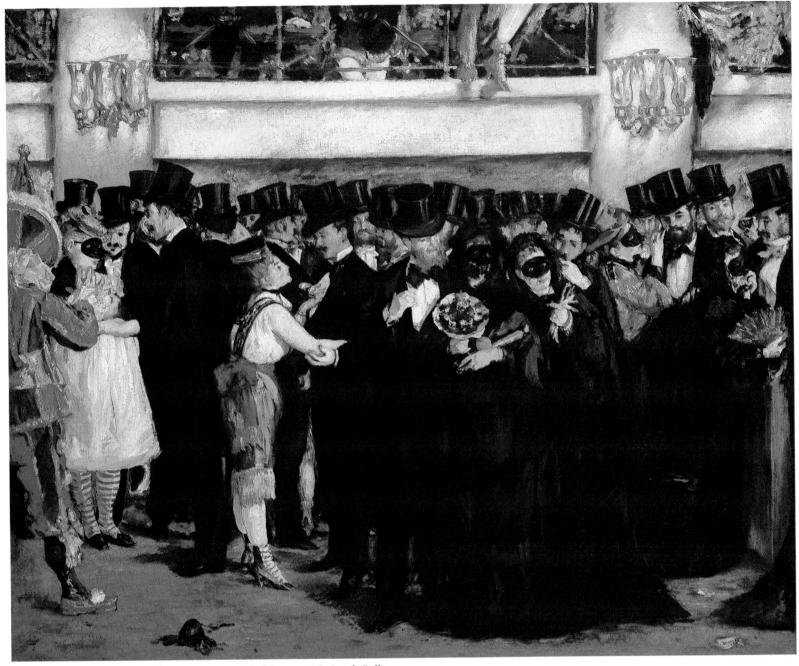

132. Manet, *Masked Ball at the Opéra*, 1873. Washington, National Gallery.

it in his guide at five francs for men on Wednesday and Saturday nights, when there were fireworks, three francs otherwise. Women could enter for only half a franc. This rather cynical policy fostered the customary Parisian sexual market: well-to-do men and lower-class women. Many respectable people and foreigners came to watch the wild dances which characterized Mabille (Pl. 134), above all, the four-person can-can, which originated here, a popular rival to a balletic pas de quatre. Long before Toulouse-Lautrec gave memorable shapes to Montmartre dancers, Mabille boasted bizarre terpsichoreans such as la Dinde, la Toquée, le Bébé, and Valentin le désossé.[72]

Not all dances were commercialized on the same scale as Mabille. In 1876, just at the time when Mabille, victim of Parisian fickleness, had closed down, Renoir began frequenting

dances at the Moulin de la Galette. Mabille, lacking a great painter, survives only in memoirs, old guide books and histories, despite its enormous importance during the third quarter of the century. The Montmartre dance that Renoir went to had no such importance, but is now the one remembered, thanks to his *Dance at the Moulin de la Galette* (Pl. 135). It was an old-fashioned Sunday dance, attracting mostly people in its own neighborhood, and utterly lacking in fame or *chic*. Montmartre, in fact, also lacked renown, which came only in the following two decades as artists and performers together helped make it a major center of entertainment. All of Montmartre deserved only three scattered mentions, totaling one page, in Baedeker's *Paris and its Environs* of 1881, and only three pages in Joanne's guide of 1885.

Renoir's site was an enclosed courtyard next to two mills

133 (following pages). Manet, detail of *Masked Ball at the Opéra* (Pl. 132).

133

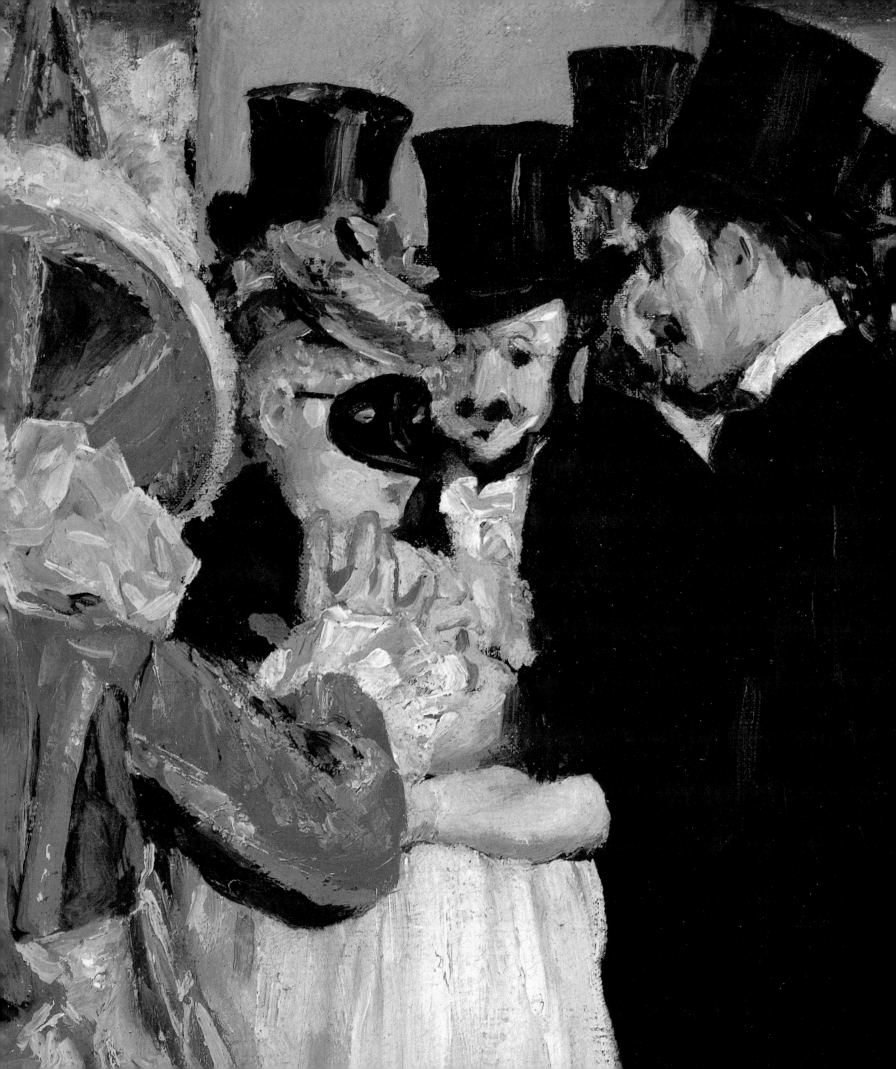

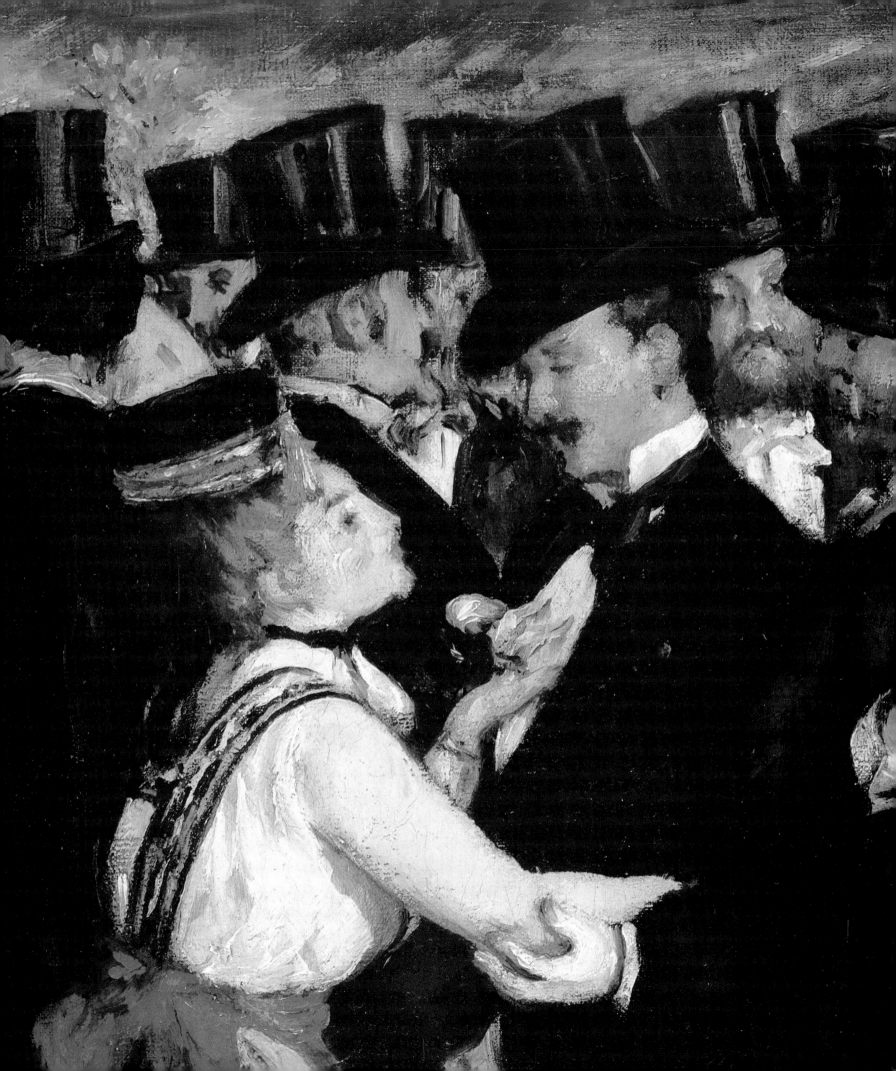

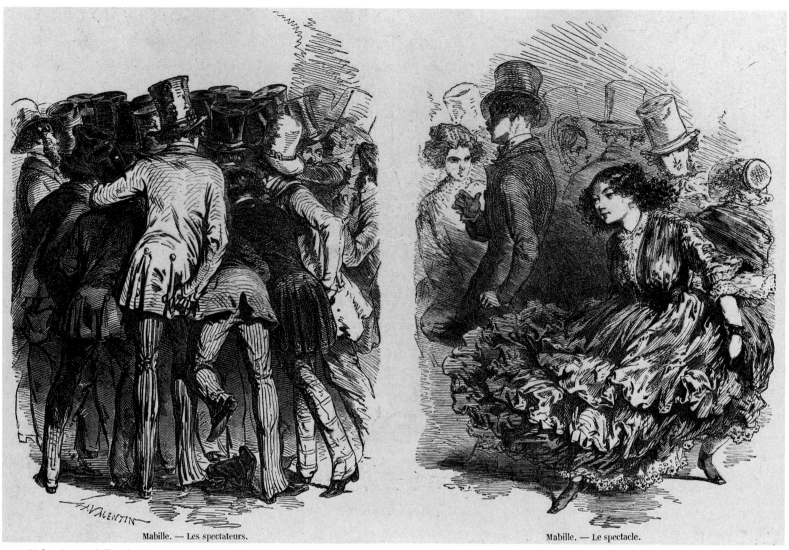

134. Valentin, *Mabille, the Spectators*, and *Mabille, the Spectacle*, 1852.

owned by the Debray family, just west of the future Sacré-Coeur (then being built). There was a third mill close by, and the profiles of the three had been a mainstay of images of Montmartre for a century or more. The Moulin de la Galette still occasionally ground iris roots for a Parisian perfumer,[73] but was essentially a picturesque landmark. Its name derived from the pancakes once sold there. The adjacent mill, the Moulin Debray, was used only to provide, at ten centimes, a view over Paris; attached to it was the café-restaurant Debray. The dance hall was between the two, a large hangar whose green planks show in the background of Renoir's picture. In warm weather the dance moved out into the courtyard, which had benches and tables around the edges, shaded by spindly acacia trees. The orchestra, "ten poor devils," according to Georges Rivière, played from an elevated platform that one sees in the rear of Renoir's composition, under the suspended mass of gas globes (Pl. 136). The balls began at 3 o'clock Sunday afternoons, and lasted until midnight (with an hour off to feed the orchestra).

From Rivière's lengthy account, we learn the identity of many of Renoir's figures. Seated in the right corner are three close friends of the artist, Pierre Franc-Lamy and Norbert

Goenette, both painters, and Rivière, a writer. The woman seated on the bench is Estelle, the younger sister of Jeanne who leans over her. Jeanne was one of Renoir's newly found models, who appears also in *The Swing* (Pl. 193). Since Rivière was certain that Jeanne was sixteen, her sister must be only fourteen or fifteen. The most prominent of the women dancers is Margot, another of Renoir's models (one of those whose surname is known: Marguérite Legrand). She dances with an acquaintance of Renoir's, the Cuban painter Solares. Among the male dancers were several close friends of Renoir's, named by Rivière but not individually identified: the painters Henri Gervex and Frédéric Cordey, the journalist Lhote, and Pierre Lestringuez, a government functionary. These men were each a decade younger than Renoir, only in their early twenties when the picture was done. Together they and the still younger models formed an ideal society for the artist, surely a welcome relief from the older Manet and Degas, and the aggressive Monet.

Rivière emphasized the working-class origins of the women who posed for Renoir, and who were regulars at the Sunday balls: seamstresses, florists, milliners, daughters of artisans and workers. Renoir had trouble convincing them to pose for

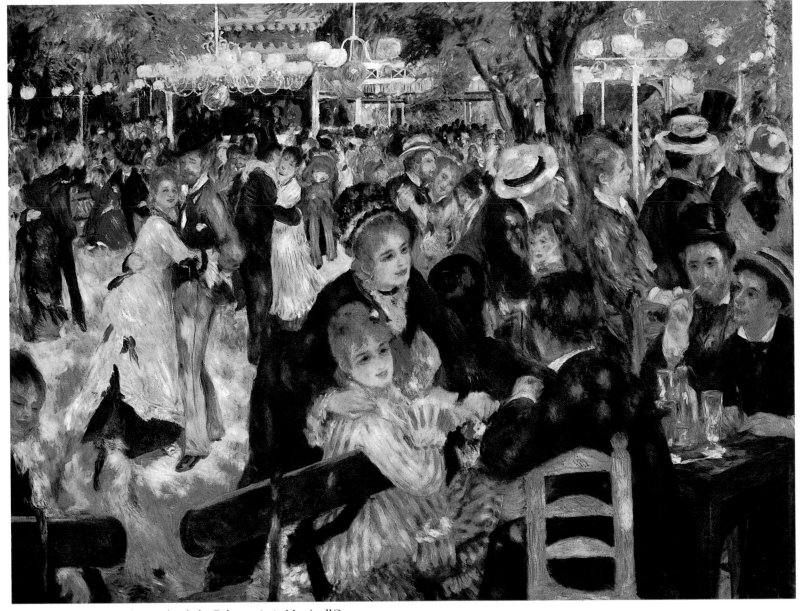

135. Renoir, *Dance at the Moulin de la Galette*, 1876. Musée d'Orsay.

him, since they had other jobs and feared the stigma attached to artists' models, but he gave them little gifts, courted their mothers, and gradually coaxed them into it. For this, his most ambitious painting of Paris life to date, he was determined to have figures who belonged in the setting, not professional models. Rivière describes their lives, which involved going to work at age twelve or thirteen, living in a tiny apartment with their mother and, usually, the mother's boyfriend. The young girls had the morals of working-class women, according to Rivière. They did not engage in prostitution (although thoroughly familiar with prostitutes and pimps, common in Montmartre), but in that harsh world they matured early, and unsanctioned pregnancies were common. Honest in the best sense of the word, they worked hard and dreamt of glamorous careers and good marriages. Meanwhile, they took solace in the Sunday dance, and impressed Rivière and Renoir with their ability to leave cares outside.

Rivière described the origins of the women in Renoir's picture, and named the male friends, but then he gave the false impression that Renoir painted an ordinary Sunday dance of Montmartre residents. An intimate friend of the painter, it is no wonder he shared his ideal and failed to see objectively behind it. What Renoir actually represented is a group of middle-class painters and writers who came to Montmartre to admire and to dance with young working women, and to use them as models. Similarly, the models departed from their habitual partners to consort with these glamorous young men. This does not mean that it was another Bal Mabille. No wild dances here, and nothing of the *canaille* of Mabille, that is, nothing of it in Renoir's painting. Rivière admitted that there were some prostitutes at the Galette, but he said they came there to dance, like the others, not to seek clients. They were excluded from Renoir's ideal society.

Evidently there is none of the *chic* of Manet's masked ball in Renoir's composition, no wealthy older men preserving a bemused detachment as they mingle with scantily clad *cocottes* in the prestigious opera house. Renoir's men and women are all under thirty and are attracted to one another without hint of

137

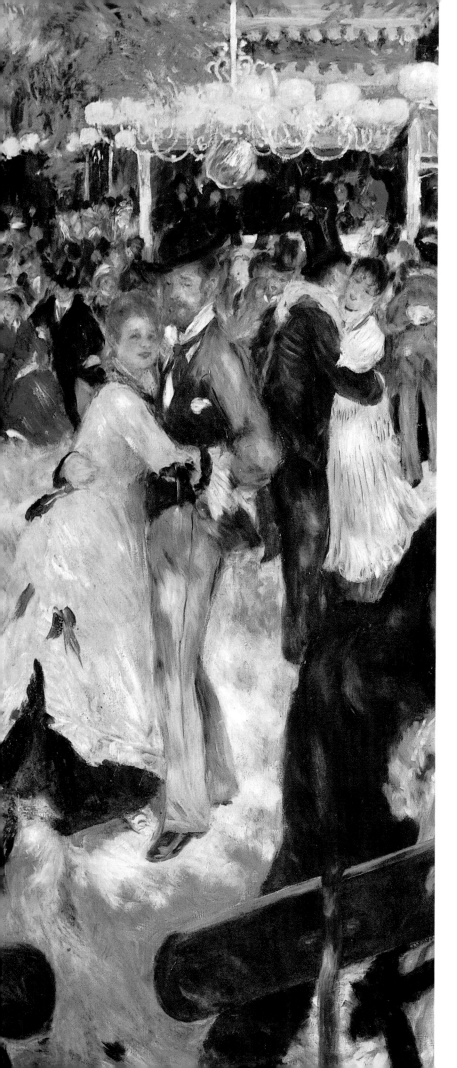

detachment. Instead of Manet's partial embraces (eager women, cool men), couples hold one another as they dance and display an inelegant, if decorous variety of pose. Instead of the touches of caricature in Manet's painting, here all is heartfelt innocence, symbolized in the child in the lower left. No post-midnight revel, this is a daytime dance on Sunday, when Manet's older men would be paying sabbath duty to their legitimate partners. The setting is a homely one, marked by scrawny trees, mediocre music, and furnishings of village simplicity.

Renoir's ideal does not admit the *chic* of Manet's radically flat composition, with its lustrous black masses which receive occasional accents of color. He unifies his canvas with dark tones, but his principle is not juxtaposition, it is integration. His dark blues, purple-blues, and violets weave in and out, binding together the lighter colors. Individual poses are constructed of soft angles and curves; groups are disposed in sweeping circles and arabesques that articulate a substantial space; edges are soft, and shaggy brushstrokes form velvety surfaces; mottled sunlight dissolves and unifies, and cannot be separated from the other elements. Precedents for these outdoor effects are found in Manet's and Monet's picnics (Pls. 171, 178), and in his own paintings at the Grenouillère seven years earlier (Pls. 212, 215), but by 1876 he had developed a more convincing, more fully integrated *plein-air* technique. It is likely that his large canvas, nearly six feet wide, was done mostly in his studio, but it preserves a convincing freshness even in areas of obvious arrangement, such as the nearest dancing couple, too conveniently surrounded by the dappled ground.

The soft light, broken brushwork, and harmonious groupings that Renoir used were the perfect vehicles for his aspirations, contemporary in their savor, and yet confessions of another feature of his ideal: they look back towards his favorite century, the eighteenth. Manet and Pissarro also admired Watteau and rococo artists for their light palette, nacreous brushwork, and responsiveness to light. For Renoir, more a figure painter than they, and a painter on porcelain from age thirteen to seventeen, the art of Watteau, Boucher, and Fragonard had a special appeal. First at the Grenouillère (discussed in Chapter Six), now at the Moulin de la Galette, he created islands of Cytherea and gardens of love that meant escape from the realities of Parisian life. Both in technique and in subject, his groups recall those of Watteau (Pl. 137), seated together or dancing in the open air. In this he was paradoxically contemporary, for Eugénie and her court had played at being eighteenth-century maidens, and rococo costumes were common at masked balls in the 1870s. Furthermore, the Goncourt brothers had made a speciality of eighteenth-century studies. Like Renoir, they were drawn to the social aspects of costume, dances and dining, especially as they concerned women.

We cannot know to what extent Renoir was aware of the artificiality of his ideal. He made frequent references to the eighteenth century in his letters and in his later polemics against machinism (see the last section of Chapter Five), so he was conscious of his roots there. On the other hand, he certainly believed that his dance was an ordinary feature of life in Montmartre. The contrast between the actual setting (it is behind the wall in the photograph, Pl. 138) and his pic-

136. Renoir, detail of *Dance at the Moulin de la Galette* (Pl. 135).

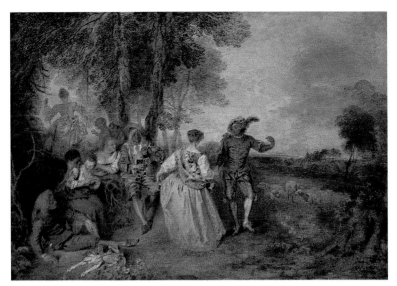

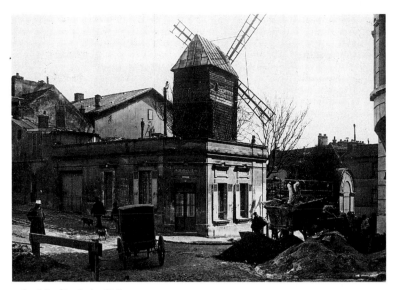

137. Watteau, *The Shepherds* (*Pastorale*), c. 1718–19. Berlin, Staatliche Schlösser und Gärten.

138. *Moulin de la Galette*, c. 1900.

ture is the same that he and Rivière knew to exist between his beautiful models' daily lives and their Sunday balls. The dance—and his painting—was a recompense, a contemporary idyll, whose unreality he hid from himself by stressing his use of Montmartre models and *plein-air* technique. Like Rivière, he believed that for Jeanne and Estelle "a smile and some shirt cuffs are enough to make them pretty," and that they had a right to be "proud of their costumes whose cloth cost so little and whose sewing, nothing."[74]

Renoir was confident that he was ennobling Montmartre women by placing them among his friends in this simulacrum of ideal social harmony. By shoving aside their actual penury, by making an element of charm out of homemade dresses, he revealed once again his own history, the working-class boy who was climbing out of poverty by aspiring to a life of ease and beauty: the delusion of the street waif. Our own era prefers cynicism to self-delusion, so Manet's *Masked Ball at the Opéra* and Degas's monotype of the green room (Pl. 108) have a more modern feeling. Still, we recognize that Renoir's delusions were of one piece with his *fête galante* at the Moulin de la Galette, and that without them, he could not have functioned. He would never have countenanced Degas's constant reminders that life has bitter and ugly sides, truths that he was aware of but that he set aside deliberately in order to cultivate his illusions.

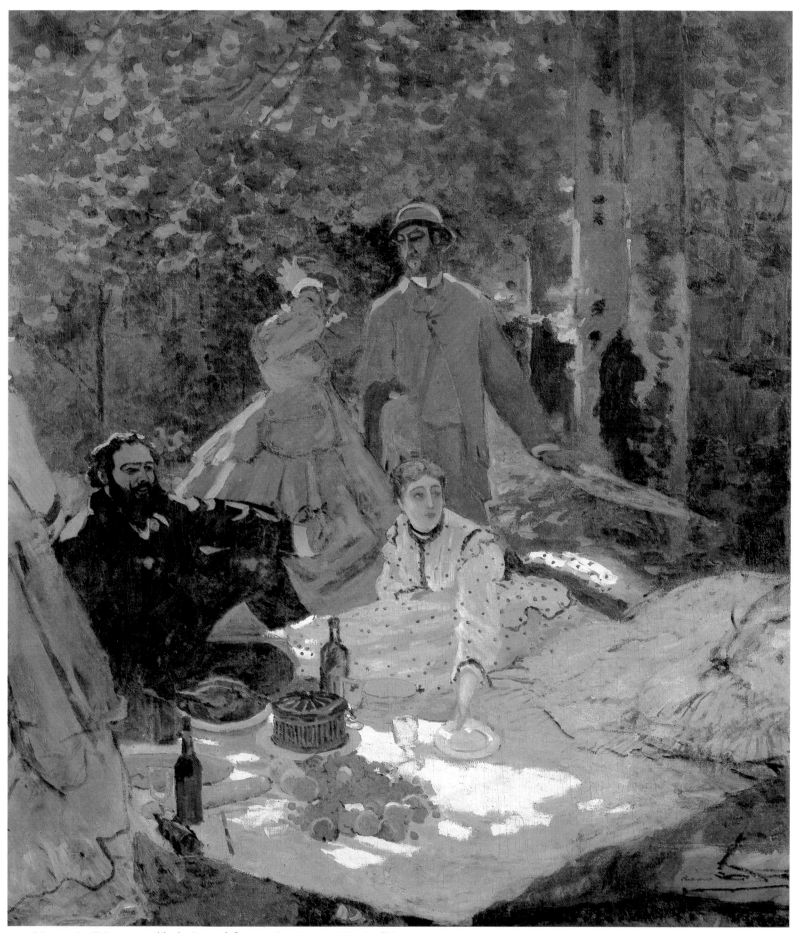

139. Monet, *Le Déjeuner sur l'herbe* (central fragment), 1865–66. Musée d'Orsay.

Chapter Five
Parks, Racetracks, and Gardens

If I were Emperor or King of some powerful state. . . I would formulate a law determining as precisely as possible an extent of land, cultivated or not, that would be required to surround every dwelling place. . . in such a way that the Air and the Sun, these two essential principles of life, would always be plentifully apportioned. This law, source of all material and consequently moral well-being, would be called *Solar Law*.
　　—Charles Meryon, 1855

Numerous gardens, squares, fountains, and public buildings, besides innumerable edifices erected by private capital, have taken the place of the former haunts of vice, suffering, and disease.
　　—James McCabe, 1869

A garden should not be an exact copy of nature, because a garden is a work of art.

A garden is a melody of forms and colors.
　　—Adolphe Alphand, 1868.

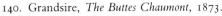
140. Grandsire, *The Buttes Chaumont*, 1873.

James McCabe, the American visitor, was convinced that Louis Napoleon had enacted Meryon's "Loi Solaire." His account of Second Empire Paris is especially revealing when placed alongside Henry Tuckerman's. Tuckerman saw through the sheen of imperial splendor to the authoritarian power it disguised. McCabe believed that Louis Napoleon had taken "a mess of crooked streets, dark, dingy buildings, dirty and unwholesome" and transformed them into a magnificent, healthy city: "Light, cleanliness, and fresh air, priceless gifts of Napoleon III to his birth-place, have accomplished this." He pointed to the new avenues, squares, and parks, pleased that they had cut through insalubrious streets and buildings, pleased also that "the crowded haunts of the *Ouvrier* class" had been broken up, and that "the working classes are scattered to the suburbs, and the danger which formerly existed from their being concentrated in the heart of Paris, is to some extent, if not entirely, removed."[1] Tuckerman viewed the same expulsion of the working class as a diminution of the vitality of the city, and a disaster for democratic aspirations.

Juxtaposed to Tuckerman's analysis, McCabe's endorsement of "private capital" and dictatorship seems disingenuous, but McCabe was not especially reactionary, nor was he stupid. He saw well into many foibles of contemporary Parisian life, and disliked its hypocrisy and commercialism. In this he was more like Taine, Théophile Gautier, Maxime Du Camp, and countless others, who could be critical of some consequences of imperial power, but who equated the new open spaces with health, progress, and morality. Louis Napoleon had ridden to power chiefly on his uncle's coattails, but he was initially favored by many on the left who admired his pamphlet *The Abolition of Poverty*, and who believed him to represent a new liberal society. They saw in him the means by which aristocrats, monarchists, landowners, and clergy could be forced to accept new industries, expanded transport and trade, freer credit, and new uses of the land. These had been the demands of the Saint-Simonians, those radicals of the previous generation who now flourished as engineers, bankers, and builders of the Second Empire. They included the Pereire brothers, founders of the *Crédit mobilier* and builders of the Grand Hôtel, Eugène Flachat, the designer of the expanded Gare Saint-Lazare, and Père Prosper Enfantin himself, imprisoned in 1832 but chief developer of the Paris-Lyon railway before his death in 1864.

Louis Napoleon, "Saint-Simon on horseback,"[2] brought enlightened ideas with him from his long exile in England, and took care that the plans for Paris incorporated parks, squares, gardens, and tree-lined avenues. This policy combined a genuine conviction in the virtue of open spaces with political expediency: the new green areas were safety-valves for urban dissent, improvements whose role in taking the steam out of the opposition equaled that of state-sponsored exhibitions, festivals, and laws that favored public entertainment. "Nature," that is, man-made gardens, marched hand-in-hand with modern industry.

In 1848 there had been only forty-seven acres of municipal park in Paris (mostly along the Champs-Elysées), plus private gardens open to the public on certain days: the Tuileries, the Luxembourg Gardens, and the Jardin des Plantes. These were all turned over to the public after 1848,

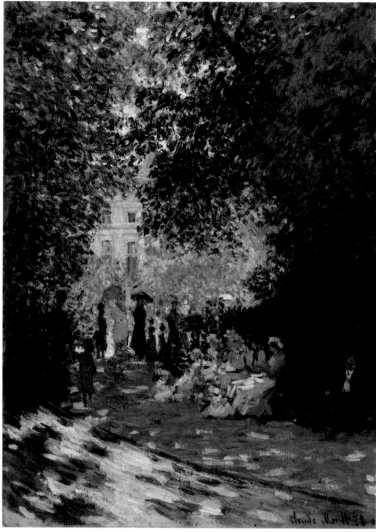

141. Monet, *The Parc Monceau*, 1878. Metropolitan Museum.

and new parks, squares, and gardens were created, totaling by 1870 not 50 acres, but 4,500.[3] The largest by far were the Bois de Boulogne and the Bois de Vincennes on either side of the city, but more than twenty new squares added up to twenty acres; redesigned and new parks within the city totaled 126 more. The Emperor was well served in all this by Haussmann, by Adolphe Alphand, whom Haussmann put in charge of park services, and by Pierre Barillet-Deschamps, Alphand's chief gardener. One of their cleverest strokes was to convert the old quarries of the Buttes Chaumont into a huge park (Pl. 140). In the heart of the working-class districts of Belleville and La Villette, it had been the site of public executions and of waste disposal. At enormous cost, twice that of redesigning the much vaster Bois de Boulogne, Alphand built a pseudo-mountainous landscape (with concrete added to the rock to form the desired picturesque arrangements), an artificial lake, two streams, and a waterfall, all fed by a pipe from the Canal Saint-Martin, a grotto with fake stalactites and stalagmites, and surmounting the whole, a facsimile of the Temple of Vesta at Tivoli. Opened in time for the Universal Exposition of 1867, the park had restaurants, cafés, chalets, and extensive greenswards laid upon topsoil laboriously brought from the outside. Not anticipating the debacle in Mexico that year, the

authorities named the various portals and nearby streets "Mexico," "Vera Cruz," and "Puebla," commemorations of imperial adventure that could have suited Offenbach's imaginary court of Gerolstein.

Not all redesigned or new parks were as well received as the Buttes Chaumont. Adophe Joanne, the guide-book author, led a fruitless campaign in 1866 against the amputations that reduced the size of the Jardin du Luxembourg by ten acres in favor of new streets. More muted was the opposition to the alteration of the Parc Monceau, since it had been a private garden and semi-abandoned when the city acquired it in 1860. New streets, including the broad boulevard Malesherbes, truncated the park on three sides, and large chunks were sold for expensive building lots. This left less than half the original area for Alphand's new lawns, plantings, pond, waterfall, and artificial grotto. These embellishments, of course, were treated as gifts to the people of Paris, because turning the park over to the public was the best disguise for the frantic speculation in the real estate created by the truncations (on one of the new lots Zola placed the town house of the speculator Saccard, in *La Curée* [The Rush for the Spoils]). Further, to treat the altered park as a splendid addition to the city's refinement, the newly created streets that led to it were named Velasquez, Ruysdael, Murillo, Rembrandt, and Van Dyck, a pantheon that was deemed appropriate to the idea of Paris as the premier nexus of international culture.

Among the impressionists, it was Monet who responded to the appeal of this former aristocratic park, a logical site because he had consistently painted the city's renovated spaces, beginning in 1867 with the area east of the Louvre (Pl. 14). In the spring of 1876 he made three paintings of the Parc Monceau, each showing an *allée* bordered by residential buildings, and in the spring of 1878, three more. These three followed his impressive group devoted to the Gare Saint-Lazare, and were in turn followed by two paintings of Paris streets decked out in flags for the national holiday of 30 June (which Manet also recorded, Pl. 35). They should therefore be assimilated with the artist's homages to contemporary Paris. The most remarkable of the paintings of the Parc Monceau (Pl. 141) combines old and new in an unwitting parallel to Alphand's renovation. The old is the central alley crowned by foliage, a traditional way of representing gardens and parks. The new is the color structure: the startling slab of yellow and green in the foreground, the complementary violets and reds of the pathway, and the daring abbreviations that register the effects of light and shade on the figures. A lone man seated to the right accompanies typical weekday visitors, a group of nannies seated with children at their feet, and to the left and beyond them, several mothers strolling with older children. Above, in slightly attenuated brilliance, the foreground colors reappear in the sunlit foliage and the facade of a bordering residence.

Monet also commemorated another of the city's redesigned parks when he painted four views of the Tuileries gardens in 1876 from the window of the impressionist collector Victor Chocquet (Pl. 142). The Tuileries palace itself, which was the westernmost extension of the Louvre, had been gutted by fire during the Commune, but the wide gardens between the old palace and the place de la Concorde remained one of the most

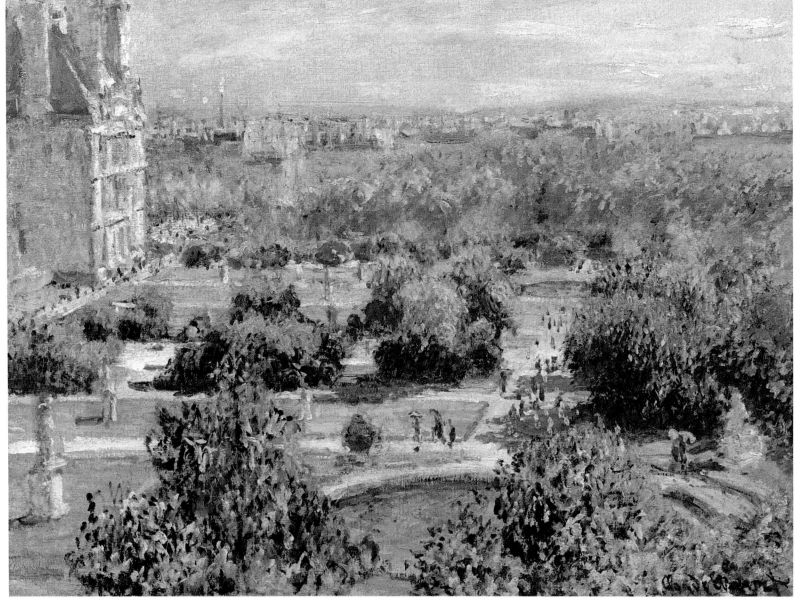

142. Monet, *The Tuileries*, c. 1876. Musée Marmottan.

pleasing memories of Louis Napoleon's reign. Some had regretted the loss of old trees and dense copses that had graced the spot before 1848. These were sacrificed to an obvious kind of open geometry and, at the west end, to those twin monuments to imperial banality, the Orangerie (1853) and the Jeu de Paume (1861). However, because the Emperor had opened the whole of the garden to the public (portions had formerly been reserved for the royalty), it became one of his popular successes.

Equally popular were the extensive plantings of trees along the new, or newly widened streets. These often amounted to strip gardens, and had benches, fountains, flowers, and shade trees. (Alphand and Barillet-Deschamps devised special wagons to transport fully grown trees; they were usually trundled in during the night to the surprise of early risers.) The Champs-Elysées was extensively renovated, with many new plantings along pedestrian paths, now more "naturally" disposed, and graced with plentiful gaslights for nighttime strolling (see Renoir's painting, Pl. 8). No matter how artifi-

cially arranged, the trees and paths were greeted as natural gardens. Even the raucous cafés-concerts, because of their outdoor settings, were called gardens: "The Parisian feels it his duty to make the rounds of the gardens once a week, to get the new songs in his memory. On either side of the grand avenue these gardens flourish."[4]

The Bois de Boulogne

The most famous and the most applauded of all the Second Empire's new parks was the huge Bois de Boulogne, the former royal forest which was entirely rebuilt between 1852 and 1858. It bordered the fashionable west edge of the city and acquired an *éclat* never matched by the equally large Bois de Vincennes which fronted the more plebeian eastern perimeter of the city, although Vincennes was given a similar overhaul in the 1860s. The luster of the Bois de Boulogne derived in part from its middle-class and upper-class patrons. Contemporary guide books were pleased to recommend its attractions

143. Hochereau, *Mare Saint-James, Bois de Boulogne*, 1873.

de Boulogne (simply the "Bois" for Parisians) had long been a goal for excursions from the city. Duellists and lovers had frequented its dense brush and woods, and for more than two centuries, Parisians had paraded out to the old convent of Longchamp to show off their carriages and finery during Easter week.

The transformation of the Bois de Boulogne appears graphically in the plans published in Alphand's famous *Les Promenades de Paris* (Pls. 144, 145). The forest had been crisscrossed with straight avenues in star-burst patterns. Only two of the *allées* were retained in the new Bois, which emulated the "natural" garden of Hyde Park and other British parks that Louis Napoleon greatly admired. The Emperor took a keen interest in the transformations and provided its general inspiration as well as some of its specific features, including the serpentine lakes. The plan of the Bois is a perfect symbol of his reign: curving paths among specimen trees, ponds and lakes, inviting lawns, broad alleys for carriages, undulating terrain punctuated by slight eminences which provide views— all that would appear casual and carefree, remote from the impositions of authority. It was also a massive deception.

to foreigners, who would not be disturbed by the sight of the working class. It quickly became "the privileged promenade of a good half of Paris, the richest half, of course."[5] The Bois

144. *The Bois de Boulogne, before 1852.*

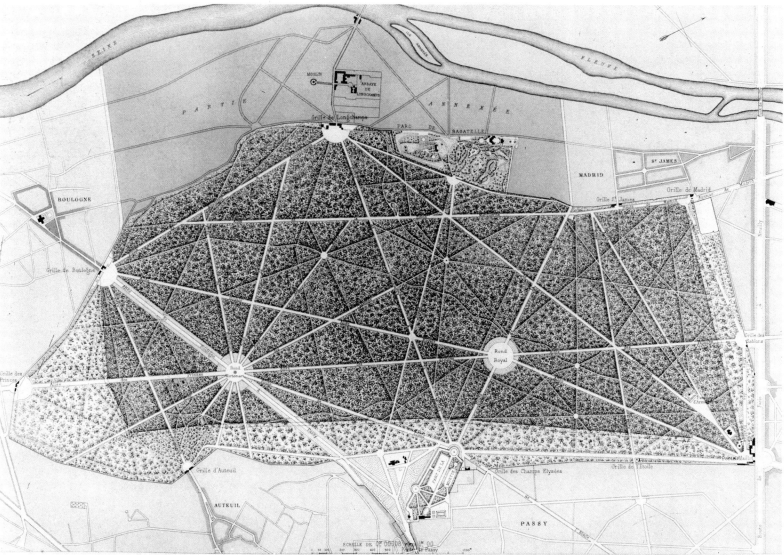

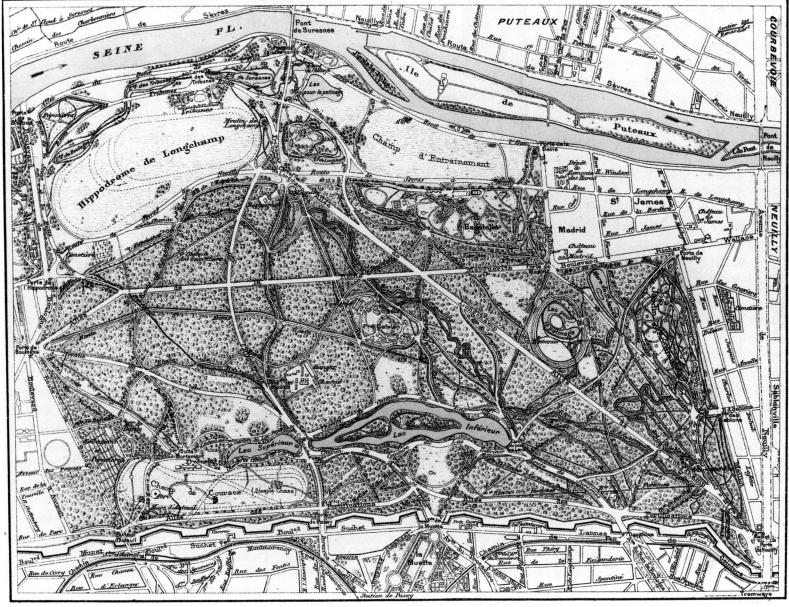

145. *The Bois de Boulogne, after 1870.*

The soil in the Bois proved too porous for the larger of the paired lakes, so it was entirely encased in concrete—a huge bathing tub. The water that fed the lakes and other artificial streams and ponds was brought from artesian wells dug for the purpose in nearby Passy; it flowed through sixty kilometers of underground pipe. Departing from the lakes, it formed a sylvan stream to the west and north, where it supplied the large Cascade of Longchamp. This fall of water was formed of stones brought from the forest of Fontainebleau, aided by cut stone and disguised cement (two grottos were provided underneath). So great was the volume of water required that it had to be accumulated in a reservoir and could be released only once a day. It performed to the promenaders at the popular late afternoon hour.[6]

Alphand and Barillet-Deschamps provided views, as well as waterfalls and grottos, views that were equally well arranged. Soil excavated for the serpentines was piled up to make the Butte Mortemart, from which there were views of the heights of Issy, Meudon and Saint-Cloud, and to the north, of the Arc de Triomphe. Elsewhere artificial eminences offered other views (Pl. 143). The lawns, ponds, streams, and woods were so disposed as to give "perspectives," that is, views that recalled famous kinds of painting, those of Claude and Poussin in the more open areas, Hobbema and Ruysdael among the small ponds and copses. Certain areas and complementary park buildings were designed to suggest the mountains and valleys of Switzerland or the American savannah. To aid these effects, the ground was sculpted in slopes, plains, and hollows, and over 400,000 trees were planted, frequently along lines that directed the viewers' perspectives. "There is as much study, arrangement and artificially sought-out effects in a picturesque composition," wrote Alphand, "as in a classical plan; and although art is not expressed the same way, man's genius ought to be equally revealed,"[7] Contemporaries agreed

146. *Plan of the Pré Catelan, Bois de Boulogne, 1867.*

with Alphand, and admired his views while recognizing his sleight of hand: "Thanks to the cleverness of the perspectives that have been drawn, this immense prairie which bears the name 'pelouse de Madrid' appears like a reminiscence of the plains of America. The illusion is complete....."[8]

Among the larger features of the Bois were the new racetrack at Longchamp, opened in 1857, the zoo and botanical garden on the park's northern edge, and the Pré Catelan, an amusement area in the center, just west of the serpentines. All of these catered to the conception of the Bois as a garden of varied pleasures for city dwellers:

> Whatever you wish you may have there. You have only to go to Longchamp for the rush and rattle of the race-course or review; to the Pré-Catelan for garden gossip and sociability of the café; to the charming lakes to gather lilies; and a few steps will take you into the wild wood. It is useless to attempt to set an image of the wood [the Bois] before you; you will make your own when you wander there....[9]

The history of the Pré Catelan (named for an old commemorative monument) is a typical one of financial speculation in the Second Empire: it was built with the connivance of government, it was based on leisure and entertainment, and it lasted only a short time. Alphand himself gave the story. Speculators, gazing upon a huge quarry which had provided sand and traprock for the Bois, convinced authorities to let them turn it into an amusement center (Pl. 146). Designed by Alphand's team (annual rents spread over forty years were to pay for it), it contained a café, a restaurant, a tobacco shop, a children's theater, various games, and a "theater of flowers" seating 1800. "Stairs, paths and grottos, contrived underneath the gardens," reported Alphand, "furnished the entrances needed by the actors and ballet dancers who gave performances in this fairyland theater, lit by footlights whose reflectors were dissimulated among clumps of bushes and flowers."[10]

There was also a photograph shop in the Pré Catelan, built on a slope so that clients could remain in their carriages or on horseback, on the lower side, or enter directly on foot, on the upper. The buildings were made of rubble and plaster, portions of which were molded to look like wood (there were also pieces of wood appliqué), agreeing with the thousands of fence posts throughout the Bois, cast in concrete to resemble wood. One particularly clever idea, perhaps by a Saint-Simonian among the speculators, was a hugh dairy housing 100 cows. Admission was charged to see them, but they made money in other ways: their milk was sold at retail within the Bois, and the balance at wholesale, in Paris (their fodder came from mowing the park's 590 acres of lawn). Alas! The crowds that were numerous in 1856 and 1857, lured by similar entertainments at more convenient locations in the city, soon faded from the Pré Catelan, except on major holidays. Only the café and the dairy remained steady attractions. The photo shop became a tiny museum displaying stuffed hummingbirds, the theater of flowers gave only occasional performances, and the city had to take over the enterprise in 1861, five years after it had opened.

The poor fortune of the Pré Catelan was not an omen for the rest of the park. The racetrack was a huge success, but more significant, since the racing seasons in spring and fall were very brief, were the steady crowds which thronged the park most of the year simply to promenade, picnic, go boating in the lakes, or skating when the winter was cold enough. There was a regular promenading hour, from about four to seven o'clock in the warm half of the year, about three to five, the rest of the time. The beautiful people came in carriages and on horseback, led by the remnants of the aristocracy, but including many well-to-do, many *cocottes* and newly rich, and an occasional student or middle-class person who rented a carriage (provided sometimes with fake coat-of-arms). Omnibuses brought pedestrians to the edge of the park, and hired cabs plied back and forth. Chairs were placed at a number of key places in the park so that the less fortunate could watch the carriages and cavaliers go by. To see and to be seen was the aim, simply an extension of Parisian habits into more open spaces.

It was not to everyone's liking. Many scoffed at the ostentation of horse-drawn fashion, including the comtesse d'Agoult ("Daniel Stern"):

> In the well-enlarged, well-graded, well-watered avenues, and around the large lakes, four or five rows of carriages meet at the hours of *fashion*: phaetons, *victorias*, baskets, eight-springs. Women of *high-life*, as one says, and young ladies, *galantes* they are pleased to mingle with, disembark there by caprice and sweep the ground with their rustling trains. In the side alleys pass rapidly by, cigars in their mouths, some horsemen, and, whips raised, some horsewomen; their shouts and loud laughs, their remarks that mix all languages and slangs of Europe, astonish the foliage.

She concludes (she is writing in 1868) that the Bois "is now the resounding rendez-vous of the vanities, the impudences of the cosmopolitan pell-mell."[11]

The main approach to the Bois from the city was the ostentatiously wide avenue de l'Impératrice (now avenue Foch) which, despite its 140 yard span, was regularly

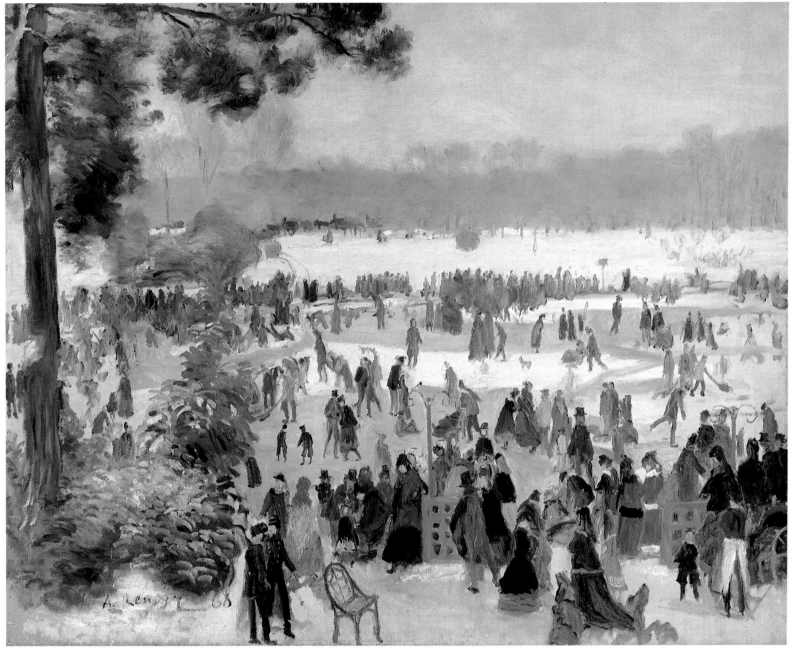

147. Renoir, *Skaters in the Bois de Boulogne*, 1868. Private collection.

described as impossibly crowded during promenade hours. Afternoon brought the largest numbers to the Bois. The crowds were so characteristic of the times that Zola began *La Curée* by having two of its protagonists caught in a traffic jam of carriages along the lakes, waiting to exit. The Bois was even frequented at night: at least two of its restaurants were well-appreciated evening spots; there were nighttime concerts; and when ice formed, there was skating on the ponds and on the rink built by the city in 1866 for the new Cercle des Patineurs. The rink was well provided with the new electric lights, the ponds with less splendid gas lamps. Gaslight marked all the major concessions, and the main internal avenues. The avenue de l'Impératrice was liberally festooned with lights, joining up with the Champs-Elysées to form a linear *féerie* (to use the guide-book term) all the way from the place de la Concorde to

the heart of the Bois. This illuminated link pointed to the continuity of urban entertainments that were surrounded by "nature," from the public concerts and cafés-concerts along the Champs-Elysées to the evening activities in the Bois.

Two paintings by Renoir give some idea of the social pleasures of the Bois (although not its nighttime festivities), *Skaters in the Bois de Boulogne* of 1868, and *The Morning Ride* of five years later (Pls. 147, 149). The earlier picture shows a skating pond in the west of the park, near Longchamp. Touches of red enliven the grey surface, picking out scarves, shawls, edges of skirts, and in the right distance, the trousers of two imperial guardsmen. To the rear a picket of onlookers completes a circle begun in the foreground. On the ice an occasional attendant pushes the snow aside (Pl. 148). A few skaters glide smoothly, one pair left of center do a joint

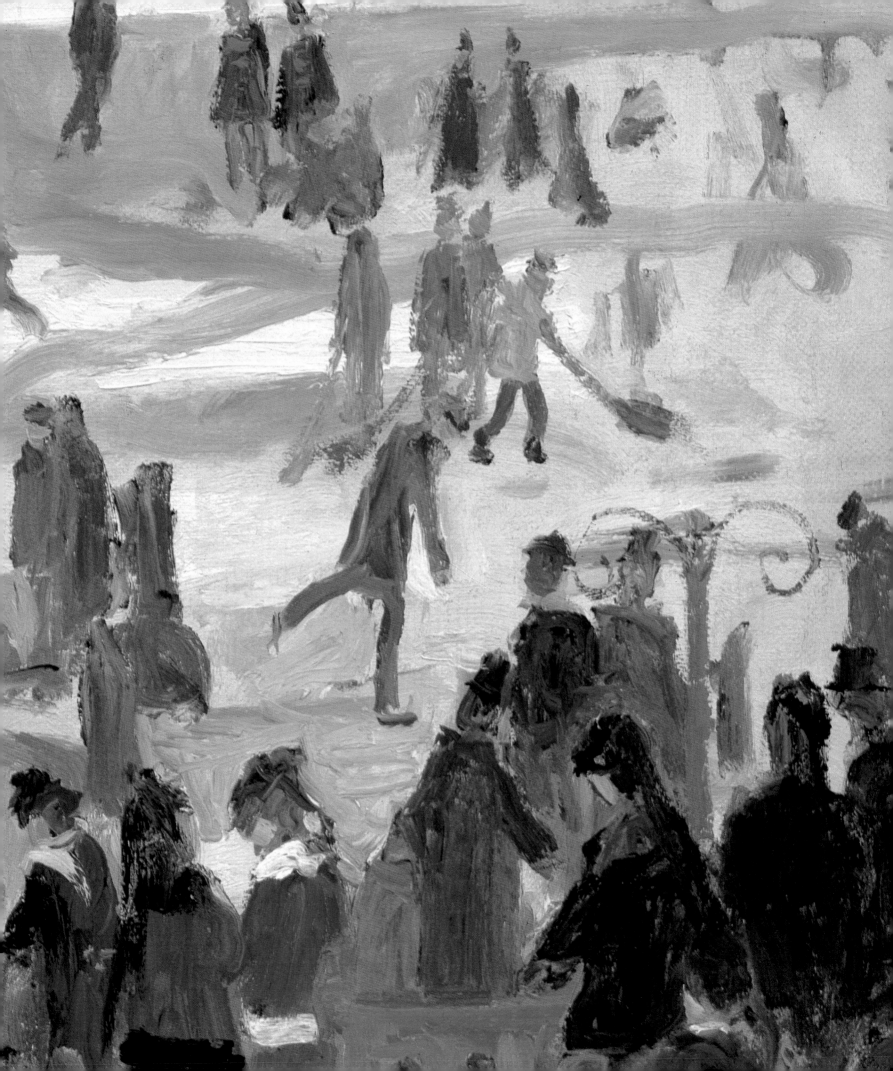

pirouette, a man pushes a bundled figure on a sled, just to the right of the central lamppost, and another does the same, further back to the right. In the foreground, partly detached from the crowd, are figures who give relief to the pleasure-seekers: two policemen on the left, and on the other side, an aproned male, probably a vendor.

Renoir's picture is a knowingly managed representation of middle-class Parisians enjoying wintry pleasures. Of course the Bois de Boulogne itself was one gigantic representation. Its perspectives, specimen trees, bathtub lakes, and performing cascades were not nature, but "nature," a reconstruction of the physical world derived from the British tradition of the natural garden—also a society's representation of an ideal. Alphand's own phrase "picturesque" means "like a picture" or "suitable to a painter," just as his "perspectives" created the desired arabesques of leisurely informality by suppressing the former straight lines that smacked too much of man's arbitrariness and power. The Bois was so evidently a representation that Alphand's contemporaries regularly used artists' terms to describe it. Snow and ice, rather infrequent adornments, were called "an opera décor painted by winter," and likened to the powdered head of a society woman at a masked ball.[12] Renoir's painting was virtually predicted by an author of one of several early books devoted to the Bois:

> Scatter this crowd along the shores of the lake, on the paths and nearby roads. Sprinkle the skaters in their hundreds over the vast expanse of ice, and give some of them the agility and grace of swallows skimming a pool. Send out light, swift sledges with beautiful women in them, and fine gentlemen to push them. Stick frost on the trees, spread a grey sky over everything, with a dull, unshining copper sun, and you will have before your eyes one of the strange pictures which you sometimes see in the Bois in the coldest season of the year.[13]

Skaters in the Bois de Boulogne is among the earliest of Renoir's multi-figured compositions, and follows in the line of his pictures of 1867, *Le Pont des Arts* (Pl. 9) and a panoramic view of the Champs-Elysées (Pl. 8). These two were somewhat more finished than the skating picture, which is more of a *pochade* or sketch. The three canvases are Renoir's first renderings of modern Parisian life. He chose out-of-door activities in newly transformed areas, celebrations of the Second Empire's devotion to social leisure that should be grouped with Monet's views from the Louvre (Pl. 14) and Manet's *View of the Paris World's Fair* (Pl. 7), also of 1867. Manet's large composition remained unfinished, and neither Monet nor Renoir had hopes of exhibiting their pictures, except perhaps in the shop of an enlightened dealer. Their cityscapes lacked sufficient narrative to qualify for genre pictures, and were too daring in their brushwork to be acceptable. Renoir nonetheless carefully worked out the composition of his *Skaters*. He arranged his figures in curves, arabesques, and tilted lines that etch out a space that one reads easily; they lead progressively back to less active horizontals whose smoother brushwork and greyer tones fortify the illusion. The high horizon line, favored also by Manet and Monet, allows the arabesques to run over the surface, separating the groups. The oversized pine tree is a rather obvious clue to the painter's

search for some accommodation to traditional recipes for landscape.

Renoir's other painting of the Bois de Boulogne is as nearly opposite a composition as one could imagine. *The Morning Ride* (Pl. 149) of 1873 is a posed studio work, awkward and unconvincing. The pond and the small figures to the rear, like the bridal path, are so indefinite that they could refer to any park. Perhaps contemporaries would have thought of the Bois despite this lack of specificity. A British observer reported that in the late 1860s, riding in the Bois was so much the rage that "the ladies have started a new fashion since the hot weather set in, and go early in the morning. Princess de Bauffremont on a dark bay mare, the Duchess of Fitzjames and her two sons, Baronness Lejeune, Countess de Baulaincourt, Baroness de Pierre and Baroness Saint Didier may be seen almost every morning enjoying a canter in the shady alleys of the Bois. . . ."[14]

Renoir's huge composition seems full of compromises with traditional art. His models were Joseph Le Coeur, the son of

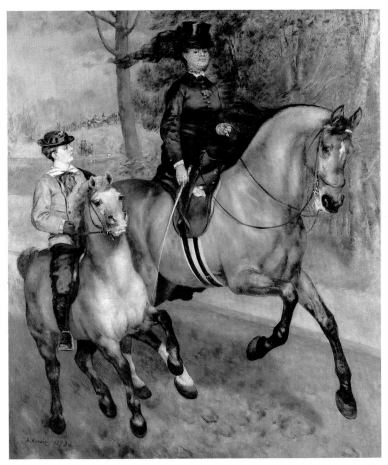

149. Renoir, *The Morning Ride*, 1873. Hamburg, Kunsthalle.

friends, and Henriette Darras, wife of Captain Paul Darras. The couple had commissioned portraits by him in 1871, and Renoir hoped that his riding picture would win him favor among their friends and others of the class who rode in the Bois. Accordingly he destined his picture for the official Salon in 1873—only to have it rejected. His disappointment was compensated for, however, because the painting was shown in

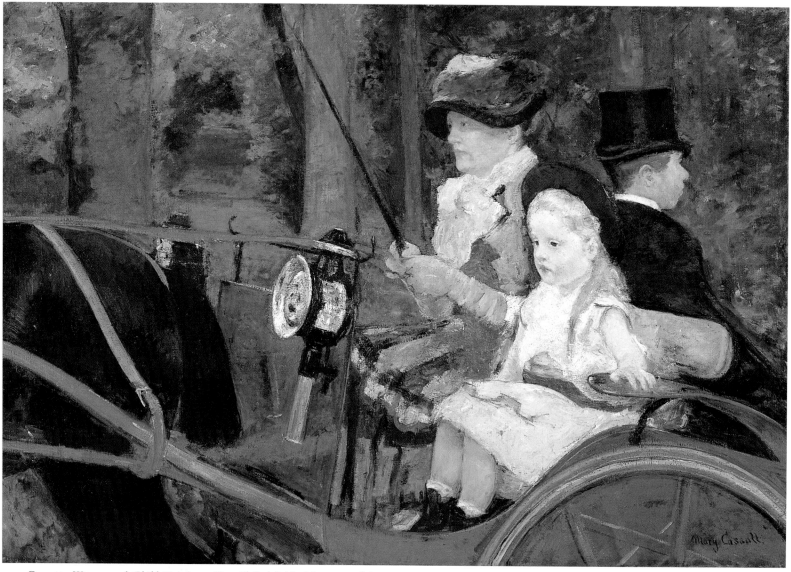

150. Cassatt, *Woman and Child Driving*, 1881. Philadelphia Museum of Art.

the Salon des Refusés, a reprise of the special exhibition of 1863, and it was purchased shortly afterwards by Degas's boyhood friend Henri Rouart, the industrialist, collector, and amateur painter.

It is easy for us to bring in a verdict against Renoir's large picture, with its palpable echoes of equestrian portraits of the seventeenth century and its respectably "finished" surface. Most of us have been taught to admire the poor artist who struggles against adversity to maintain his independence, and a compromise like Renoir's seems tainted (for moral purity is part of the myth we have constructed). Renoir was indeed poor in 1873, and he had to find clients in the free market to which he was condemned. He also wished to be accepted and praised, an urge that Manet was no stranger to, even though he was not poor. Manet refused to exhibit with the impressionists, and made more than one compromise in his attempt to penetrate official circles. The truth is that Renoir and Manet were complex beings who embraced conflicting aspirations. Renoir's *Skaters in the Bois de Boulogne* does not represent artistic truth, nor his riding picture, falseness. His art, like Manet's, was a compound of invention and recipe, of con-

temporaneousness and tradition. In this he was a perfect exemplar of a nascent industrial society still clad in the garb of pre-modern traditions. Those who went skating in the Bois were taking part in an informal middle-class activity, one that banished weighty ceremony and that did not invoke the glories of present or past rulers. Those who went riding were indulging in upper-class privilege, calling up associations with hunting and other equestrian customs of the wealthy and the powerful.

Louis Napoleon saw to it that the plan of the Bois catered to both skaters and riders. (The working class was kept out of sight, quite literally unrepresented in imperial nature.) Middle-class and upper-class leisure-seekers were encouraged to cross paths; the skating ponds were just as calculated as the bridal paths. For that reason we should regard Renoir's two paintings of the Bois as equally revealing. One looked forward to his most informal celebrations of contemporary life out of doors, the other to his "sour period" of the 1880s and its return to classical traditions. Both pictures are required if we are to understand his art, which reveals his era's use of "nature" to represent its ambitions as well as its pleasures.

Taking the air in open carriages was a more commonplace activity in the Bois than riding horseback, and Mary Cassatt's *Woman and Child Driving* (Pl. 150) affords an amusing contrast with Renoir's pretentious canvas. Its figures are stiffly posed, but they share space with a daringly sliced-off carriage, led only by the rump of a horse. Painted eight years after Renoir's huge picture, it has the looser brushwork and flatter composition shared by all the impressionists by then, but it has Cassatt's distinctive note: in its solemn figures and oddly truncated horse and cart, she deliberately created a matter-of-fact effect rather than a fashionable one. The picture nonetheless sprang from the artist's upper-class life. Her parents and older sister Lydia had moved to Paris in 1877 and subsequently bought a pony and cart. The well-off family had a groom, who sits deferentially on the right in the picture. His dark colors and backward-facing pose tell us much about a servant's place in society. Lydia is driving, and beside her is Odile Fèvre, Degas's niece. Cassatt was herself a practiced horsewoman, and perhaps the attention paid to harnesses and cart reflects her familiarity with the business end of promenading. Surely the striking pattern indicates a disdain for mere elegance. By calling attention to its skeletal configuration, Cassatt merges the structure of the composition with that of the cart. The figures, immobile and crowded to the right, are balanced by the three-pronged shaft and harness that provide a needed leftward thrust. The greenery behind, said to represent the Bois de Boulogne, is little more than a backdrop, sufficient to give relief to the brilliant colors of the women's costumes.

This is the only picture by Cassatt that can be associated with promenading, and with the Bois. Berthe Morisot, however, treated the Bois many times. She lived on the western edge of Paris, and enjoyed the large park on family outings, as well as on painting excursions. In the fifth impressionist exhibition in 1880, she showed three pictures identified with the park, *Summer's Day* (Pl. 151), *Women Gathering Flowers*, and *Avenue in the Bois de Boulogne, Effect of Snow*. *Summer's Day* shows a more mundane activity than riding, one that typified the average middle-class visitors. Rental boats were immensely popular, and the play between amateur oarsmen and their female passengers was the stuff of current cartoons. Women rowed by themselves, as well, but Morisot apparently represented her two women seated in the ferry that plied back and forth to the tiny islands in the larger lake (one of them held a café-restaurant in the form of a Swiss chalet). The tip of an island appears in the upper right of her canvas.

Morisot's painting has a startling freedom of handling (Pl. 152). This reflects not merely the progress of Impressionism over the decade of the 1870s, but the artist's particular daring. More than any other painter of the group, she broke her edges with fluttering brushstrokes and set portions of her figures

151. Morisot, *Summer's Day*, 1879. London, National Gallery.

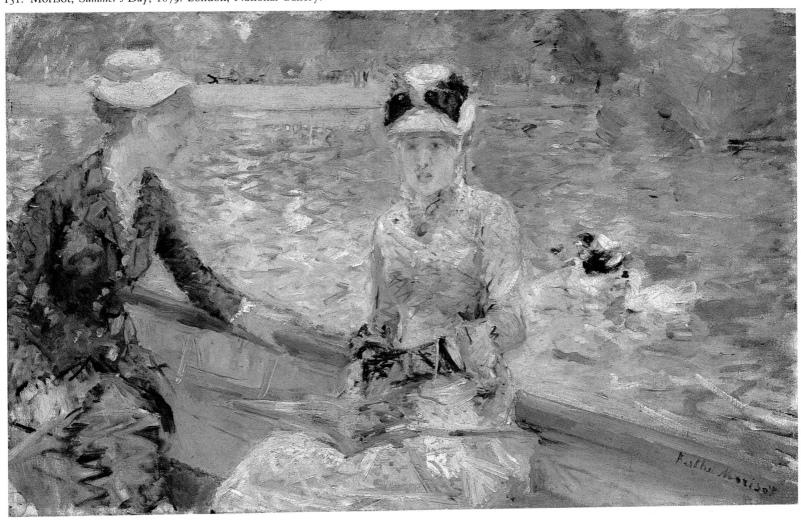

against grounds of nearly matching lightness and hue, so that one cannot readily separate the different forms. Try as one might, the viewer cannot bring into focus the three ducks is *Summer's Day*, and the struggle to do so strengthens the impression of strong outdoor light. All the critics who reviewed Morisot's work in 1880 noticed this quality (usually favorably), calling her brushwork "vaporous," "airy," and "floating."[15]

She was carrying to a further point the logic of the impressionists' abandonment of modeling in light and dark. Comparison with exactly contemporary work of Manet is revealing. In *Chez le Père Lathuille* (Pl. 67), the brushwork within the contours of each form is extremely free, and most of the edges are laid in flatly with notches and overlaps that prevent us from finding a rigid contour. However, Manet plays color against color and light against dark so that there is greater definiteness of shapes than in Morisot. In her picture, for example, there is no equivalent to the way Manet made the man's yellow smock stand out against the green foliage. The light strikes his figures strongly from above, a further aid to identifying his form as a separate volume. The sun also shines on Morisot's grey-clad woman from above, but some of her tones are repeated in the adjacent water, and there are no parallels to Manet's contrasting patches of dark and light. Instead of Manet's crispness, and his sense of reflecting surfaces, Morisot created a diffuse color-light that wraps all her forms in an atmospheric unity. Strong accents are not given to shapes, but to zones of color, such as the contrast of blue parasol and orange gunwale, or red hair and green foliage.

When she painted *Summer's Day*, Morisot must have intentionally reformulated two paintings by Manet, *Boating* (Pl. 238) and *Argenteuil* (Pl. 239), done five years earlier. It is not just men who compete with men. We should not perpetuate the idea that a woman "derives from" or merely emulates the established male artist. Morisot, uninterested in the male-female encounter so central to Manet's concerns, put two women in a boat. She separated the two, who have different poses which subtly imply dissimilar temperaments, but there is no social interaction between them. Instead, they share a lazy moment in the sunlight, young Parisiennes in proper outing costume celebrating their leisure. Like Manet, who called the picture of his dockside couple *Argenteuil*, and Degas, who entitled the painting of Lepic and his daughters *Place de la Concorde*, Morisot made her figures stand for a famous Parisian haunt: in the 1880 catalogue she listed the picture simply as *The Lake in the Bois de Boulogne*.

At the Racetrack

The most important feature of the Bois de Boulogne, judged by the attention it received in Parisian society, was the racetrack at Longchamp, opened in 1857. Its prominence was out of all proportion to its short racing seasons, a week in April, four days in late May or early June, and an equally brief period in September. The races were at the center of an elaborate social arabesque for the upper class, involving balls and parties in honor of *les turfistes*, new fashions in clothing, new or newly furbished equipages for horses and carriages, and the promenades to and from the Bois. The April meet

took precedence over the others, because its promenade usurped the age-old spring pilgrimage of fashion to the grounds of the abandoned convent of Longchamp. The new social form, in other words, benefited by swallowing up the old. It galvanized the milliners and clothiers, the vendors of jewelry and perfume, the carriage and harness workers, the gamblers, the journalists, the publishers of racing sheets, and the public who lined up along the Champs-Elysées to decipher the signs of high society. The knowing could find their clues among the open and closed carriages and the horsemen who pranced up the avenue: who was with whom, and who wore which new fashion.

Characteristically of the Second Empire, benches and chairs were placed along the edge of the Champs-Elysées so that leisure-seekers could watch the passing parade of life. Felix Whitehurst gave a lively account of an early April afternoon in 1868: "From the Place de la Concorde to the Rond Point are ranged, on either side the well-watered road, three rows of chairs, which...inevitably call to mind opera stalls on the night of a new ballet." Among the viewers were *rentiers* killing time, but also, after five o'clock, "attachés and under-secretaries...dressed within an inch of their lives." Most of the onlookers, he tells us, were respectable middle-class people, often accompanied by children who swarmed over the adjacent paths and the occasional swings and roundabouts:

> But we must look at the gorgeous procession of carriages and mounted cavaliers....Here comes M. Aguado, with two brown horses, a perfect match Mr. Vansittart (a good judge) seems to think, as he stops to examine them and light another cigarette...."Very neat T-cart." Quite right; it belongs to Mr. Ashton Blount, the Captain Little of the French Turf....That chestnut hack? Oh! that belongs to a *petite dame Anglaise*, who *can* ride....Bright yellow and very neat brougham, "C" springs, and chestnuts—Madame de Gallifet....And so it goes on—a living kaleidoscope, ever changing, ever amusing....[16]

Longchamp, the destination of this well-caparisoned exodus, was the only part of the Bois which interested Manet and Degas. Between 1864 and 1872 Manet did several oils and watercolors, and one lithograph, of the races at Longchamp. Degas was yet more devoted to the races, which are only outrivaled in his oeuvre by the ballet. Most of his pictures of horses and jockeys after about 1873 cannot be placed at Longchamp—they have a generalized, rather than a specific environment—but several of his early works apparently show the famous track in the Bois. That these two artists should be interpreters of racing is no surprise. The races were a central preoccupation of upper-class Parisian males, among whom they found many of their friends and their subjects. We know instinctively that neither Pissarro nor Cézanne would paint the racetrack—the very idea is risible—nor would Cassatt or Morisot. To map out these territories among the artists is to deal with the intersections of social history and artistic biography.

Organized racing in France was linked with the onset of the industrial revolution and the rapid expansion of Paris, and linked also with the dominant men of Paris, their clubs, their

investments, and their dependence upon British precedent. Of course horses had long taken major roles in French social life, from country fairs to military parades and royal hunts. The hunt, with its elaborate aristocratic ceremony, was the source of more than one kind of middle-class ritual in the nineteenth century. Racing on a fixed track, however, with well-codified rules, had not taken firm hold in France before the 1830s. By that decade, the British, chief investors in the expanding French economy, were in large numbers in Le Havre, Rouen and in Paris, and they set the tone for major innovations in social life. Exclusive clubs on the British model were established in Paris, the most prestigious being l'Union, founded in 1828; half its charter members were British. The next most prestigious, organized in 1833, was "The Society for encouraging the improvement of horse breeding in France," thankfully shortened to "Le Jockey-Club," or simply "Le Jockey." Just why horses should be the focus of this powerful club requires a bit of explanation.

In addition to the large numbers of British residents in Paris, there were substantial numbers of aristocratic emigrés who had returned after Waterloo. Some of their children had been born in England, and had acquired British tastes, including a love of horses. British men and some of the emigrés encouraged a taste for racing among Parisians, especially the dandified upper-class males who were seldom athletic horsemen, but who prided themselves on a gentleman's ability to ride, on his knowledge of carriages and equipages, and of course, of racehorses. Close interest in improved breeding of horses was perfectly consistent for the remnants of the French aristocracy, rightfully worried about the dilution of its own blood. Racing in Britain had been clearly marked out as an aristocratic sport, and the Dandy had derived much of his style from the wealthy who were devoted to racing (the original Jockey Club was established in the eighteenth century in order to insulate its members from the profane rabble). The French somewhat misunderstood the British Dandy, but nonetheless "le Dandy" became the lion of Parisian society. The anglomaniac dandy

> liked to fancy himself a centaur. It was more than fashionable, it was essential to ride a horse, drive a horse, own a horse, bet on a horse or, at the least (often at the most), talk horse all day and all night long. This attitude was the most foolish and the most colourful mistake in the history of anglomania: confusing the urbane dandy and the horsey buck. For Brummell and Pelham, horses had been incidentals, hunting and racing vulgarly energetic; but the French Dandy at least pretended that racing, driving and Jockey-Clubbing were his primary interests.[17]

Among the founders or early members of the Jockey Club were the Franco-British aristocrat, Lord Henry Seymour; the flamboyant Dandy, comte d'Orsay; the returned emigré, duc de Guiche (who acquired in England the expert knowledge of horse breeding which lay behind racing); Charles Laffitte, the banker and partner of Edward Blount, the British backer of French railways; Louis Philippe's son, the duc d'Orléans; the art collector and Russian emigré, Anatole Demidoff. In 1838, Monsieur de Morny, later made the duc de Morny by Louis-Napoleon, joined the Jockey and eventually became one of its

most powerful figures. The Jockey Club set the fashions for Parisian males for two generations and was one of the principal conduits for the penetration of British manners. The *chic* young men of the Second Empire wore clothes inspired by the British, engaged in the British passion for boating (*les yachts* were of British manufacture), and read the same reviews that were on the tables of the Jockey Club: *Le Jockey, Le Derby, Le Bulletin Officiel des Steeple-chases, La Chronique du turf, Le Sportsman,* and *Le William's Turf.* In 1862, the prosperous club built a new headquarters on the corner of the boulevard des Capucines and the newly devised rue Scribe, next to the equally new Grand Hôtel (it is just off the edge of Monet's famous picture, Pl. 18). "Here everything speaks of races," wrote its first historian, Charles Yriarte. "Here are special books, special reviews, emblems, escutcheons, portraits of celebrated jockeys, equestrian pictures. It is a corner of England. The paintings represent the Derby and celebrated exploits." He goes on to give evidence of the pervasiveness of British taste and British industry. Even the bathrooms were conceived

> in the English manner, provided with large marble tables and sinks which affect British proportions....I don't need to add that the details of hot and cold water faucets, of electric bells and wires, are treated with the care which characterizes the English in this sort of installation.[18]

Louis Napoleon had spent impressionable years in England, and riding paths, such as those in Hyde Park, were much in his mind when he launched the rebuilding of the Bois de Boulogne. He was easily convinced of the merits of installing a racetrack for the Jockey Club on the large plain to the west of the park, all the more so because the duc de Morny was behind the plan. Before the Empire, the club had only makeshift tracks, including the Champ de Mars in the city. Morny realized the social and financial advantages of racing, both to the club and to the new Empire, always eager to provide elegant distractions to the public, eager also to rival Great Britain. Morny devised a plan whose fruition at Longchamp required the collaboration of many interests, striking proof of the degree to which racing was imbedded in the new society.

The arrangement was this: the city of Paris remained the owner of the land, and paid for the extensive leveling and drainage of the site; the Jockey Club paid for the grandstands and attached buildings, and received a fifty-year lease in exchange for a modest annual rent. Haste and costs meant that painted decoration garnished the stands rather than the planned woods and enamels, but hierarchy was duly observed. The Emperor's section was in the center, spanned on both sides by a declension of social order, from the membership's own tribune to the public stands on the outer flanks.

Longchamp rose rapidly to international prominence in the decade that followed its opening, and French racing enjoyed an astonishing expansion. Morny got the five leading rail lines to put up half the money for the new Grand Prix at Longchamp, inaugurated in 1863 (the city supplied the other half). The winner of the first Grand Prix was an English horse, but in 1864 it was Vermouth, a French horse, which won. A French filly, Fille de l'air, won the Derby at Epsom that same year, a feat which led to an all-night celebration at Le Jockey.

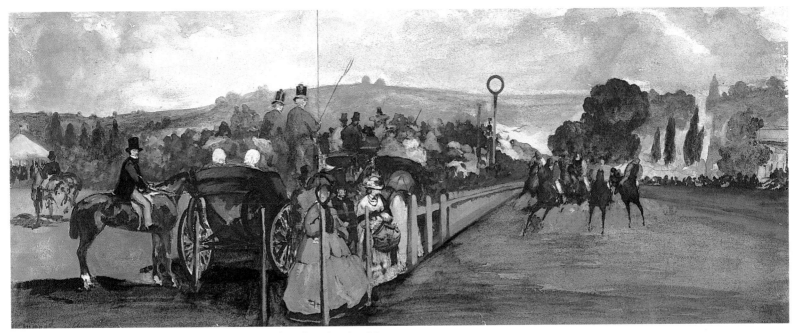

153. Manet, *The Races at Longchamp*, 1864. Harvard University Art Museums.

Its owner, the comte de Lagrange, followed this in 1865 with the double victory of his Gladiateur at Epsom and Longchamp. Gladiateur was given a triumphal parade in Paris, and the comte de Lagrange received a standing ovation from the legislature, which did not mind that his grooms, jockeys, saddles, bridles, even his horse's shoes, were British.[19] French pride was well served by Gladiateur, a most political horse.

Suiting its rivalry with Britain—the rivalry was one of the agents of France's industrialization—the Jockey Club was more open to new blood than the staid Union (for whom the very phrase "new blood" meant spurious lineage), and more clearly a cross section of the high strata of the new entrepreneurial society. Its members were leading financiers, industrialists, politicians, and military officers, along with some foreign businessmen and diplomats. Morny used the Jockey Club to favor his investments in the railroads and in Deauville (see Chapter Seven), a merging of politics, finances, and sport which added up to great power. It was an alliance that set a pattern for the whole modern era. Logically, this connection with power made racing the preserve of upper-class men, just as the ballet was the fiefdom of the Jockey Club. It is therefore fitting that Manet and Degas, who found both patrons and friends among these men, were the impressionists who most favored the races. The British sporting print on the wall of Degas's *Sulking* (Pl. 58) was a sign of being up with the times. It points to the function of racing as a conversational lubricant in business society.

Manet, whom Degas once drew at the races (Pl. 154), incorporated Longchamp in his conception of modern Paris. In his proposal of 1879 to the city for a suite of paintings on "the public and commercial life of our day," he included "Paris Racetracks and Gardens,"[20] and towards the beginning of his career he did several paintings of Longchamp. In 1865 and 1867 he exhibited pictures of the races there, and in 1872 painted another (Pl. 159). The two exhibited works were cut up or lost, but other oils, watercolors, and drawings survive to

154. Degas, *Manet at the Races*, 1870–72. Metropolitan Museum.

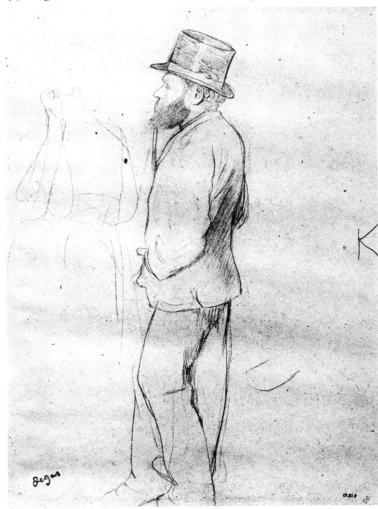

document his early interest in the chief ornament of the Bois. His watercolor of 1864 (Pl. 153) presumably approximates the

composition of the dismembered work shown in 1865. On the extreme right edge is the south corner of the public stands. Several horses race towards us, watched on the left by a crowd along the fence inside the privileged oval. Behind them are several carriages, the nearest one a Victoria driven by two uniformed coachmen, and bearing two women with raised parasols (Pl. 156). The cavalier nearby might have accompanied them up the Champs-Elysées and down the avenue de l'Impératrice, a role taken by both husbands and admirers. He is looking towards the front, not at the race, and so is the most prominent woman in the foreground. Like other Parisian entertainments, the races were distractions as much as attractions. The social rituals at Longchamp did not require constant attention to the race, and the possibility that the mounted man is looking at the woman buttresses his dominant position on the left edge of this panorama.

One of the pieces of the large oil, reworked after it was separated, shows the same foreground woman (Pl. 155). She and the other woman have their hats tied down with long scarves, the normal outdoor raiment which shows also in *Music in the Tuileries* (Pl. 41). They wear heavy, capacious garments, a protection against the chill of spring or fall. Flanking them are portions of carriage wheels whose yellow and red spokes betoken the bright trim that added to the glitter of the

155. Manet, *Women at the Races*, 1865. Cincinnati Art Museum.

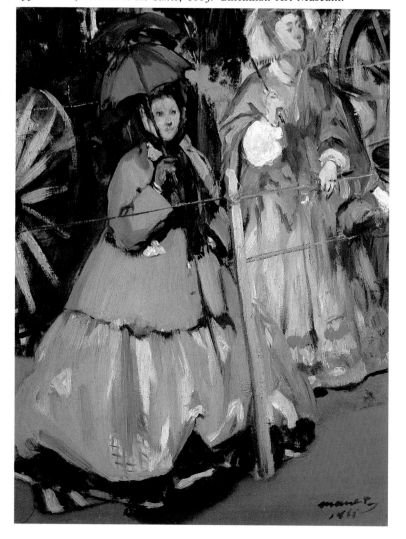

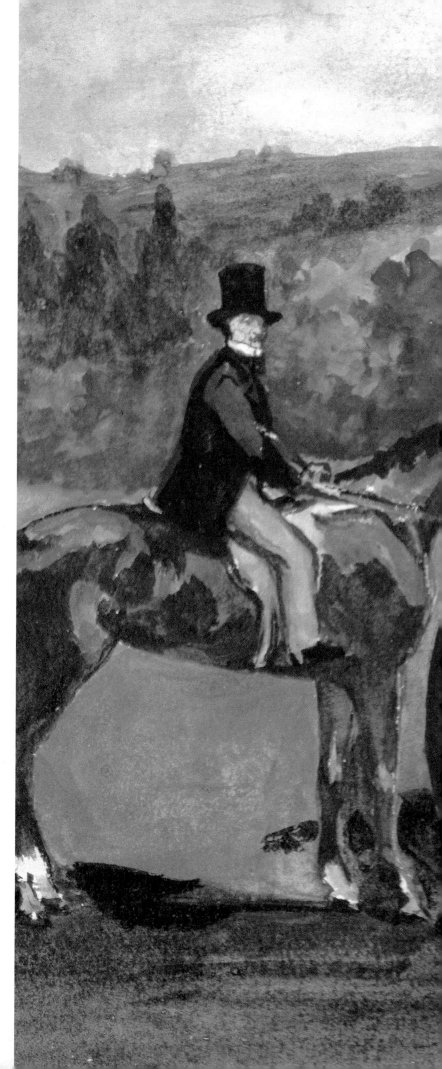

156. Manet, detail of *The Races at Longchamp* (Pl. 153).

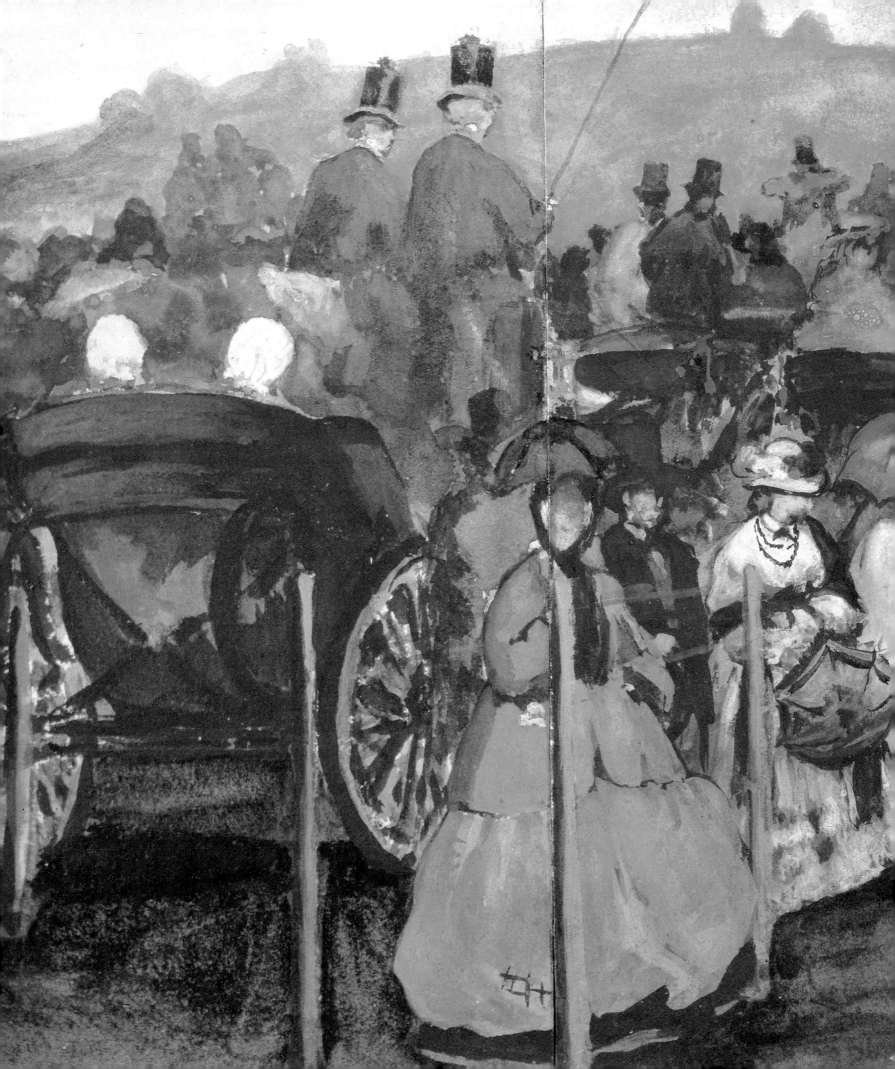

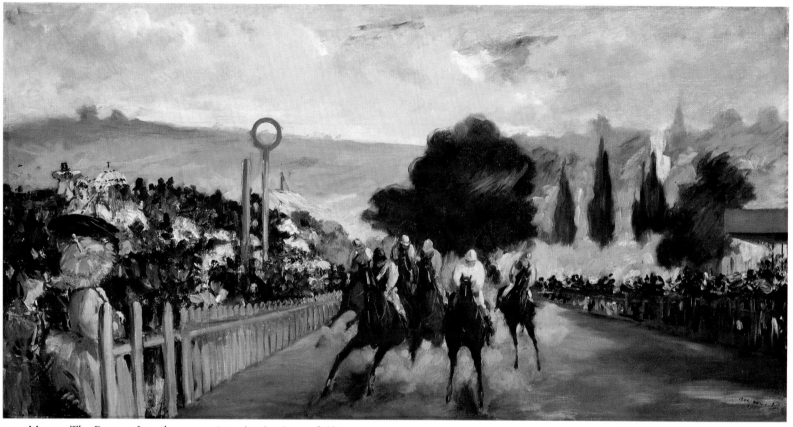

157. Manet, *The Races at Longchamp*, c. 1867. Art Institute of Chicago.

parade of vehicles. Instead of the broad expanse of Longchamp which the watercolor embraced, the now autonomous fragment is a tightly packed space, a crowding of forms that speaks more of city than of country. Were it not for the barrier and the patch of green ground, we might imagine spectators at a city parade. They are, however, far above the common herd. Entrance to the oval required a double supplement (twenty gold francs for a large carriage), so Manet's women are an élite among the élite. These onlookers have become our show, which is only reasonable, since one went to the races, as to the theater, partly to look over the women and their apparel. In a play published in 1864 (but censored for being too risqué), *Les femmes du sport* by A. Bourdois and Emile Colliot, the second act is dominated by women, some of them watching the races by climbing up on their carriages; the grandstand was relegated to the side wings. The protagonists included a ballet star, a dancer from the Prado, Lord Crockmerton, a British businessman and "pure-blood sportsman," and John, "a well-dressed groom."[21]

In contrast to the painting of the two women, which says "crowd," Manet painted a horizontal canvas which says "race" (Pl. 157). This other picture recapitulates the right-hand two-thirds of the watercolor (Pl. 153), but pulls the horses closer to us. Manet opened out the surface to the green turf, the slopes of Saint-Cloud, and the windy sky. On the left, two foreground figures can be distinguished, and further back, a man upright in a carriage, arms outspread to steady his binoculars. All the figures left and right, as far as we can make them out, are concentrating on the race. There seems to be no precedent for the foreshortened, two-legged horses they are

watching, Manet's way of suggesting speed. The horses are pinned down by the patch of foliage overhead, and pulled back by the sharply receding turf, a balance of opposites that restrains their forward surge so that the picture remains intact.

The brushstrokes of both pictures are far too loose to have pleased many of Manet's contemporaries, but they are the real building blocks of his visual architecture. For the two women, the artist used rather wide strokes whose texture and direction define both surface and volume, a process of drawing in color that prepared the way for the liberties taken by Van Gogh two decades later. For the racing scene, Manet employed smaller and more varied strokes (Pl. 158), because there are more varied images. Horizontal strokes, partly blended, define the green turf. The slope in the left distance has long, diagonal strokes that fade to horizontal ones at the crest; the sky, curving and dabbed touches; the dark-green poplars to the right, vertical strokes, and the bushy trees, diagonals. The fences consist of vertical streaks, and the spectators, of mixed dabs that separate hats, parasols, faces, and bodies which nonetheless never quite come into focus. Rounded swipes of the brush describe the hunched-over jockeys, and thin rays of yellow run over the surface of the horses to suggest reflections from glistening muscles. Whether applied to horses, viewers, or landscape, the artist's marks seem to result from spontaneous response to a scene, a perceptual quickness that we know is a trick—the composition, well pondered, repeats portions of other works—but one that works admirably.[22]

Manet painted the last of his Longchamp views in 1872, *The Races in the Bois de Boulogne* (Pl. 159). It is said to have been commissioned by a sporting enthusiast named Barret,[23] and, if

158. Manet, detail of *The Races at Longchamp* (Pl. 157).

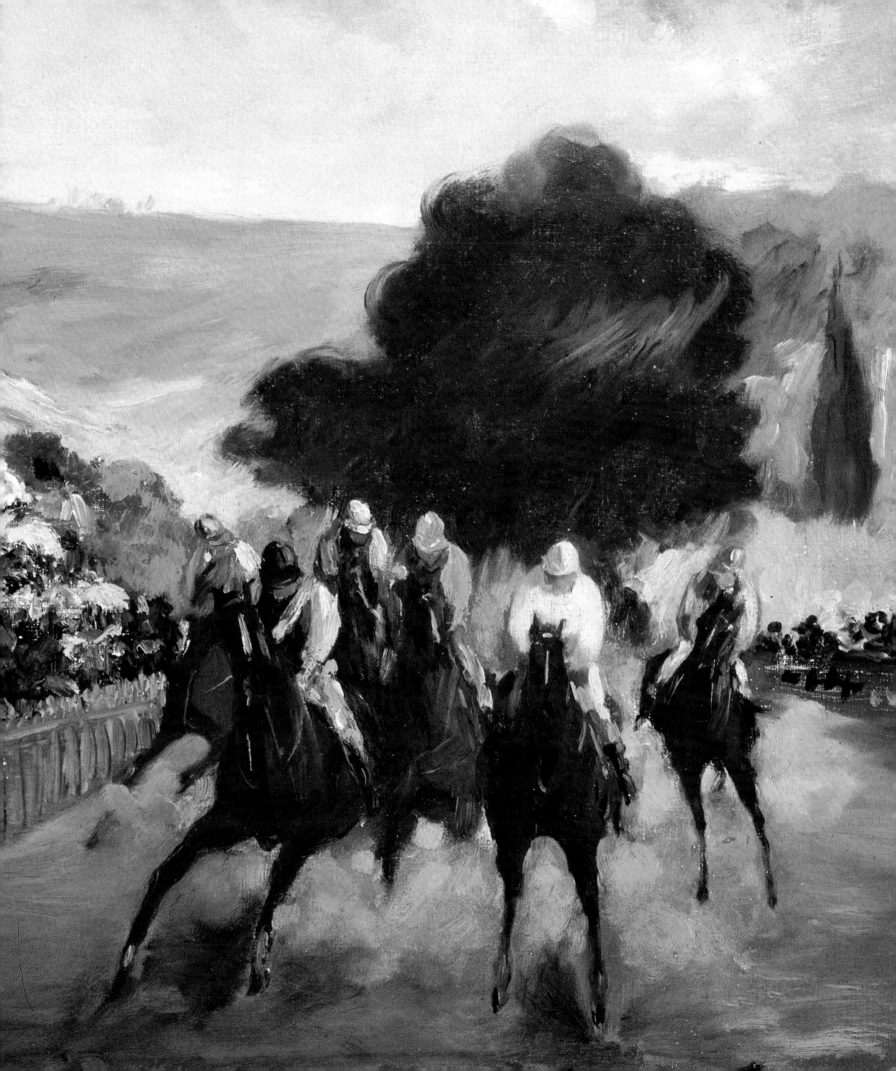

this is true, Manet may have deliberately reverted to the profile race in order to evoke the prototypes that were ubiquitous in horsey circles. In British sporting prints and in Géricault's famous *Races at Epsom* of 1821 (one of the early instances of French anglomania), the horses rush laterally across the surface in the position of the flying gallop, legs extended front and rear. Photography and cinema now make Manet's horses seem too toy-like and his jockeys too rigid—and only later did jockeys, with shortened stirrup leathers, ride forward over the horses' shoulders—but in 1872 the hobbyhorse gallop, whose flight above the ground Manet accentuates with streaky shadows, may well have channeled speed more successfully than the foreshortened poses of the earlier painting.

Drama, more than speed, is conveyed by Manet's earlier race, and this is true also of Degas's *Steeplechase, the Fallen Jockey* (Pl. 160) of 1866, his largest racing picture and the only one he ever showed in the official Salon. A fallen jockey is at least as dramatic as a frontal charge of horses. The Goncourts put a steeplechase at the very heart of their scandalous play

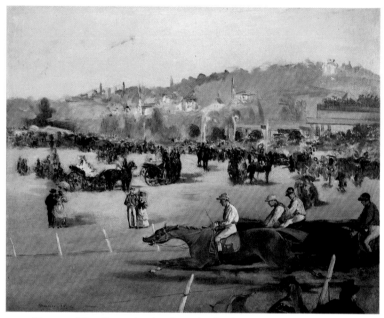

159. Manet, *The Races in the Bois de Boulogne*, 1872. Mrs. John Hay Whitney.

Henriette Maréchal, premiered in 1865 and published the next year. Young Pierre has won the adulterous love of Mme Maréchal, but at the critical juncture of the play he switches his affections to her innocent daughter, Henriette. He breaks the news to the mother by speaking of an outing to the steeplechase at Caen:

> You were not there. You had let Mlle Henriette go there with her father. My brother was racing that day. He fell, as you know, at the first barrier and remained for a moment without moving; we thought he was dead. I couldn't see anything. A hand had taken mine, a hand that I felt to tremble until my brother was gathered up. It was the hand of your daughter.

It is a coincidence that Degas's fallen jockey is dated the same year as the play, but the subject is revealing both for

painter and writers. In the 1860s, the Goncourts, Degas, and Manet often bore the imprint of the theatrical appeals which marked romantic art. Degas's picture, furthermore, is an unusually large one for him, and must mean that he wished to rival history painting by elevating a contemporary subject to such a scale. His drama comes from the danger to the fallen jockey, of course, but the threat is managed in pictorial terms, keyed to the unusual "empty" slope below the figures. The weight of the horses is all the more menacing because the lower portion of the canvas is flat and exposed, heightening our fear that the crumpled jockey is vulnerable to the moving bodies overhead. Their poses can be found in British sporting prints, but Degas frames them in an unusual and more dynamic way. The front horse is barely contained by the sides of the canvas, which means that we see him between the two edges much as we might catch a moving horse in the gap between two buildings or trees. If space opened out on both sides, he would seem frozen or suspended. And behind him, the two rear horses are hardly visible at all. Their jockeys ride the crest of brown hide and would seem to career out of the picture were it not for the power of our left-to-right vision, and the eye-catching figure of the pink-jacketed jockey on the ground.

The Salon picture of 1866 is Degas's only major rendering of a steeplechase, and one of only two that depict a race in progress (the other is Plate 166). Steeplechases were not

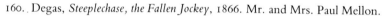

160. Degas, *Steeplechase, the Fallen Jockey*, 1866. Mr. and Mrs. Paul Mellon.

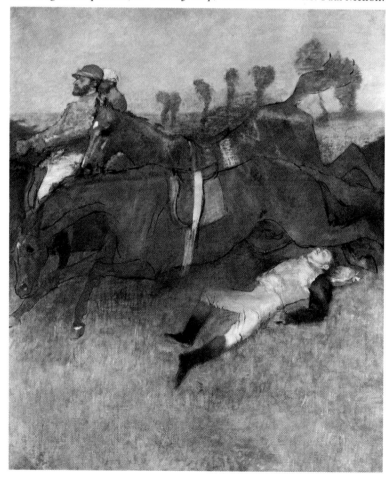

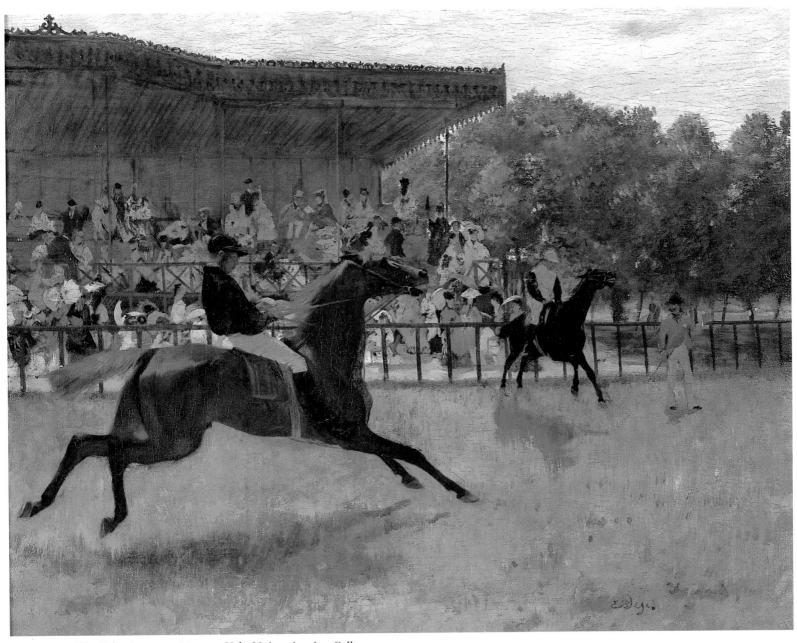

161. Degas, *The False Start*, c. 1869–72. Yale University Art Gallery.

162. Goya, *The Agility and Daring of Juanito Apinani*, c. 1815. Oxford, Ashmolean Museum.

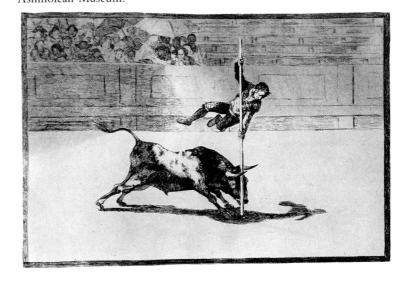

conducted in the Bois de Boulogne until 1873, when the terrain at Auteuil was opened, supplanting a wooded area that had been denuded during the Franco-Prussian War. Degas may have attended steeplechase meets at Vincennes, la Marche, or while vacationing with friends in Normandy, but his painting lacks any sense of a specific site. This is true also of his other racing scenes, even those few that have been identified with Longchamp, including *The False Start* (Pl. 161) and *Jockeys in front of the Grandstands* (Pl. 163). The stands in the latter rather closely resemble those at Longchamp, and the factory chimneys beyond are logically those of the nearby industrial region of Puteaux. The sun, however, is coming from due north! The same boreal sun is casting shadows in *The False Start*, whose stands do not closely imitate Longchamp's. (Manet's sun "correctly" comes from the west and the south in his two Longchamp races.) It is not hard to conclude that Degas made studio compositions without much regard for

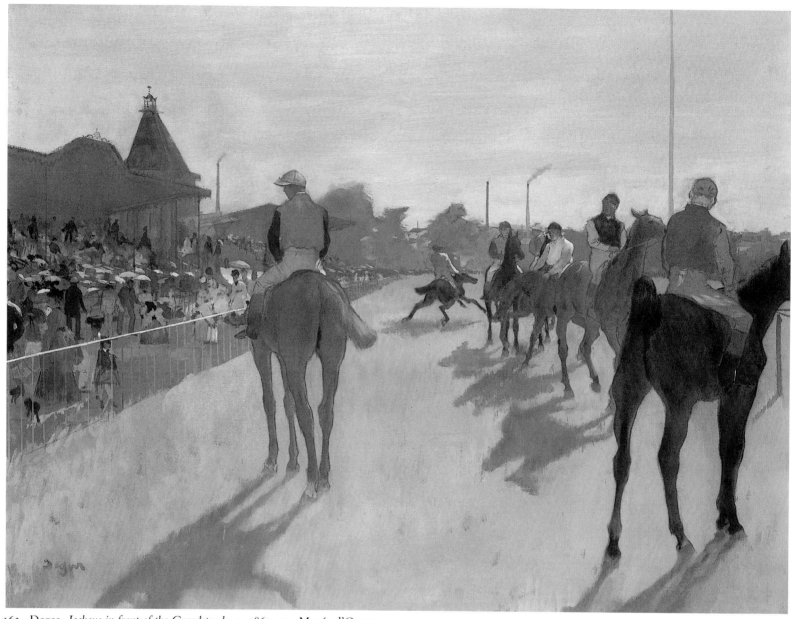

163. Degas, *Jockeys in front of the Grandstands*, c. 1869–72. Musée d'Orsay.

specific locations. He had a notorious disdain for faithfulness to landscape, and it was enough for him that a contemporary kind of racetrack was evoked. He used various studies of his own and occasional drawings after other artists, shuffling and rearranging poses (often repeating them) until he had a satisfactory result. The principal horse of *The False Start* could have come from the sporting print he painted on the wall of *Sulking* (Pl. 58), and the left foreground mount in *Jockeys in front of the Grandstands* was borrowed from a battle picture by Meissonier.[24]

Degas's racetrack compositions show horses milling about before the races, a choice he must have regarded as more subtle than Manet's races in progress, and a more suitable field for his insider's knowledge. He gave *The False Start* a touch of drama by showing the horses' anticipatory excitement. Taking a cue, perhaps, from Goya's bullfight prints (Pl. 162), he headed his horse into a clear expanse, increasing its illusory speed with the aid of the horizontal fence and railing, but then slowed it

down with the other horse, and stopped it with the starter and his red flag. In *Jockeys in front of the Grandstands*, instead of a horizontal flow of action, he used sharply receding orthogonals. One horseman splits the wedge of space formed by the grandstands and the echelon of horses. This produces a smaller wedge which heads up the center of the composition, a dynamic one because at its apex is the only exuberant horse. Its dash to the rear threatens the stability of this wedge, and also threatens the sense of control which the other jockeys preserve over their powerful animals. The potential for swiftness—one should sense it before a race—is not just in that fractious horse, it is more especially vested in Degas's artistic devices. By emptying the tracks of everything but the horses and their shadows (another parallel with Goya), Degas induces a sensation of quickness in our very perception. Our eyes can race into the imagined space, hastened along by those distinctive shadows. They result from the sun's glancing off the ground from its unusual position in the rear of the space (this is why it had to

162

come from the north!). Here and in *The False Start*, the shadows dematerialize the ground, converting it into a surface that reflects perceptual speed. To most modern observers, his two pictures suggest horses' ability to sprint more convincingly than do Manet's two races.

Degas's flat racing terrains are another instance of the impressionists' discarding the traditional complexity of modeled surfaces. If we turn back to the beginning of organized racing in France, we shall find the nearest equivalent to his cleared-out planes in the work of Carle Vernet. In *Mounted Jockeys* (Pl. 164) Vernet also creates a wedge of space with an echelon of jockeys, and endows the furthest horse with the greatest motion.[25] His horizon line is so low, however, that we read the illusion more easily than its manifestation on the surface. Additionally, he includes a still life in the foreground and models the earth with patches of growth and slight undulations, as well as with strips of shadow. Lacking pronounced area, the strips serve as slender pedestals for the horses, whereas Degas's shadows are large shapes that rival the horses as they slide downward on the picture plane. If we go back to a still earlier era, Degas's innovations will seem even more evident. Albert Cuyp's *Starting for the Hunt* (Pl. 165), for example, has a density of information along the earth that prevents us from accelerating into the space as Degas has us do.

The contrast of Degas's smooth, tilted-up plane with the earlier compositions should not be explained, as it usually is by art historians, by saying that it results from some sort of impulsion towards twentieth-century abstraction (a prevalent form of circular reasoning). The efforts of the Jockey Club had been bent on getting rid of the temporary and often uneven tracks of Vernet's day. Racetracks in Degas's era were flatter, since they were better graded, drained, rolled, and groomed in order to increase track times and diminish risk to the horses and their riders. Degas was not "influenced" by their manicured geometry—that would be a naive conception—but he adopted it as the ground on which to set his equine puppets. His pictorial devices were profound expressions of his class and his era because they literally gave shape to aspirations and anxieties that his society formulated in the races. Tracks, horses, and jockeys had all been removed from their once-countrified precincts. Like animated urban machines, horses and jockeys made their rounds on confined belts of ground, with ever-increasing speeds. Gauged by the exacting standards used by modern city dwellers to calculate time, location, appearance, and monetary value, they became one of the chief embodiments of industrial capital's drive for productivity and speed. They were parallel forms, barely different from one another, who rushed along a prescribed track, investments whose risk was measured by split seconds, mobile stock coupons who gave life to the spirit of competition and enterprise.

This is not to say that *all* horses were so viewed. The racehorse was the exponential development of an animal that Parisians saw at every turn; it was a symbol of continuity, as well as of speed and change. In the world of entertainment, equestrian shows were a staple of circuses, and more than one hippodrome was devoted entirely to "equestrian spectacles." In daily life, there had been a vast increase in the number of horses in Paris, paradoxical result of the urban-industrial revolution. They pulled the city's buses, its hired cabs, and

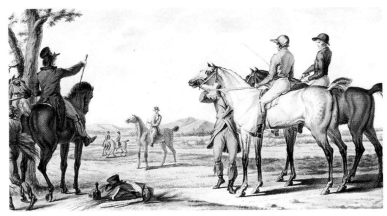

164. Vernet, *Mounted Jockeys*, c. 1820–25. Private collection.

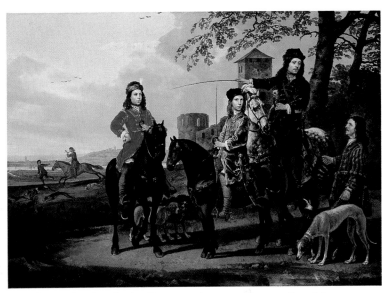

165. Cuyp, *Starting for the Hunt*, c. 1652–53. Metropolitan Museum.

private carriages, and its produce. The wealthy rode horses, so did police and military. Parisians were constantly at risk in the streets from the congestion of horse-drawn vehicles: 100,000 a day along the rue Montmartre in 1881, 20,000 on the boulevard des Italiens, nearly 18,000 across the pont Neuf.[26] Those killed or maimed by horses formed a large statistic in the city's lugubrious registers, but were only a small percentage of the 122 million passengers transported in 1875 by the city's horse-drawn buses and tramways, and 12 million, by carriages and cabs. Some of those passengers would have been taken to Longchamp, where they could leave the city's cares behind. There, in the open if well-regulated space of the track, they could indulge their thirst for leisure and entertainment by observing a more perfect form of the animal they knew so well.

In his early years, and occasionally later, Degas drew and painted all sorts of horses: ploughhorses, hunters, cavalry mounts, and carriage hacks, but he made racehorses his special choice. His preference for the moments before a race was at least partly owing to his interest in the ways horses and riders were studied in order to predict the outcome of the races. Knowledgeable observers knew, for example, that an experienced jockey could provoke an opponent's horse into a false

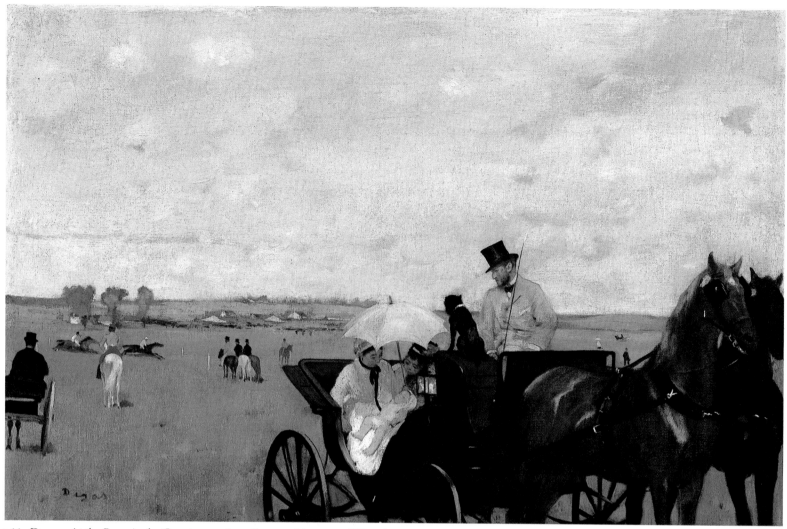

166. Degas, *At the Races in the Country*, c. 1872. Boston, Museum of Fine Arts.

start, to make both mount and rider more nervous. He could make his own mount seem unduly high strung, or the opposite, in order to throw his opponents' calculations off, for vital to a jockey's tactics during a race was knowledge of the other horses' temperaments and capabilities. Degas's concentration on the jockeys and horses was like that of the gambler who pins his hopes on close judgments of mounts and riders. He paid little attention to the social life which swarmed around track meets and seldom represented any of the officials and attendants who appear in Vernet's drawings, and in the racing scenes of his contemporaries. Of his finished works, fewer than ten show figures other than jockeys. One is *The False Start*, with its tiny starter, and among the remainder are three that let us examine the maximum variety within this realm, with due awareness of their exceptional nature.

At the Races in the Country (Pl. 166) represents the family of his boyhood friend Paul Valpinçon. Degas frequently stayed with the Valpinçons at their country estate at Ménil-Hubert, in Normandy; his letters show that it was a peaceable retreat from the cares of the city. He stayed at Ménil-Hubert during the Commune, recuperating from the siege of Paris (he and Manet had served, without action, in the artillery). He probably began the little picture then, or shortly afterwards. As he did in *Place de la Concorde* (Pl. 37) and *The Orchestra of the Opéra*

(Pl. 91), Degas put friends in an ambience that typified them, combining portraiture with genre painting. The infant Henri Valpinçon has just fallen asleep after nursing: his wet-nurse's breast is still uncovered. His mother bends under the sheltering parasol to look at him, while above, the dog imitates the father in an aloof observation (Pl. 168). Valpinçon, suitably elevated above the others, is dressed in the formal clothes of a wealthy Parisian.

The painting is more about a day's outing at a country race than about the race itself, here relegated to the left distance. There is none of the anticipatory tension that distinguishes *The False Start* and *Jockeys in front of the Grandstands*. Widely scattered over the plain are a number of observers who are either still or moving slowly. The cart on the left edge leans into the picture to suggest its swaying motion; seen from the rear, with only two of its horse's legs visible, it punctuates the space with quiet delicacy. One miniature horseman, facing forward, perches on the left corner of the open carriage as though responding to the dog; alongside the other corner are a man gazing to the right and a woman walking in the opposite direction. The tents and thin crowds in the distance, barely discernible in reproduction, locate the principal area of activity of this meet or fair. The race in mid-distance, perhaps a "gentlemen riders'" challenge, has attracted few spectators,

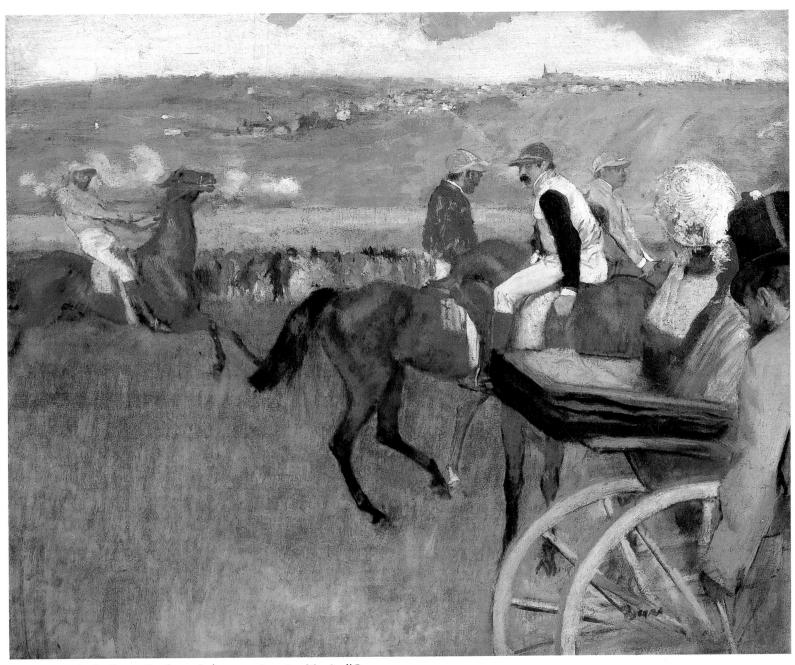

167. Degas, *At the Races, Gentlemen Jockeys*, c. 1877–80. Musée d'Orsay.

and its speed is checked by the crossing axis of the cadet astride a white horse, and by the clumps of trees above. It is true that by cutting the Valpinçon's carriage and the cart on the left with his frame, Degas produced an effect of alert vision, as though we had just come across this scene.[27] Despite this, the peaceful stasis of the whole scene is its dominant note.

At the Races, Gentlemen Jockeys (Pl. 167), painted a few years later, also has a carriage in the lower right, but it returns us to the tension of the races, even though only one of its horses is moving quickly. The excitement comes from the contrast of the charging horse with the figures to the right, and from the oppositions within the crowded group. The refractory horse starts a triangle that broadens until it reaches the far side, an encompassing shape that lets our eye dart quickly to the right. His charge is seconded by the distant train and its steam, and by the adjacent horizontals. Forward motion is nonetheless

delicately checked by the tail of the horse to the right, and more firmly counterbalanced by the forms in the corner.

The entire absence of shadows in this composition shows the extent of Degas's inventiveness by the late 1870s. In *The False Start* and *Jockeys in front of the Grandstands* (Pls. 161, 163), he needed the striking shadows because of the relative isolation of each of his horses. In just six or seven years he learned how to construct dynamic relationships by overlapping and interweaving his figures, playing one against another, reducing them to partial views. It is just like the development that his ballet pictures underwent in the same years. He also loosened his brushwork and heightened his palette, changes which were paralleled by the other impressionists. His shaggier brushstrokes produced softer edges and a more atmospheric effect than in his earlier racing scenes, dominated still by traditional modeling in light and dark, and his brighter colors helped pick

168 (following pages). Degas, detail of *At the Races in the Country* (Pl. 166).

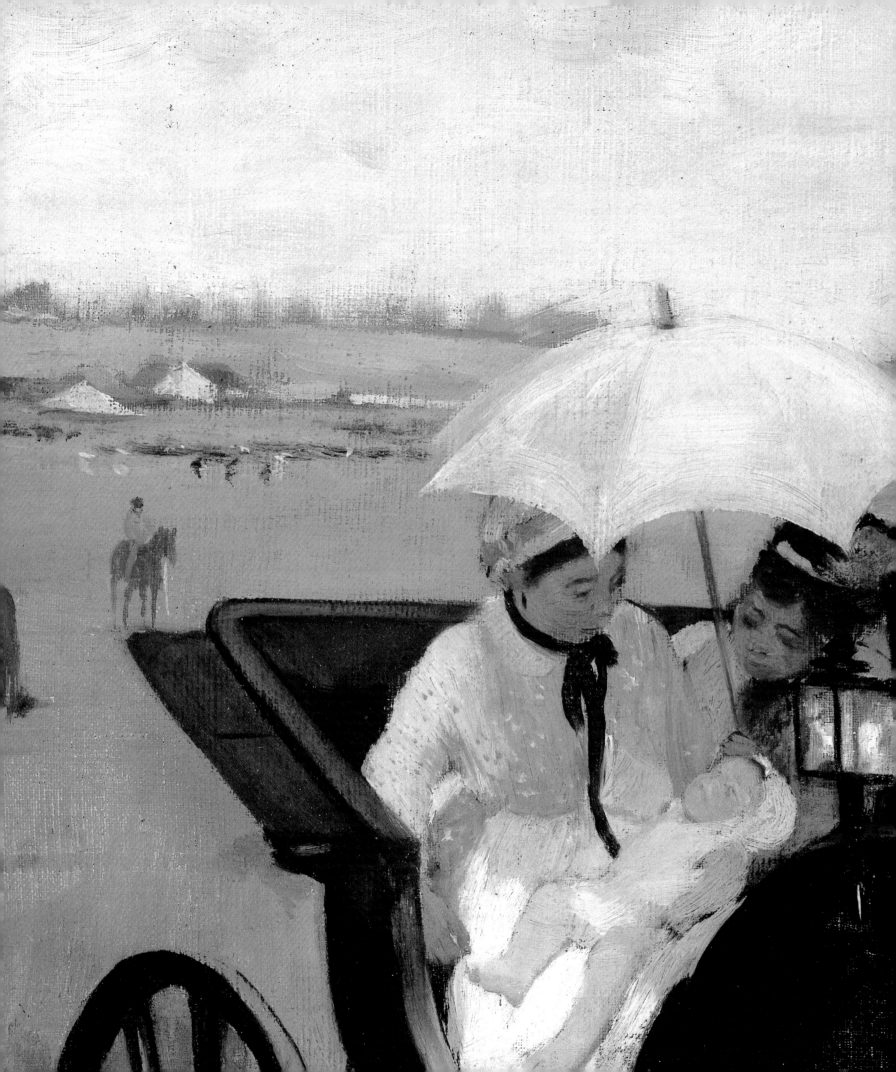

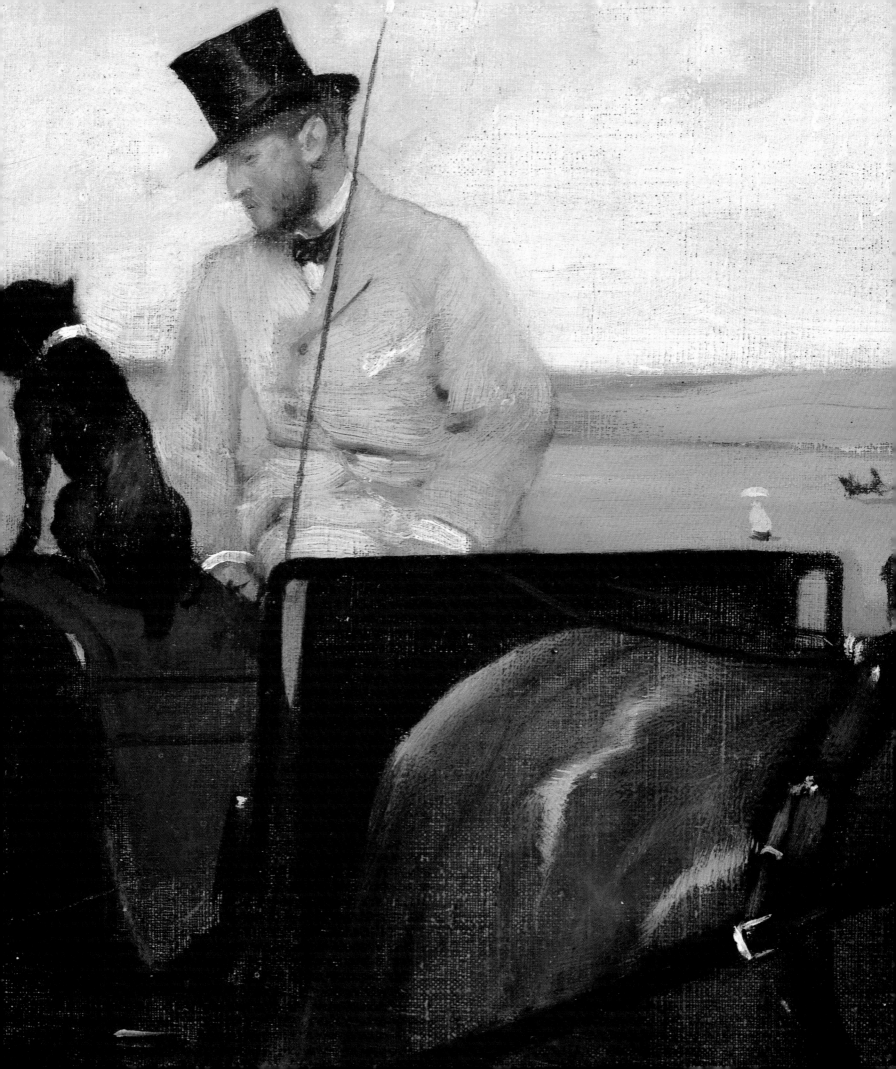

out forms that might otherwise have been insufficiently differentiated in his busy patchwork of images.

The arrangement of *At the Races, Gentlemen Jockeys* has its ancestry in seventeenth-century and later paintings which portray battles or hunting scenes. In Cuyp's *Starting for the Hunt* (Pl. 165), the left side opens out to a racing horse, whose rear hooves just touch a nearby animal, one of the cluster that crowds the right foreground (in other Cuyps, one finds a distant horse charging towards a foreground group). Cuyp activated his huntsmen and mounts by facing them in different directions, a key feature of Degas's organization. Such analogies do not deny the impressionist's effects of accelerated speed and agitation. In the Degas, Cuyp's shadows are lacking (how easily we accept their absence!), the foreground space is another incident-free wedge, and the countervailing poses of horses, riders, and spectators do not have Cuyp's up-and-down rhythms, and hence are more readily grasped in a single sweep of the eye.

The jockey facing left in this picture has the chunky body of a non-professional rider, the only visual clue to the gentlemen's race announced in the picture's title. Most racing seasons at the tracks around Paris set aside at least one race for gentlemen riders, who wore the colors of their own or a friend's stable. Bending into the picture's right corner is a man in formal day-time wear. His cane, inclined to his rear, shows that he is striding forward; he looks down as though he were watching his steps (the carriage is perhaps passing by). His hat hides the head of one woman in the carriage, but the edges of her own hat show that she is facing to the right. Her companion looks into the picture from beneath her elaborate headpiece, decked in ostrich plumes, flowers, and lace.

Neither woman's pose is easily read. One is largely headless, the other is armless, and her dress, cut in a square over her upper back, confuses us further. The well-packed corner of this painting consists entirely of fragments: the top-hatted man and the carriage are partial images, and none of the nearby horses has four legs. We see the front half of one, the rear of another, and only one leg of the furthest mount. Two of the jockeys head in the same direction (foretaste of the pending race), but the corpulent rider, the two women, and the man each look in different directions. The contrast with *At the Races in the Country* is complete, for there the carriage group concentrates on the infant, and we sense the openness of the environing plain. The field in the later picture is presumably equally broad, but it is closed off at the right and the jumble of fragments has the effect of crowding our perceptions, making us work hard to separate the pieces. We have come out from the city, in effect, to view this race, and Degas gives us a busy urban experience, rather than the peaceful country glimpse of the Valpinçon family.

The train off in the distance is another sign of the dialogue between city and country which characterizes the suburban and provincial races. The train's smoke is assimilated with the fiery breath of the galloping horse, a playful touch that also reminds us of the symbiosis that joins the iron horse and the races. It was not just that trains brought crowds from Paris out to the suburban tracks. The railroads also put up prize money, ran special excursion trains, and advertised both heavily. Thanks to the power of the Jockey Club, and particularly to the duc de Morny, a special line was built in 1859 to serve the track at Chantilly. It transported 30,000 passengers a day during the racing season. Trains were even more vital to the tracks at a further distance from Paris, for at Chantilly, only twenty-four miles from Paris, omnibuses, carriages, hired cabs, and private carriages brought a still greater number. Major races drew over 100,000 spectators. Many came for the day, and some brought food and drink, the origins of "tailgate parties" so important today in collegiate football games in America. The *chic* thing to do, however, was to rent quarters in or near Chantilly, in order to take part in the round of dinners and balls that, for some, were as important as the races. Because of the associations with the famous château, there was at Chantilly "an air of aristocracy and of high living":

> Those favored by large fortunes have the habit of renting a house for the short season of the races, colonized by all the luxury of Paris. For those who really belong to the circles of Parisian sport, Chantilly is an obligatory rendez-vous, but it is so as well for those who wish to give the impression that they own their own horses and equipages. Chantilly is...a pell-mell of individualities which provide contrasts: real gentlemen, society women, orthodox countesses and duchesses, people of eminent distinction and good fortune, then the higher bohemia, profane and doubtful crowds, financial celebrities, a colorless, prosaic, untidy bunch, disdainful of the best traditions.[28]

Degas's *At the Races, Gentlemen Jockeys* does not represent Chantilly (it is probably an invented terrain), but its "pell-mell of individualities" and its restrained excitement form an admirable interpretation of suburban races, this special form of entertainment for middle-class and wealthy Parisians. In addition to Chantilly, whose spring and fall seasons followed and extended those at Longchamp, there were meets at La Marche (near La Ville d'Avray), Le Vésinet, Versailles, Vincennes, Porchefontaine, and Fontainebleau. None of these challenged the primacy of Longchamp, but they also were epicenters for the swirl of Parisian fashion. Men could show their prowess in choosing women, as well as horses, and women, their flair for the latest fashion. The hat worn by the woman in Degas's carriage (he was also a painter of milliners' shops) is elevated to singular importance, since it is all we see of her head. Placed next to the man's shiny stovepipe, it flags the role of fashion at the races. At Chantilly, wrote an American journalist in 1869,

> one may study the most remarkable toilettes. The favorite colors seem to be pale blue, pale green, lavender, pink, pearly gray, and maize color, bordered with deep white lace or bound with satin or velvet of some contrasting shade. It is in the hat alone, with its pyramid of feathers, its large bouquets of flowers, bands of velvet, and puffs of lace that one recognizes the extravagance of the day.[29]

The appearance of fashionable spectators in *At the Races, Gentlemen Jockeys* should not distract us from observing the structure of Degas's art, that is, we should not be so attracted by his subject that we lose sight of the fact that the picture

is created, not seen. Each of its jockeys and horses appears in other paintings, proof enough of the fact that he built compositions out of pieces of art, instead of observing a scene and then copying it.[30] In *Before the Start* (Pl. 169), a track official looks at some of the same horses and jockeys. He is the fulcrum around which the jockeys pivot—another instance of the actual structure of a picture contributing to its subject—so the composition is more symmetrical than the other. Because the foreground space is more evenly balanced left and right, there is no reason to isolate the charging horse. His speed is diminished by the blocking effect of the foreground mount, well to the left of its position in the related composition. The amateur rider of the latter, slimmed down, is here over on the right edge, and his costume is worn by another.

Degas's jockeys and horses are therefore puppets that he manipulated, as he did his ballet dancers. Like the dancers, his jockeys, absorbed in their work, do not talk to one another. They are skilled specialists, workers whom Degas and the members of the Jockey Club admired and judged from their privileged vantage points. Degas moved their images around on imaginary fields, as flat as rehearsal floors. He made wax sculptures of horses and of dancers, single figures that, once made, acquired the factitious reality of manikins. Surely he preferred the moments before races and before ballet performances because he could show the movements of training and control. He could act out the role of the dominant male connoisseur, the insider who knew the fine points of jockeys and their mounts, as well as of ballet dancers. His own analytical studies, while he devised his compositions, had kindred moments in the subjects that he rendered.

Degas did not need track officials nor spectators to induce the agitation of the racetrack. *Jockeys* (Pl. 170) is a tour de force in which landscape is reduced to a token patch on the left, horses' legs are nowhere seen, and only two of the jockeys have visible mounts. We are extremely close to the horses, either on horseback or in a carriage. We can easily imagine their snorting and their motion, even to the point of being jostled by them. On the left the horses' heads are lopped off, a startling pictorial mutilation. Our instinct is to imagine the existence of those missing heads, and then we jump over to the right where two heads are just bobbing their way into the composition. The right edge of the picture somehow becomes the left edge as our minds perform this back-and-forth reading which so wonderfully suits the subject.

The jockeys in the center of this little picture have no horses. We assume that they do, because of the astute way Degas has used the conventions of scale and perspective, principally, diminished size and the declining slant of their heads. Color contributes to this, also. The foreground jockeys and horses are rendered mostly in dark and sonorous browns, purples and reds. This forms a wide V-shaped frame, through which we look to the backs of the jockeys. There we see the brightest colors: the jacket of the furthest jockey, reduced to three spots, has the most intense red in the painting. These strong hues attract out attention to the central region from all points on the perimeter, creating a funnel of space. The funnel is also a flat triangle, surrounded by other triangular shapes. The tension between the illusion of depth and the densely

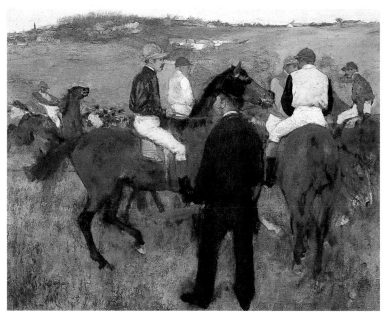

169. Degas, *Before the Start*, c. 1875–78. Private collection.

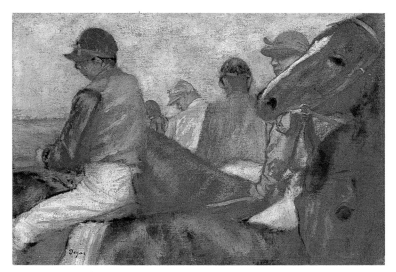

170. Degas, *Jockeys*, c. 1882–85. Yale University Art Gallery.

packed surface is simultaneously created and tamed by the artist's geometry.

Degas's astonishing modernity is fittingly embodied in his images of horses in motion. They stand for a society undergoing profound and rapid transformations. We confront an imaginary event that concentrates on the present moment, one that gives us little that is enduring or stable. It is, moreover, a passive entertainment, not truly a sport. The jockeys are hired entertainers who jostle one another in dense packs despite the open ground they are passing over. They prepare for the competition which Degas's society said was the essence of progress. His genius is to have created pictures that render the strains which underlay this "progress." Instead of a whole body or a whole scene, with its traditional unities, we are faced with an assortment of parts. We have to study the relationships among them, and this reconstruction becomes our mode of apprehension. Degas pushed the Renaissance tradition of verisimilitude to its limits and showed man's power over nature

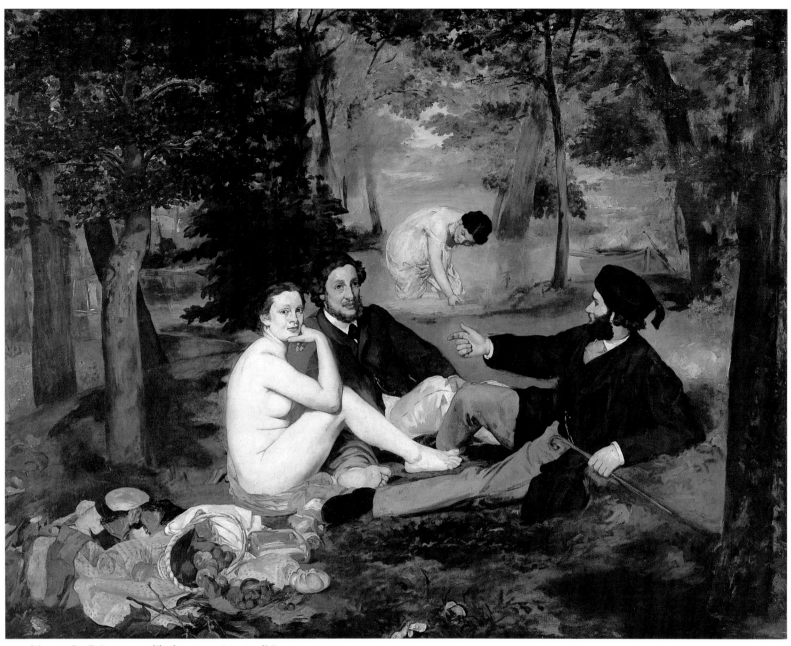

171. Manet, *Le Déjeuner sur l'herbe*, 1863. Musée d'Orsay.

by making his puppets believable, by making us accept headless horses, bodyless heads, and horseless jockeys.

Degas's dynamic vision, with its choppy rhythms and abrupt shifts, looks forward to the twentieth century's thirst for motion, for speed, for concentration upon the present moment in the hopes that it will control the future. The past is still with us, as it was with Degas, and threads of continuity keep the social fabric intact despite alterations, but the consciousness of change and rupture is one of our leading signs. The racehorse is an especially appropriate embodiment of all this. It is no accident that Umberto Boccioni, Raymond Duchamp-Villion, and Jacques Villon chose the horse as a vehicle for these modern sensations, and it is no surprise that "horsepower" and "harnessing power" are still basic conceptions, despite the anachronism of the terms. Degas's pictures are close to us because of their dynamism, their assertion of the power of humans to impose patterns upon nature, and their threat of fragmentation.

Luncheons on the Grass

When Parisians took their lunches out to the racetrack at Longchamp or Chantilly, they were indulging in a latter-day version of the hunt breakfast and the picnics which had passed from the aristocracy down to the middle class in the eighteenth century (we still eat the invention of Lord Sandwich). Picnics were one of the common ways in which city dwellers enjoyed nature, and Alphand made allowance in his design of the Bois de Boulogne for a variety of open and semi-secluded areas favored by picnickers. Cafés and kiosks sold luncheon supplies to improvident visitors, and journalistic pictures of alfresco

parties became a standard visual reference to the renovated park.

Picnics were social forms that were intimately tied to the Parisians' concept of landscape. The landscapes created by the Second Empire and those painted by the impressionists were expressions of the age-old solace that urban peoples sought in nature. It is no paradox that landscape was one of the principal manifestations of the urban-industrial revolution. In England at the end of the eighteenth and beginning of the nineteenth centuries, painting was steeped in the imagery of nature, while the country was being rapidly industralized. In France, landscape painting began its rise to prominence only a generation later, when its belated modernization began. Constable, Turner, and Bonington had a role in the development of French landscape partly because British culture and industry were then penetrating France, serving as beacons of modernity. It was fitting that Louis Napoleon's ideas for the Bois de Boulogne derived from London's parks, just as it is fitting that the impressionists exhibited pictures painted out of doors a half-century after Constable had done so.

To place the human figure in natural light was a task that most of the impressionists set themselves. Manet, Monet, Morisot, Caillebotte, Cassatt, Cézanne, and Pissarro each expressed this aim in one way or another, and their friends among the critics built their defenses around this same aspiration. Duranty, we recall, in his famous pamphlet of 1876,[31] urged artists to knock down studio walls and go outside. Even though he meant city streets and not "nature," he stressed natural light ("the vibration of sun-drenched air"), and gave the first major statement of the painters' breaking colored light into its constituent tones. Except for Pissarro and Cézanne, who disliked Paris and its society (Pissarro's views of Paris were done towards the end of his life), the impressionists painted landscape settings that were urban in feeling, even when outside the city: the strollers, picnickers, and boaters

172. Courbet, *Young Women on the Banks of the Seine*, 1856–57. Paris, Musée du Petit Palais.

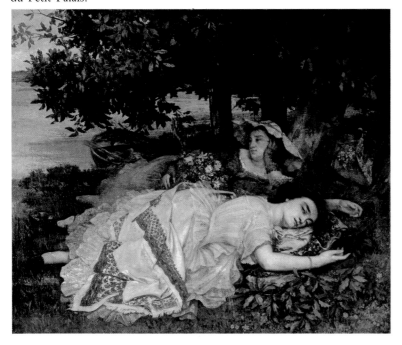

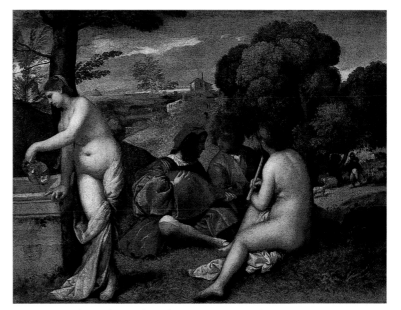

173. Titian (formerly attributed to Giorgione), *The Concert*, c. 1508. Musée du Louvre.

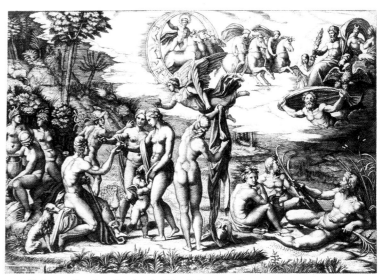

174. Raimondi, after Raphael, *The Judgment of Paris*. Yale University Art Gallery.

they showed in Argenteuil or Trouville certainly came from Paris.

As usual it was Manet who led the way. Ten years before Renoir exhibited his *Morning Ride*, Manet had shown his *Déjeuner sur l'herbe* (Pl. 171) in the first Salon des Refusés. Like Renoir's painting, it showed townspeople out in nature, and it was also a singular mixture of historical reference and current observation. In that exhibition of works rejected by the Salon jury, it was the most notable painting, the one most talked about—nearly always negatively. Like Géricault's *Raft of the Medusa* or Courbet's *Burial at Ornans*, it was one of those pictures that launched an epoch in painting by assaulting simultaneously traditional art and reigning social conventions. That it did so in a picture of townspeople relaxing in a wooded clearing is no accident. It evoked the aspirations the whole century felt so keenly, of accommodating oneself to nature, and drew to itself traditions of art history dating back to the Renaissance. From the immediate past it recalled the picnics

that were ubiquitous in romantic art, in both popular prints and the paintings of artists like Diaz, who extended the previous century's predilection for outdoor coquetry in bosky surroundings.

The *Déjeuner sur l'herbe* was painted at the outset of Manet's career. He had first exhibited in public only two years earlier, and he was only thirty-one when his picture's appearance in the Salon des Refusés in 1863 gave him sudden notoriety. Courbet, whom he now began to rival, had exhibited his *Young Women on the Banks of the Seine* in 1857 (Pl. 172), a painting of two women of dubious virtue reclining on the riverbank. One has removed her outer garment and gives the viewer a sultry look. Manet's picture put him in Courbet's camp as a realist out to shock the conservatives. The extent to which he anticipated the viewing public's scandalized reaction is not known (and has been much argued over), but by placing a nude among clothed men, he ensured a provocation that any dandy would have been proud of. The men are dressed as fashionable young students (and that is a silver flask near the basket, not a wine bottle), but this makes their companion's nudity only all the more striking. The shift worn by the woman in the background is not reassuring, either. Since Manet exhibited his huge painting as *Le Bain* (Bathing)—he changed to the present title four years later—one must conclude that the two women were so liberated that they had doffed their clothes in the men's presence in order to swim in that sylvan pool.

Because the picture contains references to past art, and because its figures have a posed and solemn appearance, Manet may have thought that his public would take the women as dryads or nymphs of spring and forest. In student days he had copied Giorgione's *Concert* (Pl. 173) in the Louvre, in which two nude women accompany a clothed lutenist and a shepherd. According to Antonin Proust, Manet conceived of his *Déjeuner* as a modern version of that famous Venetian picture; it had darkened with age and he would make it over in fresh, outdoor tones.[32] It is also known—although only Ernest Chesneau mentioned it in 1863—that Manet took the poses of his three main figures from a group of two river gods and a nymph in the engraving by Marcantonio Raimondi after Raphael's *Judgment of Paris* (Pl. 174). Because Raimondi's engraving was famous among painters, Manet's borrowing was the kind of send-up of history that many fellow artists would have appreciated.

Just how oddly Manet mixed present and past can be seen if his picture is compared with *Autumn* (Pl. 175) by Puvis de Chavannes. This singular artist, working outside all "schools," had regularly been rebuffed by the Salon juries in the 1850s, but was beginning to come into his own when the state purchased *Autumn* from the Salon of 1864. In his picture, a blue-robed woman of abundant proportions watches two nudes gather fruit. At their feet are harvested fruits, garnished with flowers and leaves; further back is another group of female harvesters. No specific sources have been recorded for the main figures, but they proclaim themselves borrowings from "art." Not only do they strike half-familiar poses, they are also partly clad (better: accompanied by drapery) in a vaguely antique fashion. Although out of doors, Puvis's setting has little sense of daylight, and few concessions to naturalistic

175. Puvis de Chavannes, *Autumn*, 1864. Lyon, Musée des Beaux-Arts.

vision. Grapes seem to be born of a tree instead of a vine, and the fruit in the basket held aloft defies all effects of gravity. There are no plebeian vegetables to diminish the beauty of the fruit, and no men to interfere with these seasonal dryads.

Puvis's figures are so thoroughly like painted statues that the absence of communication among them is not disturbing. Indeed, their distance from us and from conventional narrative is what later attracted artists like Seurat, Gauguin and Picasso to Puvis: their figures seldom converse, either. In Manet's *Déjeuner*, however, any sense of consistent, inclusive allegory is destroyed by its references to the present. It is true that we can, with effort, accept his picture as an allegory of summer-time, but it is more of a parody than an allegory, and it has a charge of irony running through it that was avoided by an artist like Puvis.[33] It is Manet's models rather than Puvis's who compare favorably with the gods and the Greek royalty in Offenbach's *La Belle Hélène* (1864). Puvis was independently minded and kept his distance from the academicians, but he loved history too much to ridicule it. Manet converted river gods, nymphs, and Venetian men into contemporary picnickers as a way of mocking history and its guardians, the academy; in doing so he insulted both traditional sources and the manner of presenting them.

The insult was carried in the broad, flat, and abridged modeling of figures and foliage, and in the bold appearance of

the nude. She was recognized as the model Victorine Meurent, because another painting of her hung alongside the *Déjeuner* in 1863, *Mlle V. in the Costume of an Espada*. Artists' models were believed to be of easy virtue, but that was not all: Meurent was not transposed into the kind of ideal nude who stayed within "art," as Puvis's women did. Her thickened body is too arrestingly real, and her frank stare fixes the onlooker's eye. At the same time, her very boldness, like that of *Olympia*, thwarts any male expectations of sexual submissiveness. She not only gives the impression of a living model, but of one who is in entire control of her actions: "She in no way engages in the erotic *fête champêtre* of which she is apparently a member; stark naked, she nonetheless refuses the erotic script."[34]

An artist's model does indeed belong in a work of art, but the irony of Meurent's "real" presence was disconcerting. She no more remained within the fiction of a distant, ideal world, than did Paris, in Offenbach's operetta, when he won the Greek kings' charade by announcing the sought-for word: "locomotive." Moreover, Meurent's form jars with the more self-contained poses of the young men, just as their forms, and hers, stand out from the landscape. Not only do they appear as virtual cut-outs, arbitrarily transported from the studio, but their wooded clearing seems as artificial as a stage set. Among other things, our view back to the water on the left cannot be reconciled with our view through the center (the foliage over the nude's head is too obvious a device to bridge the two perspectives successfully). Manet may have intended the illogical perspective as the sign of an imaginary, other-world space that would suit nymphs rather than contemporary bathers, but other features of the composition defeat such a reading.

Manet's painting, in fact, is built upon the juxtaposition, rather than the integration, of its separate parts. One can even list them in the form of a faulty equation, one side cancelling the effect of the other:

contemporary dress	poses of river gods
saucy artist's models	nymphs or dryads
undressed model	idealized nude
nude bather	clothed men
contemporary picnic	Renaissance poses
freshly observed nature	stage-set landscape
contemporary life	history painting
present	past

A brief jump forward to Manet's more naturalistic *Game of Croquet* (Pl. 176) of a decade later shows just how strangely the early *Déjeuner* straddles past and present. The croquet picture moves fully into contemporary time. Its figures are dressed in appropriate middle-class garb, they display poses of convincing casualness, and they are integrated with the landscape. The setting is rather indefinite—we know it was the Parisian garden of the painter Alfred Stevens—but its light and dark areas, aided by the echelon of players, form a unified space. Of course, the very loose brushwork would alone make the picture seem unnatural to traditionalists, but a decade after the *Déjeuner*, Manet has shaped an integral, if still avant-garde style, and he has chosen a piece of contempoary leisure that embraces a more satisfactory narrative.

176. Manet, *The Game of Croquet*, 1873. Frankfurt, Stadelsches Kunstinstitut.

In the early 1860s, however, he was still battling traditional art by including it in his compositions—in order to undermine it. He was wrenching the past into the present not only by manipulating it, but also by disclosing the signs of his manipulation. This is true of *The Old Musician* (Pl. 65) of 1862, and *Olympia* (Pl. 62), painted the same year as the *Déjeuner* (but not exhibited until 1865). His witty game required both past ideals and contemporary realities, each employed to mock the other. He committed himself to neither and, like Offenbach, he challenged authority with the instruments of irony and parody.

One can almost imagine a friend of Manet's defending the *Déjeuner* by pointing to his use of irony. Cabanel's *Birth of Venus* (Pl. 177), shown in the official Salon of 1863, was lavishly praised and purchased by the Emperor. Next to its voluptuous forms, Manet's nude seems reserved, if not chaste. In other pictures praised by officialdom, nude nymphs disported themselves in nature, so where was Manet's offense? Alphand wrote of the artificial perspectives he engineered for the Bois de Boulogne, so why should Manet's landscape be held to another standard? Leisure-time dalliance was one reason why Louis Napoleon converted a royal preserve into a public garden, and has not Manet also celebrated such dalliance? Do the government's fine-arts representatives have

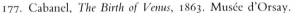

177. Cabanel, *The Birth of Venus*, 1863. Musée d'Orsay.

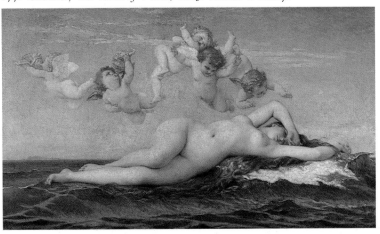

the right to assault the *Déjeuner* when they built in the Bois a fake grotto, an artificial cascade that could be turned on only once a day, a Swiss chalet for a waffle stand, and a concrete basin for a "natural" lake—on which "Venetian" gondolas were for hire?

We must surely doubt that Manet calculated all aspects of his ambitious painting along the lines of such ironic confrontations, but whether intentional or not, they served his purposes admirably. They made a disruptive presence in the history of French art, a fissure more than a bridge. In this painting, *Olympia*, and other works of the same decade, he forced open a gap with history, which could no longer be held up to the present as an intact world. It would not be imitated or emulated, only quoted, and the quotation marks would be visible.

As for the figures in Manet's composition: they were not the only ones in the Second Empire to borrow poses of mythological creatures of river and wood. Louis Napoleon's mistress, the comtesse de Castiglione, dressed for one ball as an acacia blossom; sixteen society women became naiades and salamanders for the amateur ballet "The Elements" in 1860; the comtesse de Brimont came to an imperial dance in 1863 as "a night in the forest," swathed in foliage which sheltered live insects and a tethered squirrel.[35] These naiades and countesses should have appreciated Manet's painting, because they shared something of his irreverence for mythology and for the current fad for nature, but as a matter of course, they put painting in a separate compartment and donned different clothing to view it.

Two years after Manet's painting was shown at the Salon des Refusés, Monet undertook his own *Déjeuner sur l'herbe*. It was a recasting of Manet's composition by an aggressive younger artist (then twenty-five, to Manet's thirty-three), as anxious to rival his notorious colleague as the latter had been to displace Courbet. He destined his enormous composition for the Salon of 1866, and if it had been completed and accepted, it would have raised many an eyebrow: it was to be six meters wide (nearly twenty feet), five times the surface area of Manet's canvas. Its size alone means that Monet intended it also as a challenge to Courbet, whose gigantic *Burial at Ornans* and *Artist's Studio* had marked the previous decade, and as a symbol of defiance to academic painters, whose huge history paintings were called "machines" because of the equipment required to move them. Monet's composition was, alas, never finished, and the artist later cut it into pieces. The central portion (Pl. 139) is the largest surviving fragment. It can be advantageously compared with the sketch of the whole composition, now in Moscow (Pl. 178). The sketch—itself a large picture, nearly six feet wide—was elaborated over the summer of 1865 at Chailly, a village on the edge of the Fontainebleau forest, and probably touched up in 1866 when the artist signed it. The larger canvas was worked on in Paris beginning that fall, and abandoned in the spring of 1866.

Monet's picture is revealingly different from Manet's. He did not have his elder's aristocratic wit, and there was not an ironic idea in his head. A middle-class provincial from Le Havre, he was struggling upwards, and not at all part of the dashing Parisian society that Manet was teasing from within. His picture invites comparison with Manet's *Music in the Tuileries* (Pl. 41), a painting of contemporary leisure that offers few nods to the past, and a work that must have encouraged Monet in his venture. Monet's figures, by comparison, are a notch lower in the social scale, being solid middle class where Manet's are upper class. Equally to the point, the irony that was so central to Manet was incompatible with Monet's deep commitment to a believable naturalism. Puvis de Chavannes was, as we saw, also free from irony, but these two were at absolutely opposite poles; naturalism versus anti-naturalism. Monet looked towards history, but he hid his allegiances quite effectively, and it was especially recent painting that he favored.

Chailly was the village next to Barbizon, so in the summer of 1865, Monet was in the heartland of the region that had given rise in the preceding generation to the "Barbizon school." At its center were Millet and Rousseau, but other painters were often in the region and were loosely grouped in the same school: Corot, Courbet, Daubigny, Dupré, and Troyon among them. Monet looked to all these artists, and to Boudin and Jongkind, whose seacoast paintings had already afforded him many lessons. Like the impressionists in the parks and gardens around Paris, the Barbizon artists had shared much with their contemporaries in Paris. Excursions to the edges of the Fontainebleau forest were a common form of Parisian outing before 1848, and became still more popular afterwards, when the artists' colony there helped celebrate the area. In Monet's sketch (Pl. 178), the large birch to the right bears an inscribed heart and arrow, and the letter P. "P" and friends could have reached this and other forest clearings easily: there were excursion services at Fontainebleau, Melun, and Chailly which provided transport, drink, and food. The costumed man with a food hamper to the right of the birch tree in Monet's sketch is presumably the representative of such a service.

The male attendant, when one's eye finally spots him, puts into proper relief the well-got-up group that Monet assembled in his painting. He had friends pose for him, particularly Camille Doncieux, his future wife, and the painter Bazille (the lanky figure who appears four times in the sketch). Some of the men wear bowlers, all of them have ties and jackets, and the women are decked out in the luxuriant manner of the Second Empire. They are a far cry from the woodcutters and shepherdesses whom Millet and the other Barbizon painters placed in the Fontainebleau woods. Like the men of Manet's *Déjeuner*, Monet's picnickers are contemporary Parisians who have brought the city with them. Unlike Manet, however, Monet treated them as participants in a believable fiction. Monet does not let the past jostle the present, and if his picnickers seem a bit stiff to our eyes (we look through the lenses of later standards of naturalism), they are grouped harmoniously in relation to one another. They are boldly painted with little of the careful modeling tradition demanded, but they are not cut-outs, and are more carefully related to the environing growth than Manet's foursome. The large tree to the right in the sketch is used to gather together the figures around it. Responding to it are the three standing figures on the other side, and the pair of trees in the center: together they form a triangle in space that anchors the whole scene.

Monet's naturalism of the 1860s was built upon seemingly

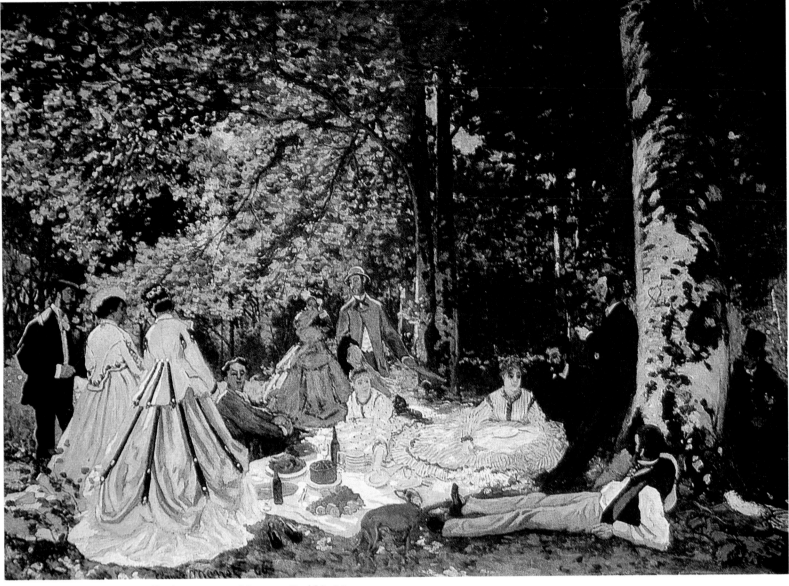

178. Monet, *Le Déjeuner sur l'herbe*, 1865–66. Moscow, Pushkin Museum.

unnatural elements, such as the broad swatches of paint that mark the edges of the figures left of center and the fall of light on the luncheon cloth. In the surviving pieces of the big composition and in the sketch, we are struck by Monet's inventiveness in creating new devices, rather abstract in themselves, which articulate convincing volume and depth while floating on the surface as zones of colored pigment. This is in many ways the heart of the modernist enterprise in painting, the paradoxical balancing of flat surface and naturalistic content which eventually tips over in favor of surface. The ribbons of paint along the shoulders and backs of Monet's figures, and the splashes of light on the ground cloth, will reappear with even greater autonomy in the work of Vuillard and Gauguin, thirty years later.

To achieve his unusual effects, Monet positioned his figures so that light struck them from behind. Compared with conventional lighting, which we would accept without thinking about it, this has the virtue of excusing his unusual means while also making light an active participant in his naturalism. Its more forceful presence is what distinguishes his paintings

from Manet's *Déjeuner* and *Music in the Tuileries*. Their bold abbreviations held more than one lesson for him, but they preserved studio light. Monet's believable daylight marks his painting out even more strongly from Puvis de Chavannes's *Autumn*, which willfully subordinated illusions of depth and immediacy to the permanence of an architectural wall. Puvis's seated figure, with her Grecian profile and thick drapery, comes from a timeless distance. Monet's seated Camille (Pl. 139), with the edges of her face lighter than its center, and with her flesh showing through her filmy garment, has a lively presence entirely alien to Puvis's conception of art. Monet's insistence on direct studies *en plein air* complicated his campaign in Chailly, but the essence of his new art was in those studies, even though they had to be transposed to a large canvas in the studio.

It was to painters of the preceding generation that Monet turned for the lessons he needed. In both watercolors and oils, Boudin summed up clothed figures in rapidly noted dashes of color, a graphism that often merged the identities of color and line; Jongkind often made sky, rooftops, water, and foliage

shimmer in separate dabs of bright paint; Corot employed broad bands of buttery pigment to give the sense of sunlight streaking through foliage to fall on meadow or forest road; Diaz and Rousseau put spots of paint side by side to create a surface mosaic of foliage; Courbet commonly used opaque paint, scraped and dabbed with a palette knife, to form a patchwork of textured areas that adhered as much to surface as to imagined depth. It was Courbet, the arch-realist, who insisted that one must paint what one actually *sees*, as distinct from what one knows, and it is tempting to think that his example was before Monet as he worked on the large *Déjeuner*. From a letter of Bazille's it is known that Courbet came to Monet's Paris studio to see his large composition late in 1865, and some of Monet's friends later claimed that Courbet had given Monet advice. Many have wanted to see Courbet's likeness in the bearded man of the central fragment who replaces the younger man of the sketch. Not everyone agrees, but in the sketch, the broadly brushed birch tree that dominates the right edge is a certain homage to the master of Ornans.

Monet's improvised technique, "sketchy" even in its most finished areas, was therefore a further development of the free, somewhat rough way of applying paint which had characterized the mid-century vanguard. In Courbet's case, free handling was equated with opposition to authority because he was an outspoken radical. For other artists of the same generation, sketchiness was considered forward-looking, independent, and "democratic" because it was opposed to the highly finished surfaces of officially sanctioned art. Daubigny was accused of giving mere "impressions" of nature instead of proper renderings, and Millet's shaggy surfaces were treated by friend and foe alike as appropriate to his peasant subjects. From the late 1850s onward, "sincerity" in an artist's response to nature was brought forward by liberal critics as a key element, usually associated with a technique that could be a vehicle for spontaneity. Sincerity, truth, immediacy, spontaneity, natural light, and color, the banishing of muddy colors, the distrust of smooth finish—these were the moral underpinnings of artistic technique that Monet adopted. For, morality is indeed an issue, one that usually lays undetected beneath the findings of historians who conceive of technique as a neutral or self-defining recipe. Monet's *Déjeuner* proclaimed sincerity, immediacy, and those other features as positive values, associated not with work or with the city, but with leisure and nature; not with the past, but with the present; not with historical or mythological personages, but with one's own society; not with government agencies or fine arts commissions, but with the individual artist. This was true also of Renoir, Sisley, Pissarro, and Cézanne. The latter two in particular equated "primitive" qualities of execution with the moral meanings they sought in village and countryside, an attitude most famously expressed in the following generation by Van Gogh. For Monet as well as for Van Gogh, the morality of *plein-air* naturalism was the source of artistic energy.

This does not mean that Monet's *Déjeuner* was so saturated in the present that it lacked ties with history. His project renewed the eighteenth-century themes of hunting parties and *fêtes galantes*. The man with the hamper in his sketch is an archaic survivor, and so is the whippet hound in the foreground. They are found in eighteenth-century paintings of hunting parties in wooded clearings or meadows, such as Carle van Loo's *Halt of the Hunting Party* (Pl. 179). There we find servants with food hampers, hunting dogs, a collation spread out on a large cloth, figures seated and standing in informal poses, women in voluminous dresses. Even Monet's food is faithful to the menu of a hunting lunch: pâté, fowl, fruit, bread, and wine. In the *fête galante* (Pl. 137), of which Watteau was the most exemplary practitioner, dancing, strolling, and conversing in flirtatious groupings often take place without food or drink, since hedonistic pleasure in the open air was sufficient pretext. Monet was aware of the two eighteenth-century themes, because an early drawing for the *Déjeuner* (Pl. 180) has motifs from both: dogs, a figure reclining with arms raised over the head, an impressive *allée* as the setting. We may doubt, however, that "P" was aware of the eighteenth century when he carved the pierced heart on the birch tree, leaving there a middle-class echo of the statues of love that Watteau painted among his dawdling *galants*.

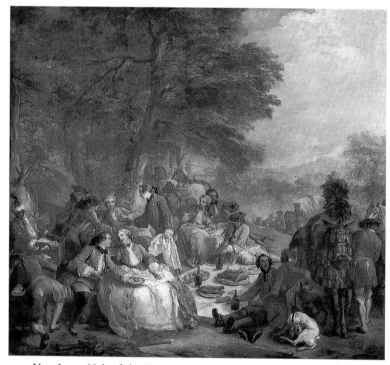

179. Van Loo, *Halt of the Hunting Party*, 1737. Musée du Louvre.

Because he suppressed his knowledge of the earlier pictures, Monet made the historian's work a bit harder, whereas Manet, heir to the same traditions, led the searcher all the way back to the Renaissance origins of the *fête galante*. By conflating Giorgione's *Concert* with Raphael's river gods and nymphs, his picture evoked the early sixteenth century's fascination with muses, gods, and mythological creatures disporting themselves in nature. This, in turn, was modernized in the eighteenth-century *fête galante* which transformed gods into courtiers.[36]

In Monet's and Manet's paintings of parkland luncheons we therefore have a confluence of historical currents which lets us confront the history of pictures with the history of French society. The sequence from Renaissance painting to eighteenth-century *fêtes galantes* and picnics, then to woodland parties in

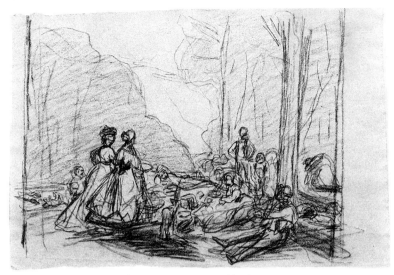

180. Monet, drawing for *Le Déjeuner sur l'herbe*, 1865. Mr. and Mrs. Paul Mellon.

romantic art, and finally to the impressionists' paintings, is paralleled in social history, from the court of Fontainebleau in the sixteenth century, and its preference for Italian artists, to Louis XV's hunting parties, then to Louis Napoleon's outings at Compiègne during which Eugénie and the court picnicked in imitation eighteenth-century costume. It was not just in Monet's *Déjeuner*, but in actuality that bourgeois picnickers went to Fontainebleau and, in former royal domains, ate the same kind of food that noble hunters had enjoyed a century earlier. On another day the same picnickers might have gone to the Bois de Boulogne, also a royal hunting park taken over by the middle class. Alphand's picturesque landscape destroyed the aristocratic spokes of the old plan of the Bois, and gave to Parisians a "natural" precinct for their relaxation. From this perspective, Louis Napoleon, Haussmann, and Alphand can be seen as instruments of the bourgeoisie. They completed the process, begun in the Revolution, by which aristocratic places and privileges became middle-class terrains:

> Monet's *Déjeuner*, true to the social dynamic of its time and accurately reflecting the artist's own class status, expresses the simple pleasures of the hitherto disenfranchised. The right to leisure rather than the privilege of pleasure, the paradisal world of the gods come to roost on earth—such is the larger subject of Monet's *Déjeuner sur l'herbe*.[37]

Flowers and Fashion

The clothing worn by the women in Monet's *Déjeuner* was one of the conspicuous signs of the artist's determination to be modern. Their dresses were of the latest style, and to a viewer of 1866 would alone have borne the message of contemporaneity. Three of the four dresses in the Moscow sketch (Pl. 178) appear again in *Women in the Garden* (Pl. 181), where they take on even greater prominence. Monet turned to that painting in the spring of 1866, leaving the ambitious *Déjeuner* incomplete. In fact, by transferring to the new canvas many of the problems of painting figures in natural light, he made the earlier composition redundant.

In April 1866, Monet moved to rented quarters at Sèvres,

near La Ville d'Avray, a suburb about two miles southwest of the Bois de Boulogne that Corot, Troyon, and other landscapists had long frequented. There, determined to carry still further the rendering of forms in direct light, he worked on the new picture without the intercession of painted studies. He apparently felt that the vitality of outdoor sketches suffered from transfer to studio compositions, a worry expressed often by Delacroix, Daubigny, and others of the preceding generation. He dug a trench into which he could lower the huge canvas, over eight feet high, so that he could work on any part of it while staring at his garden setting. He devoted himself to the task all summer, but continued working on the picture when he moved to Honfleur, where he spent that fall and winter. It therefore incorporated studio work, but it was still so uncompromisingly modern that it was rejected by the Salon jury in the spring of 1867. Apparently never exhibited in his lifetime, the painting was nonetheless a celebration of contemporary Paris and should be placed alongside his other homages to France in 1867: *The Garden of the Princess* (Pl. 14) and *Terrace at Sainte-Adresse* (Pl. 297). Its modernity can be expressed in an aphorism: the decorative in art becomes an expression of fashion in society. To inquire into this, we should first look at the way Monet set about inventing forms that would create the effect of natural light.

Women in the Garden reveals the strongest sunlight ever yet to have shone in a French painting. In the central fragment of the *Déjeuner* (Pl. 139), the impact of sunlight is largely limited to the edges of clothing and the mottled areas on the ground. In *Women in the Garden*, the two left-hand figures are in the shade, with only a few flecks of light on their dresses, but the red-haired woman to the rear is almost pushed around the tree by the force of the sun, and the broad skirts of the seated woman (posed by Camille Doncieux) seem energized by its glare, like some huge cloud that has only temporarily floated there. In a painting, light exists only in relation to shade, and here the shadow that runs across the foreground takes on a vital function. Its diagonal accent contributes to the illusion that space slants back to the right, and its separate colors on pathway, skirt, and grass call attention to light's immaterial existence and its transforming power. The patches of shadow on Camille's costume have a decided lavender tone (exalted by the yellow of her neckpiece), and the shaded portion of the sandy path has a related purplish cast, so color, and not just darkness, plays a decided role—the colored shadows that later were considered one of the hallmarks of Impressionism. The most remarkable of all the color-light passages is Camille's face, even more mask-like than the central woman in the *Déjeuner* fragment. Despite the overhead sun, her face is illuminated from below, thanks to the strength of the light bouncing off her skirt. Set against this reflected glow, her features assume a strange look, like the subject of an illustrator or limner.

The symmetry and lack of expression in Camille's face suit the decorative appearance of the whole painting. Her costume is the leading example of this decorativeness, which is a quality of the picture's structure, not just of its images.[38] The impressive width of the dress, more than half that of the painting, allowed Monet to display its embroidered pattern. Because the pattern is linear in nature, and because Monet deliberately

spread it out laterally—in the center he suppressed its expected three-dimensional undulations—it has a calligraphic look and tends to float forward to the picture's surface. It is nonetheless integrated with the rest of the painting, which accommodates many forms that jump back and forth between illusion and surface. The embroidery's arabesques are echoed in the dark-green trimmings of two other dresses, in tree branches and profiles of foliage, and in the edge of the shadow along the ground. The pathway itself is flattened out by the high vantage point (similar to the foreground of the contemporary *Garden of the Princess*, Pl. 14) and by its radical division into light and dark zones. The three figures on the left are easily read as one shape, conveniently set off by tree branch and trunk, and the other woman is a nearly separate picture, framed by tree trunk, overhead branch, foreground foliage, and ground shadow.

The prominence that Monet gave to the decorative features of his painting is perfectly consistent with his aims. *Plein-air* naturalism is not an absolute, but a relative conception. In the previous decade, for example, Millet's peasants had struck advanced viewers as naturalistic, but they no longer seemed so to Monet. His nature is a bourgeois garden, more like the Bois de Boulogne than the fields near Barbizon, and his women are middle-class city dwellers, dressed in the very latest style. In fact, they are manikins, for Monet had Camille and another friend dress for his picture and pose by the hour. They had posed for the *Déjeuner* of the previous year, but there, closer to Barbizon and its traditions, they took part in a more sociable event. The two women on the left in that picture stand a bit like models in an advertisement, but their stiffness is mitigated by the varied attitudes of their companions. In *Women in the Garden* Monet left the country behind, and placed his manikins in a suburban garden as though in a fashion print.

Monet's four women are patently on display, and engage only in the perfunctory actions associated with fashion pages. Garden settings were common in fashion journals because of the association of feminine elegance with flowers, gardens, and languid leisure. It is not enough, however, to say that Monet's women are at leisure, for leisure could mean lively conversation, a luncheon, reading, listening to music, or playing games, as in Manet's later *Croquet* (Pl. 176). They are "doing nothing," for, like the women in clothing advertisements, they are truly decorative: youthful vessels of current style and beauty, in a model setting of flowers, foliage, and a neatly managed garden. They are, in short, the bourgeois ideal. Men's income and pride were vested in the appearance of their women, in clothing that vouched for their high standing, the "conspicuous consumption" that Thorstein Veblen elevated to sociological theory. In Zola's *La Curée*, the speculator Saccard, fearful of the poverty from which he came, encourages his wife to spend vast sums on fashions by the couturier Worth (thinly disguised in the novel as "Worms"). To proclaim one's freedom (that is, one's financial ability) to dress "appropriately" was to take one's distance from the lower classes. Monet's women are far removed from Millet's not just because of their urban dress, but because they are untainted by any idea of work (Millet's are so penetrated by labor that, even at repose, they give evidence of leisure earned from work).

We should not be surprised that fashion and art shared certain features. Many artists deliberately cultivated fashion in their paintings—Boldini and Chaplin come readily to mind—and for the impressionists there was an underlying association of contemporary life with fashion. Rejection of the past meant a devotion to the present, hedonistic moment, which also typifies fashion. Georg Simmel, with his usual perspicacity, pointed to the role of fashion in modern society:

> We can discover one of the reasons why in these latter days fashion exercises such a powerful influence on our consciousness in the circumstance that the great, permanent, unquestionable convictions are continually losing strength, as a consequence of which the transitory and vacillating elements of life acquire more room for the display of their activity. The break with the past, which, for more than a century, civilized mankind has been laboring unceasingly to bring about, makes the consciousness turn more and more to the present. This accentuation of the present evidently at the same time emphasizes the element of change, and a class will turn to fashion in all fields, by no means only in that of apparel, in proportion to the degree in which it supports the given civilizing tendency.[39]

The decorative elements that dominate Monet's composition commemorate the central role that fashion played in middle-class and upper-class French society in his generation. Of course, fashion had always had its place, but in Second Empire Paris it took on vastly increased importance. The much larger middle class, typified by childless and professional people, had money to spend, and foreigners also helped make Paris the fashion capital of Western society. Fashion was not simply a question of "style," it was a commodity. The "articles de Paris" sold along the *grands boulevards* were one of the city's principal money-makers, embracing all products of the fashion trade: clothing, millinery, jewelry, and cosmetics. Since fashion thrived on change, it was the perfect product of an entrepreneurial society. As soon as a particular fashion caught on, its upper-class initiators deserted it, because its very essence was the distinction it offered from the common herd.[40] The constant renewal of fashion was a never-ending turnstyle that generated business at all levels of capitalist industry in Paris, from *grand couturier* to the department store —and the rise of the large department store in the second half of the nineteenth century is intimately related to the fashion mill. Theodore Child, another of those perceptive American visitors, summarized the social mechanism of Parisian fashion:

> Perdi, the *grand couturier*, creates a toilet for a lady of reputed elegance, for one of the princesses of Paris. If the toilet is a success Perdi's rivals will copy it for their customers; the rich foreign ladies who get dressed at Paris will introduce it into their respective countries; the fashion journals will describe it and distribute engravings of it wherever they have subscribers. Thus far the toilet will have remained the monopoly of the half-dozen *grand couturiers* and their Parisian rivals. Now the Louvre and the Bon Marché [department stores] enter the field and take possession of the new model, provided that it can be copied at a reasonable price and with cheap elements; they order enormous quantities of

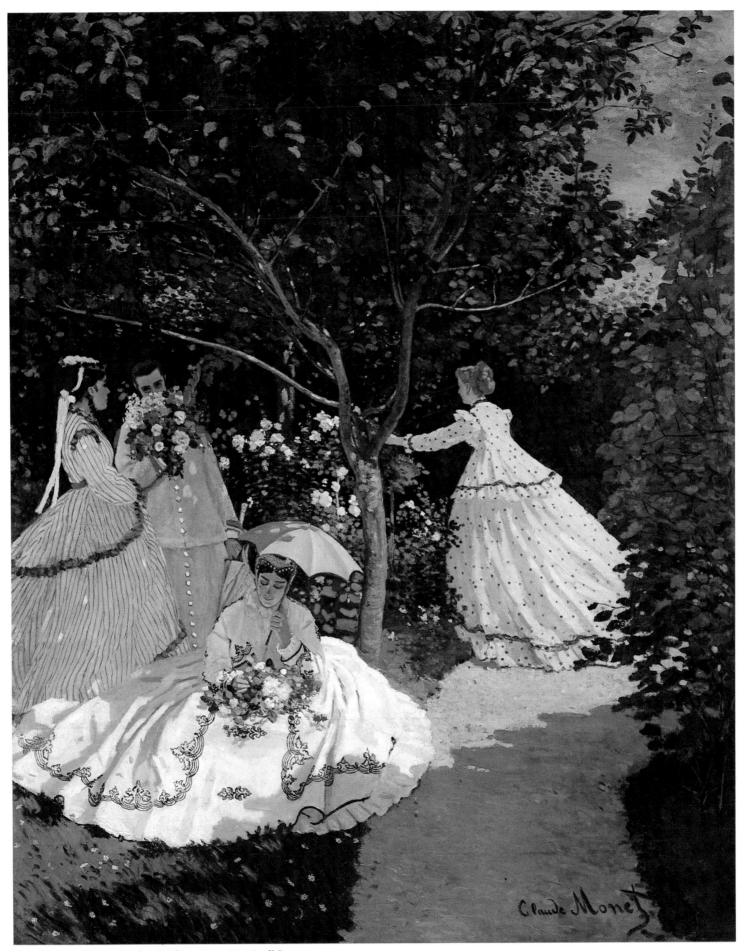

181. Monet, *Women in the Garden*, 1867. Musée d'Orsay.

materials, imitating those used by the artistic dress-makers; and in a few weeks they have for sale at moderate prices thousands of costumes, resembling more or less...the model created by Perdi for his elegant customer, la belle Madame X.[41]

In the Second Empire, Eugénie and her court were the principal initiators of fashion, partly because the upstart regime needed the aid of ostentatious costume (frequently recalling past royalty) to assert its legitimacy. State coffers provided Eugénie with 100,000 francs a year for her toilet. Etiquette required several changes of costume each day for court and guests, twenty for a stay of one week at Compiègne. "At that time there was a sort of intoxication in the very atmosphere of Paris," wrote the court governess Anna Bicknell,

> a fever of enjoyment—a passion for constant amusement, for constant excitement, and, amongst women, for extravagance of dress. This was encouraged by the court, with the intention of giving an impetus to trade, and of gaining popularity by favoring constant festivities and consequently constant expense.[42]

Once the court and elegant women had launched a new style, the new money stepped in—"encouraged by the court"—and made imitations. Upwardly mobile citizens then bought these second-generation designs as a way of associating themselves with high persons, another of the many ways the middle class was taking the place of the waning aristocracy, whose role was to provide the social patterns one aspired to. The new styles could be worn by anyone who had the money, and one could learn how to make social calls or hold garden parties. The increasingly mobile bourgeoisie used fashion as one of its principal agents in masking its separation from the upper classes, while asserting its distance from those lower down.

We must not isolate Monet from this phenomenon, despite the reluctance with which art historians approach matters of money and social ambition. In *Women in the Garden* Monet dressed his future wife in splendid costume and put her in a fine garden. She appears there as the middle-class heir of eighteenth-century *élégantes* in their gardens, and as the rival of Eugénie and her court ladies at Compiègne. Three years later in Trouville, he painted Camille on the beachfront near the fancy hotels, although they stayed in a small back-street hotel and left without paying the bill. At Argenteuil from 1872 to 1878, he represented her repeatedly in the gardens of their rented villas, as though she and he were the proprietors (they had a maid, but again left unpaid bills behind). When eventually he had a large income, he created his own gardens at Giverny, for he was every inch the Norman, shrewd in money matters, who eventually secured his own manor house and estate. In 1867, however, cadging money from friends and making an occasional sale, he was still like many another provincial trying to make his way in the big city. At least he could create the illusory world of *Women in the Garden*, and become a kind of *grand couturier* for Camille, reversing Theodore Child's analogy: "The great dress-makers...are creative artists of prodigious genius. Draughtsmen and colorists at the same time, as the perfect plastic artist should be, they produce compositions of incomparable variety...."[43]

Contemporary fashions continue to be found in Monet's paintings of the 1870s, but they no longer seem important. Most of his paintings after 1870 are landscapes, and when human figures appear, they are customarily in small scale, useful insofar as they give meaning to village street, garden, or riverbank, but not conspicuously fashionable. The only pictures in which clothing has some prominence are a few that show Camille in the garden of their rented villa at Argenteuil. She is often alone, or with their son Jean and their maid, but in one instance she is shown with visitors (Pl. 182). Her garment and hat are fashionable receiving costume, much as would be worn in Paris, and indeed, the very sign of her being a Parisian.[44] As in *Women in the Garden*, there is little going on here, but it represents a shift towards the greater naturalism that characterizes all the impressionists' work after 1870. The fashion-plate grouping of the earlier picture gives way to a more informal presentation of a quiet moment in an enclosed garden. The picture is less finished than many others of the same date, but even so it is fair to point out that the artist has

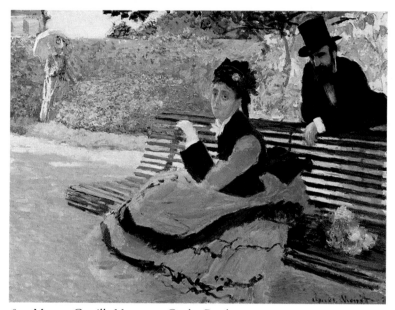

182. Monet, *Camille Monet on a Garden Bench*, 1873. Mr. Walter Annenberg.

discarded the contrasting shadows of *Women in the Garden*. The foliage, wall, and pathway are saturated in a pervasive light that creates structure and illusion through color, without significant recourse to light and dark (pinks, reds, oranges, and yellows against blues, greens, and violets). The dark tones that anchor the picture are not shadows, but portions of the park-like bench and of costume, those signs of urban life.

Camille Monet on a Garden Bench is an oddly formal picture for Monet, perhaps odd because it is one of his very rare attempts at a social encounter in which fashionable dress has a part. It was instead Manet who made fashion loom large in the second decade of Impressionism. After 1870—it was one of the less obvious, but important consequences of the Franco-Prussian War and the Commune—Manet turned wholeheartedly to contemporary subjects and gave up the dialogue with historical styles that had marked his first decade. Over the course of the 1870s he used costume to characterize class and

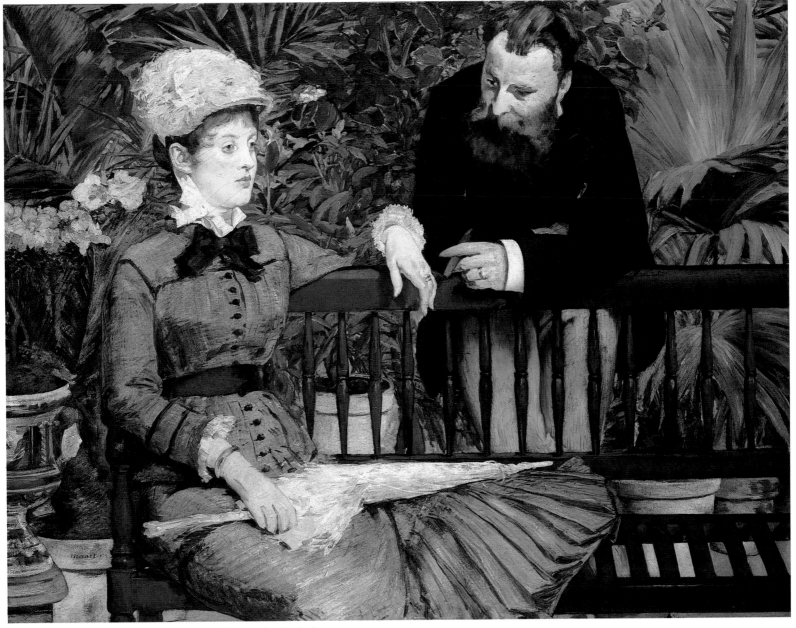

183. Manet, *In the Conservatory*, 1879. Berlin, Nationalgalerie.

place, from the city child's oversized bow in *The Railroad* (Pl. 31) and her companion's navy-blue outfit, to the boaters' stripes and hats in *Argenteuil* (Pl. 239). At the end of the decade, he heralded fashion in a number of pastel portraits and paintings, chief among them *In the Conservatory* (Pl. 183).

In the Conservatory, shown in the Salon of 1879, invites comparison with Monet's earlier canvas, but need not have been done with knowledge of it (the early history of Monet's painting is not known). Manet's Salon picture took its place logically among his views of contemporaries seen in casual moments, including *Argenteuil, The Railroad* (Pl. 31), *At the Café* (Pl. 70), and *Chez le Père Lathuille* (Pl. 67). Parisian conservatories were a development of the Second Empire, another bourgeois takeover of an installation once the exclusive preserve of the very wealthy, and another of the responses to the love of nature which marked the era. They should be associated with the rise of landscape in the middle of the century as

well as with the love of unusual plants redolent of foreign lands and imperial adventures. One garden writer described greenhouse flowers as "rare, aristocratic, titled, so to speak: they come from the lands of the sun, from the scented shores of the Pacific or the Indian ocean."[45] Natural growth became a social commodity, a garden poured into containers and enframed in a cage of glass and iron, the same modern materials used for fair buildings and for department stores. Indoor gardens became *de rigueur* in Haussmannian Paris. Notable ones included those of princess Mathilde on the rue de Courcelles, and of La Païva, the famous courtesan, in her extravagant town house on the Champs-Elysées. Zola made one the symbolic center of the new town house of Saccard, the real-estate speculator of *La Curée*.

For his painting Manet used the conservatory of the painter Otto Rosen, whose studio he rented for nine months in 1878 and 1879. Amidst palms and other exotic plants, Manet posed

his friends Jules Guillemet and his American-born wife (appropriately wearing a hat of ostrich feathers). The picture was neither commissioned nor shown as a double portrait, so we deal here with a modified genre piece. The critic Castagnary praised it as a treatment of "the elegance of fashionable life."[46] In *Boating* (Pl. 238), which hung with it in the Salon, the yachtsman and his passenger are engaged in a fashionable pastime, but are certainly not elegant. The man and woman of *Chez le Père Lathuille* (Pl. 67) form a vignette of urban flirtation, but are not elegant, either. Monsieur and Madame Guillemet are in every conventional sense both proper and elegant. They are dressed in formal daytime costume, the husband in light trousers and dark jacket, the wife in a smart outfit of grey silk. She has removed one glove (this discloses her ring), an indication, along with parasol and hat, that she and her husband are not in their own home, but have dropped in for a visit.

In this upper-class environment, there is a reserve that speaks for the cool stylishness of Manet's chosen society. The couple in Monet's garden picture (Pl. 182) is found in similar circumstances, but the man's weight is more fully on the back of the bench, his hand droops, and his posterior is thrust out. Guillemet has a frontal pose that we read as more dignified, a reading that involves both the fiction of a "real" man—he seems more self-contained—and his role in the picture's abstract structure: he has a symmetrical, flatter overall shape. A similar contrast exists between Camille Monet and Mme Guillemet. Camille makes an unexplained gesture and looks slightly puzzled or anxious. Additionally, her garments billow while her body and the floating bench are angled into depth, helping create a moderately animated scene. In Manet's interior, fittingly more confined than Monet's outdoor scene, Mme Guillemet is wonderfully upright and sure of herself, and her bodily reserve is abetted by the way it matches both picture surface and bench. Her arms and shoulders echo the left and top sides of the canvas, and she takes the place of the corner members of the bench; the pleats of her dress sound notes of antiphonal relationship to its rungs and slats (Pl. 184).

The reticent expression of *In the Conservatory* would surely be an enigma if we expected abundant signs of a happily married couple. Scholars recently have stressed the consistency with which Manet eliminated anecdote and narrative, in this case, those signs of affectionate exchange that an admirer of Victorian painting might hope for. Should we go so far as to see estrangement or tension between them? One scholar writes of an "almost brutally strained moment in an enduring relationship (the kernel of the situation offered in the stalled eroticism of the two juxtaposed hands...),"[47] but should we not see instead both the reserve of an upper-class couple and the detachment of the *artiste-flâneur* who sought them out for his picture?

The views of critics friendly to the picture in 1879 argue against estrangement and in favor of the artist's customary detachment. They greeted it as a moment in a quiet conversation, a typical male "conversation," we might add, for the wife is merely listening. Manet makes it obvious that the couple are married by adjoining their hands and exposing their wedding rings, so there is no need for one to solicit the attention of the other, as occurs in *Argenteuil* (Pl. 239) and *Chez le Père*

Lathuille (Pl. 67). And unlike *The Railroad* (Pl. 31), with which there are important analogies, the two figures do not face in opposed directions. They share a reflective moment, and are joined, not divided, by the play of repeated rectangles. The bench unites as much as it separates them, and the "stalled eroticism" of their approached hands is as much of a display as such a correct couple would have permitted themselves.

We can then put down the emotional reticence of the couple to a deliberate rendering of a wealthy marriage. More than that, however, we should recognize in Mme Guillemet the reappearance of the independent, unsubmissive woman whom Manet had favored in so many of his paintings. American women had been admired in Paris since 1867, when they were much noticed among the visitors to the Universal Exposition. Mme Guillemet not only has the favored Anglo-Saxon features, she also has the self-confidence and independence that were leading characteristics of the American woman. Manet knew her well, and chose her for his picture for the same reason that he had chosen the waitress in *Corner in a Café-Concert* (Pl. 77): she fits perfectly the pictorial role he envisioned. Her husband is there principally to exhibit his wife. To a certain extent he is like the man in Renoir's *Loge* (Pl. 90), who also displays his consort without manifesting any possessive affection. For the same reason he is unlike Degas's brother-in-law in the Morbilli double portrait (Pl. 51). Morbilli utterly dominates his wife amid signs of the striking differences between them. In the Guillemets, Manet was not looking for tokens of tension or disengagement.

"Display" is the right word for Manet's painting. The Guillemets were not only fashion plates, they were the proprietors of a clothing store not far from the British Embassy, on the fashionable rue du Faubourg Saint-Honoré. Both wear the commodities they sold, but it is distinctly the wife who is on display. She gives the impression of posing, of being placed by the artist (who must have directed the lay of the pleats, in addition to painting them) to the fullest advantage of her clothing and her slender, erect body. We can be sure that Manet studied her characteristic poses and costumes: he later sent her several saucy watercolors of her well-shod legs, presumably as a recompense for omitting them in his painting. As for Guillemet, his resemblance to Manet was publicly noted at the time, and in the painting he has not just the proprietary air of a husband, but also that of the clothier who quietly hovers over both model and wife.

In reproduction, *In the Conservatory* looks more severe than it should, for both the palette and the arrangement give to the original a delicate harmony that also argues against a reading of estrangement. The yellow of Mme Guillemet's hat, neckpiece, glove, and parasol are repeated in duller tones in her husband's trousers and in several of the flowerpots, just as the bench's dark purplish-blues are found in her belt and bow. The greenery embraces both figures, with well-managed variations that supply exuberance to the otherwise sober, squared-up composition. To the right, the burst of the palm is a witty invention that closes off the composition by hinting at masculine strength and aggressiveness. On the other side, the greenery forms a tapestry backdrop for Mme Guillemet, and the diagonal spray of pink blossoms complements her rosy complexion. The blue of the ceramic planter, added to

184. Manet, detail of *In the Conservatory* (Pl. 183).

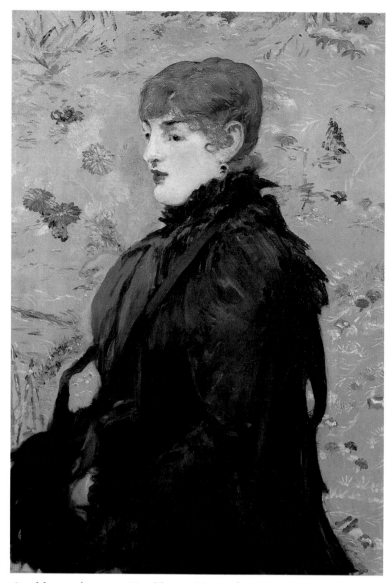

185. Manet, *Autumn*, 1881. Nancy, Musée des Beaux-Arts.

attention on women's clothing—for which seasonal changes were an essential animator. Alfred Stevens, for example, another friend of Manet and the epitome of a certain order of *chic*, did a famous set of seasons (Pl. 186), and Berthe Morisot exhibited *Summer* and *Winter* in 1880, both paintings of women. Her *Summer* (Pl. 188) shares with Manet's *Spring* the idea of a woman against a flowery backdrop, but fashion is not

186. Stevens, *Spring*, 1874. Williamstown, Clark Art Institute.

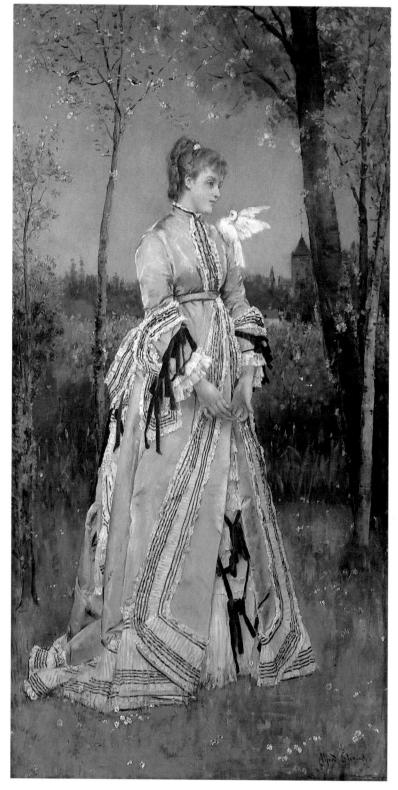

the pinks and yellows, completes the canonical triad of primary colors: offerings to the feminine half of the picture.

Flowers, fashion, and femininity make up a good deal of the output of Manet's last years. Mme Guillemet reappears in two pastel portraits, and her younger sister is shown in two oils, in stylish summer dress and hat, surrounded by the flowers and shrubbery of Manet's rented villa in the suburbs. There were also several three-quarter-length oils of women promenading in gardens, and the half-length *Jeanne: Spring* (Pl. 187), Manet's smashing success in the Salon of 1882. Although his *Bar at the Folies-Bergère* (Pl. 80) attracted more attention in that Salon, *Jeanne* was uniformly admired and it disarmed even his bitterest critics. It was the greatest public success of his lifetime, and his last Salon.

The painting, posed by the actress Jeanne Demarsy, sprang from a commission of four seasons from the artist's friend Antonin Proust. Only *Spring* and *Autumn* (Méry Laurent in a brown pelisse, Pl. 185) were completed. The representation of the seasons in the guise of modishly dressed women was a commonplace of an era which lavished so much money and

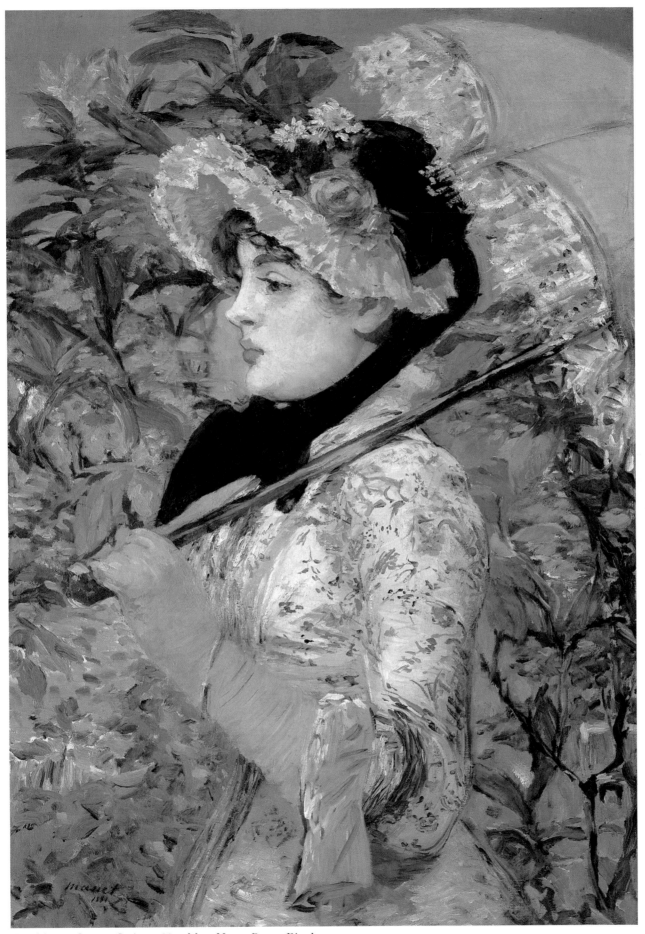

187. Manet, *Jeanne: Spring*, 1881. Mrs. Harry Payne Bingham.

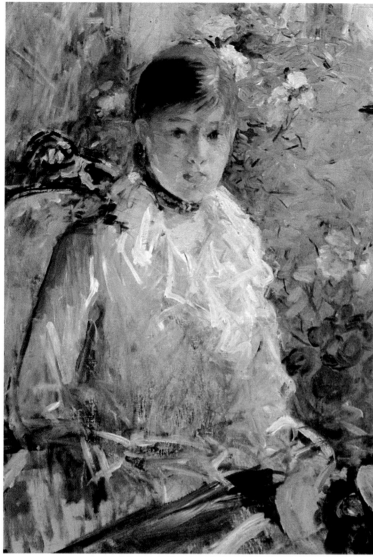

188. Morisot, *Summer*, 1878. Montpellier, Musée Fabre.

earlier Baudelaire had made fashion a key feature of his unorthodox definition of modernity:

> Fashion should thus be considered as a symptom of the taste for the ideal which floats on the surface of all the crude, terrestrial and loathsome bric-à-brac that the natural life accumulates in the human brain: as a sublime deformation of Nature, or rather a permanent and repeated attempt at her *reformation*. And so it has been sensibly pointed out... that every fashion is charming, relatively speaking, each one being a new and more or less happy effort in the direction of Beauty, some kind of approximation to an ideal for which the restless human mind feels a constant, titillating hunger. ... [Fashions] should be thought of as vitalized and animated by the beautiful women who wore them.[48]

Manet's dedication to fashion was rewarded by the critics, who praised *Spring* in words used for "articles de Paris": "She is not a woman, she is a bouquet, truly a visual perfume"; she was "a Parisian perfume to make the head spin"; her flesh was "a flower of delicious coloring."[49] In these phrases, there is a tacit recognition of the degree to which Manet's brushwork itself was among the brilliant products of Paris. Meissonier, Fortuny, Boldini, and Stevens were all admired for the jewel-like luster of their painted surfaces, proving the association of commodity with artistic means, but none of them had the daring of Manet's colored shorthand, and none so perfectly merged artistic *chic* with fashion.

There is little doubt that Manet's triumph was aided by the popularity of *la femme parisienne*, the woman who could rival the *flâneur* when she promenaded in the Tuileries or the Bois, providing masculine society with the mobile decoration it sought. Forerunner of the Belle Epoque, *Jeanne*, Manet's most decorative *parisienne*, was also the heir of the Second Empire. "In republican Paris," wrote Theodore Child,

> the conditions of the display of luxury are no longer the same as they were under the empire, but the traditions that animate the artists of luxury and their patrons are unchanged, and the leaders and marshals of fashion are still the ladies of the empire. These women made a study of elegance and a profession of beautiful appearance more complete and more intelligent, perhaps, than any of the daughters of Eve who preceded them on the face of the earth, and they achieved a perfection of harmonious bearing, an originality of composition, a stylishness, a *chic*, to use an accepted term, which has not yet been surpassed. The secret of this *chic* lies partly in the peculiar genius of the Parisienne, and partly in unfailing application, and in the striving after absolute elegance and fulness of pleasurable life in conditions of material beauty.[50]

Renoir's Gardens

More than Manet, and even more than Morisot and Monet, Renoir surrounded contemporary Parisians with flowers and gardens. He was more of a landscapist than Manet, and more of a figure painter than Monet, so combining the two genres came naturally to him. He was especially devoted to women and children and, like so many men, he believed he

involved. It is only with some difficulty that we can read the hat and parasol she holds in her lap, while the details of her costume disappear beneath the flutter of brushwork. Morisot suggests summer light and air with filmy strokes of blueish, grey, and lavender whites that float between us and the images; even the woman's lips have a light-struck indefiniteness. The brushwork in Manet's *Jeanne* has his customary brio, but we can see all the salient elements of his figure's costume. Presented to us in profile, his Spring is not merely a woman, she is a *parisienne* displaying the latest fashion by promenading in public. Morisot's Summer looks at the viewer in a rather more private pose, certainly a deliberately unostentatious one that preserves her individuality. She is not a manikin, and we are in a domestic, not a public relationship to her. Neither she nor her clothes could be considered commodities.

For *Spring*, according to Proust, Manet chose Demarsy's costume, including the hat. Like Monet for *Women in the Garden* (Pl. 181), he acted as couturier as well as painter, and like Baudelaire and Mallarmé, he instinctively associated high fashion with the essence of Parisian modernity. Mallarmé had founded a short-lived fashion review in 1874, and a decade

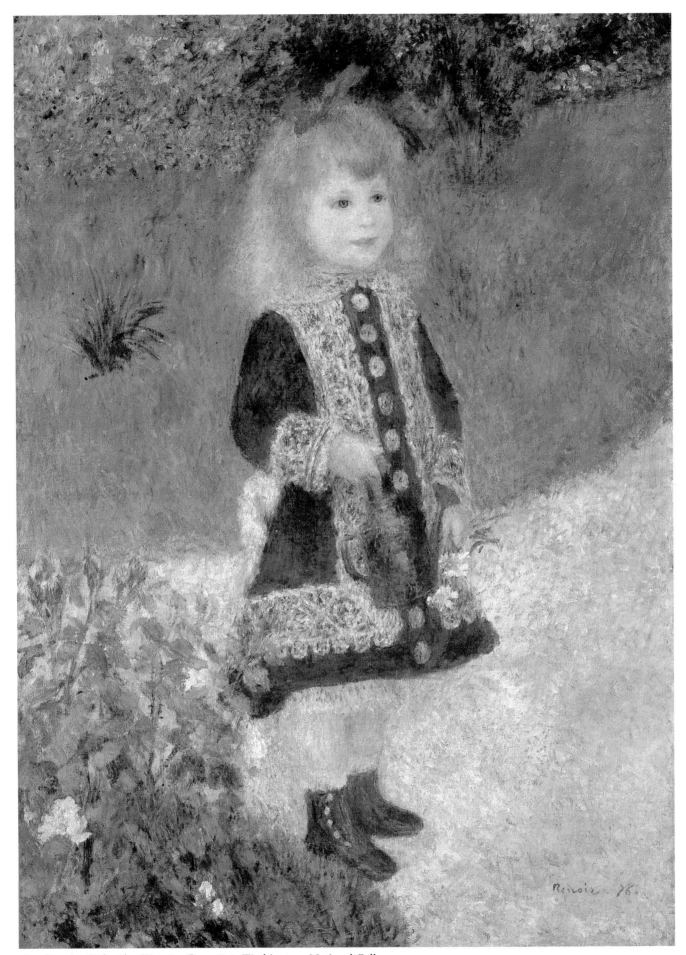

189. Renoir, *Girl with a Watering Can*, 1876. Washington, National Gallery.

was honoring them by separating them from work and life's harsh realities. This thoroughly middle-class attitude shows Renoir's distance from Millet, Daumier, and other artists of the preceding generation. In *Girl with a Watering Can* (Pl. 190), for example, the child is neither peasant nor daughter of a Parisian laundress. Her watering can is too small to be useful outdoors, and is even empty of water (otherwise it could not be held so lightly atilt). Any middle-class child in such a garden would personify carefree enjoyment, but the toy grants this child an even greater innocence from work by reminding us of an adult's task.[51] Innocent in other ways, this enchanting girl holds flowers in her left hand, and frankly poses for us. The red of her lips and her bow matches that of the bedding flowers beyond, and the tones of her hair, face, hands, and legs are found in the broad swatch of the garden path, as are those of the watering can in the green growth. Integrated in this manner with the rest of the painting, she nonetheless stands out against the flat geometry of the garden, thanks to her dark boots and costume. With the excuse of a high vantage point,

190. Renoir, *La Parisienne*, 1874. Cardiff, National Museum of Wales.

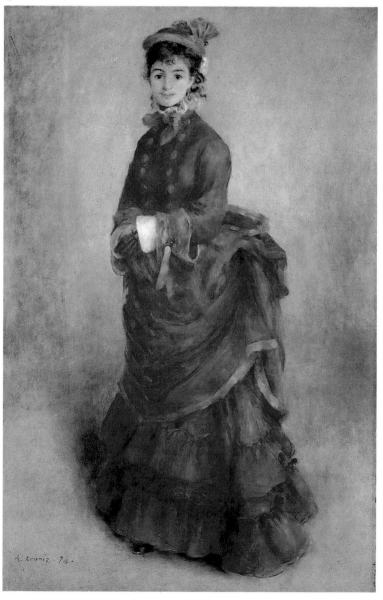

Renoir divided his canvas into large curving shapes that lack conventional perspective, as radical a construction as those of Cézanne (who is too often given right of patent for such geometry). Since the child casts no shadow, she resembles a tapestry figure, and has the innocence of the realm of the decorative textile. Worthy of Velasquez, whose royal infants come readily to mind, this splendid picture is one of the greatest of all impressionist renderings of children.

Renoir's paintings of garden figures are easily distinguished from Manet's thanks to their impression of naive innocence. There is nothing of Manet's fashion and *chic* about them. It is true that in the first impressionist show in 1874, Renoir exhibited *La Parisienne* (Pl. 190), a painting of the actress Henriette Henriot in an elaborate blue costume, and equally true that he loved contemporary dress; but he avoided (or lacked) the *panache* that lets us equate Manet's women with *haute couture*. Even Henriette Henriot lacks *chic*, despite the ravishing way Renoir painted her clothing. She has a self-conscious expression, the naiveté of a doll, that removes her from the world of high fashion. Further, she is an exception, since most of Renoir's models, like those in the *Dance at the Moulin de la Galette* (Pl. 135), wear a variety of contemporary dress that was not high fashion at all, but the more modest attire of the lower middle class.

In order to study his Montmartre models *in situ*, Renoir had begun renting a studio near the Moulin de la Galette, in May 1876. Georges Rivière recounted the painter's joy upon discovering the abandoned garden outside the dilapidated cottage on the rue Cortot. The ground floor, an old stable, served as studio, and from the two rooms above there was a view out on the luxuriant garden which extended through the center of the area between the rue Cortot and the rue Saint-Vincent. Renoir painted a great many canvases in that garden—1876 was a prodigious year in his work, hardly ever equaled afterwards—and at times his friends Lamy and Cordey brought their easels there as well. A portion of the garden shows in *The Garden of the Rue Cortot* (Pl. 191), where an abundance of dahlias gives way to a tangle of growth and a fence over which two men are chatting. The generous space occupied by the flowers makes it a "decorative" painting in the lexicon of Renoir, Rivière and their companions, a designation that is owing to its relatively large size (nearly five feet high), to its lack of narrative incident, its vertical format, and its mosaic of flowers and greenery.

The decorative feeling of this composition was not fortuitous. Renoir was preoccupied with the concept of the decorative in modern art, and he devoted two articles to the subject in Rivière's *L'Impressionniste* in the spring of 1877, when he probably exhibited the picture.[52] One is only a short letter, but the other is a veritable manifesto which decries the stultified ornamentation of Haussmann's architecture, damns the Ecole des Beaux-Arts and its derivative art, and urges the renewal of a sense of craftsmanship, based on nature. The concept of the decorative was a vital feature of the impressionists' esthetic, relating as it did to the flat surface of the canvas, which they were all acutely aware of. In the process of liberating themselves from the rules of traditional art, they looked to several arts then considered decorative, including textiles, eighteenth-century painting, and Japanese prints. In

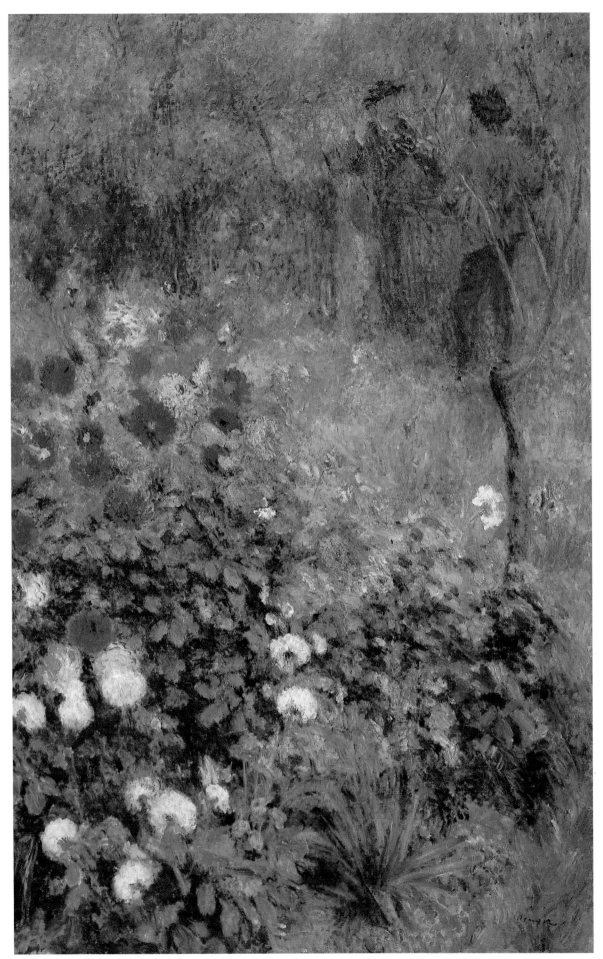

191. Renoir, *The Garden of the Rue Cortot*, 1876. Pittsburgh, Carnegie Institute.

the Western tradition, there had long been an association of flowers and gardens with the decorative, and Renoir had strong support in this from Monet. In 1876 Monet exhibited a painting entitled *Decorative Panel* (Pl. 265), and the same year painted four large works he called "decorations," for Alice and Ernest Hoschedé's château at Montgeron, a few miles southeast of Paris. All four were views of the château's grounds, and one of them is dominated by a splended display of dahlias.

Renoir showed another garden picture, *The Swing* (Pl. 193), in the banner exhibition of 1877 in which his *Dance at the Moulin de la Galette* and Monet's four "decorations" were hung. According to Rivière, the woman in *The Swing* is Jeanne, the working-class girl of Montmartre who appears in the dancing picture.[53] She has on the dress that Margot wore in the larger composition, and she is similarly situated on a mottled pinkish-white and lavender-blue ground, here representing the central alley of the rather unkempt public garden that extended beyond Renoir's, behind the rue Cortot. Compared to the bustle of the Sunday dance, this picture breathes serenity. "One feels the absence of all passion"; wrote Rivière, "these young people are enjoying life, in superb weather, with the morning sun passing through the foliage; what does the rest of humanity matter to them!"[54] Jeanne is there to be admired, but she is deferentially listening to one of the men, as is his friend, leaning against the tree. The

192. Renoir, *The Promenade*, 1870. Edinburgh, National Gallery of Scotland.

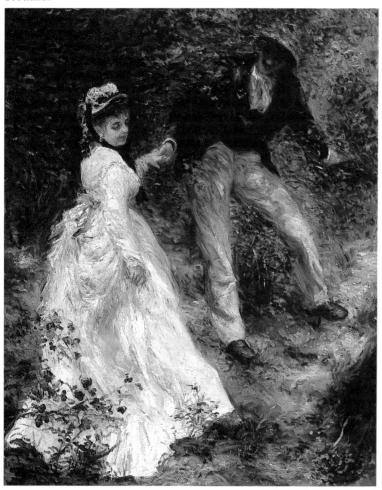

guilelessness of this benign patriarchal society is witnessed by the young child—a neighborhood girl in her everyday apron—who gazes up at the adults like some Renaissance or baroque putto. We cannot imagine Manet including such a child in his encounters among men and women. *Chez le Père Lathuille* (Pl. 67), *Argenteuil* (Pl. 239), and *In the Conservatory* (Pl. 183) would be impossible if a child were present. These compositions are a blend of cynicism and upper-class aloofness calculated to reveal contemporary truths. The husband and wife of *In the Conservatory* are shown closer together than Renoir's Jeanne and her interlocutor, but their reserve militates against sensuality, and their calculated self-display indicates Manet's interest in cool detachment of a penetrating kind. Renoir was alarmed by contemporary truths, which he found harsh and unwelcome, so he removed his models to another world.

This world is a garden oasis in Montmartre, a real place where ordinary (if beautiful) residents could be studied under natural light, for nature and real persons were essential antidotes to formula and artificiality. They are what separates his concept of the decorative from that of Puvis de Chavannes (Pl. 175), whose ideals were found in mural paintings derived from the classical tradition, with pale colors and sculpturesque, rather than contemporary, figures. Renoir's garden, though real, was nonetheless insulated from the tawdry surroundings of Montmartre, and it is obvious that he used it to transport his figures away from Manet's and Degas's Paris to a kind of utopia, one that recalls the paintings of the *fête galante* (Pl. 137). He had begun life as a porcelain painter whose figures perpetuated the delicacy of the eighteenth-century tradition, and he logically adapted the impulses of that tradition to people and settings that conformed to his ideals. He particularly loved Watteau, Boucher, and Fragonard. In the fall of 1883, writing to Durand-Ruel about bathers on the shore of the Guernsey Islands, he remarked: "nothing is so pretty as this mixture of women and men squeezed together on the rocks? I could more readily imagine myself in a Watteau landscape than in reality."[55] He found in eighteenth-century painting both an arcadian society to hold up as a model, and a palette to his liking, one that diminished the importance of light-and-dark modeling in favor of small strokes that separated the colors, and that seemed responsive to air, light, and movement.

Renoir shared his fondness for the eighteenth century with Monet, whose picnics of the 1860s, as we saw, continued the tradition of the *fête galante* and the hunting party. They were hardly alone in this, because there was a prominent vogue for the rococo, begun in the romantic era, that lasted into the 1880s. The southern painter Monticelli created a whole art based on the *fête galante*. Eugénie had sanctioned the vogue in her choice of revival costume, and the Goncourt brothers had begun publishing their notable studies of eighteenth-century art in 1859. The signs of the love affair with the rococo were everywhere after 1860: costumes, textiles, interior decoration, posters (Jules Chéret was called "the Tiepolo of the boulevards"), plays, and operettas. Renoir was swept up in this vogue more than the other impressionists, and at times was nearly swamped by it. He painted a succession of works beginning with *The Promenade* in 1870 (Pl. 192) which are

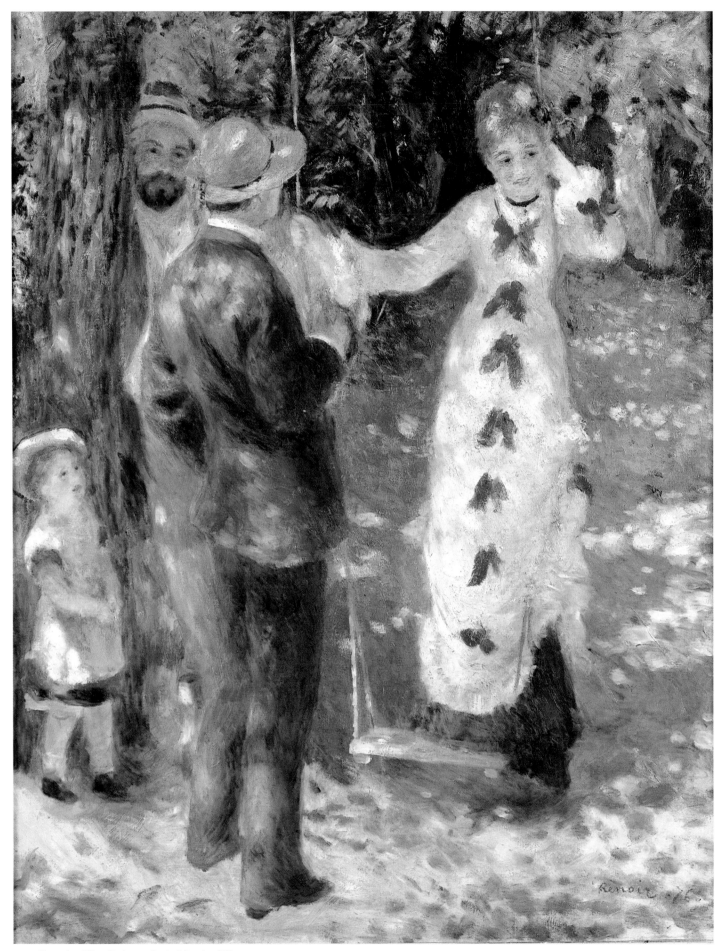

193. Renoir, *The Swing*, 1876. Musée d'Orsay.

patently modeled on the rococo theme of lovers strolling or seated in a wooded glade. In 1875 he painted two, *The Lovers* and *Confidences*, whose superb colors are almost ruined by their figures' simpering expressions. Fortunately, he overcame his weaknesses in 1876 with the astonishing group of paintings, which, like *The Swing*, extract a richness from the previous century while distilling a new expressiveness from contemporary impulses.

Writing of *The Swing* in 1877, Rivière said that "one sees there something of the voyage to Cytherea, with a note particular to the nineteenth century. It's the same spirit, the same French taste, whose tradition was just about lost in the midst of the dramatic paintings inaugurated by Greuze and David." And he added that "One must go back to Watteau to find a charm analogous to that which marks *The Swing*."[56] We know that these phrases reflect Renoir's own views, for, alone among the impressionists, he wrote essays on art that reveal his ideas clearly. In addition to the short letter and the longer polemic contributed to Rivière's *L'Impressionniste*, he sent Durand-Ruel a manifesto in 1884 for a "Society of Irregularists," he composed a whole series of social aphorisms which were later published by his son, and he wrote an introduction to a French edition of Cennini's early Renaissance treatise, published in 1911.[57] In eighteenth-century art, Renoir found an echo of his convictions that man's natural proclivities were the source of art and of goodness. Once, he tells us in his writings, religion was a support for the imagination, but modern man, devoted to industry, engineering and the "false mania of perfection," has cast God out. Like John Ruskin, he believed that nature, not God, was now man's guide to spiritual and physical goodness, and like Wordsworth, he believed that nature was the place where man could free himself from the taint of civilization. There he could listen to his instinctive inner being, and by acting according to his own nature, he could rediscover nature at large. "Go and see what others have produced," reads one of his aphorisms, "but never copy anything except nature. You would be trying to enter into a temperament that is not yours and nothing that you would do would have any character."[58]

The enemy of natural instinct, according to Renoir, was the spirit of rationalism in the urban-industrial world, the rationalism which he associated both with industry and with the Renaissance-derived traditions of the hated Ecole des Beaux-Arts, rather than with the Gothic, whose buildings he praised in his 1877 polemic. Together with others of his generation, he regarded reason as a tool of modern industrial organization, a tyranny that subjected feelings to mere calculation. At the age of seventeen, then a craftsman in a porcelain works, he had been put out on the street by new machinery which made hand painting redundant. This gave moral urgency to his proposal in 1884 for a "Society of Irregularists":

Nature abhors a vacuum, say the physicists. They could complete their axiom by adding that it has no less a horror of regularity.

Observers know in effect that in spite of the apparent simplicity of the laws which preside at their formation, the works of nature are infinitely varied, from the most important to the least. . . .

At this time when our French art, still at the beginning of this century so full of penetrating charm and exquisite fantasy, is perishing because of regularity, dryness, and the mania of false perfection that now tends to make the unadorned cleanness of the engineer into the ideal, we think it useful to react promptly against the mortal doctrines which threaten to annihilate it. . . .[59]

Renoir's society, never established, would have prevented the use of the ruler, and would have required direct study from nature. The "false perfection" which he saw in industry had its counterpart in the despised perfection of academic style. The "finish" of Salon art was reprehensible because it was the result of mindless labor, rather than the spontaneous product of instinct. In this Renoir continued the view held by so many artists and writers of the romantic era, that instinctual freedom is the source of creativity. Labor was repressive because it was not freely granted, and even if the artist or worker was duped into giving willingly of his labor, this turned out to be a kind of standardized monotony in industrial society. Spontaneity, freedom, and nature became the watch-words of the avant-garde, and here again they viewed the art of the eighteenth century as a proper model.

Nineteenth-century artists looked back to the condition of art in the previous century because they saw a "pure" art, one not enslaved by daily reality, one that was the result of aristocratic patronage which had permitted the artist a status above the herd, that is, above the bourgeoisie. This privileged standing was associated with a well-deserved leisure, namely, leisure earned by artistic genius. Like the life of the aristocrats who supported art, it meant a triumph over mere work. It was a leisure that subsidized creativity. (We have already encountered it when discussing the *flâneur*, who took on many of the attitudes and trappings of the aristocrat.) Art was non-utilitarian and had to be freed from bourgeois restraints. Leisure, nature, and hedonistic release from work became the resort of the artists' opposition to the bourgeoisie, despised because it based itself upon a materialistic work ethic and could not accept "pure" art remote from its immediate interests.

It was not the entire bourgeoisie whom the artists opposed, of course, for in this as in other matters, they aligned themselves with the progressive middle class. Already in the 1850s, a number of liberal theorists and industrialists concerned with the decorative arts, including Bonapartists like Léon de Laborde, agitated for reforms in schooling and in the applied arts that would favor the individual craftperson's gifts, thereby contributing a meaningful originality to the product.[60] Ernest Chesneau, a liberal art critic whose reviews were sympathetic to the impressionists, published an essay in 1881 whose terms are similar to Renoir's. "Every object made entirely by one hand is superior in beauty to mechanical products, despite imperfections in details," he wrote, and, in fact, "these slight imperfections themselves help give the object a personality, a soul, one might say." The value of an object lies in its individuality, and this is a product of spontaneity which must not be suppressed by too much precision of execution.[61]

Chesneau's appreciation of individuality and spontaneity in

the decorative arts probably led to his liberal attitude towards the impressionists, including their most controversial invention, their free brushwork. It was *too* free for Chesneau, but he could still praise Renoir, Monet, and Pissarro because, like them, he associated nature and hedonism with instinctual freedom. The artists themselves consistently linked individualism with spontaneity and therefore with their brushwork. This is why Renoir spurned academic finish, and why he praised the irregularities of handwork based on an immediate reaction to nature.[62] In this he was seconding the ideas expressed much earlier by Ruskin and carried throughout European culture by the Arts and Crafts movement, and by enlightened commentators like Chesneau. Even though the route of these ideas to Renoir has not yet been traced, his "Society of Irregularists" surely reflects the Arts and Crafts movement, and has a similar sense of moral outrage.

Both in that document and in the 1877 polemic published in *L'Impressionniste*, Renoir praised the Gothic over later, derivative arts. Like Monet and Pissarro, he was heir to the Gothic Revival, the forebear of the Arts and Crafts, and its conception of natural art as the product of natural man. This is why Monet would later paint Rouen Cathedral rather than a bank or a government building of classical design. This is why the impressionists gave such prominence to the hand-wrought qualities of brushwork rather than to the finish of traditional French painting. This is why originality itself, for both Arts and Crafts adherents and impressionists, was vested in the apparent imperfections of the handmade, free of the vice of mechanical perfection.

In these last phrases we find the links that join Impressionism to progressive currents of industrial capitalism. Thorstein Veblen gave the most famous formulation of the value of the hand-wrought in his *Theory of the Leisure Class*, published in 1899:

> Hand labor is a more wasteful method of production; hence the goods turned out by this method are more serviceable for the purpose of pecuniary reputability; hence the marks of hand labor come to be honorific, and the goods which exhibit these marks take rank as of higher grade than the corresponding machine product....The ground of the superiority of hand-wrought goods, therefore, is a certain margin of crudeness. This margin must never be so wide as to show bungling workmanship, since that would be evidence of low cost, nor so narrow as to suggest the ideal precision attained only by the machine, for that would be evidence of low cost.[63]

Renoir's free brushwork, therefore, is an expression of his society's longing for signs of those values that were threatened by the organization of the urban-industrial world: spontaneity, individualism, and the freedom to find consolation among natural things. For the well-to-do, those values could be translated into individually crafted paintings, furniture, or clothing. Veblen pointed out that the "honorific mark" of the handmade was not appreciated by the lower middle-class, who preferred the pseudo-perfection of the machine-made; the acquisition of "original" artifacts was consequently a way to distinguish one's "taste," that is, one's standing above the common herd.

For the less well-off, like the young women whom Renoir painted at the Moulin de la Galette or in the garden of the rue Cortot, those values were associated with leisure, with dancing, flowers, a Sunday outing in a park. His paintings of gardens and promenades embody ideals whose social meanings we readily recognize in other domains. That is, the demand that social restraints be lifted to make room for natural instincts, the demand for access to nature, for leisure to cultivate the self—what are these, in another form, but the demands of that era's labor unions and social reformers? Renoir's gardens may seem remote from politics, but in fact the campaigns to lower the work day from twelve to ten hours, and then from ten to eight, were struggles for more leisure, for more independence from the workplace, and as the unions grew stronger, the activities they organized for their members grew from picnics to suburban outings, and eventually to vacation camps in the country or on the seashore.

Chapter Six
Suburban Leisure

Paris smothers, it searches a wider horizon;
Its walls get in the way of spreading out the fulness
Of its ample frocks, it needs the suburbs;
It is pleased to see, without leaving its armchair,
The foliage and the fields...
 —P. Juillerat, 1861

La Seine river flashes a radiant belt among the vines, and the
villas seem to rise by magic from the nooks in the verdure.
 —Edward King, 1868

From one bank of the Seine to the other, one passes suddenly
from the worn suburb to the civilized countryside. The work
is over here, the *farniente* over there. On one side, flat fields,
factories, earth without shadows; on the other, stylish villas,
luxurious gardens, orchards, and even trees at liberty, bushes
that have not yet been imprisoned.
 —Louis Barron, 1886

194. Renoir, detail of *La Grenouillère* (Pl. 212).

In 1886, when Louis Barron published his book on the environs of Paris, the national census showed that only 20% of the inhabitants of the suburbs had been born in the commune they resided in. Another 24% had been born elsewhere in the suburbs or in Paris, so one could say that 44% were natives of the immediate region. This is still a striking contrast with the nation as a whole: 84% of French citizens in 1886 had been born in the *département* of their residence.[1] The suburbs were growing with a speed that matched that of Paris, and this, of course, meant drastic alterations. In the process of spreading its "ample frocks," Paris did more than encroach on its neighbors, it entangled them in a web of interchange that altered the appearance and the uses of land, river, road, and people.

The transformation of the suburbs can be crudely summarized as follows. (1) Among the growing numbers who lived in the suburbs, many worked in Paris. These included middle-class people who chose to live outside the city, and working-class people who were able to find lodgings in the less desirable and increasingly crowded areas. One result was that the daily habits and the culture of the suburbs more and more resembled those of Paris. Another was that land was often more valuable for building upon than for agriculture or other traditional uses, and it passed into the hands of entrepreneurs. (2) The suburbs produced many things needed in the city. This had long been true, but the sheer volume of produce changed the face of land and riverbank: intensive farming (some of it now aided by city sewage), and sand, clay, plaster, and stone for Paris's construction. Dredging and quarrying these materials, and transporting them, altered both land and water. (3) Industry came to the suburbs, some of it from Paris, much of it new enterprises that spread along the waterways, roads, and rail lines. (4) Commerce increased and altered, partly to serve Paris by sending it products, partly to receive Parisian goods, as one of its principal markets. The suburbs constituted a huge, annular city, and much of its commerce served its own burgeoning population. There was a corresponding growth in the traffic between suburban centers. (5) Transport was not only the servant of all these changes, it was the cause of some of the most visible alterations; the railroads actively sought increased business. (6) Parisians coming out to the suburbs for holiday pleasures were a force for change. They were the clients of innumerable cafés, restaurants, dance halls, hotels, bathing and boating establishments, vacation chalets, and pleasure parks. Old buildings were converted to these purposes, and many new ones built, as the former owners gave way to entrepreneurs. In certain areas the number of strollers was so great that the village fair or the beautiful walk along the river were altered beyond recognition.

Much of this shows in impressionist paintings. We see vacationers and pleasure-seekers, and the effects they had on the region, their boats, bathing establishments, cafés, chalets, gardens, and well-worn paths. We see the rivers, roads, and bridges that transported them back and forth. Along the edges and in the distances, but seldom nearby, we occasionally find steaming trains or tugboats, and smoking factories. Villages appear, but not as frequently as the roads and rivers that lead in and out of them. Meadows and gardens are painted much

more often than cultivated fields, orchards more than forests. None of these sites is "recorded"; each is interpreted, each is created in art. Monet, Pissarro, and Sisley lived in the suburbs; Caillebotte, Cassatt, Manet, and Morisot owned or rented summer residences near Paris; Renoir spent some summers in nearby villages, as well. They participated in the suburbanization of the area, and they brought back their produce to the Paris market: images of harmonious and productive villages, and of receptive landscapes.

Railroads and Leisure

The region near Paris favored by the impressionists was also preferred by Parisians generally: the area along the Seine that encompassed Asnières and Argenteuil to the northwest, Sèvres and Versailles to the southwest, Chatou, Louveciennes, Bougival, and Saint-Germain to the west, Poissy and Mantes further downstream (Pl. 195). It was served by the Gare Saint-Lazare, and its importance is shown by the fact that 40% of all Parisian rail passengers passed through that one station. Of Saint-Lazare's 13,254,000 passengers in 1869, approximately 11,000,000 represented suburban traffic.[2] They poured into the streets and *grands boulevards* to work, to shop, and to enjoy theaters, establishing a vital connection between the city's most fashionable commerical and entertainment district, and its principal residential suburbs. The growth of the suburbs that reached outwards from the western arc of the capital far outstripped the rest of the perimeter.

Not all the reasons for this pattern of westward expansion are clear, but they include the greatly increased commerce that joined Paris to the Channel coast and England. River and rail traffic transformed the Seine between Paris and Le Havre, and provided some of the impetus for the Parisian exodus, as well as the means of plying back and forth. For centuries Paris had been oriented towards the Mediterranean and Italy, but with the onset of the industrial revolution, it swung around to the north, drawn by the magnet of British industry and commerce. Industry went hand-in-hand with leisure. Not only did the British build the railway from Paris to Rouen (opened in 1843) and to Le Havre (1847), not only did they set up factories for producing steamships and locomotives but, as we saw in the previous chapter, they also brought along their sports and their leisure habits. The British colonies in Le Havre, Rouen, and Paris introduced rowing and sailing which, like racing, led to the adoption by the French of new customs and a new language (*le yachting*, *le rowing*). The British love of living close to "nature" also had its effect, and many *cottages* were built along the Seine, so that one could find an *Elizabeth-cottage*, with its *jardin anglais* leading to the river, where a British-built *skiff* would be moored, awaiting a forthcoming *rowing-match*. These new customs were grafted onto the French bourgeoisie's wish to adopt the customs of their aristocratic forebears, whose seventeenth- and eighteenth-century estates had once dominated the same riverbanks.

The opening of the Gare Saint-Lazare in 1837 was itself a proof of the link between the infant rail industry and suburban leisure. The stodgy French business clsss resisted the railroad, regarding it at first only as a form of amusement, but Emile and Isaac Pereire, disciples of Saint-Simon—the same ones who later developed the *Crédit mobilier* and built the Grand Hôtel—constructed a line eighteen kilometers long to Le Pecq, across the river from Saint-Germain. Their idea was not to serve industry, but to transport the Parisians who had made Saint-Germain the favorite suburban place for promenades, picnics, and fairs, at the cost of long trips by carriage or riverboat. The surprising success of the new line encouraged the building of a branch down to Versailles, opened in 1839. Because of its strategic placement, Saint-Lazare became the starting point for the main line to Rouen and Le Havre, and eventually was the portal to the whole of northwestern France.

The railroads, by no means passive servants, advertised heavily in Paris and the suburbs. They put up prize money for suburban races, as we saw, and they collaborated with regional sponsors of regattas, dances, and fairs by advertising their attractions and laying on special excursion trains. Cheap fares for weekends and holidays soon made clear the intimate connection of leisure with prosperity for both the railways and the villages. Asnières, Argenteuil, Versailles, Sèvres, Bougival, and Saint-Germain rivaled one another for the Paris crowds, and they revived or expanded their village festivals to attract them. Louis Napoleon included a number of suburban festivals in the list of amusements his government subsidized. Edward King joined a number of other visitors to the Universal Exposition of 1867 who journeyed out to Saint-Germain for one such festival. Fairgoers, "the same types one sees at Longchamp and Vincennes," walked among many dozens of booths that provided food and entertainment:

> Everywhere high poles were erected, bearing the national coat of arms and the imperial letters "N" and "E" interlocked. We passed up through a double lane of peddlers' booths nearly half a mile long. Here, on tables, were arranged great gilded squares of gingerbread, fancy boxes, imitation Sèvres ware in profusion, and Catholic images.... The canvas booths were all decorated with the "N, E," and in them were gay hundreds, drinking and singing. The rural theaters, in tents, excited our risibles. There were two separate streets devoted to Thespis.

There were also areas set aside for dancing, for concerts, and for dining alfresco. The attractions of nature were not forgotten, else why would one go out to "the country?"

> Inasmuch as there is a fete for every day of the year in France, the French people who had come out with us from Paris cared very little about the festivities, and we finally followed them to a cool nook on the wood's edge, where we could look off beyond the terrace into the beautiful valley. We rented two of the light cane chairs near by, and listened to the concert by the regimental band.[3]

The thirst for nature's solace led also to a great deal of building along and near the Seine, from vacation villas to residential enclaves. Le Vésinet was the most unusual case, and it was intimately linked to the railroad. In 1856 the real estate entrepreneur Alphonse Pallu acquired from the Emperor nearly one thousand acres near the station of Le Pecq, in exchange for lands to be added to imperial forests at Marly and Saint-Germain. He sold lots to his garden city, which he formed by imitating Alphand at the Bois de Boulogne. The

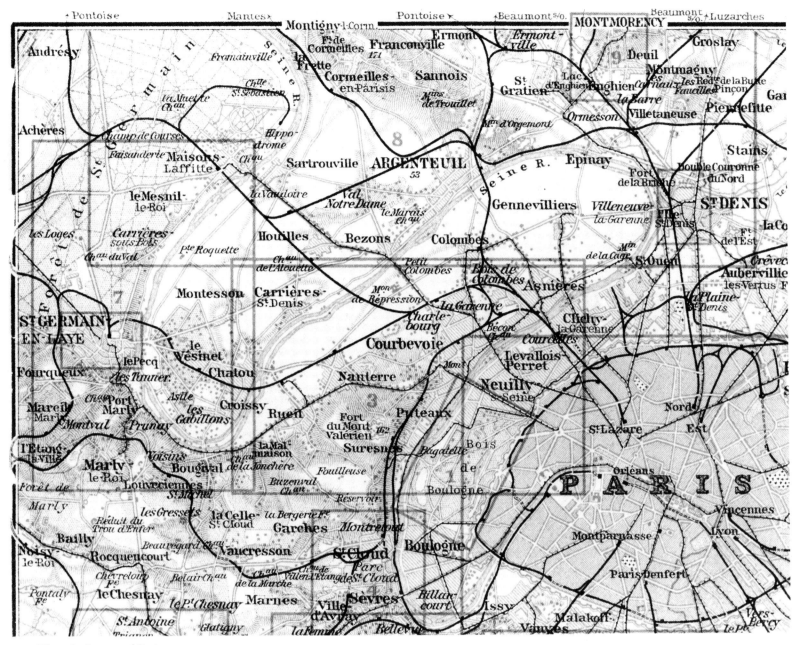

195. *The suburbs west of Paris, 1903.*

straight avenues of the old forest were replaced by curving roads, lawns, and artifical ponds, among which the lots were placed. Pallu prospered so much that the railway from Saint-Lazare opened a new station at Le Vésinet in 1862. Pallu was a friend of the duc de Morny, who was among his financial backers. Morny had a number of railroad directorships among his activities, and this might have facilitated his bargain with the Saint-Lazare line: new proprietors at Le Vésinet received four years of free travel to and from Paris.[4] A racetrack was inaugurated at Le Vésinet in 1866, a guarantee of periodic social seasons that lent *éclat* to the new investment community.

Suburban development did not take place without struggle, and one reason for the railroads' eagerness to cooperate with organizers of festivals, regattas, and races was to dampen the opposition to their mutilation of the countryside. It was a parallel to Louis Napoleon's use of entertainment to buy off dissent from his dictatorship. Well-organized but futile opposition came from the overland carriage companies and the riverboat industries, which were in direct competition with the railroads. Resistance came also from thousands upon thousands of individuals whose lands were cut through or otherwise changed by the railways, or whose jobs were jeopardized. On 25 and 26 February 1848, roving bands, inspired by news of the revolution in Paris, attacked and largely demolished the railroad bridges at Asnières and Chatou, and the stations at Reuil, Chatou, and Le Pecq.[5] No political revolutionaries these, but ferrymen, towpath workers, owners of towpath horses, employees and proprietors of riverside inns or village stagecoach stops, and others whose livelihoods had been threatened or destroyed by the rail routes. Bridges were favored targets perhaps because they were so visible, certainly because they usurped the role of ferry crossings, and because they served "others," not local people.

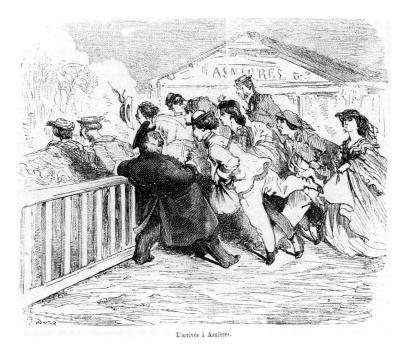

L'arrivée à Asnières.

196. Doré, *Arriving at Asnières*, 1861.

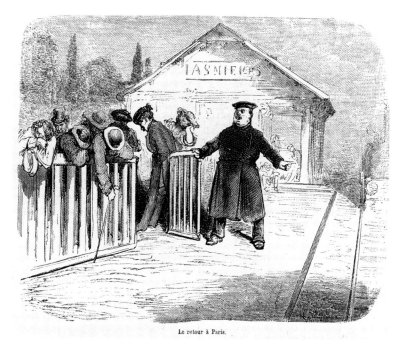

Le retour à Paris.

197. Doré, *Leaving Asnières*, 1861.

None of this, of course, would be evident in advertising and literature sponsored by the railways. A whole new industry sprang up to provide travelers with schedules, guides, and histories that praised the speed of the new transport, its ability to link formerly backward or isolated spots with the metropolis (cultural, as well as industrial "progress"), and its virtue in taking travelers to beautiful villages, historic monuments, and lovely nature. These books, many of handy purse size, gave employment to artists; among their leading illustrators was Daubigny, the older friend of the impressionists. Merged with the tradition of tourist guides, the railroad books made adroit use of historic sites and natural beauty to enhance travel. The new bridges that leapt across the Seine were represented—the wonders of progress were regularly touted—but most of the illustrations showed quaint villages, famous monuments, and verdant riverbanks. Their texts encouraged stopovers at village festivals and usually listed the dates of regattas, races, and other leisure activities.

From Village to Suburb: Asnières

By the summer of 1856, the popularity of the Sunday festivals at Asnières was so great that as many as 6,000 people crowded the grounds of the old château where they were held. They came in all manner of vehicle, but the largest number used the railroad. Less than ten minutes from the Gare Saint-Lazare, the station at Asnières was the first stop across the Seine northwest of the city. The rail line joined in the advertising for Asnières's festivals, and opened a special branch office there on Sundays to handle the demand for return tickets. Gustave Doré's cartoons (Pls. 196, 197), published in 1861 in a study of the city's environs, poke fun at the morning exodus and the evening return, already notorious by-products of the scramble for leisure that reached a climax on summer Sundays. Asnières in the Second Empire provided Parisians with an astonishing number of outlets for leisure: swimming, rowing, sailing,

shooting, riding, picnicking, dining, dancing, promenading, or attending regattas, concerts, cafés-concerts, circuses, fairs, and produce markets (aimed at the Parisians). Each of these was commercialized, and provided employment for seasonal itinerants and for Asnières's surging population. There were swimming instructors and sailors who taught rowing or simply took passengers aboard excursion boats; renters of several kinds of boat; managers of pigeon shoots and riding stables; vendors of hot and cold food; acrobats, clowns, and singers; individual musicians and whole bands.

The convenience of the railway also encouraged Parisians to settle in Asnières, some all year around, others (the word was *villégiature*) for vacations or for the whole summer. The village underwent the inevitable: its population rose from 1,300, in 1856, to 15,200 by 1886.[6] The history of its transformation is essentially that of many of the communities along

198. Foulquier, *Rowing Meet at Asnières*, 1855.

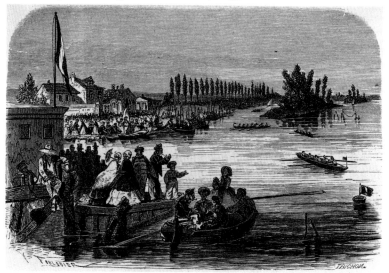

the rail lines west and north of Paris: the search for leisure was one of the principal agents of their alteration. The chief attractions of Asnières in its early heyday were its boating, its Sunday festivals, and its balls, usually held on Thursdays and Sundays. The railroad guides gave pride of place to rowing meets (Pl. 198), which they could praise unstintingly. As for the dances, the guides had to warn the reader in delicate phrases that they were rather like the Bal Mabille, for at Asnières also there were men escaping from their families, women on the lookout, enterprising young dancers strutting their latest, artists and writers who thrived in this less restrained atmosphere, and proper middle-class people (also readers of the guides!) who came to stare at them. The particular tone of Asnières was sounded by the Goncourt brothers in their novel of 1867, *Manette Salomon*. The painter Anatole moors a boat at Asnières, not far from a riverside cabaret where his friends can readily find him. They all tumble into his boat,

> comrades of both sexes, approximations of painters, species of artists, vague women known only by nicknames, actresses from Grenelle, unemployed lorettes, all tempted by the idea of a day in the country and a drink of claret in a cabaret.[7]

We can readily picture the Goncourts' boating party, for contemporary illustrators had made such outings the stuff of their engravings. In one of 1857 by Andrieux (Pl. 199), a boatload of carefree youth, supplied with picnic basket and wine, has just arrived at one of the islands that dot the Seine near Asnières. Andrieux made sure that we see it as it truly was, a no-man's land between city and country. On both sides of their mooring are old posts, boxes, and a barrel, the detritus of a well-used shore, while in the fields beyond the other boat that they are hailing are a factory and an abandoned wheelplow. The men wear a mixture of artists' and mariners' costumes, and two of them smoke the plebeian clay pipes affected by city bohemians. The name of their boat, "La Gammina," is a pun on *gamin* (street urchin or tomboy), and another of the satirist's references to the Parisians' invasion of "nature."

Informal boating of this kind was very popular by the 1850s, particularly on Sundays when the well-advertised fairs drew great crowds. The fairs were first held on the grounds of the château of Asnières, which was also open on weekdays for paying visitors. Perfect symbol of the middle-class having displaced the aristocracy, the château had been built in the eighteenth century for the marquis d'Argenson, but in 1848 was taken over by a local group who charged admission to enter the park. There one could stroll along the river, enjoy a picnic, or dine in the château itself, converted to a restaurant. On Sundays and special days there were games, music, and dancing. For masked balls and other nighttime dances the château and grounds were festooned with gas lamps, and there were fireworks.

By 1861—the pleasure industry was as volatile in Asnières as in Paris—the château had given way to the Folie-Asnières, nearer to the railroad station. Cafés and restaurants, some with dance floors, proliferated along the river, and in the evenings were thronged with Parisians who adopted extra-

199. Andrieux, *Boating at Asnières*, 1857.

vagant costumes, often modeled on mariners' clothing, like those seen in Andrieux's engraving:

> From eight o'clock to midnight, the cafés are bursting; beer foams, punch flames, billiards roll, one party follows another, clouds of smoke thicken. The stranger brought there by hazard might think himself at the bar of a masked ball, so great is the singularity of the attire. Some men wear the red shirt of the Garibaldians; others have their peacoats or their sailors' jackets, striped in all colors of the rainbow. An eccentric cut, lacy arabesques, loud colors, and fantastic trimmings distinguish feminine wear.[8]

The physical aspect of Asnières was drastically altered by the pleasure-seekers and those who catered to them. Already by 1856, the old village buildings were being jostled by a motley assortment of cabarets, shops, boating establishments and small apartment blocks. New residential villas were springing up along the banks, both upstream and downstream. Adolphe Joanne, in his guide of 1856, showed little sympathy with the nouveaux riches who were erecting them:

> These dwellings, more pretentious than picturesque, affect every form and style of architecture. Over here is a garden of a few square meters, possessing a fountain in a little basin, some statues, a kiosk, and a greenhouse; it is called an English garden. Over there, facades of houses have been erected, some on the model of the Alhambra, others on that of a villa of Herculaneum or Pompeii.[9]

By the 1870s, these villas stretched all along the banks, accompanied by new or remodeled shops and apartment buildings; the grounds of the old château were being divided up for building lots.

Something of the variety of these buildings, like so many weekend revelers in bizarre costumes, can be found in Monet's *The Seine at Asnières* of 1873 (Pls. 200, 201). Across the massive shapes of commercial barges we see a disconcerting array of buildings, ranging from the grand manor on the right, with its own gate and lawn, to chunky rental buildings and small,

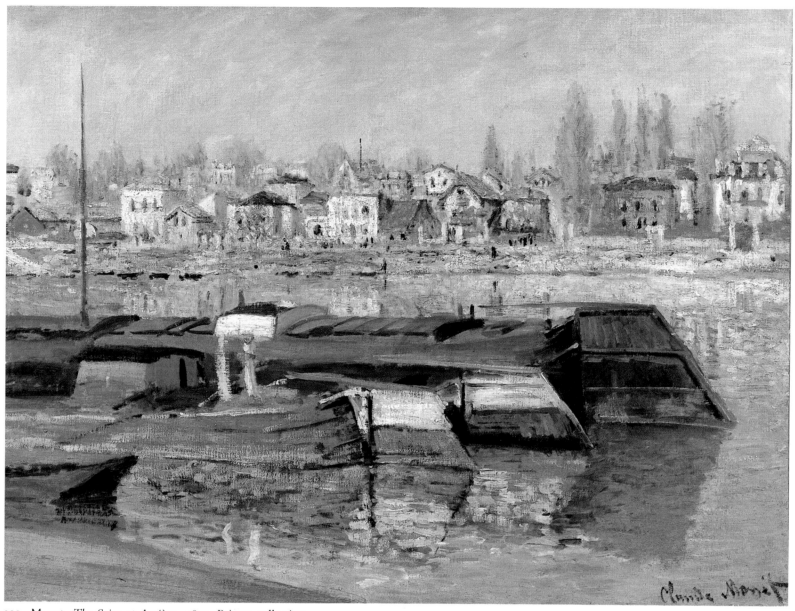

200. Monet, *The Seine at Asnières*, 1873. Private collection.

gabled villas. Monet was then living downriver in Argenteuil, and therefore only an observer of bustling Asnières, but other artists and writers had been taking an active role in the village's growth. In the 1850s, Alphonse Karr, a notable boating and swimming enthusiast, Eugène Chapus, Emile de LaBédolliere and others wrote glowing accounts of the village in articles and books on sports and on the environs of Paris. Henri Thiéry and Adolphe Dupeuty had a success with *Les canotiers* (Boaters) in 1858, a three-act vaudeville that honored Asnières and its Parisian mariners, and that helped further the vogue for songs about boating. Illustrators and cartoonists published views of the river village, often satirical ones like Doré's. Musicians, songwriters, and performers took part in Asnières's weekend and evening distractions, since excursions to the "countryside," for Parisians, really meant another form of entertainment. In fact, one cannot imagine the rapid growth of Asnières without the services of all these artists, who publicized its charms in words, songs, and pictures, and whose

example was followed by others, the "beautiful people" who trailed after the artists. And artists were more than casual visitors at Asnières. Several stars of the café-concert lived in the village, beginning with the famous Thérésa, who built a villa there, Amiati, and Planquette. Living there also were the playwright Armand Silvestre, and the writer and journalist Paul Alexis, friend of Zola and Cézanne.[10]

Monet's painting of Asnières reveals more than the patchwork of villas on the embankment. The barges in the foreground are the other side of life along that part of the river, for facing Asnières were the loading docks, warehouses, and factories of Clichy and Saint-Ouen. In the taverns at Asnières, sailors from barges and the small ships that plied the Seine mingled with the weekend mariners and were a source of their "authentic" costume. River boatmen were also employed as instructors by the swimming schools and boat-rental agencies (some of them can be seen in the guide-book illustration, Pl. 198). They were the equivalent of Parisian workers, whose

201. Monet, detail of *The Seine at Asnières* (Pl. 200).

dress and language were incorporated into café-concert songs, and who provided source material for middle-class painters and writers. Monet's picture offers the same confrontation of classes. The lower half of his composition is taken up by the elongated barges, whose huge rudders (required for manoeuvring in narrowly channeled current) are painted in loud stripes, prideful signs of their importance on the river. The upper half locates Asnières's prosperity where it truly was, just across the river from industrial activity.

Of course, all visitors to Asnières saw the contrast between the two banks, but most of them turned their backs on Clichy and represented in their minds, or their art, only the engaging aspects of the suburbs. Once in a while the truth peeped through the conventional accounts of Asnières. In his book of 1861, LaBédolliere noted not just the industry along the Clichy bank, but also "the fetid and black muck" expelled there by the gigantic "collector of Asnières," the *cloaca maxima* that dumped most of Paris's sewage (except for human waste) into the river opposite the village to form a black spoor that trailed down the river all the way to Argenteuil.[11] It was not the belated romantics like LaBédolliere, but the naturalists who probed into the truths of life at Asnières, even if they were ugly by prior standards. The Goncourts' novel *Renée Mauperin* (1864) begins with the heroine, a young painter, swimming in the Seine just above Asnières, near Saint-Denis. She and Reverchon, who is courting her, are clinging to the ropes of a moored barge as the novel opens. Reverchon is hardly enthusiastic about their surroundings, but Renée, one of the most astonishing women in French fiction, praises the beauty of the industrial and commercial banks, which the authors describe as "dirty and sparkling, miserable and gay, popular and alive, where Nature passes here and there among shacks, work, and industry, like a blade of grass between a man's fingers."

Monet, like the Goncourts and other naturalists, was aware that the two banks of the Seine were partners in this locked embrace of work and leisure. In a variant of *The Seine at Asnières* painted at the same time, he made the contrast even more explicit by situating a sailboat beyond the barges, near the Asnières shore. Furthermore, between 1872 and 1877, the year he completed his series of the Gare Saint-Lazare, Monet made several paintings of the industrial banks of the Seine. However, the tension between city and country was a strong force that Monet could not always accommodate. There was, it turns out, a good deal of LaBédollière in him—one might better say, a good deal of Daubigny or of Corot in him—and in those same years most of his paintings excluded industry and presented the suburbs as a realm of leisure seldom intruded upon by signs of labor. Then, after 1877, all paintings of industry ceased. By 1879, when he moved well downriver to Vétheuil, Paris also disappeared from his oeuvre. In retrospect, we see that in the years immediately following the upheaval of the war and the Commune, Monet had been alert to the dialogue of city and suburb, but that subsequently, like Cézanne, or like Van Gogh, he sought solace by creating landscapes that released him from the tensions of urban life.

With that thought in mind, we have jumped beyond the decade of the 1870s in Monet's work. For him, as for Renoir, Pissarro, and Sisley, there is much more to the story of painting in the suburbs. Asnières, in the early 1870s, was no longer the preferred haunt of landscapists—it is a measure of Monet's mutable devotion to contemporary life that he worked there—and a fuller history of leisure in the suburbs, as it appears in impressionist paintings, requires a trip further down the Seine, to the great arc of the river as it flows southwest from Argenteuil and Chatou, and then bends westward by Bougival and Marly before it turns north again. The banks of this undulating river are "the island of France," the *Ile de France*, and most Parisians, when they quit the capital, played the game of landing on a distant shore while knowing full well how close they were to the city of cities.

Bougival

There was more than one reason why the impressionists and many other Parisians preferred the environs of Bougival to Asnières. By 1869 Asnières had gone through the cycle of discovery and exploitation, and was no longer *chic*. Crowded, hemmed in by industry, it had become an appendage of the city. Bougival, Louveciennes, and Marly (Pl. 195) had long since been "discovered," but still offered a reasonable facsimile of countryside. Here and there along the riverbank were sawmills, loading docks, and chalk quarries, but these were flanked by generous stretches of green growth and were, moreover, pre-modern industries that could be regarded as picturesque. (Sisley and Pissarro frequently painted such sites in the early 1870s.) From Chatou all the way around to Port Marly, the two banks were separated by three narrow islands that were not much built upon, but were well provided with paths, open fields, and woods. Along their willow-laden shores were several establishments which catered to visitors, including the "Grenouillère," given enduring fame by Monet and Renoir (Pls. 194, 211–215, 217). A new road bridge had been built in 1858 to span the two branches of the Seine between Croissy and Bougival, and new villas were appearing on the riverbanks and inland. These were more elegant than those at Asnières, and many were surrounded by park-like grounds. The whole region had the special advantage, vital to the aspiring bourgeoisie, of its rich historical heritage.

What was left of history at Asnières had been largely engulfed by rapid development, but the slopes of the Seine above Bougival and Port Marly still had a number of seventeenth- and eighteenth-century châteaux, and along the river were other reminders of the area's glamorous past, among them, the famous waterworks between Bougival and Port Marly. Louis XIV had commissioned the waterworks at the end of the seventeenth century to pump water up the steep bank to the new royal château of Marly, from whence it flowed southwest to Versailles. Louis Napoleon had the "machine de Marly" entirely rebuilt in 1858, so the pink and tan building that shows in so many paintings of the 1870s by Sisley was essentially new. It embodied the blending of past and present that was characteristic of the whole region.

Under Louis XIV and his successors, this bend of the Seine had become a dependency of Versailles, its court, and its hangers-on. The Sun King had built the château at Marly to escape from the obligations of state at Versailles. Many noble families had summer residences in nearby Louveciennes (Louis

XV built a small château there for Mme Du Barry), and along the river at Bougival at one time were the châteaux of the princesse de Conti, Boissy d'Anglas and Malesherbes. The estates of other notables and of well-connected bourgeois dotted the area from Reuil around to Saint-Germain, always under the lee of the vast royal forests and domains which occupied the lion's share of the whole region. With the Revolution and its aftermath, many of the great estates were sold, some of their buildings (including Marly) were torn down or extensively remodeled, and their grounds often subdivided for sale. By the middle of the nineteenth century, most of the old families had been replaced by bankers, publishers, financiers, and successful writers; they remodeled some of the old villas or built new ones. The Pereire brothers, whose railway served the region, had a villa at Croissy, and the politician Odilon Barrot held forth at Bougival.

Artists were among those who were active in the transformation of the region, which grew in popularity after 1830. Their paintings and writings circulated its charms among Parisians, and so did their example: by living there, artists confirmed the association of nearby "nature" with artistic genius and with poetic release from worldly cares. Just beyond Port-Marly, Alexandre Dumas *père*, at the height of his success in the 1840s, built "Monte-Cristo," a villa on the slope

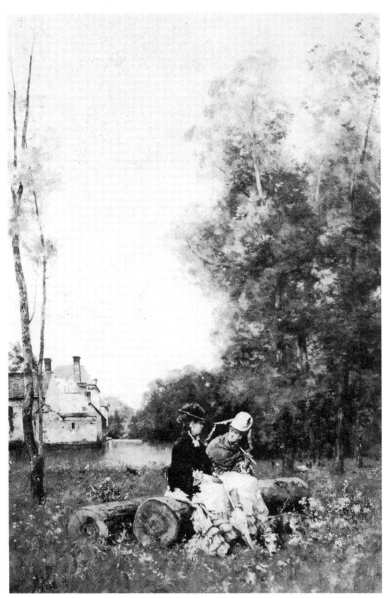

203. Heilbuth, *Bougival*, c. 1876–82. Collection unknown.

above the Seine (Pl. 202). Its three stories rose from an impressive terrace. Above, its windows were bordered in decorations patterned after the Renaissance sculptor Jean Goujon, and their keystones bore the images of Homer, Virgil, Dante, Shakespeare, Corneille, Goethe, Chateaubriand, Lamartine, and Hugo. A dry moat separated the villa from the road, where its gate bore a gilded escutchen that read "Monte-Cristo, historic property" (*propriété historique*). Subsequently, the playwrights Emile Augier and Victorien Sardou lived nearby, Augier at Croissy, and Sardou at Marly. More modest than Dumas, Sardou affixed the letters M and S to the gateway of his eighteenth-century mansion, confirming that the villa Montmorency was now his. He doffed his hat to ancient history by setting five Egyptian sphinxes along the *grande allée* of his formal garden.[12]

Painters had an equally important role in increasing the fame of the region. In the 1830s, a veritable summer colony of painters was established along the Seine between Chatou and Saint-Germain. Célestin Nanteuil and F. L. Français were among its animators, and their periodic dinners at Souvent's

202. *Dumas's villa "Monte Cristo" at Port-Marly.*

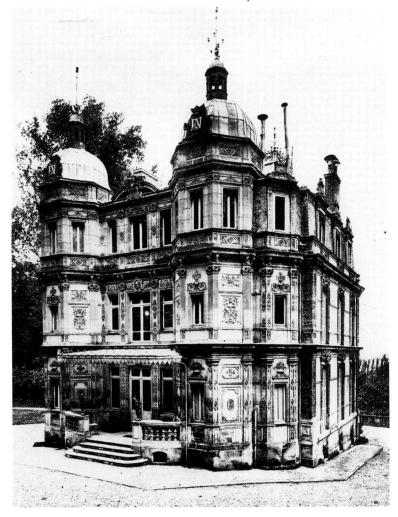

inn at Bougival were frequently attended by Corot, Auguste Anastasi, Eugène Desjobert, and other landscapists, who decorated their host's walls with views of the riverbanks and hills. Their fame and their region were partly eclipsed, after 1850, by the rise of Barbizon and its painters, but guide books of the 1850s and 1860s regularly pointed to the artists' colony in and near Bougival, and led their readers to hope for encounters with notable painters and writers. When the Goncourt brothers visited the aged Célestin Nanteuil in 1855, they could still write that Bougival was "the homeland and the studio of landscape, where every tree, every willow, every fissure of the earth reminded you of an exhibition, and where one walked about hearing 'This was done by ***, this was drawn by ***, this was painted by ***.' "[13]

Thanks to engravers and painters, the landscape itself had entered into history by the Goncourts' time, with the singular advantage that it recalled the glories of the seventeenth and the eighteenth centuries, so evident at every hand. In his *Bougival* (Pl. 203), Fernand Heilbuth seated two *parisiennes* on logs, with an eighteenth-century château in the background.[14] To some, the fashionable women are an intrusive bit of modernity in a Corotesque landscape, but Heilbuth might have purposively inserted the present into the past, for the cut logs seem to be a piece of conscious irony.

204. Weber, *Bougival*, 1869.

In an article of April 1869, the connection between nature, idle pleasure, and the appeal of the region's past was made clear—without irony. The author began with metaphors that treat Bougival as an extension of a fashionable city garden: "The trees form the most agreeable pattern. On the shaded island, one can walk on lawns fresh and gentle to the feet, veritable carpets of greenery." She or he then continued immediately: "On the heights that crown the village, one has a rich choice among sites of a ravishing picturesqueness and, above all, these woods, these hills, these country seats are full of historic memories, which never spoil anything."[15] In the engraving after Charles Weber accompanying the article (Pl. 204), the hill is crowned by the famous aqueduct which

received the water pumped from the "machine de Marly." To the right is Croissy Island (also called "Ile de la Chaussée"), to the left, Bougival, where at one point a low wall encloses a garden that was probably a survivor from the previous century's large estates. Numerous sailboats and at least one barge are moored along the shore. A fisherman comes down the road, and near the center a man and woman are enjoying the scenery. At Bougival, middle-class vacationers could assert their rights to the privileges of the bygone aristocracy. "Historic memories" (*souvenirs historiques*) were a kind of portable possession, a representation of the past that could be found in paintings and engravings (hence the word "picturesqueness"), a representation that one could walk through, as though it were a stage set, at Bougival, Louveciennes, and Marly. When Edward King hiked along the hills above the river, in 1867, he not only thought constantly of the building of past glory, but remarked that even the trees near Marly "seemed haunted by some remorseful shade of the old king and his dead century...."[16]

To modern observers, the region is most memorably represented not by Louis XIV, but by the impressionists. Pissarro moved to Louveciennes in the spring of 1869, the presumed date of his *Springtime at Louveciennes* (Pl. 206). He remained there until the outbreak of the Franco–Prussian War the following year, and returned occasionally after 1871. Monet took up residence in the hamlet of Saint-Michel, on the heights above Bougival, in late May or early June, 1869. From mid-summer until late September he was joined by Renoir, who spent the period at nearby Louveciennes; his parents had moved there the previous year. Their paintings of the Grenouillère are the best-known representations of the Bougival area and have often been considered the first "impressionist" works (the term was applied to them only five years later). Monet stayed on that fall and winter, and visited Pissarro in December; they both painted the snow-clad road

205. Monet, *The Seine at Bougival, Evening*, 1869. Smith College Museum of Art.

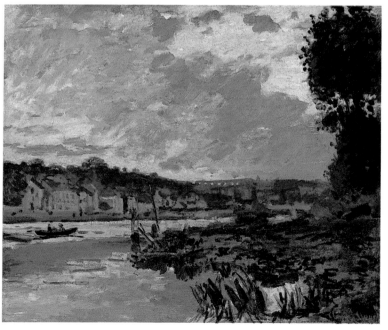

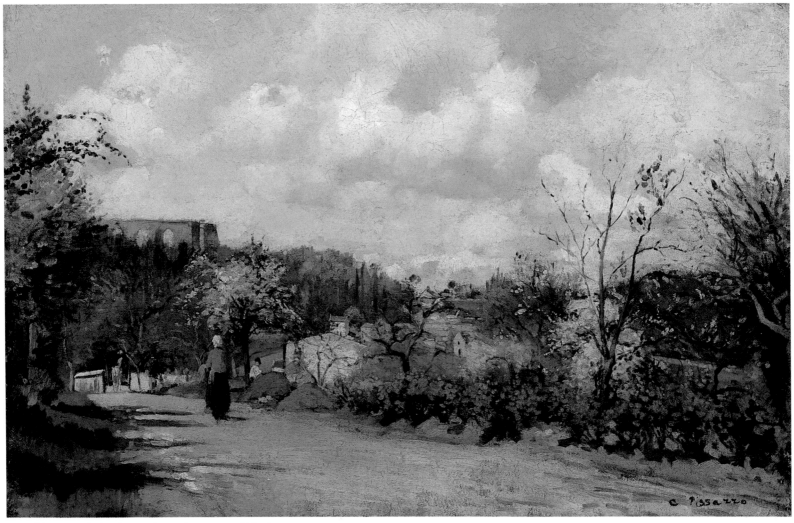

206. Pissarro, *Springtime at Louveciennes*, c. 1868–69.

on which the older painter lived. Monet and Pissarro left by early summer, 1870, but Sisley moved to Louveciennes during the seige of Paris. He lived there until 1874, and at nearby Marly until the autumn of 1877. His body of work is the largest devoted to the district, but not the last. Between 1881 and 1884, Berthe Morisot was frequently there with her family, and painted views of the riverbank and village, as well as of her husband, daughter, and maid in their rented villa and garden (Pl. 258).

Pissarro's *Springtime at Louveciennes* is apparently the first impressionist painting of the area. The artist places us on the road that runs along the heights of Louveciennes, facing west towards Marly, with Bougival just behind us; below we glimpse the river at Port Marly. In the upper left is the Marly aquaduct, the "souvenir historique" that dominated this bend of the river. It is accompanied, as it were, by another historic reference: the paintings of Corot, whose manner it resembles, particularly in the broadly painted road and in the delicate tones of spring foliage that screens the river to the right. Like many of Corot's paintings, it combines fresh observation with a view that is unmarked by signs of the immediate present. No tourists are shown, only locals along the road or working by their villas.

Monet's first painting at Bougival (Pl. 205), done later that spring or early summer, also has visible echoes of the preceding generation. It recalls two painters Monet knew and admired, Daubigny for the composition, Boudin for the sky, and both, for the free brushwork. It resembles also the right two-thirds of Weber's engraving from *L'Illustration* (Pl. 204), but there is no need to believe that the print "influenced" Monet. Both illustrator and painter drew from a tradition dating back half a century or more. Monet did not have the illustrator's purpose of supplying topographical information, and instead was looking for a striking "effect." He discarded the pathway and tree on the left edge, customary in such river views, so that our eye rushes directly into the agitated sky and its reflection in the river. Because we do not have the expected position on a road that Weber and Pissarro give us, one that allows us to keep a certain distance, we gain a feeling of immediacy, of "being right there," close to the marshy bank. The large and liquid brushwork also transmits an effect of spontaneity, in contrast to Pissarro's more refined and detailed strokes. The sunset has tinted some of the clouds with cinnamon reds and purples that resonate against the moist greens of Croissy Island in the foreground. The aqueduct is dramatically silhouetted against the fading light, outcompeting the modern bridge which takes an inconspicuous place below it. Neither has the prominence that Weber grants them, since Monet inte-

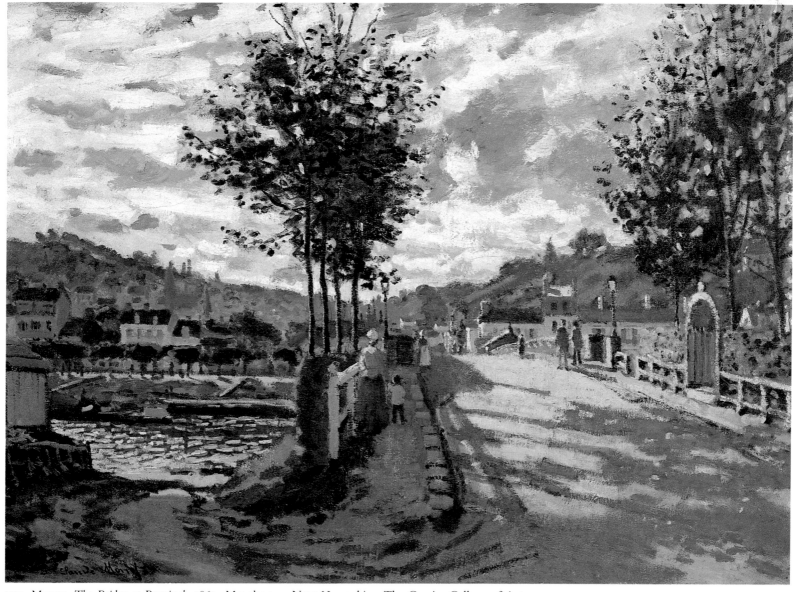

207. Monet, *The Bridge at Bougival*, 1869. Manchester, New Hampshire, The Currier Gallery of Art.

grated all features of the river and its banks, and subordinated them to the majestic sky. A rowboat signals the peaceful setting (the steam tugs that plied the river are not shown), and the picturesque houses of Bougival line the bank. Were it not for the bold manner of applying paint, we might think ourselves in an earlier era.

Past and present cohabit more comfortably in Monet's *Bridge at Bougival* (Pl. 207), painted that autumn, after the intervening pictures of the Grenouillère which will be discussed shortly. Less sketchy than the sunset view, more "finished" within the range of the artist's practice, this astonishing painting—Monet was only twenty-nine—is one of the great landscapes of the era. We are looking across the bridge from Croissy Island towards Bougival, a route that the artist had frequently taken that summer to get to the Grenouillère. Like Pissarro, in his pictures of the region, Monet excludes vacationers and shows the village in an imaginary moment (for *he* is there) when no Parisian is present. The raking light from the east tells us that it is an early morning in the fall, a non-tourist

hour and season when only people in local dress are visible. It is the ideal river village, seemingly remote from Paris. Whether calculated or not, the picture has the comfortable feeling of tradition. By avoiding an angled view of the bridge that would have revealed its modern aspect, Monet makes it seem more like a roadway; the absence of any vehicles contributes to its tranquility.

Among the most attractive features of this masterwork are the conjoined effects of color and light. The raking angle of the autumn sun produces strongly lit edges on the left sides of the central tree trunks, the figures on the bridge, the houses at the end of the bridge, the bridge railing, and the tree trunks on the right (Pl. 209). The shadows that sweep across the road are a dramatic indication of the sun's seasonal angle. They are a rough approximation of the broken reflections of the sky on the river's surface. Effects of light, in other words, are a metaphor of the paired relationship of river and bridge. The play of sun and shade continues in miniature on the quai in the left distance, where tiny figures walk among the trees.

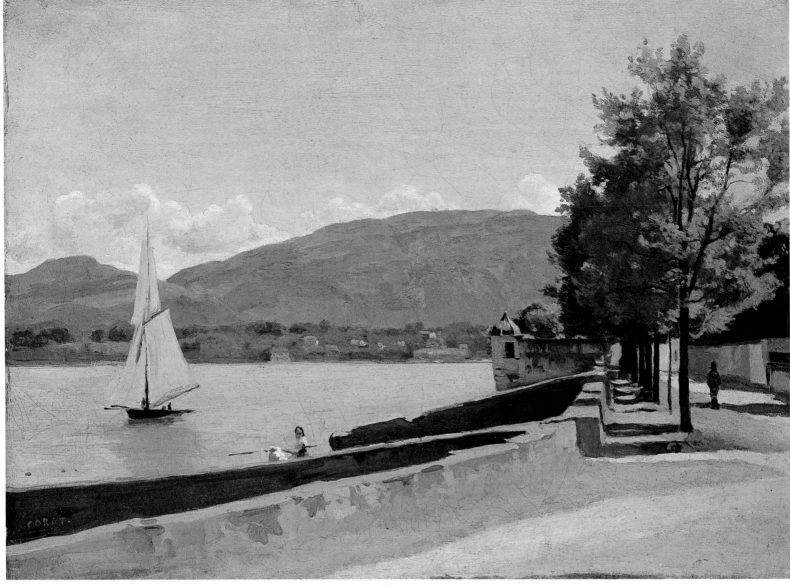

208. Corot, *Le Quai des Pâquis, Geneva*, 1842. Geneva, Musée d'Art et d'Histoire.

Beyond, morning mist and distance produce a blueish-grey haze in the hollow of the valley.

Monet's colors, laid down in brushstrokes which are carefully dragged over the surface and which take on a unifying role, have the relatively subdued intensities that suit autumn. The blues of the sky are repeated in the distant hills and are mixed with some red to form the grey-purples and grey-blues of the foreground (from left to right they shift progressively from ruddy to blue tones). Together with the browns and dull greens of hillside, trees, and hedges, they act as a stable matrix for the brighter touches, the orange crowns of the plane trees, the orange and mustard yellows of bank and hedge, the brick red of the long roof to the right. The classical color opposites are embedded in the structure, although reduced in saturation to satisfy the artist's muted scheme: orange and blue, red and green, yellow and purple.

Color takes on the vital role of integrating a composition that has two nearly self-contained halves, one stretching from the left edge over to the line of the curbstones, the other, from the right edge over to the four trees. Of course the two halves share the central portion of trees and sidewalk, and are framed above by the sweep of the curving hills (which lead to those all-important trees), and below by the shaded roadway. They tend, nonetheless, to separate into two views, and in doing so, they afford us a composition of surprising richness. This device, a composition of two spatial vistas, was common in the work of Hobbema and other Lowlands painters, and can often be found in Corot's paintings. In Corot's *Le Quai des Pâquis, Geneva* (Pl. 208), for example, the two spatial openings are divided by masonry walls and a line of trees. The left side of Monet's bridge occupies less room on his canvas, but performs the same function. Its rush into space is slowed by the stasis of the figures and by the flattening effect of the four trees, whose trunks do not come closer together as they recede. The same is true of the three trees on the right side, abetted in their effect by the horizontal that joins the top of the hedges with the succession of rooftops. This horizontal works with the central verticals to establish a rectangle in the

209 (following pages). Monet, detail of *The Bridge at Bougival* (Pl. 207).

Claude Monet

lower right quadrant which embraces the bridge's surface, flattening it despite its plunge into the distance. Across the river, the line of plane trees and quai forms another strong horizontal, and the water takes on a symmetrical shape that repeats, in reverse, the configuration of the road leading down to its edge.

Compared with Corot's view of Geneva, Monet's picture is full of internal symmetries, repeated horizontals and verticals, and shapes that lie rather flatly on the surface. Corot made use of the alternate light and dark of his diagonal masonry, powerful indicators of receding depth. The foliage of his trees, similarly, is more massive and shifts from light in the foreground to dark, further back. The gaps between his tree trunks diminish with distance, and as a result we cannot flatten them as easily as we do Monet's. Corot's foreground slants steadily back to meet the line of trees; his road penetrates space more deeply than Monet's bridge.

It is not enough to say that these are two different scenes, for each artist could have chosen a view like the other's. There is always a dialogue between a site and the pictorial structure a sensitive artist establishes for its reception, each helping to determine the other. Corot, like Daubigny, Théodore Rousseau, and other landscapists of his generation, sought out unaltered roadways and riverbanks, and old cities, in preference to those that showed the effects of the urban-industrial revolution. Monet chose a setting that would have been foreign to Corot's esthetic, a recently built bridge and a vantage point that diminishes the picturesqueness of the village. In its complicated network of geometric shapes, his picture expresses his generation's wish to impose order and regular intervals over nature. It speaks unwittingly for the Second Empire's diagrams of control.

This assertion will appear extreme to anyone unused to finding social meaning in the structures of art. However, one of the benefits of twentieth-century formalism has been the demonstration that the forms of music, poetry, dance, and the visual arts embody fundamental beliefs, varying from attitudes towards nature to the struggles between an individual's subjectivity and concepts of social organization. Monet's painting of the bridge at Bougival does indeed incorporate some of his generation's aspirations in the very way he shaped his images. This is difficult for us to appreciate because the agitation of urban life in the twentieth century has changed the way we perceive things, and Monet's picture now strikes us as a peaceful realm far from a city. Moreover, later paintings, like those of Van Gogh or Jackson Pollock, have altered our sense of pictorial structure, and compared to theirs Monet's picture appears extremely calm. It is true that the bridge at Bougival was a peaceful spot, and at first glance it might not seem like an appropriate expression of the new Paris. However, Bougival was only a half-hour from the city, and urban sensibilities are clearly at play here. Next to the Corot, Monet's two openings into depth have a startling effect, and his composition has an abruptness, a lack of traditionally integrated edges and spaces that speaks for the rapidly changing character of the capital.

Monet's striking geometry was not unique to his picture of the suburban bridge. His *Garden of the Princess* (Pl. 14) and his *Terrace at Sainte-Adresse* (Pl. 297), painted two years earlier,

also have clearly marked-out planes that rise upward on the surface. It is true that painters of landscape, by the very nature of their work, have always imposed pattern on their settings. French painters were willing to exhibit their patterns openly, unlike British landscapists whose penchant for naturalness resulted in less obvious pictorial devices. Painters in France worked in harmony with landscape architects who had developed a preference for artificial arrangements. Louis XIV's gardens at Versailles and at Marly have often been likened to the assertion of state power;[17] these and other formal gardens scattered around the bend of the river near Bougival are one of the reasons why this region appears so thoroughly French. Their kind of order, however, suits the conventions of artists of the seventeenth and eighteenth centuries. Monet's patterns no longer observe their careful stagings and deep perspectives. Nor in his compositions is there room for the picturesqueness of Corot and other landscapists of the preceding generation. Instead, he created forms that suited the Second Empire's sudden and quite ruthless redesigning, not just of Paris, but of the nearby suburbs: highways and bridges that formed new channels of traffic across the countryside; railways that speeded up travelers' perceptions of village and field; housing developments that brought residential geometries to lands once devoted to agriculture or forest; riverside docks and factories that reshaped the banks of the Seine; steam tugs that gave visibility to industrial power. Equally significant, but less dramatic, are the alterations brought about by canoeists, yachtsmen, bathers, and promenaders, the Parisians, accompanied by painters, who sought escape from the city, but who brought so many of its patterns with them.

The Grenouillère

Croissy Island, which forms the foreground of Monet's *Bridge at Bougival*, was ideal for strolling and for painting pictures, and was one of the chief reasons for coming to Bougival. "It's not even an hour since we left the boulevard des Italiens," wrote the author of the article accompanied by Weber's engraving in *L'Illustration*, "and already we feel far away from Paris." The peaceful solitude the writer praises was, however, of the Parisian variety, for the text continues:

> One hears noises and outbreaks of voices on the island, but these are gay choruses. Life seems to have pushed far away all its dreariness, and shows itself to be good-natured and easy for this population of nomads, of independents who know how to free themselves from the vexations of civilization. For some that only lasts a few hours. For others, that lasts the whole warm season. Fortunate, the latter.[18]

Monet and Renoir had been among the fortunate nomads that summer, and like the others, they had been drawn to the Grenouillère, the noisiest and most Parisian of the bathing places on the island. It had long benefited from the presence of artists, who as usual were among the vanguard of the leisure-seekers, and who had taken a major role in the development of fishing, boating, and swimming at Bougival. The Grenouillère itself seems to have become *the* voguish place only in the early 1860s (evidence is scanty before then), but it was the bene-

ficiary of the prior generation's activity. Already in 1854 it was noted that

> The country near Chatou, Croissy, and Bougival is inhabited by a swarm of writers, men and women belonging to the artistic life of Paris. They have the habit of finding one another along the banks at certain hours of the day, sometimes for fishing, sometimes for the pleasures of bathing in open water, which usually takes place towards four o'clock. If, on a warm afternoon of a fine summer day, your spare-time activites direct you towards Croissy Island, ...facing the villa of Messrs Pereire, you will find yourself in joyful sporting community with this attractive society....[19]

Chapus then lists a whole host of Parisians whom he credits with popularizing swimming and fishing there: the writers Carcano, Maquet, Wey; the painters Nanteuil, Chenevan, Meissonier; the musicians Tulou, Thomas, Morelli, Chapuis; the dancers Mérante, Berthier, Mabille. Some of the same men welcomed boating, also, and only fifteen years later, the article in *L'Illustration* could declare that "For a few years now, Asnières, the cradle of Parisian rowing, has been dethroned by Bougival." Two more articles in the same magazine that year, in May and August, touted the attractions of Chatou and of the Grenouillère, confirming that, for rowing and for swimming, this bend of the river had taken preeminence. The August article announced that the Grenouillère had received the accolade of accolades: Louis Napoleon and Eugénie, seldom at a loss for gestures of grand condescension, stopped there briefly in mid-summer 1869, while on a steamboat excursion, and were shown about by the proprietor, Seurin. The author of the article was prompted by this visitation to list many of the historic sites nearby, going back to the pavilion where Gabrielle d'Estrées supposedly entertained Henri IV.[20]

As for Monet and Renoir, already familiar with the region, they hardly needed to be prompted by the Emperor's visit or the flurry of articles in 1868 and 1869 that helped make the place a distinctive fad. Still, Monet, as we know from his letters, was eager to produce a picture worthy of exhibiting in the next Salon, and the publicity enjoyed by the Grenouillère may have encouraged him to choose the site.[21] To reach the Grenouillère, he and Renoir, like other vacationers, had only to go down the steep streets of Bougival, cross the bridge to Croissy Island, and walk along it to the shaded spot. Others summering nearby could follow the same route or be ferried there from several places along the two banks. There were some villas and cabins on the island itself that could be rented by the week or month, and on holidays and weekends, many day visitors came from Paris. It required only a twenty-minute

210. Yon, *La Grenouillère*, 1873.

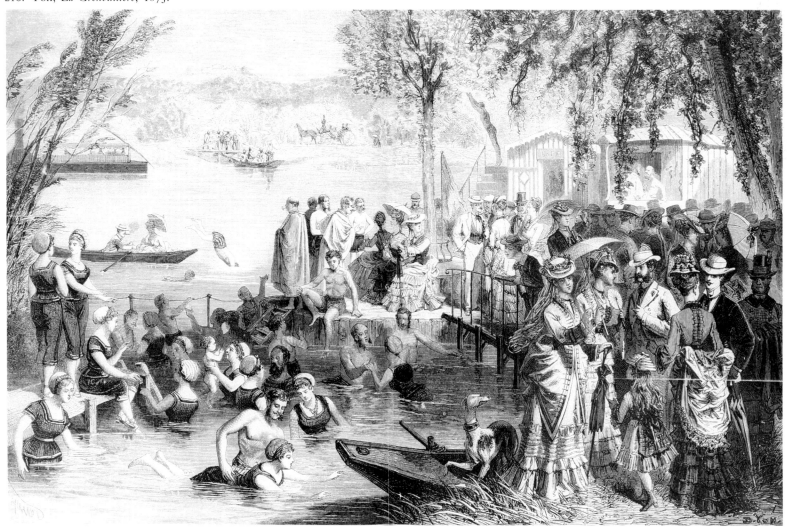

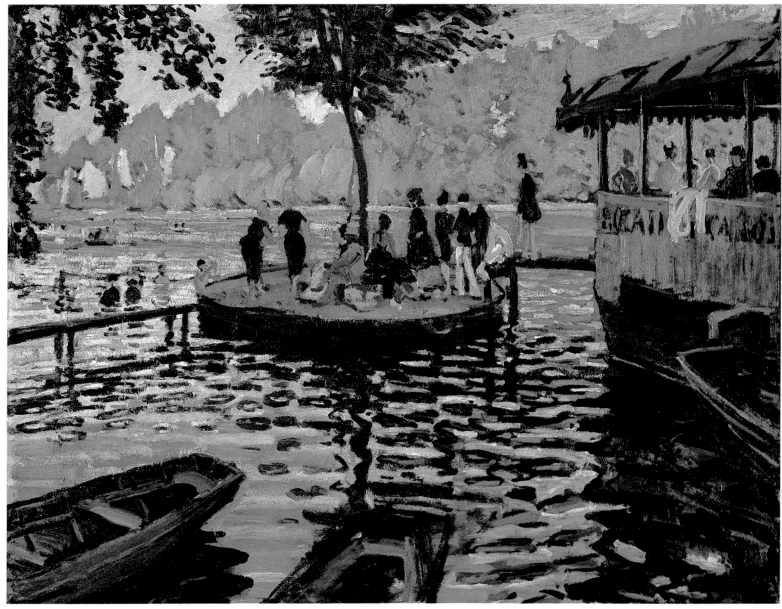

211. Monet, *La Grenouillère*, 1869. Metropolitan Museum.

train ride from the Gare Saint-Lazare to Reuil or Chatou, and then a walk of about a mile, or else the services of a carriage. Seurin's establishment consisted of two old barges moored under the trees, on top of which were built simple shelters for dining and dancing. They were connected to the bank by footbridges, and to the adjacent, artificially rounded island (the "Camembert," or the "Flowerpot"), which had its own bridge to the shore.

Seurin's clients seemed happy to make his fortune. Bathing had become a major sport for Parisians before mid-century, and was growing apace. The river was salubrious there, or appeared so, and instead of the fixed bathing structures in the busy Seine at Asnières and Paris, there was a broad span of water under open skies. Boats mingled with the swimmers in frolicsome ways, and Seurin's dances and regattas were supplemented by those close by, at Bougival and Chatou. Along the bank were rustic tables and seats, simple changing rooms, boathouses, rental cabins, and supply buildings which

blended well with the nearby boat repair shacks. Seurin had as many ways of making money as the entrepreneurs of Paris's cafés-concerts (many of the clients were the same). In his restaurant and among the trees he sold food and drink, and tickets to his balls; he rented boats and bathing costumes; he charged for swimming lessons and for being ferried about; he charged also for using his changing rooms, and for his vacation cabins.[22]

A print of 1873 (Pl. 210) by D. Yon shows a panorama of society at the Grenouillère and introduces us to many of the elements taken up by the impressionists. On the right is a crowd of Parisians in fashionable promenading costume. A child and a dog are present, for family outings were commonplace at the Grenouillère, and were a staple of contemporary prints of the place (in one painting Renoir shows a dog; in another, a child). The little bridge right of center leads to the Camembert, but its separation from the two floating structures to the rear is not at all apparent. On it are three women,

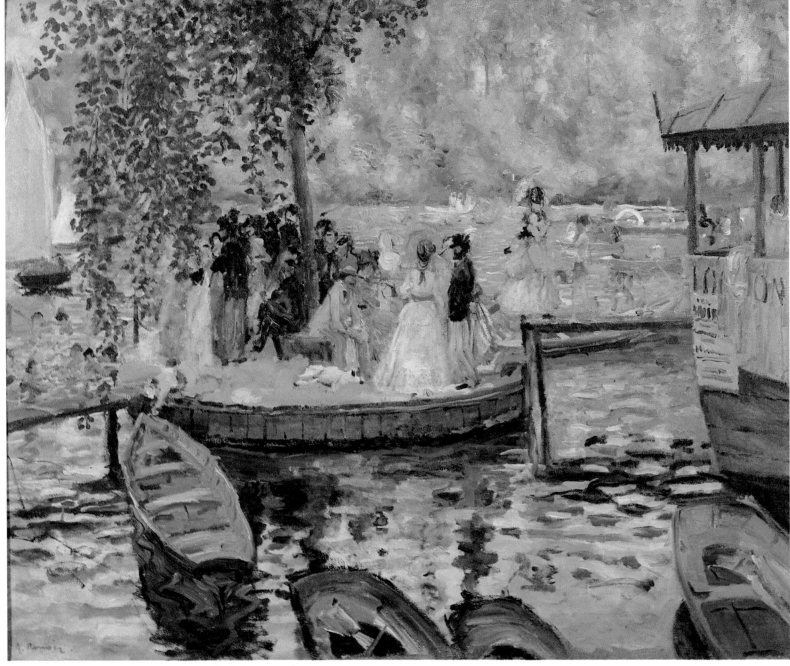

212. Renoir, *La Grenouillère*, 1869. Stockholm, Nationalmuseum.

seated on the bench around the tree, and several men, either in bathing trunks or loose bathrobes. On the left, four women bathers in identical rented suits are on the end of a narrow dock, while in the water several are receiving instruction from Seurin's staff; one holds a baby aloft. Beyond, a man dives from a boat rowed by an urban mariner who sports a cigar and a straw boater. On the bank of Reuil beyond is a small crowd on a dock, where several visitors are being deposited or fetched in a boat. To complete the setting, a carriage and a promenader move along the shore, and a rival dining or bathing boat appears in the upper left.

The illustrator's job was to supply an abundance of information, in a familiar style that would not offend the readers of his magazine. Monet and Renoir were working in oils, and

making sketches, not more finished paintings, so we should expect something quite different. The overall arrangement of the place is, in fact, clearer in their pictures that center on the Camembert (Pls. 211, 212) than in Yon's print, for they separate the tiny island, its two footbridges, and one of the floating buildings. Their figures, however, are less distinct. Beyond the left footbridge in each painting we see the abbreviated shoulders and heads of swimmers, who share space with the river's broken surface. Were it not for the image of the safety rope in Yon's print, we could not have interpreted correctly the smudges that form the vertical post and swaying rope just beyond the bathers.

Renoir was more of a figure painter, less of a landscapist, than Monet, and he renders the crowd on the Camembert

213

with greater complexity of pose and costume. Despite the sketchy technique, we see the play of light and dark over individual figures, more details of clothing and gesture, and a more artful staging of the group in three dimensions. Monet depended instead on the flat silhouettes of his figures, whom he lines up across the island with little overlapping. Because he was clever at this—the two bathers conversing on the left are quite wittily conceived—we quickly gain an idea of this mix of seated and standing vacationers. Renoir requires more time from us, although we are rewarded with more variety.

Other features of the two pictures confirm the differences between the artists. Renoir fills his canvas with more incident: sailboats on the left, several rowboats beyond the footbridge on the right, a more conspicuous poster on the boathouse, more fully modeled (if still summary) foliage on the far shore, and more prominent willow foliage dropping down from overhead. The latter, mixing with the bunched figures, is a key to the tapestry-like arrangement that emphasizes a busy surface pattern. Monet hollows out a deeper space by placing the Camembert higher up on the surface so as to give a greater expanse of water, in turn more easily read because fewer elements interrupt its sweep. He points the boats toward the center, and also aims the boathouse and the left footbridge inward. Since, additionally, the dangling foliage in the upper-left corner responds roughly to the roof of the boathouse, the whole composition is rather symmetrical, and the elements around the edges create a tunnel for the Camembert (a framework used in the previous generation by Théodore Rousseau and J. M. W. Turner).

At the Grenouillère, both artists were in the midst of finding techniques that would convey an ostensible naturalness of vision. They had to develop new means to communicate what they sought: the effects of spontaneous vision, one that would appear to be unmediated by prior, arbitrary conventions, although, in fact, it was just as arbitrary, since there is no such thing as a simple imitation of what one sees. They accomplished this convincingly by the mid-1870s, but already here in 1869 they were using several new devices. These would not have seemed "natural" to most contemporaries, since naturalness is a function of familiar artistic conventions, but they were creating a new pictorial language that would eventually supplant earlier ones. Because they were producing sketches, they were less inhibited by established ideas about well-formulated pictures. Both used rather large, separate brushstrokes that could not model forms with the subtlety of traditional means, so the strokes took on different roles.[23] By their directions they molded the images they described, and by their hues they differentiated forms as much by color as by alterations of light and dark. The strokes on the boats, for example, follow the directions of the boards that form them; those on the water are mostly horizontals with suitable dips and sways; those on women's costumes coincide with the massing and disposition of the cloth.

Form-creating brushwork was not by itself new, nor was the use of rather large brushstrokes. Corot, Daubigny, Courbet, and Jongkind all laid in color with visibly separate touches. The difference is that their strokes were usually of closely related color and degree of light and dark, so that from a slight distance a given area or image tends to cohere. Monet

and Renoir used more colors and often more saturated tints (including some of the new, industrially derived pigments), so from the same viewing distance, the separateness of their touches remains evident. (Jongkind, by the mid-1860s, had already moved in this direction, but his dabs and streaks were of finer grain and were embedded in a more traditional structure of spatial illusion.)

A careful look at Monet's and Renoir's paintings will convince a skeptic that their brushwork was indeed based upon close observation and was not mere slapdash. In the group to the right of Renoir's Camembert—one is tempted to say "despite," but, in fact, *because* of the gestural application, we can see that the bearded man has his hat at a jaunty angle, and stands with his hands behind his back (Pl. 194). His grey trousers are rendered with vertical strokes that veer off at the knee to show the relaxed lower limb. To indicate sunlight on the upper leg, Renoir painted "wet" by dragging some yellow and dull red along with the blueish grey. A brighter patch of yellow at the man's feet shows the same pool of light coming down from a break in the foliage above. To his right, the striped costume of the woman behind him appears as slanted streaks of white and brick red. By contrast, the woman on the footbridge just above has shorter curved and dabbed strokes that model a different kind of dress; the lower portion is touched with pale pink where the sunlight strikes it. In the V-shaped area (about 3½ inches high) between this woman and the bearded man, the water is captured in undulating horizontals that shift from greenish blue to mixed golden tones near the far shore, a form of color perspective that employs separate strokes of blue, white, blueish white, greyish blue, green, green-blue, yellow, yellow-green, orange, and pink, several of these partly blended.

The broken strokes in the right foreground of Monet's painting may be the most remarkable of these innovations of 1869 that resulted from concentrated staring at effects of light (Pl. 213). They form saucer-like hollows in three tones, dark-greenish black, medium-greenish brown, and blueish white. The darkest streaks indicate the farther slopes of the hollows, those that face towards us and that reflect the dense shadows of foliage over our heads. The olive tones are in the bottoms of the dips and reflect the foliage of the opposite shore. The whites mark the near edges of the hollows, those that bend away from us, so that sunlight bounces at an angle into our eyes. The environing blue, of course, embraces the areas that reflect the sky more flatly.

That the two artists collaborated very closely seems certain from the nearly identical motifs that they treated in pairs, first the pictures of the Camembert, then—to judge by the greater assurance with which they handled their improvisations—the two views along the shore (Pls. 214, 215). Collaboration meant sharpening their differences as well as exchanging ideas, and from our familiarity with Impressionism, we can easily see through the shared style to the features that distinguish them. Many of the same disparities are visible in this second pair. Renoir used a wider spectrum of color than Monet, applied with smaller brushes; he gave his figures more varied and complicated poses, although he treated their costumes more summarily than in the first painting. Monet's picture has fewer colors, and is dominated on the right by whites and

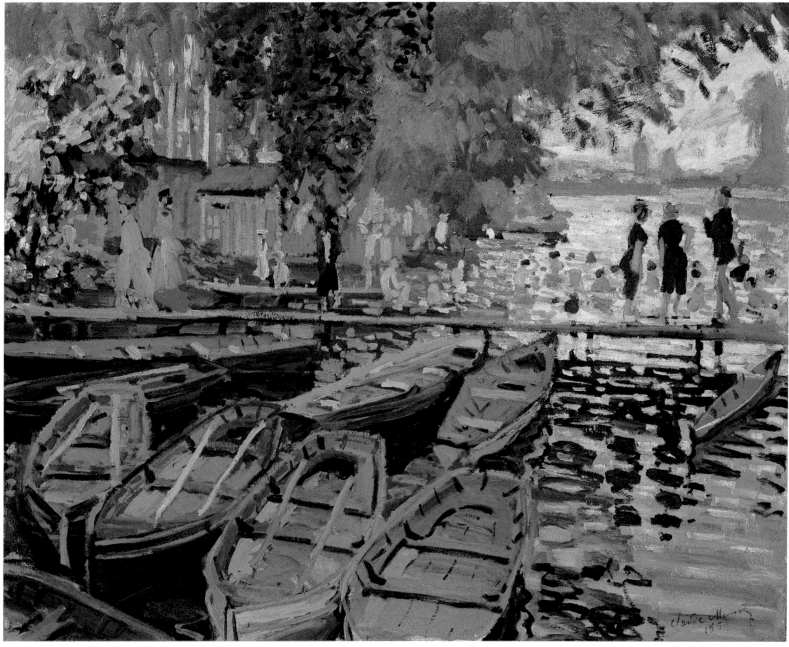

214. Monet, *Bathing at la Grenouillère*, 1869. London, National Gallery.

blues, elsewhere by greens and blues, relieved by touches of red. His penchant for striking surface geometry appears in the stark horizontal of the footbridge which not only divides the canvas into two halves, but almost darts off the right edge, restrained there by the skiff which touches its end, and by the leftward facing man. He and the two bathers (borrowed from the other picture) loom up in silhouettes against the glaring water, their flatness punctuated at regular intervals by the spots of dark hair that crown the heads of the swimmers. Monet's flotilla of rental boats is the most astonishing feature of his composition (Pl. 217). Renoir's boats take on the more discreet role of edging our eye back along the shore, but Monet's, jammed together, activate the foreground with assertive flair. He makes them cut back sharply into depth, but he terminates the group on the right so as to leave a rectangle of water that flattens out. This tension between depth and surface is repeated in each of the foreground boats, because our high vantage point, combined with Monet's broad bands of paint, makes them float up on the canvas despite their strong angles.[24] (It is the same order of tension that later characterizes Degas's compositions.)

The Grenouillère pictures assumed pivotal roles in the development of Monet's and Renoir's Impressionism. For Monet, the lively setting seems to have inspired more daring paintings than his first work of his season there, *The Seine at Bougival, Evening* (Pl. 205), a stock landscape brought partly up-to-date. In some ways his bathing scenes go back to his *Déjeuner sur l'herbe* of 1865 (Pl. 178), but an appreciation of Parisian life has intervened, and the social activity at the Grenouillère was not the stiff affair of the earlier project. There was an intermediate work, *The Boat Landing* (Pl. 216), done earlier in 1869 or even the year before.[25] In the Cézanne-

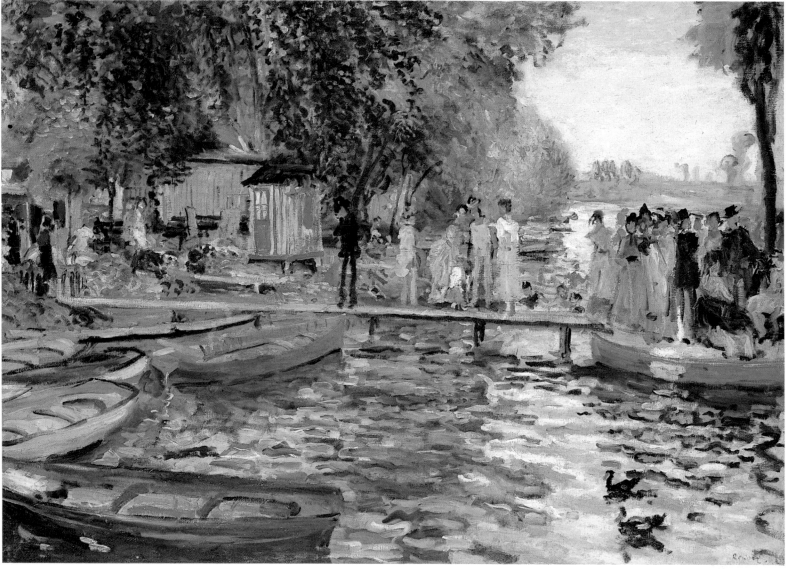

215. Renoir, *La Grenouillère*, 1869. Winterthur, Oskar Reinhart Collection.

like awkwardness of the figures in this picture we sense that the posiness of the *Déjeuner* has not yet been overcome by the more contemporary subject. Compared to the Bougival paintings, it has a lower horizon line, a less scintillating palette, and a humdrum, bourgeois aspect. The plunge into the active, less restrained society of the Grenouillère brought out a more saucy challenge to tradition. This brashness was toned down that autumn, when he turned to *The Bridge at Bougival* (Pl. 207), not a sketch, but a more finished painting whose color is relatively muted and whose brushwork is more integrated. The lessons of the Grenouillère canvases were nonetheless vital to Monet, as he was subsequently to demonstrate in pictures done in Holland in 1871 and in Argenteuil the following year.

Much the same can be said about the place of Renoir's Grenouillère paintings in his development. Before 1869, most of his canvases of men and women out of doors were essays in the monumental figure, clothed and unclothed. More fully contemporary in subject were his paintings of Parisians and visitors in the gala year 1867 (Pls. 8, 9), and his skating picture of 1868 (Pl. 147). The latter is a precedent for the Bougival

216. Monet, *The Boat Landing*, c. 1868–69. Mr. J. Ortiz-Patino.

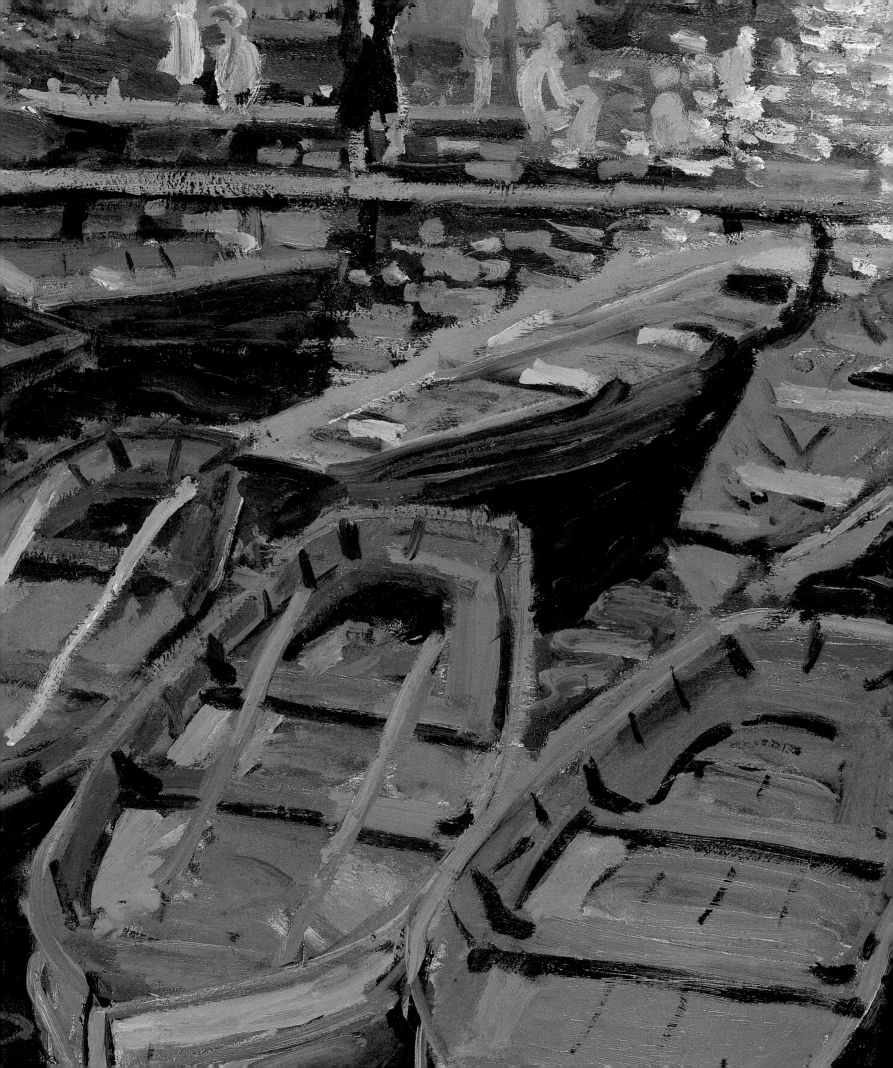

compositions both in the informality and inventiveness of the sketch and in its subject, a wintertime parallel to his bathing crowds. Even if we allow for the change to a more strongly colored summertime scene, however, the Grenouillère paintings mark a large step in the direction of heightened chroma and rough-grained brushwork. He never forsook ambitious figure paintings of a more traditional kind (he showed his *Bather with Griffon* in the Salon of 1870), but the Bougival sketches were an intensive colloquy with contemporary life that invigorated his art. The nude bathers that preoccupied him all his life were a way of claiming traditional subjects for modern art, by investing them with a sense of palpable air and colored light. The swimmers and the costumed crowd on the Camembert, the reflections of sky, foliage, and people in the water, the garishly colored boats and the slender footbridges—all these features, combined with sunlight, air, and water, those insubstantial but vital realities, inspired in Renoir, as in Monet, a lively inventiveness that pushed his art towards the fluttering, polychrome surfaces of the mid-1870s.

The modernity of Monet's and Renoir's paintings of bathing at Bougival did not quite cover over all allusions to the past, although they are more latent than manifest. For the painters, as for the swimmers, to go out to Bougival was to claim a right to a modern-day Isle of Cythera, to the same riverbanks that the upper class had enjoyed in the eighteenth century. The pictures of 1869 were further steps in the artists' adaptation of the present to the continuity of social life and of picture-making embraced in the *fête galante* and the *déjeuner sur l'herbe*. Contemporary writers used the phrases "picturesque" and "historic memories" to describe Bougival, and we now see that the same terms can be applied to Monet and Renoir. There is, after all, a connection with Watteau (Pl. 137), and with Corot, Français, and other intermediaries who garnished Souvent's inn at Bougival with evocations of the eighteenth century.

These remarks fairly characterize the internal evolution of Renoir's and Monet's art, although their contemporaries had little awareness of it.[26] Monet exhibited one of his Grenouillère

218. Monet, *Train in the Countryside*, c. 1872. Musée d'Orsay.

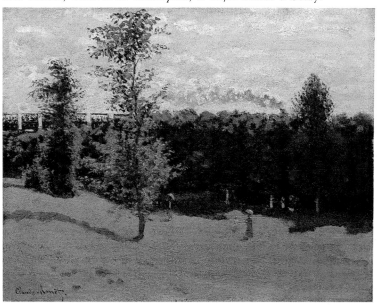

217. Monet, detail of *Bathing at La Grenouillère* (Pl. 214).

pictures seven years later, in 1876 (probably the lost painting formerly in the Arnhold collection), and another in 1889 (Pl. 214); Renoir seems not to have shown his at all. Only at the turn of the century, a whole generation after they were painted, did more frequent reproduction and exhibition let them enter the active arena of the history of art. The work of Matisse, Derain, Vlaminck, and other Fauves, stimulated by the impressionists and founded also on themes of leisure and hedonism (Derain and Vlaminck painted at Chatou), eventually made the Grenouillère paintings appear to be more complete pictorial statements than Monet and Renoir had intended. Then we, in our turn, later in the present century, have so prized spontaneity and daring, that we have elevated the Grenouillère compositions to a high place in the canons of early modern art. Bathing, boating, and dining-out in the "country" are among our desires, escape from urban cares is our yearning, bright colors and sensual movement are our solace and our stimulation. These are all explanations for the fame of Renoir's and Monet's sketches of the Grenouillère.

Artists' Trains and Bridges

The paintings at the Grenouillère marked short-lived episodes in the careers of Renoir and Monet. Like the holiday-makers they painted, they were transients at Bougival, although, unlike the other visitors, they were working on their own kind of suburban produce, with their city market in mind. At Bougival, as elsewhere in the region, the continuity of their vision was provided by Parisian culture: they took Paris with them, wherever they went. This is true also of Pissarro and Sisley, despite the fact that after 1870 they settled in villages near Paris for longer periods. In the work of these two artists, even so, the signs of the visitor are prominent. They were especially fond of the roadways that led into or out of villages, and of towpaths and embankments, the axes of movement along the river.

After the turbulent period of the Franco-Prussian War and the Commune, the lives of the impressionists settled into similar patterns. Like many well-to-do Parisians, they spent most of their summers in nearby villages, or at sea resorts. The Manets owned property in Gennevilliers, Caillebotte at Petit-Gennevilliers, the Cassatt family, by 1880, at Marly; Morisot frequently summered at her sister's, in Maurecourt. In the 1870s, Monet had brief periods of residence in the city, but lived in villages along the river: Argenteuil from 1872 to 1878, then at Vétheuil. He was constantly back and forth to Paris, where his major painting campaign, appropriately enough, centered on the Gare Saint-Lazare (see Chapter One).

Train in the Countryside (Pl. 218) is the first canvas, as far as we know, on which Monet placed a train. Its connection with leisure is clear, for in the foreground is a park.[27] Along a raised embankment steams a train with its double-decker cars, the upper part open on the sides for the hardy travelers who braved cinders and weather to take advantage of the elevated position and cheaper seats. Monet's horizontals and verticals, cushioned by the gentle undulations of foliage, smoke, and shadows, commemorate the integration of the railway with the well-tended landscape of the Parisian perimeter. The train moves behind a thick screen of foliage, a harmonious alliance

because Monet minimized the train's mass and integrated it with the horizontal run of his foliage. In the foreground is a public park where seven strollers have sought the shade, while in the open, a lone man protects himself from the summer sun with a parasol (Pl. 219). Nearby stands a woman, also with parasol, and a child. The three sunlit figures are standing stock still, facing us. Whatever the origins of Monet's idea (perhaps similar figures stared at him as he painted?), the curious result is to make *us* feel like train travelers looking out upon a passing scene. We are viewers being viewed, and since the train passengers are over there in the distance, the whole picture from front to back seems to be about the pleasures of sightseeing in what the French would call "nature."

About a year later, after he had settled in Argenteuil, Monet again painted a train (Pl. 220). This time he minimized foliage, and exposed the impressive railway bridge, which sweeps in dramatically from the left edge. Instead of a rolling lawn, the foreground consists of a homely pathway. Two boats are under sail, and the day is sunny and calm, yet we have the impression that Monet is not so much celebrating leisure as asking us to marvel at a wonder of modern engineering. Painters of the previous generation would not have shared his enthusiasm. Corot and Daubigny, from whom Monet learned so much, would never have painted this bridge, because for them it would have been an obtrusive sign of the encroachment of Paris on the countryside. They used the railroad to go back and forth to the suburbs, but they painted older bridges precisely to distance themselves from the city. In his *Bridge at Mantes* (Pl. 221), Corot chose a structure that was admirable because it was centuries old, and had resisted progress. His view is mediated by the swaying tree trunks and the grassy slope, in contrast to Monet's urbanized foreground. The only activity on the river is the pirogue of the local boatman, although the pollarded tree trunk and, of course, the bridge, speak for the ways in which humans have bent the riverbanks to their uses. It is not untouched nature that Corot presents, but a pastoral image intended to remove us from present time.

We do not see Monet's bridge by looking through tree trunks, but abruptly, directly. Instead of a restful slope, there is a scruffy pathway in the foreground, and along its edge, a retaining barrier that makes so little concession to traditional railings that it looks to us like a modern highway buffer. Monet used this piece of utilitarian design to help speed the eye along the near shore, and this makes all the more dramatic the opposing thrust of the bridge. The more comforting arches of older spans have been displaced by a linear structure which was built in units on the ground, then hoisted into place atop the impost blocks that surmount the piers. The bridge hurtles in from the left edge and cuts sharply across the canvas in a way that would have been anathema to Corot. He introduced his bridge on the left edge of his canvas with a zone of shadow and reflection that weds it to the water, and he made the Y-shaped tree join the sides of the bridge's first arch and mimic the pier of the second bridge, just beyond.

In all art that is capable of moving us, structure interprets subject. Monet's painting is a homage to the railway not just because it represents a new bridge, but because its composition has the framework of modern engineering. The opposing lines of the embankment barrier and the bridge are snapped as tightly as the chalked lines of a builder (Pl. 225). From the two men our eye passes to the nearby sailboat, then to the second set of piers, and on to the other sailboat, an oblique line that penetrates space at a sharper angle than that of the bridge. The alternating light and dark of the men's clothing is repeated in the piers of the bridge and in the two sailboats, a rhythmic contrast that aids the march of our eye off to the right. The two men are at the nexus of a whole network of crisscrossing diagonals. They stand on the axis of the shoreline, an angle which their shadows accentuate. Their heads *just touch* the other shoreline, which is another of the slanting lines of this cat's cradle design. As though there were invisible strings in their hands, they take position within the lines of the composition, lines whose arbitrariness is the embodiment of modernity. This is because those lines are actions that embrace humankind's ability to surmount nature, to span her chasms and waterways, to impose unnatural patterns upon her for their own purposes. Their modernity resides in their very "unnaturalness," now made the servant of a new naturalism.

The bridge in Monet's picture was only about two years old, rebuilt after its demolition during the Franco-Prussian War. The nearby highway bridge had also been destroyed and rebuilt, and Monet painted it many times from 1872 to 1874 (Pl. 244). Consciously so or not, his renderings of the bridges are symptomatic of the mood of post-war reconstruction and the rebuilding of France's wounded pride.[28] Pissarro and Sisley, in the same years, painted bridges and commercial activity along the waterways near Paris, as did their contemporaries Adolphe Hervier, Stanislas Lépine, and Armand Guillaumin. Taken together, these paintings interpret a mood of secular optimism that had had little counterpart before 1870, when such subjects were rarely found in these artists' work. Monet's two men, looking out over the water, are like the men pictured in nineteenth-century books devoted to the marvels of modern construction, figures that stand both for the builders (they are men, not women) and for the ordinary mortals called upon to witness promethean triumphs of industry. The illustrations in railway guides (Pl. 222) often show a bridge chopped off at both sides to heighten the sense of its leaping across the river (and the page!). This homely severity was allowable in graphic arts, but not in painting. Monet need not have been "influenced" by these illustrations, but they are closer to him than the Japanese prints so often touted by art historians. Like Degas and Manet, he turned his back on many of the rules of the fine arts, and adopted some of the formulations of journalistic illustration because of a common devotion to contemporary life.

Argenteuil was an appropriate choice for Monet's exploration of modernity. Only nine kilometers from Paris, it was a bustling town with substantial industry, and also a beneficiary of the Parisians' thirst for leisure. The iron bridge that Monet painted was made at a large iron works only a few hundred yards away, and his boats were among many moored at Argenteuil, the center of yachting in the Paris region. The constant coming and going between the town and Paris is signaled by the two trains on the bridge. One heads to the left, coasting into the station that is only one street from the river's edge; the other, having just quit the station, is picking up speed and therefore belching smoke as it heads towards the

219. Monet, detail of *Train in the Countryside* (Pl. 218).

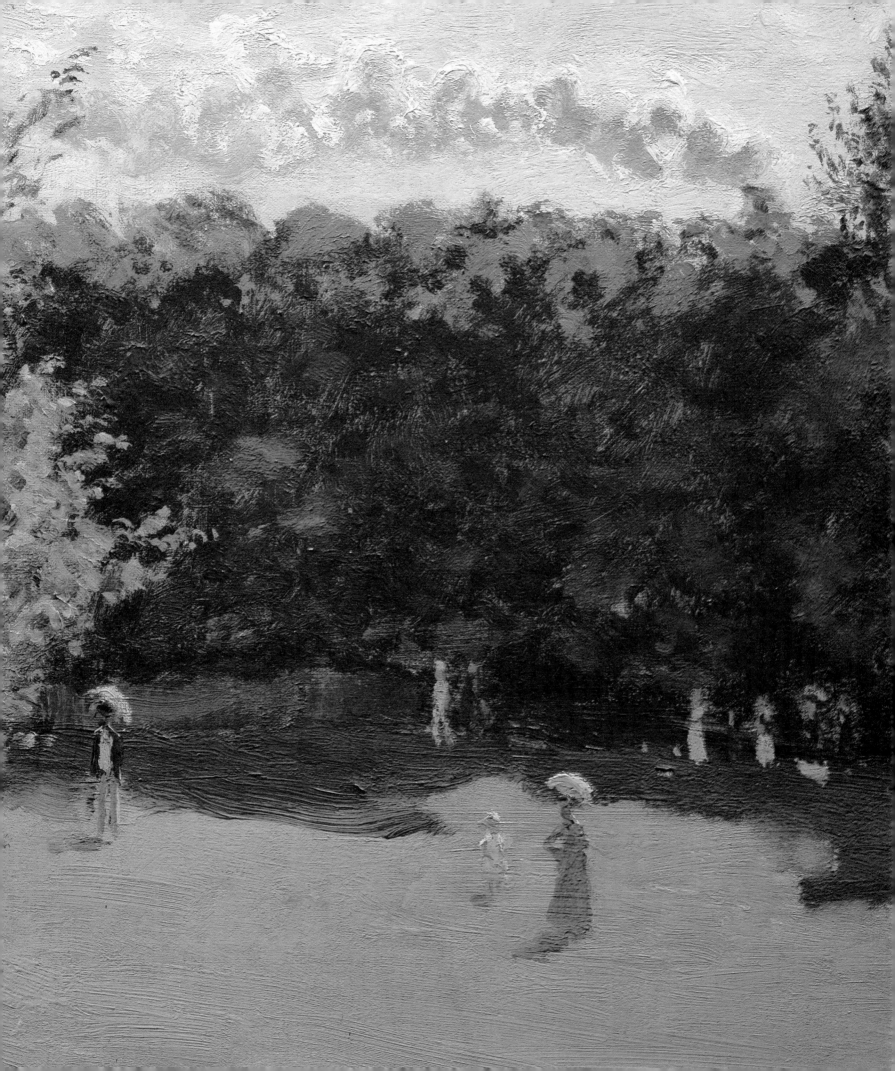

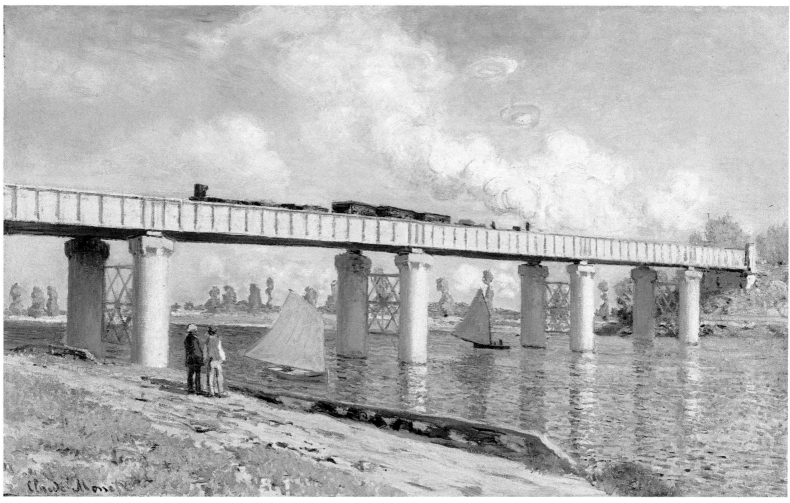

220. Monet, *The Railroad Bridge, Argenteuil*, 1873. Private collection.

capital. Above, the windblown smoke and the clouds form a canopy of blues and pinkish-whites that help relieve the starkness of the bridge. The wind that blows the smoke upriver also propels the sailboats and they, too, alleviate the severity of the bridge. The near boat beats upwind while the other runs in front of the strong breeze. They move in opposite directions, as do the two trains, and their paths cross under the span, caught there along the artist's organizing diagonal.

The parallel harmonies of city and country, and of work and leisure, are symbolized in the smoke and the clouds, a peaceful blending of man-made and natural vapors. "Peaceful" to us, we should add, from our vantage point in the twentieth century, but Monet's art was still too daring an embrace of modernity for most of his contemporaries. Industrial subjects were not considered proper for "fine art," particularly in images of the countryside. Barbizon art, only then coming into general acceptance, had reinforced the traditional association of rural villages with the unchanging past. Monet did have predecessors, however. In the previous generation, the Saint-Simonians had preached the virtues of industry, especially of transport: canals, steamships, and railways. One of Pierre de Lachambeaudie's utopian poems, "Smoke of Altar and Smoke of Forge" (Pl. 223) admonishes those who believe that only the fumes of incense should rise in the sky. Factory smoke has the same right. "Mix together fraternally," says God, "For work is equal to prayer." Transport had a special attraction for the Saint-Simonians because, by linking remote areas with modern centers, it helped overcome ignorance and isolation, and it led towards universal social harmony. "Steam accomplishes these poetic dreams," reads another Lachambeaudie poem, in which he also attacks the romantics, mired in their private agonies, who would fight industrial progress:

> Poet, may your lute call truce to pain;
> Truth will soon supplant the dream,
> And reality will be marveled at.[29]

In the Second Empire and Third Republic, former Saint-Simonians like the engineers Eugène Flachat (designer of the Gare Saint-Lazare's train sheds) and Prosper Enfantin were foremost in railroad contruction, so what was once a radical credo became absorbed into the working philosophy of advanced capitalism. Earlier, the Pereire brothers, also Saint-Simonians, had had the foresight to join industry and leisure when they opened their rail line to Saint-Germain, and we saw that subsequently the railroads emphasized leisure, tourism, and the pleasures of nature, in order to win customers and parry the opposition to their march across the countryside. Monet's *Railroad Bridge at Argenteuil* therefore aligned him with the progressive elements of the middle class, although it

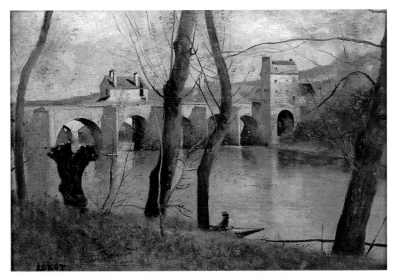

221. Corot, *The Bridge at Mantes*, c. 1868–70. Musée du Louvre.

would require two decades or more before the rest of the bourgeoisie applauded his paintings.

Monet's painting of the bridge did not mean a wholesale adoption of the industry which was then rapidly expanding at Argenteuil. By comparison with Corot or Daubigny, who could not bring themselves to paint railroads, Monet seems like a spokesman for the changes affecting the once-rural villages along the Seine. However, there is abundant evidence that at Argenteuil he screened out much of local industry. He showed factories only at a considerable distance, with very few exceptions, or else he avoided them entirely. The examination of another bridge picture will reveal why his reconciliation of nature and railroad is a surprisingly complicated issue.

For *The Railroad Bridge at Argenteuil* [from upstream] (Pl, 224), done a year later, Monet moved upstream along the same bank, going under the bridge to arrive on its other side. Our point of view is part way up the slope of foliage-covered

earth which supports the tracks above; below us, unseen beyond the makeshift fence, is the pathway at river level. The more we compare the two pictures, the more we realize how unalike they are. In the later picture the bridge darts drama-

223. *Smoke of Altar and Smoke of Forge*, from Lachambeaudie, *Fables*, 1855.

224. Monet, *The Railroad Bridge at Argenteuil*, 1874. Philadelphia Museum of Art.

222. *The Railroad Bridge at Bezons*, 1855.

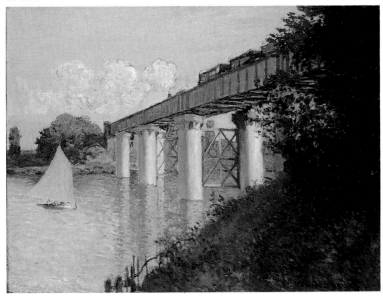

225 (following pages). Monet, detail of *The Railroad Bridge, Argenteuil* (Pl. 220).

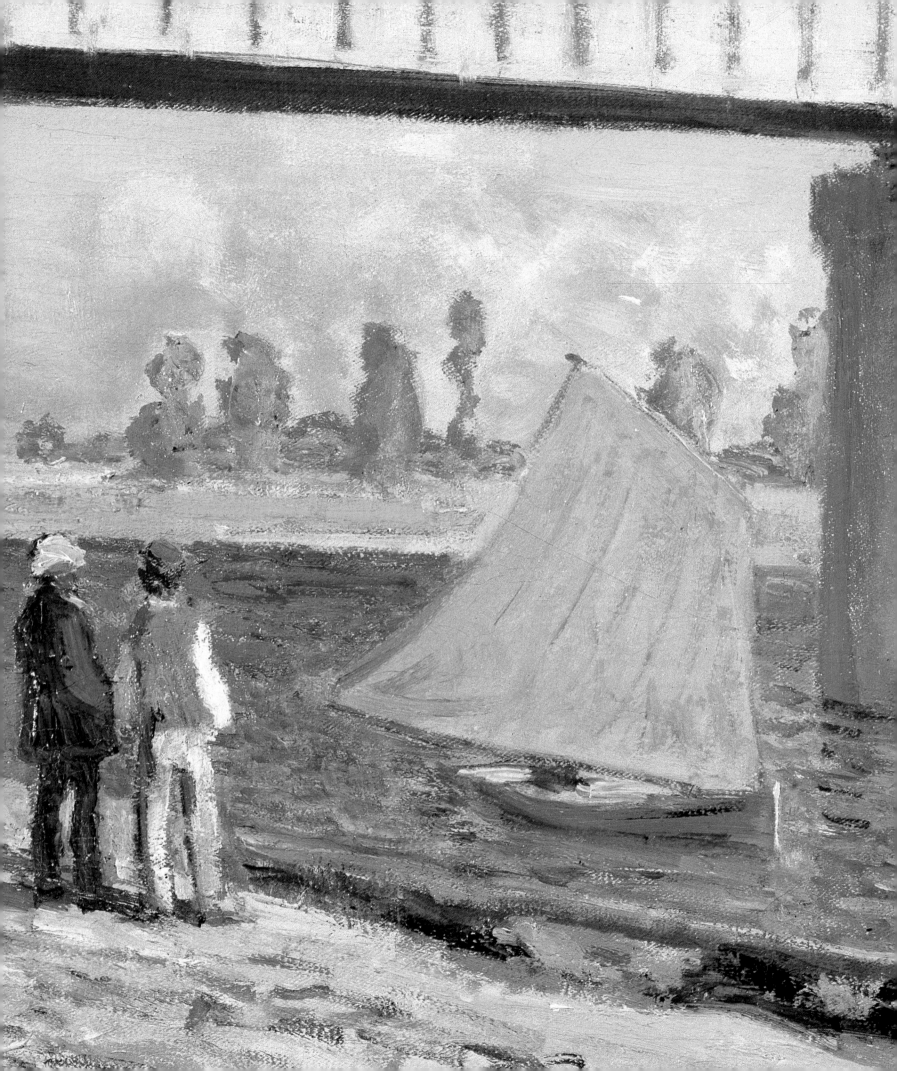

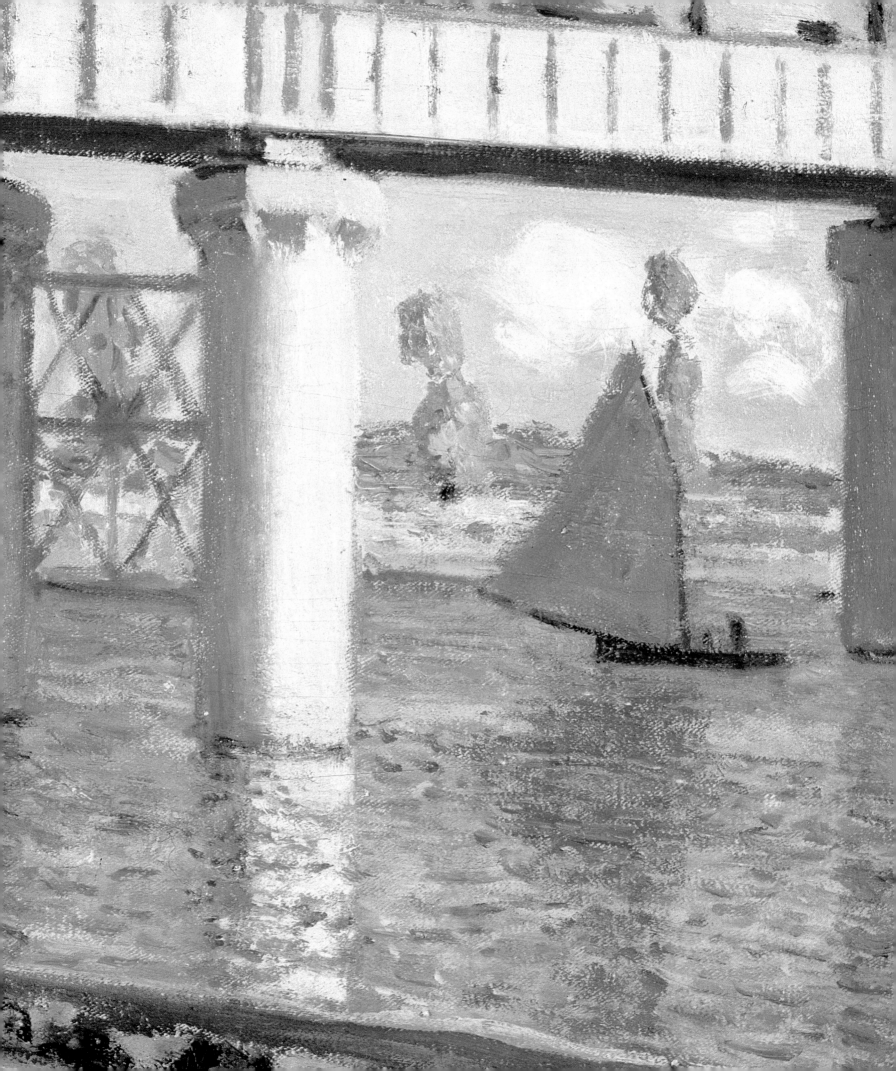

tically back into space to give us a sense of the movement of the train, but here the mound of foliage cushions the juncture with the picture's edge (which, anyway, is not the left edge where our eye enters). We are on a verdant bank, no longer on the barren riverside of the earlier work, and so our associations are with the colorful natural growth here and on the shore opposite. This goes some way towards integrating the bridge with its setting, instead of emphasizing its separation.

Natural forms, in other words, are arranged by the artist so as to frame his dynamic bridge and train. There is simply much more greenery here than in the other painting, and a much stronger palette that creates the impression of a strong, natural light. The sun seems almost visible in the yellows of the piers and the smoke, and the oranges of the far shore contrast strongly with the blues of the water. The sailboat is tacking against the wind, which must be fairly strong because it pushes the train's smoke sideways. By stressing that sun, wind, and sailboat are all going along the axis of the river, at right angles to the bridge, Monet reinforced the symbolic confrontation of the boat, symbol of leisure, with the train. (It was a very deliberate choice, for a variant of this composition, and a small study of the same site, show no boat at all.) Together the boat and the railroad stand for the modern suburb which has relinquished its agricultural role to the pressures of industry and of urban leisure. Both boat and railroad represent the new forces that were radically altering Argenteuil, forces that disrupted traditional life in this river village, creating wholesale changes in the use of the river and its embankment.

Artists must distill their pictorial ideas so as to make striking statements, and Monet eliminated a great deal in order to concentrate on the harmonic opposition of boat and train. Were we able to stand where Monet places us in the later picture, we should realize how artful his choice of view was. Behind us and to our left were several large factories, and along the shore immediately to our left were industrial loading

docks and warehouses. Argenteuil was a major river port, but Monet uniformly avoided the industrial uses of the river there. He did paint several views of the industrial banks of the Seine, near Rouen and near Asnières, but at Argenteuil the images that expressed the town and its relationship to Paris were the train, as it charged over his head, and the opposed, calm movement of the sailboat. They stood for the reconciliation of city and country, of industry and leisure, of railroad and river, of metal and foliage, of industrial steam and natural wind. Steam and wind are forces that move things, and motion is the essence of change.

It is Monet's willingness to accept change, even to glorify it, that distinguishes him from Renoir, Sisley, and Pissarro. This is not a measure of superiority, but simply a characteristic of his art. One could well argue, for example, that Pissarro's *Railroad Bridge at Pontoise* (Pl. 226), painted about 1873, is just as beautiful, just as great a painting, as either of the Monets. It shows a similar railroad bridge cutting across the Oise river. At the right end of the span, barely noticeable, a locomotive sends up a plume of smoke. The contrast with the two Monets is obvious. Not only has Pissarro chosen a morning of glassy calm that eliminates all movement, he has also put the bridge in mid-distance to integrate it with the site. It runs parallel to the surface, not at a dynamic angle, and it is partly screened by a tree as well as joined to the village at both ends. The change represented by the bridge is minimized, although we recognize its modernity in the straight lines it superimposes over the picturesque old town.

It might be objected that Monet frequently painted Argenteuil's highway bridge from a similar distance (Pl. 233), and therefore that the comparison is flawed. However, a road bridge (moreover, of an earlier design) does not at all have the same symbolic meaning, and Monet invariably showed pleasure boats nearby. Pissarro never made dynamic, close-up views of a railroad bridge, nor did he paint sailboats or skiffs. He painted other views of Pontoise and its railroad bridge, some of them showing a puffing train, but they are kept at a distance and their activity is subordinated to the townscape. Monet's pairing of pleasure boat and train is the kind of concentrated symbolism of modernity that the older artist avoided.

Monet's railroad bridges can also be distinguished from Sisley's paintings along the Seine. More than Monet, Sisley painted scenes of artisanal and industrial work along the canals and rivers near Paris: barges at anchor, the loading or unloading of produce, boats under repair, men dredging sand. Although he occasionally painted pleasure boats, he avoided the symbolic juxtaposition of industry and leisure that marked Monet's pictures. He was drawn principally to the ordinary preoccupations of local people and the boatmen along the river. They are regularly shown in small scale, so that their activity characterizes the riverscape to which, nonetheless, they concede the dominant interest.

In *The Bridge at Villeneuve-la-Garenne* of 1872 (Pls. 227, 228), one of his finest canvases, Sisley gives us a portrait of this bridge and river village upstream from Argenteuil, closer to Paris. The highway bridge slices into the picture with justifiable drama. Road bridges lacked the theatricality of the railway, but they often had a remarkable effect on small

226. Pissarro, *The Railroad Bridge at Pontoise*, c. 1873. Private collection.

227. Sisley, *The Bridge at Villeneuve-la-Garenne*, 1872. Metropolitan Museum.

towns. A rail bridge serves long-distance interests more than local residents, and its tracks, being dangerous, are blocked off from adjacent streets. A highway bridge serves villagers as much as travelers, and its approaches are accessible. Opened in 1844, the Villeneuve bridge joined Saint-Denis to the village, ending its relative isolation.[30] By rail or horse-drawn bus, one could go north from Paris to Saint-Denis, a matter of only seven kilometers, and cross the bridge (which rested on the island of Saint-Denis) to Villeneuve. The satellite community of Saint-Denis benefited from access to the village, one of several examples of a suburb within the suburbs. Parisians, however, also went to Villeneuve for day trips and vacations, and many built villas near there. At the same time, Villeneuve was a river port for Gennevilliers, the village in the center of the bulge of land circumscribed by the northern loop of the Seine, as it bends around to Argenteuil. Manet's family was among those who owned land and a home at Gennevilliers,

and Berthe Morisot spent the summer of 1875 nearby. She also painted Villeneuve (Pl. 229), a buttery sketch that emphasizes boats more than the span across the river, although she stresses the structure's thin, hovering quality and thereby reveals it as a suspension bridge.[31]

Sisley's Villeneuve picture is all idleness—or nearly so. It is an idyllic summer day, only a year after the violent end of the Commune in Paris. A local boatman is under the bridge, with two vacationing women as passengers: one person's leisure is another's work. The boatman might not be a Villeneuve resident, for boat-rental agencies were dotted all along the river, but his mariner's costume, in proximity to the moored boats, suggests that he was stationed at the bridge. Under its shadow is a pair of visitors, the man in shirtsleeves, the woman retaining her hat. To their right, part way up the bank, stand two women in the plain clothing of villagers. All the figures are along the bridge's axis, and nearly everything

227

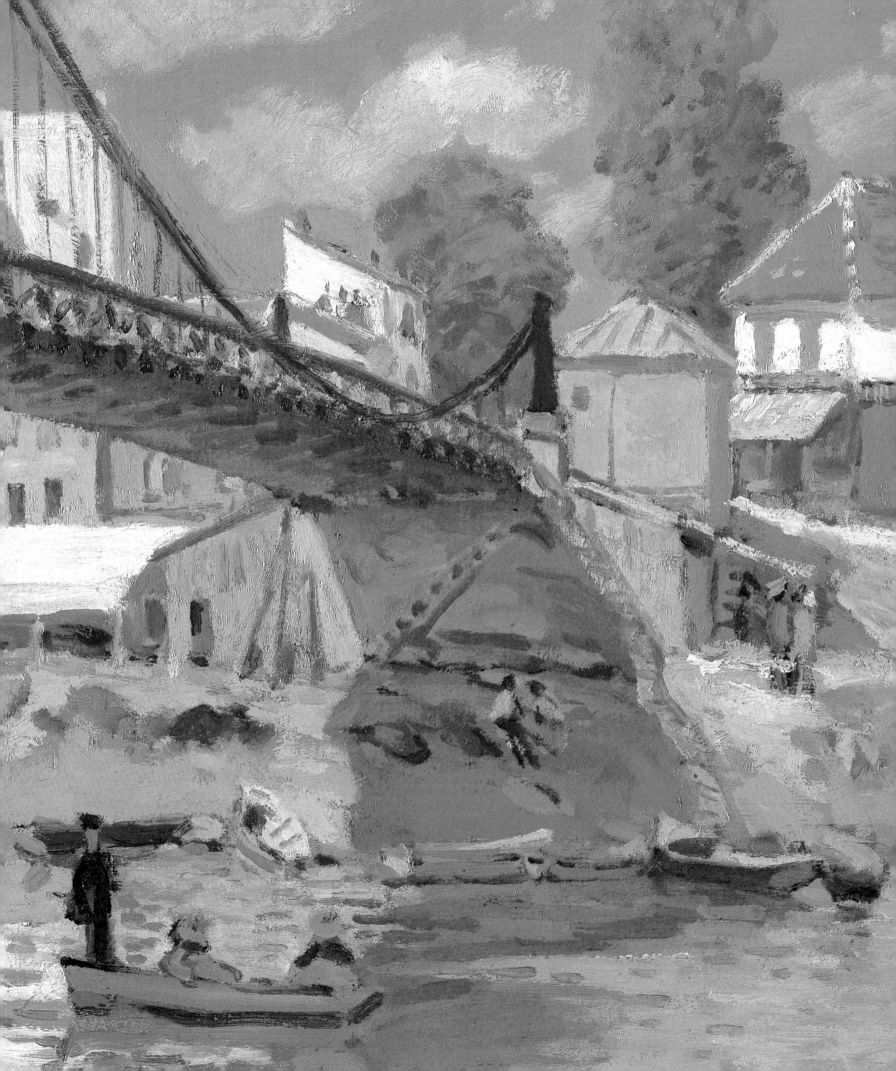

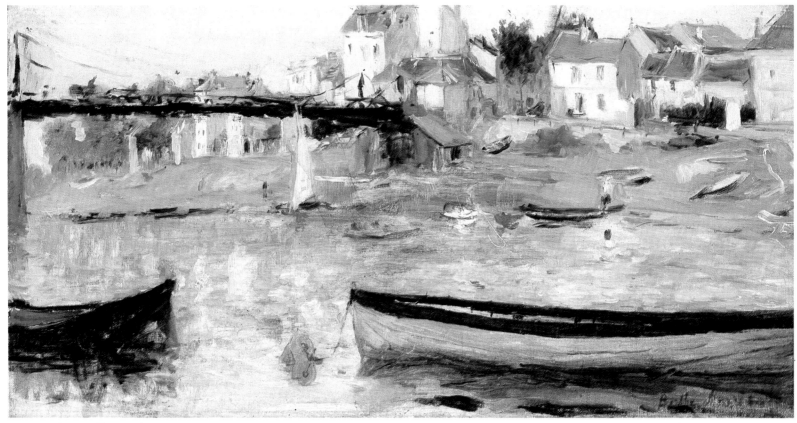

229. Morisot, *Villeneuve-la-Garenne*, 1875. Collection unknown.

else reflects its role. The olive-green color of its shadow on the water is found in the horizontal dabs on the water and on the embankment they reflect. The main shadow frames the seated couple, and the simulacrum of the sun-pierced railing runs skittishly down to the water. Above, the grey tollhouse partly blocks our view and makes more gentle the rush of the bridge into the village. The large building to the right, more than once added to, probably acquired its odd corner structure when the bridge road was cut through. Its pink awning proclaims it a store, and the green swatch (either painted boards or a tarpaulin) apparently shelters the interior from the sun; the same green patch shows in Morisot's painting.

It is these many touches of local life that distinguish Sisley's conception from Monet's view of the railroad span at Argenteuil from upsteam (Pl. 224). Monet's bridge is headed towards Paris, not into the town, and only one sailboat is there to characterize local activity. In his picture we are looking away from the village towards the two principal agents of its transformation. In Sisley's, we see a public bridge and holiday-makers, but they invite us into the village, there to contemplate many features of its relation to the bridge. There is no comparable painting in Monet's oeuvre. His highway bridge (Pl. 244) runs towards Argenteuil, but we see screens of foliage, or angled views downsteam or upstream, not the village. Moreover, Monet's paintings of the bridges have an order of distilled geometry and concentrated symbolism (the two cannot be separated) that is quite foreign to Sisley.

Like Pissarro, Sisley can make us feel that he lived among his villagers along the Seine. He succeeded more than Monet

in displacing himself from Paris and in creating an environment of harmony: one ideal of the seeker-after-leisure. Monet was always the visitor who treated suburban villages like so many outdoor studios, seldom penetrated by local life, except for its artifacts. Perhaps this is why his painting of sailboat and bridge (Pl. 224) looks less like Sisley's Villeneuve, and more like this own view, four years later, of the tracks of the Gare Saint-Lazare, looking up at the Pont de l'Europe (Pl. 28).

Sailing at Argenteuil

Argenteuil, about four miles downriver from Villeneuve, was so closely identified with Monet that it derived much of its subsequent renown from his pictures. (Painters have often performed this role for French villages: Millet and Rousseau for Barbizon, Daubigny and Van Gogh for Auvers, Gauguin for Pont-Aven.) He had settled there at the end of 1871, not long after his return from a *Wanderjahr* that had taken him to England, to avoid the Franco-Prussian War, and then to Holland, where he sat out the Commune and its aftermath. The paintings of the railroad bridge at Argenteuil that we have already looked at were not, in fact, typical of his lengthy campaign there, devoted mostly to his garden, village streets, nearby fields, boats on the river, and the banks of the Seine downstream from the railway. Out of about 175 surviving paintings done at Argenteuil, 75—by far the largest single category—are devoted to the boat basin adjacent to the highway bridge (Pl. 230) and to the area near the Ile Marante,

228. Sisley, detail of *The Bridge at Villeneuve-la-Garenne* (Pl. 227).

229

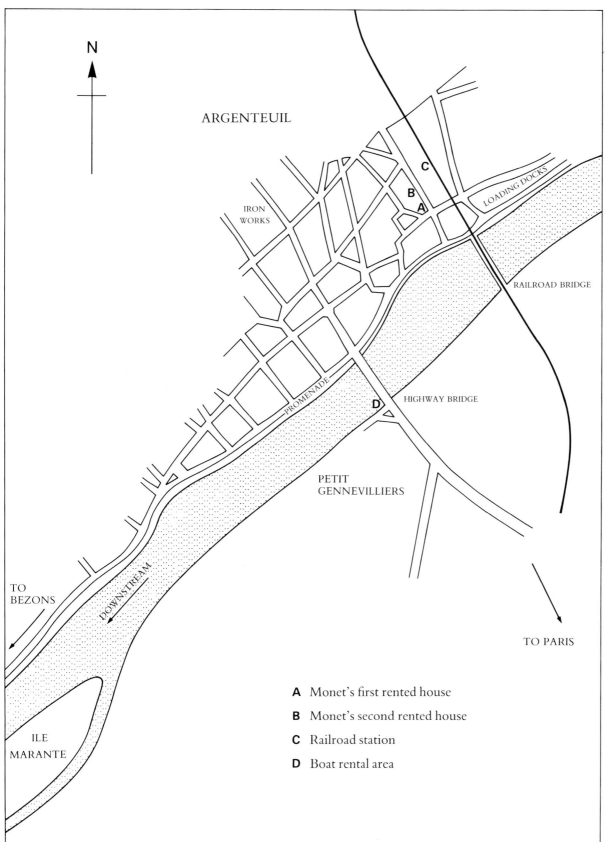

N

IRON
WORKS

C

B
A

LOADING DOCKS

RAILROAD BRIDGE

PROMENADE

D HIGHWAY BRIDGE

PETIT
GENNEVILLIERS

DOWNSTREAM

TO
BEZONS

TO PARIS

A Monet's first rented house

B Monet's second rented house

C Railroad station

D Boat rental area

ILE
MARANTE

230. *Schematic map of Argenteuil.*

which splits the river into two channels downstream from the village.

The Seine widens at Argenteuil, giving yachtsmen more water and steadier breezes than at Asnières or Bougival. Near the village, the river is over 200 yards wide, and for about three miles upsteam from the Ile Marante its bed, straight and deep, is unobstructed by islands. Since Argenteuil was less than half an hour from the Gare Saint-Lazare, it was readily reached by the Parisians who kept boats there and by those who came out to watch them. Joanne's guide of 1870 reported

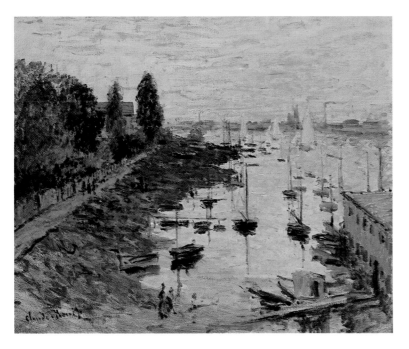

200 sailboats moored in the Argenteuil basin; many were privately owned, others could be rented by the hour or the day.[32] In Monet's *Argenteuil Basin Viewed from the Highway Bridge* (Pl. 232), the viewer is positioned well above the water, looking downstream. The shore here, opposite Argenteuil, lacked a village center and consisted of a scattering of small shipyards, plank docks, and vacation villas, lumped together as Petit-Gennevilliers. The promenade along the embankment was one of the principal vantage points for viewing the frequent regattas. In the distance is the southwestern edge of Argenteuil (the Ile Marante is out of sight around the bend). Looming up in the lower right is the floating building of a boat rental agency; moored alongside its gangplank is Monet's own studio boat, whose stocky blue cabin rises above its neighbors.

If we were able to cross the bridge and walk down the other bank towards the factory chimney that smokes on the horizon,

231. Monet, *The Argenteuil Basin Viewed from the Highway Bridge*, 1874. Bloomington, Indiana University.

232. Monet, *The Argenteuil Basin*, 1872. Musée d'Orsay.

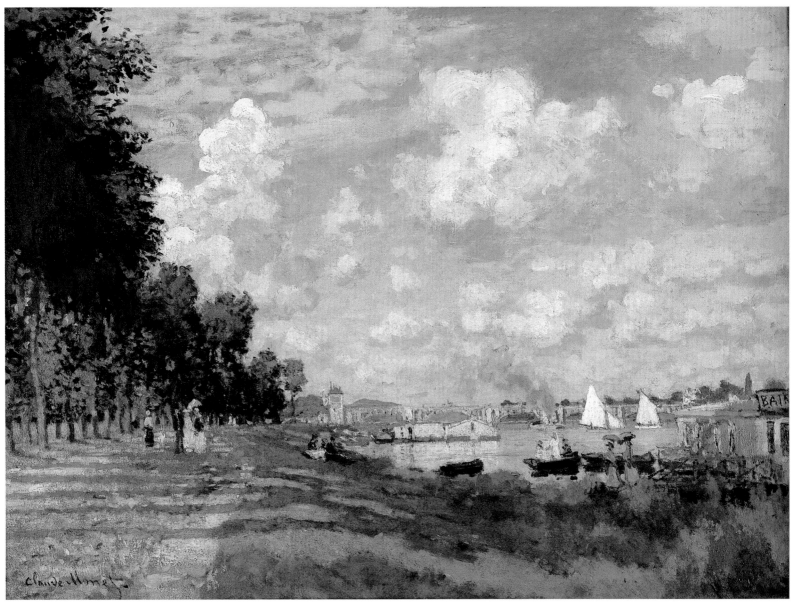

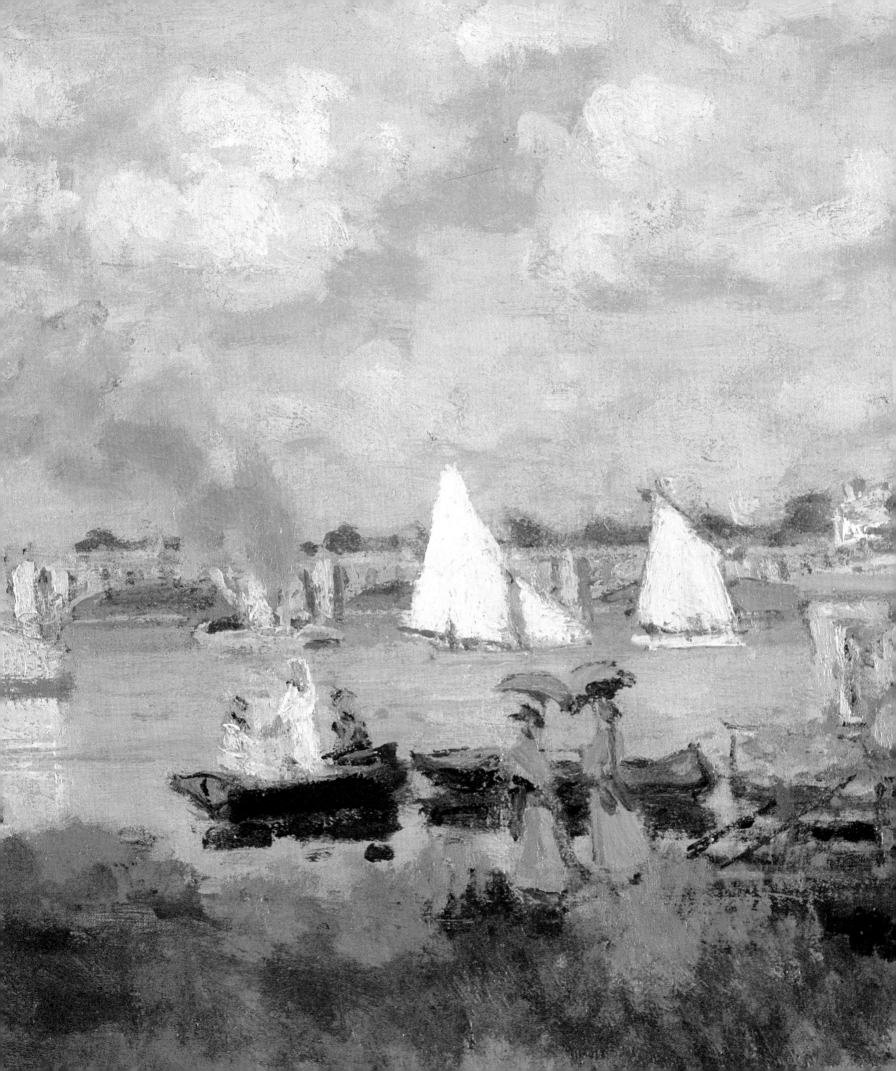

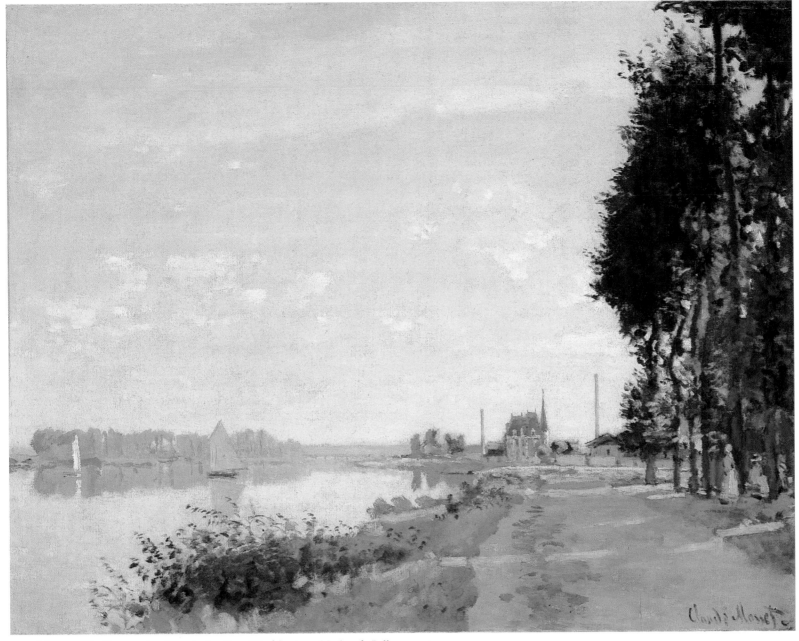

234. Monet, *The Promenade, Argenteuil*, 1872. Washington, National Gallery.

and then turn around to face the highway bridge, we should have the view that Monet had painted two years earlier (Pl. 232). The vantage point is much lower down, inviting us to walk into the picture. A late afternoon sun stripes the foreground, where we find several promenaders walking along the pathway and three women seated, facing the water. In this picture the river is a narrow zone between the sky and the green bank, but a surprising amount of activity is crammed into it (Pl. 233). It is a well-pondered composition, full of many decisions, taken slowly, and therefore a more "finished" painting than the panorama from the bridge. Two white-clad women, one of them standing, are in a rowboat conducted by a seated mariner. Nearer to us, inconspicuous in their grey garments, are two women who hold parasols aloft. They stand on the bridge leading to a bathing establishment that floats there; further along the shore are other bathhouses. To their right a steamboat sends up a plume of pur-

plish smoke, whose tones are almost matched by the undersides of the clouds that billow out over the site. Nearby, conforming to the horizontal arrangement that regulates the bottom third of the composition, are two sailboats, one picked out with a green hull, the other with a red pennant. Beyond is the road bridge. It had been rebuilt that year, following its wartime demolition. (When Monet had arrived at Argenteuil the previous winter, it was still under scaffolding, and he had so painted it more than once.)

A month or two later in 1872, Monet turned around on that same spot and looked in the opposite direction to paint *The Promenade, Argenteuil* (Pl. 234). It is early autumn, no longer a busy summer day on the Seine. Two sailboats glide slowly or wait for a breeze on the river's main channel. The Ile Marante is behind them, with the mouth of the secondary channel opening on the far left. To the right are two factory chimneys, an imitation Louis XIII château, a church steeple that gives the

233. Monet, detail of *The Argenteuil Basin* (Pl. 232).

233

false impression of being attached to it, and several low factory buildings. Further to the right are a few promenaders among the trees, through which another later afternoon sun is casting long streaks, colored simulacra of tree trunks, yellow on the grass and orange-red on the dirt road (which is rendered lavender-grey by the shade). The Sunday quiet of this peaceful afternoon is abetted by the absence of smoke from the tall chimneys, a deliberate decision on the artist's part, for in other paintings he shows them smoking, or else he suppresses them entirely, as though they did not exist. In this idyllic picture, sailing has none of the confrontational energy of the views of the railroad bridge (Pls. 220, 224), although the factories, focused by the pathway, are a reminder of the other side of Argenteuil's activity.

Surely these two paintings of the Argenteuil embankment live up to the ideal their promenaders sought, a well-ordered suburb where nature and humans met in agreeable harmonies. Neat, smokeless chimneys and a puffing steamboat integrate industry with the landscape in a pleasing way, for no actual work is hinted at. Men are mostly absent (only one male promenader), presumably at their employment in Paris, allowing their women and children this display of leisure: nonwork, nature, and family are the things that a man labors for. Pictorial harmony and social harmony are merged—it is Monet's unwitting goal—in a setting that permits middle-class Parisians to let light, air, and river sports soothe away anxieties of the city, where work and workers must be regularly confronted, and where memories of the recent war, the workers' commune, and its bloody suppression, are still disturbing.[33] Although his pictures were unappreciated in 1872, Monet was using echoes of Barbizon art to induce a vision of pre-war serenity. His summertime painting, with its active sky and saturated greens, should remind one of Daubigny, and his autumn view, with its air of arcadian stillness, of Corot.

Of course there is hardly any untouched nature in either painting. Well-groomed banks and well-groomed pictures equally reveal humankind's patterns superimposed on nature, whose warts and bumps are largely suppressed. If we looked for the symbolic center of this perfect world, it would be the sailboats that, more than anything else, characterized leisure at Argenteuil (rowing was enjoyed there, also, but less importantly than at Asnières and Chatou). Except for the steamboat in Monet's painting, there is no sign of the extensive industrial traffic that plied the river here. Elsewhere, in these same years 1871 to 1874, he painted commercial shipping (Rouen, Le Havre, Amsterdam), but he recognized that pleasure craft were the vessels that symbolized Argenteuil. In truth the major changes along these shores had been brought about by the pleasure boats, so the artist was right to give them first place in a modern landscape. They represented the inroads of Parisians who were transforming the village. The changes were not yet as drastic as at Asnières (later they would become so), but new villas were springing up along the shore of Petit-Gennevilliers and spreading out from the old center of Argenteuil on the other bank (Pl. 235). The influx of weekend and holiday visitors meant a great increase in the number of cafés, restaurants, and boating establishments, and wholesale changes in the local economy.

The history of sailing and rowing is just as instructive for

235. Monet, *Houses at the Edge of the Field*, 1873. Berlin, Nationalgalerie.

the study of Parisian society as the history of horseracing. Indeed, they are closely connected. Like organized racing, pleasure boating (*canotage*) in France grew from emulation of the British. The British colonies in Le Havre, Rouen, and Paris, so vital to the industrialization of France, introduced competitive rowing and sailing in the 1830s. By the mid-1850s, Asnières became the headquarters of the Cercle nautique (Nautical Club, also called "le Boat-Club" and "le Rowing-Club"), devoted principally to rowing by from one to eight oarsmen, and Argenteuil became the seat of the Cercle des voiliers de la basse Seine (Sailing Club of the Lower Seine). Regattas were organized by these and other clubs at many spots along the river, from Charenton, southeast of Paris, around to Bougival and Saint-Germain. Their meets were spaced out over the warm months, regulated by inter-club committees the way the Jockey Club watched over rival racing seasons. Rowing meets were occasionally held in the center of Paris, as well as in the lake in the Bois de Boulogne, for enterprising politicians (the Emperor among them) and businessmen quickly learned the attraction of water sports. River villages sought regattas for the glory and the money, and there was even a Société de canot-concert (Society of Boating Concerts), founded in 1853 to give nautical concerts along the Seine. The Yacht-Club de France had its offices on the *grands boulevards*, and it was presided over by the Minister of the Marine, under the Emperor's sponsorship.[34]

The clubs based at Asnières and at Argenteuil initially formed an élite apart. Until the 1870s, when membership rules were liberalized, their upper-class and British tone was guaranteed by their directors, who included the ubiquitous duc d'Albuféra, the prince de Joinville, the comte de Mosbourge, the writer Alphonse Karr, and various British diplomats and businessmen, among them, John Arthur, Lord Cowley, and William Short. At first membership was limited to the wealthy, for early chroniclers left no doubt: to compete with the British in industry and politics meant that the French had to adopt gentlemen's sports. Eugène Chapus began his book of 1854, *Le Sport à Paris*, by pointing to the value of these

"aristocratic diversions," which, by stimulating courage, agility and fortitude, prepare men for high social careers:

> If the English early on understood the importance of the practice of sports, and if they perfected some of them so as to leave behind all rival nationalities, there are yet some in which the French follow them closely....
>
> The brilliant devotion to sport implies a grand and aristocratic existence in a peaceful and continuous enjoyment of its prerogatives, and it is for this reason that its development has long been restrained among us. In France one attacked too much all the things that breathe an air of nobleness....

Chapus then congratulates France on the establishment of the Second Empire ("the society of élites is being organized, reconstituted"), for now the way is open to match the British:

> There are regatta societies in all English cities, boating clubs whose membership consists of young men of good and noble families.... Boating in England is not a game, it is a serious occupation, an education that has its disciples, its centers, its clubs, its statutes, its rules, its support.[35]

Boating was therefore one strand of the web of social, political, and commercial relationships that was being rewoven in Second Empire France. The new entrepreneurial society signaled its cross-Channel debts in its vocabulary: *le sport, le turf, les jockeys,* and *le rowing, les skiffs,* and *les yachts.* Its fabric was patterned on the British model, one that led the rising middle class to adopt leisure activities heretofore limited to the upper class. Boating had the advantage of being a relatively costly and conspicuous form of leisure that marked off its devotees from the lower classes. It is true that struggling artists and sales clerks could rent boats, but they were kept in their place because they did not own their own craft and were excluded from membership in the prestigious boat clubs. To paddle about at Asnières or on the lake in the Bois de Boulogne was as much water-borne glory as the average Parisian could aspire to.

The *flâneur,* of course, turned up his nose at the plebeian Sunday boaters, and hobnobbed instead with the more privileged *sportsmen.* Alfred Delvau, in his book on the pleasures of Paris, refers to many gentlemen sports figures and names dozens of their winning horses and prize boats. The central chapters of his book follow this order: cafés, restaurants, theaters, circuses and popular shows, balls, social clubs, horseracing, nautical sports. The upper-class man-about-town made his appearance at all of these and had to be knowledgeable about each, so it is no surprise that Manet, who was one of them, came out to Argenteuil in 1874 to celebrate boating. The Argenteuil basin had risen from a modest to a clamorous fame after 1871,[36] and Manet was ever on the qui-vive for the social institutions that characterized his time. He spent much of that summer at his family's place in Gennevilliers and frequently came over to Argenteuil, only two miles distant. Renoir was also there that summer, visiting Monet as he had the previous year, and there was a lively exchange among the three.

In *Monet Painting in his Studio Boat* (Pl. 236), Manet shows the artist seated in the bow of the boat he adapted as a studio.

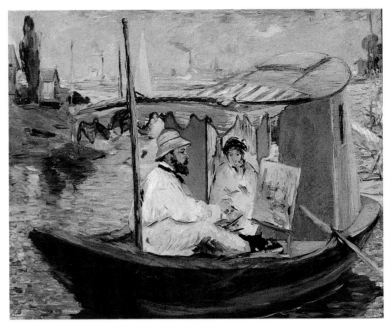

236. Manet, *Monet Painting in his Studio Boat*, 1874. Munich, Neue Pinakothek.

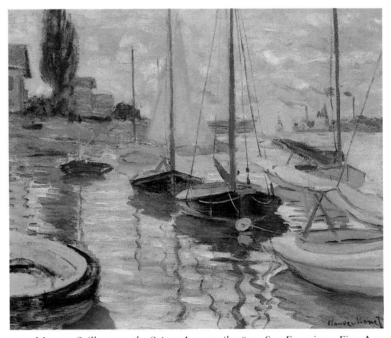

237. Monet, *Sailboats on the Seine, Argenteuil*, 1874. San Francisco, Fine Arts Museums.

Our vantage point can be found by looking at Monet's picture of the basin from the highway bridge (Pl. 231). We are located at water level in the foreground of that space, looking in the same direction. In the distance are the chimneys on the southwestern edge of Argenteuil. Monet, shaded by the kind of awning used for marine cafés (see Pl. 251), rests his palette on his right leg, casually propped up on the port gunwale. His wife looks on from the doorway of the tiny cabin while he debates another touch on his canvas. He has been looking over his left shoulder for his motif (Pl. 237), a view along the shore that Manet has recapitulated in the upper-left corner of his own canvas. The oar that projects on the right shows Monet's normal mode of propulsion; the stubby mast supports the

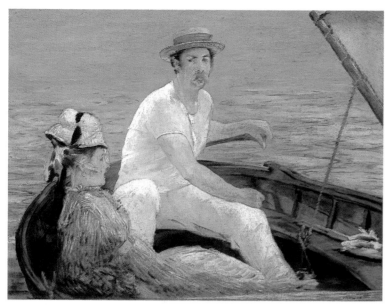

238. Manet, *Boating*, 1874. Metropolitan Museum.

awning, not a sail. His boat is not like the pleasure craft that he painted, but it is the vessel of an itinerant whose mobility it facilitates (he got the idea from Daubigny, who plied the Oise and the Seine in his *Botin*). Manet presents him not as a resident of Argenteuil, but as a painter-sailor, dressed in an artist's blouse and tie, and crowned by the same sportsman's hat that he gave to another of his boatsmen at Argenteuil (Pl. 239). The seriousness of Monet's preoccupation should not disguise the fact that he and his muse, like Andrieux's boaters at Asnières (Pl. 199), had come out from the city to enjoy these shores.

In addition to the painting of Monet in his floating studio, Manet did four other boating pictures that same season. For *Boating* (Pl. 238) Manet posed his wife's brother Rodolphe Leenhoff, wearing the colors of the eminent Cercle nautique headquartered at Asnieres: white shirt, white flannel trousers, straw hat with blue border.[37] Such a costume guaranteed distinction from a real river boatman (whom bourgeois amateurs had imitated), so too did the presence of a *chic* female companion, who has the same hat the artist's own wife wears in two seacoast paintings of the previous year.[38] When Manet later showed *Boating* in the Salon of 1879, he matched it with *In the Conservatory* (Pl. 183), for it is a suburban equivalent of that other composition. The same kind of couple could be found in fashionable visiting costume in a classy city greenhouse and in boating outfits at Argenteuil. Both couples are "doing nothing" in the parlance of working people, and both are shown in the restrained attitudes of society's leaders. (The contrast of Manet's boating pair with the couples in Andrieux's print, Pl. 199, is one of upper class versus middle class.) Neither title nor attributes of Manet's *Boating* refer to a specific place, for the composition has an emblematic simplicity. The Japanese prints which it certainly reflects—it was noted at the time[39]—assisted the artist in distilling his images. Water, sail, and boat are cut off abruptly by the frame, and each is reduced to the minimum, just enough to make us read "boating" instantly. The rather shallow space is activated by the way the man's body and limbs twist to the right.

Argenteuil (Pl. 239) shares much with *Boating*, but it does not require many moments to see that it projects a quite different mood. For one thing, it lays out a more complicated assortment of images and cannot be read instantly as an ideographic condensation of boating. Argenteuil is identified not alone by the picture's title, but by the play of moored sailboats and boaters against the factories and other buildings on the opposite shore. Our position is in the boat basin, roughly as we are in Monet's *Sailboats on the Seine* (Pl. 237)— some of the boats are the same—but looking more to the right. Manet here places leisure against a backdrop of industry, the essential confrontation that is the truth of Argenteuil, one we have already seen Monet paint the previous year, when he matched sailboats and the railroad bridge (Pl. 220). Manet shows that commercial sailing has been transformed into pleasure-boating: older river craft have become yachts, specifically designed for leisure, and real river boatmen have been displaced by gentlemen amateurs. There is almost nothing here of "nature" as it would have been understood a generation earlier, only water, sky, and a few trees. Manet's figures are passively seated near the boats, typical Parisians engaged in social by-play, not in the sport itself. (If pictures could sing, we might hear the popular refrains of café songs about *canotiers*, which of course were another leisure-time transformation, since they were derived from seamen's shanties.)

In effect, Manet, perhaps owing to his association that summer with Monet and Renoir, has brought up to date his own *Déjeuner sur l'herbe* (Pl. 171). In 1863 he had been thinking primarily of the history of painting and of modernizing it by the irruptive presence of his contemporary figures. By 1874 he has become much more the naturalist, drawing upon a well-known, not an imaginary setting, and one that had distinctive resonance in the contemporary mind. Argenteuil was associated with yachtsmen who favored female companions of indifferent morals. Art critics of the period and Manet's male friends alike assumed that the blank-faced woman was such a one, and surely the boatsman is assiduously soliciting his companion's attention. She is, further, dressed in the showy clothing of lower middle-class women, rather than in the more elegant and restrained dress of the woman in *Boating*, or in Morisot's later *Summer's Day* (Pl. 151). Her straw hat, a popular one of the period, floats upward in a diverting way, and its swatch of white cloth hints at both sail and cloud (perhaps a bemused artist indulging in a bit of visual mockery). Still, Manet is more subtle than his critics believed, and we need a closer look.

The critics' views, after all, may well reflect male assumptions that a woman shown as the object of a man's attention was necessarily a *cocotte*. This woman has a conspicuous aplomb and, like the women in *The Plum* (Pl. 75) and *A Bar at the Folies-Bergère* (Pl. 80), she has none of the gestures or looks that were among the well-catalogued characteristics of a strumpet. Everything in the painting, in fact, differentiates its two figures. On the left, the woman's uprightness is supplemented by the nearby verticals of masts and ropes, while on the right, the man's active body finds echoes in the diagonals and curves of the adjacent yacht. Even his shirt has horizontal stripes to contrast with the woman's verticals. Unlike the

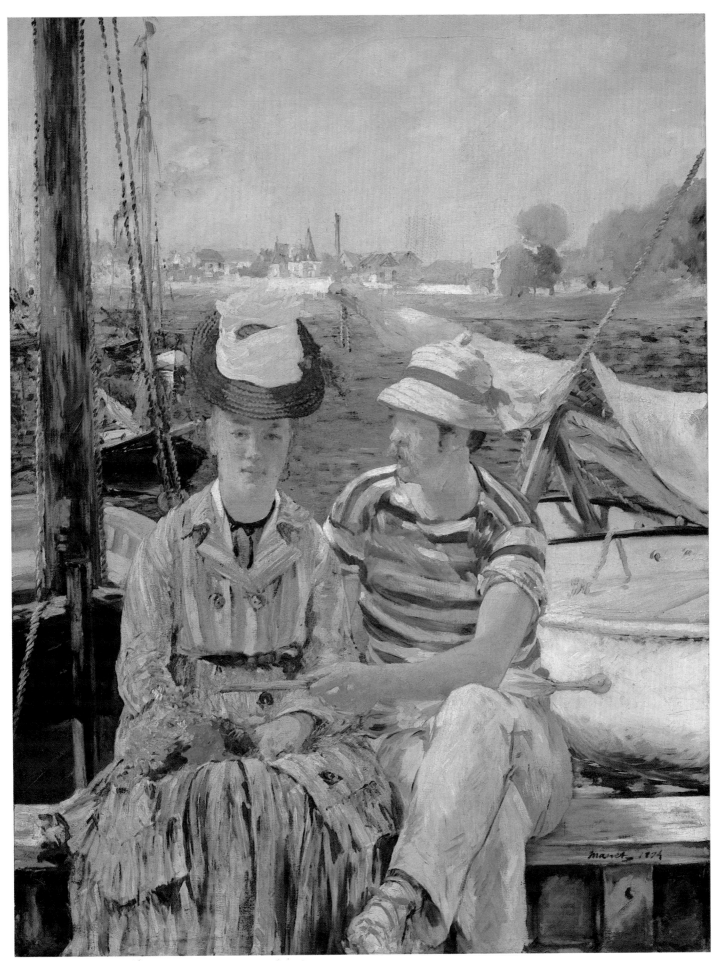

239. Manet, *Argenteuil*, 1874. Tournai, Musée des Beaux-Arts.

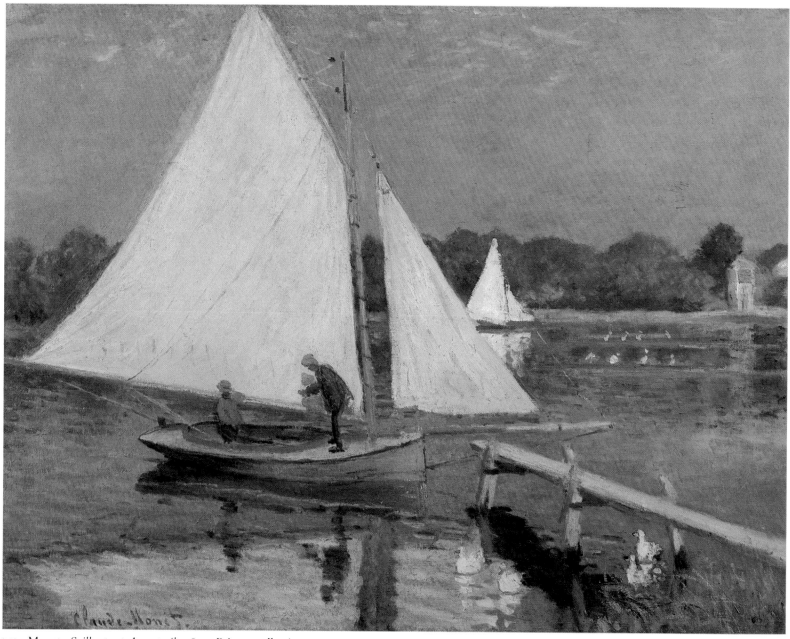

240. Monet, *Sailboats at Argenteuil*, 1874. Private collection.

helmsman of *Boating*, whose body aims away from his companion, this man is using the encroaching manoeuvres of the gallant in the later *Chez le Père Lathuille* (Pl. 67). The debonair boater has one arm behind the woman, his leg overlaps her dress, and he not only holds her parasol, he positions it aggressively (in *Boating* the woman's parasol rests unattended, opposite her). We get the impression that he is urging a reluctant or indifferent woman to take an excursion with him. It is midday, as we see from the sun's steep angle, and the carelessly covered sail beyond his shoulder suggests a boat only temporarily moored, ready to depart at a moment's notice. In many ways *Argenteuil* is the suburban equivalent of *Chez le Père Lathuille*. Both represent places on the fringes of the city where men would be expected to pursue women. Manet's subtlety in each case lies in his refusal to let us know the results of the pursuit.

Argenteuil is the most provocative painting Manet did that

summer of 1874, and that alone may have been the reason for submitting it to the Salon the following year. It is differentiated from *Boating* not just because of its more involved imagery; its colors are far brighter and full of contrasts, rather like *Monet Painting in his Studio Boat*: yellows, oranges, and touches of bright red against saturated blues.[40] It was Manet's sole entry in the Salon of 1875, and it made a suitable splash, once again ensuring his reputation as the *enfant terrible* of the artistic world. Its bright palette was shocking because to those unused to it, the individual colors jumped out of relationship and made the picture seem unintegrated, hence crude. Although Manet had not shown with the impressionists in their first group exhibition in 1874, he was now taken by many critics as the leader of the new *plein-air* school. Indeed, no such brilliantly hued picture had been seen before in the official Salon. Monet and Renoir had not exhibited there after 1870, and their recent work, limited to the exhibition of 1874 and to

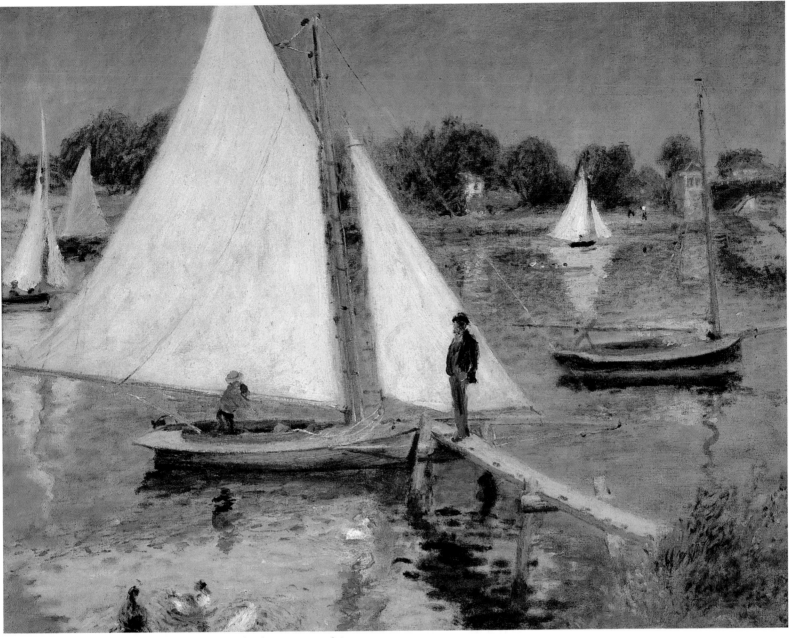

241. Renoir, *Sailboats at Argenteuil*, 1874. Portland, Museum of Art.

occasional dealers' shows or sales, would have been unfamiliar to most. There was good reason to elevate Manet to the leadership position. In addition to his greater fame, he had learned a lot from the younger artists that summer. He adopted their saturated palette, and his painting of Monet in his studio boat is almost surely indebted to the picture Monet then had on his easel (Pls. 236, 237), for their renderings of the shore are similar, and their brushwork appears to have benefited from a mutual exchange.[41]

The reciprocity between Monet and Renoir was equally important, and had a longer history. Younger than Manet, from whom they had learned so much over the previous decade, they were often together. Their work at the Grenouillère in 1869 had been a veritable partnership, and again at Argenteuil, from 1873 to 1875, they frequently pursued the same motifs: ducks on the edge of the river, Monet's garden, the meadows near the village and sailboats on the river. In

1874 they painted a justly famous pair of *Sailboats at Argenteuil* (Pls. 240, 241), whose palettes, with their contrasting orange-blue, red-green, and yellow-purple, were catalysts for Manet's evolution that summer. Brilliant contrasts, involving both large, sun-flooded patches and small, broken brushwork, proved their efficacy in translating the effects of freshly viewed outdoor light. Broadly similar, the two paintings reward close study because they reveal the nuances that separate the two, differences that are consistent with those at the Grenouillère five years earlier. Renoir continued to take the lead in the use of a variety of intense and contrasting hues, Monet, in the articulation of clear surface pattern.

Both pictures were taken from the shore of the boat basin, looking directly across the river. The Argenteuil end of the highway bridge just shows on the right edge of each (the plank dock in their foregrounds is the thin streak in the middle distance of Monet's panorama from the bridge, Pl. 234).

242 (following page). Monet, detail of *Sailboats at Argenteuil* (Pl. 240).

Renoir's vantage point was slightly higher on the bank than Monet's, leading to a greater expanse of water, and less sky. This allowed him to supply the river with more visual ballast than we find in Monet's canvas: five sailboats instead of two, and a more elaborate play of reflections on the right (Pl. 243). In the right distance, for example, the reflection of the sailboat, intersected by an orange-red canoe or rowing shell, is surrounded by purples and olive greens. Further to the right, similar purples form the reflection of a span of the highway bridge and terminate an arabesque of purples and greens that play over the water. Compared to the same area of Monet's picture, this portion of the river is a calm stretch, and our attention is dispersed rather equally among its parts. Monet concentrated instead on the two carmine racing shells, speeding downriver to the left (Pl. 242). They oppose the implied direction of the two sailboats, reducing activity on the river to the contrasting pairs.

Other features of the two canvases ratify the disparities. Monet's surface geometry aids a quick reading, whereas Renoir's tapestry of varied effects makes us scan his picture more slowly. Monet's dock is a straight plank that sharply cuts the right edge of the frame; Renoir's sags slightly, and is eased into the composition from the corner full of marshy growth. The reflections of Monet's sailboat have well-defined shapes, outlined in the oranges of boom, mast, and bowsprit (especially striking is the reflected mast, an orange stripe that splits a rectangle of contrasting blue before slicing the bottom of the frame); Renoir's reflections have broken edges whose quavery dance is more important than easily grasped shapes. Even the ducks are differently viewed. Monet's are in symmetrically disposed couples (echoes of the two pairs of boats); Renoir's are scattered and help ruffle the reflections.

The contrasts extend to the implicit narratives the artists lay before us. Monet juxtaposes sailing and rowing, allied yet opposed ways of using the water, huge vertical triangles borne along by the wind versus the thin horizontal streaks of the shells, the minimum support for coordinated rowing effort. His river is narrower than Renoir's, and its flow is emphasized by the oarsmen who are about to streak into the gap between the two sailboats. Renoir's conception is more relaxed, his river almost as broad and directionless as a lake. One tiny shell makes us aware of rowing, but there is no hint of competitive urgency. Both pictures deal with leisure-boating at Argenteuil, but Monet conceived of competitive action in the forms of a clean-cut, bold organization, whereas Renoir thought of a tranquil boat basin rendered in the soft-edged patterns of a looser fabric.

Monet's picture, which seems to typify boating at Argenteuil, has one feature that is nearly unique in his work there. It and one other are his only paintings that clearly show people on their sailboats.[42] The boats are otherwise shown at a distance or, if close to us, they are invariably moored, as in *Sailboats on the Seine* (Pl. 237) and in *The Bridge at Argenteuil* (Pl. 244). Of fifty-one Argenteuil compositions that depict sailboats, including those in small scale at a distance, only three deal with the regattas that drew the crowds on weekends and holidays. Twenty-one others give prominence to boats under sail (including Pls. 232 and 234), but this adds up only to twenty-four. Twenty-seven, more than half, concentrate on moored boats. Of these, in turn, eleven have sails off in the distance (like Pls. 231 and 237), but sixteen are entirely limited to boats at anchor. Pictures of moored boats, with no humans present, were not interesting to Manet, Renoir, or Sisley, and we shall learn more about Monet if we inquire why they loom so large in his work.

Unlike his comrades, Monet was a resident of Argenteuil even though we know that he preserved much of the visitor in his attitudes and was not very sociable with his neighbors. Like other artists who colonized the suburbs, he associated himself sufficiently with his adopted locality to feel indifference or disdain for the holiday visitors. Alexis Martin later gave witness to the dual life of a suburban artist. Asnières, he tells us,

> is inhabited by artists, writers, administrative employees, and business people who have both the joy of living in the healthy air and the convenience of being only a few moments from Paris. Shut up in their own places on Sundays, they leave the village, its cafés, its restaurants...at the disposition of the crews from Paris.[43]

Monet avoided the Sunday crowds, and his silently anchored boats give us the weekday aspect of the river. The boats enjoy, as it were, their own repose before the holiday onslaught. Embodiments not of local residents, but of well-to-do Parisians, they make us think of their absent owners, rather the way an empty chair summons up a human body. They have the appeal of anticipation, of waiting peacefully for their owners who, contemplating such paintings in the city, could dream of holiday sport in the open air. The exclusion of people in these paintings aids such dreams of leisure. We, the viewers, are the sincere lovers of boating and quiet rivers, and we do not have to rub elbows with the mass of weekend boaters (nor with local factory workers or laundresses). The paintings let us become the ideal visitor; we are the ones who are enjoying a genuine experience, and we do this in part by taking our distance from mere tourists, thankfully excluded from our sight.

Monet's paintings of moored sailboats are considerably varied, but they share this dual character. The boats are the sign of Parisian leisure, but they are seen as a local person might view them, free of the clamor of the weekenders. In *Sailboats on the Seine* (Pl. 237), we have the vantage point of the locals who know the river. Monet took on this role, for he was an artist-worker-resident in his homely studio boat, and not a pleasure-seeker. He places us alongside him, in his boat, so close to the yachts that the nearest ones are cut off by the edges of the frame, so near to the water that the undulating reflections, like so many eels, work their way right under our feet. This is an initiate's view, that of the perceptive observer who lets us join him in this conspiracy of intimate knowledge. No view of a regatta could do this, for then we would be passive witnesses to a public spectacle. In a way Monet is like Degas, who preferred the insider's view of horse race and ballet, that is, the moments of anticipation and rehearsal rather than the actual events. *Sailboats on the Seine* has striking affinities with Degas's *Jockeys in front of the Grandstands* (Pl. 163): a tipped-up, nearby surface over which our eye glides quickly; forms at rest, or nearly so, that are valued for their speed; potent

243 (previous page). Renoir, detail of *Sailboats at Argenteuil* (Pl. 241).

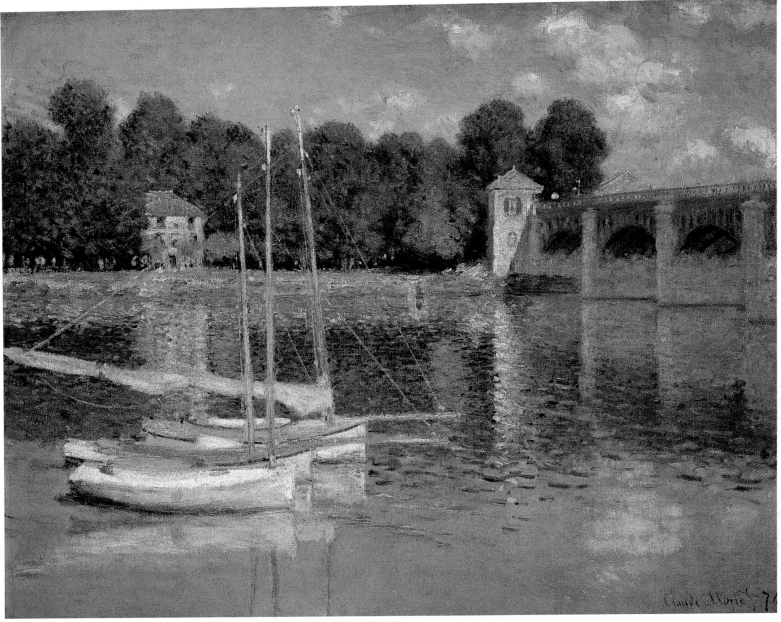

244. Monet, *The Bridge at Argenteuil*, 1874. Musée d'Orsay.

wedges of space that infuse the scenes with energy. In both paintings there are smoking factories in the distance, the suburban industry that is in symbiosis with suburban leisure, each positing the other, and both assuming the urban visitor.

The Bridge at Argenteuil (Pl. 244) is a more contemplative picture. No industry here: Argenteuil is screened rather than revealed by the row of trees. The old ferryman's house, converted to a popular café-restaurant, appears among the trees as though it were a private villa. Unlike Sisley's *Villeneuve* (Pl. 227), there are no figures to activate the scene, and the road bridge does not plunge into the village (we cannot even see a break in the trees). It slides laterally into the composition, and the effect of the diminishing gaps of its spans is largely denied by the play of the vertical reflections of tollhouse and piers that march flatly and evenly across the surface. The three sailboats contribute to this horizontality not only by their orientation, but also by the way their masts and guys form a large triangle

(would the foreground mast really have been taller than the one rising from the middle boat?).

In keeping with its more meditative mood, *The Bridge at Argenteuil* has a less agitated surface than *Sailboats on the Seine*. The latter was done with a Manet-like brio, and its long and fairly wide strokes were thinly painted, to emphasize the quickness of application, the effortlessness of well-honed skill. In the picture of the white-hulled boats, the water in the foreground is so smoothly painted that we cannot easily detect separate brushstrokes. The reflections above this blue zone are rendered in short horizontal and tilted dabs that speak more of studied care than of virtuoso speed (Pl. 245). Here the color harmonies are at their most complex. The picture as a whole depends principally upon the contrast of orange and blue, but among the reflections of shore and bridge are violets to contrast with the yellows, as well as blue-greens, olive greens, tans, oranges, pale blues, and yet other tints.

This composition is one of the best examples of early mature Impressionism, in which the brushwork varies according to the image being created: blended mixtures for clear water, choppy aggregates for reflections, wide, dragged horizontals for boat hulls, streaky verticals for masts, finely bunched diagonals and swirls for foliage, curves and irregular dabs for clouds. These different marks are also of varied thickness. The smoother ones for water and sky are so thin as to have negligible substance, but the boats, trees, clouds, and muticolored reflections have substantial impasto. In front of the original painting (in reproductions, tactile textures have little role), the viewer unconsciously lets the thicker strokes confer a factitious "reality" on their images, compared to the insubstantiality of water and sky. Before Impressionism, painters had varied the direction and texture of their brushwork according to the images they defined, but for Monet these manipulations of paint were even more vital, because he had renounced the traditional underpinnings of modeling in light and dark. It is an obvious remark, but one that can bear repeating: the representation of leisure was the result of hard work.

Sailing, as everyone knows who ventures on the water, involves real work. Monet nonetheless took no interest in the hauling, pulling, and other movements of the body that are an integral feature of the sport. Comparisons with the boating pictures of his younger contemporary Caillebotte make it clear that Monet interpreted sailing as an effortless indulgence of leisure. Caillebotte shows that physical effort was indeed a feature of boating, although he concentrated on rowing, which demands more steady effort than sailing. Alone among the impressionists, he was an avid sailor and rower and competed in races. Thanks to his wealth, he had several rowing skiffs and sailboats, some of them built to his own designs. His family had a home on the Yerres river south of Paris, and in 1877 and 1878 he did a whole group of rowing pictures there. He was also frequently at Argenteuil in the mid-1870s and settled permanently in Petit-Gennevilliers by 1882.

Caillebotte's *Oarsmen* and *Oarsman in a Top Hat* (Pls. 246, 247) are studies in contrast from an insider's viewpoint. In each case the viewer is the proverbial fly on the wall and has no psychological presence in the fiction of the picture. *Oarsmen* shows two experienced rowers with arms, legs, and oars outstretched to capture the exertion involved. In the powerful thrust of his forms towards us, paired with the opposed plunge of the boat inwards, Caillebotte suggests the alternating surge and rest of the rowers' actions. His men wear the straw hats and clothing of the serious *canotier* that distinguish them from both the working riverman and the mere amateur. Their skiff is no longer the heavy, all purpose riverboat of the previous generation (Pl. 199), but a craft expressly designed for the middle-class boater. Its slender shape bespeaks its place in the realm of competitive sport, that particularly modern form of leisure. The broader boat of *Oarsman in a Top Hat* better suited the unskilled amateur, although it, too, had a lighter structure than the traditional rowboat. Caillebotte's oarsman is a middle-class Parisian on an outing, as we can tell from his clothing and from his concerned look off to the left. He has a right to be concerned: his two oars are not being pulled evenly. Like most right-handed beginners, his strong

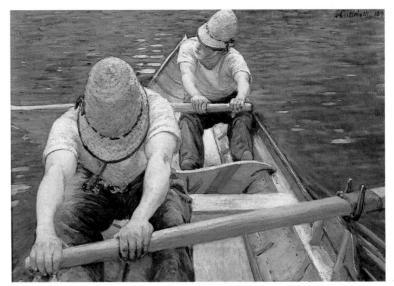

246. Caillebotte, *Oarsmen*, 1877. Private collection.

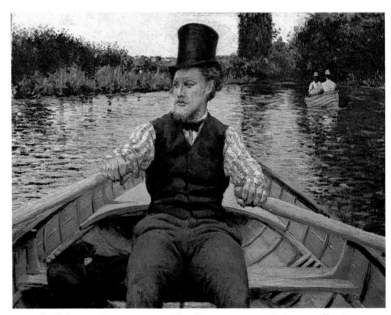

247. Caillebotte, *Oarsman in a Top Hat*, 1877–78. Private collection.

arm has pulled the stroke further on that side. The imaginary back-and-forth of the other painting lacks here, despite the similar composition, since the rower's body leans back and covers the prow of the boat. Body and boat form a single, large rhythm, with the shoulders taking the place of the prow; even the folds of the trousers repeat the curve of the forward seat. Caillebotte's composition might owe a debt to Manet's *Boating* (Pl. 238) of 1874, but if so, he chose to emphasize the awkward amateur in contrast to Manet's seasoned veteran.

Both of Caillebotte's pictures have the zooming perspective of his Paris scenes (Pl. 27), and therefore a feeling of urban dynamism, as though the city were just over our shoulder. In other paintings of rowing on the Yerres he transports us more wholly into a realm of peaceful leisure, away from the city. *The Skiffs* (Pl. 248) is typical of these. Over a reach of calm water we look at three men in slim skiffs, wielding kayak paddles without, it seems, much effort. A light-suffused land-

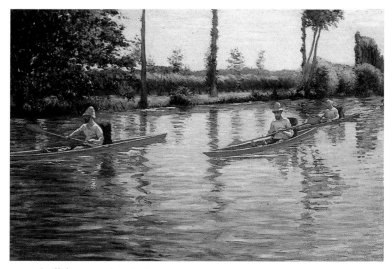

248. Caillebotte, *The Skiffs*, 1877. Milwaukee Art Center.

scape and the river's gentle diagonal replace the darker tones and plunging perspectives of the other two compositions. The skiffs glide smoothly along, not in competitive alignment, but in a casual order that is subtly controlled by the tree trunks and their reflections. Taken together, Caillebotte's several paintings of rowers display the gamut of this sport and treat it with an insider's concentration. Unlike Monet, he brings us close to the activity of boating, while he also excludes the social encounters that were Manet's chief concern. For pictures of rowers, Caillebotte's only rival was Renoir, but, like Manet, Renoir was interested less in the sport itself than in the ways it brought men and women together in a lively suburban society.

Rowing and Dining at Chatou

In Renoir's work, the counterpart to Monet's sailboats at Argenteuil and Caillebotte's oarsmen on the Yerres, was a group of paintings that featured rowing along the Seine, including men and women in the boats and along the shore. *The Canoeists' Luncheon* (Pl. 250), painted at the end of the decade, is one of the most beautiful of these. In the five or six years since he and Monet had painted side by side at Argenteuil, his palette has shifted further in the direction of light-flooded colors, whose orchestration drowns out the play of light and dark, that is, of sculptural modeling which was heretofore the basis of painting. (Monet and Morisot, also, had altered their palettes in the same direction.) Here the overall harmony relies on the contrast of orange and blue, together with a secondary opposition of red and green. These pairs are interwoven, so that the orange of the boats reappears, in duller tones, in the chairbacks and still life on the table, and the greens, in the same still life as well as in the jacket and shirt of the man on the left. The brushwork has the silken quality peculiar to Renoir, a way of using texture to achieve compositional unity and to express in the very structure of paint the delight in harmonies of nature and society that so sharply distinguishes this artist from Manet and Degas. None of the brilliant cynicism and underlying tensions that mark Manet's boaters (Pl. 239); none of Monet's indifference to the human figure, either, and none

of Caillebotte's sometimes clumsy directness. This small picture is resplendent in its balance of fragility and intensity; it hovers on the edge of ecstasy.

The Canoeists' Luncheon is the quintessence of suburban leisure. If we compare it to its urban counterpart, Renoir's contemporaraneous *End of the Lunch* (Pl. 73), we understand that the airy colors and cornsilk texture are deliberate ways of embracing outdoor sensuality and relaxation, as distinct from the darker, more controlled tones of the urban interior. Paint and subject are, once again, intimately related. To the feathery colors and textures correspond the relaxed poses and the dispersed incidents of the riverside picture. On the left a man is seated, relaxed after his meal, with his napkin still in his lap. He looks at the woman nearest us while to the right is another contented diner, cigarette in hand, whose mouth hints that he is talking, although he might be silently ruminating. The two men are split apart, but joined by the woman's form, by the overhead arch, and by the linking movements of the boats. The boats are prominent because of their orange color, in that Matisse-like aperture towards which everything draws us, including the angle of the smoker's body and that of the table. The further boat, a four-man racer with coxwain, is darting down the river—an axis we might might not otherwise be conscious of—but the near boat is more sociable, since it is headed in towards us. It has a woman at the oars, and her boat points directly at the woman in the foreground, who looks in that direction; they both wear the blue flannel dresses of female boaters.[44] Although separated from the foreground, the woman in the boat makes up a kind of foursome and links the diners with the boating that they came here to enjoy.

Renoir's picture was probably, though not certainly, painted at Chatou, three miles downstream from Argenteuil. If sailing was the emblem of Argenteuil in the 1870s, it was rowing that distinguished Chatou. Not needing the winds that favored Argenteuil, rowing could be enjoyed up and down the Seine and its tributaries. Its early center, as we saw, was at Asnières,

249. Renoir, *The Railroad Bridge at Chatou*, 1881. Musée d'Orsay.

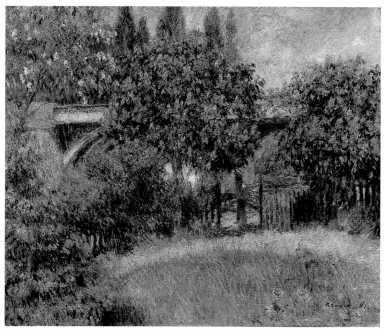

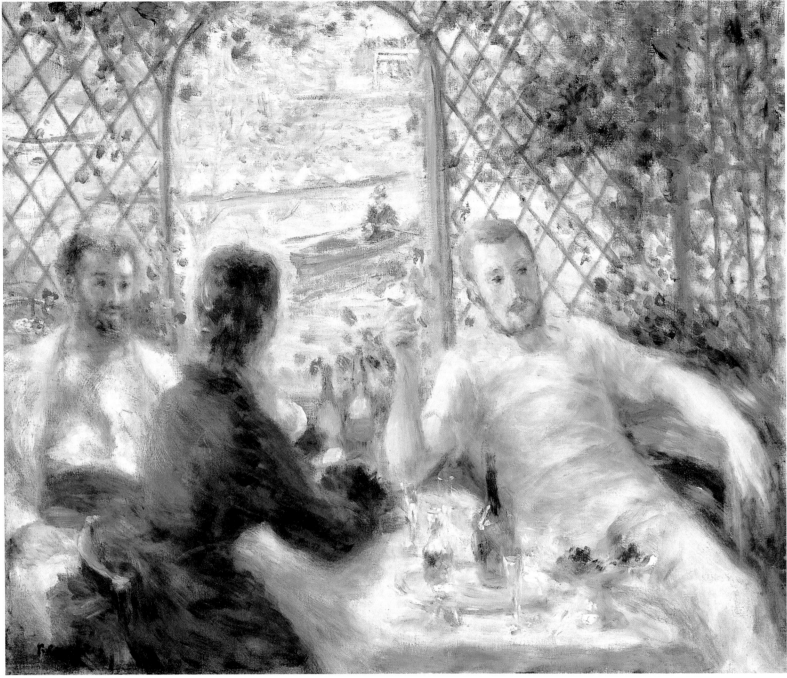

250. Renoir, *The Canoeists' Luncheon*, 1879–80. Art Institute of Chicago.

but as that suburb grew more industrialized and populated, Chatou was increasingly preferred by rowers. It was Renoir who paid tribute to them and their activities. He began frequenting Chatou in the middle of the 1870s and for several years was a regular at the Restaurant Fournaise, a popular spot on the island there. Nine of his figure paintings and seven riverscapes have been identified with Chatou, and several others, including *The Canoeists' Luncheon*, whose sites cannot be specified with assurance, apparently also show its banks.

The attractions of Chatou were well appreciated by the middle of the century. It was only nine miles from the Gare Saint-Lazare, and by 1841 was served by stations on both sides of the river, at Chatou and Reuil. Joanne's guide of 1856 lists a population of 1,200 for the village, clustered on the west bank

around the highway bridge, but he noted that since the railroad had made it so accessible, the once large eighteenth-century estates nearby were being cut up for pleasure villas. The rising bourgeoisie could prove it was taking over the country, for it now built homes on lands once owned by Louis XV's minister Bertin and the chancellor de Maupeou. *L'Illustration*, in the series of articles that touted Bougival and the Grenouillère, wrote that Chatou, formerly "a mediocre village," could now boast that "A whole colony of Parisians, friends of country life, has spread along both banks of the river. Elegant villas have taken the place of little rustic houses."[45] Its population rose to 3,000 by 1886, but through the impressionist era the nearby riverbanks were more open and verdant than at Argenteuil or Bougival.

The Seine at Chatou was divided into two channels, separated by the continuous band of narrow islands that ran for miles, beginning at Bezons, just south of Argenteuil, and continuing past Chatou around to Bougival and Port Marly. From the road bridge, which crossed over the southern tip of Chatou Island, there were stone steps down to a jetty that led to the wider Chiart Island (also called Chatou Island). The Restaurant Fournaise was there, facing Reuil, and just south of it was the railroad bridge that rested on the island on its passage across the Seine. It shows in the distance of several of Renoir's paintings and, more prominently, in *The Railroad Bridge at Chatou* (Pl. 249). Here we are positioned in a fenced-in clearing (a private garden or the courtyard of a café) on Chiart Island, looking south; in the gateway is a man in a straw boater. It is the ideal setting for leisure: domesticated flowers and trees surrounding a clearing alongside the river, and above, the means of getting there, a bridge so generously enveloped in foliage that it makes a graceful capriole, not a dynamic industrial leap. Further downstream, beyond the railroad bridge, a narrow spit of land linked Chiart to Croissy Island. The Grenouillère was therefore only a ten- or fifteen-minute walk from the Chatou bridge.

Commercial traffic used the deeper west channel of the Seine at Chatou and Croissy, leaving the other, on the Reuil side, mostly for pleasure-boating. The Reuil shore was less built upon, and the islands were largely in fields and woods, sprinkled with a number of small boaters' cafés and more ambitious, if still casual, *guinguettes*, generally, like the Grenouillère, offering some cabins and rooms together with food, drink, rental boats, and dancing. Many artists and writers lived in Chatou and Reuil, and others, like Flaubert, François Coppée, and Renoir, were regular visitors. Guy de Maupassant was an avid rower and sailor who favored the river near Chatou, which he described in a number of short stories. Perhaps it was Maupassant whom Louis Barron had in mind when he described the bend of the river near Chatou as "an artificial paradise, whose changing elect are millionaires ruining themselves or artists getting rich."[46]

Renoir's most famous painting of Chatou, *Luncheon of the Boating Party* (Pl. 251), begun in late summer, 1880, shows the terrace of the Restaurant Fournaise whose spirited clientele was described by Maupassant (as the "restaurant Grillon") in *La Femme de Paul* (Paul's Mistress) of 1881. The painting is devoted to this society, but its view of the river, framed by tree-top foliage and the translucent awning, is more than a mere backdrop. It instantly identifies a riverside restaurant whose customers were boaters and their friends. Thanks to patches of white and flashes of orange-red, we see two sail-boats, one rowboat and, on the left edge, a moored barge with a red-roofed building on the bank above (Pl. 252). Barely discernible is the railroad bridge, up behind the scalloped edge of the awning (which flutters to the same breezes that favor the sailboats). Dominating the river view is Alphonse Fournaise, son of the proprietor. His muscular arms served him well, since he helped launch the boats that the establishment rented out from its quai below. He wears a straw hat, and so does Renoir's friend Lhote, in the upper-right corner. Brim up or brim down, with or without a band, it was the current form of a boatman's sun hat, derived from a cheap country

model of woven straw; Manet gave it to his sailors at Argenteuil and to Monet (Pls. 236, 238, 239), and Caillebotte to his oarsmen (Pls. 246, 248). Three of the women wear variations of this basic straw hat, and in the right corner, a young customer sports a more citified and debonair boater, the kind worn by several men in *Dance at the Moulin de la Galette* (Pl. 135). (He was apparently modeled by Caillebotte, by then a close friend of Renoir's.)

The hat and costumes in Renoir's picture tell us a great deal. Alphonse Fournaise is paired with the man opposite, who looks in his direction. The client's bare arms and shirt are the certain sign of the *sportsman* who emulates the real riverman. Alphonse's gaze takes us back to the top-hatted man (the model was Charles Ephrussi, rich collector and writer), in a contrast of male types that foretells Seurat's *Sunday on the Island of the Grande Jatte* of 1886. Two men wear bowlers. One of them, in the upper right, is Lestringuez, Renoir's comrade who, with Lhote, had appeared in the picture of the Moulin de la Galette. The other, in the center, his back to us, was posed by another acquaintance, the former cavalry officer baron Barbier, equally a friend of Maupassant. Furthest back is a man wearing what appears to be the mariner's cap that was more favored a generation earlier. Completing the masculine assortment is the bareheaded young man in his *chic* striped smock; he is yet another member of Renoir's circle, the journalist Maggiolo. Chief among the women is Aline Charigot, Renoir's future wife, who purses her lips at the hirsute lap dog. Below the top-hatted Ephrussi, raising her glass, is Angèle, a teenaged model from Montmartre. The originals of the other women are disputed, but the woman in the upper right, adjusting her hat with gloved hands (she is about to leave), wears the costume appropriate to an actress or a woman about town.

The luncheon picture is a suburban equivalent of *Dance at the Moulin de la Galette*, and the artist's most ambitious figure composition since 1876. It also shows Renoir's preferred grouping of writers, artists, and models, set off by the local restaurateur-boatman and the top-hatted collector, a relaxed and harmonious society dominated by men (they outnumber women by nine to five) for whom women are models and *matelottes* (female sailors) to be admired. It is a world of convivial but unprovocative sensuality, built around a table full of good things that are painted with a lushness worthy of Velasquez, worthy also of the still life in Manet's *Bar at the Folies-Bergère* (Pl. 80). Except for its colors and brushwork (big exceptions nonetheless!), Renoir's painting is more traditional than Manet's, and its forms are more sculpturally rounded that those of his own *Canoeists' Luncheon*, a smaller and less formal canvas. It is a large exhibition picture whose conservatism harks back to Renaissance and baroque banqueting scenes. The figures form a hollow for the splendid table: those on either side look towards the center, and two in the rear look frontwards. So stable is the result that we hardly notice the signs of impressionist structure that depart from tradition: the high horizon line, the rapid plunge into depth (the heads of the rear figures are "too small" for the distance, like many of Degas's), the diagonal of open space that separates the two on the left from the others.

Renoir, not usually thought of as a cunning painter, wove

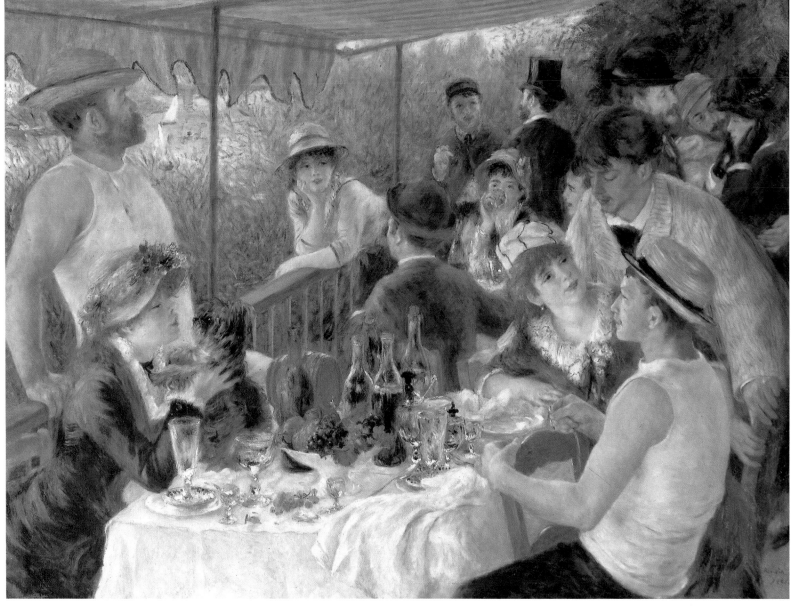

251. Renoir, *Luncheon of the Boating Party*, 1881. Washington, Phillips Collection.

his picture together by adroitly adjusting his edges and colors. The top of Alphonse Fournaise's hat just touches the awning (so does the tip of the adjacent sail), and it shares orange and yellow with the cloth above; the blue that edges his hat reappears as the band on the hat of the woman at the railing; the red of the awning's border has dropped down to mark her collar and cuff, and the same vermillion dances over the collar of the woman nearest us, on the right; Aline Charigot's head and hat are neatly framed by Alphonse's chest, and her upper arm continues the bend of his hand; one hand of the man in the right foreground lines up with that of the woman near him, and the prow of his boater fits snugly into the V of Maggiolo's smock; the crowd to the right of Alphonse and Aline forms a triangle, with its apex at the girl leaning on the railing; within the crowd the heads are arranged in triplets and pairs, interlocked by arabesques and reverberations of colors and shapes.

Lest we exaggerate the conservatism of Renoir's luncheon painting, we should take a look at his earliest effort of com-

parable theme and size; it will help us mark out the route he had traveled. *The Inn of Mother Anthony, Marlotte* (Pl. 253), done in 1866, was his first large figure piece. The inn was a rustic center for artists and bohemians who gathered near Marlotte, on the edge of the Fontainebleau forest. They coated the plaster walls with caricatures, which show in Renoir's canvas; the one in the upper left reproduces his own contribution, a burlesque of Murger, author of the famous *Vie de Bohème*. In the subject, as well as in the dark tones and rounded forms, Renoir's painting recalls Courbet, the controversial mid-century realist and self-proclaimed socialist who was a hero to the younger vanguard. The woman clearing the table is a Courbet type, Nana, the daughter of Mère Anthony, who glides away to the right. The standing man, preparing his tobacco, is Renoir's older friend, the well-off painter Jules Le Coeur, with whom he frequently stayed at Marlotte, and whose family commissioned pictures of Renoir. Below him is an unidentified man, but the seated figure with a broad-

249

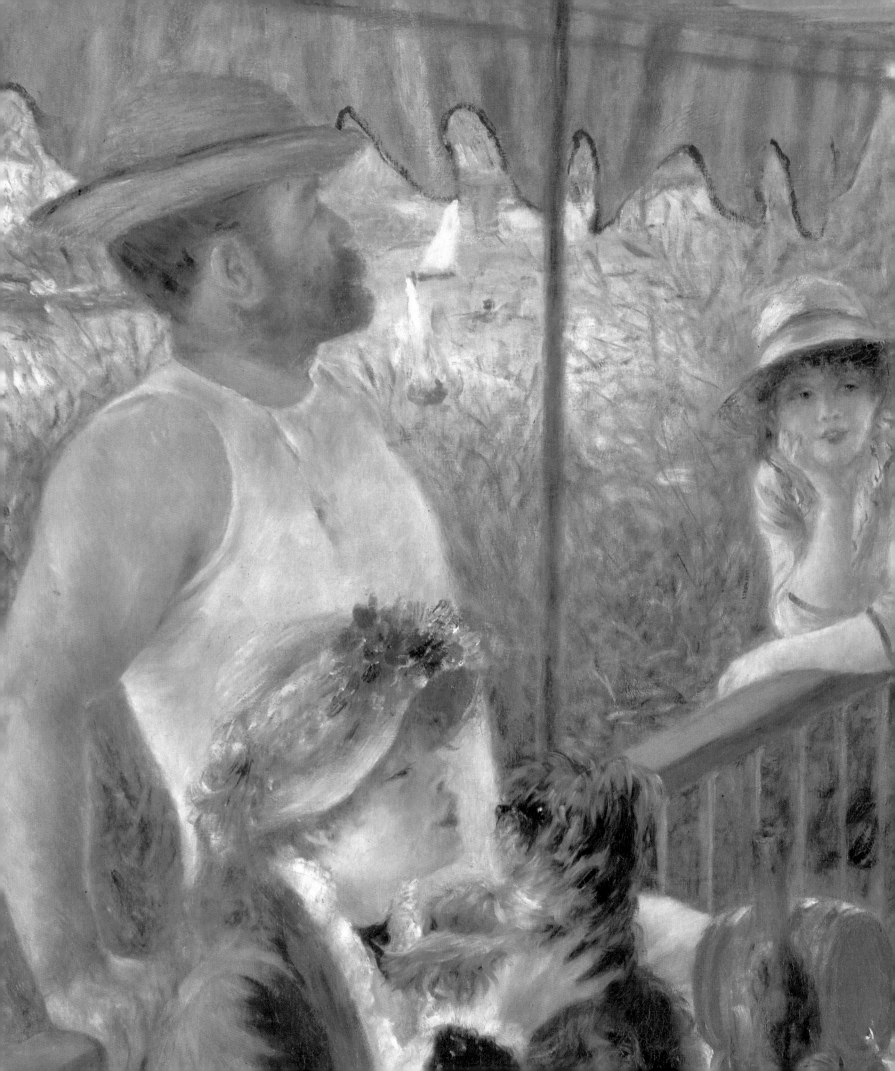

brimmed hat is known to be Sisley, who was working with Renoir at Marlotte. On the table is *L'Evénement*, the Paris newspaper which that spring published Zola's reviews that took up the cudgels for Manet and favorably mentioned Monet. These are three young men who continue to discuss Parisian events while outside the city to partake of a "natural" environment. Artists of democratic leanings, they feel close to innkeepers and villagers, who were a welcome contrast to city sophisticates. They look forward to the artists and writers in the Chatou luncheon composition, as Nana does, to Alphonse Fournaise.

In the leap from Renoir's Marlotte inn to the Chatou restaurant, a whole generation seems to have intervened. The changes are equally in the subjects and the ways they are painted. The ordinary china cups and plates, the pears and the bread at Mère Anthony's, have turned into stemware, compotier, liqueur, and grapes at Fournaise's. Wood beams and plaster are exchanged for striped awning and railing; a dark village interior, for the luminous edge of a river; sober, plain-spoken cloth and brushwork, for canoeists' costumes and brilliant colors. In the fifteen years between the two pictures, Barbizon art has been converted to Impressionism, social realism to suburban realism. Both restaurants were artists' haunts, but Mère Anthony, content to have them "discover" her inn, has been replaced by Monsieur Fournaise, an entrepreneur like Seurin at the Grenouillère or Sari at the Folies-Bergère, who uses the fame of visiting artists to assist a thriving business in leisure.

Contemporary writers often tell us of the ways in which old inns and country drinking places were transformed by the ever increasing number of Parisians coming out to the suburbs. The *flâneur* Alfred Delvau, for example, writing in 1862, lamented the spoiling of a favored village restaurant, Au Père Cense, near Fontenay, south of Paris; it would be the rough equivalent of Mère Anthony's in nearby Marlotte. He loved it partly because of the artists who went there, including Courbet, Murger, and Baudelaire. He regrets that he and his friends who had "discovered" Père Cense had to witness its alteration (note the disdain for the ordinary middle class):

For a dozen years, this bouquet of villages is peopled every Sunday with promenaders who formerly would not have known the way there.... thanks to their reiterated encouragements, this adorable spot has been made into a sort of fair, ornamented with restaurants and pistol shoots. It absolutely lacks gaiety and poetry. These aimiable Sunday Parisians could not touch a painting by the good Lord without spoiling it; they have found the means of replacing the woodsmen and hamadryads of former times with picnic debris and empty wine bottles.

He then describes Au Père Cense, at the beginning, a plain thatched cottage where one shook Père Cense's hand, patted his dog, and then had a glass of wine at a simple wooden table under the trees. Alas!,

Where is it now, Père Cense's old wine barrel? Plaster and stone have replaced the thatched roof and the walls of yellow earth, so picturesque in their nudity, so clean and joyous in their simplicity. There are still wine barrels and

the arbor of poplars, but they are hidden, as though shameful, by constructions serving as dining rooms for ladies and gentlemen who hope to rediscover Paris in the countryside. One wears silk dresses these days in Père Cense's cabaret... and on silverplate, attended by waiters in proper jacket and white apron, one dines on all manner of charming things, but detestable, and very expensive.[47]

In Renoir's own life, he made the change from Mère Anthony's to the boater's restaurant at Chatou—without regret. The history of Impressionism is in part the acceptance of, even the indulgence in these changes. Courbet, Millet, Corot, perhaps even Delvau, could still feel close contact with villagers, but by 1880 most of the impressionists were too urbanized for that, too devoted to exploring contemporary life; Mère Anthony and Père Cense were an anachronism by then for the vanguard, even though hordes of tourists, not yet up with Impressionism, were descending on Ganne's inn at

253. Renoir, *The Inn of Mother Anthony, Marlotte,* 1866. Stockholm, Nationalmuseum.

252. Renoir, detail of *Luncheon of the Boating Party* (Pl. 251).

251

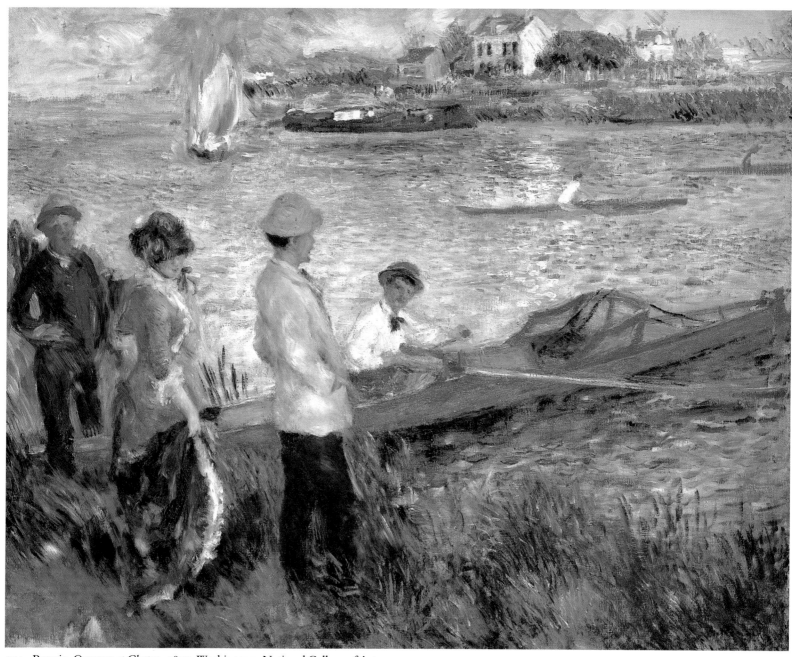

254. Renoir, *Oarsmen at Chatou*, 1879. Washington, National Gallery of Art.

Barbizon and other quaint places where they could sit in seats once warmed by artists and look at their caricatures on the walls. It is true that Pissarro and Cézanne maintained the outward appearance of Barbizon artists, and something of their identification with villagers, but neither of them was a Parisian. Renoir preferred the company of artists, writers, and rowers at Chatou.

One more painting will complete Renoir's gamut of boaters' leisure at Chatou. In *Oarsmen at Chatou* (Pl. 254), the riverside restaurants are somewhere behind us as we look from Chatou Island over towards Reuil. On the opposite bank is La Mère Lefranc, a well-known inn that catered to boaters; its shaded courtyard extends to the right.[48] In front of it, a barge is making its way slowly upstream, but, in contrast to Monet's powerful barges at Asnières (Pl. 200), it gives only a hint of commerce. It is framed on the left by a sailboat, and

on the right by two single sculls, loosely sketched in. The centerpiece of the picture is the two-person gig that angles across the foreground. These gigs were built for one rower and a passenger, who faced forward and adjusted the rudder with two hand-held lines. Such boats were favored by amateurs for their ease in steering and their companionability (in another painting Renoir showed two women in an identical boat),[49] but they were also used by skilled oarsmen in competitions. Here the rower, holding his boat against the current, is apparently issuing an invitation to one of the people on the shore. He is dressed in an urban rower's garb, flat-topped straw hat, white shirt, and flaring tie. He faces a man identified as the painter Caillebotte, equally in the dress of a gentleman boater. The four figures (the woman is Aline Charigot) are loosely, if symmetrically arranged, implying their companionship and shared interests, with none of the provocative

252

contrasts that Manet gave the two boaters of his *Argenteuil* (Pl. 239), and none of the aloofness that Monet manifested in front of his silently moored boats. The trousers and skirt of the two figures nearest us almost merge with the marshy vegetation, but their upper garments, where they reach the level of the boat, change color to suit the bright hues and light tones of boat and water. Lushness is the word for Renoir's color, as well as the setting: saturated oranges and orange-reds against blues and greens. Full sunlight explains the prominence of the oranges, whereas in *The Canoeists' Luncheon* (Pl. 250), the shaded terrace is bathed in indirect light, hence its preponderance of blues. The different palettes of these two pictures, in other words, is consistent with Renoir's manner of making color suit varying conditions of light.

Renoir's bright colors have mellowed with time, and because we are familiar with Matisse and other modern colorists, we readily accept brilliant oranges, blues, yellows, and greens as part of a vision of beautiful "nature." Orange boats, however, could hardly be regarded as blending with nature and, like the boaters' costumes, they stood out against traditional river colors and shapes. Ostentatious assertions of leisure and class, they were the clamorous tones of city dwellers laying claim to the river. In the seventeenth and eighteenth centuries it had been aristocrats and wealthy bourgeois who had launched boats on these same waters, but it was rivermen and servants who rowed them about. Now it was the far more numerous middle class that vacationed on the dismembered estates, many of them self-made men (or aspiring to be such) who propelled themselves in slender craft, created specifically for sport. Like Caillebotte, Alphonse Karr, Maupassant, and the Goncourts, Renoir conceived of boating as a perfect expression of modern life, of middleclass—and artistic!—liberty, hedonistic enjoyment, essential escape from city work. In the Goncourts' *Manette Salomon*, the phrases that accompany Anatole's boat down the Seine harmonize well with Renoir:

> . . . foliage pocked with shadows, copses edged in strips of grass worn by Sunday walks; barks with their vivid colors drowned in the trembling water, moires stirred by moored yawls, sparkling shores. . . . On the hillsides the splendid daylight gently deposited the sweetness of velvety blue into the hollows of the shadows and the greens of the trees. . . . On little islands, red-roofed houses with green shutters stretched out their yards full of gleaming laundry.[50]

The strong colors and liberated hedonism of the Goncourts and Renoir were insistently modern, and yet we easily see, especially in the painter, that there were substantial links with the past. Renoir's *Oarsmen at Chatou* is not merely a representation of friends along the Seine, it is an allegory of summertime, a modern version of a humanist theme, prominent since the Renaissance, that managed to thrive in a Christian culture. The picture has the air of a fable, of an ideal world of leisure without work, of sensual pleasure without tarnish (none of the floating detritus and scattered picnic debris that contemporaries complained about). Its modernity should not blind us to its participation in this age-old European tradition. For example, Renoir's older contemporary, Puvis de Chavannes, painted more than one allegory of summer. In *The Pleasant Land* (Pl.

255. Puvis de Chavannes, *The Pleasant Land*, 1882. Yale University Art Gallery.

255), as in *Oarsmen at Chatou*, life is easy.[51] Women and children rest and play, fruit is easily gathered, and men draw fish from the sea with little effort. No industry here, for Puvis created his comforting arcadia, with its vaguely classical garments and poses, as compensation for the constant upheavals in modern society. He drew from the Mediterranean past, that deep well of history, myth, and art which still nourished so many of the French, even as they voyaged rapidly into a new era.

Puvis, recipient of numerous commissions for public buildings, offered contemporaries a reassuring version of familiar ideals of leisure, invigorated by a deliberate primitivizing style (the reclining woman, hand on hip, anticipates Gauguin and Picasso). His colors are subdued and his forms flattened, recalling the tones of sculpture and of old wall decorations. Their organization follows a compositional archetype well established in earlier centuries: the land occupies the lower-left foreground, and some of the figures, by looking to the right, aid the sweep of our eye in that direction. They, and we, look out over a body of water that is a passage to another shore off in the distance (the water is a triangle that repeats, upside-down, the shape of the land). Renoir used the very same structure—proof of his ties to tradition—and his picture also removes us from the city by engaging us in longings for an unspoiled realm. The contrast with Puvis nevertheless tells us much about both artists. Renoir's peaceful land, idealized though it is, was on the edge of Paris. It was a tangible, reachable place, a goal that one could strive for, a blending together of the real and the ideal, of past and present.

Renoir succeeded more than Puvis in modernizing tradition, in making it a viable element of vanguard practice and, eventually, part of the dominant pictorial conception of the modern era. The tug of tradition was always strong in Renoir, and just four or five years after *Oarsmen at Chatou*, he turned openly towards past art (his "Ingres" or "Sour" period). That might seem a reactionary turn against Impressionism, but we can see it also as a way for the energies of Impressionism to penetrate the somnolent body of grand art, giving it enough life to appeal to the younger generation. The upstart Seurat, in his *Bathing Place, Asnières* of 1884, made a radical style by mixing Impressionism with the classicizing tradition (he was called a "modernizing Puvis"). Furthermore, Renoir's Ingres period underpinned Maillol's monumental nudes at the turn

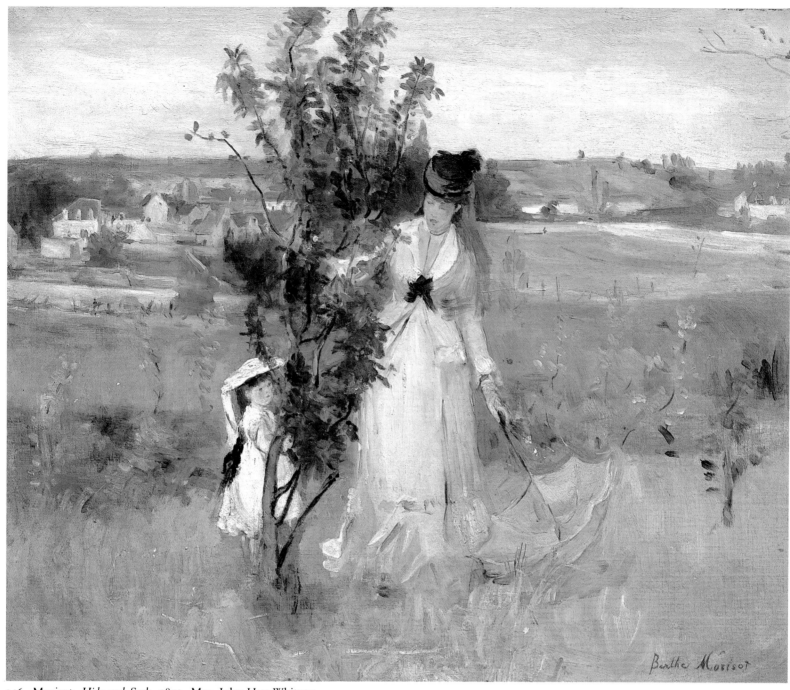

256. Morisot, *Hide and Seek*, 1873. Mrs. John Hay Whitney.

of the century and also had something to say to Matisse and Picasso. As for his impressionist work at Chatou, the Fauve paintings of Derain and Vlaminck, done twenty-five years later along the very same shores, are unthinkable without Renoir, whose vivid oranges and blues proved their efficacy in translating the imagery of leisure.

Artists' Gardens

Renoir created images of the perfect suburb, where benign nature was arranged to suit the young Parisians who had come out from the city. No old, infirm women or men in his pictures, but beautiful young ones; no hard labor, but play; no picnic debris, but flowery banks. Chatou and the other riveraine suburbs became pleasure gardens in his compositions, so much so that it is often impossible to specify the sites. Young couples sit or stroll in a flowered glade or along a lush embankment that might be anywhere in this pleasant world, since it was invented by Parisians as a stage for their leisure. Even when a particular place is identified, as in *The Railroad Bridge at Chatou* (Pl. 249) we seem to be in a garden or at the edge of a park. Monet made the same juxtaposition in his *Train in the Countryside* (Pl. 218), where we see the train across a park whose strollers look over at us. The trains are a reminder that "nature" in the suburbs was increasingly in the hands of the various enterprises that profited from leisure: the railroads, the boat-rental agencies, bathing establishments, village fairs, riverside *guinguettes* (Seurin's Grenouillère, Four-

naise's restaurant). Parisians and visitors to the capital expected nothing less.

The great gardens of Paris, meanwhile, overtop even the *cafés chantants* as "side-shows." Asnières, a few miles from Paris, on the Versailles and Saint-Cloud railways, is the most popular of the suburban gardens; and there is no special description of it necessary, for when trees, flowers, lights, music, crowds and unrestrained dancing are mentioned, and the additional suggestion is made that they are all in perfection, the whole fact suggests itself to those who have any "experience." This of the night: by day Asnières has its boat-races on the Seine....[52]

The suburbs and the near countryside were also gardens in the quieter sense of the term, well-disposed places where one could seek out a personal if not a private experience. Renoir, Monet, and Morisot did many pictures that show figures strolling through meadows near suburban villages, or along the Seine. These are invariably women, or women accompanied by children, as in Morisot's *Hide and Seek* (Pl. 256). They do not play the peasant, but wear the dress of middle-class visitors from the city. Men are seldom present in such compositions because of the venerable association of women and children with nature. Men were placed in other settings suggestive of productivity or energetic display (in the suburbs, this meant rowing, sailing, or courting women). Women were more appropriately positioned among flowers and fields, those signs of nature's bounty, a bounty that seemed to spread itself out, like the flowers, without hard work. Morisot's woman and child play around a flowering bush that rises from the broad fields for their pleasure, a symbol both of their leisure and of the fruitfulness of the land. This is a very companionable "nature," one that suits the middle-class city dweller very well since it does not remind her of sweat, of poverty, of those other women who bend their backs in the fields or in the barns. Morisot, like Monet and Renoir, represented her generation's aspirations by turning her back on dark forests, rocky glades, rugged hillsides, and laboring peasants, the images now hopelessly romantic that had dominated the work of Courbet, Millet, and Théodore Rousseau. She favored instead the subjects and the techniques of Corot and Daubigny, major predecessors because they had preferred the country stroll to mountain fastnesses and farm workers. Landscape indeed rose to great prominence on the Paris art market, but in Morisot's generation it dealt mostly with the garden suburb, less often with the more remote places free of the city's presence.

Morisot's models were apparently her sister Edma and her daughter, whom she frequently visited at their estate in Maurecourt, near Auvers on the Oise river, northwest of Paris. She often showed them in their park-like garden, usually with another child. In *The Butterfly Chase* (Pl. 257) a young woman poses for us, holding her net at an angle that links a young sapling with an ancient flowering bush. On the other side of the sapling one child also poses for us, while another has squatted down to reach for a flower or a butterfly. Beyond her, barely decipherable through the foliage, a woman sits reading, facing away from us. Despite the neat framing of the central woman, the picture has a casual order and a light touch that suit this kind of garden, a *jardin anglais* or natural

257. Morisot, *The Butterfly Chase*, 1874. Musée d'Orsay.

garden, more popular now than the formal French garden, which carried the connotations of imperial order, no longer desirable.

Later, after her marriage to Manet's brother Eugène, Morisot continued to favor suburban gardens. Vacationing at Bougival in the early 1880s, she painted her daughter Julie in the garden of their rented villa, sometimes alone, sometimes with a maid, and often with Eugène. *Eugène Manet and Daughter at Bougival* (Pl. 258) shows Julie playing with a large toy set (perhaps a train station?) supported on her father's lap. Typically impressionist, Morisot presents them in a dispassionate manner; their closeness is evident from their shared activity, but not from any overt diaplay. Both are in the proper country costume of well-to-do Parisians, rendered in the unique sketchy manner that Morisot had developed over the several previous years. The feeling of pervasive color-light is captured in dashes of light-toned strokes that hover and dance around the figures' edges, without defining their three-dimensional substance (Pl. 259). It is a technique that roughly parallels the changes in Monet's and Renoir's work over the decade of the 1870s, but her strokes dart about the surface more than theirs do, like so many large electric sparks that have a vital energy of their own. She worked on a ruddy-colored ground that shows prominently along the left edge and bottom. Unlike the off-white grounds that Monet favored, it acts as an intermediate tone, a foil for the light colors that run over it; it is a basic constituent of Eugène's brown jacket.

While Morisot was spending that summer of 1881 at Bougival, Manet had rented a house at Versailles, and there painted *The Bench* (Pl. 260), one of the most memorable of impressionist gardens. He had gone there to seek rest from the debilitating disease he had suffered from since 1879, the locomotor ataxia that killed him two years later. When viewing this picture, or those done in the garden of his rented villa at Reuil the following summer, we inevitably think of his early death and are unable to set aside the poignancy that results.

258. Morisot, *Eugène Manet and Daughter at Bougival*, 1881. Private collection.

We should not feel guilty, however. Art is not a "pure" experience, and we always bring to a picture a whole set of associations. Manet had moved to Versailles for the repose offered by the suburbs, and we share with the artist and his doctor, who urged him to seek a restful place, the idea of consoling nature (consolation and condolence are closely linked).

Manet had gone to Versailles with the intention of painting Le Nôtre's formal gardens. Their fame and elegance would have been suitable challenges to his ambitions. However, hampered by his illness, he had to give up the idea: "I've had to content myself with painting only my garden, which is the unloveliest of gardens."[53] By Le Nôtre's standards, his rented garden was indeed modest. The grassy areas are untrimmed, geraniums rise from a rough mulch, and only a sparse growth makes its way up the trellis to the rear. A sense of delicate

abandon hovers over the garden, abetted by the artist's yellow smock tossed over a bush behind the bench and by the untenanted bench itself. In front of it stands a brass and marble table that holds a carafe of water (or perhaps a vase). The brilliant reds of this garden, vibrating against the greens, are a recompense for what Manet deemed unloveliness, as is the secondary pairing of attenuated yellows and purples. There is also a nicely calculated, very French order to the arrangement. The bench emphasizes the diagonal of the path that takes our eye back to the horizontal run of the multi-arched trellis. Morisot, in the painting of her husband and child, had much the same organization (if we discount the two figures), but the exuberant drift of her brushstrokes and her more complicated palette give a quite different result.

The forms of Manet's painting look quite crisp compared

259. Morisot, detail of *Eugène Manet and Daughter at Bougival* (Pl. 258).

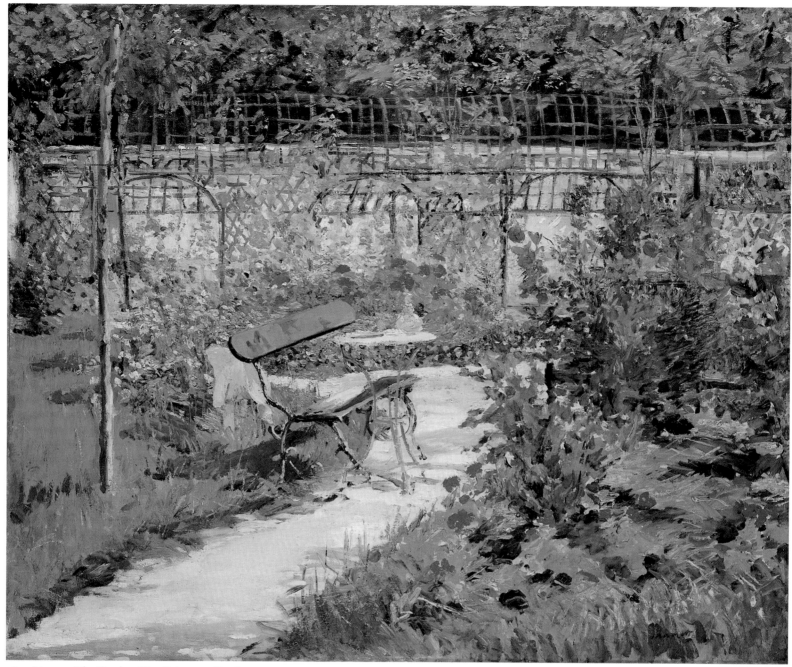

260. Manet, *The Bench*, 1881. Private collection.

with Morisot's, but regain their informal character when placed alongside yet another impressionist garden, Caillebotte's *Orange Trees* (Pl. 261). This picture has something of Le Nôtre's formality both in its organization and in its imagery. The intimate character of Manet's and Morisot's paintings is missing, for instead of small rental gardens, we face the grounds of a large estate. Paradoxically, the property of Caillebotte's family at Yerres seems more "public" than the other artists' rented spaces, for it has been arranged like the grounds of a great château, whose patterns are traceable to functions and privileges of state. The same patterns were used in the gardens that successive governments provided to the public, so Caillebotte's metal chairs, boxed trees, and neatly trimmed paths would suit a corner of a Parisian park. This mixture of private and public finds expression in the contrast

of the setting with the isolation of the artist's brother Martial and their cousin Zoé, each lost in private moments of reading, like visitors to a public garden who have retreated into personal spaces. (Except for his slippers, tokens of the domestic setting, Martial is dressed just as the artist himself is, in Renoir's *Oarsmen at Chatou*, Pl. 254)

The odd perspective and the color contrasts of Caillebotte's painting contribute to its strange aspect. The bottom half is dominated by purples that form a very separate realm from the intense greens and orange-reds above. Nothing here of Morisot's interwoven hues nor of Manet's unifying balance of warm and cool tones. The foreground is curiously foreshortened (a slatted bench, which might have explained the sharp recession, is mostly hidden by Martial's folded figure), and the distance is flattened like a theater backdrop. Although we

know the land rises upwards, there is little to explain its tilt. Zoé's silhouette, psychologically remote from Martial—and from us!—separates the two halves instead of uniting them, although her upper body is embraced by the curved lawn. We are therefore apt to conclude that the composition lacks Manet's finesse, indeed, that is is quite clumsy, but we should also think of painters of a decade later, of Gauguin, Emile Bernard, Paul Signac, and Seurat. The wooden finials of the planters, and the slumbering dog, have a prescient quality if we look at them from Seurat's vantage point. Caillebotte, halfway between the ages of Monet and Seurat, and the same age as Gauguin, was already leaving behind the qualities of the intimate and the personal, the private views that characterize the older impressionists, in search of the anonymous and the statuesque that Seurat exploited in his renderings of suburban parks and riverbanks.

Of all the impressionists it was Monet who was chiefly responsible for elevating the suburban garden to the ranks of the most admired and influential paintings of the early modern era. His pictures of the water gardens at Giverny are prized possessions and have led to the restoration of his house and grounds, now a popular tourist attraction although ungraced by any paintings. This phenomenon, by which an artist's life, his paintings, and a notable garden became interdependent, evolved only after the late 1890s, when the estate at Giverny came into its own following years of work (Monet had moved there in 1883). However, gardens had already loomed large in Monet's life and work much earlier. From 1872 to 1876, in his successive rented gardens at Argenteuil, he gave evidence of the ambitions only fully realized later at Giverny. He became an avid suburban gardener, lavishing much time on the gardens of the two houses he rented in succession, and painting at least thirty canvases of them. We have already seen one of them, *Camille Monet on a Garden Bench* (Pl. 182), introduced earlier in the context of flowers and fashion. Renoir and Manet also painted Monet's garden in Argenteuil, so it served as the center of intersecting friendships and rapidly evolving *plein-air* style.

The first rented garden appears in *Monet's House at Argenteuil* of 1873 (Pl. 262). His son Jean, elegantly dressed and holding a hoop, stands facing away from us on the firmly rolled sand. A woman, presumably his mother,[54] peers out from the ivy-clad house, fronted by rich plantings and a phalanx of oriental vases that the artist apparently brought with him from Holland. The foreground is in shadow, like that in Caillebotte's later *Orange Trees*, but the contrasts between areas of sun and shade are not very strong, and we have a more naturalistic result—within the canons of the new impressionist color and brushwork. *The Luncheon* (Pl. 265) shows a different view of the same garden, this time on a much larger canvas that Monet exhibited with the impressionists in 1876 as a "Decorative Panel." This appellation arose from its huge size, for unlike a smaller painting, it would take over a whole wall; the designation "decorative" also excuses its casual subject which lacked the prominent figures one would have expected in an ambitious painting. Jean, again dressed like a proper middle-class child, sits playing in the shade by the abandoned luncheon table. Its two place settings are matched by the two women who stroll to the rear. The

parasol and bag on the bench suggest that one of them is a visitor; the amusingly placed sun hat might be an auxiliary useful for country strolls.

These two pictures, along with *Camille Monet on a Garden Bench* and other garden scenes of 1872 to 1874 (fifteen altogether), create the impression of a prosperous middle-class home in the suburbs. Monet's belated marriage had taken place in the summer of 1870, and that fall he had fled France for a year. When he moved to Argenteuil at the end of 1871, he at last established a conventional bourgeois household. Although he was constantly borrowing money, he was selling more paintings and his family lived well for a time, cheered on, one assumes, by the mood of post-war reconstruction. It is therefore fitting that his garden paintings show his pride in providing wife and child with a comfortable garden where, appropriately dressed, Camille could receive visitors from Paris, like any other suburban matron. The Monets were among the city dwellers who moved to the suburbs in increasing numbers, no longer vacationers, but year-round residents who could easily reach Paris on the convenient rail line. (The Monets' rented house was across from the railroad station, which the artist painted several times.) The newcomers could pay more than the locals for lodgings and grad-

261. Caillebotte, *The Orange Trees*, 1878. Houston, Beck Collection.

259

262. Monet, *Monet's House at Argenteuil*, 1873. Art Institute of Chicago.

ually took over more and more of the village. Townspeople and farmers (the two were not always distinct) sold their land to Parisians or built villas for rent and sale; as a result whole new quarters arose on the edges of Argenteuil. Monet's district was one of those undergoing drastic change, a result of the railroad having been extended across the Seine at that point in 1863.

Monet's next-door neighbor, Alexandre Flament, a land-owning carpenter, built a new villa to take advantage of the burgeoning market, and Monet became his first tenant, moving there (at a 40% increase in rent) in the middle of 1874. The artist immediately set about gardening again, and before long had another flower-rich precinct for his always well-dressed child and wife. He devoted five paintings in 1875 and a further ten in 1876 to the garden. *Gladioli* (Pl. 263) is one of these and is typical of the later garden views in the way it

263. Monet, *Gladioli*, 1876. Detroit Institute of Arts.

crowds the canvas with blossoms, watched over by Camille Monet. Unlike the women whom Renoir surrounds with flowers in a number of contemporary paintings, she is not equated with the flowers as an example of sensual beauty. She is instead a stock figure, presented by the artist-husband less as an object of love than as mistress of his (rented) property, like the flowers, an essential proof of the good life; she is never shown at work. The flowers crowd forward on the surface, as they do in most of the later garden pictures at Argenteuil, giving a tapestry-like, enclosed space, rather than the open display of the earlier views. In *Monet's House at Argenteuil* (Pl. 262), the space is like that of a stage with side wings, and each area has its own brushwork. In the later painting the brushwork also varies with the images, but it is everywhere fluttering and shaggy and contributes to the feeling of a sultry closeness.

Flower gardens are such a pleasant feature of middle-class life that we might think that they always characterized villages like Argenteuil. Not so. Monet's flowers were those of the city dweller who has taken over village property to create for his family an ideal environment away from the city and its pressures, one that contrasts with the customary use of the land. A village garden of former days would look like those preferred by Pissarro (Pl. 264) with their vegetable plots, fruit trees, and often a few chickens or pigs. Elisée Reclus, the geographer, lamented the loss of these traditional gardens and their farmyard aspect. Like Pissarro, he preferred unspoiled

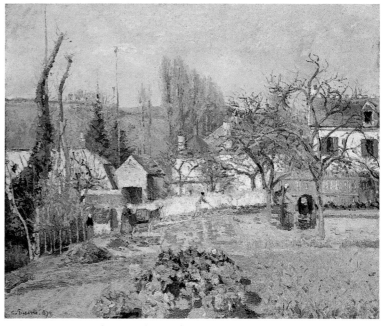

264. Pissarro, *Kitchen Garden at l'Hermitage, Pontoise*, 1874. Edinburgh, National Gallery of Scotland.

villages to those in the suburbs: "For strollers walking down the muddy lanes of this make-believe countryside, nature is represented only by well-trimmed bushes and masses of flowers seen through the bars of fences."[55] Pissarro and he shared a disdain for such gardens and instead felt close to Millet and earlier artists for whom peasants and villagers had formed a society devoted to work, not leisure. Van Gogh's

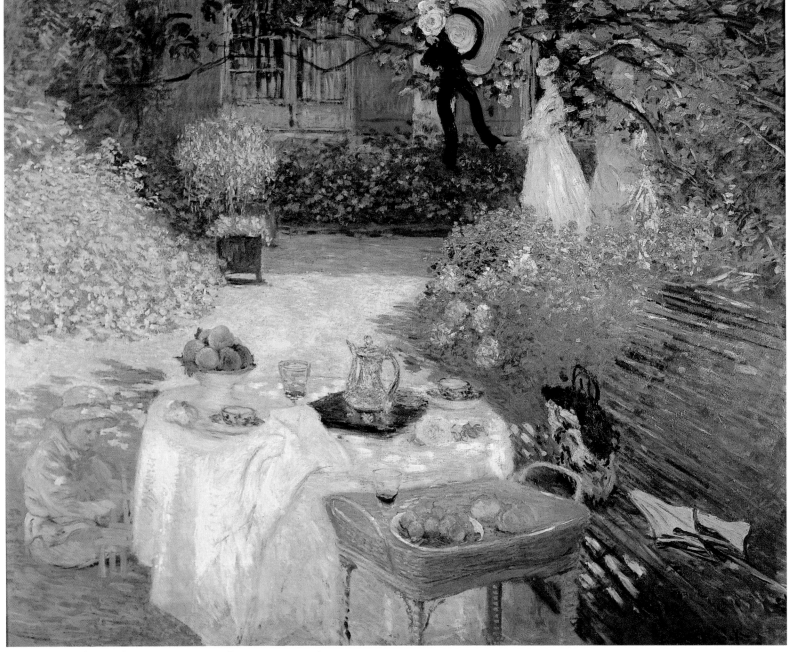

265. Monet, *The Luncheon* (*Decorative Panel*), 1874. Musée d'Orsay.

similar passions, in the next generation, show that Pissarro's old-fashioned ideals were not necessarily backwards, but for Monet, as for Renoir, they were. We could state the contrast in the form of an equation: Monet's flower gardens were to the old village plots as Fournaise's restaurant was to Mère Anthony's inn. In all domains, old country forms were giving way to new ones under the impact of leisure-seeking Parisians. For that matter, Monet's flowers had their equivalent among the new produce of Argenteuil. Thanks to the rapid transport that linked the village with Paris, and thanks also to the rising prosperity of the capital, there was now a thriving market for flowers, which became a rapidly expanding enterprise in the village. Each in his own domain, the flower grower and the flower painter were taking produce to Paris. "Monet is little attracted by rustic scenes," wrote Théodore

Duret; "you will seldom find rural fields in his paintings, you will not find cattle or sheep in them, and even fewer peasants. He feels himself drawn towards decorated nature and urban scenes, and prefers to paint flower gardens, parks, and arbors."[56]

Monet was constantly back and forth to Paris, and the garden pictures (and his active gardening) were certainly recompenses for his constant worries over finding a market for his art. His income had dropped off since 1873 and in 1876 totaled a little over 12,000 francs.[57] This was about six times the income of an Argenteuil worker (and does not count his borrowing), but Monet had been living high on the hog, and like any upwardly mobile entrepreneur, he had to scramble hard to raise money. He painted rather little that year at Argenteuil (the ten garden pictures were his principal effort

261

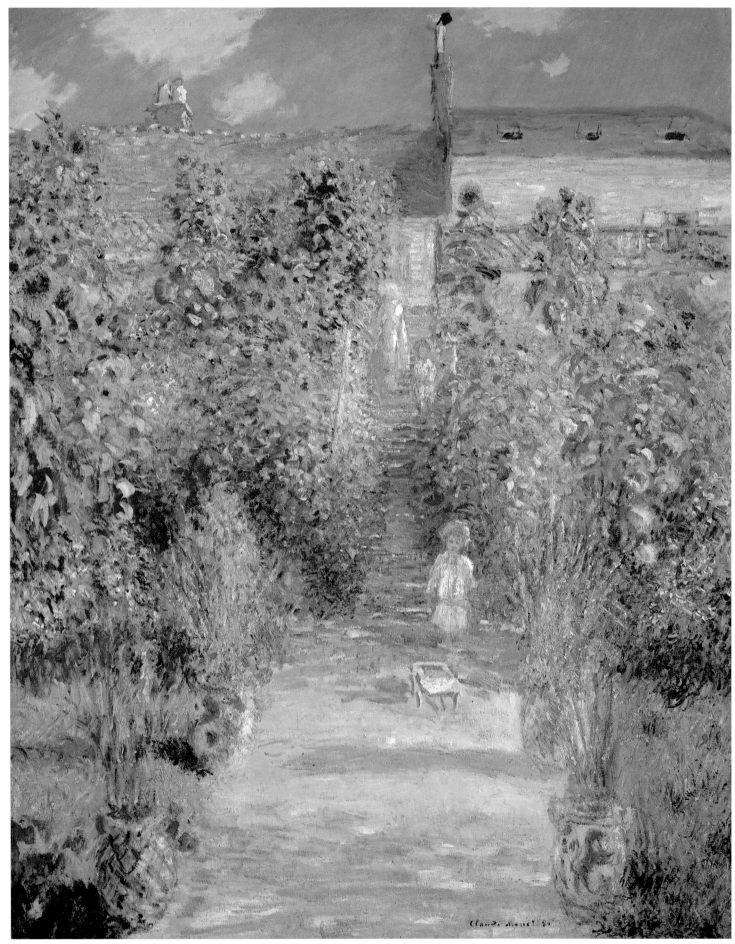

266. Monet, *Monet's Garden at Vétheuil*, 1881. Washington, National Gallery.

there), and spent much of the time away. In the spring he busied himself with contributing to the second exhibition of the impressionists and with numerous appeals to friends and possible clients. He painted views of the Tuileries gardens and of the Parc Monceau (Pls. 141, 142) with the express hope of finding clients for these famous sites. That summer and fall he spent at Montgeron near the Yerres, south on Paris, where he painted a number of landscapes on the grounds of the château of one of his clients, Ernest Hoschedé. Hoschedé commissioned him to do four large "decorative panels" (now dispersed) that featured his estate. The comparison between the real château and its splendid gardens, and the modest rented house at Argenteuil, must have been constantly in Monet's mind, but any envy of Hoschedé's estate would have been tempered by the facts.

Ernest Hoschedé was a flamboyant, but disastrous businessman, who was in the process of ruining his family's textile firm and of squandering the inheritance of his wife, Alice Raingo (the château was hers). An important patron of Monet and the other impressionists—Manet was his guest at Montgeron for two weeks in 1876—Hoschedé had been forced into two sales of his paintings in 1874 and 1875 and was in dire financial straits. He nonetheless lived on borrowed funds and retreated to Montgeron where "nature," ostentatiously embellished, was his solace. Did Monet see through him, or were they enough alike that the painter also lived on Hoschedé's hopes? In any event, Hoschedé went into complete bankruptcy in 1877, and the château was sold the following year. This was not the end of the Monet-Hoschedé alliance, however—far from it. Alice apparently became Monet's mistress while he was at Montgeron, and her sixth child, Jean-Pierre, is presumed to be his.[58] Like sailors roped together on a storm-tossed ship, the Monets and Hoschedés were thrown together. Monet was owed money by Hoschedé, and his market was affected by the financier's sales of his paintings. In their different ways, both had to race about Paris in constant crisis, selling and borrowing where possible. Neither was willing to give up a high standard of living. At Argenteuil Monet bought wine from Bordeaux and Narbonne, had two maids and a parttime gardener, and maintained a studio-apartment in Paris. When he left the village in 1878, his creditors were still clamoring for payment; he did not acquit his laundress's bill until 1891. Despite more staggering debts, the Hoschedés kept a household staff. In the summer of 1878 the two families joined households in Vétheuil, forty miles down the Seine from Paris, where the artist had found promising landscapes. Camille died the following year of a lingering illness, and Ernest took his distance. The new ménage was gradually accorded recognition, although they married only in 1892, after Ernest's death.

By 1881, towards the end of the stay at Vétheuil, Monet had once more found consolation in gardening. In *Monet's Garden at Vétheuil* (Pl. 266) we see again the oriental vases, stuffed with gladioli, brought from Argenteuil. Three children of the combined families look at us from the steeply rising steps, flanked by glorious sunflowers. We would hardly guess from this picture that this is a rented house, so firmly does the artist plant not only his vases and terraced ground, but also, with their aid, an idea of belonging. We would not guess, either, that a public road separated the garden from the house, any more than we sensed the nearby railroad when confronted by the dense blossoms of the Argenteuil garden. Monet's landlady at Vétheuil had allowed him to cultivate the land across the road from the row of tightly joined houses. It sloped down towards the Seine, which is at our back in this picture. For his children and those of Alice, formerly proprietress of a real château, he could paint this splendid garden, a real place of beauty, and an imaginary estate. Two years later they moved further downstream to Giverny, where eventually Monet planted extensive gardens, detoured a stream to make a waterlily pool, built successively larger studios, and received the visits of journalists, poets, collectors from America and Japan, leading government figures, and the president of the Republic.

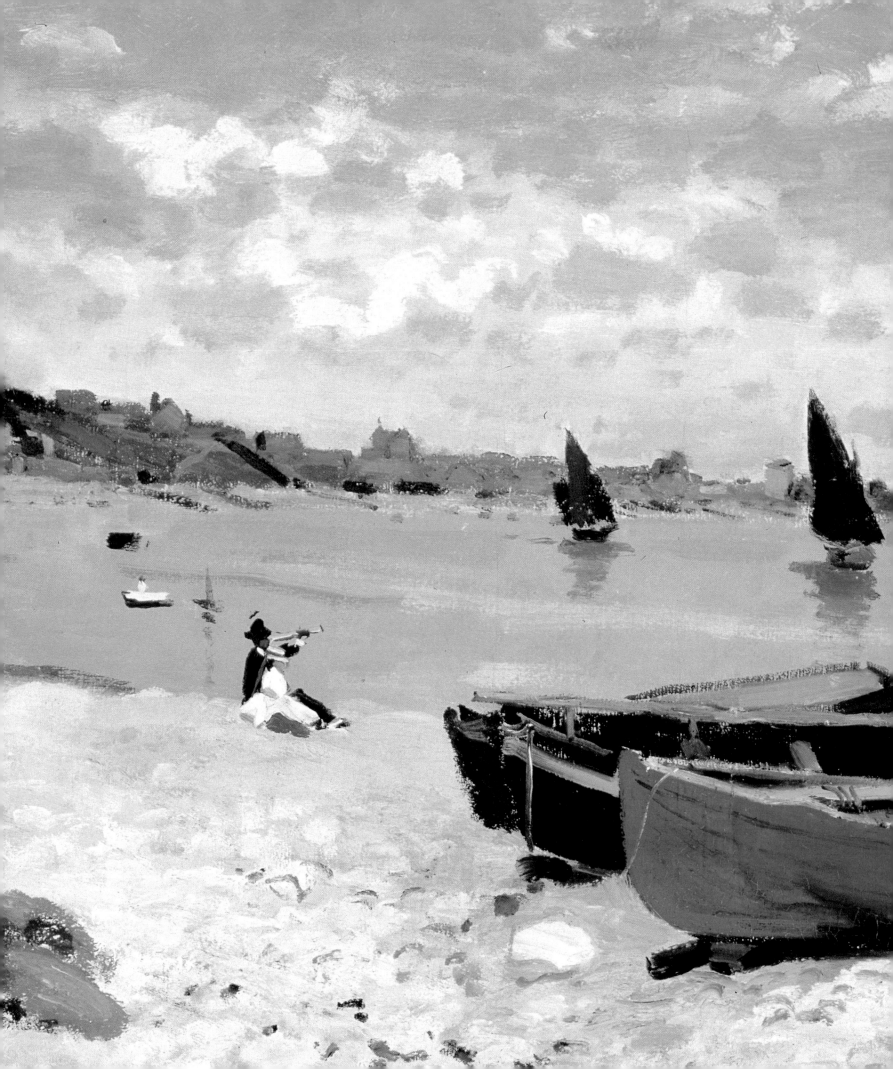

Chapter Seven
At the Seaside

[Sainte-Adresse:]...there reigns here still all the seductions of solitude, of silence, and of oceanic contemplation, although for a few years now the little houses, the taverns, the kiosks, and the pavilions multiply themselves in this delicious valley, preparing somehow, thanks to brick and stone, the hour of its imminent transformation.
 —Eugène Chapus, 1855

[Trouville:] It's the rendez-vous of sick people who are well, it is Paris, with its qualities, its foibles, and its vices, transported for two or three months to the edge of the ocean.
 —Adolphe Joanne, 1867

[Trouville:] The artists' excursions will one day be very profitable, because they *know how to look*, they do; they store up excellent materials in their memories.
 —Henri Létang, 1868

[Etretat:]...Parisian painters came to ask the beautiful cliffs of Etretat for inspiration and points of view which, reproduced on canvas, exhibited in our museums, bought by these too rare Maecenases who voluntarily exchange their gold for artistic works, carried far and wide the fame of these natural and splendid illustrations.
 —J. Morlent, 1853

The same forces that transformed the suburbs of Paris were also at work along the English Channel. Vacationers, ostensibly seeking nature, poured into fishing villages and larger ports in such numbers that traditional life there was forever altered. "Bathing" along the Channel meant the encounter of two peoples, both undergoing fateful changes: the leisure-seekers, mostly from Paris, and the locals, metamorphosed from fisherfolk into a servant class or into shopkeepers supplying the newcomers. A number of the natives retained their traditional costumes and became living illustrations, so that visitors could find the picturesque life that proved their distance from home. The confrontation of residents and visitors is the subject of numerous contemporary caricatures and illustrations. An anonymous engraving of 1866 (Pl. 268) shows an undeveloped stretch of shore near Boulogne. Several fisherwomen look at one of their number, who poses for an artist, probably for a modest fee. The draughtsman, in middle-class costume save for his mariner's hat, has unpacked part of the traveling kit that identifies him as a professional. Two well-dressed women and a child look over his shoulder and that of a prosperous older man, who perches his boater jauntily on the tip of his walking stick. Like some Mr. Cheeryble out of Dickens, he is reaching into his pocket for a few coins to give to the three local children who are begging. The vacationers may be a family group, but then again they may not, since tourists were thrown together during vacations without the reserve that kept them apart in their cities. This lowering of barriers was, in fact, one of the attractions of vacation resorts. Faced with quaint natives and a different landscape, they were drawn together because they shared their distinctiveness as strangers and as members of the leisured class. The otherness of the natives was essential to this feeling: it was the means of defining one's class. In the engraving, we can imagine the sense of well-being among the visitors as they stare at the locals. Giving alms confirms one's high morals and social standing, and drawing the natives is a proof of selfless, serious interest (although it is also an appropriation: the artist sells his work).

 The dialogue of vacationers with the local setting was an intermittent one, and the institutions of seacoast leisure allowed

268. *Sea Bathing at Boulogne, The Shrimp Woman*, 1866.

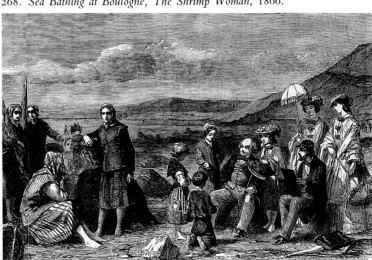

267. Monet, detail of *The Beach at Sainte-Adresse* (Pl. 294).

them to retreat into their own society. After a stroll beyond the resort out among fishing people and seaweed-covered rocks, they would return to their own kind in the hotels, casinos, and rented rooms. Alfred Stevens, the witty Belgian painter established in Paris (he moved in Manet's circles), treated this society in his *Trouville* (Pl. 269). No natives appear, nor does the beach. Against the backdrop of a sunny Channel, with its symbolic steamer and small sailboat, nine women, a child, two lap dogs, and two men lounge on a hotel porch. The preponderance of women was normal. They and their children stayed for several weeks at the shore, but often their husbands accompanied them only on holidays and Sundays, returning to work during the week (the Monday morning train to Paris was called the "cuckolds' train"). One man holds two women in conversation, while another looks towards a woman mounting the steps. She seems to know the woman who leans on the railing, having temporarily abandoned her fashionable Japanese parasol and her jacket. Further back two pairs of women read or chat, while in the foreground a mother knits near her daughter. The child displays her age in

that marvelously awkward pose. She is perhaps emulating the natives by working on a net; in any case, she wields her bobbin to make a net-like fabric. The abandoned book and the folding chairs are appropriate to the mixture of transiency and lassitude that characterizes so many moments of a vacationer's stay.

To Stevens's hotel society and to the engraver's encounter of fisherwomen and sightseers we should add a third image if we want to see more of the activity of seaside visitors. In Eugène Boudin's *The Beach at Trouville* (Pl. 270), the resort guests are out on the beach, near the portable bathing huts. In contrast to Stevens's fenced-off guests, who pay scant attention to sea or beach, Boudin's figures are saturated in moist sunlight. They are the same people who at other moments will lounge on a hotel veranda or walk out beyond the town to see the local sights. Here, the expanse of beach, water, and sky is more than a mere stage for their activities, it is the natural realm they have come to enjoy, and it almost overwhelms them with its vastness. Of course "natural" needs qualification. The view is certainly not that of untouched

269. Stevens, *Trouville*, c. 1880–85. Collection unknown.

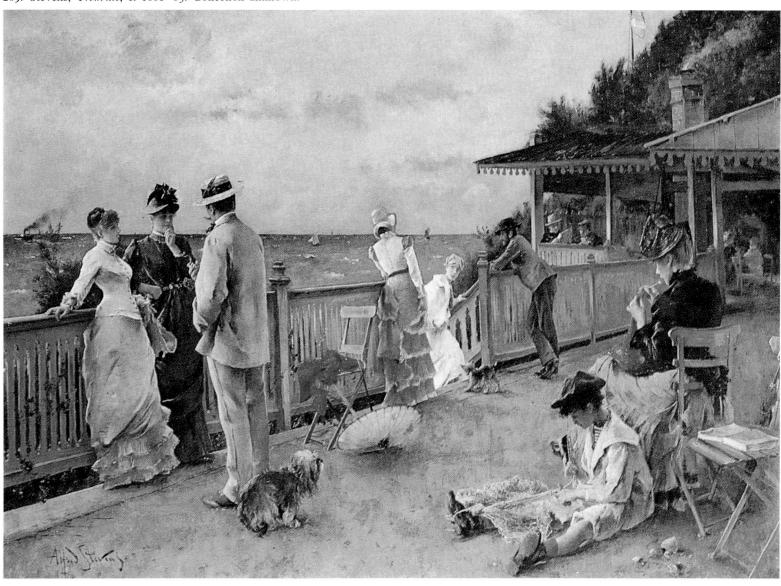

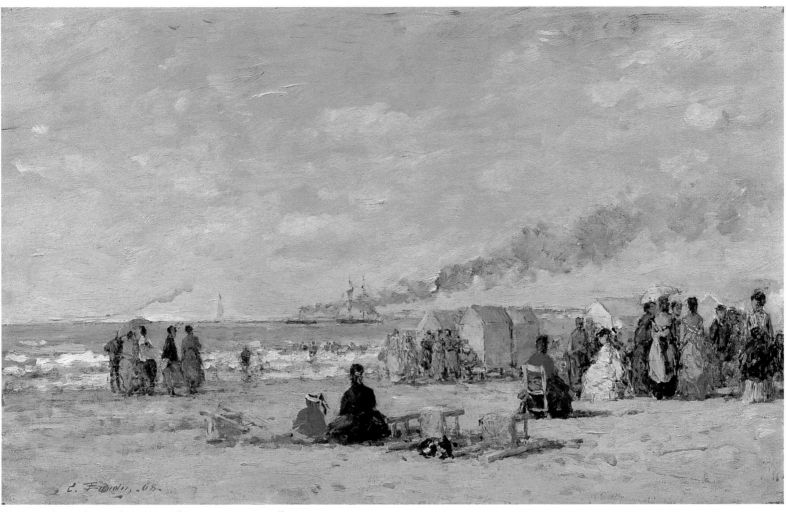

270. Boudin, *The Beach at Trouville*, 1868. Private collection.

nature (and none of the natural, local inhabitants are seen). We look across the broad estuarial bay of the Seine, towards Le Havre. A two-masted ship is partly obscured by the smoke from a steamer (sign of commercial enterprise and not of pollution, as our late-twentieth-century eyes might have it). This prominent plume, echoed by a thinner one off in the left distance, gives us a sense of the wind, and also figures the immensity of the sky.

The Channel coast was indeed far from the banks of the Seine, and in this open bay we are very distant from the enclosed space of the Grenouillère as it appears in Monet's and Renoir's paintings of the following year (Pls. 211, 215). The organization of Boudin's picture is correspondingly different. He places his figures in horizontal clumps that add to the feeling of expanse provided by the broad bands of beach, water, and sky. Our eye sweeps in from the left, that is, from the sea, and encounters progressively more solid knots of people. Five people stand together on the left, a man talking to two women who share a parasol, and two women who look towards a gaggle of bathers in the surf. Near us a woman and child sit among scattered rush chairs and gaze out at the bathers and the ships. This off-center axis—woman and child, bathers, and ships—is the principal foil for the dominant horizontals. Just to the right of center is a larger group, standing near the huts, their individuality lost in the strong light and

its reflections. Further to the right sits a single woman, prominent in her red jacket; she leads us to the largest cluster, rendered in just enough detail to give a hint of the very full and fashionable garments habitually worn at the beach.

These three images, Boudin's, Stevens's, and the engraver's, do not represent different kinds of vacationers, but different moments in the same persons' lives. To take the sea air, to bathe, to watch the evening sunsets over the ocean were part of every day's activity; to gather on porches and in dining rooms was another vacation practice; to stroll out to nearby promontories or quaint villages was a common distraction. It was a fruitful syndrome whose varied preoccupations fulfilled different but compatible aspects of one's being. Bathing benefited the body, and taking in the salty air, the lungs; both were nature's restoratives, and so was the mere contemplation of the sunset. Yet these were also occasions for displaying clothing and for socializing, and therefore not divorced from promenading or dining. As for visiting the local sights, that was, like the concerts and the plays, a proof of being cultured, of doing something more than merely indulging in healthful leisure. Guide books catered to all three kinds of activity by describing the beaches and their bathing centers, the accommodations, and the charming thatched cottage or picturesque old church in the vicinity. A history lesson was offered in the latter case, so education and tourism merged with "bathing."

From the vantage point of the bathers, there was nothing amiss in this enjoyment of the seacoast. From that of the natives, however, things would have looked differently, although they had few spokespersons to articulate their dilemma. We do get a glimpse, although not a clear one, of the confrontation of cultures in the life and work of Boudin. For him, painting the tourists was not the same as for Stevens, who came from Paris along with them and was very much part of their society. Boudin was a native of Honfleur, the son of a mariner, and he spent his entire life painting the seacoasts of France. His youth and early adulthood along the Seine estuary coincided with the rise of tourism, and he was disturbed by the clash of the vacationers with the society of fishermen, sailors, and coastal villagers he knew intimately. In 1867, after returning to Trouville from several weeks in Brittany, he wrote to a friend:

> Should I confess it? This beach at Trouville which used to be my delight, now, since my return, seems like a frightful masquerade. One would have to be a genius to make something of this bunch of do-nothing poseurs. When you've just spent a month among people devoted to the rough work of the fields, to black bread and water, and then you see again this bunch of gilded parasites who have so triumphant an air, it strikes you as pitiable and you feel a certain shame in painting such idle laziness. Fortunately, dear

271. Boudin, *Breton Pardon*, 1865. Mr. and Mrs. Paul Mellon.

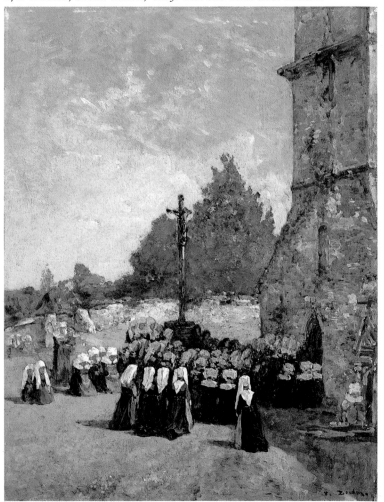

friend, the Creator has spread out everywhere his splendid and warming light, and it is less this society that we reproduce than the element which envelopes it.

In his last phrase lay one solution to his dilemma, the conviction that he was painting light and color more than the "gilded parasites." Another solution appeared in a letter witten a year later:

> Peasants have their painters of predilection: Millet, Jacque, Breton.... That's good, but between us, these bourgeois who promenade along the pier towards sunset, don't they have the right to be fixed on canvas, *to be led towards the light*? Between us, they are often resting from hard labor, these people who come from their offices and their studies. If there are some parasites among them, aren't there also some who have fulfilled their tasks?[1]

Both statements nonetheless reveal Boudin's uneasiness in painting vacationers. He could not quite overcome a discomfort at the clash of old and new, although it was the new that provided his market. He restored himself periodically by painting peasants (Pl. 271), washerwomen, and fishermen (he also painted seascapes and harbor views), yet the two worlds seldom met on a single canvas. But then, we know that their separation was the truth of life in seaside resorts.

From Paris to the English Channel

The origins of the seaside resort are found in the habits of the wealthy who, since Roman times, had sought distraction and health by quitting the cities for thermal centers. Until the Second Empire, the French had had no equivalent to Baden-Baden, Spa, or Bath, but they made up for that after 1850 by developing Vichy, inland, and a number of resorts along the coast. From the older spas came the idea of health-giving waters, and the seaside bathing centers at first emphasized hydrotherapy. Learned medical men wrote treatises on the virtues of the salt and iodine in sea water and sea air, and social reformers claimed that city life required the periodic cleansing of lungs and body that the seashore provided (for those who could afford it). The famous Jules Michelet devoted the last quarter of his book of 1861, *La Mer*, to the beneficial effects of seashore bathing, despite his horror of resort honky-tonk. Bathers immersed themselves (women, often, with the aid of male instructors) to absorb the water, more than to swim. There were indoor pools, both salt and fresh, some of them heated, to complement the sea. Bareskinned hedonism and widespread swimming became common only at the end of the century, for in mid-century one wore substantial garments while bathing, partly from modesty, partly to guard against the sun. On shore, very full clothing was worn, and women used parasols to shield themselves from the sun. White skin was a sign of a pampered life and distinguished one from the lower classes whose weathered skin bespoke their working condition.

The bathing resorts along the northern coast, so characteristic of the Second Empire, developed in remarkably short time. Most of them were still fishing ports in the 1830s. To certain villages such as Sainte-Adresse or Trouville (Pl. 272), a

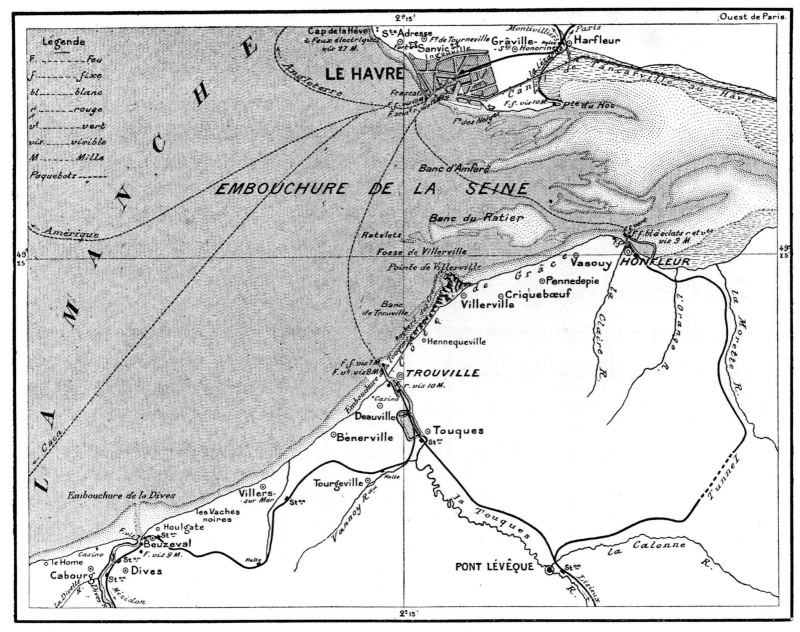

272. *The Seine Estuary*, c. 1890.

few well-to-do residents of Paris, Le Havre, or Rouen (and also many from Britain), emulating the aristocracy of old, would come for a few weeks to take the sea air. Artists and writers would also come, and their work spread knowledge of these still unspoiled places. Then fishing cottages would take in lodgers, seaside taverns would become restaurants, bathing tents would turn into casinos, irregular paths into boardwalks, and soon hotels and costly villas would take over the seafront. After mid-century, other municipalities, not "discovered" by writers or painters, would see the rising fortunes of their neighbors and would build casinos and hotels to lure vacationers. Because land values rose rapidly, fishing families and small shopkeepers were displaced by entrepreneurs, increasingly backed by speculators from Paris (when not Parisians themselves). The proportion of local residents diminished, and the lives of those who remained were changed. Fishermen became swimming instructors, hauled portable bathing huts

along the beach, and rowed vacationers about; their wives and daughters took in laundry or worked in the new hotels and casinos. Parisians, who dominated the ranks of vacationers after 1850, could indeed smell the sea air, but the "fishing village" and its people had turned into a resort, a vast service industry in which the residential population cared for visitors who outnumbered them five or six to one.

For many vacationers, if not most, bathing was an excuse to partake in a select society devoted to leisure and self-display. From the thermal centers the coastal resorts adopted the varied institutions that catered to the habits of high society. In addition to one or more buildings that housed pools, changing rooms, and the like, a gaming casino was *de rigueur*, usually a central one regulated by the municipality. The casino and the larger hotels provided various rooms for gambling, billiards, cardplaying (whist was popular), and reading, a nursery, an indoor and an outdoor café, a more formal restaurant, a dance

hall, a small theater, and a concert hall (these latter often used one room, rearranged for the different functions). Costumes were correspondingly varied, especially for women, and were frequently changed, to the amusement or dismay of some visitors.

Municipal governments, eager to raise income, and private entrepreneurs took advantage of the vacationers' idle hours. There were seaside versions of Parisian cafés-concerts, for example. By the late 1870s the Alcazar had its troupe at Trouville, and the Eldorado, at Deauville. The city fathers and the managers of casinos and hotels also catered to families. For further distraction they organized regattas, occasional horse races and polo matches (often conducted on the beach), pony rides, magicians' shows, and children's theater. There were even provisions for the ubiquitous lap dogs that guests brought with them. By the early 1870s at Deauville there was a clinic for ill dogs, and it sold "antiseptic and perfumed soaps for apartment dogs."[2]

The casinos and the fancier hotels, emulating the spas, treated their guests as members of a private club, a comfort to those who feared upstarts with money but without "class." A portion of the beach was reserved for each hotel willing to pay the municipal fees, a further device to keep strangers together as a "club." To confirm this replication of earlier patrician privilege, each casino and bathing center had aristocrats on its governing board and published seasonal lists of its guests (usually called abonnés notables [notable subscribers]). The list for Trouville's casino in 1865 included seventy-two persons, among them three dukes and duchesses, five princes and princesses, eleven counts and countesses, seven barons and baronesses, and five marquis and marquises. Among them were some of the leading socialites of Paris, the prince and princesse de Metternich, prince and princesse Poniatowski, comte and comtesse d'Hautpoul, the duchesse de Morny, and the notable art collectors prince Demidoff and the comte and comtesse de Pourtalès. Perrin, the director of the Opéra, and the sculptor Montier were among the noteworthy commoners.[3]

The seaside resorts also disseminated lists of foreign guests, because a cosmopolitan clientèle, echoing the society of Paris, was a proof of quality. British vacationers were especially numerous, not only because it was easy to cross the Channel, but also because they resided in large numbers in Normandy. In fact, the prominence of the British in France was a significant factor in the preeminence of Channel resorts. Since the 1820s the British had been major investors in French industry and commerce, and they had established a particularly strong presence in northern France. All the railroads north from Paris, laid out before 1848, were designed and built by the British, who set up locomotive works in Rouen, and who brought over 5,000 construction workers from Britain. They also had an immense influence on French agriculture and animal husbandry, from selective breeding of animals to methods of drainage. As manufacturers, agents, and salesmen, as purchasers of Norman dairy products, cloth, and seafood, as sellers of all manner of finished products, the British were prominent in every major city in the north of France. Murray's guide of 1848 listed 66,000 English residents in France, and twenty-five towns in which English church

services were held.[4] There were so many in Ingouville, the suburb of Le Havre that led to Sainte-Adresse, that it was dubbed "la ville anglaise."

British customs relating to boating and horses, already mentioned in connection with Paris and the suburbs, also affected the Channel resorts. Brighton, famous well before any of the French resorts, was the social model for many municipalities as they developed their bathing centers. The rapidly expanding Trouville of 1855 was called "a bourgeois Brighton, pretty, cute" by the writer Chapus; he used the word "bourgeois" because he was aware of the aristocratic origins of the British resort.[5] An "English garden" was the staple of many of these replanned villages and small cities, and the word "cottage" was the second only to "villa" as the name for the new summer homes that sprang up everywhere. Almost every port had its "Victoria Cottage," its "Clover Cottage," and its "Elisabeth Cottage." The pretentious and eclectic private villas, likened by Chapus to overly loud parrots, had their "Renaissance-Elisabeth" libraries to keep pace with their Louis XIII dining rooms, and in the public reading rooms of hotels and casinos, "keepsakers" and British journals were commonly found.

Important though the British were, it was the Parisians who actually dominated the seaside resorts. Brighton was evoked for its social tone, but the planners looked towards the formal arrangements of Haussmann's Paris as they laid out their new cities. The new streets and squares were a great contrast to the old Norman villages and were described in Parisian terms: allées, boulevards, squares (a term long in use in the capital), jardins. The new plan for Houlgate in 1863 included a little "Bois de Boulogne." Although local entrepreneurs were usually involved, Paris supplied many of the architects, most of the money, and most of the purchasers of the new villas. From 1859 to 1877, twenty-four of twenty-nine owners of newly constructed houses at Houlgate were Parisians.[6] It was the railroads that permitted this colonization of the coast, and one can follow the spread of the resorts, in part, by tracing the routes of the rail lines from Paris. The railroads collaborated with the coastal developers by offering excursion tickets and special trains, and they advertised resort seasons in all major media, including their own railway guides.

Artists and Entrepreneurs

Katherine Macquoid, introducing Trouville to her readers in 1874, remarked that

> she is very young for a town, only forty years old, and, like Etretat, she has sprung out of the sea at the fiat of artists, both painters and writers. Trouville was a mere fishing-village when M. Isabey began to paint and Alexandre Dumas to describe her....[7]

She was pointing out the commonly known fact that it was painters and writers who put most of the seaside resorts on the map. Alphonse Karr's writings were credited with popularizing Sainte-Adresse and Etretat (both villages eventually named streets after him), while the coast near Le Havre, from Trouville and Honfleur over to Sainte-Adresse, had been recorded first by British artists in the 1820s and 1830s, then

by Charles Mozin, Isabey, Daubigny, Jongkind, and L. A. Dubourg in the following decades. Unlike the texts and illustrations commissioned for guide books, these writings and paintings did not smack of public relations. It was perhaps their very disinterestedness that contributed to their influence. Parisians could imagine "discovering" Sainte-Adresse or Etretat by admiring Karr's essays and novels, or Mozin's paintings. When they then went to these villages they were consciously following in the footsteps of artists who, like Karr and Monet, wore mariners' clothing, which allowed them to be partly assimilated with the natives.

Guide books often held out hope of seeing notable artists by pointing out their residences or their favored haunts. In Etretat one could hope to see Maupassant, and it was easy to station oneself near Offenbach's "Villa Orphée" (built there with the proceeds from *Orpheus in Hell*). A promotional guide to Trouville, Deauville, and their environs headed one chapter "Causerie, Aux Artistes" (Little Chat, To Artists); the heading was surmounted by a vignette that pictured a sylvan glade complete with brook, deer, and herons. The "chat" begins by invoking not professional artists, but the artistic spirit in everyone:

> Oh all of you! You who are fortunate enough to dispose of your time for a month or two, as you wish; you who are not enslaved by the demands of a mediocre administration, who do not possess a numerous family, always difficult to transport; profit from the beautiful season. Here you will have your eyes and lungs refreshed by a splendid, generous, and calm nature, a real countryside.

The author follows the "countryside" with promises of beautiful women, luxurious accomodations, bathing, and suggests that, then, when tired of that, one take

> the charming walk to Hennequeville. What freshness, what a perfumed route! How the fields are green, how the trees are beautiful. What a beautiful row of elder trees through which you see the sea, calm, beautiful, transparent....

He then imagines cows peacefully grazing and asks the reader to conjure up a bronzed young man:

> It's all the same to you, isn't it, if he's bronzed? With the straw hat and the grey coat of the artist. I don't ask him to be *remarkably handsome* like the hero of a novel, but I require him to have heart, spirit, imagination, and as for his beard, he can wear it as he wishes, I won't impose anything on him.[8]

Artists were truly intermediaries between the villagers and the tourists. They were the interpreters of local landscapes (from which they eliminated the tawdry), the providers of images that were in the visitors' minds when they arrived at the shore. In the engraving of 1866 (Pl. 268), it is the artist around whom the action revolves. Remove him, and the fisherwomen would not remain there, the tourists would not have this human buffer between themselves and the natives. Of course, once the crowds came, the artists moved on to less peopled places. The tourists who liked to feel they were the only ones to savor a site would again follow in their wake, and the "discovery" process would begin all over again.

Nearly every guide and travel book after 1858 began its capsule histories of seaside resorts, as did Macquoid, by paying homage to the artist-discoverer. The mythic stature of the artist had arisen in the romantic era, when writers brought back poems from rocky escarpments in the Auvergne or primitive villages in Brittany, and bearded painters settled in fishing villages or hiked into forests clad in rough clothes, a rucksack on their backs. It was a functional myth for tourism and bathing, since it supplied welcome qualities of poetry, the healthy outdoors, and vagabondage, in short, freedom from urban confinement. In its article of 1844 devoted to "Sea Bathing at Trouville," *L'Illustration* used two engravings. One showed the then sparsely tenanted beach (one can imagine a Paris entrepreneur saying "Now there's a good investment! Look at those open spaces!"), and the other, "the house of M. Mozin at Trouville." It no longer seemed surprising that an artist's house was the featured vignette in such an article, and the accompanying text gave it more words than any other. The first two homes mentioned were those of comte d'Hautpoul and of the marquis de Rouzan, then came Mozin's,

> which has the form of an old manor house. M. Mozin has a delicious studio that overlooks the sea, and furnished in a most original fashion. Certainly he always works after nature; the ocean is there before his eyes, calm or riled up, and he has only to draw his curtains aside to have his model.[9]

If we are inclined to think of Claude Monet when we read those words, it is because impressionist landscape painters built upon the nature worship of Mozin's generation. For many artists it was no longer the city, nor neo-classical architecture, but out-of-the-way, "natural" places, and picturesque gothic architecture, that were worthy of painting.

Artists were not the only intermediaries between nature and the tourists, it is true. Before the crowds could come, entrepreneurs had to step in as developers to provide the bathing centers, lodgings, and transport. They were often among the cultured élite who were up with the latest paintings and writings, and were the first to follow in the artists' wake. As builders of the new society, they were not much beholden to old traditions and shared something of the artist's creativity, his spirit of discovery.[10] Sometimes artists were among the entrepreneurs: Charles Mozin at Trouville, Jollivet at Deauville, Jouvet at Houlgate, or Félix Pigeory at Villers-sur-Mer, but usually big money was involved, and speculators banded together in entrepreneurial societies, backed by Paris banks. At first they, too, had sought only health and tranquility away from the city, but soon they played host to other Parisians and gradually reconstituted a Parisian society on the shore. It was then that their business sense took over, and they began to "modernize" the fishing villages. They justified their colonization of the coast as Europeans had justified taking over Indian lands in America: they were making progressive use of underpopulated lands which the natives did not manage advantageously.[11]

Deauville was the most remarkable of the newly developed Channel resorts, and it was entirely the work of Parisians; furthermore, Parisians of a particular Second Empire type. In 1850, Deauville was a dying fishing village above the shifting sands across the Touques river from Trouville. Dr. Joseph

271

Olliffe (self-styled "Sir Joseph"), a wealthy British emigré living in Paris, had visited Trouville often and had cast his eye on those shifting sands. He was, among other things, a quack, but nonetheless the official doctor for the British Embassy in Paris and private physician to the duc de Morny. He was a skilled agent in improvement, having made his fortune chiefly on a medicine for women based on small doses of arsenic. It had the immediate benefit of improving their complexions; its more iniquitous long-term results were not discovered until the good doctor's fortune was secure. To create a French Baden-Baden, Olliffe needed money and influence. In 1859 he formed a syndicate, the money coming from the banker and diplomat Armand Donon, the influence from Morny, who had been a regular visitor to Trouville. They bought the dunes and, beginning in 1861, spent a fortune to level and consolidate the sands. Thanks to Morny, the state judged it in its interest to assist in the extensive diking and dredging of the Touques to create a yacht basin, and a bridge was built across the river to Trouville. The new city was rapidly laid out, with both Anglican and Catholic churches, and with broad avenues reminiscent of the new residential quarters in Paris. The permanent population went from 113 in 1850, to 1,150 in 1866, augmented by summer visitors. Two hundred and fifty villas

were built in three years.[12] Morny's was in Renaissance style (in Plate 273 it is the one with twin-peaked towers, left of center); Olliffe's was in "Anglo-Saxon" and called "Victoria Lodge;" Donon's was "le pavillon Elisabeth." The essential aristocrats were lured to the new resort (the comte de Choiseul, prince Demidoff...), and their presence helped sell the syndicate's villas to monied commoners.

In 1863, Morny inaugurated the new railroad line that came to Deauville (not to Trouville) thanks to his influence. The following year, Morny, "this indefatigable sportsman, so well known among Parisian turfists," as one guide put it,[13] opened the new racetrack at Deauville. He won official support for it on the grounds that there was no other distinguished racing season in France during the month of August, and it would lure tourists away from Baden-Baden. He succeeded, and later guides could boast of the important *high life* during August, when Deauville became "the rendez-vous of all the aristocracies, among others, the Jockey-Club."[14] Boudin made a spirited sheet of studies of the new racetrack in 1866 (Pl. 274). Deauville was soon called the "faubourg Saint-Germain" of Trouville, a reference to the elegant residential quarter of Paris, for commerce was largely excluded from the new resort, and Trouville was treated as a dependency, pro-

273. Lemaître, *View of Deauville*, 1864.

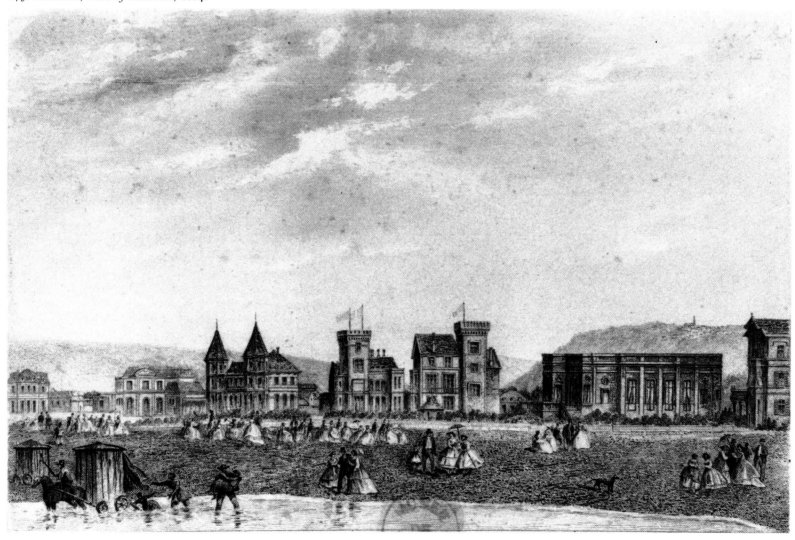

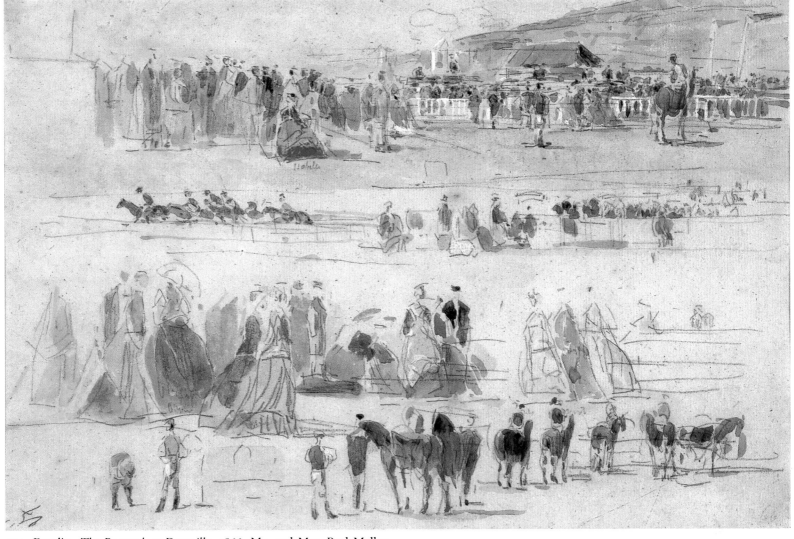

274. Boudin, *The Racetrack at Deauville,* 1866. Mr. and Mrs. Paul Mellon.

viding domestic help and the supplies and services that one's own household could not manage.

The upper-class elegance of Deauville could not quite disguise the new money involved. The guide of 1868, already cited, made a frank appeal to

Messieurs the French speculators, stockbrokers, manufacturers, businessmen, etc., who wish to make a fecund and honorable enterprise, bring the cooperation of your capital and your intelligence. . . .[15]

The same guide reveals two interesting features of this nouveau-riche society. The city government consisted of ten men, among them the architect Breney, who built many of the villas, the painter Jollivet, the writer Crémieux, the manufacturer Arthus, an entrepreneur, a notary, a head foreman, and a farmer. These were middle-class men who effectively used the princes and countesses to embellish their casino list. Furthermore, some of the city fathers and some of the aristocrats were not above overt speculation. Arthus had a seafront villa, but also another on a side street which he rented; prince Poniatowski had no fewer than three villas for rent.[16]

Although artists had not first "discovered" Deauville, they soon found their way there and contributed to its reputation.

The most notable of the artist-visitors was Courbet, who spent a month there in 1866, in circumstances that reveal the benefits of enlightened patronage. This most controversial of living artists, self-proclaimed socialist, prickly burr under the saddle of clergy and government, was the guest of the comte de Choiseul. Courbet had spent three months at Trouville in 1865, and he boasted not only of the many seascapes he had done, but also of the portraits of society women, including that of the princesse Karolyi. Choiseul bought seascapes from him that winter, and Courbet accepted his invitation for a month's stay at Deauville in 1866. His letters reveal how pleased he was with the count's luxurious villa and with his society. He was also pleased with his pedigree greyhounds, which he painted against the backdrop of the Channel. It was at the count's behest that he invited there both Boudin and Monet. Choiseul seems to have collected artists, as well as their paintings, to ornament his new villa. Guests and setting were alike proofs of his advanced ideas. As for Courbet, the paintings he did at Trouville and Deauville encompass the whole range of a vacationer's interests: seascapes, one bathing picture (a woman in the surf on a curious "podoscaphe"), numerous society portraits, and a native fisherwoman with dead seagulls over her shoulder (Pl. 275). She would never be

confused with the princesse Karolyi, but she shared space with her on the artist's easel, for, along with splendid sunsets over the water, she was, like the native woman in the Boulogne print (Pl. 268), part of the vision of a Parisian in search of motifs at the seaside.

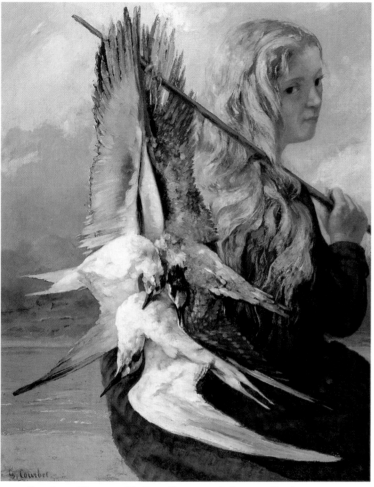

275. Courbet, *Woman with Seagulls*, 1865. Private collection.

Manet at the Seashore

Manet's first paintings along the Channel coast were several marines done at Boulogne in the summer of 1864. He visited Trouville briefly in August 1867, but did not paint there. It was not until 1869, when he and his family spent the summer at Boulogne, that he undertook a series of pictures that interpret the activities and the preferred views of vacationers. Unlike Courbet, he had no prospective clients at his elbow (he first sold some of the Boulogne pictures to the dealer Durand-Ruel in 1872), but the seaport logically entered the canvassing of modern life to which he was dedicating himself. Like other well-to-do Parisians, he often took his family to the seaside. They had spent the previous summer at Boulogne, but he seems not to have painted the coast then and absented himself often, like other professional men, with trips to London, to Le Havre, and several to Paris. Settled in Boulogne for most of the summer of 1869, he did six pictures. Together with the earlier Boulogne marines, these were his only landscapes

outside Paris in the 1860s, proof of the significance of Channel resorts in drawing Parisians away for the summer.

One of the paintings of 1869, *Moonlight over Boulogne Harbor* (Pl. 276) is what one might have expected from an artist of the prior generation, were it not for its spirited shorthand. From a sky streaked in clouds and dotted with stars, a full moon casts its blanched light over fishing boats that have just brought in their catch, awaited by a cluster of women in Norman bonnets. It is the kind of local life that guide books urged tourists to witness, and indeed such scenes were essential to the sense of being away from home. Another of the paintings, *The Pier at Boulogne* (Pl. 277), gives an altogether different impression. Instead of the "pure" tourist's view of a local event (no vacationer is shown in the nighttime picture), we are looking over at other vacationers. Through a misty but bright morning light we see two parallel jetties, so close together as

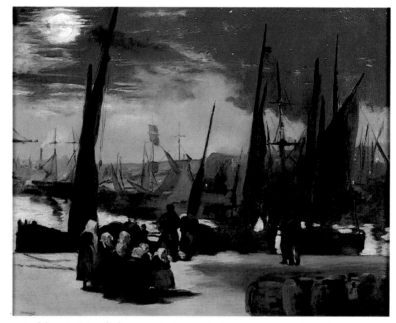

276. Manet, *Moonlight over Boulogne Harbor*, 1869. Musée d'Orsay.

to hide the narrow seaway between them, where a fishing boat is slowly making way; to the left appears the bowsprit of another departing boat. On the far jetty two men and a couple, the woman with her parasol raised, look out at three ships under sail. Two of them have the rigging of commercial ships, the central one might be a pleasure boat. On the near jetty, to the left, a man in dark clothes, possibly a mariner, has applied a telescope to his eye; to the right, a woman and a boy stare down towards the buoy on which the artist signed his name. In the center, seven or eight people, apparently a mixture of tourists and natives, hover over the fishing boat. The light streak of the second railing keeps them on the jetty, but even so, they are amusingly assimilated with the boat. It appears to be too far down in the channel (the bowsprit of the other boat floats at the expected level), and may be the result of an observation taken at low tide and then joined to the rest of the picture. The effect is to puzzle us slightly but also to activate the remarkably flattened planes that make this such a striking composition. Many of Boudin's seacoast pictures consist of

horizontal bands, also, but his objects and figures observe the locations and proportions of conventional perspective.

Equally modern is *The Departure of the Folkestone Boat* (Pl. 278). On a sunny morning, a crowd has gathered around a steamer. Some are presumably waiting to board, while others, nearer us, may be seeing them off or merely taking in the event. No figure is rendered in detail, but Manet's flowing outlines and bright colors, which have the quickness of his *View of the Paris World's Fair* of two years earlier (Pl. 7), convey the richness of vacationers' costumes. At the stern of the ship one mariner handles the wheel (the ship might be docking, not departing), while another gesticulates on the far side of the piles of baggage. To the right stand three seamen between the paddle-boxes and the smokestacks, resplendent in their white and black. The uppermost seaman points, perhaps to aid the manoeuvering of the steamer. Simple though his

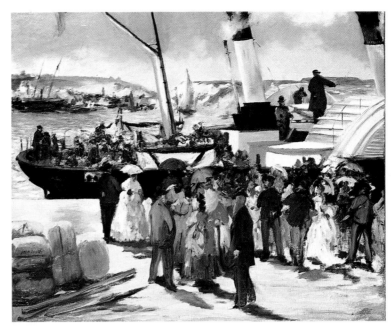

278. Manet, *The Departure of the Folkestone Boat*, 1869. Philadelphia Museum of Art.

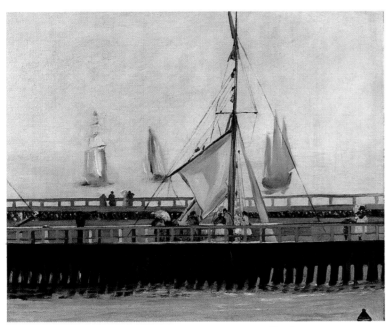

277. Manet, *The Pier at Boulogne*, 1869. Private collection.

gesture is, it helps give him a commanding presence over the crowd below. Beyond are several ships, including a two-master at anchor and a smaller ship under sail, and then the chalk cliffs which characterize Boulogne, as well as Dover or Folkestone.

Where the moonlit picture was all native, this painting is all tourist, or nearly so. It requires both kinds to have a truthful idea of Boulogne, which for centuries had been a principal port of entry and exit along the Channel; for long periods it had belonged to the British. The comings and goings of the steamer to England were held out by guide books as a lively amusement for vacationers, who had so much time on their hands. That this was a conventional idea is proved by Chapus's guide book of 1855, whose vignette introducing the chapter on the environs of Rouen (Pl. 279) shows a similar packet about to depart. Manet need not have seen this vignette, but when he turned towards this episode of modern life he was taking up a motif that had first been established in journalistic illustrations. His painting of the harbor by

279. *The Quai at Rouen*, 1855.

night instead evoked the traditions of the fine arts: romantic seascapes and Dutch nocturnal scenes. It was the one he chose to exhibit in the Brussels Salon that very summer upon the urging of Alfred Stevens and was by far the largest of the Boulogne group. It therefore had the ambition and the relative conservatism of a work destined for public viewing, whereas the painting of the steamer fits into a more daring category.

The Departure of the Folkestone Boat was Manet's response to the vitality of the present day and was the current in his art that ran increasingly strongly until, after the Franco-Prussian War and the Commune, it triumphed decisively over the artist's preoccupation with the grand manner. In another of his

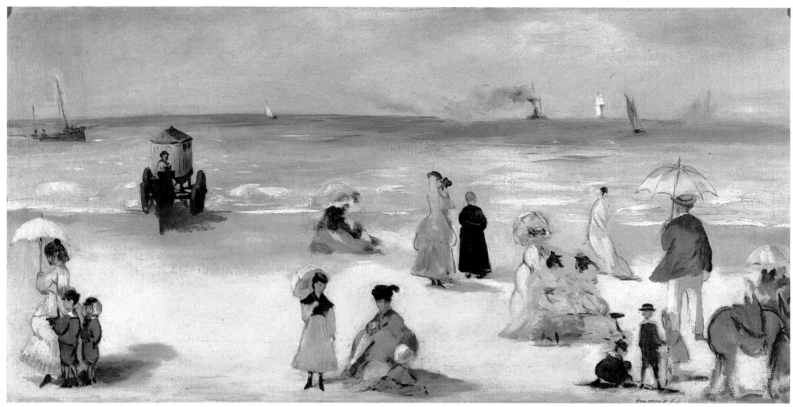

280. Manet, *On the Beach at Boulogne*, 1869. Richmond, Museum of Fine Arts.

Boulogne canvases, we can sense both currents at work. *On the Beach at Boulogne* (Pl. 280) is an aspect of contemporary life at the seashore, but its organization has the stiffness of a studio painting. Only two men are shown (it is probably a weekday), an overlarge vacationer with parasol aloft, on the right, and an employee who hauls a private cabin ashore. The other figures are women and children, unless the black-robed figure right of center is a Franciscan (confessors were known sometimes

281. Manet, *Women on the Beach*, 1873. Detroit Institute of Arts.

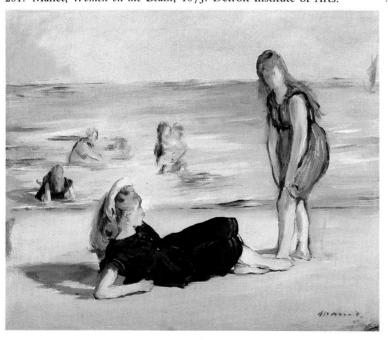

to accompany their penitents to the shore). The woman in the center looks out over the water through opera glasses; the children at the right perhaps await a chance to ride the nearby donkey, while the other vacationers sit or stroll about. In isolated positions that form neat diagonals, the figures have the conscious order of those in Manet's view of the 1867 fair (Pl. 7). On this plain shore, however, there is none of the complicated play of hillslope and fairgrounds which integrated figure and setting in the earlier canvas. The contrast with Boudin (Pl. 270), who pioneered such views, is even more striking. His vacationers are usually grouped in set places against the three horizontal stripes of beach, water, and sky. Unlike Manet's, however, his groups are overlapped, or linked by beach furniture, scampering children and dogs, or elongated shadows. His horizon lines are much lower (this permitted the overlappings), and his skies therefore dominate, skies on which he lavished special attention (like John Constable, he painted autonomous cloud studies). Manet's beach scene treats the sky as a pale lavender-blue backdrop, and the sea has just enough activity to be convincing. Manet is still the Parisian, bringing an urban vision to the seashore to which Boudin had devoted himself all his life.

Manet's next appearance at the seaside was in the spring of 1871, when he recuperated from the siege of Paris by spending a month at Arcachon, near Bordeaux. He did several marine views and began a painting of his wife and Léon Koëlla in the salon of their rented house, with a view out over the bay. Later that year he and his family spent a short period at Boulogne, where his only picture showed Koëlla and several adult friends playing croquet on the lawn of the casino, overlooking the sea. Then in 1873, he returned for the last time to the north coast,

to Etaples, near Berck-sur-Mer, with his family. Berck was not yet "developed," and the family may have chosen the region so as to avoid the busy society of the resorts. In a very productive three weeks, Manet did eight or nine marines (including fishermen working on their boats) and three figure pieces. Two of these show the beach at Berck, one with his wife and brother, seated, dominating the foreground, the other with bathers (Pl. 281). In the bathing picture, we again detect the artist more anxious to rival the traditions of painting than to respond to a vision of the immediate present. The models' flowing hair and exposed limbs, rendered in Manet's liquid gestures, have a sensual freshness in an era when such exposure was uncommon, but the reclining bather has the form of many a familiar female figure, nude and clothed, including Corot's bacchantes, and the other adopts a statuesque pose that takes away the immediacy of her gesture.

The other, more naturalistic current in Manet's art is found in *The Swallows* (Pl. 282). Instead of the museum attitudes of the two bathers, Manet's mother and wife are in informal poses that in less gifted hands might have appeared ungainly. Suzanne sits with feet splayed out, watching the swallows that sweep the field for insects. She wears the white straw hat that was one of Manet's favorites (it is worn by the woman in *Boating* (Pl. 238), and both women have veils to protect them from sand and wind. The artist's mother reclines on one elbow while she reads. She wears dark clothes which conveniently flatter her daughter-in-law's more fashionable costume, a common deference to youth and beauty. For all the freshness of their appearance, they form a calculated triangle, set off by the disc of the parasol, whose aureole alludes to the absent sun.

Instead of the three rather abstract strips which cover the surface of *Women on the Beach*, the land and the sky in *The*

282. Manet, *The Swallows*, 1873. Zürich, Bührle Collection.

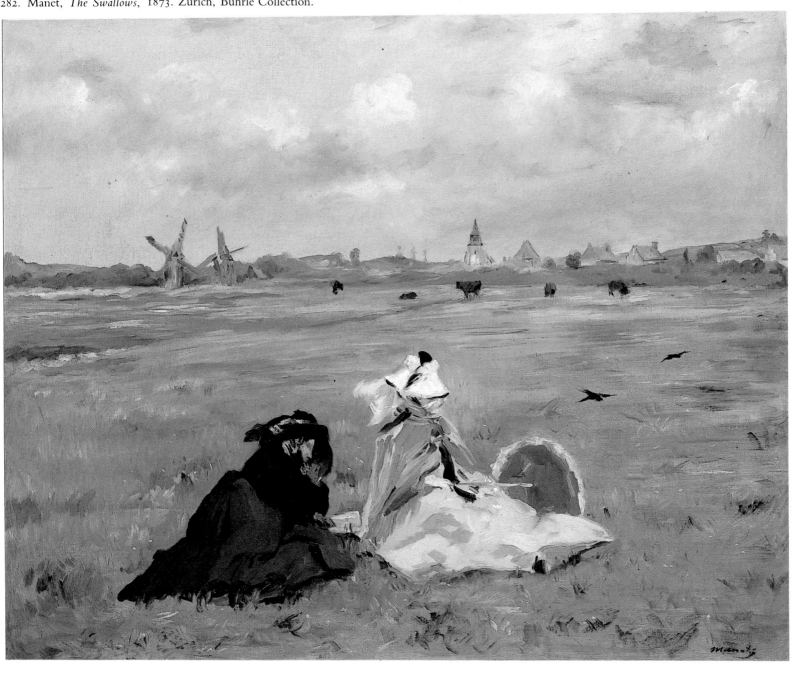

283. Degas, *Peasant Girls Bathing in the Sea at Dusk*, 1875–76. Private collection.

had been in Holland the previous year, and in the weeks before he went to Berck he had savored a real triumph in the Salon with his *Bon Bock*, a painting of a stout burgher with pipe and beer whose Dutch ancestry was immediately recognized. *The Swallows* has a broad sweep of flat land, a village in mid-distance, and an active sky which were staples of Dutch prints and paintings. The sky is the most convincingly naturalistic of any of Manet's coastal pictures to date and reflects a knowledge of Boudin and of Daubigny, both of whom had made a speciality of painting along the Channel coast; except for the figures' black and white, the palette is very close to Daubigny's. Berck was not far from the Lowlands and has the level shore and the constantly moving clouds that inspired the Dutch and then Boudin, Daubigny, Jongkind, and Monet. Boudin is also the artist who specialized in rendering costumed vacationers at the shore in a vigorous shorthand, both in watercolors and oils. Manet's wife and mother have been customarily likened to Japanese prints, but their liquid abbreviations are much closer to Boudin's work of the previous decade, well known to Manet. It is probably this painterly bravura which led to the picture's rejection by the Salon jury in 1874.

To our modern eye, schooled as well by Monet and the other impressionists, Manet's picture seems far more naturalistic than his earlier beach scene (Pl. 280) and the two other figure pieces done at Berck. It is also a more plausible outdoors painting than Degas's slightly later *Peasant Girls Bathing in*

Swallows have so much incident that we almost ignore the fact that they constitute two rectangles. The windmills, facing the sea off to the left and behind us, are a convenient reminder of the northern tradition that underpins this composition. Manet

284. Degas, *Beach Scene*, 1876–77. London, National Gallery.

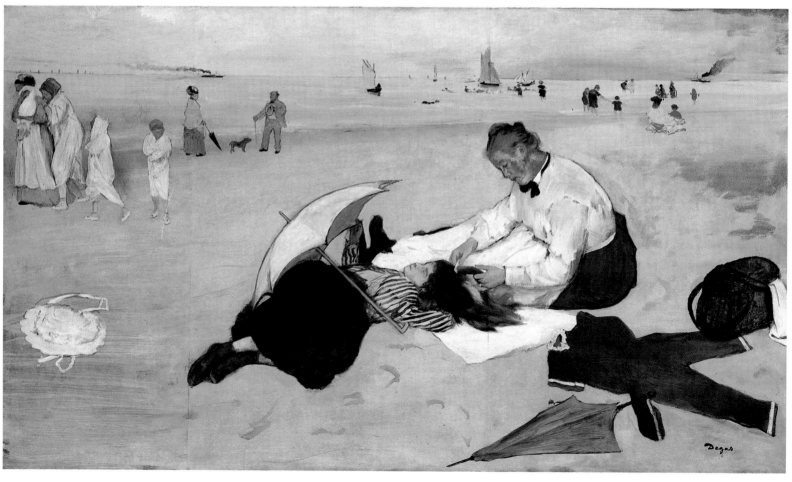

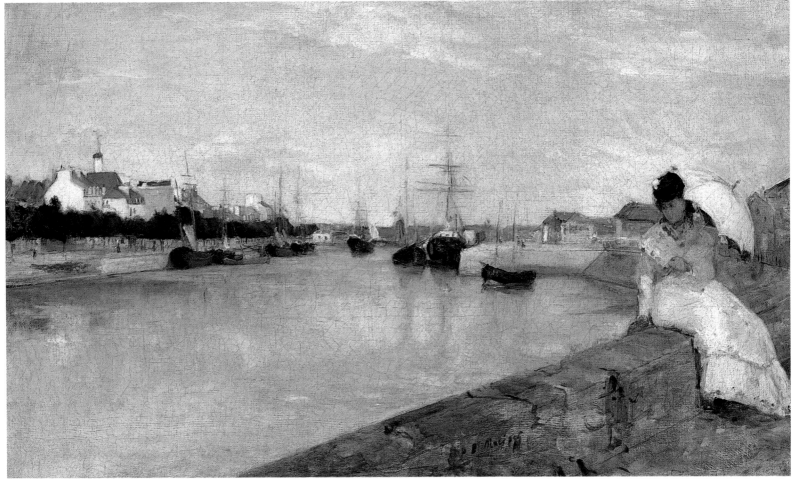

285. Morisot, *The Harbor at Lorient*, 1869. Washington, National Gallery.

the Sea at Dusk of 1875–76 (Pl. 283) and his *Beach Scene* (Pl. 284). Although Degas had done a large number of pastels at Boulogne in 1869, they were exclusively seascapes and landscapes without significant human figures, and the two later oils are his only pictures of seaside leisure. *Peasant Girls Bathing* is one of his strangest pictures, one that Gauguin would gladly have signed. Against an unfinished scumble of browns, tans, greys, and dull greens, three young women, nude, tilting curiously to the left, join hands in an ecstatic scamper in the shallows. Behind them are three smaller figures, a wooden pier, and two ships in front of a setting sun. Despite its unfinished appearance, Degas included it in the impressionist exhibitions of 1876 and 1877, in part, one feels, to challenge the public to come to terms with a daring sketch.

In its second showing, this picture of local girls was accompanied by *Beach Scene*, a view of vacationers. The nudity of the native girls tells us of their uninhibited nature, whereas the abundance of clothes and gear in this other painting bespeaks the well-provided vacationer, here a young girl whose maid is combing her hair. With his customary wit, Degas plays the three-dimensional forms of parasol, two figures, and the hamper against the flattened-out parasol and swimsuit. By neatly fitting into the corner of the composition, the still life calls attention to itself, as though being stretched out on the canvas were tantamount to being staked out on sand. The remaining figures are a supporting cast for the protagonists. On

the left, in another beguiling contrast with the nude bathers, a chilly, well-wrapped family follows a nanny who bears an infant on her shoulder. The mother bends forward solicitously and daughter dutifully follows, but wilful son has paused to look over towards the foreground. Beyond the family is a woman, wrapped in a shawl, with her parasol lowered. She and her dog are being greeted politely by the only adult male on the beach, a balding middle-aged man who has doffed his hat, and who answers the parasol with his cane. To his right a woman is seated on a folding chair, facing the water, with another woman or child seated nearby. In the shallow water are a number of bathers and further out, several ships. The two tiny steamships on the horizon frame the scene, but leave us wondering if the wind could really blow in opposed directions, or if the artist is mocking nature.

All Degas's minor figures are positioned on the paper (the work consists of oil on several joined sheets of paper) in such a way as to lead our eye back to the horizon with some subtlety, in contrast to the less believable placement of the vacationers in Manet's *On the Beach at Boulogne* (Pl. 280). Degas had been in Boulogne in 1869 and later may well have decided to rival Manet's picture with one of his own. His water tips back more convincingly than Manet's, but the three horizontals of beach, water, and sky (an attentuated version of the triad of orange, green, and purple) are a studio invention, even though their simplicity is excused by the idea of a calm day along a flat

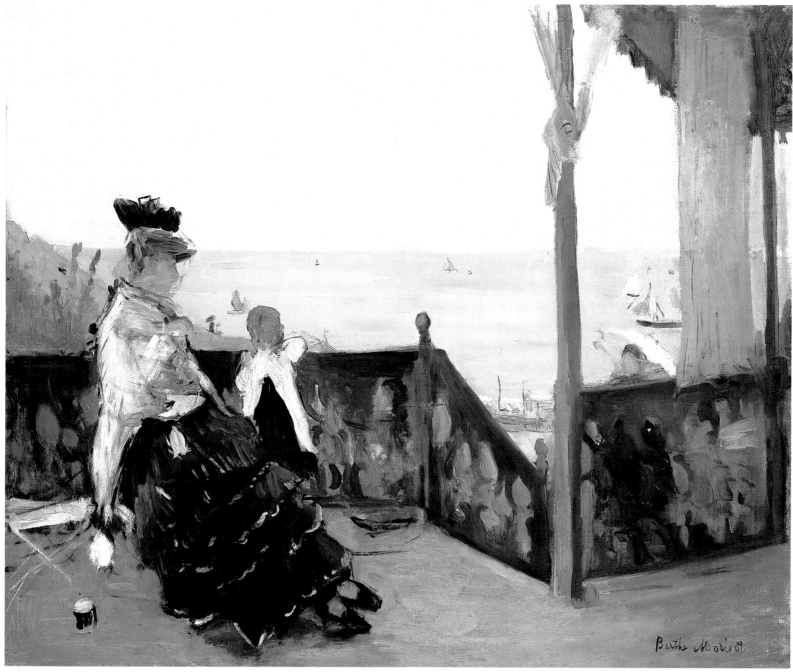

286. Morisot, *Villa at the Seaside*, 1874. Norton Simon Foundation.

shore. Degas openly disdained any slavish attention to nature and told one interviewer how he composed the foreground group: "I spread my flannel waistcoat out on the studio floor and had my model sit on it."[17] In some ways, then, this beach picture is closer to Manet's similar subject of 1869 than to *The Swallows* of 1873, in which the studio truly seems to have been left behind in Paris.

Morisot's Vacationers

Berthe Morisot, several years younger than Manet and Degas, was still an apprentice when she painted along the seacoast in the mid-1860s. She was at Beuzeval, west of Trouville, in the summer of 1864, and at Pont-Aven, in Brittany, two summers later. By 1869, when she painted *The Harbor at Lorient* (Pl.

285), she was a mature artist working in a late Barbizon manner. She was at Lorient that summer to visit her sister Edma, who had recently married. Edma had also been trained as an artist, but gave it up for the role of wife and mother. When Morisot married Manet's brother Eugène in 1874, she did not deviate from her path as a fully engaged professional. Both before and after her marriage she usually summered outside Paris and in various years painted at Maurecourt, Gennevilliers, and Bougival, and further afield at the Isle of Wight, the Channel Islands, Fécamp, Nice, and Cimiez. She traveled also to Spain, Belgium, Holland, and Italy, and if one plotted all the stops in her career, it would not form a pattern different from that of most male painters. One detects the middle-class woman, nonetheless, in the frequency with which she incorporated her family and made domestic references in her seaside

paintings, far more often than did Manet or Monet. The viewer is frequently placed within a family setting and shares the imaginary space with women and children, most often, and after her marriage, with her husband.

If from *The Harbor at Lorient* we were to exclude Morisot's sister, seated on the parapet, we should have the kind of unmediated view of a port that was commonplace in the nineteenth century (covering her image with the hand, then uncovering it, produces two different effects). The viewer could then imagine herself alone, occupying a privileged vantage point unspoiled by the presence of other tourists. Being alone in front of a site is the ideal way to sense distance from home. One feels transported to another realm and time, for being alone allows reality to become the desired illusion. Morisot's patches and streaks of blue, white, tan, red, green, and brown have transformed the harbor into an impression of delicacy and nostalgia. It recalls two of her preferred artists, Corot and Daubigny, but is painted in a thinner and more linear manner. Neither of these artists, however, would have placed a tourist in the foreground of such a view. It would have been a piece of present-day reality which would have shattered their fiction of distance. In Corot's *Quai des Pâquis, Geneva* (Pl. 208), it is a local fisherwoman who looks at us. She is part of this other world that we have come to admire, whereas Edma Morisot is part of our own world. By sharing the site with us, she keeps us from accepting the harbor as an illusion of past time and distanced place.

Four years later, at Fécamp, on the Channel between Le Havre and Dieppe (Pl. 286), Morisot makes tourism or, better, *villégiature* (holiday stay), the subject of the painting, not the landscape. We see the Channel and several sailboats, also a bit of hillside and the bathing huts stacked along the beach. This distant view is the goal of our visit, but our realm is that of the rented villa or resort hotel, defined by the carved railing and porch supports. For all the open vista, there is a sense of enclosure and privacy here, signalled by the partly drawn sunshade. A woman in vacation garb, presumably Edma, sits near a child who is peering out over the railing; a contemporary hat perches on her head like some errant ship. Near her is a campstool, a piece of vacation furniture that distinguishes this spot from a permanent household. The seated figure directs our eye towards a woman on the landing below, conspicuous despite her position because her parasol is so clearly framed by porch and curtain. Her aperture is vacation time in capsule form: woman with parasol, sea, sailboats, and sky (Pl. 287).

Morisot's Fécamp painting is the world familiar to us from her *Interior* (Pl. 48), the society of the upper middle class where mother and child receive a woman visitor. We are remote in both pictures from Manet's *The Railroad* (Pl. 31) and Degas's *Place de la Concorde* (Pl. 37), in which urban spaces engender a vastly different relationship of adult and child. We are remote also from Alfred Stevens's vacationers at Trouville (Pl. 269). Although a child and her mother sit on Stevens's terrace, we are not in a domestic enclave, but amidst a gregarious public society that encourages encounters of women and men. One woman watches another mount the steps, an incident which forms the whole of Morisot's story, but here a man watches them. Stevens crowds in a lot of little events, and his style

287. Morisot, detail of *Villa at the Seaside* (Pl. 286).

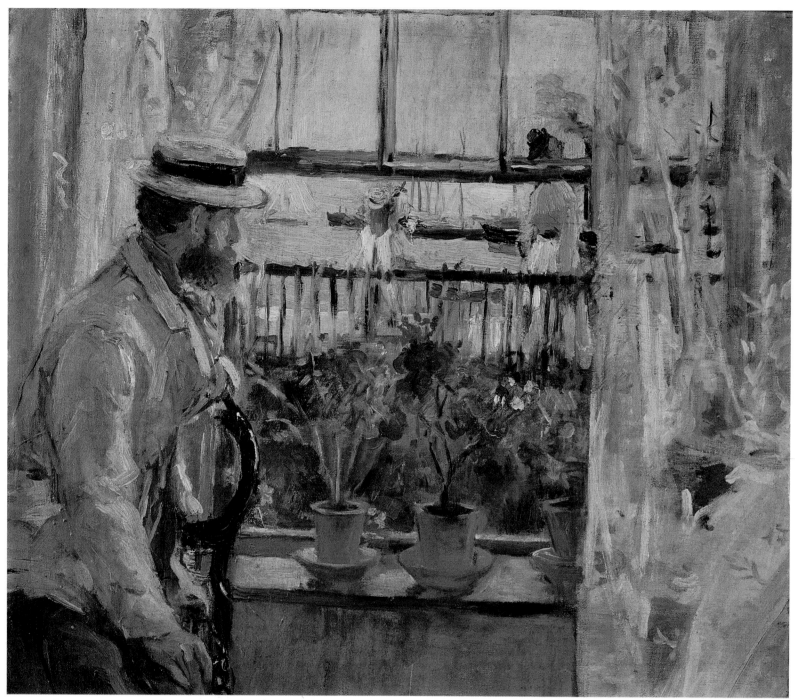

288. Morisot, *Eugène Manet on the Isle of Wight*, 1875. Private collection.

can properly be called narrative because his crisp detailing supports his multiple anecdotes. Morisot, by contrast, is the impressionist who eschews narrative detail (her women even lack facial features). She has given up the relatively precise application of her Lorient harbor view, and now conveys meaning in a broad, free handling. Her porch architecture is similar to Stevens's, but she uses it to produce fewer and stronger visual ideas. Degas owned this picture (and Manet, her Lorient harbor),[18] and we can see why he admired it. The zig-zag of the porch railing and the dynamic spatial structure to the right create an active foil for the placidly seated woman. It is a brilliant invention, one that had no counterpart in Degas's own work until two or three years later.

Morisot spent the next summer at the Isle of Wight, where she painted several seascapes and harbor views, and the astonishing *Eugène Manet on the Isle of Wight* (Pl. 288). Its freedom of handling seems to take a leap forward towards her work at Bougival half a decade later (Pl. 258). Eugène frames the window view, he does not dominate it as does Caillebotte's Parisian at his window (Pl. 23). Like the woman on the porch at Fécamp, he unassertively shares the vista with the viewer. His pose is, nonetheless, not that of a woman awaiting a visitor, but of a man reconnoitering his environs. In a typical male pose, sideways on his chair, he has twisted his upper body around towards the outdoors. There is no hint that the woman and child are potential guests. Even though the child

289. Morisot, detail of *Eugène Manet on the Isle of Wight* (Pl. 288).

is pausing, no signal of recognition or anticipation is exchanged among the figures, and the barriers between us and the public thoroughfare remain unbroken.

Eugène's gaze initiates the horizontal opening in which we see a young girl, facing away, a woman walking to the left, and on the pale green water, several ships at anchor (Pl. 289). Among them is a green and black steamer that belches smoke. We do not notice the smoke at first, because it is readily confused with the scumble of the nearby curtain. Morisot teases our eye with such an unclear reading because she delights in pulling her images forward from imaginary depth by using obvious surface movements. The woman's head is occluded by the double window sash, and both outdoor figures are partly hidden by the fence, which in turn picks up the rhythm of the window panes and so seems on the same plane. These veiled images and back-and-forth readings give us a feeling of fresh discovery that suits a quick grasp upon the scene, as though Morisot were doing this in front of our eyes.

The picture, of course, is quite carefully constructed, the result of experience and cunning. Eugène's light jacket and hat are partly assimilated with the lace curtains and the sky, so the windowsill and outdoors form a picture within the picture. In it are concentrated all the bright hues; they appear all the more intense because of the grey interior, as though the outdoors had exclusive rights to strong color. Spots of red, pink, and orange-yellow fairly vibrate against the criss-cross streaks of greens, blues, and greyish purples. Light from the outside is discolored by the flowers as it enters the house, so there are yellowish reflections on the left flower pot, pink ones on the central pot. Saturated colors appear through Eugène's chair-back to assert the integrity of the window frame and to push it back from the foreground. On the other side, the large and freely drawn strokes of paint—they *look* like paint—help the curtain hug the picture's surface. The vertical rectangle it forms has echoes in the window panes and the fence and is nearly matched by Eugène and the curtain behind him. All these verticals are set against the equally prominent horizontal rectangles. Together they comprise a grid whose regularity is partly disguised by the freedom with which Morisot moved her brush. Because she is so often subordinated to Manet, his brushwork is usually cited as a precedent, but one might instead remark that this marvelous canvas looks forward to Matisse, whose Mediterranean interiors exploit similar window views. That Matisse's pictures also conjure up a world of vacation hedonism is no accident. Morisot shared with Manet, Monet, and Renoir the invention of a coloristic language that arose from the study of leisure and outdoors light, those paired concerns that proved so vital to early modern art.

Monet at Sainte-Adresse

For Morisot and Manet, both native Parisians, one attraction of vacation spots along the Channel coast was their unfamiliarity and the resultant pleasures which new landscapes offered a painter. For Monet, raised in Le Havre, the shore of the Channel was his birthright. He, too, could contrast it with Paris where he lived for several years, where he exhibited and found most of his clients. Unlike the others, however, to paint

290. Le Gray, *Dumont's Baths at Sainte-Adresse*, c. 1856–57.

the Norman coastline was to return to the landscapes of his youth, to construct images that could accommodate his memory, his well-tutored awareness of the constantly shifting, moist skies, of the winds that swept across the harbors, the beaches, and the chalk cliffs. It is true, he painted landscapes in the Forest of Fontainebleau in 1864 and 1865, in Paris in 1867, and at Bougival in 1869, but far more extensive were his campaigns in and around the estuary of the Seine: Honfleur in 1864, Sainte-Adresse and Honfleur in 1865, 1866, and 1867, Le Havre in 1867 and 1868, Sainte-Adresse, Fécamp, and Etretat in 1868, Trouville in 1870. Much of the following decade was spent near Paris, notably at Argenteuil, but he returned to his native coast beginning in 1881 with successive stays at Fécamp, Pourville, and Etretat. When he settled permanently in Giverny in 1883, he confirmed his preference for Normandy, even if Giverny is a riverside, not a coastal village.

Sainte-Adresse, which Monet painted repeatedly from 1864 onwards, was two and a half miles from the center of Le Havre. One reached it by bus through Ingouville, "the English village," a residential quarter on the heights northeast of the harbor. From there one descended to the open bay of Sainte-Adresse terminated by the Cap de la Hève. A number of Monet's paintings look along the shore towards the Cap (Pl. 291), others back towards Ingouville (Pls. 294, 295). Sainte-Adresse had been "discovered" by the British in the 1820s (they were already then important residential tradesmen in Le Havre), and before mid-century it was Le Havre's principal watering place in summertime. Corot, Isabey, Jongkind, and other artists painted there, and Alphonse Karr carried its fame to Paris in his many essays, articles, prefaces, and pamphlets. He made another contribution by establishing new plantings of domesticated and wild flowers along the bay, including the waterborne arrowhead plant. This he had admired while boating and swimming in the Seine near Paris, and by introducing it to the streams above the beach, he was colonizing the coast in a unique fashion.[19] By the time of Monet's first boyhood visits to Sainte-Adresse, its gardens were listed

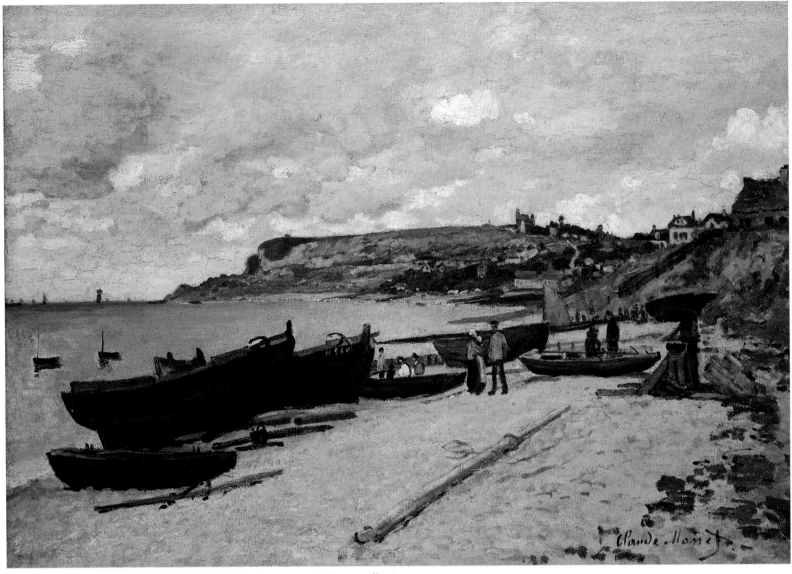

291. Monet, *Sainte-Adresse, Fishing Boats on the Shore*, 1867. Private collection.

among its charms, although they were minor embellishments of the main attractions, the bathing establishments and the casino. Bathers could while away their time by visiting the locally famous twin lighthouses perched on the far side of the Cap de la Hève.

When Monet returned to Sainte-Adresse in 1867 for a long summer's stay, he painted the view along the shingle beach towards the Cap (Pl. 291), one especially recommended to tourists, who were reminded that it had been Bernardin de Saint-Pierre's favorite haunt at the beginning of the century. The tops of the lighthouses are just visible on the brow of the promontory. More conspicuous against the sky is the chapel completed eight years earlier, dedicated to Our Lady of the Waves (Notre Dame des flots). In front of it is a white cone affectionately called "the sugar loaf" by the natives, a cenotaph honoring Admiral Lefèvre-Desnouettes.[20] Both monuments, like the lighthouses, surmount a bay and village that had long been devoted to the sea. In the foreground are several beached fishing boats, a lone mast in the sand, a capstan to the right, and a number of fishermen and women. No vacationers are present, although the white buildings off in the distance

below the chapel, just touched by the light brown sail, would have been recognized by locals as the casino. It shows more clearly in a photograph of the site take a decade earlier by

292. Jongkind, *Sainte-Adresse*, 1866. Private collection.

293 (following pages). Monet, detail of *Sainte-Adresse, Fishing Boats on the Shore* (Pl. 291).

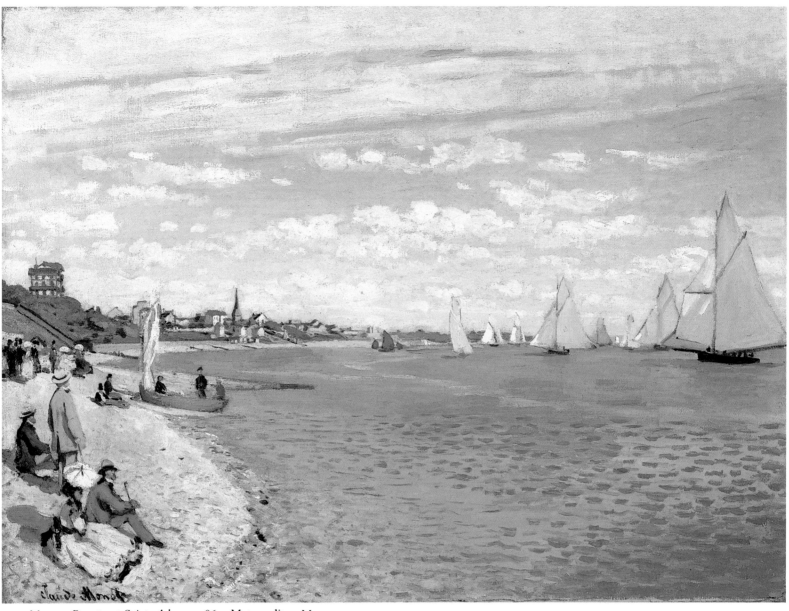

294. Monet, *Regatta at Sainte-Adresse*, 1867. Metropolitan Museum.

Gustave Le Gray (Pl. 290). (The "sugar loaf" stands by itself, since the chapel had not yet been built.)

Monet had painted the Cap de la Hève several times since 1864, following in the footsteps of J. B. Jongkind, who had long before made it a favorite site. Monet had met the Dutch painter in 1862, and in 1864 the two of them and Boudin painted together at Honfleur. Jongkind, twenty-one years older than Monet, had come to Paris in 1846 and spent most of his time thereafter in northern France, with frequent returns to the Lowlands. He cultivated his Dutch origins and contributed importantly to the shift of landscape painting in France towards the north, away from Italy. In his *Sainte-Adresse* (Pl. 292), he shows ordinary activity along the bay, without recourse to dramatic incident, much as Dutch painters of the seventeenth century had done at Scheveningen. His brushwork is varied and flowing, and owes a great deal to his habit of filling whole albums with watercolors done on the spot, often annotated, in emulation of Constable, with the hour of the day.

Jongkind was second only to Boudin as Monet's mentor, and yet we can readily distinguish the young artist's work from his. Jongkind thought in terms of large planes, each given a broad treatment that conforms more to a sense of the whole than to closely observed particularities. The distant point of land, compared with Monet's, seems to be summarized in large abridgements of light and dark. The foreground, rising up to the building on the right, clings to one lateral plane, set against the water and the distant headland. Monet's painting is much more complicated, and the rather gradual movement back to the Cap along the rising land is punctuated by many small patches of color which are easily read as buildings, pathways, rocky outcroppings, and vegetation (Pl. 293).

Monet's foreground is also more complex than Jongkind's. It is controlled by diminishing lines which all meet at the building on the right edge above center. The boats along the water's edge, the mast in the center, and the patchy vegetation to the right all lead our eye to that building. The boats, unified by their shared diagonal, are the most striking feature of the

295. Monet, *The Beach at Sainte-Adresse*, 1867. Art Institute of Chicago.

picture. Monet took advantage of the fact that they were of different sizes, although most have the same shape. Our eye cannot quite assimilate all of them in a single movement back into depth as it can the horse in Jongkind's picture. On the left, our eye jumps upward to the large boats, then drops down in steps to reach a group of tiny figures, three seated and one standing. To their right, surprisingly large, a blue-frocked fisherman faces us (a characteristic figure from Jongkind's repertoire), standing next to his wife and infant. Upon reflection the jump in scale is resolved by realizing that the low boat below the little group hides the fact that the beach slopes away at that point; they are so small, compared to the fisherman's family, because they are farther away than we had anticipated at first. Further reflection reveals the great care with which Monet built his forms and images. He placed the family in the gap between the two small boats, in effect creating the gap for them. They are centered on the boat behind them, and its top edge, marked by their heads, coincides with a groyne that forms a continuous line linking the largest boats with the

rising land to the far right. Over the water, the groyne completes the trapezoid that shelters the tiny fishermen. They are echoed, in turn, by the two figures who stand behind the boat to the right of the family; they have their own boat-shaped aperture.

All the figures in Monet's painting are seacoast residents. In the family group, the husband has a mariner's cap and blue jacket, the wife, a Norman coiffe and apron; her baby is rendered uniquely by its white bonnet. They could have had good reason to be on the beach, but, of course, it is Monet who put them there as representatives of Sainte-Adresse. This makes us out to be the visitors—that is why the fisherman is posing for us—who have come to admire the sea and to look at local boats and people. Paintings of the seashore gave the tourists's view and were destined for Le Havre and Paris (Monet had exhibited one of the same site in the Salon of 1865). What drew Monet to Sainte-Adresse also drew the mass of vacationers there, and the increased favor of seascape painting in France coincided with the rising tide of tourism.

Vacationers and fishermen share the beach in two other paintings Monet did that summer, both looking away from the Cap de la Hève towards Ingouville and Le Havre. In one (Pl. 294), a number of visitors watch a regatta while three mariners talk together in their beached boat. In the other (Pl. 295), fishermen and their boats dominate the foreground, but a pair of seated vacationers are prominent despite their small size. In the regatta picture, water and sky take up four-fifths of the surface. Puffy clouds float below a high streaked layer; the sky's greyish blue has a violet cast that is repeated in the shallows of the water, which elsewhere is marked by saturated greens and blues. The sailboats together form an elongated triangle that matches the shape of the land in mid-distance; the largest yacht closes off the right edge, and responds to the three-story villa on the opposite edge (one of those garishly colored "parrots" that Eugène Chapus deplored). In this painting we have the same mixture of a mariner's and a vacationer's coastline that Chapus noted in 1855: nouveau-riche villa and the old church steeple, fishing boats and yachts, vacationers and sailors.[21] The dominance of leisure forms was already assured, for fishermen had been selling out to vacationers or entrepreneurs, and yachts were more numerous than fishing boats.

To locate ourselves in the pendant to this picture (Pl. 295), we must imagine walking along the beach of the regatta view and stationing ourselves to the left, closer to the beached boat. In the pendant, that boat and two others hide the dip in the beach that is visible in the other painting. Nothing else in the modeling of the beach explains the distance between us and the tiny seated couple, so again we have curious juxtapositions that flatten the picture, calling attention to its surface. The startling blue of one boat pulls it forward, and the stubby, flat profiles of those on the left make them also cling to the surface rather than dip back convincingly into imaginary depth. Because the foreground is bleached by the grey light of a sunless day, there are none of the shadows of the regatta painting, and so the three fishermen are unmodeled silhouettes. The diffuse light also reduces the variety of color and the contrasting planes of the buildings in the distance, compared to the crisp treatment of the sunlit painting.

Although the blue boat was a fisherman's, it is the most modern element of this picture. It has the obtrusive presence of the blue color of modern campers' tents or boaters' tarpaulins. It is held in the picture—but barely—by the fact that the water is a lighter blue whose greenish tinge mediates between the boat's blue and the yellow of its gunwales and stepped mast. It is also held by the brown sailboats above, which weigh it down, as it were, and integrate it with imaginary depth by carrying our eye across the bay. The bowsprit of the foremost sailboat ends directly above the stern of the blue boat. Together they form a vertical, dividing the canvas into a broad area full of activity and a narrow one free of incident. Our eye sweeps into the narrow zone, suitably clear because it carries us out towards the sea, with its indefinite distances.

The more we look into this picture, the more we realize how well calculated it is. The large active part that ends at the vertical formed by the two boats is an exact square. Employing one of the most common of all painters' devices, Monet measured the height of his canvas out across its width from left to right, and erected a vertical there. On the other side, the church spire marks the same measurement from right to left. The spire, the church of Saint-Michel in Sainte-Adresse (the oldest in greater Le Havre), outrivals the new villa on the left edge because it is the focal point of a number of constructive lines. One runs over through the brown sailboats, another across two minuscule boats to the seated tourists, and then to the bows of the beached boats, and a third drops down the dark mast to the boats and men in the left foreground. The diagonal along which the seated couple are located ensures their importance (Pl. 267). They also sit at the apex of a triangle formed when our eye picks up the opposing diagonal that takes us from the boats in the left back to the furthest sailboat. Tiny they may be, but the couple sit at the very center of this painting's key events. Everything else is a setting for these visitors. The woman's red and white costume guarantees our attention and distinguishes her from the natives. The man's raised telescope becomes the picture's symbol: the view of a man of leisure who stares out over the water.

The modernity of all three paintings of the shore of Sainte-Adresse becomes more obvious when we compare them with a picture of the previous generation. In Isabey's *View along the Norman Coast* (Pl. 296), all the figures are native, as is true of the first Monet we looked at (Pl. 291). At least one of the figures, possibly two, are staring at us, for we are like the artist in the anonymous engraving of 1866 (Pl. 268). We are the painter-visitor who, in the words of Morlent (see the epigraph to this chapter), is going to take away one of "these natural and splendid illustrations." Monet's view of fisherfolk and their boats takes up Isabey's subject, but he produces a series of shapes that interlock with an abruptness and a flatness that the older painter could not have countenanced. The structure of the other two Monets is superficially close to Isabey but there, too, the higher horizon line, the lack of detailed modeling, and the large areas of nearly flat and stronger color produce a very different result. If we needed proof of the distance landscape had traveled since 1852, we need only compare Isabey's water, with its ruffled light and shade, with Monet's sheets of greenish blue.

296. Isabey, *View along the Norman Coast*, 1852. Houston, Museum of Fine Arts.

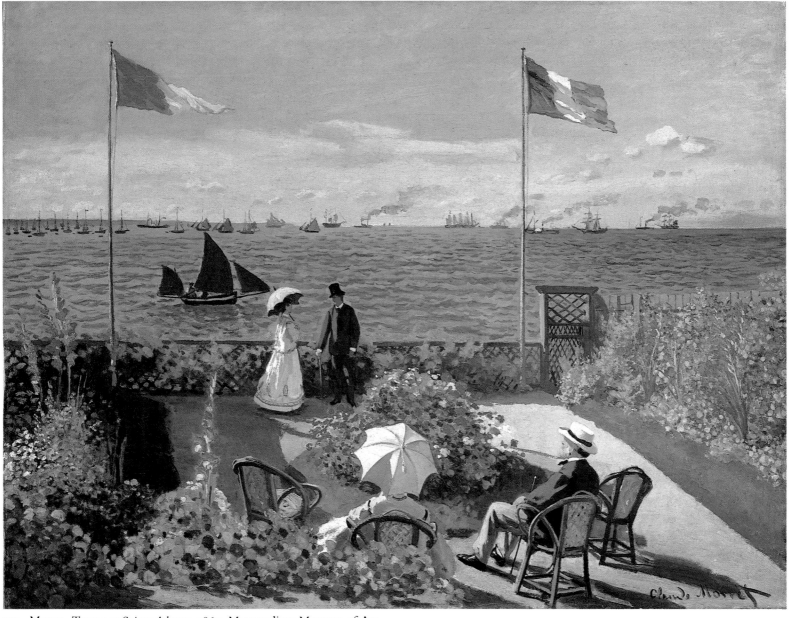

297. Monet, *Terrace at Sainte-Adresse*, 1867. Metropolitan Museum of Art.

The tourists who appear in two of Monet's paintings would be unthinkable for Isabey who, like Daubigny, Corot, and Jongkind, preserved the fiction of an unmediated past, as though the viewer were the only tourist present. Monet had attempted this in the first of the pictures we examined, as Manet had in *Moonlight over Boulogne Harbor* (Pl. 276), but in the two other pictures, Monet combined vacationers and natives. Increasingly the painter of the modern landscape (only months before he had painted Paris from the balcony of the Louvre), he was unwilling to exclude the truth of contemporary life along the coast. In *Terrace at Sainte-Adresse* (Pl. 297), the most famous painting of that summer's campaign, he devoted himself entirely to vacationers.

From a window of his aunt's villa, where he stayed that summer, he looked out over the Channel; in the left distance is the thin purple band which marks the coast to the west, beyond Honfleur. In the center foreground Mme Lecadre sits in a bentwood chair, under her parasol. Monet's father is next

to her, looking towards the young couple at the edge of the terrace, the artist's cousin Jeanne-Marguérite Lecadre and an unidentified man. Out in the water are a number of ships, varying from the pleasure boats moored on the left, towards Le Havre, to the Channel steamers on the right, towards England. Monet had often painted such boats, entering and leaving Le Havre and Honfleur. The more we look at the boats, the more we realize that they have been assembled to tell us a story. They include a mixture of old and new ships that represent this transitional generation of sail and steam. On the horizon are four old-fashioned sailing vessels, one of them a survivor from the past, a five-masted bark. Alternating among them are four steamships, including a paddle steamer in red, white, and blue that just nudges the righthand flagpole—an encounter of surface and depth that is one of Monet's rare pieces of wit. The steamer bears government colors, as does the flagpole it touches, lending official sanction to this scene of maritime prosperity. The large ships stand for

the busy transatlantic, Channel, and coastal traffic that had recently made Le Havre the chief port of France, outdistancing Marseilles in volume of produce. In the middle distance is another contrived juxtaposition, the fishing boat that symbolically touches Jeanne-Marguérite's parasol. It is the same local boat that appears in the two views towards Ingouville (Pls. 294, 295), a brown-sailed ketch readily distinguished from the white-sailed yachts (white sails were more expensive), and the only clear sign of traditional life at Sainte-Adresse before its transformation by vacationers.

In the foreground, Adolphe Monet gazes out upon the scene. He looks in the direction of Le Havre, linking foreground with distance. This is only as it should be, because his vacation at Sainte-Adresse was earned by keeping shop in the nearby city. Both he and his son have the forward-looking spirit of the men of Le Havre, praised by the German visitor Jacob Venedey in 1841 for their cosmopolitan outlook, a "pattern" derived, he said, from constant intercourse with England and America:

> ...they there find patterns, who give them daily fresh lessons on the high interests of trade, and point out to them what urgently requires to be done. . . .Hence their notions respecting free trade; hence their enmity to everything that looks like monopoly and privilege, at least in commerce.

Venedey then takes his reader out to Ingouville on the heights above Sainte-Adresse: "The wealthier merchants of the wealthy commercial town have here built a number of palaces, where they enjoy themselves in summer after the toils of the day. Many English live in those which the owners are willing to let that they may thus make money even of their villas." From such villas, Venedey writes, he had evening views over the Channel, "and while my eye roved over the expansive sea, imagination has accompanied the vessels leaving the port to other regions of the globe. A spring morning, or a summer evening here, is a treat on which you may feast all your life. . . ."[22]

Not only was Le Havre oriented towards England and the northern seas, so too was the drift of French landscape painting. In the 1820s, when British tourism and the Channel resorts began to develop, Constable, Bonington, Turner, and the Fielding brothers became influential in Paris. To their northern naturalism, so different from the Mediterranean heritage which had heretofore dominated, was added a growing appreciation of Lowlands painting. The landscapes of Delacroix. Huet, Rousseau, Daubigny, Courbet, and Boudin are unthinkable without the precedents set by Ruysdael, Hobbema, or Van de Velde, seconded by the recent work of the British (and by Jongkind, a direct transmitter). Monet, Sisley, and Pissarro typified their generation by traveling not to the Mediterranean but to England and Holland (Monet visited England in 1870–71 and Holland in 1871 and 1874). It would be futile to try to draw the lines too tightly between landscape painting and the role of Britain in France's industrial revolution, but we are justified in making the broad equation: as Le Havre displaced Marseille, so Constable displaced Poussin.

Monet's terrace, in other words, looked north across the Channel, not south towards the *grande tradition*. He was learning from Daubigny, Boudin, and Jongkind, not from the italianate painters who still taught landscape at the Academy. He set out on his own and, to apply Venedey's phrases to him, "hence *his* notions respecting free trade; hence *his* enmity to everything that looks like monopoly and privilege. . . ." He painted Le Havre's suburb with the enterprise of one who set his sights rather ruthlessly towards the future, eager to sever ties with the past. It is no accident that his terrace, lit by that splendid afternoon sun, represents the outward-looking view of Le Havre's suburb. He erected Venedey's "pattern," a platform of earned leisure in front of the sea, the cycle of work and leisure in one composition. He marshaled his images more programmatically than Morisot did in her later *Villa at the Seaside* (Pl. 286), where there is no hint of maritime commerce nor of a whole family. His pattern is also different from Stevens's saucy rendering of young vacationers at Trouville (Pl. 269), since it presents the domain of a staid middle-class family. Adolphe Monet and his half-sister represent the older generation; they have the established positions that pay for such a villa. The two young people stand for youth, and their courtship is more decorous, more bourgeois than the flirtatious encounters preferred by Stevens. They are upright and by themselves, to show their youth, but the empty chairs integrate them with the older pair. Were they seated, they would be separated by proper middle-class distance.

It is well that Monet was an optimist, for the prosperous scene that he painted was a contrast with his fortunes that summer. In late spring he had left his mistress Camille Doncieux alone and penniless in a Paris apartment (no wonder he had consoled her with *Women in a Garden*, Pl. 181!). There, in early August, she gave birth to their son, Jean. Monet recognized the child by having a friend act as his proxy in signing the birth certificate. His father had opposed the liaison and urged his son to desert Camille. He seems to have kept pressure on Claude to adopt a conventional life; there was certainly friction between father and son. Monet's aunt was apparently more welcoming. The artist could live with her while pursuing his craft, but she would not lend him money.[23] He spent the summer begging his friend Bazille to send money to Camille while he tried to improve his fortunes by going back and forth to Le Havre, painting a large picture of the harbor for the next Salon in Paris. The *Terrace at Sainte-Adresse*, therefore, seems the work of a young artist (he was then twenty-seven) surprisingly confident in his talent despite setbacks, determined to put into his picture an ideal world he could not yet realize. In view of Camille's miserable situation in Paris and his own worries, the young couple in the picture project a poignant optimism.

To convey the sunny outlook of his images, Monet used a compositional scheme of striking simplicity which draws attention to the symbolic juxtapositions. Top and bottom halves are united by the soaring verticals of the flagpoles and by the repetition in the flags of the brilliant reds of the gladioli, geraniums, and nasturtiums that festoon the foreground. In its confident geometry the picture speaks for the incursion of modern forms of organization into this fishing village. Even the flowers are cultivated plants, not the ones that grew naturally along the slopes of Sainte-Adresse. The

terrace is cast up starkly against the sea, a one-to-one confrontation of leisure and commerce which eliminates the customary view of the shoreline that mediated the two in Boudin's views of seacoast society (Pl. 270). Boudin's pictures are equally characterized by broad horizontal rectangles, but our eye can move continuously from beach to water to sky, and the borders of each rectangle are softened and partly hidden by overlapping forms. We cannot imagine his painting the railing of Monet's picture, which impounds the sea as though it were a dam. It defines a rising plane whose abruptness is reinforced by the vertical divisions of the flagpoles. To give a sense of depth despite this flatness, he exaggerates the role of diagonals which we habitually read as indicators of recession. The chief diagonal is the line on the right which separates sand from grass. Almost as prominent is the one which leads from Adolphe Monet through the mound of flowers to the young couple, then to the fishing boat. The arbitrariness of this scheme, which divides the canvas into geometric segments, is one that only Manet could match in 1867 (Pl. 7).

The modernity of Monet's picture resides in its structure, not just in its images. Stevens's Trouville terrace (Pl. 269) has just as modern a subject, but his organization follows long-established conventions. Monet instead uses the assertive patterns with which industrial society was colonizing the countryside, the straight lines of railroad tracks and bridges, of macadam turnpikes and canalized rivers. The transformation of fishing villages into modern resorts was marked by intrusive geometries that echoed Haussmann's Paris: broad avenues, squares, sidewalks, formal gardens, and huge buildings.[24] For the entrepreneurs who boasted of them, these new shapes were signs of progress; in them were traced the institutions of leisure which catered to visiting strangers. Monet unwittingly used similar shapes because they were a young painter's way of establishing his modernity, of organizing his perceptions of his native coast which he would take to Paris to exhibit and sell. They are what make this composition an important forebear of Georges Seurat's *Sunday on the Island of the Grande Jatte*, that well-organized statement of suburban leisure in the next generation. It is also a foretaste of what was to come in Sainte-Adresse by the 1880s (Pl. 298), when the irregular topography of the beachfront, no longer sufficient for the crowds that paraded there in bustles and on velocipedes, was replaced by a wide roadway that led to the center of Le Havre. Monet's painted terrace is like that avenue (and his aunt's villa was like the one on the far right and very close to its emplacement). Municipal authorities and owners of villas were constantly filling in or leveling land, pushing landings, porches, and roads out towards the water, creating those artificial spaces that "belonged" to the Parisians and other visitors, not to the fishermen and shopkeepers who had once lived there.

Monet at Trouville

In 1868, following his summer at Sainte-Adresse, Monet painted a number of seascapes and coastal views in the region of Le Havre. None of these showed vacationers, and resort society did not reappear in his work until mid-summer 1870, when he went to Trouville with Camille and their three-year-

298. Després, *Sainte-Adresse towards the Cap de la Hève*, c. 1890.

old son Jean. They had married in Paris on 8 June 1870, hardly a calm moment, however, since rumors of war were swirling about; it is likely that Monet married then at least partly to escape military service.[25] France declared war on Prussia on 19 July, but Monet's choice of Trouville need not be related to this fatal move, since he usually left the capital during the summer months. He and his family arrived at the resort on an unknown day in July or early August, and remained there until autumn. Louis Napoleon's debacle at Sedan had led to the declaration of the Third Republic on 4 September, but the disastrous war continued. Monet fled to London, followed shortly by Camille and Jean. He did not return to France until late the next year, preferring England and Holland to France, racked successively by war, the siege of Paris, and the Commune, and its bloody repression.

Trouville was an attractive place for a combined vacation and campaign of painting. Although Monet and Camille had been living together for several years, they could here celebrate their sanctioned marriage by joining other vacationers at the watering place uniformly referred to as the "jewel" or the "queen" of the Channel coast. It was a cut above Sainte-Adresse. Monet knew it well, although no painting of it before 1870 has survived in his work. Trouville had often been painted by two artists he admired and who were influential in his development, Boudin and Courbet. Boudin had painted there off and on for nearly a decade, and Courbet, as we saw, had triumphant seasons at Trouville in 1865 and at its new neighbor, Deauville, in 1866. Courbet had been one of Monet's marriage witnesses in June and might have reminded the young artist of his earlier good fortune there. As for Boudin, he and his wife arrived at Trouville in mid-August and became the couple's companions. Caught in his usual tangle of borrowing and spending, Monet went over to Le Havre in September to try to dislodge money from his father for his hotel bill; he wrote Boudin to ask him to look after Camille during his absence. They had been staying at the Tivoli, a middling hotel well back from the prestigious waterfront, cheaper than the best but still fairly costly.[26]

During his stay at Trouville Monet painted only one non-tourist landscape, a view of the outlet of the Touques river, which separated Deauville from Trouville and formed their

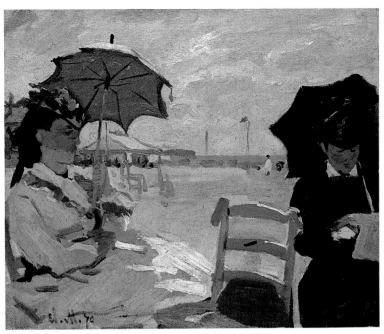

299. Monet, *The Beach at Trouville*, 1870. London, National Gallery.

though they remain far from conventionally finished. *The Boardwalk at Trouville* (Pl. 301) recalls Boudin's subjects, but its plunging space contrasts with the horizontal bands that the older artist customarily used (Pl. 270). The nearest approach to Monet's perspective that Boudin painted is a work of 1863 (Pl. 300). Even here, however, his horizon line is much lower, his figures line up along horizontals, and the retaining wall bends around nearly parallel to the surface. Monet fills his foreground with the boardwalk which assumes astonishing importance, as do the green steps that Boudin rendered more discreetly. These shapes have an urban look that foretells the later terracing of the beach or the modernization of the shorefront, already mentioned in connection with Sainte-Adresse (Pl. 298). Monet's dynamic wedge focuses on the potential for moving about, whereas Boudin's horizontals suit contemplation. The green stairs are another sign of walking to and fro, and the figures in mid-distance are either walking to the left or back and forth along the boardwalk. The phalanx of hotels faces the sea and, together with the tourists, dominates the natural setting. "Trouville," according to its quasi-official publication of 1868,

is the boulevard des Italiens of Norman beaches. If the *flâneur* of city pavement, dozing on a divan at the Café Richelieu while digesting his succulent dinner, were suddenly transported by the rug of One Thousand and One Nights to the casino in Trouville, he would not believe that he had left Paris when he awakened there.[27]

300. Boudin, *The Beach at Trouville*, 1863. Private collection.

The largest building in the distance of the boardwalk picture was "the king of the Norman coast,"[28] the Hôtel des Roches Noires, named for the nearby seaweed-covered rocks where fisherfolk once gathered mussels and where vacationers now removed their shoes and played at being natives. Monet's masterpiece of the Trouville campaign (Pl. 302) features this hotel. It had opened only four years earlier, the latest in a rampant building campaign along the beach. Its emblem was an eight-foot high statue of Neptune, the baroque form that salutes the sky from the top of the facade in Monet's painting. The hotel boasted 150 rooms (with attic quarters for staff and clients' servants), communal rooms devoted to indoor bathing, cardplaying, billiards, and reading, as well as a café, a restaurant, a concert hall (with Paris orchestra), and attached

joint harbor. Three paintings represent the beachfront and its phalanx of principal hotels (Pls. 301, 302). Four smaller ones show Camille on the beach, and a fifth, an unidentified woman who might also have been posed by Camille. The best known of these is *The Beach at Trouville* (Pl. 299). Like the other figure pieces, it is a *pochade*, or sketch, probably a project for a larger, unrealized picture. Upon first glance it seems casual in its brushwork, as though it were not well thought-out. Some of its dash can be put down to an emulation of Manet, which is the case, but Monet has already made most of the decisions required for a major figure composition. His wife is given pride of place out on the beach. The other woman is that kind of companion—aunt, or friend—who sets off the more glamourous younger woman. Camille is on display not only because of her flowered hat and light dress, compared to the other's dark clothing, but also because she dominates the composition. She is on the left, where our eye enters, and her profile looks out over the beach towards her plain companion. The older woman, who is either reading or doing needlework, has propped her parasol on her shoulder to leave her hands free, but Camille holds hers grandly above her head. Her hands are otherwise unoccupied, as befits her youth and higher station. One segment of her parasol continues the lines of her forehead and hat, and the top of one stay just touches the crest of the beach tent. Springing, as it were, from her head, Camille's parasol lays claim to large spaces, whereas the other woman's shelters her head symmetrically and confirms her more modest place.

In painting Camille on the beach, Monet was celebrating her as a fashionable vacationer, the kind of offering an impecunious artist can make to his bride. We can only guess at the life they led that summer, always short of money, yet rubbing elbows with Trouville's dashing society. Monet showed that society in three paintings where vacationers stand and stroll in front of the prestigious hotels that faced the sea. These beachfront views are larger than the studies of Camille, and they were carried to a further degree of completion,

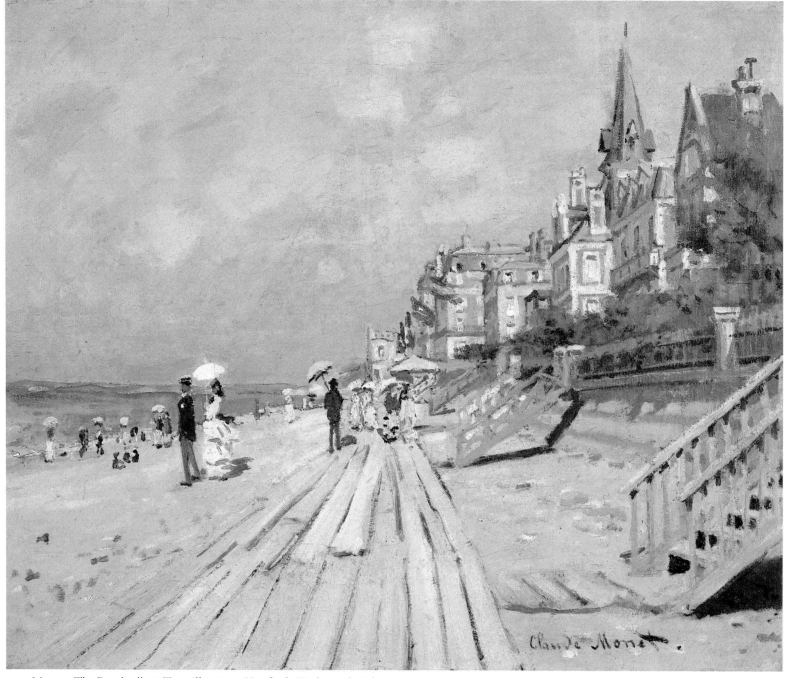

301. Monet, *The Boardwalk at Trouville*, 1870. Hartford, Wadsworth Atheneum.

stables. In describing these, the local guide in 1868 compared it favorably with three different buildings in Paris,[29] including the Grand Hôtel on the boulevard des Capucines, which Monet was to paint in 1873 (Pl. 18). Everything was done to remind visitors that staying at the Roches Noires was the next thing to being in Paris itself. Monet seems to have agreed, for he relegated the water to a small wedge on the left. By concentrating on the hotel and its terrace, he took up a theme common to all the guide-book descriptions of life at Trouville:

> It is between the casino and the water, at certain hours of the day, that you can see coming and going, rivaling one another in luxury, bathing in order to undress, dressing again an hour later in order to change costume, all these ele-

gant Parisians, English, Spanish, Russians, or Americans, for whom life is a perpetual fair and costume a masquerade that is ordinarily renewed five or six times a day.[30]

To signal Trouville's international flavor, Monet painted the large American flag overhead (summarily, so as to prevent our eye from focusing there), and another, apparently British, beyond the French flag. The flags give a sense of the sea, that is, of its vigorous onshore breeze, a necessary touch, since we see so little of the water. The prominence of the flags also counterbalances the weight of the hotel front (and the shape of the sky under the large flag repeats the shape of the hotel). Unlike the boardwalk picture (Pl. 301), whose open beach is so different from its crowded assemblage of hotels, this

painting sets up a rough equality between its left and right sides. The flags, lampposts, and grouped figures form an open vertical plane that offsets the closed plane of the hotel. The monumental brick and stone facade blocks off the land, converting the terrace into something between the deck of a luxury ship and the street of a modern city. The only touch of the past is the crenellated cylinder of the Malakoff Tower beyond the pavilion, a kind of toy castle or architectural mascot for this elaborate social game.

Our plunge into depth is not as rapid as in the boardwalk picture (Pl. 301), and this gives the terrace a more intimate feeling. Nonetheless, the composition is based upon movements which rush inwards from each of its four corners. In the lower-left corner, a woman sits on a folding chair, taking the sun while protecting herself with a parasol and a very full costume. Next to her a man in a grey suit is doffing his hat to two women. All these figures on the left are part of the network of railing and lampposts which together form a rather exact triangle that points back into depth. Precisely halfway across the picture is a woman in pale blue, holding a parasol, coming towards us (Pl. 303). Behind her to our left is another woman, walking away from us, and to the right sits a woman in a peach-colored costume. Lime-green patches, symmetrically disposed on both sides of the central woman, mark potted plants under the pavilion, where a crowd is seated. Closer to us, on the right, a man with a cane is walking idly away, his head turned to the left. This slight movement connects him with the centrally placed woman, an association confirmed by the path of the large shadow that embraces them both. These delicate hints at social relationships are a far cry from Stevens's more flirtatious encounters in his Trouville picture (Pl. 269) and once again demonstrate the reserve of the impressionist painter and his refusal to engage in anecdote. The man with a cane is the only figure outlined in black, a last-minute touch (in the same paint as the signature) which helps separate him from the adjacent areas. From him our glance moves up the staircase, where two figures mark the steep rise of the railing. On top of the steps is a small group of patrons, and from them our eye continues along the shallow balconies of the main floor, where white urns are easily confused with a few people who are leaning out. A few more lean forward from the balcony and the windows in the extreme upper right.

The careful arrangement of all features of this composition is disguised by its "unfinished" texture, by its loosely brushed images which refuse to come into sharp focus. Monet's picture is a brilliant interpretation of the leisure society of Trouville because of this blending of the well-regulated with the spontaneous. It is the strong, overall pattern which lets the artist get away with his painterly abbreviations. Were it not for the wedge of receding space, the scumbled paint of the terrace would float upwards, and the filmy grey-blue strokes that hover over it, reflecting the sky, would seem only like paint. The prominent curving shadow is not modeled as it recedes, and its adherence to the diagonal is what lets it tilt inwards (aided by the figures that pin it down).

The loose and unmodeled brushwork is also unified by the consistent way Monet used color to convey the effects of sunlight and shadow. In this summer of 1870, following upon the previous summer's inventive work at Bougival, he was well on his way towards the central innovation of impressionism: the supplanting of modeling in light and dark by a new conception of chromatic harmony. Monet's shadows take on different colors according to their locations. On the terrace the shadow has a faintly greenish tinge that derives from the nearby foliage; it is also the color opposite of the red flowers. On the white awning the shadow is blue, since the cloth reflects the sky with little alteration. On the facade above the entryway, the diagonal shadow is purplish, the color opposite of the sunstruck yellow. The left side of the painting has predominantly cool colors, the right side, warm ones. Each is punctuated with its opposite, however: the reds of the flags on the left, and the blues that appear as window openings on the right. The hotel facade is alone a miracle of observation and invention: the vertical blue streaks carve out niches among the yellows and dull oranges; subdued rose streaks suggest the brick that we do not otherwise see, and a medley of intermediate browns, olive tans, and purplish tones serves as bass to the brighter trebles.

The Hôtel des Roches Noires takes its place, along with the other Trouville compositions, in the sequence of works that made the young artist one of the chief interpreters of contemporary life in its landscape settings. Between his twenty-sixth and thirtieth years, this gifted artist, matching Manet at the same age, created notable pictures which helped change the direction of French painting. *The Garden of the Princess* (Pl. 14) is a homage to the expansive mood of the capital during the Universal Exposition of 1867. Vacationers at Sainte-Adresse look out on pleasure boats (Pls. 294, 295) or gather on a flowered terrace, politely deployed to indicate the correct social pattern (Pl. 297), while on the horizon, a fleet of ships gives evidence of maritime prosperity. Paintings of the Grenouillère (Pls. 211, 214) celebrate leisure on the outskirts of the city. The Trouville canvases are a thorough absorption of resort leisure, paintings that relegate the sea to a minor role, while beach, boardwalk, and terrace serve as platforms for vacationers' performances. They could serve as painted excerpts from that most contemporary of novels, the Goncourts' *Manette Salomon* of 1867, in which Coriolis demonstrated his devotion to modernity by painting the beachfront society at Trouville. In painting and literature Trouville was never far from Paris. The Goncourts' readers were mainly Parisians, and so were those who attended *Niniche* in 1878, a vaudeville whose first act takes place at Trouville:

> Let us take the air on the beach,
> And contemplate the Ocean so tranquil.
> Ah! If Paris only had the sea,
> It would be a little Trouville.[31]

"The great building which seems to guard the entrance to Trouville is the Hôtel des Roches Noires," wrote Katherine Macquoid in 1874. "This is the chief hotel, and the resort of the most gaily dressed of the loungers; it is worth seeing." She then goes on to say that "There is not so much as a beggar to destroy the illusion. Truly Trouville would have seemed a paradise to that Eastern philosopher who wandered about in search of happiness; and the paradise would last—perhaps till he was called on to pay his hotel bill."[32] Monet did nothing to shatter the illusion, and his appeal still today—especially

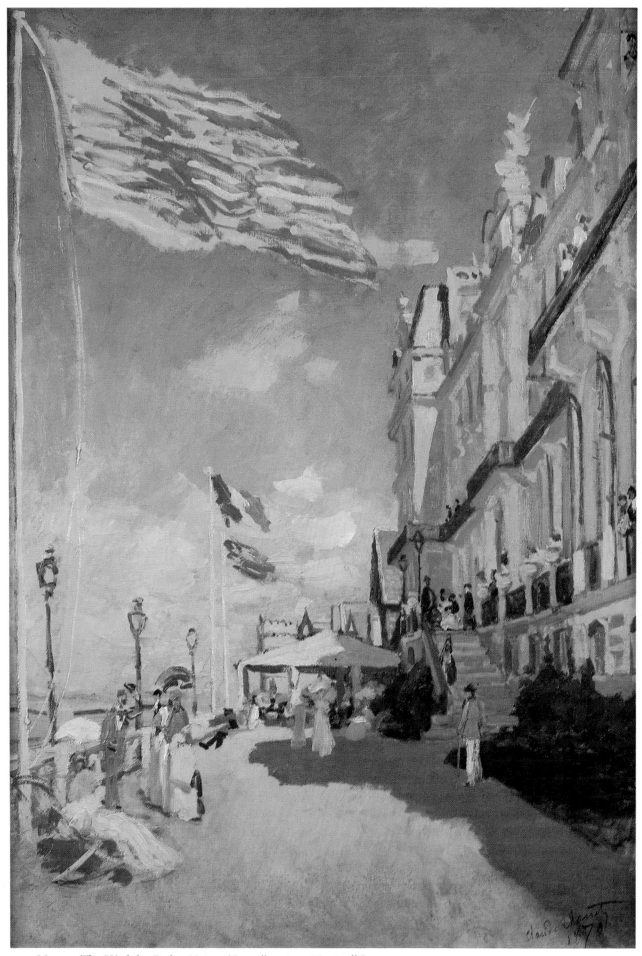

302. Monet, *The Hôtel des Roches Noires, Trouville*, 1870. Musée d'Orsay.

today!—owes much to his creation of this beggarless society, this world in which no labor is shown, this well-ordered landscape in which light and color stand for that longed-for ideal: nature, spontaneity, outdoor pleasures, harmonies of color and of human relationships.

Epilogue: Monet at Pourville and Etretat

In the decade following the summer at Trouville Monet did not paint seaside vacationers. He paid brief visits to the Seine estuary in 1873 and 1874, but his pictures, devoted to boats, harbors, and the shore, give no hint of tourism. This does not mean that he was yet ready to forsake the theme of leisure for, from 1872 to 1878, he gave the pleasure boats, promenades, and gardens of Argenteuil prominent places in his repertoire. Drastic changes were in the offing towards the end of the decade, however. In 1877 and 1878 he painted his last pictures of Paris, including the famous series of the Gare Saint-Lazare. He moved to Vétheuil in 1878 and never again painted Paris or its near suburbs. Camille Monet died in September 1879, after a long illness, and Monet and Alice Hoschedé thenceforth lived together, merging their families. In 1883, after three years at Vétheuil and an interim stay at Poissy, Monet and his enlarged family settled in Giverny, further down the Seine in his beloved Normandy. All these changes coincided with the artist's virtual abandonment of figure painting. After 1878, except for a few paintings of family and friends, large-scale figures disappear from his easel, along with Paris.

Amidst this reshaping of his life and his work, Monet sought out landscape sites in a new way. Beginning in 1881, he left his studio and family for concentrated periods of several weeks, sometimes months. Alice and the children joined him for the summer of 1882 at Pourville, but usually he went by himself. The first of these tours was along the Channel: Les Petites Dalles in 1880 (again in 1884), Fécamp and the Seine estuary in 1881, Pourville and Varengeville in 1882, Etretat in 1883, 1884, 1885, and 1886. He widened his travels in the middle of the decade, south to Bordighera and Menton in 1884, to Belle-Isle off the Breton coast in 1886, south again to Antibes in 1888, and inland to the Creuse valley in 1889. For most of each year the landscape of Giverny and its environs served as a settled base for these outlying campaigns. Away from home he often sought out dramatic sites that restored some of the images of romanticism, the kind of image that he had avoided in the 1870s. Paintings of Pourville, Varengeville, Etretat, Belle-Isle, and the Creuse valley include isolated rocky promontories (Pl. 303), waves crashing against bizarre rocks or threatening beached fishing boats (Pls. 307, 308, 310), lugubrious valleys illuminated by fitful, wintry sunsets.

We do not know the reasons for all these changes in Monet's subjects after 1878. The death of Camille was a watershed in his life, as was his union with Alice Hoschedé and her bevy of children. Furthermore, Monet reached forty at the end of 1880, an age when many artists begin to reorient their work. These are all possible factors, but they deal with psychology, usually a circular terrain of "explanation" for a painter's subjects. Surely, the artist's emotions were deeply engaged in his subjects, but an artist does not live independently of his dealers, his clients, his exhibitions, his thirst for success, all of

304. Monet, *Rocks at Belle-Isle*, 1886. Copenhagen, Ny Carlsberg Glyptothek.

which form a complicated dialogue with society. The 1880s were the decade of Monet's rise to great fame and considerable fortune, and his letters reveal his success in manipulating his market. He was anxious about the reception of his successive campaigns of painting, and it is no accident that all his sites along the French coast were tourist spots whose fame preceded their appearance in his dealers' Parisian showrooms. They were his challenges to fame, to earlier artists like Turner or Courbet, and proof that he could render in memorable form the great landsapes of France (later he undertook London and Venice, as well). That he succeeded is indeed a tribute to his genius, but his work would have disappeared if society had not granted importance to it. One thing is certain: as the decade progressed, Monet's prices rose dramatically (despite occasional ups and downs), and so did his reputation and his influence. He passed from the status of young rebel to recognized living master. A few remarks on his Channel coast pictures will not suffice for a theory of social value, but they can point to the paths which connect the personal with the social, the unchartable but ever-intriguing realm of an artist's psyche with the accessible phenomena of acclaim from dealers, collectors, and critics.

In 1882, following short visits to Fécamp and Les Petites Dalles in the previous two years, Monet spent nearly six months at Pourville and Varengeville, just to the west of Dieppe. Of the ninety-six seascapes that resulted from this productive period, only four show tourists. Like *Cliff Walk at Pourville* (Pl. 304), each of the four has two women looking out over the water. They are the vacationers who take in nature in the recommended fashion, by putting the resort village behind them in order to commune with nature. In the cliff-walk picture, they look out over a flock of pleasure boats, probably one of the regattas organized with vacationers in mind. In contrast to Pierre Outin's *The Look-Out Point* (Pl. 305), Monet's two women merely stand there, figures of detachment whose presence is vital, but who put no specific

303. Monet, detail of *The Hôtel des Roches Noires, Trouville* (Pl. 302).

299

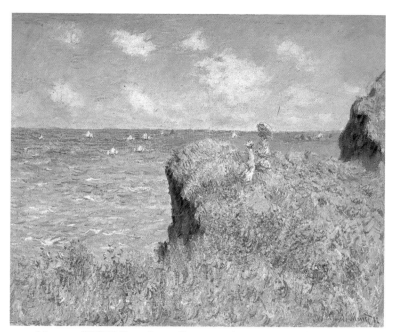

305. Monet, *Cliff Walk at Pourville*, 1882. Art Institute of Chicago.

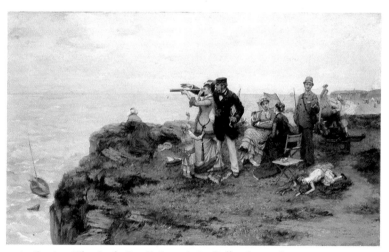

306. Outin, *The Look-Out Point*, 1878. Collection unknown.

thoughts in the viewer's mind. Outin does not let us alone with our thoughts but makes us deal with a busy clifftop society: the well-dressed salt who has lent his telescope to an attractive tourist, her annoying daughter, that wonderful fop admiring his cigar, and, among other figures, the woman in a Norman coiffe peering over the cliff, a local person used by Outin to point up the visitors' amusing society.[33]

This comparison does not deny merit to Outin, a clever story-teller, but redounds to Monet's credit because he painted for enlightened viewers—and later for us!—who were then discarding the petit bourgeois love of anecdote in favor of a landscape that seems to leave one alone, or nearly so, in front of nature (even if "nature" includes regattas), free to devise one's own poetic response. Painting and nature become equated in this curious visual fiction in which we observe Monet's painting as though we were these two women observing the landscape. Increasingly, the alert observer was being schooled by the impressionists to believe that amusing anecdotes were incompatible with the "correct" conception of art and nature,

one that combined a certain detachment with an expressive poetry of means. Monet's agitated brushwork was proof of the sincerity of his personal response to maritime light and wind, proof also of freedom and of individual, inventive genius, those shibboleths of entrepreneurial society. Displaced from the realm of politics and business to this ostensibly pure realm of art and nature, these ideals were all the more powerfully felt. One function of impressionism was, precisely, to praise freedom from restraint, freedom from urban congestion and artificiality, freedom to indulge in poetic feelings for "nature."

The vacationers who appear in four of Monet's Pourville paintings were dispensed with in all the other canvases. In the absence of fellow mortals, the viewer assumes the position of an unaccompanied vacationer overlooking the sea. The ideal position of the urban tourist is to be alone, to pretend that one is not part of a throng, that one's experience is free and unqiue. This is a myth, of course, for one lives in congested societies, restrained by all manner of conventions. The organizers of industrial societies have needed the myth, and vacations on the seashore are a prime instance of turning it temporarily into reality. Thousands of prosperous Parisians rushed to the seashore, but Monet's paintings of famous resorts in the 1880s appear to embrace an entirely private experience. Frequently, he cultivated the viewer's sense of solitude by featuring a detached promontory or an isolated building perched above the sea. He painted seven views of the clifftop church of Varengeville that season and seventeen of the coastguard cabin near Pourville. In *The Coastguard's Cottage at Pourville* (Pl. 307), the stone cabin rises from a luxuriant growth of bushes and wild flowers. Its reds and oranges, rendered vivid by the sunny afternoon light, stand out against the water's greens and blueish purples. The white sails of yachts form an equilateral triangle, complementing the section of sea they occupy as well as the cabin's gables. The balanced rhythms and intense colors of this picture bespeak mankind's joy in the harmonies of welltamed nature.

An altogether different mood springs from *Pourville, Flood*

307 Monet, *The Coastguard's Cottage at Pourville*, 1882. Boston, Museum of Fine Arts.

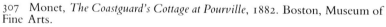

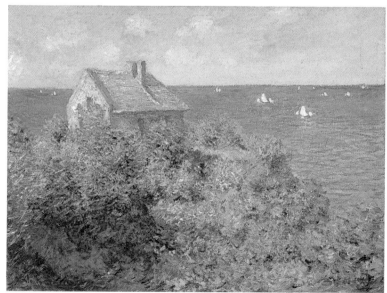

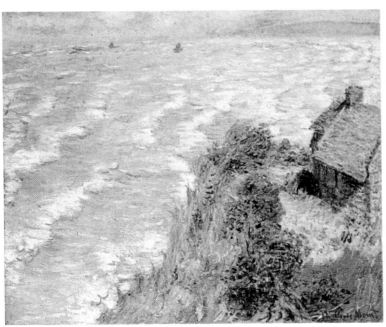

308. Monet, *Pourville, Flood Tide*, 1882. Brooklyn Museum of Art.

Tide (Pl. 308), for Monet knew how to extract a variety of meanings from the same landscape. Comparison of the two paintings shows that it is not "nature" but the artist's organization of his canvas that produces divergent meanings. No yachts in this other picture, just two fishing boats beating out against wind and tide under a threatening sky (Dieppe harbor is off to the right). Instead of calm water, a roiled-up sea, its odd color a result of the sand and seaweed caught up in the turbulence. No flowers either, but the windswept growth of a headland being besieged by the rightward pounding of the waves, abetted by the left-to-right sweep of our eye. Around the cabin the foliage has been trampled by the watchmen's pacing. What in the other picture looks like an idyllic vacationer's cottage here appears to be a lonely holdout against the adverse forces of sea and wind.

The interrelationships of tourism and lonely seascapes are more easily grasped in Monet's paintings of Etretat. Pourville and Varengeville were small outposts of Dieppe's leisure colony, but Etretat, sixteen miles northeast of Le Havre, was a major resort in its own right. Its fame owed initially to its spectacular setting: three promontories that jut out into the Channel, each with an arch pierced through its mass of limestone and flint. Delacroix had painted there, and Courbet had made it something of a specialty. Among notable Parisians who had villas there were Manet's patron, the singer Faure (who lent his house to Monet in 1885), Maupassant, and Offenbach. Some, like Offenbach, treated Etretat as a northern frontier for Parisian society: he set the village on its ear by giving spectacular parties for his operetta troupes in his "Villa Orphée." Others, like Michelet, lamented the transformation of the old fishing village and wanted to preserve untainted the experience of its titanic arches.[34]

Monet sided with Michelet. His compositions never show tourists, nor even the thriving village itself, only its shorefront and the cliffs beyond. *The Cliffs at Etretat* (Pl. 309) was painted from the top of the easternmost of the three pierced cliffs, looking over towards the middle portal, the one accompanied

by a detached needle rock. From the picture alone we would never guess that the village is immediately below and to the left, filling in the large bay (Pl. 310). In this, and all the other paintings where he might have shown it, he kept the village just off one edge or the other of his canvases. These are really quite extraordinary examples of editorial selection and beg for an explanation—what an artist omits is often a vital clue to his interpretation of a site. Perhaps he felt that the resort was tawdry and regretted the demise of the old village. Certain it is that by eliminating both vacationers and the village, he was expiating the sins of tourism and restoring one's view of Etretat to its "historic" and "natural" condition of a generation earlier.

The only views interior to the village are several which show fishing boats along the gravel beach. Like *Boats in Winter Quarters* (Pl. 311), these were painted from a window of the Hôtel Blanquet, the oldest of Etretat's hotels, where Monet

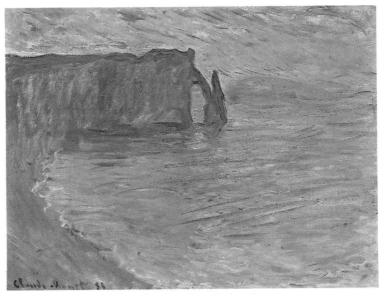

309. Monet, *The Cliffs at Etretat*, 1884. Basle, Kunstmuseum.

310. *Etretat towards the Porte d'Aval*, before 1911.

311. Monet, *Boats in Winter Quarters, Etretat*, 1885. Art Institute of Chicago.

usually stayed (from the same windows he painted several views of the central pierced cliff). He was often there out of season, in autumn and winter, another way of distancing himself from vacationers. *Boats in Winter Quarters* was done in November 1885.[35] Fishing boats have been drawn up above the pounding surf. In the foreground are three *caloges*, old boat hulks covered in tarred planks which served as storehouses. To the right is the stone building that lets us locate Monet's vantage point in photographs of the village. We do not require citations from romantic poetry to feel that the agitated sea, the beached boats, and the dark *caloges* all stand for nature's forces setting seige to humankind. The planked hulls, huddled together, are especially poignant symbols of the approach of winter. Our empathetic reaction comes not just from the images: the paint moves in slashing streaks and flowing runnels which suggest, without representing, various planks, boat gear, the marks made when boats are winched over the gravel, and the pathways formed by constant foot and wagon traffic.

The expressive brushwork of this canvas goes well beyond the most freely painted works done earlier in the decade and has a confessional quality that looks forward to Soutine and Pollock. It is quite typical of the pictures of Etretat and Belle-Isle which Monet exhibited in 1887, and was among those that so disconcerted the critic J.-K. Huysmans:

> By Claude Monet, a series of tumultuous landscapes, of abrupt and violent seas in ferocious tones...under enraged skies....The savagery of this painting envisioned by the eye of a cannibal is at first disconcerting, then in face of the

force that it reveals, the faith that animates it, the powerful inspiration of the man who brushes it, we fall under the spell of the forbidding attraction of this rough art.[36]

Van Gogh also admired *Boats in Winter Quarters* when he saw it in 1887,[37] and it is easy to see why. Its remarkable brushwork, a kind of free drawing in colored pigment, appealed to the younger artist, as did the emotional nature of the setting. Van Gogh was still subjecting himself to the discipline of Neo-Impressionism in 1887, but the lessons learned from Monet helped him to transform his style the following year at Arles. Because the two artists have been inserted in different historical slots, we do not usually see that they shared a lot in the 1880s. What a contrast Monet's Etretat and Belle-Isle pictures are to those from Sainte-Adresse and Trouville! The author of *The Hôtel des Roches Noires, Trouville* (Pl. 301) was a very different artist back in 1870, and everything that picture expressed has been set aside by 1885. No more strollers along the beach, nor fancy hotel terraces, not even a hint that Etretat had been radically altered over the previous century. Contemporary life has surrendered to premodern images of sublime nature and old boats, and "the eye of a cannibal" has developed unconventional means to express these altered feelings. Leisure activity is as unthinkable in Monet's Etretat pictures as it is in most of Van Gogh's late work, for both artists were aware of the gulf that increasingly separated humans from nature, the nature that they now identified with the non-urban world and therefore with the past.

For Monet and Van Gogh, for Pissarro and Cézanne, the modern city and its life, especially leisure and entertainment, were no longer eligible subjects because their values lay elsewhere. It was not a tranquil perception, for one could not simply walk out in the countryside and forget the urban world and its anxieties. The contrast between the actuality of contemporary life and the ideals of untainted nature led to an agonized awareness. In Monet's case the contrast is evident in the verychoice of sites. At Pourville, Varengeville, Les Petites Dalles, Fécamp, Belle-Isle, and Etretat, he was in landscapes which had been transformed by leisure-seekers, and nonetheless—even from hotel windows!—he produced images of aloneness. He was following the well-beaten trail of vacationers and earlier artists rather than unknown paths, but he was still a mythic figure, a hero who could bring back to the capital's art galleries "tumultuous landscapes, of abrupt and violent seas." His paintings helped perpetuate the myth that one could experience nature alone. It is a myth that humankind has needed in the modern era, and this explains, in part, why Monet, Van Gogh, and Cézanne are among the most popular artists the world over: our comprehension of nature consists of a deep yearning, but, since we know how thoroughly we have trampled over it, we respond best to paintings that stir our emotions.

Conclusion
Impressionism, Leisure, and Modern Society

The less you eat, drink and read books; the less you go to the theater, the dance hall, the public-house; the less you think, theorize, sing, paint, fence, etc., the more you *save*—the *greater* becomes your treasure which neither moths nor dust will devour—your *capital*. The less you *are*, the more you *have*; the less you express your own life, the greater is your alienated life. . . .

 —Karl Marx, 1844, from *Economic and Philosophic Manuscripts*.

In this book I have tried to show that impressionist paintings cannot be separated from the history of the events, places, persons, and social institutions they represent; indeed, that to talk only of "style" or "motif" is to diminish the true richness of art by limiting the extent of its domain. I have tried also to show that the paintings are not the results of some ineluctable social process, that paintings do not simply illustrate social history, that one cannot detach color, brushwork, and compositional structure from the images they conjure up. Painting is an inventive process that produces an imaginative result; the artist's critical faculties are engaged in reformulating both the language of art and the subjects chosen from events and places shared with other members of society. The floating planes of Monet's *Garden of the Princess* (Pl. 14) are inconceivable without the cleared-out perspectives of Haussmann's new Paris; the dynamic movements of Degas's milling jockeys and racehorses give visible form to his era's competitiveness and its hunger for controlled motion; the puzzling close-ups and odd spatial encounters of Manet's *The Plum* (Pl. 75) and *A Bar at the Folies-Bergère* (Pl. 80) are brilliant interpretations of urban tensions; the caressing colors and textures of Renoir's *Moulin de la Galette* (Pl. 135) and *Oarsmen at Chatou* (Pl. 254) shape modern Arcadias full of longing for social harmony.

Although the impressionists were part of their society, and not separate from it, they occupied a peculiar place. Historians have exaggerated their isolation and the radical nature of their painting, but it is apparent that they formed a vanguard whose role was to reeducate the eyes of contemporaries. They did this in different ways, according to their origins and their temperaments. Manet had the security of an upper-class position, one that let him indulge in a *chic* world of fashionable elegance, but also allowed him to probe beneath the surfaces of Parisian leisure and entertainment to reveal unexpected psychological and social complexities, couched in terms of bemusement and irony. Morisot, equally upper class, gave professional vision to landscapes and to woman's domain: domestic interiors, park-like estates, vacation villas. Degas associated with the wealthy and privileged among whom he was born but, embittered by the decline of his family's business enterprises, he revealed the anxieties and the tensions of his contemporaries with surgical cruelty. Caillebotte, from a wealthy family and younger than the other impressionists, was first interested in the psychology of urban spaces, and then in rowing, sailing, and the landscapes associated with his own suburban properties. Monet was more the upstart provincial, devoid of irony and cynicism, determined to make his way by celebrating the landscapes of modern life. Renoir, the only major impressionist from the working class, was equally incapable of irony, and created the social harmonies that he feared were disappearing amidst the cruel calculations of modern life.

The impressionists were therefore devoted to interpretations of a contemporary life with which they were intensively involved. After youthful essays in mythological, religious, and historical subjects, or in landscapes in the manner of the previous generation, they turned to the characteristic haunts of modern urban life. They frequented the cafés, theaters, parks, and suburbs that they painted, and knew many of the performers and promenaders who appear in their pictures. Since

prior conventions of painting were linked with the discarded subjects of traditional art, they had to create new ones. Line, color, shape, compositional design, brushwork, all these had to be recast in response to subjects which until then had been principally the province of illustrators and caricaturists. This they did within the parameters of naturalism, encouraged often by writers who saw in their paintings the common territory of modern life.

Naturalism, for the impressionists, did not mean the detailed narratives of contemporary Paris found in the paintings of fellow professionals and friends like Béraud, Duez, or Stevens (Pls. 22, 74, 269). These other painters did not renew the language of art to the same extent, and they had no significant roles in the development of modernism. Subjects of contemporary life did not suffice for a place in history. It is the particular ways in which the impressionists interwove pictorial form and subject that made their art the dominant vision of early modernism. Their denial of conventional anecdote and inventories of vision sprang from an attitude of detachment in which, like the scientist or detective, the author's presence was hidden from the viewer in order to give the appearance of objectivity. This detachment or objectivity was not at all passive, but instead a highly concentrated, active force. Vested in paintings, this analytical activity became visible in brushwork and structure as well as in subject, all the more effective a means of communication because the viewer is led to believe that she has deduced the picture's meaning by herself, without the painter's interference. Additionally, the subjects of contemporary life did not seem to contain the moral and educational lessons that underlay history painting, and the viewer was further disarmed.

One of the curious features of Impressionism that at first was difficult for viewers to accept was the apparent casualness of their work. By shedding the careful modeling of prior generations, the painters gave the impression of hastily concocted canvases which resulted more from inspiration than from patient labor. The effortless stroke of genius became a leading measure of artistic quality, partly because it denied mere "work." To examine the paired opposites of creativity and labor is to uncover the profound contradictions of the impressionist era—and of our own. As we shall see, it takes us back to the all-important issue of leisure.

The idea that imaginative products should be free from mere labor is usually traced to the romantics earlier in the nineteenth century. They, in turn, had looked back to the previous century's ideal of the "natural" person, because they felt that the calculations of industrial life were rooting out instinct, which was seen as the vital force of creativity. Nineteenth-century artists were no longer commonly supported by royalty, aristocracy, and church, which were being shunted aside by the rising middle class. Some artists who went through government schools and submitted themselves to the protective regime of fellowships and government purchases, could fashion successful careers. Others had to go out into the market and sell their products, an expulsion from the shelter of traditional patronage that they converted to the doctrine of "freedom." It was nothing other than freedom to compete on the open market. At the same time, the prosperity and high culture that they aspired to had to be sharply distinguished from the money-grubbing activity of the bourgeoisie, as well as from the repressive and monotonous character of labor in shop, factory, or field. "Art for art's sake" was an invention of the romantic era in France, when artists were anxious to establish their own new aristocracy of esthetic virtue. They looked towards a mythical past in which the "natural" person could cultivate self-expression, free of the claims of social utility. This fantasized past, loosely based on eighteenth-century protoypes, had an anti-industrial character. It linked creativity with spontaneity and individuality, with freedom from social restraints and from demands for usefulness. Work was despised because the growing industrial revolution was separating it from inventiveness, originality, and individualism. The products of the factory were despised because they were standardized and marked by a superficial kind of polish or finish. The owners of the factories were despised because they used rationalism and utility as instruments by which to deny the creativity of the worker, to thrust down natural feeling and variety, to subject society to the results of naked calculation.

The inventiveness and spontaneity that independent artists sought were therefore opposed to industrial work, to industrial products (with which they associated academic art), and for many of them, to industrial cities as well. Nature was the desired realm, both the inner world of untrammeled instinct and the outer world of field, forest, riverbank, or seashore. In mid-century, Barbizon art, with its pastoral animals, its peasants and villages, its meadows and harvests, offered consolation to the unwelcome realities of the urban-industrial world. Heroes were made of artists who painted out of doors in order to steep themselves in nature, the better to express this profound longing. Well into the twentieth century, until Impressionism took over, the art of Corot, Diaz, Daubigny, Théodore Rousseau, and Millet constituted the natural vision of the world, the most sought-after art in Western culture. They portrayed a pre-industrial, countrified province where the viewer could recover a sense of pastoral nature that served human needs in its forests, orchards, and fields. Landscape painting, and the closely allied genres of animal and peasant art, rose to prominence in France in the middle third of the century alongside the urban-industrial revolution. It is no real paradox, for "nature," unspoiled but productive, was one of the city dweller's essential fantasies. The collectors who towards the end of the century vied for Corot's forest glades, Daubigny's ducks, and Millet's peasants were not farmers, but factory owners, railway magnates, and financiers (and the Japanese who now emulate them are corporate executives and bankers).

Impressionism was grafted onto mid-century painting and slowly made its way during the period when Barbizon art was considered the natural way of seeing. Among vanguard collectors and critics it gradually displaced its predecessor and then, after World War I, it became the dominant form of naturalism. Among the reasons for this is its citified conception of nature and the prominence it gave to leisure and entertainment. Millet's and Courbet's social realism was turned into suburban realism. Women and men held parasols and croquet mallets, not sickles and hoes, and dahlias were more attractive than cabbages. (It is true that Pissarro retained much of the outlook of Barbizon artists, but most of his villagers are resting or

frankly posing for us.) The work ethic implicit in Barbizon art—it is that which has made the Japanese into the prime collectors of Barbizon art, quite like Bostonians of a century ago—was done away with by the impressionists. The suburb and the coastal resort, not the farm, is the landscape of Morisot, Renoir, Manet, and Monet. This is one of the reasons why Impressionism made Barbizon art seem outmoded: leisure became a vital element of urban longing and one of the chief links with nature. Leisure was a way the city dweller had of sopping up nature by indulging in outdoor exercises beneficial to body and spirit: swimming, boating, or promenading, those middle-class versions of necessitous rural occupations (washing animals, crossing a river, ferrying produce, walking to market).

Within the city, the arenas of leisure that characterized the Second Empire and Third Republic became the preferred subjects of the impressionists. They were no admirers of Louis Napoleon and Haussmann, nor of MacMahon, but they preferred the new Paris to the old. Renoir and Monet redesigned Haussmann's projectile avenues with the aid of sparkling brushwork and amended perspectives, while avoiding the monuments the Prefect would have been proud of. Caillebotte, Degas, and Manet showed Parisians strolling or loitering along the widened streets, some of them *flâneurs* like themselves, reconnoitering public places for the sake of their art, others staring through ironwork at the railroad tracks, converting modern industry into a spectacle. It is true that Monet was drawn to the tracks of the Gare Saint-Lazare, and Degas to the shops of laundresses and milliners, but the workplace remained exceptional in Impressionism. Monet bracketed his paintings of the railroad with views of the Tuileries gardens and the Parc Monceau, and in the same years Renoir was engaged in converting the courtyards and seamstresses of Montmartre into gardens of love from which work and the misery of surrounding streets were excluded.

The technique of the impressionists, at first highly controversial, eventually was accepted as the perfect vehicle for their themes of leisure. Between the two World Wars it was commonplace to liken Monet's brushwork to the flitting of butterflies or the flight of birds. Impressionist technique embodies an apparent spontaneity that suits the idea of life seized on the qui-vive, a lack of finish that leaves room for improvisation, a heightened color, and animated brushwork that appeal to the sensuousness of our leisure-oriented culture; in short, a way of working that springs from our "natural" depths, not from the authority-ridden dogmas that thwart true feeling. This is why both the institution of the café-concert, and Degas's spirited renderings of it, look forward to rock-and-roll concerts of our own era.

The harmony of technique with impressionist subjects has been all the more persuasive an ideal because it merges with the view born of the industrial revolution which separates life's finer things from work. Leisure, nature, beauty, femininity, and culture are loosely grouped together, in opposition to labor. This is an especially pervasive view among the better-educated and better-off members of the middle and upper classes. Leisure and diversion for the lower classes take on forms that retain the anxieties of the workplace and that do not require departure from the city: radio, recorded music, concerts of popular music, professional sports, and television. Those higher up in the social scale can escape into "nature" more readily, out to their suburban dwellings and to Caribbean vacations. In the city they take ballet, classical music, legitimate theater, art collecting, and fine arts museums as their fiefdoms. For them culture and leisure are inseparable because they are the opposite of work, which is the domain of masculinity, rational calculations, machinery, abstract relationships, those harsher things of life that it is better to avoid. Of course, as we saw in the impressionists' Paris, work is not literally banned from the precincts of culture and entertainment. Behind the scenes at the opera, the sea resort, or the museum are legions of workers, from the performers to the costume-makers, from the groundskeepers to the curators. An exhibition of Impressionism is the result of hard effort, but viewers can nonetheless indulge their own leisure thanks to the high culture involved, which insulates them from the reality of work. Impressionism has become the perfect expression of a culture of leisure.

In its own era, it was the hegemony of entertainment and leisure that linked Impressionism with Parisian society. American and European visitors to the capital were struck by its preoccupation with theaters, cafés, operettas, concerts, dances, promenading, racing, and boating. Paris became Europe's playground, thanks in part to the fact that Louis Napoleon wielded leisure and entertainment as instruments of public policy, designed to buy off dissent from his autocratic rule and to enhance his government's prestige. Earlier restrictions on public performances were done away with by imperial fiat, and quick fortunes were built upon the phenomenal rise of cafés-concerts, operettas, vaudeville, music halls, and circuses. Not only were there government-sponsored festivals, concerts, regattas, holidays, and expositions, but also the vast system of parks, squares, and tree-lined avenues which were settings for the simpler forms of leisure. Light and air, those shibboleths of Impressionism, were the gifts that the Second Empire offered to Parisians. Amidst the highly artificial designs of parks and streets, light, air, and foliage functioned as a kind of fashion, an embellishment that exploited progressive social concern for salubrity while it covered over the ruthless uprooting of the old Paris: clean air and entertainment were significant features of the massive transformation of the city.

The fact that leisure was an agent of social change, and not just a symbol or by-product, shows most conspicuously in the suburbs. Parisians seeking distraction along the banks of the Seine forever changed its appearance and the lives of former residents. Traditional uses of water and riverbank gave way to rowing, sailing, swimming, promenading, and dining at Bougival, Chatou, and Argenteuil, those favored impressionist subjects. Entrepreneurs of entertainment and real estate bought out fishermen and farmers, or cut up former aristocratic estates into lots for suburban villas. Further from Paris, along the Channel coast, vacationers produced the same kinds of pressure, so that fishing villages were turned into resorts, fishing families into artists' models, laundresses, or swimming instructors, beachfronts into boardwalks and promenades. A portion of the capital's entertainment industry moved in summer months to Trouville or Deauville, to play to the Parisians

and foreigners who gathered in such places to perform their elaborate social games in the bosom of "nature."

Artists and writers, as we have seen, were not just observers of these transformations but participants, and for this reason their paintings cannot be regarded as timeless pieces of beauty that rise above social history to some purified realm. Writers like Alphonse Karr, painters like Charles Mozin, and musicians like Offenbach owned resort property, and their activities helped propagate the fame of their chosen villages. The impressionists frequented the suburbs and the seashore in summer months, where they joined other middle-class vacationers (except for Cézanne and Pissarro, so little in sympathy with Parisian society). The families of Morisot, Caillebotte, and Manet owned property in the near countryside; Renoir and Monet, by painting the banks of Argenteuil and Chatou, gave them an enduring fame they probably would not otherwise have enjoyed. Boulogne and Sainte-Adresse did not need Manet's and Monet's paintings to ensure their renown, but impressionist pictures, exhibited and sold in Paris, nonetheless had their share in the dialogue between city and resort; they helped prop up the illusions of holiday-seekers. The association of nature and leisure with art meant that eventually, in the twentieth century, tourists went to certain villages and sites *because* the artists had painted there. Ruskin said that nature replaced God in the nineteenth century. We might add that in the twentieth, art has replaced nature.

The themes of this book could be profitably pursued over the twenty-five years that followed the last impressionist exhibition in 1886. The café was an important subject for Seurat, Van Gogh, and Toulouse-Lautrec, and retained a key place in pre-war Cubism and Futurism; promenaders, gardens, and parks characterize the work of Seurat, Bonnard, Vuillard, and several of the Fauves; horses and the racetrack reappear in the work of Toulouse-Lautrec, Boccioni, and Jacques Villon; riverbank leisure was taken up by Seurat, and later by Derain, Vlaminck, and other Fauves; *déjeuners sur l'herbe* and bathers are among Matisse's favored subjects; seaside resorts were painted by Seurat, Signac, Dufy, Matisse, and Braque. Painters continued to frequent the society of bohemians and marginals, and some of them, notably Toulouse-Lautrec and Picasso, featured circus performers, prostitutes, and urban itinerants to such an extent that the lines between their lives and their art cannot be clearly drawn.

This continuity demonstrates the vital place that leisure and entertainment took in the evolution of modern art. Of course, this does not mean that later artists simply continued Impressionism. The detachment that characterized advanced painting of the 1860s and 1870s virtually disappeared in the following decades. Seurat's "scientific" objectivity emerged as a puppet-like world of artificial design; instead of the variety and individuality of Degas's café-concert performers, musicians, and audiences, he gave his figures an Egytian-like solemnity; his and Signac's seaports are vacuumed clean of sociability; in Toulouse-Lautrec's and Picasso's Blue Period cafés, the reportorial neutrality of Degas and Manet gives way to poignant appeals to the viewer's emotions; Matisse's bathers and dancers undulate in a timeless world more evocative of art history than of contemporary life; in Picasso's and Braque's cubist cafés, the provocative displacements and subtle disunities of Manet's pictures turn into a world of fragments and juxtapositions.

By comparison with Cubism, the mother lode of twentieth-century art, and all that evolved afterwards—Constructivism, Dada, Surrealism, Abstract Expressionism, Pop Art—Impressionism now seems distant from us. Although we credit it with being the gateway to modern art, we also treat it as the last of the great Western styles based upon a perception of harmony with natural vision. That harmony, long since lost to us in this century of urbanization, industrialization, and world wars, remains a longed-for ideal, so we look back to Impressionism as the painting of a golden era. We flock into exhibitions of paintings that represent cafés, boating, promenading, and peaceful landscapes precisely because of our yearning for less troubled times. The only history that we feel deeply is the kind that is useful to us. Impressionism still looms large at the end of the twentieth century because we use its leisure-time subjects and its brilliantly colored surfaces to construct a desirable history.

Notes

Chapter One

1. Tuckerman 1867, p. 17.
2. Tuckerman 1867, pp. v–vi.
3. Tuckerman 1867, p. 67; for other phrases cited, see pp. 15–17.
4. Cited in Citron 1961, vol. 1, p. 335.
5. Preface to Fournier 1855, pp. iii, xi.
6. Du Camp 1858, preface, p. 5.
7. King 1868, p. 1.
8. See Mainardi 1980 for an astute analysis.
9. In Isaacson 1966 the three paintings are perceptively studied.
10. Isaacson 1966, p. 20.
11. Tuckerman 1867, p. 20.
12. In a letter of 5 June (Morisot 1950, p. 58), Mme Morisot wrote her daughter that Degas and Manet "continue to condemn the drastic means of repression. I think they are mad, don't you?"
13. For population and transport figures, see Merlin 1967 and Levasseur 1889–92.
14. Veuillot 1866, ed. c. 1914, p. 2.
15. Gourdon de Genouillac 1893–98, vol. 5, p. 476.
16. King 1868, pp. 45–46. For charming and well-documented accounts of life along the boulevards, see Carnavalet 1985.
17. Joanne 1875, p. 62.
18. James 1875–76, p. 6, letter dated 22 November 1875.
19. "Le nouveau Louvre et les nouvelles Tuileries," *Revue des deux mondes* 64 (1 July 1866): 93.
20. Letter to the editor, *L'Impressionniste* 3 (21 April 1877): 8. See also below, the last section of Chapter Five.
21. The kiosk is a "Morris column," a typical piece of Haussmannian management; in 1868 Haussmann granted an exclusive license for its use to the Morris advertising agency. See Carnavalet 1985.
22. See above, note 5.
23. P. 93 in article cited above, note 19.
24. Cited in Citron 1961, vol. 1, p. 336. "Pour les couvrir, montez, o lierres,/Brisez l'asphalte des trottoirs,/Jetez sur la pudeur des pierres/Le linceul de vos rameaux noirs."
25. All these photographers' shops were listed among the attractions of the *grands boulevards* in Joanne 1875.
26. "L'Exposition des Impressionnistes," *L'Impressionniste* 1 (6 April 1877): 6, cited in Venturi 1939, vol. 2, pp. 313–14. Most of the articles in this journal, which had only four issues, are reprinted by Venturi.
27. Cited in Rewald 1973, p. 430.
28. Berhaut 1978 and Caillebotte 1976–77.
29. Duranty 1876, p. 45. Duranty and Caillebotte were compared in Caillebotte 1976–77 (drawing upon earlier work by Marie Berhaut).
30. Duranty 1876, pp. 45f, 47. Duranty insists more than most of his contemporaries on the window as a compositional frame, but the idea was widespread in this generation. Henry James, for example, in 1876 referred to his hotel window as a frame, and to

what he saw through it, as a "canvas" (James 1875–76, p. 191).
31. There is a parallel here with the changes in French politics begun by Louis Napoleon in the 1850s, and continued by later republican politicians. They gained power by manipulating the public through plebicities, elections, and other devices, more than by employing the autocratic fiats of earlier leaders. The political leader of giant stature gave way eventually to the democrat, as the romantic hero-author did, to the naturalist.
32. Fournel 1858, p. 271.
33. See above, p. 00 and note 26.
34. From *Les Années funestes* (1852–76), poem of about 1869, cited in Citron 1961, vol. 2, pp. 281–82. Hugo refers to the ubiquitous N which Louis Napoleon had emblazoned on buildings, banners, and proclamations; "gourdins" means thick-headed louts as well as cudgels.

> Aujourd'hui ce Paris énorme est un Eden
> Charmant, plein de gourdins et tout constellé d'N;
> La vieille hydre Lutèce est morte; plus de rues
> Anarchiques, courant en liberté, bourrues,
> Où la façade au choc du pignon se cabrant
> Le soir, dans un coin noir, faisait rêver Rembrandt;
> Plus de caprice; plus de carrefour méandre
> Où Molière mêlait Géronte avec Léandre;
> Alignement! tel est le mot d'ordre actuel.
> Paris, percé par toi de part en part en duel
> Reçoit tout au travers du corps quinze ou vingt rues
> Neuves, d'une caserne utilement accrues!
> Boulevard, place, ayant pour cocarde ton nom,
> Tout ce qu'on fait prévoit le boulet de canon.

35. Figures from Sutcliffe 1970, p. 155.
36. Caillebotte 1976–77, no. 16 and passim. Kirk Varnedoe and Peter Galassi have shown that the surface of the bridge slants upwards at this point, but that Caillebotte cleverly disguises the fact and so reinforces the effect of the inrushing lines.
37. Huysmans 1883, "L'Exposition des Indépendants en 1880," p. 122.
38. "L'Exposition des Impressionnistes," *L'Impressionniste* 1 (6 April 1877), reprinted in Venturi 1939, vol. 2, p. 312.
39. My attention has been drawn, just before going to press, to a paper given by Karen Bowie at the annual meeting of the Society of Architectural Historians, Pittsburgh, 1985, "Polychromy in the 19th Century Parisian Railway Terminals: Creating a Picturesque Atmosphere." Bowie points out that Monet pictured the old, simple tie-rods under the skylights, rather than the somewhat broader trusses that Flachat had installed. She posits that the painter deliberately chose the thinner rods in order to enhance the effect of the structure's airiness. Making a further parallel with painting, she deduces that the designers of the Parisian train sheds sought to "frame" the tracks with an enclosure that would convert them to a "scene," and thereby diminish the threat of rail travel.
40. Theodore Reff (Reff 1982) concludes that Manet's

vantage point was on the western side of the tracks, but in that case the sun, which comes from above and slightly to the viewer's left, would be coming from the north. Earlier writers have said that Manet's site was a private garden along the tracks and that Manet must have suppressed indications of the street which would have intervened between such a garden and the tracks. However, in the panoramic view of the bridge that Reff reproduces (a print from *L'Illustration*, April 1868) and in other contemporary prints, the iron grill shows directly over the tracks at all points where the bridge's girderwork ceases and the ordinary streets resume. The same prints show figures looking through the grill to the tracks. Although Manet would not have felt obliged to adhere exactly to any site, everything in this picture is consistent with a position along one of the streets bordering the tracks, namely the rue de Londres, close to its intersection with the place de l'Europe.
41. Fervacques (Léon Duchemin), cited in Moreau-Nélaton 1926, vol. 2, pp. 8–10.
42. A good summary is found in Jules Bertaut's *La Troisième République, 1870 à nos jours,* 9 (1931), pp. 100ff.
43. The ironic presence of this figure has been treated by Bradford Collins, "Manet's *Rue Mosnier Decked with Flags* and the Flâneur Concept," *Burlington Magazine* 117 (November 1975): 709–14, and more extensively by Ronda Kasl in Farwell 1985. Manet drew the figure of the one-legged man on a sheet entitled "Les Mendiants" (Beggars) which he destined as the cover of an album of music by his friend Cabaner, based on poems by Jean Richepin, *La Chanson des gueux.* Celebrating the outcasts of French society, Richepin's volume had been suppressed in 1876, and the author fined. No copy of Cabaner's proposed album has survived. (See Manet 1983, no. 163.) Monet made two paintings of Paris streets festooned with flags for the holiday of 30 June (Musée d'Orsay and Musée des Beaux-Arts, Rouen), but neither has a hint of Manet's irony.
44. Manet's letter, published in Edmond Bazire, *Manet* (1884), p. 142, was translated in Hamilton 1954, ed. 1969, p. 224. *Le Ventre de Paris* was the title of a novel by Zola.

Chapter Two

1. The painter as *flâneur* has been analyzed in Sandblad 1954, Reff 1976, Hanson 1977, and Caillebotte 1976–77. Degas's associations with naturalist writers have been admirably studied by Reff in an essay of 1970, revised for Reff 1976, pp. 147–99.
2. Particularly well in Bazin 1833, vol. 2, pp. 298–323.
3. That this association of writer/artist with newspapers was a fundamental aspect of modern life is shown by its continued importance; one might cite cubist and futurist collage, Dada art, Rauschenberg

and Warhol, to say nothing of Hemingway, Orwell, and Benjamin.

4. Benjamin 1973, p. 37.

5. Bazin 1833, vol. 2, p. 308: "préfet de police" (police commissioner).

6. Moers 1960, p. 264.

7. All Manet scholars have discussed Baudelaire, but the first profound discussion of Manet as the *flâneur* is Nils Sandblad's (Sandblad 1954). The best recent account of the links between Manet and Baudelaire is by Druick and Zegers: see below, note 15.

8. This interpretation owes a great deal to Benjamin's famous essays collected in Benjamin 1973.

9. Reff 1976, p. 104. Since Degas's day, the painting in question has been demoted from Cranach's work to that of his followers.

10. More likely wit, since Degas was the last artist to be unaware of what he was doing. And he got away with the suppression of the leg, since no Degas specialist has drawn attention to it! Degas also eliminated any legs under the tables in his *Absinthe* (Pl. 76).

11. Fournel 1858, p. 263.

12. Proust 1913, p. 29.

13. Proust 1913, pp. 39–40.

14. The multiple meanings of cherries (*cerises*) in Manet's era have been confirmed by the historian François Caradec (personal communication, 1986). *La guigne* is a common variety of sour cherry, but the verb *guigner* meant "to give a sidelong glance," in the sense of a malevolent look. Hence to have *la guigne* and to have *la cerise* both meant to have bad luck.

15. Douglas Druick and Peter Zegers, "Manet's 'Balloon:' French Diversion, The Fête de l'Empereur 1862," *Print Collector's Newsletter* 14 (May-June 1983): 38–46.

16. See the first chapter of Sandblad 1954.

17. Whitehurst 1873, vol. 2, p. 95, and Tuckerman 1867, p. 56.

18. Tuckerman 1867, pp. 156f.

19. Tuckerman is not quite the prude that my citations might suggest, and, moreover, he so fervently wished the French to oppose Louis Napoleon that he interpreted their hedonism as political submission. This colored his perceptions, since he believed their saturation in the artificial and the theatrical was merely an extension of the Emperor's tinselly, shallow regime: "Simplicity and earnestness are the normal traits of efficient character, whether developed in action or Art, in sentiment or reflection; and manufactured verse, vegetation and complexions indicate a faith in appearances and a divorce from reality, which, in political interests, tend to compromise, to theory, and to acquiescence in a military *régime* and an embellished absolutism." (Tuckerman 1867, p. 157.)

20. Moers 1960, passim.

21. Baudelaire 1964, p. 11.

22. Sandblad 1954, p. 63.

23. Wechsler 1982, and Isaacson 1982.

24. Art historians first began commenting on this by focusing on specific borrowings, such as Degas's from Daumier, or Manet's from popular illustrations, and subsequently by broader inquiries into the whole phenomenon. See Reff 1976 and Hanson 1977, and for broader studies, Beatrice Farwell, ed., *The Cult of Images* (Santa Barbara, exhib. cat., 1977), Isaacson 1982, and Ross 1982.

25. For example, all of his brothel scenes (Pl. 115), and such paintings as *Sulking* (Pl. 58), *Mme Dietz-Monin* (Chicago, Art Institute), or *The Stock Exchange* (Pl. 56).

26. Degas himself referred to Lavater, the famous phrenologist (Reff 1976, p. 217).

27. The group is discussed by Ronald Pickvance in Degas 1879 (Edinburgh, exhib. cat., 1979, nos.

55–60, and in Thomson 1987, pp. 27–30.

28. Benjamin 1973, p. 41. Benjamin was probably thinking of the passage from Balzac's *Théorie de la démarche* (A Theory of Bearing) which has recently been cited in Wechsler 1982, p. 22: "The observer is incontestably the man of genius. All human inventions come from an analytic observation in which the mind acts with an incredible rapidity of insight. Gall, Lavater, Mesmer, Cuvier...Bernard de Palissy, the precursor of Buffon...Newton, and also the great painter and the great musician, are all observers...those sublime birds of prey who, while rising to high regions, have the gift of seeing clearly in matters here below, who can at the same time abstract and specify, make exact analyses and just syntheses."

29. As early as 1833 the *flâneur* was likened to a policeman. See above, note 5.

30. Fournel 1858, pp. 269–71.

31. Goncourt 1956, vol. 11, entry for 22 August 1875.

32. Duranty in *Le Réalisme*, 15 March 1856, cited in Crouzet 1964, p. 441; the Goncourts in their journal, May 1859, cited in Caramaschi 1971, p. 43.

33. *L'Avenir de la science, pensées de 1848* (Paris, 1890), pp. 192, 194–95.

34. Delvau 1867, p. 78: "belles de nuit." Delvau names five similar cafés along this boulevard, and his description of the Café de Madrid could serve as the legend for Degas's composition. On its terrace, he writes, "from 11 o'clock at night to 1 a.m.: swarms of young beauties—it doesn't take too much imagination to call them *beauties of the night*—display themselves like espaliers on this terrace where, with the pretext of having ice cream or Bavarian cream, they wait for galant cavaliers to offer an arm to accompany them to the next *Bignon*."

35. See Chapter One, p. 18.

36. Lemoisne 1946–49, vol. 1, p. 119: "Un tableau est une chose qui exige autant de rouerie, de malice et de vice que la perpétration d'un crime, faîtes faux et ajoutez un accent de nature."

37. When reviewing the impressionist exhibition of 1881 (Huysmans 1883, "L'Exposition des Indépendants en 1881," p. 233).

38. See Kirk Varnedoe's analysis in Caillebotte 1976–77, no. 47.

39. Boggs 1962, p. 18, gives a very perceptive analysis of this picture which underlies mine, although we are not in entire agreement. David R. Smith, "Rembrandt's Early Double Portraits and the Dutch Conversation Piece," *Art Bulletin* 64 (June 1982): 259–88, calls attention to Dutch prototypes for paintings which disclose "an interrupted moment of domestic intimacy" with hints of tension.

40. Reff 1976, pp. 200–38.

41. It is true that Theodore Reff and some other art historians who specialize in Impressionism have reinforced the relationship to naturalism, but in an influential text, César Graña accepted the idea that the impressionists painted their surroundings in a rather unreflecting way. Graña does not condemn Impressionism, but rather, praises it for being "a peripatetic, tremulous art, thoroughly occasional and typically free of philosophical proclamations." He refuses to regard impressionism as a pictorial form of naturalism, for "not only was naturalism exclusively a literary movement, it was also the ideology of the rebellious intelligentsia of the Second Empire. Impressionism, on the other hand, was, quite obviously, an art created by men who felt socially comfortable and politically unconcerned and who celebrated with a kind of amiable lyricism the bourgeois pleasures surrounding their lives." (Graña 1971, p. 74.) Because they do not understand the real significance of the Impressionists' detachment, Graña and other observers do not see behind

the glitter of their painted surfaces. (Besides, Manet *was* a member of the "rebellious intelligentsia.")

42. In Simmel 1971, pp. 143–49 and 324–39.

43. Simmel's conception lies behind the analyses, already utilized in this chapter, of Siegfried Kracauer and Walter Benjamin, both former students and admirers of his (Kracauer 1937 and Benjamin 1973). Graña's brilliant and sometimes wrong-headed "Impressionism as an Urban Art Form" takes Simmel to task, but also builds upon his ideas. Graña is the first commentator on Impressionism to have linked Simmel's idea of the stranger to Impressionism (p. 93), by way of their detachment or "dégagé" attitude. He does this hesitantly, since he denies Simmel's underlying definition of "objectivity" and its ties to the money economy.

44. Simmel 1971, p. 145.

45. See above, Chapter One, p. 20. Simmel's views seem to have benefited from familiarity with the writings of the *flâneurs*. Benjamin, in turn, draws both from Simmel and the *flâneurs* when he notes that the seeming lack of involvement of *flâneur* and detective is a disguise for their penetration (see above, Chapter Two, p. 34).

46. For example, in Baudelaire's famous formulation: "To be away from home and yet to feel oneself everywhere at home; to see the world, to be at the centre of the world, and yet to remain hidden from the world—such are a few of the slightest pleasures of those independent, passionate, impartial natures...." (From "Le Peintre de la vie moderne," 1863, in Baudelaire 1964, p. 9.)

47. Simmel 1971, p. 146.

48. And Degas's wit, bordering on the ruse, is revealed by the illogical treatment of the wall above the man's shoulder. The curio cabinet and the table share a common axis, but the wall seems to bend back at another angle, judging by the frame that holds that jumble of small pieces. The ruse succeeds because Degas uses the man's head to hide the juncture of wall and cabinet.

49. "Accident and the Necessity of Art," *Journal of Aesthetics and Art Criticism* 16 (1957): 18–31.

50. Simmel 1971, pp. 327–28. The aptness of Simmel's formulation has been pointed to in Clark 1985, pp. 238–39.

51. The phrase is Elizabeth Latimer's, in *France in the Nineteenth Century, 1830–1890* (Chicago, 1892), p. 176.

52. Marilyn Brown, preparing a publication on Degas's *Portraits in an Office*, has identified the members of the municipal committee in Pau who purchased the picture in 1874. They were largely ardent Republicans and progressive businessmen.

53. Simmel 1971, p. 331.

54. Fournel 1858, p. 263.

55. Reff 1976, pp. 116–19. The print on the wall reproduces J. F. Herring's "Steeple Chase Cracks." The woman was posed by the model Emma Dobigny, and the man presumably by Edmond Duranty (judged by resemblance). For interesting parallels with visiting card photographs of two persons, see McCauley 1985, p. 161.

56. "Urbanism as a way of life," (orig. 1938) in A. J. Reiss, ed., *Louis Wirth on Cities and Social Life* (Chicago, 1964), p. 75.

57. "Estrangement" and more commonly "detachment" are the right words for Degas, not "alienation." Except for his *Interior* (Pl. 52), "alienation" is too strong a term for him. It should be reserved for the next generation, say Van Gogh or Edvard Munch. Degas's own estrangement should be linked to his anti-semitism, which turned virulent after 1890, as he became more and more reclusive. See the penetrating essay which appeared just as this book was going to press: Linda Nochlin, "Degas

and the Dreyfus affair: Portrait of the Artist as an Anti-Semite," in the exhibition catalogue *The Dreyfus Affair* (New York, 1987–88), pp. 96–116.

Chapter Three

1. McCabe 1869, p. 65; McCabe got his figures from city officials.
2. All demographic figures from Weber 1899, ed. 1963, and Gourdon de Genouillac 1893–98, vol. 5.
3. Tuckerman 1867, pp. 25–27.
4. Kracauer 1937. For Offenbach one should consult also Faris 1980.
5. Kracauer 1937, p. 176.
6. Faris 1980, pp. 142–46, recounts the political difficulties Offenbach encountered with this operetta, giving grist to Kracauer's mill, although elsewhere he somewhat naively denies the validity of Kracauer's political analysis.
7. Kracauer 1937, p. 289.
8. When in Rome in 1885, Debussy admitted that he was homesick and yearned "to see Manet and hear Offenbach." Cited in Faris 1980 p. 221.
9. See the appendix devoted to documents about the composition and its censorship in Manet 1983.
10. Citron 1961, vol. 2, p. 318 and passim. See also Françoise Cachin's remarks in Manet 1983, no. 90.
11. Identified by Marilyn Brown (Brown 1978), who made an astute analysis of the picture's combination of naturalism and allegory. Her book (Brown 1985) is the first thorough social history of the gypsy and the artistic Bohème in nineteenth-century French art. For *The Old Musician*, see also Hanson 1977, pp. 61–66 and Reff 1982, pp. 170–91.
12. Chapus 1855, p. 8.
13. For these aspects of Haussmannization, see Clark 1985, ch. 1.
14. The various ties with earlier art are summarized in Reff 1982, pp. 171–91.
15. King 1868, p. 113.
16. Delvau 1867, p. 64. These words immediately precede those I have cited in epigraph at the beginning of Chapter Two.
17. Barrows 1979.
18. James 1875–76, p. 190.
19. Constantin 1872, p. 108: "...et l'on ne verrait plus dans la capitale du monde civilisé, l'ignoble chope remplacer la dive bouteille."
20. Edouard Noël and Edmond Stoullig, eds., *Les Annales du théâtre et de la musique* 3 (1877): 602.
21. Isaacson 1982.
22. Rewald 1973, pp. 430–31 and passim.
23. Graña 1971, pp. 87–88.
24. Gauthier-Lathuille's memoir of this encounter is cited in Tabarant 1947, pp. 352–53. The painting has recently been studied by Bradley Collins (Manet 1985) who summarizes previous discussions and adds perceptive observations.
25. The site is described in Rivière 1921, pp. 140–44, 187.
26. For Renoir's social ideals see below, the last section of Chapter Five.
27. The friendship is recorded in Proust 1913, p. 110.
28. The painting probably does not adhere to a particular geometric scheme, but its overall proportions (2:3) are duplicated in some of the subdivisions which, additionally, make use of a few repeated intervals.
29. For example, Reff 1982, no. 18. I prefer the more guarded view of Theresa Ann Gronberg (Gronberg 1984). Although she calls Manet's woman an "urban slut," far too strong a phrase in my view, she also shows why it would be difficult to affix a label to such a person.
30. So defined in Delvau 1866, q.v. For the early history

of Degas's painting, see Douglas Cooper, *The Courtauld Collection* (London, 1954), pp. 43ff, and Pickvance 1963.

31. Cited in Pickvance 1963. Pickvance reports George Moore's view that the woman is a "slut" and that the scene takes place in the morning.
32. Delvau 1862, pp. 250–51. For a straightforward account of absinthe and its constituent elements, see Avenel 1900–1905, vol. 3, pp. 152–55, the source of the facts that I cite in this discussion. Absinthe was outlawed early in the twentieth century, succeeded by presumably less deleterious drinks like Pernod. For an intelligent study of the whole issue of drink in this era, see Michael Marrus, "Social Drinking in the Belle Epoque," *Journal of Social History* 7 (winter 1974): 115–41.
33. By Maxime Du Camp, cited in Barrows 1979. In her canny article, Barrows deals with the temperance movement of the 1870s, the covert and public attempts to control drink, and Zola's opposition to such hypocrisy. She also has in preparation a book dealing with all aspects of cabarets and cafés.
34. Even in reproduction the strip of canvas Manet added to the right of this picture shows readily, its edge running up the back of this figure. This painting was once part of the Winterthur café composition (Pl. 70); both were substantially altered after the original canvas was cut in two (analysis of this complex history in Manet 1986, pp. 65–71). Such alterations have not deterred Manet specialists from claiming that these two, and other café paintings, including *The Plum* (Pl. 75), are renderings of specific places that they attempt to name. Much as one would like to agree, the fact that Manet altered the pictures' backgrounds in reworking them and omitted all precise clues to location (at least, none has been revealed) seems to argue for the reverse.
35. In the sword hilt that hangs on the brass rack to the rear, Manet may have intended a reference to the figure derived from Neapolitan comedy, Polichinelle. As Theodore Reff has shown ("The Symbolism of Manet's Frontispiece Etching," *Burlington Magazine* 104 [May 1962]: 182–87), Manet introduced his album of etchings of 1862 with a surrogate of the artist, a Polichinelle whose sword, one of his leading attributes, hangs nearby. This etched figure bears striking resemblance to the man in *Café-Concert*. Further, "Polichinelle" in the slang of Manet's day meant "an amusing and eccentric man" (Delvau 1866, q.v.).
36. Hollis Clayson (in a public lecture, February 1980) first raised this issue in connection with Manet's two café-concert pictures, concluding that they represented *brasseries à femmes*. Subsequently, Theresa Ann Gronberg (Gronberg 1984) published a detailed analysis of clandestine prostitution as it might relate to impressionist painting, and she also stated that the two Manets show *brasseries à femmes*. Intelligent though both interpretations are, the internal workings of the paintings do not bear them out.
37. Joel Isaacson puts it well when he says of Manet and Degas that "seriousness of purpose takes the form of a content respectful of human dignity within the compromising and precarious urban world they chose to depict." (Isaacson 1982, p. 110.)
38. For the institution, Derval 1955, and for Manet's painting, Manet 1986, pp. 76–83. My information derives also from posters, photographs, advertisements, and music sheets, as well as from contemporary guide books.
39. That there were two spaces with different activities and *mises-en-scène* for long escaped the notice of art historians, who confused the interpretation of Manet's picture by trying to adjust it to the wrong

interior. An illustrated program reproduced in Manet 1986 gives the correct setting for Manet's picture, as does Chéret's poster (Pl. 79) and a reproduction in Derval 1955, opp. p. 59.

40. See the lithograph exhibited no. 334 in Carnavalet 1985.
41. Identifications summarized in Manet 1983, no. 211; the barmaid Suzon was identified in Tabarant 1931, p. 412. The Folies appears in numerous contemporary writings, the best known being J.-K. Huysmans's *Croquis parisiens* (1880) and Maupassant's *Bel ami* (1885). However, both authors had a writer's interest in exaggerating its role as a prostitutes' market.
42. T.J. Clark did so at first (Clark 1977), flatly calling her a "whore." His book (Clark 1985), however, is a more nuanced argument and he correctly hedges: "a woman in a café-concert, selling drinks and oranges, and most probably for sale herself—or believed to be so by some of her customers" (p. 253). The relevant tradition of the *dame de comptoir* is extensively discussed in connection with the *Bar* in Ross 1982.
43. Mortier 1875–85, vol. 3, pp. 37–38, entry for 4 February 1876. Mortier's volumes give a good running account of the Folies, e.g., 1874 (vol. 1, pp. 283ff) and 1877 (vol. 4, pp. 140ff). This book has an introduction by Offenbach.
44. An interpretation first proposed by Hans Jantzen, "Edouard Manet's 'Bar aux Folies-Bergère,'" in *Essays in Honor of George Swarzenski*, ed. Oswald Goetz (Chicago, 1951).
45. See the discussion of Simmel in Chapter Two. Clark invokes Simmel when he writes of this picture (Clark 1985, pp. 253–54). He also uses the stronger term "alienation" and believes that Manet's painting, in both subject and form, indicates a truly profound malaise in his society and a deep crisis in French art.
46. Common, however, in fashion illustrations from the 1830s onward in which, by discarding conventional perspective, an "illogical" mirror view shows the rear of a hat or cloak, e.g., "Petit courrier des dames, Modes de Longchamp," *Modes de Paris* (20 April 1835).
47. Except for Plates 83 and 85, exhibited in 1877, the dates for all these are disputed by specialists. It is agreed that the largest number were done between 1875 and 1878.
48. Changes in the laws pertaining to entertainment were regularly noted in newspapers and in guide books. They are conveniently summarized in Gourdon de Genouillac 1893–98, vol. 5, pp. 263–67 and passim.
49. Joanne 1870, p. 616. Café-concert staffs, average salaries, and costs are summarized by Emile Mathieu, cited in Caradec and Weill 1980, pp. 12–16.
50. Cited in Shapiro 1980, p. 155. It is Shapiro who identified Ducarre as the subject of *The Impresario*. The sheet of studies is reproduced in Boggs 1962 (her fig. 94), collection unknown. Studies and oil are dated c. 1876–77. Shapiro also identified the singer Libert as the subject of another sheet of studies of the same date (his fig. 4, p. 156).
51. Letter to Henri Lerolle, 4 December 1883, in *Lettres de Degas*, ed. Marcel Guérin (Paris, 1945), p. 75. The apt phrase "la Patti de la chope," referring to the great soprano Adelina Patti, is Alfred Delvau's (Delvau 1867, p. 180), but is frequently credited to Louis Veuillot.
52. Paul Foucher, *Entre cour et jardin*, 1867, cited in Alméras 1933, p. 422. In Clark 1985, pp. 216–29, there is an acute analysis of the working-class origins of café songs.
53. She does not quite look like Thérésa, but Michael Shapiro (Shapiro 1980) convincingly relates a study

for this work (his fig. 8) to caricatures of the famous singer, so at the least she is derived from Thérésa. The "chanson du chien" has never been identified and might have been inferred from the pastel itself.

54. Reported in Shapiro 1980, p. 156. "Turbot, turbot de mon coeur/Tu m'ah! Tu m'ah! Tu f'ras mon malheur."

55. King 1868, p. 231.

56. Physical resemblance and gestures are close to her representations in posters: Shapiro 1980, pp. 160–61. See also Caradec and Weill 1980, pp. 54–56.

57. For both songs see Caradec and Weill 1980, pp. 55, 56. "Je voudrais etr' la chaise de bois blanc/Où tu t'assieds,—afin de mieux t'entendre"; "Moi, j'cass' des noisettes/En m'asseyant d'ssus!"

58. From a list given in Constantin 1872, p. 94. "J'vous conseille pas d'fourrer vot'nez là-dedans"; "Ça presse. Balayez-moi ça"; "J'ai tapé dans le tas!"

59. For Bordas see Caradec and Weill 1980, p. 72. The pro-communard sentiment is made clear by Marc Constantin (Constantin 1872, p. 98) when he characterizes the applause for Bordas as "un vrai trépignement démocratique" (a really democratic stamping).

60. From Vallès's *Le Tableau de Paris* (Paris, 1883), cited in Clark 1985, p. 225. Clark seems reluctant to credit Thérésa with helping undermine the Empire, but he gives a persuasive account of censorship and its ramifications, pp. 227–34 and passim. Censorship is usefully documented in Caradec and Weill 1980, pp. 63–69, as is the politicization of the café-concert, pp. 69–75. For the *Sire* and its interpretive burlesque, see Alméras 1933, pp. 34–36.

61. See Anne Joly, "Sur deux modèles de Degas," *Gazette des Beaux-Arts* 69 (May–June 1967): 373–74.

62. Caradec and Weill 1980, p. 67. It is tempting to associate this crisis with the impressionists' surge of interest in the café and café-concert. Several of Degas's works on this theme antedate the "coup de 16 mai," but all of Manet's and all but one of Renoir's (Pl. 72) are dated from 1878 to 1880 (1882, if we include *A Bar at the Folies-Bergère*). Just why the impressionists did nothing on this subject until about 1875 (in Degas's case), and ceased about 1880, is a mystery. A partial explanation might be found in the euphoria of 1878: MacMahon's regime on its way out; World's Fair, for which Paris received a concentrated embellishment; vast numbers of fair visitors; national holiday (see above, last section of Chapter One); return of the *Marseillaise* after years of government interdiction.

63. "Causerie du dimanche," 1872, *Oeuvres complètes* (Paris, 1970), vol. 14, p. 201. For evidence of class stratification of cafés and cafés-concerts, see Constantin 1872, pp. 47–59, Alméras 1933, pp. 327–31, and witness accounts in Tuckerman 1867, p. 90, King 1868, p. 113, Hake 1878, pp. 166–71, and Vandam 1892, vol. 2, pp. 235–36.

64. Veuillot 1867, pp. 138–39.

65. Reff 1976, pp. 70–86. See Isaacson 1982 for other journalistic images close to Dagas.

66. "L'Exposition des Impressionnistes," *L'Impressionniste* 1 (6 April 1877), reprinted in Venturi 1939, vol. 2, p. 313. Siegfried Kracauer reported that a British woman, hoping to establish a salon in Paris, hired Thérésa to impress her guests (Kracauer 1937, p. 260).

67. See above, the second section of Chapter Two.

68. Degas's model was an acquaintance, Alice Desgranges, not a café singer. She is identified in Lemoisne 1946–49, vol. 2, p. 262, and is discussed in Shapiro 1980, pp. 161–62. She is wrongly called Thérésa in Clark 1985, p. 221, but she strikes a pose that Thérésa favored in many posters and photographs.

Chapter Four

1. Morford 1867, p. 237.

2. McCabe 1869, p. 65.

3. Tuckerman 1867, p. 113.

4. The painter Piot-Normand, the composer Souquet, a "doctor Pillot," and Gard, the Opéra's dance director. These and other identifications were made in Lemoisne 1946–49, vol. 2, no. 186.

5. Boggs 1962, p. 29, drew the parallel, expanded upon in Reff 1976, pp. 76–80, and in Isaacson 1982. Isaacson also illustrates a number of cartoons which reduce dancers to legs being ogled by men.

6. For the several paintings, drawings and prints of Lola de Valence and the Spanish troupe, see Manet 1983, nos. 49–53. The best recent analyses of Plates 91 and 92 have been made by Anne McCauley (McCauley 1985, pp. 173–81), who shows Manet's use of *carte-de-visite* photographs in their construction.

7. In two variants of *The Ballet of "Robert le Diable"* of 1872 (Metropolitan Museum) and 1876 (Victoria and Albert Museum), and in the pastel *The Duet* of about 1877 (formerly Robert von Hirsch).

8. Taine 1875.

9. Taine 1875, pp. 158–63. I greatly abridge his six pages on this young woman, without indicating all the omitted portions. It is on page 146 that he says he went to the Italiens, his favorite theater, twice a week.

10. The work that most resembles Degas is *In the Loge*, a pastel of c. 1879 (Boston, Museum of Fine Arts). Cassatt's works on theater loges include the oil *Lydia in a Loge* (Philadelphia Museum of Art), the related pastel (Kansas City, Nelson-Atkins Museum), and an oil *In the Box* (Mr. and Mrs. Edgar Scott, Villanova), all of 1879, and the etchings *In the Opera Box* of 1880 and *Two Young Women in a Loge* of 1882. Mention might be made also of the painting by Manet's *émule* Eva Gonzalès, *A Loge at the Théâtre des Italiens* (Musée d'Orsay), shown in the Salon of 1879.

11. Pollock 1980, p. 10.

12. See Renoir 1985, no. 50.

13. See Deborah J. Johnson, "The Discovery of a 'Lost' Print by Degas," Rhode Island School of Design, *Museum Notes* 68 (October 1981). 28–31. This article was the first revelation of the underlying monotype.

14. Figures from Edmond Renaudin in 1867, cited in Alméras 1933, p. 435.

15. For a sample description see Vandam 1892, vol. 2, p. 116. The Emperor's many mistresses are discussed in Alméras 1933, pp. 116–22.

16. Guest 1974, p. 244.

17. This work is analysed in Shackelford 1984, pp. 31–32.

18. One of these is reproduced in Guest 1974, p. 17; on pp. 14–23 there is an excellent digest of the backstage privileges assumed by the men.

19. Taine 1875, pp. 11–12. A more sensitive view was expressed by Charles de Boigne (Boigne 1857, pp. 273–74), who deplored rules that permitted the opera managers to fire pregnant dancers and deny them any pension, "a cruel and barbarian rule, under the pretext of morality." To condemn them to poverty was to encourage the birth of sickly children. "One must accept the Opéra as it is, with its moral infirmities, its strange customs, and its more or less legitimate pregnancies, and not establish differences between the woman who is married and she who is not."

20. These and other subscribers are listed, with loge numbers and locations, in Alméras 1933, pp. 440–41. See also Maugny 1891, p. 184.

21. For Morny's life and his relations with painters,

writers, and musicians, see Parturier 1969 and Kracauer 1937.

22. Browze 1949, p. 26.

23. For the series of monotypes see Janis 1968, checklist nos. 195–232, and Adhémar and Cachin 1974, monotypes nos. 56–82; for Halévy and Degas, see Reff 1976, pp. 182–88. Halévy recounted the beginning of the Cardinal vignettes in his notebooks (Halévy 1935, vol. 1, pp. 95–97, 116–20). He gathered them all together in 1883 as *La Famille Cardinal*.

24. Eugenia Parry Janis (Janis 1968, cat. 48) gives the relevant passages from Halévy. Her catalogue is a thorough exposition of the techniques Degas employed in producing monotypes. See also Boston 1984.

25. *Madame Cardinal* (1872), cited in Adhémar and Cachin 1973, p. LV.

26. See Guest 1974, p. 19.

27. Kracauer 1937, p. 193.

28. Halévy 1935, vol. 1, p. 119.

29. See Corbin 1978, and S. Hollis Clayson, "The Representation of Prostitution in France During the Early Years of the Third Republic," Ph.D. diss., University of California, Los Angeles, 1984.

30. Manet 1983, no. 157. The Hamburg Kunsthalle devoted an exhibition to the picture and its iconographical antecedents, *Nana: Mythos und Wirklichkeit* (January–April, 1973).

31. Boigne 1857, p. 40.

32. Cited in Guest 1974, pp. 12–13.

33. See Guest 1974, pp. 8–14, for a summary of the origins, training and salaries of the ballet corps.

34. Guest 1974, pp. 8–9, cites the account of a typical day of a child dancer from Berthe Barnay, *La Danse au théâtre* (Paris, 1890).

35. Halévy 1935, vol. 1, p. 213.

36. Lillian Browze interviewed one daughter, Blanche, to establish the family history (Browze 1949, pp. 60–61).

37. Jean Boggs saw in her face "an expression of all the misery of childhood" (Boggs 1962, pp. 66–67).

38. McCauley 1985, pp. 141–72.

39. Huysmans 1883, "L'Exposition des Indépendants en 1880," pp. 113–14, cited in this connection (with wrong page reference) in Lemoisne 1946–49, vol. 2, no. 576.

40. Boigne 1857, pp. 34, 33.

41. Lillian Browze (Browze 1949, p. 54) claimed that the colored sashes were Degas's inventions, but contemporary witnesses prove their use. Ivor Guest (Guest 1974, p. 12) points out that Halévy referred in 1870 to the dancers' colored sashes, and in *Scènes de la vie de théâtre* (Paris, 1880), p. 148, Abraham Dreyfus gives a typical *costume de classe*: "low-necked short-sleeved shirt, muslin skirt, rose stockings, well-worn satin slippers; for finery (optional): neck ribbon and blue sash. . . ."

42. Goncourt 1956, vol. 10, entry for 13 February 1874. The last phrases, with the Goncourts' emphases: "parlant du *boueux tendre* de Velasquez et du *silhouetteux* de Mantegna."

43. Daniel Halévy, *My Friend Degas*, trans. Mina Curtiss (Middletown, Conn., 1964), pp. 48, 53.

44. First reproduced in Shackelford 1984, p. 50, and briefly discussed in Thomson 1987, p. 53. This discovery is a further proof that McCauley is correct to posit Degas's use of *carte-de-visite* photographs (McCauley 1985, pp. 141–72).

45. The group is discussed in Shackelford 1984, pp. 43–63. One should probably add *The Dance Lesson* (Lemoisne 1946–49, no. 403), whose male figure is a free variation on Perrot's form. I draw heavily on Shackelford's analysis in my discussion of Plates 128 and 129. For Perrot, see Guest 1974, pp. 227 and passim, and Ivor Guest, *Jules Perrot, Master of*

the Romantic Ballet (London, 1984).

46. The drawing is in the collection of David Daniels, New York; the painting was sold at Christie's, London, 3 July 1979.
47. It is tempting to connect the watering can with Marie Taglioni, who was a dance instructor through the 1860s. Ivor Guest reports that the "protector" of one of her dancers presented Taglioni with a model of a watering can engraved with the legend "Je fais naître les fleurs" (I give birth to flowers). (Guest 1974, p. 136.)
48. Cited in Lemoisne 1946–49, vol. 1, p. 115.
49. Fournel 1858, p. 271.
50. Caramaschi 1971, p. 41.
51. Huysmans 1883, "L'Exposition des Indépendants en 1880," pp. 115–16.
52. Mortier 1875–85, vol. 1, p. 437.
53. *My Friend Degas* (note 43 above), p. 55, entry for 1891.
54. Duranty 1876, ed. 1946, p. 29.
55. Lemoisne 1946–49, vol. 1, p. 119. "L'art c'est le vice, on ne l'épouse pas légitimement, on le viole!"
56. One of eight sonnets written about 1890, reproduced in Lemoisne 1946–49, vol. 1, p. 208. To be sure of Degas's meaning, I have made a literal rather than a graceful translation.

> Danse, gamin ailé, sur les gazons de bois.
> Ton bras maigre, placé dans la ligne suivie
> Equilibre, balance et ton vol et ton poids.
> Je te veux, moi qui sais, une célèbre vie.
>
> Nymphes, Grâces, venez des cimes d'autrefois;
> Taglioni, venez, princesse d'Arcadie,
> Ennoblir et former, souriant de mon choix,
> Ce petit être neuf, à la mine hardie.
>
> Si Montmartre a donné l'esprit et les aieux
> Roxelane le nez et la Chine les yeux,
> A ton tour, Ariel, donne à cette recrue
>
> Tes pas légers de jour, tes pas légers de nuit...
> Mais, pour mon goût connu! qu'elle sente son fruit
> Et garde aux palais d'or la race de sa rue.

57. Vandam 1892, vol. 2, p. 115.
58. Cited in Alméras 1933, p. 253 ("beaucoup trop exacte de costume").
59. Bicknell 1895, pp. 86–87.
60. Maugny 1891, pp. 47–49.
61. King 1868, p. 76.
62. Bicknell 1895, pp. 87–88.
63. Bicknell 1895, p. 69.
64. For sample descriptions of such balls, see Alméras 1933, pp. 250–55.
65. Tuckerman 1867, p. 112–13.
66. King 1868, p. 79.
67. King 1868, p. 78.
68. McCabe 1869, p. 742.
69. The picture was not exhibited in Manet's lifetime, but it was commented upon by Fervacques, Mallarmé, Bazire, and Duret; see Nochlin 1983 and Manet 1983, no. 138. The latter gives the erroneous impression that there was only one masked ball at the Opéra each year.
70. King 1868, p. 79.
71. It is treated as such in Manet 1983, no. 138, but the popularity of the Opéra balls is enough to explain Manet's choice, and nothing in the picture is specific to the Goncourts' text.
72. Goose, Cracked One, Baby, Valentin the boneless. Valentin, beyond his prime, reappears in Toulouse-Lautrec's world of the 1890s. For the Bal Mabille and its dancers, see, in addition to the guide books, Gasnault 1986, passim; Alméras 1933, passim; pp. 379–87; and for witness accounts, McCabe 1869, pp. 696–705, and Morford 1867, pp. 240–45.
73. Rivière 1921, pp. 121–40, provides the best account

of the site, its people, and Renoir's painting.
74. Phrases from Rivière's review of the impressionist exhibition of 1877, reprinted in Venturi 1939, vol. 2, 308–14.

Chapter Five

1. McCabe 1869, pp. 60–62.
2. Albert Guérard, *Napoleon III* (Harvard, 1953), p. 214.
3. Pinkney 1958, passim.
4. King 1868, p. 231.
5. Delvau 1867, p. 31.
6. In Joanne 1885, pp. 186–200, are figures for the extent of lawns, pipes, trees, etc., and one of the best capsule histories and descriptions of the Bois.
7. Cited by Ernest de Ganay, *Les Jardins de France* (Paris, 1949), p. 291.
8. A guide book of 1856, cited in Villefosse 1942, p. 319.
9. King 1868, p. 152.
10. Alphand 1867–73, vol. 1, p. 95.
11. From *Mes souvenirs* (Paris, 1868), cited in Villefosse 1942, pp. 320–21.
12. By Amadée Achard, in a guide book of 1867 (cited in Renoir 1985, p. 74), and by Whitehurst (Whitehurst 1873, vol. 1, p. 227), also in 1867.
13. Edouard Gourdon, *Le Bois de Boulogne* (Paris, 1861), p. 281, cited and translated in Richardson 1971, p. 209.
14. North Peat 1903, p. 95, entry for 1865. Isaacson 1972, fig. 30 and n. 61, gives evidence of the popularity of the *amazone*, the woman rider, in contemporary illustrations.
15. See the excerpts cited in San Francisco 1986, nos. 95–97.
16. Whitehurst 1873, vol. 2, pp. 95–97.
17. Moers 1960, p. 117.
18. Yriarte 1864, pp. 108, 117.
19. North Peat 1903, p. 291.
20. Proust 1913, p. 94.
21. Published in the series *Bibliothèque dramatique* 268 (1864): 107ff.
22. Richard Shiff has made the most astute analysis of impressionist brushwork in its multiple meanings (Shiff 1984, passim).
23. Tabarant 1947, p. 202.
24. *Napoleon III at the Battle of Solférino* (Musée d'Orsay), 1863 (Theodore Reff, "Further Thoughts on Degas's Copies," *Burlington Magazine* 113 [1971]: 537–38).
25. By introducing Vernet, and then Cuyp, I wish to deal in broad precedents, not in "influences" on Degas. A more thorough discussion of representations of horses and races would have to deal with the British tradition, particularly with Stubbs.
26. See Gourdon de Genouillac 1893–98, vol. 5, p. 476 and passim; Avenel 1900–1905, vol. 5, pp. 140–41, 156–57 and passim; Merlin 1967, pp. 14, 36–44.
27. This painting has been a favorite of those who posit an influence of photography on Degas. They point particularly to the truncated cart on the left. This claim now seems much exaggerated, for cut-off figures are common in painting and graphic arts. In Vernet's *Mounted Jockeys*, for example, a figure exiting to the left is cut by the frame, as is the horse above. In another of this series, only the front half of a horse and half its rider protrude into the picture space. One can readily imagine Degas grafting his innovations on similar precedents. Moreover, historians frequently cite Japanese prints as sources for such cut-off forms, but surely the stasis of those prints would cancel out the other "influence." Besides, there is nothing photographic about the deliberate placement of all the tiny figures, and of

course the little race itself would have to be called "anti-photographic." Degas's known use of photographs (e.g., Pls. 122, 123) shows no interest in such effects, and the ones he later took or posed himself are notable for their centrality and symmetry. The charging horse in Plate 167, for its part, has the customary pose of the flying gallop, not that of contemporary motion photography. Ironically, when Degas did borrow poses from Eadweard Muybridge's stop-action photographs of horses, after 1882, the result was stiff images with less potential motion.
28. Chapus 1854, p. 27.
29. McCabe 1869, p. 523.
30. The painting also has signs of numerous changes in its gestation. Pentimenti reveal that the carriage wheels were once much larger, and that there was a barrier or fence cutting across the now open foreground space, just below the central horse's tail.
31. See Chapter One, p. 20.
32. Antonin Proust, "Edouard Manet: Souvenirs," *La Revue blanche* (February–May 1897). 171–72. The Louvre's picture is now given to Titian by many specialists. For Manet's *Déjeuner*, the most recent interpretations, incorporating mordant commentaries on earlier writers, are Anne Coffin Hanson's (Hanson 1977, pp. 92–95) and Françoise Cachin's (Manet 1983, no. 62).
33. For this reason, the association of Manet's picture with the theme of earthly paradise seems a bit strained, even though attractively put forward by Werner Hofmann and Beatrice Farwell (see Isaacson 1972, p. 106, n. 50).
34. Lipton 1975, pp. 58–63.
35. Mme Jules Baroche, *Le Second Empire, notes et souvenirs* (Paris, 1921), p. 225. See also Chapter Four, p. 130.
36. Fritz Saxl, "A Humanist Dreamland," in his *A Heritage of Images* (Harmondsworth, 1970), pp. 89–104. Isaacson 1972, p. 106, n. 50, draws attention to Saxl's essay, which situates Manet's *Déjeuner* in this tradition. I am indebted to Isaacson's perceptive analysis of Monet's project.
37. Isaacson 1972, p. 41.
38. A point made by Monet specialists, among them, Joel Isaacson in his dissertation "The Early Work of Claude Monet" (Berkeley, 1967). Isaacson's subsequent publications form the best analysis of *Women in the Garden*. See especially Isaacson 1972, pp. 50–51, 83–89.
39. "Fashion," 1904, in Simmel 1971, p. 303.
40. In addition to Simmel, see Veblen 1899, ed. 1953, pp. 112–18, and passim.
41. Child 1893, pp. 89–90. This whole process lies at the heart of Zola's *Au Bonheur des Dames* (Ladies' Delight) of 1883.
42. Bicknell 1895, pp. 117–18. Bicknell—no radical she!—remarks that "Paris was a sort of fairyland, where every one lived only for amusement, and where every one seemed rich and happy. What lay underneath all this, would not bear close examination—the dishonorable acts of all kinds, which too often were needed to produce the glamour deceiving superficial observers." On page 40, Bicknell discusses the state subsidies for Eugénie's wardrobe. She describes the veritable costume theater involved in clothing the Empress, comprising several rooms for the wardrobes, and an elevator permitting one of the costumed dummies to descend through the ceiling for approval or alteration.
43. Child 1893, p. 90.
44. Tucker 1982, pp. 134–35.
45. Fulbert Dumonteil in 1887, cited in Los Angeles 1984–85, p. 211.
46. Cited in Hamilton 1954, ed. 1969, p. 215.
47. Isaacson 1982, p. 110.

48. *The Painter of Modern Life*, in Baudelaire 1964, pp. 32–33.
49. Maurice Du Seigneur, cited in Hamilton 1954, ed. 1969, p. 249; Armand Silvestre, then J.-K. Huysmans, both cited in Rouart and Orienti 1970, no. 352. Demarsy's real name was Anne Marie-Louise Josephine Brochard.
50. Child 1893, p. 92.
51. Middle-class people would have regarded watering flowers as a pleasant task, but this, in turn, is a parody of the real labor that goes into an outdoor garden.
52. It was probably shown alongside a similar, smaller picture in the third impressionist exhibition of 1877, when the *Moulin* made its appearance. Two of Renoir's entries, simply listed *Jardin*, have not been identified, but Plate 191 seems to conform to Rivière's passing reference in his review: "the large panel where there are magnificent red dahlias in a mass of plants and vines. This big painting is a splendid decoration." (See above, Chapter Three, note 66.) The smaller painting (in a private collection, Paris), two feet high, shows a man and woman talking over the fence.

 It is in his later book that Rivière describes the discovery of the rue Cortot studio and its garden. "As soon as one passed through the narrow corridor of the little house, one faced a vast unkempt lawn whose grass was sprinkled with poppies, bindweed, and daisies. Beyond, a pretty walk planted in large trees traversed the whole width of the garden and, further still, one saw an orchard, a vegetable patch, then thick shrubs in the midst of which tall poplars balanced their leafy heads." (Rivière 1921, p. 130.)
53. Rivière 1921, p. 136.
54. See above, Chapter Three, note 66.
55. 27 Sept. 1883, reprinted in Venturi 1939, vol. 1, p. 126.
56. "Les Intransigeants et les Impressionnistes," *L'Artiste* (Nov. 1877): 298–99.
57. In addition to the Cennini introduction, the "Société des Irrégularistes" (manuscript in the Archives du Louvre), and the two articles in Rivière's *L'Impressionniste*, Renoir wrote a large number of aphorisms on art and society, reminiscent of Delacroix's unfinished dictionary of the arts (portions of which were published posthumously). They are undated but probably were done about 1884 when he was most enthusiastic for Cennini; they were published by his son Jean in Renoir 1962, pp. 241–45. Renoir had Pissarro's cousin Lionel Nunès do some library research for him in 1884 in connection with his work on Cennini and the "Irrégularistes," but it is not known if Nunès had a share in Renoir's ideas or was merely supplying him with material. See Renoir 1985, p. 381, and Janine Bailly-Herzberg, ed., *Correspondance de Camille Pissarro* (1980), p. 299. Although there is some risk in using later, and undated, sayings to analyze ideas of the 1870s, Renoir's writings, largely in germ in the published 1877 articles, are entirely consistent, and there seems little reason to doubt their application.
58. Renoir 1962, p. 244.
59. Venturi 1939, vol. 1, pp. 127–28.
60. Albert Boime, "The Teaching of Fine Arts and the Avant-Garde in France during the second half of the Nineteenth Century," *Arts Magazine* 60 (December 1985): 46–57.
61. Introductory essay to Edouard Guichard, *Dessins de décoration des principaux maîtres* (Paris 1881). Chesneau's ideas owe a definite debt to Ruskin, with whom he corresponded extensively. In the same essay he champions color "as an element of art sufficient by itself without the aid of idea," and

boosts it over design as the key element of the decorative arts.
62. In "The End of Impressionism," his essay in San Francisco 1986, as in his earlier writings, Richard Shiff shows why and how apparent spontaneity involves complicated mental processes, and an amalgam of vision, earlier practice, and apperception.
63. Veblen 1899, ed. 1953, p. 114. I have pointed out the appropriateness of Veblen in this regard in "Impressionism, Originality, and Laissez-faire," *Radical History Review* 38 (1987): 7–15.

Chapter Six

1. Chevalier 1950, pp. 40–46.
2. Sutcliffe 1970, p. 155.
3. King 1868, pp. 194–95.
4. Merlin 1967, p. 78, and Catinat 1967, pp. 99–102.
5. Joanne 1856, p. 45; LaBédollière 1861, pp. 33–38.
6. Department of the Seine, Commission de statistique municipale, *Résultats du dénombrement de 1896* (Paris, 1899), p. 447. It rose to 24,300 by 1896.
7. Manette Salomon (Paris, 1867), p. 98.
8. LaBédollière 1861, p. 137.
9. Joanne 1856, pp. 10–11.
10. Georges Duval, *Mémoires d'un parisien, première période* (Paris, n.d.), passim, records these and other artists living in Asnières. Alexis became a friend of Signac and Seurat in the 1880s, and both painters worked at Asnières, as did Van Gogh. Seurat's *Bathing Place, Asnières* of 1884 (London, National Gallery) gave enduring fame to the location.
11. LaBédollière 1861, p. 138. For the story of Paris's sewers and the Asnières outlet, see Pinkney 1958, pp. 132–42, and Tucker 1982, pp. 151–52.
12. Barron 1886, p. 484.
13. Goncourt 1956, vol. 1, entry for late August 1855.
14. The painting is undated, but the costumes are of the late 1870s or early 1880s. See below, note 21.
15. G.B., "Les Environs de Paris, Bougival," *L'Illustration* 53 (24 April 1869): 267.
16. King 1868, p. 169.
17. Most effectively by Vincent J. Scully, in lectures and a book now in preparation.
18. See note 15.
19. Chapus 1854, p. 208.
20. C.P., "La Grenouillère," *L'Illustration* 54 (28 August 1869): 144.
21. "I really have a daydream, a painting of bathing at the Grenouillère, for which I've done a few bad sketches [*pochades*], but it's a daydream. Renoir, who just spent two months here, also wants to do this picture." (To Bazille from Bougival, 25 September 1869, cited in Wildenstein 1974–85, vol. 1, p. 427.) Monet completed a much larger painting of the Grenouillère, presumably the one rejected by the Salon jury in 1870, and quite certainly the one, known only from old photographs, that disappeared from the Arnhold collection in Berlin during World War II. It is best reproduced in Gordon and Forge 1983, p. 45. Monet's idea that the Grenouillère painting would make a good Salon entry was vindicated, in a manner of speaking, by the fact that Fernand Heilbuth's picture of the site was accepted by the Salon jury of 1870. Known from an engraving (reproduced in Catinat 1967, p. 111), it shows the bathing spot with the elements generally disposed as they are in Renoir's Winterthur canvas (Pl. 215). Heilbuth was a friend of Manet's, but it is not known if his composition, conservative in structure and modeling, had any direct relationship with the impressionists' pictures.
22. Maupassant, in his well-known short stories *La Femme de Paul* (Paul's Mistress) (1881) and *Yvette* (1884), treated the Grenouillère as a scandalous

place, rife in prostitution. Art historians, citing passages from his racy fiction, have exaggerated the extent to which Seurin's emporium was a den of iniquity *in 1869*. True, it was, like the Bal Mabille, a place where the rigors of bourgeois morality were absent, and where amorous play was encouraged by the very nature of communal activity. However, the Emperor's visit in 1869, and the well-documented presence of families with children, should alone prevent us from converting a liberated environment into an open-air brothel. Furthermore, Maupassant's stories were written more than a decade after Monet's and Renoir's paintings, and by then the character of the place had indeed changed. From Barron 1886, p. 494, we know that the Grenouillère was certainly over the hill by the mid-1880s. We should not be surprised: the volatility of Parisian entertainment virtually guaranteed that a decade's time would bring about great alterations.
23. In Monet's *Grenouillère*, the colors on the surface were brushed over an understructure of large, sweeping, already dry strokes, which do not always coincide with the size or the direction of those that render the images. In the lower left, these subsurface strokes form a sail-like triangle, so it is possible that Monet was using an old canvas. However, he already had the habit of roughing in a composition with large brushes, letting the paint dry, and then working on top of this first layer.
24. Monet's structure, more immediately grasped than Renoir's, has usually been praised as more "progressive," because it seems to foretell the twentieth century's love of rapidly encompassed and geometric surfaces. It is also seen, often unconsciously, as a more aggressive and "masculine" organization, compared to Renoir's softer one. In male-dominated art history, that makes him the superior artist. These assumptions and value judgments, thoroughly embedded in the history of modern art, are virtually impossible to set aside, but one could as easily argue that Monet's compositions lack subtlety, or that Renoir's look forward to Vuillard and Kandinsky. A less value-oriented comparison would distinguish Renoir's greater variety of hue and his tapestry effects from Monet's chunkier vision.
25. Wildenstein 1974–85, vol. 1, no. 138, said to refer "probably" to the Island of the Grande Jatte, by Clichy.
26. Manet owned Plate 211, but it is not known when or how he acquired it, nor whether others saw it while it was in his possession.
27. Wildenstein 1974–85, vol. 1, no. 153, dates the picture 1870–71, but the palette and touch agree instead with the works done in the first months at Argenteuil, in 1872. Wildenstein speculates that the site is somewhere along the line to Saint-Germain, but it is possible also that it was in the Bois de Boulogne, on its eastern edge, facing the talus that formed the city's fortified wall there. The Circular Railway ran just behind the embankment on its own high elevation, before it curved over to cross the Seine on the Auteuil bridge. In 1878, Sisley painted the double-decker trains crossing that bridge, so we know the quaint cars ran along that line.
28. For this, as for so many aspects of Monet's work at Argenteuil, see Tucker 1982, pp. 70–76, and passim. Although the association with post-war rebuilding had been noted before, Tucker is the first to have shown that the bridge pictures are limited to Monet's early years at Argenteuil, that his later subjects there are very different, and that these groupings should be interpreted in the light of Monet's shifting attitudes, as well as of the history of the town itself.

29. "Steam," in *Fables* (Paris, 1855), p. 203.
30. Merlin 1967, p. 80.
31. Morisot's painting, not previously identified with Villeneuve, once belonged to Mary Cassatt; it was sold at Christie's, New York, 16 May 1986, no. 253.
32. Joanne 1870, p. 645.
33. Tucker 1982 gives an excellent account of the post-war mood that provides a context for Monet's pictures of Argenteuil, and Clark 1985, a perceptive analysis of why labor and work are not shown in those paintings.
34. *Paris dans sa splendeur*, vol. 2, 1861, p. 32, and Joanne 1870, p. 645.
35. Chapus 1854, pp. 3–4, 194.
36. Sections on boating in guide books of the early 1860s mention Argenteuil briefly or not at all; Asnières dominates their accounts, as does rowing. By the end of the decade, Argenteuil and sailing are given important place, e.g., Joanne 1863, pp. 616–18, and Joanne 1870, pp. 644–46.
37. LaBédollière 1861, p. 135.
38. *On the Beach* (Musée d'Orsay) and *The Swallows* (Pl. 282). The model in *Boating* has not been identified.
39. Huysmans 1883, "Le Salon de 1879," p. 36. Modern historians have pointed out that Leenhoff originally held the rope in his hand, and that by moving it to the boat cleat, Manet flattened the composition in a *japoniste* manner. However, the original position of the rope would have produced an even flatter zig-zag; the change opened out a space between helmsman and sail. No commentator seems to have noticed the curious piece of wood that Manet painted along the bottom of the composition, slanting up towards the right. Is it perhaps an oar laid athwart the boat, or the edge of a piece of decking (unorthodox structure, in that case)? Furthermore, the boat is an old-fashioned kind, like the one on the left in *Argenteuil* (Pl. 239), not one of the sleek yachts that Monet and Manet otherwise painted, with their curving decks and cockpits. The significance of this has also escaped comment.
40. The two highly colored paintings were probably painted after *Boating*, *The River at Argenteuil* (London, The Dowager Lady Aberconway), and *Sailboats at Argenteuil* (Stuttgart, Staatsgalerie), for these three have a less contrasted palette closer to the work of 1872–73. Clark 1985, pp. 164–73, makes astute observations on the relation of brushwork and palette in *Argenteuil* to the images they construct.
41. Manet must have borrowed Monet's picture, or studied it assiduously. It is as though Manet projected the studio boat onto Monet's composition, covering up the center but preserving left and right sides.
42. The other, Wildenstein 1974–85, vol. 1, no. 326 (private collection), was also painted in 1874.
43. Martin 1894, p. 38. He follows this with a description of the mad rush in late evening to the train station, then the crowded ride back to the city, further horrors to be avoided by the suburban dweller.
44. Maupassant identifies the *canotières'* dress in *Yvette* and other stories.
45. G.B., "Les Environs de Paris, Chatou—Le Vésinet," *L'Illustration* 53 (22 May 1869): 333. For popu-lation figures, see Joanne 1856, pp. 44–45, and Barron 1886, p. 497.
46. Barron 1886, pp. 493–94.
47. Delvau 1862, pp. 283–84, 286.
48. Identified in Catinat 1952, p. 39. Eventually, through a punning transformation, it became La Merle Franc.
49. *The Seine at Asnières*, 1879 (National Gallery, London). Despite the traditional title, Renoir's site does not accord with Asnières, but it has not yet been identified.
50. *Manette Salomon* (Paris, 1867), pp. 98–99.
51. Puvis's canvas is a small version of the picture exhibited in 1882, done for the Parisian town house of the painter Léon Bonnat (now in the Musée Bonnat, Bayonne).
52. Morford 1867, p. 240.
53. Letter to Eva Gonzalès, 23 September 1981, cited in Manet 1983, p. 476.
54. Her features are indistinct, and some have worried over her identity, even conjecturing that she might be a maid. No maid would be shown dressed that way, however, and the proud father and husband must surely have wished to represent his family, as he did in so many other paintings. Recent historians (Isaacson 1978, pp. 205–206, and Tucker 1982, pp. 135–42) have said that several of Monet's garden paintings at Argenteuil, including *The Luncheon* (Pl. 265), indicate the artist's growing estrangement from his wife, but this might be a case of reading biography back into the pictures. Over the course of this decade, Monet was gradually leaving virtually all figure painting behind; besides, his failure to paint his future second wife Alice Hoschedé could hardly be put down to estrangement from her.
55. Reclus 1866, p. 377.
56. Duret 1878, ed. 1885, pp. 71–72. One might add that raising and showing flowers had become a major preoccupation in the Paris region, patronized by the wealthy who, together with municipal governments, sponsored clubs, exhibitions, and prizes. See Phlipponneau 1956, passim.
57. Tucker 1982, p. 47, and Wildenstein 1974–85, vol. 1, p. 80.
58. The relationship is summarized in Wildenstein 1974–85, vol. 1, p. 83. See pp. 80–83, 91–96, and passim for an account, subtle and suggestive, of the intertwined fates of Monet and Ernest Hoschedé.

Chapter Seven

1. Letters of 28 August 1867 and 3 September 1868 to his friend Martin, in Jean-Aubry 1968, pp. 65, 72. Boudin underlined the key phrase: "d'être amenés à la lumière."
2. Désert 1983, p. 160.
3. *Guide annuaire* 1868, p. 70.
4. *Murray's Handbook for Travellers in France* (London, 1848).
5. Chapus 1855, p. 262.
6. Rouillard 1984, pp. 30, 97, 343–44, and passim. It would be difficult to overpraise this excellent book.
7. Macquoid 1895, p. 316 (written in 1874).
8. *Guide annuaire* 1868, pp. 109–11.
9. Reproduced in Rouillard 1984, p. 43.
10. Rouillard 1984, pp. 56–63, and passim.
11. Another of Rouillard's perspicacious observations.
12. *Guide annuaire* 1868, pp. 49–50.
13. *Guide annuaire* 1868, p. 53.
14. *Album-guide* 1881, p. 64.
15. *Guide annuaire* 1868, p. 37, written in 1866.
16. *Guide annuaire* 1868, pp. 103–106.
17. Ambroise Vollard, *En Ecoutant parler Cézanne, Degas et Renoir* (Paris, 1938), p. 112.
18. Degas acquired the picture from its first owner, Henri Rouart; Morisot gave Manet the Lorient picture shortly after it was painted.
19. Chapus 1855, p. 230. Did Monet, later such an avid gardener, derive inspiration from Sainte-Adresse's famous horticulturalist?
20. Joanne 1873, p. 46.
21. See the epigraph at the head of this chapter, and for the parrot villas, Chapus 1855, p. 264: "...bourgeois houses of natty aspect, even with boisterous colors"; "All these houses have the look of parrots; they make the eyes wince."
22. Venedey 1841, vol. 1, pp. 43, 178.
23. See Wildenstein 1974–85, vol. 1, pp. 36–38, and the letters reprinted pp. 423–25.
24. Rouillard 1984, chs. 4 and 5.
25. See Wildenstein 1974–85, vol. 1, p. 46.
26. *Guide annuaire* 1868, p. 80, lists it among eleven "principal hotels" at Trouville, with room and board pegged at six to seven francs a day.
27. *Guide annuaire* 1868, p. 17.
28. Désert 1983, p. 89.
29. *Guide annuaire* 1868, pp. 75–78.
30. *Album-guide* 1881, p. 58.
31. A collaboration of Alfred Hennequin and Albert Millaud, first performed in 1878. According to Mortier 1875–85, vol. 5, p. 55 and passim, it had 170 performances by mid-summer. The scene in the first act was decorated with bathing cabins, and the performers were dressed in bathing costume; the third act of this trendy play includes jockeys at the racetrack.
32. Macquoid 1895, p. 317.
33. Outin's painting, recently on the art market, is almost certainly *Sur la falaise*, exhibited in the Salon of 1878, no. 1709.
34. For Offenbach, see Kracauer 1937, pp. 155, 197, 279, 307, and for Michelet, his *La Mer* (1861), pp. 404–407. Monet also may have regretted the advent of tourism, for it is possible that the touristic "Château des Fréfossés" which perched atop the Porte d'Aval (it shows in Pl. 310) was built by 1886 when he painted there; it shows in paintings by Boudin signed and dated 1887, but never in Monet's pictures. He may have deliberately omitted it, although this remains mere conjecture. The earliest surviving municipal records concerning this absurd conceit, dynamited in 1911, are dated 1891 (communication from Jacques Caumont); researches so far have failed to specify when it was built.
35. Letters reprinted in Wildenstein 1974–85, vol. 2, p. 268.
36. "L'Exposition internationale de la rue de Sèze," *La Revue indépendante*, 3 (June 1887); 352f. The key phrase reads. "La sauvagerie de cette peinture vue par un oeil de cannibale déconcerte d'abord,..."
37. *The Complete Letters of Vincent van Gogh*, 3 vols. (Greenwich, Conn., 1958), vol. 3, p. 78, letter of 1888 to Theo Van Gogh.

Bibliography

Annotated Bibliography

For intelligent histories of Paris and France of the impressionist era, see Agulhon, Chouay, et al. 1983, Braudel and LaBrousse 1977, Burchill 1971, Cobban 1965, Dansette 1976, Dubech and Espézel 1931, Gaillard 1976 and Seignebos 1921. Among the best histories of social life of that era, including the roles of artists and writers, are Alméras 1933, Avenel 1900–05, Bancquart 1979, Carnavalet 1985, Crubellier 1974, Daumard 1970, Duveau 1946, Elwitt 1975, Fleury and Sonolet 1928, Gourdon de Genouillac 1893–98, La Gorce 1899–1905, Miller 1981, Poète 1924–31, Richardson 1971, Seigel 1986, Sennnett 1977, Tabarant 1942, and Zeldin 1973 and 1977. Since the duc de Morny is of special importance, see Boulenger 1925, Parturier 1969, and Pflaum 1968.

Paris guide books are an invaluable source of information and attitude. The successive editions of Joanne are especially good, although guides aimed at foreign visitors by Baedeker, Galignani, and Murray are sources of comparable merit. In addition, one should consult *Chamber's* 1863, Delvau 1867, and *Paris-guide* 1867. For proper orientation, in view of the many changes of street names since the impressionist era, see Hillairet 1964.

Witness accounts by foreigners and Parisians are abundant, and any selection is bound to be arbitrary. For foreigners, my choices include Child 1893, Hake 1878, James 1875–76, King 1868, McCabe 1869, North Peat 1903, Sala 1879, Tuckerman 1867, Vandam 1892, Venedey 1841, and Whitehurst 1873. For French authors, Delord 1869–74, Delvau (several volumes), Du Camp 1858, Fournel 1858 and 1865, Goncourt 1956, Maugny 1891, Privat d'Anglemont 1854 et seq., Taine 1875, Veuillot 1867, Villemessant 1872–84, Vizetelly 1908, and Yriarte 1864.

Studies of the social history of art, or sociological works of first importance for the arts: Benjamin 1973, Bouvier 1914, Brown 1985, Citron 1961, Clark 1985, Corbin 1978, Goffman 1963, Graña 1967 and 1971, Kracauer 1937, Liefde 1927, Lofland 1973, Lukacs 1936, Moers 1960, Nochlin 1971, Rose 1984, Simmel 1971, Stanton 1980, Veblen 1899, and Williams 1981. I should single out Kracauer, Simmel, and Williams because their analyses are especially stimulating, although they do not deal with painting.

The study of Impressionism begins with Rewald 1973, the fundamental work whose first edition in 1946 set the conditions and the vocabulary of its history. Of more recent books, one should begin with Clark 1985 and Shiff 1984, two contrasting works that have enormous value (see remarks about them in the Preface). Bouillon 1981 gives an excellent account of modern writings on Impressionism. Blunden 1981 is a serviceable and lively book that is more accessible than the others mentioned, but more of a good journalistic account than a revealing analysis. (Most of the detailed history of Impressionism and many of the best insights are found in the monographic literature, which is discussed below.) Some recent exhibitions take up the social context of Impressionism: Grad and Riggs 1982, Los Angeles 1984–85, Reff 1982, and San Francisco 1986.

My choice of writings on individual artists favors the most recent works of merit, not necessarily catalogues raisonnés nor landmark publications of an earlier era, which can be found in the bibliographies of the works I cite. Cassatt: Breeskin 1970, Lindsay 1985, and Pollock 1980. Caillebotte: Berhaut 1978, and Caillebotte 1976–77. Degas: Adhémar and Cachin 1974, Armstrong 1987, Boggs 1962, Boston 1984, Browze 1949, Chicago 1984, Janis 1968, Lemoisne 1946–49, Lipton 1980, Reff (several works), Shackelford 1984, Shapiro 1980, and Thomson 1987. Manet: Brown 1978, Cailler 1945, Gronberg 1984, Hamilton 1954, Hanson 1977, Mainardi 1980, Manet 1983, Manet 1986, Moreau-Nélaton 1926, Proust 1913, Reff 1982, Ross 1982, Sandblad 1954, and Tabarant 1931 and 1947. Monet: Gordon and Forge 1983, House 1986, Isaacson (several works), Levine 1976, Paris 1980, Tucker 1982, and Wildenstein 1974–85. Morisot: Bataille and Wildenstein 1961, Morisot 1950, Morisot 1987–88, and Rey 1982. Renoir: Daulte 1971, Nochlin 1986, Renoir 1985, Renoir 1962, and Rivière 1921.

Chapter One

For the transformation of Paris, in addition to the histories of Paris and France, listed above, see especially Alphand 1867 and 1873, Ariste and Arrivetz 1913, Chapman 1957, Costanzo 1981, Fournier 1855, Haussmann 1890–93, Hoffbauer 1875–82, Loyer 1987, Mainardi 1987, Pinkney 1958, and Sutcliffe 1970. Pinkney and Sutcliffe are the key modern works on Haussmann's Paris; Pinkney is very thorough, but politically naive; Sutcliffe covers less ground, but is alert to the social and human costs of the rebuilding of Paris. Studies of demographics and transport have special value for assessing the changes in Paris after 1850: Chevalier 1950, Dauzet 1948, Gastineau 1863, Gourdon de Genouillac 1893–98, Henderson 1954, Levasseur 1889–92, Merlin 1967, and Weber 1899.

Paintings of the new Paris by Caillebotte, Manet, and Monet are discussed particularly well in Brown 1978, Caillebotte 1976–77, Clark 1985, Isaacson 1966, Mainardi 1980, Reff 1982, and Sandblad 1954. Tuckerman 1867 stands out above most witness accounts because of the author's astute political and social observations; King 1868 and North Peat 1903 are chatty rather than profound books, but they reveal a great deal about Parisian entertainment and leisure.

Chapter Two

The Parisian dandy and the *flâneur* are well treated in Moers 1960, a book of real penetration, in Stanton 1980, and earlier by Walter Benjamin in his gifted aphorisms, gathered together in Benjamin 1973. Kracauer 1937 is especially good on the *boulevardier* and his apparent political indifference under the regime of Louis Napoleon. Manet is analyzed as *flâneur* in Sandblad 1954, and Caillebotte in Caillebotte 1976–77. Reff 1976 treats Degas's ties to naturalist writers. Journalistic illustrations and caricature are studied in relation to the impressionists by Gronberg 1984, Isaacson 1982, Reff 1976,

Ross 1982, and Wechsler 1982. The most profound interpretation of the apparent objectivity that was so vital to the impressionists' generation are in Georg Simmel's essays from the beginning of the century, anthologized in Simmel 1971. Parallels in naturalism are considered by Brown 1978, Caillebotte 1976–77, Caramaschi 1971, Crouzet 1964, Lukacs 1936, Reff 1976, Richardson 1982, and Sandblad 1954.

Chapter Three

The best study ever published of Parisian entertainment is Kracauer 1937, valuable for its many insights although painting is not discussed. Kracauer has wonderful pages on bohemians, and on Degas's intimate friend Halévy, as well as on the socio-political meanings that abound in Offenbach's operettas. Marginals and bohemians are examined by Brown 1978 and 1985, Hanson 1977, Seigel 1986, Reff 1982, and Rivière 1921, and they are given witness by Delvau 1862 and 1867, and Fournel 1858. For café and café-concert, the most valuable contemporaneous accounts are Constantin 1872, Delvau 1862 and 1867, Menetrière 1870, and Paulus 1908. Joanne's Paris guides regularly listed the better known cafés and cafés-concerts, usually with indication of prices; the changes in his entries for cafés in successive editions reveal shifting fortunes and altered patterns of café entertainment. Modern studies of café and café-concert: Barrows 1979, Caradec and Weill 1980, Clark 1985, Courtine 1984, Gronberg 1984, Manet 1986, Marrus 1974, Pickvance 1963, Poète 1924–31, Ross 1982, and Shapiro 1980. Caradec and Weill are especially thorough in their canvasing of café-concert libretti, and their well-illustrated book gives information about leading impresarios, librettists, and performers. For the Folies-Bergère, see Derval 1955. Modern sociological studies examine public behaviour in cafés and make useful observations, even though they are limited to twentieth-century environments: Goffman 1963 and Lofland 1973.

Chapter Four

Modern histories of Parisian theater, opera, ballet, and dance are found in Alméras 1933, Avenel 1900–1905, Gasnault 1986, Guest 1974, Kracauer 1937, and Poète 1924–31. Because of Degas's life-long involvement with the ballet, see Boggs 1962, Browze 1949, Janis 1968, Reff 1976, and Shackelford 1984. Since entertainment loomed so large in Paris, the best witness accounts treat theater and opera in some detail. French authors include Boigne 1857, Delvau 1867, Dreyfus 1880, Halévy 1935, Mortier 1875–85, Taine 1875, and Véron 1860. Boigne, Dreyfus, and Mortier examine life behind the scenes at the opera with apparent objectivity. The liveliest foreign memoirs of theater life are King 1868, McCabe 1869, Morford 1867, and Vandam 1892. Joanne and other guide books regularly list theaters of all types, sometimes with prices and typical programs. The Jockey Club, whose role in the Opéra was paramount, is well studied in Roy 1958 and Yriarte 1864.

Chapter Five

The Bois de Boulogne and other parks are examined in Alphand 1867 and 1873, Ariste and Arrivetz 1913, Audiganne and Bailly 1861–63, LaBédollière 1861, Pinkney 1958, Reclus 1866, Sutcliffe 1970, Villefosse 1942, and in relation to artists in Grad and Riggs

1982, Isaacson 1972, Los Angeles 1984–85, and Reff 1982. Guide books are, once again, a good source; Joanne 1885 is particularly good on the Bois de Boulogne. Longchamp, the Jockey Club, and other racetracks near Paris are discussed in Chapus 1854, Roy 1958, and Yriarte 1864. Lively witness is given by Delvau 1867, Joanne 1868, North Peat 1903, and Whitehurst 1873. For Degas and Manet at the races, see Harris 1966, Manet 1983, nos. 99–101 and 132, Reff 1982.

Fashions are easily documented in the contemporary illustrated press (both articles and advertisements) and in numerous fashion reviews. Zola was alert to the significance of fashion in more than one novel, and *Au Bonheur des dames* (Ladies' Delight) revolves around the way a department store magnate manipulated his clients with the aid of changing fashions. For fashion see also Baudelaire's "The Painter of Modern Life" in Baudelaire 1964, Bicknell 1895, Child 1893, Rivière 1921, "Fashion," in Simmel 1971, and Veblen 1899.

Chapter Six

Suburbs and suburban leisure are considered in Barron 1886, Bastié 1964 (very useful despite its concentration on the twentieth century), Chapus 1854, Dauzet 1948, Gasnault 1986, Gastineau 1863, King 1868, LaBédollière 1861, Liefde 1927, Martin 1894, Merlin 1967, Morford 1867, Phlipponneau 1956, Reclus 1866, and Touchard-Lafosse 1850. Numerous Paris guide books had sections on the suburbs, and some guide books were devoted solely to the environs of the capital; among the best are Joanne 1856 and 1868, and *Paris-guide* 1867. Suburban boating was often included in books on sport; leading examples are Chapus 1854 and Karr 1858.

For painters' activity in the suburbs, see Caillebotte 1976–77, Catinat 1967, Catinat 1952, Clark 1985, Grad and Riggs 1982, Herbert 1982, Los Angeles 1984–85, Reidemeister 1963, Rewald 1973, Tucker 1982, and Wildenstein 1974–85.

Chapter Seven

Seaport leisure is well treated in *Album-guide* 1881, Chapus 1855, *Désert 1983, Guide annuaire* 1868, Los Angeles 1984–85, Macquoid 1895, Michelet 1861, Rouillard 1984, and Venedey 1841. Rouillard's book is of unusual distinction. Guide books to Normandy, including Murray and Baedeker, pay close attention to resorts and their amenities. MacCannell 1976 concerns the twentieth century, but has important insights for seaport tourism of the impressionist period. Some works on individual artists have general value as well: Jean-Aubry 1968 on Boudin, and Wildenstein 1974–85 on Monet.

Conclusion

Although there are many studies of leisure and entertainment in mid- and later twentieth-century culture, rather few deal with it in the nineteenth century. The interested reader has to apply to the impressionist era the lessons learned from these publications: Huizinga 1938, Goffman 1963, MacCannell 1976, Marrus 1974, Pieper 1953, Roberts 1970, and Veblen 1899. Rearick 1985 is one of the rare books to concentrate on Parisian entertainment and leisure, but it begins in the 1880s, at the point my book ends.

List of References

Unless otherwise stated, Paris is the place of publication for books. Dates of first editions are recorded in brackets when later editions have been used. Short titles used in the Notes and Annotated Bibliography frequently refer to the most famous edition, regardless of the one used.

Research for this book ceased in 1986; some important publications of late 1986 and 1987 have been listed here, even though I was unable to incorporate their findings.

Adhémar, Hélène. See Paris 1980.

Adhémar, Jean, and Françoise Cachin. *Degas: The Complete Etchings, Lithographs and Monotypes*. Trans. Jane Brenton. London and New York 1974 [1973].

Agulhon, Maurice, Françoise Chouay, et al. *La Ville de l'âge industriel*. Vol. 4 of *Histoire de la France urbaine* (Georges Duby, ed.). 1983.

Album-guide illustré des voyages circulaires, Côtes de Normandie. 1881.

Alméras, Henri d'. *La Vie Parisienne sous le Second Empire*. 1933.

Alphand, Adolphe. *Les Promenades de Paris....* 2 vols. 1867 and 1873.

Ariste, Paul d', and Maurice Arrivetz. *Les Champs-Elysées*. 1913.

Armstrong, Carol M. *Odd Man Out: Readings of the Work and Reputation of Edgar Degas*. Ann Arbor 1987.

Arnheim, Rudolph. "Accident and the Necessity of Art," *Journal of Aesthetics and Art Criticism* 16 (1957): 18–31.

Audiganne, M., and P. Bailly. *Paris dans sa splendeur: Monuments, vues, scènes historiques....* 3 vols. in 2. 1861–63.

Avenel, Georges d'. *Le Mécanisme de la vie moderne*. 5 vols. 1900–1905.

Bancquart, Marie-Claire. *Images littéraires du Paris 'fin-de-siècle.'* 1979.

Barron, Louis. *Les Environs de Paris*. 1886.

Barrows, Susanna. "After the Commune: Alcoholism, Temperance and Literature in the Early Third Republic," in *Consciousness and Class Experience in Nineteenth Century Europe*. Ed. John M. Merriman. London 1979.

Bastié, Jean. *La Croissance de la banlieue parisienne*. 1964.

Bataille, Marie Louise, and Georges Wildenstein. *Berthe Morisot, catalogue des peintures, pastels et aquarelles*. 1961.

Baudelaire, Charles. *The Painter of Modern Life and other Essays*. Trans. and ed. Jonathan Mayne. London 1964.

Bazin, A. [Anais de Raucou]. *L'Epoque sans nom, Esquisses de Paris 1830–1833*. 2 vols. 1833.

Benjamin, Walter. *Charles Baudelaire: a Lyric Poet in the Era of High Capitalism*. Trans. Harry Zohn. London 1973.

Berhaut, Marie. *Gustave Caillebotte: sa vie et son oeuvre*. 1978.

Bicknell, Anna L. *Life in the Tuileries under the Second Empire*. New York 1895.

Blunden, Maria and Godfrey. *Impressionists and Impressionism*. Geneva and London 1981.

Boggs, Jean S. *Portraits by Degas*. Berkeley 1962.

Boigne, Charles de. *Petits mémoires de l'Opéra*. 1857.

Boime, Albert. "Entrepreneurial Patronage in 19th Century France," in *Enterprise and Entrepreneurs in 19th and 20th Century France*. Ed. E.C. Carter, R. Forster, J.M. Moody. Baltimore 1976.

Boston Museum of Fine Arts (Sue Welsh Reed and Barbara Stern Shapiro). *Edgar Degas: The Painter as Printmaker*. 1984.

Bouillon, Jean-Paul. "L'Impressionnisme," *Revue de l'art* 51 (1981): 75–85.

Boulenger, Marcel. *Le Duc de Morny, prince français*. 1925.

Bouvier, Emile. *La Bataille réaliste (1844–1856)*. 1914.

Brame, Philippe. See Lemoisne, Paul-André.

Braudel, Fernand, and Ernest LaBrousse. *Histoire économique et sociale de la France*. III. *L'Avènement de l'ère industrielle (1789–années 1880)*. 2 vols. 1977.

Breeskin, Adelyn D. *Mary Cassatt: a Catalogue Raisonné*. Washington, 1970.

Brettell, Richard R. *Pissarro and Pontoise: The Painter in a Landscape*. Ph.D. diss. Yale University 1977.

———. See Los Angeles 1984 and Pissarro 1981.

Broude, Norma. "Degas's 'Misogyny,'" *Art Bulletin* 59 (March 1977): 97–107.

Brown, Marilyn. "Manet's *Old Musician*: Portrait of a Gypsy and Naturalist Allegory," *Studies in the History of Art* (Washington, National Gallery) 8 (1978): 77–87.

———. *Gypsies and Other Bohemians*. Ann Arbor 1985.

Browze, Lillian. *Degas Dancers*. Boston 1949.

Burchill, S. C. *Imperial Masquerade: The Paris of Napoleon III*. New York 1971.

Cachin, Françoise. See Adhémar, Jean; Manet 1983; Pissarro 1981.

Caillebotte 1976–77. Houston, Museum of Fine Arts, and Brooklyn Museum of Art (J. Kirk T. Varnedoe, Thomas P. Lee, et al.). *Gustave Caillebotte: a Retrospective Exhibition*. 1976–77. See Varnedoe 1987.

Cailler, Pierre, ed. *Manet raconté par lui-même et par ses amis*. Geneva 1945.

Caradec, François, and Alain Weill. *Le Café-concert*. 1980.

Caramaschi, Enzo. *Réalisme et impressionnisme dans l'oeuvre des frères Goncourt*. Pisa and Paris 1971.

Carnavalet, Musée. *Les Grands boulevards*. 1985.

Catinat, Jacques. *Douze grandes heures de Chatou et la naissance du Vésinet*. 1967.

Catinat, Maurice. *Les Bords de la Seine avec Renoir et Maupassant; l'Ecole de Chatou*. Chatou 1952.

Chambers's Handy Guide to Paris...together with an account of the permanent Exposition of 1863. London and Edinburgh 1863.

Champa, Kermit S. *Studies in Early Impressionism*. New Haven and London 1973.

Chapman, Joan and Brian. *The Life and Times of Baron Haussmann*. London 1957.

Chapus, Eugène. *Le Sport à Paris*. 1854.

———. *De Paris au Havre*. 1855.

Chevalier, Louis. *La Formation de la population parisienne au XIXe siècle*. 1950.

Chicago 1984. Art Institute of Chicago (Richard R. Brettell and Suzanne Folds McCullagh). *Degas in the Art Institute of Chicago*. Chicago 1984.

Child, Theodore. *The Praise of Paris*. New York 1893.

Citron, Pierre. *La Poésie de Paris de Rousseau à Baudelaire*. 2 vols. 1961.

Clark, Timothy J. "The Bar at the Folies-Bergère," in *The Wolf and the Lamb: Popular Culture in France*. Ed. J. Beauroy, M. Bertrand, and E. Gargan. Saratoga, Cal. 1977, pp. 233–52.

———. *The Painting of Modern Life, Paris in the Art of Manet and his Followers*. New York 1985.

Cobban, Alfred. *A History of Modern France*. 3 vols. in 1. New York 1965.

Constantin, Marc. *Histoire des cafés-concert et des cafés de Paris*. 1872.

Corbin, Alain. *Les Filles de noces; misère sexuelle et prostitution: 19e et 20e siècles*. 1978.

Costanzo, Dennis Paul. "Cityscape and the Transformation of Paris during the Second Empire." Ph.D. diss. University of Michigan 1981.

Courtine, Robert. *La Vie parisienne, cafés et restaurants des boulevards 1814–1914*. 1984.

Crespelle, Jean-Paul. *La Vie quotidienne des impressionnistes*. 1981.

Crouzet, Maurice. *Un Méconnu du réalisme, Duranty (1833–1880)*,

l'homme, le critique, le romancier. 1964.

Crubellier, Maurice. *Histoire culturelle de la France, XIXe-XXe siècles.* 1974.

Dansette, Adrien. *Naissance de la France moderne, le Second Empire.* 1976.

Daudet, Alphonse. *Le Nabab.* 1877.

Daulte, François. *Alfred Sisley: Catalogue raisonné.* Lausanne 1959.

——. *Auguste Renoir. Catalogue raisonné de l'oeuvre peint.* Vol. 1: *Figures 1860–1890.* Lausanne 1971.

Daumard, Adeline. *Les Bourgeois de Paris au XIXe siècle.* 1970.

Dauzet, Pierre. *Le Siècle des chemins de fer en France.* 1948.

Delord, Taxile. *Histoire du Second Empire.* 6 vols. 1869–74.

Delvau, Alfred, Edmond Duranty, et al. [etchings by L. Flameng]. *Paris qui s'en va, et Paris qui vient.* 1859.

Delvau, Alfred. *Histoire anecdotique des cafés et cabarets de Paris.* 1862.

——. *Dictionnaire de la langue verte.* 1866.

——. *Les Plaisirs de Paris.* 1867.

Derval, Paul. *The Folies-Bergère.* Trans. Lucienne Hill. New York 1955.

Désert, Gabriel. *La Vie quotidienne sur les plages normandes du Second Empire aux années folles.* 1983.

Distel, Anne. See Paris 1980 and Renoir 1985.

Dreyfus, Abraham. *Scènes de la vie de théâtre.* 1880.

Dubech, Lucien, and Pierre d' Espézel. *Histoire de Paris.* 2 vols. 1931.

Du Camp, Maxime. *Les Chants modernes.* 1858.

——. *Paris, ses organes, sa fonction et sa vie dans la second moitié du XIXe siècle.* 6 vols. 1869–76.

Duranty, Edmond. *La Nouvelle peinture: à propos du groupe d'artistes qui expose dans les Galeries Durand-Ruel.* Ed. Marcel Guérin. 1946 [1876]. For English trans. see San Francisco 1986.

Duret, Théodore. *Les Peintres impressionnistes* [1878], in his *Critique d'avant-garde.* 1885.

——. *Histoire d'Edouard Manet et de son oeuvre.* 1902.

Duveau, Georges. *La Vie ouvrière sous le Second Empire.* 1946.

Elwitt, Sanford J. *The Making of the Third Republic, Class and Politics in France 1868–1884.* Baton Rouge 1975.

Faris, Alexander. *Jacques Offenbach.* New York 1980.

Farwell, Beatrice, ed. *Manet,* special issue of *Art Journal* 44 (spring 1985).

Flameng, Léopold. See Delvau 1859.

Fleury, Comte, and Louis Sonolet. *La Société du Second Empire.* 4 vols. 1928 [1911].

Forge, Andrew. See Gordon and Forge 1983.

Fournel, Victor. *Ce qu'on voit dans les rues de Paris.* 1858.

——. *Paris nouveau et Paris futur.* 1865.

Fournier, Edouard. *Paris démoli.* 2nd ed. 1855.

Gaillard, Jeanne. *Paris la ville (1852–1870).* Lille 1976.

Gasnault, François. *Guinguettes et lorettes, Bals publics et danse sociale à Paris entre 1830 et 1870.* 1986.

Gastineau, Benjamin. *Histoire des chemins de fer.* 1863.

Goffman, Erving. *Behaviour in Public Places.* New York 1963.

Goncourt, Edmond and Jules de. *Journal des Goncourts: Mémoires de la vie littéraire.* Ed. Robert Ricatte. 22 vols. Monaco 1956 [1887–88].

——. *René Mauperin* (1864); *Germinie Lacerteux* (1864); *Henriette Maréchal* (1865); *Manette Salomon* (1867); *La Fille Elisa* (1875); *Les Frères Zemganno* (1879).

Gordon, Robert, and Andrew Forge. *Monet.* New York 1983.

Gourdon de Genouillac, H. *Paris à travers les siècles.* 6 vols. 1893–98.

Grad, Bonnie L., and Timothy Riggs. *Visions of City and Country, Prints and Photographs of 19th Century France.* Exhib. cat. Worcester, Mass. 1982.

Graña, Cesar. *Modernity and its Discontents.* New York 1967 [1964].

——. "French Impressionism as an Urban Art Form," in his *Fact and Symbol.* New York 1971.

Gronberg, Theresa Ann. "Femmes de brasserie," *Art History* 7 (September 1984): 329–44.

Guest, Ivor. *The Ballet of the Second Empire, 1858–1870.* London 1974 [1953, 1955].

Guide annuaire à Trouville-Deauville, Villers-sur-Mer et Cabourg. 1868 [1866]. Some texts signed Henri Letang.

Hake, A. Egmont. *Paris Originals.* London 1878.

Halévy, Ludovic. *Mme et M. Cardinal* (1872); *Les Petites Cardinal* (1880); *La Famille Cardinal* (1883).

——. *Carnets.* 2 vols. 1935.

Hamilton, George H. *Manet and his Critics.* New Haven 1954.

Hanson, Anne Coffin. *Manet and the Modern Tradition.* New Haven and London 1977.

Harris, Jean C. "Manet's Racetrack Paintings," *Art Bulletin* 48 (1966): 78–82.

Henderson, William O. *Britain and Industrial Europe 1750–1870.* Liverpool 1954.

Herbert, Robert L. "Method and Meaning in Monet," *Art in America* 67 (September 1979): 901–908.

——— "Industry and the Changing Landscape from Daubigny to Monet," in *French Cities in the Nineteenth Century.* Ed. John M. Merriman. London 1982.

——. "Impressionism, Originality, and Laissez-Faire," *Radical History Review* 38 (spring 1987): 7–15.

Hillairet, Jacques. *Dictionnaire historique des rues de Paris.* 2 vols. 2nd ed. 1964.

Hoffbauer, T.J.H. Fédor. *Paris à travers les ages.* 2 vols. 1875–1882.

Hofmann, Werner. *Nana: Mythos und Wirklichkeit.* Cologne 1972.

House, John. *Monet: Nature into Art.* New Haven and London, 1986.

——. See Manet 1986 and Renoir 1985.

Huizinga, Johan. *Homo Ludens, a study of the play element in culture.* Boston 1955 [1938].

Huysmans, Joris-Karl. *L'Art moderne.* 1883.

Isaacson, Joel. "Monet's Views of Paris." Allen Memorial Art Museum *Bulletin* (Oberlin) 24 (fall 1966): 5–22.

——. *Monet: Le Déjeuner sur l'herbe.* London 1972.

——. *Claude Monet, Observation and Reflection.* Oxford and New York 1978.

——. "Impressionism and Journalistic Illustration," *Arts* 56 (June 1982): 95–115.

James, Henry. *Parisian Sketches, Letters to the 'New York Tribune.'* Ed. Leon Edel and Ilse Dusoir Linde. London 1958 [1875–76].

Janis, Eugenia Parry. *Degas Monotypes.* Exhib. cat. Fogg Art Museum, Cambridge, Mass. 1968.

Jean-Aubry, G. *Eugène Boudin d'après des documents inédits.* Lausanne and Paris 1968 [1932].

Joanne, Adolphe. *De Paris à Saint-Germain, à Poissy et à Argenteuil.* 1856.

——. *Paris illustré.* 1863.

——. *Les Environs de Paris illustrés.* 1868.

——. *Paris illustré en 1870.* 1870.

——. *Normandie.* 1873.

——. *Paris Diamant.* 1875.

Journal de la Société de Statistique de Paris. Annual, 1860–1914.

Karr, Alphonse. *Le Canotage en France.* 1858.

King, Edward. *My Paris, French Character Sketches.* Boston 1868.

Kracauer, Siegfried. *Offenbach and the Paris of his Time.* London 1937.

Kranowski, Natan. *Paris dans les romans d'Emile Zola.* 1968.

LaBédollière, Emile de. *Histoire des environs du nouveau Paris.* 1861.

La Gorce, Pierre. *Histoire du Second Empire.* 7 vols. 1969 [1899–

1905].

Lemoisne, Paul-André. *Degas et son oeuvre.* 4 vols. 1946–49. Supplement, accompanying reprint, by Philippe Brame and Theodore Reff. New York 1984.

Levasseur, Emile. *La Population française.* 3 vols. 1889–92.

Levine, Steven. *Monet and his Critics.* New York 1976 [1974].

Liefde, Carel Lodewijk de. *Le Saint-Simonisme dans la poésie française entre 1825 et 1865.* Haarlem 1927.

Lindsay, Suzanne G. *Mary Cassatt and Philadelphia.* Exhib. cat. Philadelphia Museum of Art 1985.

——. See Morisot 1987–88.

Lipton, Eunice. "Manet: A Radicalized Female Imagery," *Artforum* 13 (March 1975): 48–53.

——. "The Laundress in Late Nineteenth-Century French Culture: Imagery, Ideology, and Edgar Degas," *Art History* 3 (September 1980): 295–313.

Lofland, Lyn. *A World of Strangers. Order and Action in Urban Public Space.* New York 1973.

Los Angeles County Museum of Art; Art Institute of Chicago; Paris, Grand Palais (Richard Brettell, Scott Schaeffer, et al.). *A Day in the Country.* 1984–85.

Loyer, François. *Paris XIXe siècle. L'Immeuble et la rue.* 1987.

Lukacs, Gyorgy. "Narrate or Describe," in his *Writer and Critic.* Trans. Arthur Kahn. New York 1971 [1936].

McCabe, James D. *Paris by Sunlight and Gaslight.* Philadelphia 1869.

MacCannell, Dean. *The Tourist. A New Theory of the Leisure Class.* New York 1976.

McCauley, Elizabeth Anne. *A.A.E. Disdéri and the Carte de Visite Portrait Photograph.* New Haven and London 1985.

McMullen, Roy. *Degas: His Life, Times, and Work.* Boston 1984.

Macquoid, Katherine S. *Through Normandy.* London 1895 [1874].

Mainardi, Patricia. "Edouard Manet's View of the Universal Exposition of 1867," *Arts* 54 (January 1980): 108–15.

——. *Art and Politics of the Second Empire. The Universal Expositions of 1855 and 1867.* New Haven and London 1987.

Manet 1983. Paris, Grand Palais, and New York, Metropolitan Museum (Françoise Cachin, Charles Moffett, et al.). *Manet 1832–1883.* 1983.

Manet 1986. London, Courtauld Institute Galleries (Juliet Wilson Bareau, essay by John House). *The Hidden Face of Manet. An investigation of the artist's working processes.* Separately paginated insert in *Burlington Magazine* 128 (April 1986).

Marrus, Michael. "Social Drinking in the Belle Epoque," *Journal of Social History* 7 (winter 1974).

——, ed. *The Emergence of Leisure.* New York 1974.

Martin, Alexis. *Tout autour de Paris: promenades et excursions dans le département de la Seine.* 1894.

Maugny, Comte de. *Souvenirs of the Second Empire.* London 1891.

Menetrière, Albéric. *Les Etoiles du café-concert.* 1870.

Merlin, Pierre. *Les Transports parisiens.* 1967.

Michelet, Jules. *La Mer.* 1861.

Miller, Michael. *The Bon Marché: Bourgeois Culture and the Department Store, 1869–1920.* Princeton 1981.

Mirecourt, Eugène de. "Alphonse Karr," in his *Les Contemporains.* 1858.

Moers, Ellen. *The Dandy.* New York 1960.

Moffett, Charles. See Manet 1983 and San Francisco 1986.

Moreau-Nélaton, Etienne. *Manet raconté par lui-même.* 2 vols. 1926.

Morford, Henry. *Paris in '67, or The Great Exposition, its Side-shows and Excursions.* New York 1867.

Morisot, Berthe. *Correspondance de Berthe Morisot avec sa famille et ses amis.* Ed. Denis Rouart. 1950. English language eds. (trans. Betty W. Hubbard) New York 1957, London 1959 and 1986.

Morisot 1987–88. South Hadley, Mount Holyoke Museum of Art, and Washington, National Gallery of Art (Charles F. Stuckey, William T. Scott, Suzanne G. Lindsay). *Berthe Morisot Impressionist.* 1987–88.

Mortier, Arnold. *Les Soirées parisiennes par un monsieur de l'orchestre.* 11 vols. 1875–85.

Nochlin, Linda. *Realism.* London 1971.

——. "A Thoroughly Modern Masked Ball," *Art in America* 71 (November 1983): 188–201.

——. "Renoir's Men: Constructing the Myth of the Natural," *Art in America* 74 (March 1986): 103–107.

North Peat, Anthony B. *Gossip from Paris During the Second Empire.* London 1903.

Orienti, Sandra. See Rouart and Orienti 1970.

Paris-guide par les principaux écrivains et artistes de la France. 2 vols. 1867.

Paris, Grand Palais (Hélène Adhémar, Anne Distel, Sylvie Gache). *Hommage à Claude Monet.* 1980.

Parturier, Maurice. *Morny et son temps.* 1969.

Paulus [Habans, Jean Paul]. *Trente ans de café-concert.* 1908.

Pflaum, Rosalynd. *The Emperor's Talisman. The Life of the Duc de Morny.* New York 1968.

Philadelphia Museum of Art; Detroit Institute of Arts; Paris, Grand Palais. *The Second Empire 1852–1870: Art in France under Napoleon III.* 1978–79.

Phlipponneau, Michel. *La Vie rurale de la banlieue parisienne.* 1956.

Pickvance, Ronald. "L'Absinthe in England," *Apollo* 77 (May 1963): 395–98.

Pieper, Josef. *Leisure, the Basis of Culture.* New York 1953.

Pinkney, David. *Napoleon III and the Rebuilding of Paris.* Princeton 1958.

Pissarro 1981. London, Hayward Gallery; Paris, Grand Palais; Boston, Museum of Fine Arts (Richard Brettell, Françoise Cachin, et al.). *Pissarro 1830–1903.* 1980–81.

Poète, Marcel. *Une Vie de cité, Paris de sa naissance à nos jours.* 4 vols. and atlas. 1924–31.

Pollock, Griselda. *Mary Cassatt.* New York 1980.

Privat d'Anglemont, Alexandre. *Paris anecdote.* 1854 et seq.

Proust, Antonin. *Edouard Manet: souvenirs.* 1913.

Rearick, Charles. *Pleasures of the Belle Epoque.* New Haven and London 1985.

Reclus, Elisée. "Du Sentiment de la nature dans les sociétés modernes," *Revue des deux mondes* 63 (15 May 1866): 352–81.

Reed, Sue Welsh. See Boston 1984.

Reff, Theodore. *Degas, The Artist's Mind.* New York 1976.

——. *Manet and Modern Paris.* Washington 1982.

——. See Lemoisne, Paul-André.

Reidemeister, Leopold. *Auf den Spuren der Maler der Ile de France.* Exhib. cat. Berlin 1963.

Renan, Ernest. *L'Avenir de la science, pensée de 1848.* 1890.

Renoir 1985. London, Hayward Gallery; Paris, Grand Palais; Boston, Museum of Fine Arts (John House, Anne Distel, et al.). *Renoir.* 1985.

Renoir, Jean. *Renoir, My Father.* Boston 1962.

Rewald, John. *The History of Impressionism.* New York 1973 [1946].

Rey, Jean-Dominique. *Berthe Morisot.* Naefels 1982.

Richardson, Joanna. *La Vie Parisienne.* London and New York 1971.

Richardson, John Adkins. "Estrangement as a Motif in Modern Painting," *British Journal of Aesthetics* 22 (summer 1982): 195–210

Riggs, Timothy. See Grad and Riggs 1982.

Rivière, Georges. *Renoir et ses amis.* 1921.

Roberts, Kenneth. *Leisure.* London 1970.

Rose, Margaret A. *Marx's Lost Aesthetic. Karl Marx and the Visual Arts.* Cambridge 1984.

Ross, Novalene. *Manet's 'Bar at the Folies-Bergère' and the Myths of Popular Illustration.* Ann Arbor 1982.

Rouart, Denis, and Sandra Orienti. *Tout l'oeuvre peint d'Edouard Manet.* 1970 [1967].

Rouillard, Dominique. *Le Site balnéaire.* Brussels 1984.

Roy, Joseph-Antoine. *Histoire du Jockey Club de Paris.* 1958.

Sala, George Augustus. *Paris herself again in 1878–9.* 2 vols. 1879.

Sandblad, Nils G. *Manet, Three Studies in Artistic Conception.* Lund 1954.

San Francisco, The Fine Arts Museums, and Washington, National Gallery (Charles S. Moffett et al.). *The New Painting: Impressionism 1874–1886.* 1986.

Schaeffer, Scott. See Los Angeles 1984.

Schapiro, Meyer. "Nature of Abstract Art," *Marxist Quarterly* 1 (January–March 1937): 77–99; reprinted in his *Modern Art: 19th and 20th Centuries.* New York 1978.

Scott, William T. See Morisot 1987–88.

Seigel, Jerrold. *Bohemian Paris. Culture, Politics and the Boundaries of Bourgeois Life 1830–1930.* New York 1986.

Seignebos, Charles. *Le Déclin de l'Empire et l'établissement de la 3e République (1859–1875).* Vol. 7 of *Histoire de la France contemporaine* (Ernest Lavisse, ed.). 1921.

Sennett, Richard. *The Fall of Public Man.* New York 1977.

Shackelford, George T. M. *Degas, The Dancers.* Exhib. cat. Washington, National Gallery 1984.

Shapiro, Barbara Stern. See Boston 1984.

Shapiro, Michael. "Degas and the Siamese Twins of the Café-Concert: The Ambassadeurs and the Alcazar d'Eté," *Gazette des Beaux-Arts* 95 (April 1980): 153–64.

Shiff, Richard. *Cézanne and the End of Impressionism.* Chicago 1984.

Simmel, Georg. *On Individuality and Social Forms.* Ed. Donald N. Levine. Chicago 1971

Stanton, Donna. *The Aristocrat as Art.* New York 1980.

Statistique générale de la France. Annual, with special issues devoted to Paris (1881, 1891, 1896), and in 1876, comparisons with provinces.

Stuckey, Charles F. See Morisot 1987–88.

Sutcliffe, Anthony. *The Autumn of Central Paris, the Defeat of Town Planning 1850–1970.* London, 1970.

Tabarant, Adolphe. *Manet: Histoire catalographique.* 1931.

———. *La Vie artistique au temps de Baudelaire.* 1942.

———. *Manet et ses oeuvres.* 1947.

Taine, Hippolyte. *Notes on Paris; The Life and Opinions of M. Frédéric-Thomas Graindorge.* New York 1875.

Texier, Edmond A. *Tableau de Paris.* 2 vols. 1852–53.

Thomson, Richard. *The Private Degas.* Exhib. cat. London 1987.

Touchard-Lafosse, G. *Histoire de Paris et de ses environs.* 6 vols. 1850.

Tucker, Paul Hayes. *Monet at Argenteuil.* New Haven and London 1982.

Tuckerman, Henry. *Papers about Paris.* New York 1867.

Vandam, Albert D. *An Englishman in Paris.* 2 vols. London 1892.

Varnedoe, J. Kirk T. "The Artifice of Candor: Impressionism and Photography Reconsidered," *Art in America* 68 (January 1980): 66–78.

———. *Gustave Caillebotte.* New Haven and London. 1987. Revised version of Caillebotte 1976–77.

Veblen, Thorstein. *The Theory of the Leisure Class.* New York 1953 [1899].

Venedey, Jacob. *Excursions in Normandy.* 2 vols. London 1841 [1838].

Venturi, Lionello, ed. *Les Archives de l'impressionnisme.* 2 vols. Paris and New York 1939.

Véron, M. L. *Paris en 1860, les théâtres de Paris depuis 1806 jusqu'en 1860.* 1860.

Veuillot, Louis. *Les Odeurs de Paris.* 1867.

Villefosse, René Héron de. *Prés et bois parisiens.* 1942.

Villemessant, J. H. C. de. *Mémoires d'un journaliste.* 6 vols. 1872–84 [1867].

Vizetelly. *Court Life of the Second French Empire 1852–1870.* New York 1908 [1907].

Weber, Adna Ferrin. *The Growth of Cities in the 19th Century.* Ithaca 1963 [1899].

Wechsler, Judith. *A Human Comedy. Physiognomy and Caricature in 19th Century Paris.* London and Chicago 1982.

Weill, Alain. See Caradec and Weill 1980.

White, Barbara Ehrlich, ed. *Impressionism in Perspective.* Englewood Cliffs, New Jersey 1978.

———. *Renoir, His Life, Art, and Letters.* New York 1984.

Whitehurst, Felix. *Court and Social Life in France under Napoleon the Third.* 2 vols. London 1873.

Wildenstein, Daniel. *Claude Monet, biographie et catalogue raisonné.* 4 vols. Lausanne and Paris 1974–1985.

Wildenstein, Georges. See Bataille and Wildenstein 1961.

Williams, Raymond. *Culture and Society, 1780–1950.* New York 1981.

Wilson Bareau, Juliet. See Manet 1986.

Yriarte, Charles. *Les Cercles de Paris 1828–1864.* 1864.

Zeldin, Theodore. *France, 1848–1945.* 2 vols. Oxford 1973 and 1977.

Zola, Emile. *Thérèse Raquin* (1867); *La Curée* (1872); *Le Ventre de Paris* (1873); *Son Excellence Eugène Rougon* (1876); *L'Assommoir* (1877); *Nana* (1880); *Au Bonheur des Dames* (1883); *Germinal* (1885); *L'Oeuvre* (1886); *L'Argent* (1891).

Index